ALICE AYCOCK

ALICE AYCOCK

Sculpture and Projects

ROBERT HOBBS

The MIT Press
Cambridge, Massachusetts
London, England

Contents

Acknowledgments

While working on this book, I have had many occasions to appreciate the original perceptions of fellow art historians and critics as well as the keen insights of scholars in fields outside art. It is indeed a pleasure to note that scholarship continues to be a collaborative venture and an ongoing conversation.

Even though my graduate school training took place almost three decades ago, I would like to acknowledge the searching questions of such professors at UNC Chapel Hill as Jaroslav Folda, Frances Heumer, and Joseph C. Sloane that keep coming back to me, creating the impetus for extended conversations over time that have bridged our very different areas of interest. The Socratic teaching method of my dissertation director, Donald Kuspit, was wonderfully stimulating and continues to be deeply appreciated.

The work of several generations of colleagues such as Robert Herbert, Ann Coffin Hanson, Lawrence Alloway, Lucy Lippard, Gail Levin, Elsa Fine, Thomas W. Leavitt, Andrew Ramage, Ester Dotson, Jacqueline Falkenheim, Robert Calkins, S. A. Mansbach, Creighton Gilbert, Craig Adcock, John Hallmark Nett, Stephen Foster, Christopher Roy, Gaylord Torrence, Joanne Kuebler, Fredricka Jacobs, Charles Brownell, Babatunde Lawal, and Howard Risatti (who has also written on Aycock's art) reminds me that valuable scholarship can take many different and exciting forms.

In the course of working on this monograph, I have enjoyed in particular reflecting on past conversations with Ed Fry, a colleague at Yale who first introduced me to Aycock's work. A trenchant curator and critic with a first-rate mind, Ed viewed art history in terms of major problems and provocative questions, and he found Italian mannerism, cubism, and Aycock's work intriguing because of their resistance to easy explanations. His casual yet pointed allusions to Aycock's sculpture during the academic year of 1975–1976 were compelling for the far-reaching questions they posed.

Four years later while researching material in the John Weber Gallery's Robert Smithson archives, I was fortunate to spend time with a key Aycock exhibition then on view at this Soho space. This show featured two of her most important works—*The Machine That Makes the World* and *How to Catch and Manufacture Ghosts*—that represented, in the former, an impressive formal entry into the world of heavy machinery and, in the latter, an homage to the continued magic and ghostlike mystery that even rudimentary forms of electricity are capable of evoking.

In 1982 the prescient Italian collector Giuliano Gori invited me to write an essay on the inaugural sculptures then being built for his Fattoria di Celle sculpture park near Pistoia, which included Aycock's

The Nets of Solomon. I took advantage of the opportunity to meet this artist and was impressed then as now with her far-reaching heroic ambitions and wide range of sources.

In 1996, while viewing a show at the Weber Gallery, director Elyse Goldberg asked me to visit with John Weber in his office. During our conversation he suggested that I write a book on Aycock's art since it merited in-depth study. The idea was of great interest, a meeting with Alice was arranged, and she and I agreed that a monograph would be a worthwhile undertaking. Unlike some research projects, this book necessitated in its beginning stages the full cooperation of its subject, and Alice has been particularly generous with her time, recollections, out-of-print catalogues, and requests for images. Our working relationship, which has continued far longer than either of us initially anticipated, has been excellent.

Shortly after Aycock's separation from Mark Segal in the late 1970s, he decided to reflect on his experiences with her by writing a detailed roman à clef. Since he often attended Robert Morris's seminars with his wife and acted as her assistant on a number of occasions, his concrete recollections fill an enormous gap in understanding the artist's early period. Several sections from his manuscript are gratefully cited in the text.

Besides Ed Fry, Aycock's art has attracted a number of perceptive scholars and critics who have returned to her work over the years. The three most dedicated have been Monroe Denton, Jonathan Fineberg, and Stuart Morgan, who have each conducted excellent interviews, made discerning comments on the art, and undertaken the type of legwork that has both enriched and helped to facilitate my work on this monograph. For their important contributions to the understanding of Aycock's art, I am deeply grateful.

My position as the Rhoda Thalhimer Endowed Chair of Art History in Virginia Commonwealth University's School of the Arts has fortunately provided the necessary time to undertake a project of this magnitude. In addition to a particularly understanding and encouraging Dean, Richard Toscan; Senior Associate Dean for Academic Affairs and Director of Graduate Studies, Joe Seipel; and department Chair, James Farmer, I have been privileged to work with a number of excellent graduate students who have served as the Thalhimer Assistant. These include Vittorio Colaizzi, Nicole De Armendi, Dennis Durham, Chris Gilbert, Heather McGuire, and Kathryn Shields. All have made valuable contributions to this study by assiduously collecting research materials and responding critically to my developing ideas. During the final stages of this project, Colaizzi, De Armendi, and Durham have persevered in finding difficult-to-locate illustrations and

obtaining permissions. Jean Scott of vcu's Interlibrary Loan Department at Cabell Library has been indefatigable in searching for little-known and long-out-of-print sources, and her enthusiasm and generosity are greatly appreciated. In addition, Joshua Poteat's interest in this topic continues to be respected, and his comments are duly noted in the footnotes.

With the manuscript for this book complete, the publisher that seemed to me most appropriate for it was the MIT Press. Fortunately the Press's executive editor Roger Conover agreed. His great enthusiasm for the project and abiding respect for Aycock's work, in addition to his thoughtfulness and immense practicality, have been greatly appreciated. At the Press, Lisa Reeve, assistant acquisitions editor, responded to my many inquiries with good humor; production manager Terry Lamoureux has been painstaking in her quest for a high-quality book; copy editors Paula Woolley and Matthew Abbate provided the manuscript with an assiduous, insightful, and most helpful reading; and Emily Gutheinz created an inspired low-key and elegant design that sympathetically frames Aycock's work while tactfully refraining from competing with it.

Since work on the Aycock manuscript continued for over seven years while I was also curating several exhibitions and researching and writing catalogues for them, I am indebted to the truly marvelous support of my wife, Jean Crutchfield—a former gallerist who showed Aycock's work several years before we met. I thank her not only for her belief in this and other projects but also for her willingness to read and reread sections of the Aycock text and thoughtfully respond to them.

It is a privilege to acknowledge, on Alice Aycock's behalf, the enthusiasm, energy, and expertise of the following individuals and companies (listed in chronological order) who have assisted her with fabrication, management, and design. In the area of fabrication they are: Kenneth Morris, Andrew Ginzel, Aaron Goldblatt, David Schaeffer, Mary Patera, Jersey City Welding and Ken Greiff, Michael Rice, Gary Kulak, Susan Burek, Luigi Kurmann, Larry King, Kern/Rockenfield, Dover Tank and Plate and Dave Lawless, Kurt Wulfmeyer, Michael Talley, Tom Dorchak, Grand Arts, Seth Hanselmann, Arrow Dynamics, Michael Wenzel, and Perfection Electricks and Marty Chafkin. Aycock's studio managers, who have been thoughtful and resourceful multi-taskers, include: Ruth Cutler, Carmella Saraceno, Wenda Habenicht, Jesse Rosser, and Sam Korsak. Working in the areas of drafting, model building, and making computer renderings have been: Michael Shakespeare, Carlos Martin, David Troutman, Tom Andersen, Haeyoung Yoon, Michael Randazzo, Jacek Malinowski, and Mark Watkins. To all these individuals as well as Mark Segal, Lauren Ewing,

Monroe Denton, Wynn Kramarsky, Jonathan Fineberg and Nicholas Quennell of Quennell Rothschild Associates, James Ingo Freed of Pei, Cobb, Freed and Partners, Nat Oppenheimer and Kirk Mettam of Robert Silman Associates, Aine Brazile of Thornton-Tomasetti, Joyce Pomeroy Schwartz, Susan Pontious, Trudy Wang, and Vincent Ahern, Aycock extends her deepest gratitude for their willingness to become so involved in her ideas and committed to her goals. And finally, she wishes to thank her son, Halley Aycock-Rizzo.

ALICE AYCOCK

1 The Beginnings of a Complex

The problem seems to be how to connect without connecting, how to group things together in such a way that the overall shape would resemble "the other shape, if shape it might be called, that shape had none," referred to by Milton in Paradise Lost, *how to group things haphazardly in much the way that competition among various interest groups produces a kind of haphazardness in the way the world looks and operates. The problem seems to be how to set up the conditions which would generate the beginnings of a complex.*

Alice Aycock
Project Entitled "The Beginnings of a Complex..."
(1976–77): Notes, Drawings, Photographs, 1977

In Book II of Milton's *Paradise Lost,* Death assumes the guise of two wildly dissimilar figures near Hell's entrance, each with an extravagantly inconsistent appearance. The first, a trickster, appears as a fair woman from above the waist and a series of demons below, while the second—a "he," according to Milton—is far more elusive. It assumes "the other shape" that Aycock refers to above.[1]

When searching for a poetic image capable of communicating the world's elusiveness and indiscriminate randomness, Aycock remembered this description of Death's incommensurability, which she then incorporated into her artist's book *Project Entitled "The Beginnings of a Complex..." (1976–77): Notes, Drawings, Photographs.* Although viewing death in terms of life is certainly not an innovation, as anyone familiar with Etruscan and Greco-Roman culture can testify, seeing life's complexity in terms of this shape-shifting allegorical

figure signaling its end is a remarkable poetic inversion. In this trope, death not only culminates life; it is its chimerical and dark equivalent. Standing at the threshold of Hell, it looks back at the vital forces it terminates, reflecting at once both time's multitudinous shapes and its cessation. Viewed metaphorically, Milton's Death is a mirror and a fissure in a closed universe that provides glimpses of heretofore unimagined possibilities.

This type of opening is a key stratagem in Aycock's work, which seeks to unlock a new space between juxtaposed worldviews. The price for this realization is high, of course, since it disrupts established patterns and ways of reacting to them. Ultimately it places all worldviews on notice and thus goes far beyond Marxist art's proclaimed ability to undermine a dominant ideology's mode of seeing and understanding. Moreover, this art supersedes the defamiliarization Russian formalists theorized that new works are capable of effecting when they alter the ideological and cultural terms used for both framing and experiencing the world. Aycock's art does so by empowering viewers so that they might continue the process of transforming the world long after a given piece has been created. In addition to subscribing to Viktor Shklovsky's admirable assessment that "the technique of art is to make objects 'unfamiliar,' to make forms difficult, to increase the difficulty and length of perception because the process of perception is an aesthetic end in itself and must be prolonged,"[2] Aycock willingly abrogates part of the artist's traditional responsibility as the prime generator of a work's meaning when she enlists viewers as her ongoing collaborators in this process.

In citing Milton's mysterious image, Aycock condenses life's intricacies into a disruptive complex that she views as architectural and sculptural as well as mental and emotional. As we will see, this complex joins the presence of art with the otherness of schizophrenia: it builds even as it tears down. Moreover it demonstrates how this artist regularly enlists images from the past and from other disciplines to serve double duty in her work, to create it even while dissipating it. In many of the pieces from the 1970s and early '80s for which she became famous, Aycock choreographs both her sculptures and scripts about them so that the binary opposites of presence and absence, creation and destruction—low-key late-twentieth-century surrogates for Life and Death—are deconstructed. Although her art might appear to have an edge over her art writing, since we are accustomed to regard artists' statement as supplements, neither the act of viewing the sculpture nor the reading of its supplementary text should be given primacy. Binaries in Aycock's art give way to *différance*— Jacques Derrida's special conjunction of "difference" and "deferring"—that is spatial in demarcating distinctions among closely associated entities and time-bound in delaying ultimate or transcendent meanings. Presence as authoritative meaning is destabilized in this postmodern work, and Aycock's sculpture—like Milton's shape-shifting Death—provides new perspectives on life.

Working in this vein in *"The Beginnings of a Complex . . . ,"* Aycock may have chosen to leave the ending of the above statement inconclusive because she envisioned the beginnings of the complex constituting her art as the first installment of an ongoing contract with her viewers. Aycock provides these viewers with a great number of meaningful and often contradictory clues and then encourages them to negotiate individually the terms in which her art is to be perceived. The basic stipulations may be hers, but the outcome, as she intended, can be highly personal, depending as it does on the individual understanding attained by viewers who willingly submit themselves to the initial and, in many cases, dizzying features of this obsessive work.

This book is concerned with Aycock's purposefully unwieldy complex, its development, and the many deliberate breaks in it, beginning in the late 1960s and early '70s and continuing for almost two decades of extraordinarily intense research that was based on a belief in art and sculpture as a mode of inquiry and not a stable

2

entity. This study will contend that Aycock rethought not only the role of the art object but also the mode of apprehending it. She attempted to discover the type of information art might convey and how it might do so. Moreover she intended to place viewers in situations where they would have to face this same problem. This two-phased epistemological quest, undertaken first by the artist and then by her viewers, involves taking substantial risks, as the process of looking at and understanding a given work of art is far more open-ended than usual: responses can be generalized even though individual reactions cannot be predicted.

Although her highly complex individual works might appear to lack a coherent meaning and a fixed identity, Aycock's overall oeuvre must be regarded with some sense of closure, as her series of works reveal overarching patterns and concerns that partially militate against the epistemological quandaries specific pieces can initiate. Moreover, by leaving individual pieces susceptible to the references and associations she provides, Aycock has created a situation of putative presence and notable absence that is applicable to her work and to the artist's traditional role. This inherent contradiction between single works and entire series—as well as between an individual piece's cogency and the accompanying text's apparent disruption of any straightforward efficacy—is one of the disconcerting and exciting dialectics on which her art is predicated. Although she often refers to her family history, voluminous reading, and far-ranging image file, her work, which remains insistently open to her own contradictions and therefore to viewers' interpretations, can frustrate those who wish to view individual pieces as closed circuits synonymous with their creator, as did the abstract expressionists and their critics.

Because I will be considering Aycock's individual works in terms of her overall oeuvre, this study may be able to achieve an overall conclusiveness about this challenging work that is impossible when examining only one example or a small group of them. To provide the necessary wider perspective, I will attempt to identify as many of the iconographic sources for Aycock's works as possible and unravel many of its mysteries and deliberate obfuscations, knowing that such an approach will enrich the reader's overall understanding at the expense of impoverishing the direct apprehension of individual pieces, making them less confrontational and puzzling. While my approach may appear at times to undermine Aycock's radical attempt to project the task of making meaning out to viewers, I hope that readers will recognize this artist's incredible leaps from one symbolic system to another as concerted attempts to undermine established ideological pathways.

This book will also demonstrate how the openness Aycock courts in her art is relatable to new ways of viewing the world in the late twentieth century that are a legacy of the information age, first in terms of the widespread advance of the mass media in the mid-twentieth century and then in terms of the creation of PCs in the 1970s followed by changes enacted by the Internet at the century's end. Developed in tandem with this plethora of information were concomitant innovations in its storage and retrieval, as well as an increasing awareness of the ways it can be marshaled to ratify some worldviews while undermining others. By looking at Aycock's work chronologically, we can begin to see how it participates in the sheer wealth of this information age at the same time as it casts aspersions on monolithic views. Repeatedly this type of epistemological work creates puzzles with distinct breaks, establishing perceivable gaps in the ideological fabric of its contemporaneous world and in the individual work's rhetoric so that both its time and our views of it are fluid and disruptive. It allows us to imagine how people in the past might have fantasized, for example, about the ability to fly and to be in two places simultaneously that became realities in the twentieth century when airplanes and telephones substantially changed people's modes of travel and communication.

Moreover, this work makes us aware of the information age's enormous contributions to our ability to travel through time, and it enables us to assess the past from manifold perspectives that include present views while going far beyond them. Although individual pieces might appear strangely idiosyncratic and whimsical, as they often have in critical writings on Aycock's work, the first full-scale assessment of this art presented here reveals them to be part of a concerted and far-ranging attack on the limited understanding that comes from accepting a prevailing ideology. Though her work does participate in an information-age ideology, it attempts to counter, as we will see, ready acquiescence to the dictates of this and other worlds by viewing them all as contradictory, often mythic and poetic, and certainly subject to the playful excesses of debating that the Greeks dubbed "sophistry." Aycock's sculptures puncture the information age's apparently seamless web, making what she terms "tears in the universe," at the same time as they interrupt themselves, forcing viewers to think about both art's presumed cogency and the disinclination of her work to play into these assumptions. The consequent breaks in the ideological fabric of our time and the overturning of the ontological work of art, which in the past was deemed a surrogate being, will constitute two of the major subtexts in the account of her work that follows.

After looking at how Aycock pursued an epistemological mode for almost two decades, I conclude my investigation when she begins in the late 1980s to create elegiac and retrospective views of her previous works. Although her subsequent public sculptures build on a substantial number of the ideas examined in this study, they open a new and different chapter deserving its own publication. A postscript at the end of this book adumbrates the direction taken in Aycock's more recent pieces, briefly noting their reliance on the same virtual imaging techniques employed by such architects as Frank Gehry and Zaha Hadid.

Moving from the 1960s to the '70s

Maturing as an artist after the climactic 1960s, when vanguard art had often been equated with fashion and new styles seemed to coincide almost too conveniently with new fall listings, Aycock relied on fundamental aspects of three of the major and lasting currents of this hectic decade when she developed her work.

The first was epitomized in the '60s by the color field painting of Morris Louis, Kenneth Noland, and Jules Olitski. It adhered to the Platonic system of limiting viewers to a stirring and discrete format, termed "opticality" by critic and scholar Michael Fried to connote "a space addressed exclusively to eyesight," which it then encouraged viewers to transcend in the interest of universal values.[3] This art's high aspirations were indirectly critiqued by Fried's former close friend at Princeton in the 1950s, Frank Stella. Often associated with color field painting in the late 1960s, Stella offered the famous laconic observation, "What you see is what you see."[4] Aycock viewed his shaped paintings as the beginning of a trajectory that removed the art of painting from its close affiliation with the wall, so that it might become associated with the "specific objects" of minimalist Donald Judd.[5] Although she rejected the opticality of color field art, she regarded the shaped canvas as an antecedent for her own work.

The second major current that influenced Aycock's art is minimalism, a new development in the '60s known primarily through the work of Judd, Carl Andre, Sol LeWitt, and Robert Morris (Aycock's professor in graduate school). Minimalism perpetuated aspects of formalism's holistic approach while, according to Morris, beginning to project works of art outward to their viewers, making their apprehension provocative exercises in phenomenological seeing—an approach crucial to Aycock's development.

The third approach that Aycock drew upon was conceptual art. Evidenced by the investigations of LeWitt, Joseph Kosuth, Lawrence Weiner, and Art & Language members, among others, conceptual art endeavored to equate art with concepts that could be circumscribed by language. LeWitt took pop artist Andy Warhol's tongue-in-cheek yet resigned view of himself as his television's consort and tape recorder's lifelong mate and transformed it into the dynamics of an "idea becom[ing] a machine that makes the art."[6] Aycock's art, as we will see, modifies aspects of both Warhol's and LeWitt's approaches by characterizing these couplings as schizophrenic and cyborgian.

Instead of making "art investigations"—Kosuth's term for his own conceptual work—traditional sculptors and painters had become content with art's "presentation" and with the viewer's transfixed expectation of a transcendent experience. Consequently, Kosuth saw such artists as decorators of "naïve art forms" rather than as philosophers.[7] Mindful of the difficulty, Aycock, who went through a conceptually oriented phase in her early work, first brings viewers close to her work before distancing them from it. She encourages them to come to terms with contradictory ways of perceiving it so that they straddle traditional boundaries by working both within and outside the limits of established media. In this way she differs from conceptual artist Douglas Huebler, who was willing to dispense with the importance of the art object. As critic and art historian Jack Burnham writes, Huebler

propos[ed] that the percipient is the "subject" of art engaged in a self-producing activity through language, that has, itself, replaced "appearance" and become the virtual image of the work. Perception then, not being available through normal sensory experience, shifts "empiricism" to "metempiricism": concepts and relations conceived beyond objects or material known through experience albeit related to such knowledge.[8]

Although Aycock, like the conceptualists, wished her viewers to become involved in the work of interpretation, she was reluctant to dispense with the object, which often assumed the scale of architecture in her work. We might say that her best art in the 1970s and '80s connects Robert Morris's minimalist object, with its emphasis on phenomenological seeing, to a conceptual emphasis on the work that viewers must undertake in order to understand how art functions epistemologically. Then she complicates this process by subscribing to Derrida's open-ended signifiers.

In the 1960s, formalism and conceptual art used a number of strategies to ordain meaning, respectively, as transcendental or categorical. In contrast, some minimalists—Morris, in particular—aimed at restricting their viewers to a self-evident content attained through their physical bodies, which would ideally be situated in the pristine white galleries in which these works were then frequently exhibited.

One of Aycock's early important contributions to sculpture was to focus on the repetitive shapes of light and relatively easy balloon-frame wood construction, which optimistically reflected the skeletal frames of new buildings. She used this nineteenth-century type of construction—first developed in the United States to replace cumbersome, half-timbered work—together with minimalism's hybrid sculptural/architectural forms and conceptual art's emphasis on language. And she reconfigured these diverse elements, using ordinary lumber as her favored material, to engender a heretofore unparalleled complexity and freedom that could be as daunting and disorienting as it was exhilarating. One might say that she employed these carpentered formalist elements to attract viewers to lightly constructed skeletal forms that appeared domestic, or at least

5

familiar, without being sentimental. She augmented this '70s balloon-frame art with poured concrete and concrete block construction, again relying on a readily available building vernacular to create her sculptures. In creating these works she used minimalism to make viewers aware of their own bodies, and conceptual art to help them think epistemologically about their experiences while trying to reconcile the often contradictory clues her art provides. I believe her tact has been to turn the perception of sculpture into an apperception of the spatial and mental stages involved in approaching it. Only after moving through these processes are viewers equipped to frame these intentionally disjunctive experiences so that they might become meaningful for them.

From the beginning Aycock has believed in using her writings either on their own or in combination with a series of quotations as a means for elaborating on her drawings and sculptures. In her early work these conceptualist descriptions, which were affixed to gallery walls, were clear-cut ways to enumerate process and calculate measurements, particularly for outdoor installation pieces that were represented in the gallery by photographs. Soon Aycock began fantasizing about pieces as she was making them, and these reveries were in turn appended to the work in the form of extended labels. In 1977 the texts assumed the form of elaborate and strange stories, again presented on gallery walls, that complicated and enriched the possible meanings for a given work. Although not all of her sculptures were shown with texts, most of them were displayed this way, either separately or together in the form of an exhibition. Moreover, preliminary studies would often contain texts that were connected to them by labels or actual writing on the drawing itself. This penchant for joining art with allusive writing and suggestive titles, which has continued over the years, is a distinctive quality of this art.

Aycock's artistic contributions are part of a momentous transition separating modern from postmodern art that was undertaken by a number of artists coming of age in the early '70s. In addition to Aycock, members of this nonaffiliated group include Vito Acconci, Siah Armajani, Chris Burden, Gordon Matta-Clark, Mary Miss, and George Trakas, among others. The innovations of these artists, together with the work of minimalists and conceptual artists, presage the major direction art has taken in the past three decades, when its former autonomy has been undermined, making works more open-ended and meaning an ongoing, dynamic arbitration between artists and their viewers. Today, the change from an acceptance of styles based on formal similarities to an awareness of such designations as often highly artificial tags is widely accepted, even though the overall reasons for this transformation are not yet fully understood. As curator Donna DeSalvo has pointed out, "Understanding the shift in art from the late '60s to the '70s is one of the key problems facing art historians and contemporary art curators today."[9]

Elements of this change are no doubt due in part to the increasing respect for Marcel Duchamp's work, including his notes, that followed in the wake of his revived reputation, beginning in the late 1950s and continuing into the '60s. It is also evident in the epistemological turn in '60s art indebted to his work, which was subsequently transformed into an overall, verbally articulated program by such conceptual artists as Kosuth. This move from art's formerly intuited ontology to an epistemology of its strategies was also a driving force of the poststructuralist French theories of Roland Barthes, Jacques Derrida, and Michel Foucault. Reviewing Ferdinand de Saussure's structural analysis of the symbol, Barthes and Derrida focused on ongoing insights formulated by readers. Differing in his emphasis, Foucault historicized epistemology while examining it in terms of specific sets of codes that have wielded inordinate power on the human body when

information has been unquestionably accepted as knowledge. The net effect of these new critical views was to render empiricism problematic by regarding it as a consequence of a socially and historically constructed universe and not a direct mode of perceiving. While museum educators—still a relatively new profession in the 1960s—were relying overwhelmingly on empirical theories when demonstrating the power of art, artists were beginning to reassess this presumed bedrock of unmediated knowledge as well as their own reputed role in disseminating it.

As a key player in the modern/postmodern divide, Aycock is of interest for her reassessment of the work of art's presumed autonomy, as part of the widespread crisis of the art object following in formalism's wake, when it could no longer be regarded as the sole conveyor of meaning. This crisis was predicated on the concomitant problem of the artist's role, which was changing from modernist mythic form-giver to postmodern agent provocateur.

Since the early 1970s, the parameters of any discussion about postmodern works of art and their producers appeared to have been clearly drawn by Roland Barthes's 1968 essay "The Death of the Author."[10] Spelled with a capital "A," for irony, Barthes's Author may have been an esteemed individual in the past, but in the mid-twentieth century this personage was being reduced to the function of a *scriptor* who predictably conformed to a set of ongoing conventions. In his essay's conclusion, Barthes goes beyond this polarity to empower a new protagonist—the reader—and he predicts that "the birth of the reader must be at the cost of the death of the Author."[11] The situation, however, is not so easily resolved as his coup de grâce urbanely suggests. Although subjectivity may well be constructed through ongoing social practices, based on deeply ingrained ideological formations, it still assumes distinct forms that are one among a number of factors affecting the disposition of works of art.

Seen from a slightly different perspective, artistic intent is a wily and unreliable force. Writing almost a century apart, both Charles Baudelaire and Mark Rothko describe the element of surprise occurring to artists at the completion of a work. At that point they find themselves cut off from their art, and they recognize that their subsequent comments will be relegated to the category of informed viewers and no longer accepted as those of the indisputable creator. We might go further and question artistic intent before the work's completion as well. Since so many different and often contradictory ideas occur to artists during the creative process, which may extend over months and years, how, we might well ask, can one idea be privileged over others? Aycock refuses to solve this conundrum and instead exacerbates it at times, providing a series of quotations or statements about a given piece or several works in an exhibition that may or may not represent her intent. Rather than identifying the work with the artist and with her stated though often contradictory intentions, viewers are placed in the preeminent position of postmodern readers who are encouraged to rethink and reorient the work in the process of interpreting it.

This book is predicated on the internal rupture initiated by the proclaimed death and continued survival of the author, particularly in light of Aycock's own fascination with schizophrenia as a subject and also a strategy for making art. As an approach to art, schizophrenia provides a raison d'être for this study's necessary disparateness, in that meaning will be considered in terms of an ongoing dialectic between scriptor as an assigned function and author as a distinct individual. This dialectic is particularly apparent in the ways artists fulfill certain expected roles that are already scripted for them—presenting a heightened view of the world, for example, while provocatively refusing to provide a conclusive meaning for their work. In this situation, significations are posed without being entirely resolved, forcing critics

and art historians to look further afield for interpretive frames and encouraging them to focus on different contexts, each suggesting a range of interpretations. This approach of looking both closely and from a distance is crucial to understanding the mechanisms for meaning central to this type of art.

The problem facing anyone investigating Aycock's work is ultimately how one deconstructs a deconstructionist. How does one cope with an iconography of slipping signifiers that are explicitly presented as part of the structure of the work of art? In many respects Aycock's art is iconographic in a traditional as well as in a striking new sense. Its many references, which take great effort to unravel, do not seem pat and formulaic after one has analyzed them. Like involved mazes seen with clarity from a bird's-eye view, they again confuse and confound once one starts to traverse them. An artificer of intricate spatial and semiotic networks, Aycock in her mature work fabricates literal and figurative mazes that astonish viewers with a sense of the modern world's inordinate contingent "haphazard" complexes that are at once architectural, sculptural, and mental.

But like mazes, Aycock's complexes can be circumscribed and cogent pieces, even though their unity encapsulates the wrong turns, dead ends, and backtracking that often both fascinate and frustrate viewers accustomed to works of art with less recondite and more readily transcendent meanings. Coming soon after the hegemony of late formalist works that quickened viewers' perceptions with gestalts intended to stamp themselves at once on observers' minds, Aycock is part of a generation of artists who wished to slow down perception in order to draw out the complexities of apprehension. Derrida's *différance* is again apposite here, suggesting the puzzling and sustained route of reception central to Aycock's work.

The Complex: Sculpture as the Expanded Field

In 1979, two years after it appeared in Aycock's *Project Entitled "The Beginnings of a Complex . . . ,"* critic Lucy Lippard used the term "complex" in the title of an essay on eleven younger artists working with the concept of shelters.[12] A few months after Lippard's piece, minimalist critic and scholar Rosalind Krauss appropriated "complex" as the central term for one of her most highly lauded essays about new art, "Sculpture in the Expanded Field."[13] Although she focuses only on its landscape and architectural references rather than on the psychotic dimensions Aycock enumerates, Krauss's choice of the term is a fitting tribute to Aycock. After bemoaning the historicist category of modernist sculpture, which transforms new art into endless permutations of old ideas, thereby diminishing its radicalness, Krauss argues:

There is no reason not to imagine an opposite term [for sculpture]—one that would be both landscape *and* architecture—*which within this schema is called the* complex. *But to think the complex is to admit into the realm of art two terms that had formerly been prohibited from it:* landscape *and* architecture—*terms that could function to define the sculpture. . . . Our culture had not before been able to think the complex although other cultures have thought this term with great ease. Labyrinths and mazes are* both *landscape and architecture. . . . The expanded field is thus generated by problematizing the set of oppositions between which the modernist category* sculpture *is suspended.*[14]

Krauss's analysis updates Jack Burnham's "unobjects." Describing these new constructs in 1968, Burnham points out, "A polarity is presently developing between the finite, unique work of high art, i.e., painting or sculpture, and conceptions which can loosely be termed 'unobjects,' these being either environments or artifacts which resist

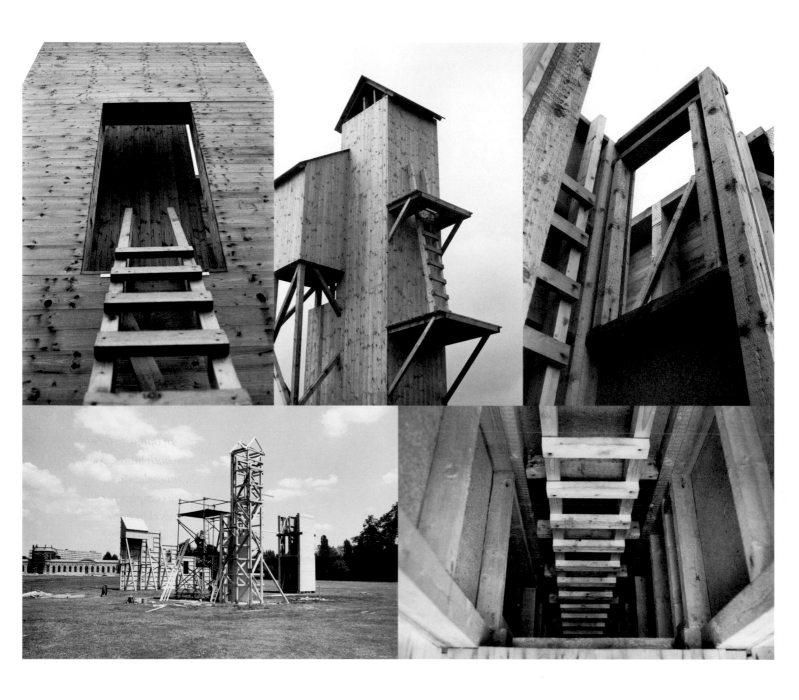

1.1
Alice Aycock, *Project Entitled "The Beginnings of a Complex . . .": For Documenta*,
1977. Wood and concrete; wall facade 40′ long; 8′, 12′, 16′, 20′, 24′ high, respectively;
square tower 24′ high × 8′ square; tall tower group 32′ high. Exhibited at
Documenta 6, Kassel, Germany. Collection of the artist. Photos: artist.

prevailing critical analysis. . . . Looming below the surface of this dichotomy is a sense of radical evolution which seems to run counter to the waning revolution of abstract and non-objective art."[15] In place of Burnham's strict separation of object and conception—a polarity that Aycock incorporates into uneasy tensions in some works of the late '70s and early '80s—Krauss views innovative sculpture as predicated on oppositions between buildings and the land. She lists Aycock as one of several artists expanding this postminimalist work so that it no longer resembles its modernist counterpart.

Even before Krauss's essay was published, Aycock had become known for her series of imposing carpentered and otherwise constructed pieces that combined aspects of sculpture and architecture. These works were poised on the cusp separating sacred and secular spaces, and as the epigraph to this chapter indicates, they were intended to maintain a freedom from given categories of thought, an open-endedness in terms of viewers' responses, and a disparate yet seemingly casual organization consistent with Aycock's view of the modern Western world.

At a time when artists were starting to eschew clear stylistic affiliations for less circumscribed ways of working, Aycock's early work became associated with such terms as "site-specific art," "earthworks," and "installation art." Her discrete indoor pieces were the subject of solo exhibitions at the Museum of Modern Art, New York (1977), and the Museum of Contemporary Art, Chicago (1983). Concurrently with these two exhibitions, both institutions acquired important works by her. In both 1977 and 1987 she exhibited pieces in the prestigious Documenta exhibition in Kassel, Germany, and her art was shown in 1978, 1980, and 1982 at the Venice Biennale. During the late 1970s and early '80s, when neoexpressionist tendencies were competing with late conceptual and minimalist initiatives, curators at the Whitney Museum of American Art deemed Aycock's work

so crucial to ongoing debates about recent art that they included it in both their 1979 and 1981 Biennials. Aycock's sculptures and drawings were subsequently heralded in major retrospective exhibitions at the Württembergischer Kunstverein in Stuttgart (1983) and the Storm King Art Center in Mountainville, New York (1990).

The extensive and often excellent criticism on Aycock's work since the 1970s has established its importance and underscored its daunting intricacies. But as criticism rather than history, it has not had sufficient time to demonstrate how her work interacts with some of the major social, cultural, and political debates of this incredible period, and it has lacked the necessary perspective to understand how the work's structuralist/poststructuralist polarities inform it. Looked at historically, Aycock's artistic subjects rely on Thomas Kuhn's radical rethinking of the nature of scientific innovations; at the same time, they benefit from new paradigms of cybernetics and systems theory predicated on interdisciplinary studies begun by the mathematician Norbert Wiener and neurophysiologist Arturo Rosenblueth. Aycock's art also exhibits a profound affiliation with the political activism of the late 1960s and '70s when civil disobedience focused on the dissenting human body. Her work's contemporaneity ranges from a comprehension of the creative role of embodied perception represented by phenomenology to an appreciation of the usefulness of schizophrenia as a poetic means for describing the radical fragmentation of modern life—a fragmentation that resonates with quantum mechanics, poststructuralist criticism, and the proliferation and democratization of data processing created by the personal computer. Aycock's view of schizophrenia no doubt builds on Warhol's conception of himself as the long-term companion of his TV and tape recorder, while moving it in the direction of age-old mnemonic devices.

10

Scientific Paradigms and Prime Objects:
Science and Art as Ideology

The contemporaneity of Aycock's art is evidenced by its connections with one of the most important books of the past century, Thomas Kuhn's groundbreaking study *The Structure of Scientific Revolutions*, which was published in 1962 and has since sold over a million copies in twenty languages.[16] Aycock first read this book in either the late 1960s or early '70s when its findings were beginning to be accepted by the academic community.[17] At the time, she was taking classes with Robert Morris and was setting up the initial parameters of her art, which included discontent with formalism's self-sufficiency, minimalism's restrictive literalism, and conceptual art's often foreordained closure of competing ideas.[18]

With her reading of Kuhn's book, Aycock ceased to see science as the absolute model for Truth and instead thought of it as a series of historical and sociological constructs that she could weave into her complexes. Both the concept and term "scientist" are romantic-era constructs: in the 1830s the physicist and science historian William Whewell first proposed the word to replace the label "natural philosopher." Due to this origin, much of the same romantic ideology that informs modern art's understanding of poets and artists as rugged individualists is also applicable to scientists. Particularly relevant is the view of them as unique individuals capable of making singular discoveries through autonomous activities that separate them from everyday humanity. In the early nineteenth century, romantic poets and artists proclaimed themselves aristocrats (dandies), while scientists similarly insisted on being acclaimed academe's nobility and tried to shield themselves from the pragmatic interests of industry and technology.

Kuhn uses the term "paradigm" to signify both the revolutionary and reactionary assumptions and standards that join together members of established scientific communities. His *Structure of Scientific Revolutions* constituted "a historiographic revolution in the study of science" in its infancy.[19] It had the enormous impact of redirecting this field from a view of itself as a linear, progressive, and cumulative picture of the world to a collection of disciplines rife with partisan politics and vested interests. Crucial to Kuhn's work is his recognition of science's split personality; he was amazed, for example, that researchers practiced openness and debate when undertaking specific projects but preached certainty in their teaching and descriptions of accomplishments in their respective fields of expertise. For Aycock the concept of the paradigm shift in both its innovative and conservative aspects was liberating because it enabled her to invoke long-discredited scientific discoveries as if they were a series of artistic constructs that might understand and describe, with a degree of magical accuracy, their contemporaneous surroundings.

At the time, Kuhn's new regard for science as an ideology correlated with the relative disenchantment with this entire field after the world-shattering release of the Manhattan Project's atomic bombs in Hiroshima and Nagasaki. This view became particularly timely in the late 1960s because of the highly publicized role of science in the development of chemical weapons employed in the Vietnam War. Aycock's subscription to Kuhn's theories signals her ready acceptance of a less august role for science; at the same time, the many references in her work to no-longer-relevant scientific paradigms transform them into artistic metaphors germane not only to the times in which they were created but to later times as well. As we will see, this understanding of science as an ideological construct similar to art correlates with the thought of Foucault and his theories pertaining to the discourse—the statement that can be accepted as truth at a given time—that was to be crucial for Aycock's work. Rather than

accepting a new paradigm as an ultimate worldview, her art attempts to remove blinders associated with any one system and to present paradigms and their replacements as parts of an open-ended dialectic. Thus observers of her work can enjoy alternative and radically different perspectives without having to opt for one or the other.

Aycock's work considers life in terms of creation and destruction: at times the world seems stable, then an infraction occurs and the dominant view is rendered problematic. A paradigm shift occurs like a fissure in the universe, rending the web and opening new possibilities. Milton's shape-shifting Death rears its monstrous head, and a new complex appears that reconfigures aspirations of an old world in terms compatible with a new one. From the seventeenth to the twentieth century this series of transformations was particularly pronounced: magic was forsaken for science, and intuition was replaced by logic.

Before that time, according to French anthropologist and structuralist Claude Lévi-Strauss in *The Savage Mind*—a book Aycock has considered most useful—magic and science were more closely related. Calling magical thinking or myth a "concrete science," Lévi-Strauss concludes:

The first difference between magic and science is therefore that magic postulates a complete and all-embracing determinism. Science, on the other hand, is based on a distinction between levels: only some of these admit forms of determinism; on others the same forms of determinism are held not to apply. One can go further and think of the rigorous precision of magical thought and ritual practices as an expression of the unconscious apprehension of the truth of determinism, *the mode in which scientific phenomena exist.*[20]

Besides embracing this appraisal of magic as a form of prescientific thought (and Lévi-Strauss's conclusion that an enduring scientific tradition was behind the Neolithic domestication of animals and plants), Aycock was convinced by his hypothesis that two types of scientific thought—one definitely closer to art—can be differentiated as alternative and equal approaches. Of these two types of thoughts, Lévi-Strauss writes, "one [is] roughly adapted to that of perception and the imagination: the other at a remove from it. . . . It is as if the necessary connections which are the object of all science, Neolithic or modern, could be arrived at by two different routes, one very close to, and the other more remote from, sensible intuition."[21]

Another source that supported Aycock's view of magic as akin to science is Jean de Menasce's essay "The Mysteries and the Religion of Iran." De Menasce suggests that magic may be an ideological cloak for more prosaic knowledge:

The mystery of a magic word, of an initiating rite, sometimes conceals the revelation of very commonplace realities. . . . Accordingly we believe that it is a mistake to specialize the meaning of the word mystery *by applying it exclusively to a ritual initiation. It is for the historian of religions or for the ethnologist to determine the relative importance of the speculative and the practical in any particular instance of revelation.*[22]

As an artist, Aycock has needed to buttress this more objective view of magic with an intuitive understanding of prescientific thinking and deeply felt reactions to the world. An aesthetic orientation to this type of material can be found in the work of surrealist artist Kurt Seligmann. Calling his book on magic a work intended for general readers, Seligmann noted: "As an artist, I was concerned with the aesthetic value of magic and its influence upon man's creative imagination. The vestiges of ancient peoples tend to indicate that religio-magical beliefs have given a great impulse to artistic activities, a stimulus which outlasted paganism and produced belated flowers in the era of Christianity."[23]

Even though old yearnings, such as a desire to transcend the body's limits through flight,

continued to haunt people in the seventeenth through nineteenth centuries, these aspirations slowly lost their traditional spiritual overtones and assumed the language of technology. Using art as a means to bridge this gap between magic and science is one of the major goals of Aycock's work. Working in accord with Lévi-Strauss's estimation that "art lies half-way between scientific knowledge and mythical or magical thought,"[24] Aycock finds sorcery and science as well as alchemy and quantum physics extraordinarily close in their aspirations and effects, if not in their methods. And she has found paradigm shifts a way to account for the dramatic changes that appear to have irrevocably separated the two.

One of the most self-conscious references to paradigm shifts in her work is her discussion of how the onset of World War I parallels changes from classic to quantum mechanics. The conjunction of the lights going out in Europe with the loss of a clearly perceivable physical universe appears in her highly personal recital of these events:

Some stories are worth repeating. The story of World War I is like that. I like to hear it again and again because of one short conversation that comes at the end, or rather at the beginning of the war, but at the end of everything else. On the evening of August 4, 1914, a month and a half after the assassination at Sarajevo and on the eve of the German invasion of Belgium, Sir Edward Grey was looking out the windows of the British Foreign Office. He turned to a friend and said, "The lamps are going out all over Europe; we shall not see them lit again in our lifetime." By now I've worn out his remark in thinking about it. The trouble is that in order to really savor that scene in the London twilight one has to know all the things that came before—I guess. I used to know. Now I only remember a little: Michelson-Morley and the constancy of the speed of light; Einstein and his clock paradox; Max Planck and his quanta; Picasso and his Les Demoiselles d'Avignon, *and poof! the*

stability of the Newtonian world is gone. A pity, it was all so hard won. Why, it was Newton himself who, while spending time in the country in order to escape the Great Plague of London, discovered the Law of Gravity. But I don't want to get off the track—the plague or, rather, the Black Death which wiped out a third of the population of Europe and created a labor shortage and thus led to the Industrial Revolution—the plague and the Middle Ages, that's my next story . . .[25]

Kuhn's new view of science as developmental and historic also accords with the innovative mathematical metaphors for characterizing artistic styles, such as prime objects and linked sequences, developed by the pre-Columbian specialist and art historian George Kubler. Published the same year as Kuhn's study, Kubler's book *The Shape of Time* was of singular importance to Aycock and others of her generation. Kubler describes prime objects as initiators of styles, a concept similar to Kuhn's paradigms:

Prime objects and replications denote principal inventions, and the entire system of replicas, reproductions, copies, reproductions, transfers, and derivations, floating in the wake of an important work of art. . . . Prime objects resemble the prime numbers of mathematics because no conclusive rule is known to govern the appearance of either, although such a rule may someday be found. The two phenomena now escape regulation. Prime numbers have no divisors other than themselves and unity; prime objects likewise resist decomposition in being original entities. Their character as primes is not explained by their antecedents, and their order in history is enigmatic.[26]

Kubler's mathematical analogy for style, which replaced the biological metaphor then predominant in art history, encouraged such artists in the 1960s as LeWitt and Robert Smithson to use the physical sciences as metaphors in their

work and to take on mathematical constructs and engineering designs as legitimate subjects. This respect was shared by Aycock and was to be a crucial factor in her work, as we will see.

The historicity of science, which is the basis for Kuhn's revelatory approach, had already been anticipated in the work of German surrealist Max Ernst, who often used antiquated science textbooks as a basis for stirring juxtapositions predicated on no-longer-accepted theories. His appreciation for out-of-date science as a source for outlandish fantasies bordering on dreams (fig. 1.2) has constituted a Kublerian sequence that Aycock views as still open-ended and worthy of investigation. However, instead of aligning radical views from different worlds and time periods on the same plane—as Ernst did—so that they would look stirringly surreal, Aycock implicitly emphasizes their difference from current views. In this way she discovers a highly ambiguous yet potent space capable of disrupting ensconced attitudes. Her sculptures, which play on the extraordinary fancifulness of such superannuated views and thereby undermine their credibility, demonstrate by implication the imaginative and certainly creative role that science continues to assume in constructing our worldviews. In this semiotic we might conclude contradictorily that either science is a form of magic or magic is science's legitimate precursor. And we can appreciate how Aycock found this connection between the two a useful metaphor for critiquing the ideological construction of our worldviews, even our scientific ones.

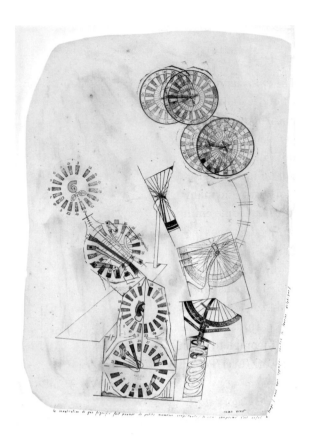

1.2

Max Ernst, *La canalisation de gaz frigorifié . . . [Canalization of a refrigerated gas],* 1919–1920. Aquarelle, gouache, and ink on paper, 21¼″ × 15″. Courtesy of The Menil Collection, Houston, Texas.

The 1960s represented a high point for structuralism, when Gestalt theory and Lévi-Strauss's cultural anthropology among other developments persuaded people to think in terms of systems rather than particulars. Not only anthropologists but family therapists, industrial psychologists, biologists, and many others believed that the world would become eminently intelligible if one bumped up one's inquiry to the next level so that the contours of a superintending structure could be drawn. Completing her graduate training at the end of this time, Aycock summed up the basic tenets of systems theory, a variant structuralist approach, at the beginning of her M.A. thesis, entitled "An Incomplete Examination of the Highway Network/User/Perceiver System(s)":

Systems theory states that processes can no longer be treated as the result of simple and linear cause and effect or one-to-one relationships. Based on the premise that the whole is more than the sum of its parts, systems theory directs itself to complex wholes, wherein a number of "active elements" or parts and subparts "couple" to and integrate with each other to form a system. On a primary level these elements or parts are defined as energy processes which undergo various "transformations" and assume various positions within a system. Systems theory views these processes as taking place in space and time. Moreover, if the system is an open system, it reacts to and upon or is limited by and limits its environment. Therefore, the theory states that if one can determine all the variables and constants within an open system, the kind and amount of input-output with the environment; in short, if one can determine the initial state of a system one can with the aid of research teams, mathematics, and computers determine or predict the state of the system at any given moment in space and time.[27]

Not restricted to verifiable subjects, systems theory could be used to assess hermetic concepts and occult views. It was thus widely applicable, since truth was to be found in abstract connections rather than particular beliefs.

Initiated in the late 1920s and given its name in 1949 by the Austrian-American biologist Ludwig von Bertalanffy, general systems theory was created with the express desire of bringing science and the humanities together, making it both interdisciplinary in its approach and holistic in its aspirations. Its main goal was to transform the world into an eminently readable text replete with dynamic interactions, constituting a field of cogent similarities and equivalencies. The aesthetic dimensions of this theory were affirmed by Jack Burnham in two *Artforum* articles published in 1968 and 1969, "Systems Esthetics" and "Real Time Systems."[28] In the first he proposed a non-materialistic basis for art using von Bertalanffy's concepts, and in the second he elaborated on relationships among art, computers, and human brains, predicting: "Presently it will be accepted that art is an archaic information processing system, characteristically Byzantine rather than inefficient. To emphasize this cybernetic analogy, programming the art system involves some of the same features found in human brains and in large computer systems."[29] One artist whom Burnham regarded as exemplary of this approach was the German-American Hans Haacke, whose early work featured a systemic quest to understand art in relationship to the world. Haacke set up a model of an enclosed universe that is subject to outside influences, using a Plexiglas condensation cube (1963–65). He also created a series of discrete ecological pieces that comprised living systems. In a performance of 1969, he asked art viewers to watch chickens hatching from eggs and to consider how these conjoined systems of art and life confirmed the intellectual appeal of art while assuring the metaphorical resonance of life. Haacke believed artists should be involved with

15

every aspect of their work and not limited to any material or subject matter. "An artist is not an isolated system," he pointed out. "In order to survive . . . he has to continuously interact with the world around him. Theoretically there are no limits to his involvement."[30]

Although most of the realms studied by general systems theorists were defined as open to outside influence, they were examined in terms of closed loops, which permitted negative feedback. This term, Aycock notes, is "used to describe the process by which the system is informed of failures, changes, and events occurring within the system or its environment."[31] Discoveries about communication and interconnection made through such investigations were thought to be so revealing that claims began to circulate in the '60s about humans' ability to translate the entire world, including the human mind and even the universe, into one big feedback system.

These grand, sweeping aspirations are not as far-fetched as they might seem when one recognizes them as the optimistic outcropping of the new interdisciplinary science of cybernetics. Initiated by Wiener and Rosenblueth in the 1940s, cybernetics can be considered in retrospect as a subset of systems theory. Wiener had looked at such servomechanisms as antiaircraft guns as exhibiting intelligent behavior, and Rosenblueth had studied humans as biological machines. Both were interested in understanding communication and control in the human-machine entities they investigated. Derived from the Greek word *kubernetes,* meaning "pilot" or "rudder" and used by Plato to connote the art either of steering or of governing, cybernetics represented a new set of tools for approaching the organization of complex human-machine elements and their interdependence. In the 1950s it served as a basis for studying memory and pattern recognition and for looking at adaptation and modes of learning. Coupling engineering and physiology, cybernetics became involved in bionics, creating machines

such as industrial robots that imitated aspects of living beings. In the 1960s cybernetics, which is analytic, and its close relation, systems theory, which is more descriptive, contributed to an ongoing fascination with artificial intelligence and theories about the usefulness of computers.

Cybernetics' reliance on relationships between engineering and physiology was to be crucial for Aycock's art, which joins aspects of the two. This influence is first evident in her master's thesis, where she compares the highway system to both the human brain and the circulatory system.[32] Later, her drawings often assume the look of engineering diagrams, while her sculptures of the '70s, which are intended to be traversed by viewers, appear to have been carpentered, built by masons, or created with the help of machinists. In works of the 1980s she transposes the earlier emphasis on viewers' physiology to the mind and makes implicit comparisons between calculators and the elaborate mnemonic strategies that have been employed from the time of the ancient Greeks. Differing from first-generation cyberneticists, who viewed systems as static and closed, Aycock takes into consideration the role of the viewer, who is a kinesthetic participant in the systems she creates. In accord with the tenets of quantum mechanics, which Aycock also studied, the situation that she sets up in her work demonstrates the extent to which viewers are inextricably connected with their views, which depend to a certain extent on their orientation.

Aycock's thoughts about systems and humans were not developed in a vacuum. Burnham was an important influence; one of his key statements on the topic of cybernetics is found in the catalogue to the high-profile exhibition *Software: Information Technology: Its New Meaning for Art,* which he curated in 1970 for New York City's Jewish Museum. While computers and their software programs were an important component of this exhibition, Burnham looked beyond the mechanics of the new digital information technology to see

the impact it would have on people's sense of themselves. Citing mathematician and computer scientist Marvin Minsky, Burnham notes,

Minsky concludes that we build machines in our own self-image—although such a separation between body and mind may be no more than an illusion fostered by our lack of scientific knowledge about human biology and communication systems in general. While the integrationist tendencies of systems design tend to play down such differences, in a very real way the division between software *and* hardware *is one that relates to our own anthropomorphism.*[33]

This separation between mind and body has a source in René Descartes's dualism of the ineffable mind and the mechanical body, which in Burnham's terms becomes the body as one's hardware and the mind and emotions as one's software. Thus, the body's perceptions need to be channeled along the lines that one's thoughts are able to provide. According to this analogy, the body/hardware's connection with the world needs to be linked to the "introspection" that the mind/software can provide.[34] This point—a crucial one for Aycock's work—is made explicit by participating artist Les Levine: "Software in 'real' terms is the mental intelligence required for any experience. It can also be described as the knowledge required for the performance of any task or transmission of communication."[35]

Burnham recalls the example given by the exhibition's technical advisor, Theodor H. Nelson, who dramatically deduces that "our bodies are hardware, our behavior software."[36] Burnham goes on to interpret software, in viewers' terms, as a mode of reading and understanding the work of art, which can be regarded as mere hardware. This comparison is fully in sync with many pieces of conceptual art included in the exhibition.[37] Invoking semiotics, Burnham considers works of art in terms of signs that assume meaning within the particular context or structure, i.e., software, in which they are viewed.

Burnham's analogy of humans and their thoughts as hardware and software is part of the cultural nexus on which Aycock's work of the 1970s develops, particularly its tendency to confront viewers with sets of physical challenges that must be traversed if its spaces are to be understood. At the same time as participants confront her work, they also face rosters of competing meanings that force them to reflect on their experiences. The different rationalities represented by these perspectives are analogous to various types of software that oblige viewers to follow their specific type of reasoning, thus becoming distinct perspectives that must each be considered before being rejected or accepted. Because these distinct points of view often contradict one another or are internally inconsistent, they throw viewers back on themselves and their judgments. In this way Aycock's art goes beyond Burnham's basic concept in *Software* of emphasizing the viewer's creative role in assessing meaning: she deliberately complicates the work viewers must do. We might propose that her art functions in a similar way to Ned Woodman and Theodor H. Nelson's *Labyrinth: An Interactive Catalogue* (1970), billed as "the first public demonstration of a hypertext system," which enabled museumgoers to produce their personalized interactive catalogue of the *Software* exhibition which they could then print out. Unlike this rather straightforward hypertext, however, Aycock's art subscribes to a Derridean open-endedness of meaning. Embracing new French poststructuralist ideas, Aycock was already beginning in the 1970s indirectly to critique the new machine age of hardware and software when she looked at the complicated relationships that ensue when phenomenological understanding meets Derrida's slipping signifiers.[38]

*Cybernetics in Action: Artificial Intelligence and
the Transformation of Machine-Age Values*

In the late 1970s Aycock became aware of the threat to humanity's self-definition that cybernetics and the metaphor of "artificial intelligence" were capable of inspiring. A slightly earlier cultural manifestation of this apprehension is the computer Hal in Stanley Kubrick's film *2001: A Space Odyssey* (1968) who undertakes a Caine-like mutiny by orchestrating an astronaut's death. This anxiety about an unbridled and retaliatory robotics, which has been one of science fiction's staples, reflected the enormous challenges posed by the then little-understood field of computer technology.

These early concerns were subsequently shared by social scientists, philosophers, and others who feared that computer programs may have superseded human ingenuity in a number of strategic areas. People were finding themselves in direct competition with increasingly competent machines, which forced philosophers to rethink traits that had previously been assumed to characterize the essence of the human mind. Computers, for example, demonstrated an uncanny capacity to retrieve and store information on a scale far greater and more efficient than that of humans. Their manufacturers continued to refine computers' capacities so that they could achieve effective solutions and then analyze them as a basis for making reasoned predictions. In addition, computers demonstrated an ability to learn from past mistakes and to develop new approaches in concert with their own programmed goals. Not only did they adopt aptitudes that would be called "creative" and "ingenious" in humans, but they also excelled in effectively and speedily adopting them. In certain domains, computers even established a level of efficiency far in excess of their human creators.

Taking a decidedly original view of computers on a par with Burnham's assessment that "art is

an archaic information processing system," Aycock looks at them as only a slight advance on antiquated devices for short-cutting calculation. Although she regards intelligence as a uniquely human asset, in her work it becomes dislocated and lodged in systems that separate people from their creations, in much the same way that memory theaters became separate repositories for some Elizabethans subscribing to mnemonic systems.

Throughout most of the twentieth century, artists took a very different approach to machines. Rather than new versions of obsolete types or distinct entities capable of displacing thought, the canonical view has been of machines as beneficent adjuncts capable of supporting and sustaining humanity's prominent position, as well as inspiring harbingers of future developments and wonderful models for helping to overcome such unnecessary and embarrassing human impediments as their penchant for deviating from any and all established norms, their tendency to slowness, their inefficiency, and their inability to accord with the demands of progress. Much of the history of twentieth-century art has consisted of an ongoing romance between artists and mechanics in which the former have courted the latter (metaphorically and ironically metamorphosed by Marcel Duchamp into his mechanomorphic bride). This love affair took the form of an aesthetics of functionalism in the second and third decades in the twentieth century, streamlining in the 1930s, and aerodynamic styling in the 1950s and '60s.

Aycock's machine art seems to be unmoved by claims about this gadgetry's superiority to its very fallible human creators. Instead of supporting the utopianism that was considered a necessary concomitant of most earlier machine styles, her work appears to interrogate it. Rather than focusing on the newest technology and the most advanced computer software as signs of progress, her art implicitly questions the assumption that a distinct and unequivocal endpoint has been reached. Using the tactic of deliberate regression, her works look to the past for the prodigious accomplishments of

memory experts, thus inadvertently playing on early descriptions of computers as "memory machines." Her works imply that computer innovations are no more remarkable than were the stunningly crafted astrolabes of the late Middle Ages, which had the bonus effect of humanizing machines. These instruments of Islamic origin, which resemble circular slide rules, are distant forerunners of analog computers since they obviate many of the tiresome and routine calculations involved in spherical trigonometry.

In addition to hypothesizing a trajectory connecting early scientific instruments with new technologies that displace and reify thought, such as eighteenth-century views of electricity as ghostly and apparitional and twentieth-century inventions that have found ways to codify information in terms of the on/off pulsation of electricity that made the digital revolution possible, Aycock is convinced that religious aspirations and occultist intuitions can be connected with modern innovations, thereby conflating long-fixed oppositions. Her rationale parallels that of chronicler Maurice Bessy, who considered the feats of computers to be tantamount to magic. "Science, the substitute for insight," according to Bessy, "is now producing an infinite number of miracles."[39] However, Aycock goes beyond this type of layman's wonder to the concept that modern science might be part of a search for transcendence that has defined humanity since the first works of art were created.[40] And she wonders if medieval manuscript illuminations might be reconstrued as embodiments of intense and even insane longings for the future, marked by a desire to understand inventions centuries in the future and light-years away from their spiritualized worldview. Thus she regards these early images as both forward-looking and arcane, since their creators were only able to envisage future worlds within the closely circumscribed limits of the time in which they lived. Her critique of the future's past and present goes far beyond the strangeness of science fiction by looking at the future as the wild fantasies of the distant past, thus placing science's so-called advances in a very human perspective.

Civil Disobedience as Embodied Criticism, Phenomenology as Embodied Seeing, and the Human Potential Movement as Embodied Knowing

Aycock's early architecturally oriented sculptures of the 1970s resonate with the use of the human body in civil disobedience, the major form of political activism of the 1960s and early '70s. Civil disobedience depended on the human body as a primary means of expressing objections in widely broadcast nonviolent public demonstrations, marches, and sit-ins inspired by Gandhi's model of withdrawn consent. At times Aycock's art indirectly dramatizes this new emphasis on the body by making viewers aware of how their own persons process information (a legacy of minimalism), and acknowledges this new awareness of one's physical being as a distinct sensibility and primary means for gaining control of one's world. Surprisingly, though Aycock's early sculptures demand viewers' direct participation and interaction—and often carry the additional burden of danger, as manifested by the claustrophobia of some of her masonry and concrete block construction, the acrophobia of her wooden towers, and the sheer terror of her blade machines—they have never been viewed in terms of the contemporaneous emphasis on the body that took the form of marches to end segregation and demonstrations against the Vietnam War. Related forms of civil disobedience, requiring acts of physical dissent, resulted in the violence that took place during the 1968 Democratic National Convention in Chicago and the demonstrations in 1970 at Kent State University when several students were killed.[41] Thus the body was conceived as a primary means for knowing and for making one's political concerns known.

1968 was the year of an international student-activist protest movement in which dissenters used their bodies to testify to the strength of their beliefs. In France this student movement was

labeled a fight against the insidiousness of the spectacle that commodifies and mediates human relations through objects and images.[42] In the United States, the spectacle assumed the name of "the establishment," and many students at the time overoptimistically connected their protest to the Mike Nichols film *The Graduate* (1967), whose main character Benjamin (played by Dustin Hoffman) refuses to pursue a career in plastics and instead attempts to seek real values through a picaresque series of adventures, ultimately affiliating his body with his ideals in a mock crucifixion scene. In employing a media-generated figure as a model of how they might physically fight the media, u.s. students thus inadvertently demonstrated the spectacle's far-reaching hold.

In 1960s America, a major effort to combat the widespread perception of life as mediated and unreal was being made through a hopeful integration of mind and body, a joining of human efficacy with lived experience that began to become a mantra of mass-media advertising. This emphasis on actuality in the face of rampant mediation—so important to Aycock's work—can be traced in the contemporaneous relevance attributed to open-air theater, street theater, living theater, and happenings.

Two philosophers were crucial to the period's approach to the body, as well as to Aycock's early work that places observers in distinct sculptural/architectural situations. The first is Maurice Merleau-Ponty, whose major study, *Phenomenology of Perception*, was initially published in French in 1945 and was translated into English in 1962.[43] This book analyzes the far-ranging effects of embodied perception so that the seer affects what is seen, as a way of combating the hegemony of the Cartesian strain in French culture which in the seventeenth century had begun to separate the mind from the body and to privilege the former over the latter. Emphasizing the viewer as the primary determinant of reality, Merleau-Ponty discounted the authority ascribed

to the external world by empiricists. He cautioned, "We must not, therefore, wonder whether we really perceive a world, we must instead say: the world is what we perceive. . . . The world is not what I think, but what I live through."[44]

The second important philosopher of the body is Merleau-Ponty's rebellious student Michel Foucault. In his 1960s publications, Foucault began denying that the body is a presocial and stable entity—one of Merleau-Ponty's central theses—and conceived it instead in terms of dominant forms of knowledge. In the modern world, Foucault argues, knowledge has become a primary means for wielding power:

The fundamental codes of a culture—those governing its language, its schemas of perception, its exchanges, its techniques, its values, the hierarchy of its practices—establish for every man, from the very first, the empirical orders with which he will be dealing and within which he will be at home. . . . Between the already "encoded" eye and reflexive knowledge there is a middle region which liberates order itself. . . . This middle region, then, in so far as it makes manifest the modes of being of order, can be posited as the most fundamental of all: anterior to words, perceptions, and gestures, which are then taken to be more or less exact, more or less happy, expressions of it (which is why this experience of order in its pure primary state always plays a critical role). . . . Thus, in every culture, between the use of what one might call the ordering codes and reflections upon order itself, there is the pure experience of order and of its modes of being.[45]

The fact that one's empiricism is preordained and culturally determined is a powerful coda to the concept of the spectacle that so envelopes and historicizes perception that people are only able to see what has already been prescribed as perceptible.

Aycock's early architectural sculptures can also be linked more broadly to deeply held convictions regarding the power of the human body that became the subject of a wide range of disparate therapies known generally as "the human potential movement." Aycock was not interested in these therapies and in fact ridiculed them.[46] However,

when viewed alongside her skeptical art, the human potential movement helps us gauge how far an interest in the intelligibility and efficacy of the human body cuts across the boundaries of high and popular culture, to become one of the defining characteristics of this period.[47]

Beginning in the early 1960s with Mike Murphy's Esalen Institute at Big Sur, California, a number of techniques relying on body awareness, the immediacy of Zen, massage therapy, fantasy, breathing, nonverbal communication, and role playing were widely practiced. These techniques were developed under the auspices of sessions that were variously labeled "encounter groups," "T-groups," "getting together," "sensitivity training," "frankness sessions," "high-intensity marathons," and "body therapy." The overriding message of organizations advocating such therapies— agencies bearing such intentionally formidable names as Gestalt Institute, Bioenergetic Analysis, Personal Growth Lab, and Aureon Institute—was the simple adage "It is more important to experience than to analyze." In the words of the Berkeley human-potential therapist Stanley Keleman, "You don't have a body. You are your body. Your body is your past and your past is your body."[48] Repeated like a mantra, this advice transforms Merleau-Pontian phenomenology into popular "feel good" therapy with the utopian ideal of unmediated experience in a highly mediated age.

Finally, a number of body artists also shared a belief in the overall force of the human body. Unlike the canonical body artists—including Lynda Benglis, Chris Burden, Hannah Wilke, and Dennis Oppenheim—Aycock did not view her own physical frame as a surrogate canvas on which to operate. Instead, her discrete pieces of sculpture comprised spaces in which the bodies of her audience were induced to perform. As her work developed, she countered the efficacy of physical agency with the encumbrance of contradictory scripts or formal signs that forced viewers to contend with one of the primary contradictions of this time: a desire for authenticity in the face of the spectacle's presumed far-reaching, mediating nets.

The Disjunctive Body: Schizophrenia

Although some schizophrenics' senses may be dulled by their condition, others are stimulated by it, becoming hypersensitive to sounds and colors, creating a chaotic situation problematic for them to process. Their brains experience difficulty responding in the way normal brains do, and they frequently react inappropriately: laughing when they are sad, crying when they are happy. The world is strangely disconnected for them: they may even see other people as personifications of their features, so that eyes, ears, and noses—strange embodiments of notable features—populate their world.

The breakup of the integral self and consequent loss of autonomy now known as schizophrenia differs from the earlier concept of this form of mental illness as a type of split personality. A psychotic human brain disorder, schizophrenia still confounds experts in the medical field. Its causes are not clearly understood, though new imaging techniques strongly suggest a genetic basis for this disease, with distinct physiological ramifications that suggest possible atrophied brain tissue. Although the condition may be primarily biological in origin, it can be exacerbated by adverse environmental conditions. Its hallmark positive characteristics include hallucinations involving third-person voices and second-person imperatives, which patients believe they are actually hearing, and delusions about alien beings or forces taking control of them.[49]

Schizophrenia is particularly cogent as a generative metaphor for postmodern art. Both can be seen as signaling the breakup and radical reconstitution of objects once considered monolithic by a series of seismic fractures that develop when the links between signs and their assumed signifieds cease to be simple equations and become dependent on the slipperiness of meaning that attends creative reading. Working with the concept of schizophrenia, Aycock employs

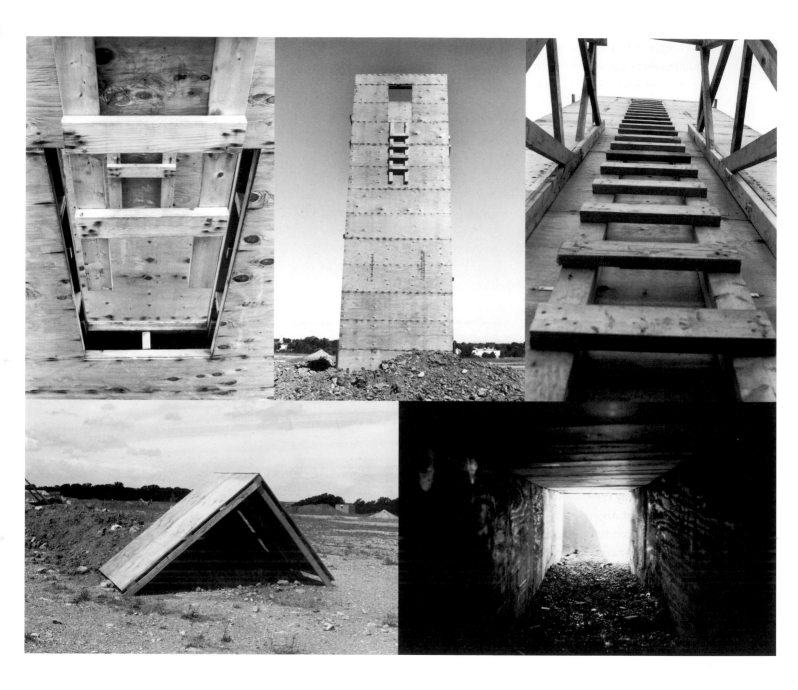

1.3

Alice Aycock, *Project Entitled "The Beginnings of a Complex . . .": Excerpt Shaft #4/Five Walls,* 1977. Wood, 28′ high × 8′ wide × 16′ deep. Exhibited at Artpark, Lewiston, New York. Collection of the artist. Photos: artist.

allusive texts to help transform her early phenomenologically oriented architectural sculptures, which depend on the role assumed by viewers' actual bodies, into schizophrenic pieces whose cores are disassembled so that meaning is directed away from them. This process, which acknowledges the effects of mediation, is akin to the tendency of schizophrenics to lose essential connections with their thoughts by attributing them to dislocated, alien, and objectified parts of themselves that transgress boundaries of inside and outside as well as self and other. With the addition of such texts the significant content of Aycock's schizophrenia-inspired works of art begins to be controlled by outside forces that are disparate and nomadic, not monolithic and paranoid. In these pieces, she makes an important contribution to the overall understanding of art by rethinking the art object so that direct experience is first encouraged and then tied to a puzzling script that disperses art's meaning; the overall work might then be reframed in terms of the schizophrenia that Aycock views as the contemporary modern world's most characteristic feature. In this way the work of art offers a new model of inherent disparateness that ultimately is tied to the transcending and overarching signified "schizophrenia," which in turn dissimulates itself into discrete and separate entities.

The diagnosed schizophrenic known under the pseudonym N. N. has provided Aycock with particularly memorable and poetic manifestations of this illness. She discovered N. N.'s vivid and poignant descriptions of his condition around 1977 when she read Géza Róheim's little-known study *Magic and Schizophrenia* (1955). Since that time she has found this book an enduring source of inspiration. Róheim provides a sketchy background of N. N., whom he queried about his somatic delusions, using a folkloric method for collecting information for approximately eighteen months in 1938 and 1939 while working at the Worcester State Hospital in Worcester, Massachusetts. At that time N. N. was thirty-two years old and unmarried. Before his psychosis, according to Róheim's notes, he had been able to function in the world and hold a job. Later his sense of being an integral self was dispersed so that there was not one N. N. but several. Róheim outlines this confusion before allowing N. N. the opportunity to speak for himself:

He seemed to have the feeling that there are two N. N.'s, and that he is foiled in all his attempts to get work by this other N. N., who usually gets the job. He stated that he felt that everyone was against him, that "the other fellow" interfered with him in every way, even with his girls.

When asked how he knew about there being another N. N. just like himself, he replied, "All my life I've trained myself to be—you know what I mean— a service man, all my life I've trained myself to trail things." Then he stated that he had looked it up and found there were other N. N.'s in another city.[50]

Because schizophrenia is a crucial metaphor for Aycock's reorientation of art's structure and characterization of late-twentieth-century life, an appreciation of its dramatic way of seizing hold of individuals and dispersing their sense of organic integrity will prove helpful to analyzing her work. This can be done by citing N. N.'s own wrenching description of his first realization of his illness and its effects, particularly its way of turning words into the objects they signify:

I was thinking of how that trouble began. On a Sunday when I could not eat and could not make myself understood, it felt as if I were being lifted right out of the house. As I have told you—when I went home I would upset everything, or everything looked upset, or I was upset. My shoes were always knocked off, and then there was trouble in my brain—and it would be difficult to say things. So one of the doctors gave me the advice to take off the shoe and put it in my brain. Then the shoe would

*help me talk. When I say the word "shoe," a shoe
would form itself in my mouth. Or I would feel the
chair, or the street I was living on. This would
happen when somebody who knew me—maybe my
aunt or mother—would touch me through the air.
When I said "street," the whole street would be in my
mouth, and it would be difficult for me to pronounce
it. Or when I ate soup, the whole can of soup would
be in my mouth. Or a house.*

*Then I was knocked on the head by a blow. But
it was not a natural blow, only hot air.*

*I had the trouble with the sundial. It was like a
well—and I was dazed, lost in the shadow. It was
like a bug. The words were* angered *in my head—
they would not come out.*

*Pronouncing the word "street" and at the same
time feeling the street in your head—that is
insanity. I ate a pie and I was too anxious. That is
insanity.*

*When I tell you these stories I am afraid that
you might not understand or the words might be
wrong. Even my own father might not understand
me. Insanity is when I speak through my head. I
think I hear the words, but I am not saying anything
and people don't understand me. I am talking and
eating through some other part of my body than I
ought to. Perhaps the bottom of my tongue.*[51]

Unlike the surrealists' cultivation of paranoid
derangement, Aycock does not assume the
symptoms of schizophrenia but rather mines its
effects and strategies in her writing. The surrealists
subscribed to a disjunction between conscious and
unconscious minds such as occurred when they
played the game of the Exquisite Corpse and were
struck by the chance surprises arising from the
process of psychic automatism (a painterly version
of automatic writing). The game that Aycock plays
is a far more open-ended and fragmented one of
interpretation. She first fully undertook this
approach in a deliberately puzzling script written
in 1977 for the piece *The True and the False Project
Entitled "The World Is So Full of a Number of*

Things," which is then intended to be interpreted
and personalized by people observing the work.

In her readings of N.N.'s schizophrenic
writings, Aycock acknowledges a strange and
discombobulated poetic universe in sync with her
own belief in her sense of destiny: "While the
feeling of being present at the beginning of the
world and getting one's name when the universe
was created is enormously narcissistic, this is how
I felt as a child and a young artist."[52] She has
compared her own feeling with the following
passage by N.N.:

*This business about somebody—my father or
brother—putting his head inside mine and making
the food disappear was very much like Adam and
the apple in the Garden of Eden. It was not just an
ordinary apple—it had to be* translated. *You can
eat an ordinary apple. But suppose the apple
belonged to someone else—was in the other person's
orchard—then you couldn't eat it. If you did, the bug
would know all about it. Someone wanted to take
the food or the apple or Adam's birthright away
from him; but the bug would know this and would
not permit it.*

*I myself was Adam years ago, or perhaps a
crown prince. We were sitting at home at the
table—me, my father, my mother, my brother, my
sister. Then maybe somebody—maybe me—would
think that the food on my father's plate or my
brother's plate looked better and would try to
exchange it. Maybe he wanted to get into
somebody's head and eat other people's food in their
insides. But the bug would not allow this to happen.
Maybe I was a bug once or maybe I was in the bugs
that destroy people.*[53]

The critical distinction connoted by the word
"poetic" is crucial to Aycock because schizophrenia
constitutes a means for her to achieve special
artistic insights. Unlike diagnosed schizophrenics,
she is ruled by neither external nor internal voices
that might impede her ability to differentiate

between significant and trivial information. While Aycock appreciates N. N.'s statement "On Sunday I was trying to eat a beef stew and could not eat it, and I could not make anybody understand what I was trying to say, and consequently the world war broke out,"[54] she suffers from none of his delusions.

Although she recognizes that it is impossible to assume a schizophrenic mindset, her discovery of N. N.'s statements encouraged her to employ some of his strategies in her own writings. A comparison of the following narrative by N. N. with one of her own demonstrates these connections. For example, N. N. describes being possessed by creatures called "Teethies":

My own Teethy regularly eats with me. This does not disturb me. But other people send their Teethies into my mouth—these are the ones that make my food disappear. I used to carry a Teethy inside my body—it looked exactly like me and fitted exactly into my body. My father would sometimes let me have his Teethy for a while—this one was called Man-Man. My father used to have lots of Teethies. Then I lost my Teethy, as I lost the snake and the surgeon (sturgeon) fish. Somebody took it away from me.[55]

Like N. N., Aycock invokes the theme of possession in the following passage, but her figures are chosen to conjure both positive and negative cultural connotations, such as Frances the Talking Mule, a lowbrow film character popular when she was growing up, and a variety of brand names:

My name is Frances like Frances the talking mule. My name is Squeeze, "Squeeze it. Oh, Squeeze it! Oh squeeze it harder." My name is Ice Cream. My name is ticket. My name is Visa. My name is Round The Clock. My first name is DNA. Sometimes I am also called DDT or DT's or DOA or Ducky-Wucky. "Hi Ducky-Wucky! Oh, Ducky-Wucky, you're custom tailored. You'll make good custard pie." That is why I am called Mine or My-My or Shavy Lee. But my real true name is mine. I created sunshine when I was born. That is why there are sunbeams up my ass, too. One day I watched myself walking down the street carrying a white blanket. Now my name is Best B-E-S-T BEST. Now my name is Nous-Doux or Nous-Deux. Now my name is Snack. My name is the Brand Name. My name is Holiday. Now my name is ABC. Now my name is Kennel Ration.[56]

The slipperiness of identity, the permeability of a self that can be held hostage by a variety of names, the lack of clear boundaries between outside and inside as well as between personal, cultural, and commercial terrains, and the importance of puns and far-fetched associations that are able to warp one's sense of reality all exhibit lessons Aycock has learned from N. N. Her images are not insular as are N. N.'s, and her references are clearly signs, not physical manifestations of them conjured into reality by her words. In fact, they are ironic and hence fully intelligible as cultural signs. Because of their repetitions and distance, Aycock's schizophrenia-inspired writings seem more like incantations than statements testifying to the permeability of the self and its consequent loss of autonomy.[57] Reinforcing her connection with N. N., she follows this portion of the text with another that employs such terms as "Angelbabies" and "Depth Kodas" that she has lifted directly from N. N.'s writings.

The Digital Divide: PCS and Mnemonic Devices as Reified Schizophrenia

For all its importance, the critical literature on Aycock's work has not grasped its relationship to the broad-based changes inaugurated by personal computers. Innovations in her art of the 1980s in particular constituted an implicit response to the development and widespread sale of PCS in the late 1970s and 1980s, when these machines initiated and helped to disseminate the information age. In the late 1960s Burnham had predicted that computers would form an inextricable part of the events they regulated;[58] a decade later they assumed a type of reified schizophrenia when they became enmeshed with their users while their artificial intelligence remained separate from them.

The tremendous number of references Aycock used to amplify and disperse the meaning of her work anticipates by several decades the astonishing amount of information on the Internet provided by such search engines as Yahoo (invented in 1994). While their appearance in her art might indicate a keen interest in the entropy caused by information overload, her work (this study will contend) is less concerned with the sublime exhilaration that occurs when reason shuts down in the face of too many options than with its opposite, negentropy, a word that has not been used in the past in connection with Aycock. Cited by Burnham in his essay "Real Time Systems," this term describes the ability of open systems to counteract the entropy associated with closed ones: "Negentropy is the ability of information to increase the structure and potential energy within a system. Such information is only obtained by expending the energy of systems outside the one receiving information. Thus the art system has maintained its vitality by constantly reaching outside of itself for data."[59] In Aycock's work, negentropy signals the ability of the work of art to replenish itself from the outside and to remain open to viewers, who reframe and reinterpret the meaning of the many options that her systemic pieces provide. Instead of closing off information, the situation allows it to expand.

But this expansion still has distinct limits because not all interpretations are relevant, and the artist's overriding goal appears to be privileging openness to the point that it serves as a central theme and subject of her work. Because her art achieves closure in terms of its overall subject of openness and unity in terms of its scripted and catalytic negentropy, I will undertake interpretations that acknowledge such contradictions and such conclusiveness. Strangely enough, artists who consciously use French poststructuralist theories, as Aycock does, end up employing them as both the critical means and the subject matter of their work. Since poststructuralism is not so much a total repudiation of structuralism as an awareness of its limited range, Aycock's subscription to poststructural theories is itself a type of overarching and closed system with underlying rules governing its overall operation. Therefore, any reading of the negentropy occasioned by her art must be a structural one, and any assessment of her post-structuralism must construe it similarly. Her dialectics of openness and closure dictate an interpretive community attentive to the general patterns governing this approach.

Aycock's sculptures diverge from the accustomed perspective of linear time, with its concomitant ideology of progress, by expanding viewers' awareness so that they might look backward to the past's fantastic vision of future developments, such as the view of electricity as a ghostlike apparitional force. Although there is historical justification for such a position, Aycock looks at these glitches in time as forms of heightened sensitivity akin to N. N.'s poetic schizophrenic insights, and as spaces where the rent in a given ideology's apparently seamless fabric begins to be apparent. In her art, as we will see, Aycock aims both to unhinge time's linear path and to render the resulting conflation of different periods spatially into disruptive complexes that are sculptural and architectural as well as mental and emotional.

2

Aycock on Her Family: Facts into Myths

My grandmother used to tell the story, "You know how the sea got salty? There was a ship at sea that would grind salt. One day the ship sank, but it continued grinding at the bottom of the sea. And that is the reason why seas are salty." I later realized that her story was about the randomness and mindless energy in the world. It became the basis for my sculpture, The Machine That Makes the World.

Alice Aycock
interview with author, 1996

Alice Aycock was born in Harrisburg, Pennsylvania, in November 1946. Her mother, for whom she was named, was in her late thirties, as was her father, Jesse, who had returned home from World War II. A former assistant to the chief engineer of the Pennsylvania Turnpike, Jesse Aycock had been stationed in China, where he had gained additional construction experience working on large projects as an army engineer. On his return he built on this knowledge by establishing first the Cumberland Bridge Company and later Aycock, Inc., which developed a national reputation for the large mechanical construction needed by the power industry. Alice's mother participated in the inauguration of this company by working for a time in the front office, and later Alice's half-brother Edwin ran the company with their father. Over the years Aycock, Inc., became known for its large contracts with energy-producing plants.

Recognized widely for its ability to move heavy power equipment weighing as much as 750 tons, this company over the years has installed giant condensers, transformers, and generators. Its specialty has been erecting turbine generators with a range from 20 to 1200 megawatts. The massive turbines and their blades left a marked impression on Alice, as did the overall visual vocabulary of industrial components that her parents' business employed.

During the early years of Aycock, Inc., Alice's childhood paralleled the impressive success stories of many American families who benefited from the country's ability to transform almost overnight its wartime armament plants to peacetime factories. However, her father's many triumphs, which assumed in the Aycock family annals the type of gloss found on Norman Rockwell's *Saturday Evening Post* covers, were overshadowed in the early 1950s by the medical diagnosis that her younger brother Billy had cystic fibrosis. Alice's confidant and friend, Billy assumed over the years the role of an artist's muse who demanded that his sister challenge herself to the extreme.

Making this childhood seem at times wonderfully bizarre were the gothic tales told by Alice's paternal grandmother from North Carolina, Martha Morgan Aycock (fig. 2.2). Martha Aycock would regularly personalize and embellish Aesop's fables, stories by Mark Twain, Edgar Allan Poe, and O. Henry, tales of Sinbad the Sailor, and Jonathan Swift's *Gulliver's Travels* so that their fantasy and irony would appear distinctly southern and familial. According to the artist, her grandmother's retelling of these stories stimulated her visual imagination. Reading them later in school, she realized that she had already heard great works of literature before she learned to read. Although she does not subscribe to Swift's caustic satire, his elaboration of highly improbable yet seductive alternative worldviews, which she gleaned secondhand, deeply impressed her at an early age with life's absurdity as well as with truth's

2.1
Alice Aycock and Bill Aycock, Philadelphia, c. early 1970s.

relativity. This understanding paved the way for her later appreciation of Foucault's investigation of discredited forms of knowledge. Moreover, Swift's emphasis on the way the world changes depending on one's size and viewpoint—evidenced by Gulliver's towering frame among the Lilliputians, followed by his minuscule proportions among the Brobdingnagians—may be a basis for Aycock's ready acceptance of Merleau-Ponty's approach, followed by her subscription to Foucault, who historicizes it.

In a series of extensive interviews, Alice has created a coherent albeit mythic picture of the four family members crucial to the formulation of her art.[1] The stories belong to her and so should the telling, especially when she points out, "I aggrandized these stories of my family, I built on them, and fictionalized them."[2] They not only serve as background for the artist by providing a basis for her future work, but they are also partially fictive constructions on which her elaborate subject matter is predicated. While she has attempted in the passages that follow to be factual, she has needed to condense and at times entirely ignore whole portions of her upbringing while emphasizing other salient details. The following narrative is a condensation of these interviews, with a few pertinent additions from her writings. To make the telling as clear as possible, the narrative has been slightly altered to accord with a chronological sequence.

My mother, Alice Frances Haskins, was either thirty-seven or thirty-eight when I was born. A devout Irish Catholic, she met my father while working for the Pennsylvania Turnpike Commission. Later on they both worked in New York City on wartime projects. My mother worked for the engineering firm Parsons, Brinkerhoff. During World War II she saved my father's army paychecks so that he could start his own business after the war. For a time she worked with my father in the business.

My father first trained as an architect and then as an engineer. He had studied at Chapel Hill

2.2
Martha Morgan Aycock, Fremont, North Carolina, c. 1960s.

29

and at the University of Pennsylvania (architecture); later on he studied engineering at New York University. As a young man he detailed buildings in Philadelphia, worked on art deco buildings in Miami, and helped plan the Pennsylvania Turnpike for the Pennsylvania Highway Department. From a previous marriage he had two sons and a daughter: Edwin, Jesse Nelson, and Elizabeth.

During the war he was stationed in Burma where he worked on the Lido Road. When he returned, he took the savings that he and his wife had accrued during the war and in 1946 started a construction company that built highway interchanges and installed heavy machinery for paper mills and hydroelectric plants. He thought it was brave to go out on a limb with his projects. Like many children, I regarded my father as a hero.

Jesse had some involvement with the nuclear energy business. In the 1950s there was the myth of the good bomb. I remember a family vacation visiting a muddy construction site called Peachbottom. At one point he and other engineers designed and built a crane that could lift 750 tons.

When I was a child, my father would come home every day and work obsessively on a little scale model of a house that had many pitched roofs. He would make drawings that I mistakenly thought were in the style of Frank Lloyd Wright, and I would join him and make drawings of houses, too. My very first drawings were of houses on graph paper. Then my father had the model house built in full scale and gave me the model to play with. He had the house constructed when I was five, and we moved in when I was six. This was the house I grew up in. I could hold the model of the house in my hand; I could be enmeshed in the everyday world of my home and then pull back and look at the model. So I had an experience that was very important for me because I could mentally possess this house, control it, and see it whole at the same time that I was inside of it.[3] The house later became the occasion for many of my stories and for my ideas.

I had a supportive mother, who took me very seriously the way a mother might take a son's interest and desires seriously. Throughout my life, in a childlike fashion, I believed my father could solve any problem. When his last child was born and was ill, Jesse was determined to solve that problem. He found a doctor in New York City who was working on cystic fibrosis. And because of that our family made frequent trips to New York. From the time I was six years old until I was eighteen, I must have seen every musical on Broadway from South Pacific *to* Golden Boy. *My mother and I would stand on Broadway watching for famous people. She once made me disrupt an entire row of people in the theater to get Marlene Dietrich's autograph. My youngest brother was bright and self-reflective. I felt as if we could read each other's minds. Like most little girls, I tried to be his mother and would force him to play pioneer house and teacher. When he was young and would be coughing, I would lie on his body to try to stop the coughing.*

Throughout our lives, my brother and I were very close. He went to many of my exhibitions, as did the rest of my family. Nobody ever questioned my decision to be an artist or what it would mean in terms of my life. In that sense my family's support was unconditional. But I could leave home whereas my brother, Billy, could not. When I look back on much of my early work, it seems to me that Billy was my collaborator. I was the advance man cooking up some risky adventure, and he was Joseph Campbell's Hero with a Thousand Faces *who would always survive in the end. Unlike Tennessee Williams's sister Rose, who had a lobotomy and was rendered helpless, and unlike Dante's Beatrice, who died, Billy could figure things out with me. With our black sense of humor we would joke about his being the poster boy for* CF. *He was not supposed to live beyond 12, then statistically beyond 17, but he did.*

On one of our many trips to New York, my grandmother took me to the Met for the first time, and she gave me John Canaday's writings about art. She was born in 1883 and was the daughter of a

Methodist missionary who went to Yokohama before the turn of the century to convert the Japanese to Christianity. She was seven when she moved to Japan. When she returned to the United States at age fifteen traveling alone with her younger brother across the Pacific and then across the country, she had lost her southern Methodist moorings and was imbued with Japanese culture. She had a curious mind and was considered the creative and intellectual center of the family. She went to college and then was hired to teach the Aycock children, one of whom (my grandfather) was almost her age and also was one of her students. After her marriage, she taught school and enabled her sons to go to college during the Depression. She was a mathematics teacher, and she painted landscapes in the vein of the Hudson River School; she wrote stories and poems; she read widely.

When I was a child, she would promise at the end of each of her visits to make me something for the next time she came up North. Sometimes she would sew a fantasy dress for one of my circus or safari plays with the kids next door. She tutored all her grandchildren in math. She had a marvelous, overrun southern garden with winding paths, along which she would point out to me markers of my father's life—here his favorite dog, Buck, was buried; there is where he and his brothers played war, spraying milk from the cows' teats. Along the lines of the Flannery O'Connor story "A Good Man Is Hard to Find," she held robbers at bay with a pearl-handled pistol when she traveled with her children alone through the countryside. She slept with it under her pillow. She lived until the age of 102. In her later years, she became senile. I did not see her for the last ten years of her life.[4]

The story that Aycock included in *Project Entitled "The Beginnings of a Complex . . ."* comes from her memories of her grandmother:

My grandmother lives in a little town in the South. The ground floor of her house is divided in half.

Each side is exactly like the other side, room for room. A hallway runs down the center of the house. Granny always kept the door to the half in which she didn't live locked. At the back of the hall are stairs to the second-floor bedrooms. The second floor is like any floor in a regular house. There are three bedrooms and a storeroom. The ceilings are very low and it is very hot up there in the summer. At one end of the hall is a door to a room that my grandmother always keeps locked. She said that it was my father's bedroom. She said that when he was a boy she gave him that room to do whatever he wanted—that it was his place and she wouldn't go in it. When he grew up and went away to school, she went into the room, fixed it up and locked it. Several mornings, as I was going down the steps, Granny would be coming out of that room and I would catch a glimpse into it. It was always very light.[5]

A story about Alice Aycock's Granny's room was published in *Tracks*:

The hallway on the second floor is unusually long. There are at least fifteen doors on either side of it. One door leads to a broom closet, one to a linen closet, and one to the back stairs. The rest of the rooms are bedrooms. The fifth door on the left leads to a bedroom, the floor of which is missing. The bedroom is papered with flowers on a beige background with flecks of gold. A white molding runs around the line where the walls meet the ceiling and a white baseboard runs around the line where the floor and walls should have met. The window across from the door is slightly opened. And there is a door on the right wall for the closet. I cannot tell whether there was a floor in this room. There are no indications on the walls where the beams should be. But in the middle of the wall opposite the closet, there is a large water stain, and beside it, a little higher up, two greasy smudges, the kind that come from heads pressing against the wall.[6]

Returning to Alice Aycock's narrative about her family:

At the dinner table my father didn't expect his children to tell him things he already knew. That was hard to do. When I was eleven, my father went to Scribner's in New York and bought me fifty books. He told me if I read them all, he would buy me fifty more. Among the books were Camille *and* The Picture of Dorian Gray, The House of the Seven Gables, Tess of the d'Urbervilles, Uncle Tom's Cabin, *and* Huck Finn, *Shakespeare, and Bulfinch's* Mythology *or Plutarch's* Lives *and an anthology of short stories called* Tales of Terror and the Supernatural *from the Modern Library Series. I thought that if I read enough books, I could know everything without having to experience it all for real. I could do everything in my imagination and stay safe. For me, even now, my safety net is books.*[7]

32

3

Incarnating Thought as Baby Boomer, Cold War Soldier, and '60s Radical

If a course didn't demand at least one "all-nighter" a month, it was a gut. If working on a project became fun and almost effortless instead of dull, didactic drudgery, then the project was too superficial. And worst of all if one's major wasn't of practical value and did not demand an ulcer, a neurosis, and insomnia, then the student might as well forget about the whole business—become a secretary now, instead of waiting until after graduation. She [the student] just wasn't intelligentsia material.

Alice Aycock
"Melange," 1966

Alice Aycock was subject to the excesses and constraints of the postwar baby boomers, who were known for their sheer numbers and collectively regarded as the country's great hope for the future. As a young child, she thought herself destined to be an artist. She also fantasized briefly about becoming either an actor or a dancer. When the Russians launched the first Sputnik satellite into orbit on October 4, 1957, thus inaugurating the space age and consequent space race, Aycock was eleven years old. People in the United States suddenly wanted their children to become cold warriors by excelling in academics, preferably math and science, and Aycock reconsidered her options. She decided that the only viable creative avenue would be writing, not art. In fact, like so many of her peers in the late 1950s and early '60s,

she succumbed so completely to this dominant postwar and cold war ideology that she began to assume that art was only made by dumb people. In high school she chose not to enroll in art courses and was even embarrassed by her former interest in the subject. Rather than making art, she turned to ideas and constructed elaborate historical puzzles. Even though her senior paper in high school was ostensibly about art—its subject was the work of George Inness, Thomas Eakins, and Winslow Homer—her approach was guardedly historical.

In the fall of 1964 she entered the entirely female Douglass College, part of Rutgers University. She intended to study creative writing, but during her sophomore year a teacher dissuaded her from pursuing this field. This negative feedback is surprising when one considers the quality of Aycock's first installment to her infrequent column entitled "Melange," published in the college newspaper, *The Caellian,* from March 1966 until February 1967.[1] Dated Friday, March 11, 1966, this piece intended to determine the effects of the Vietnam War on the Douglass College campus:

Yet the war in Viet Nam has slowly come to occupy a definite place in our lives. For me, it began as only a faint twinge of fear or shock when I would hear that the government was lowering the draft age or that we had suffered three or four casualties in several minor raids. . . .

But now the small twinge of fear has grown into a huge amorphous Presence for me. Perhaps, it is because people I know will soon be fighting in Viet Nam. And yet, I feel that it is something more than that. I find myself listening more intently to the conversations in Center or looking at people more closely as they walk to and from classes. I watch them act out the normal and the everyday. And now and then, I breathe the air a little more cautiously as if I sensed the Presence of Viet Nam there, too. I tell myself that I don't want to be caught unawares.

It is the little things that I want to remember afterwards. Yet, there may not be an afterwards.

Though self-consciously laboring under a symbolist personification of ineffable feelings about the war as a "Presence" lurking around campus like a displaced ghost, Aycock's column creates the haunting sense of foreboding then felt on college campuses throughout the country. Moreover, this piece indicates her ability to tell a story and imbue it with a distinct mood.

At this time Aycock luckily misread her liberal arts requirements in the college bulletin and believed she should take a studio art course as an elective. The course was interdisciplinary, combining art with its history and requiring her to read John Cage, Erwin Panofsky, and studies in experimental psychology. She loved the course and decided then to major in studio art and to minor in art history.

She documented this career move in a "Melange" installment published on September 30, 1966. Now a junior, Aycock wrote that in order to rethink her major, "I had to conquer every stodgy, ague-ridden practical, pseudo-intellectual bone in my body. And for me, that was an accomplishment!" In this column she elaborates on prejudices that had prevented her in the past from majoring in art. There was a need at Douglass to maintain "a certain intellectual status," she notes. "I went along for two years listening to that kind of attitude," Aycock confessed. "And then, suddenly, I stopped! Just like that—finished! I changed my major to what I was really interested in, practical or not, scholarly or not."

Although this brief excursus indicates a willingness to give up academics, such was not the case. She was privileged to be attending Douglass College at a special time in its history, when the vanguard activities in the 1950s and early '60s for which the school is now renowned were being incorporated into its art curriculum. Both Douglass College and its close affiliate Rutgers

University had established a reputation for their impressive vanguard art faculty, which included Fluxus artists Bob Watts and Geoff Hendricks. The year before Aycock arrived at Douglass, Allan Kaprow, the originator of the happening, left, but he bequeathed the school a legacy of openness to the world, including the incorporation of his audience into his happenings; and the school continued to encourage adventurousness regarding the ways that art and life can connect.[2] Kaprow reinterpreted Jackson Pollock's impact on future artists in terms of a need to reject painting and move into the world, a characterization that was to be significant for Aycock: "Pollock, as I see him, left us at the point where we must become preoccupied with and even dazzled by the space and objects of our everyday life, either our bodies, clothes, rooms, or, if need be, the vastness of Forty-Second Street."[3]

During her last undergraduate years at Douglass, Aycock remembers being interested in the work of Keith Sonnier and Jackie Winsor, who were Rutgers University graduate students, and having wonderful conversations with other graduate students on a number of topics. At the time, her teachers did not know whether she would become an artist or an art historian. "My grounding in art history made me tell all the sources of my work," Aycock recalls, "to tell and tell and tell. I presented sources or footnotes for everything."[4]

Aycock spent the summer of her junior year as an intern at the Guggenheim Museum. Most of her time was spent in the conservation lab, where she helped to conserve one of the Brancusi sculptures in the collection. After working on the piece for a number of weeks under the strict guidance of a museum conservator, Orrin Riley, Aycock felt that she had examined every inch of its surface. During her breaks from this department, she would go to the Guggenheim's library and read. The sculptural experience of daily walking through the spaces of Frank Lloyd Wright's highly eccentric building may have had a far greater

impact on her later development as an artist than her familiarity with Brancusi's sculpture.

Throughout this crucial period when Aycock was first learning about art, a constellation of mostly serendipitous forces reinforced the viability of a new hybrid, the artist-engineer, which became a crucial role model for her. Such a crossbred specialty appealed to her, since it duplicated in part her father's early training and combination of interests. The model of the artist-engineer was central to the first festival of Art and Technology held in the fall of 1966 at the Sixty-Ninth Regiment Armory in New York City, which Aycock remembers attending. Organized under the auspices of Billy Klüver, the Bell Labs physicist who had served as advisor for a number of kinetic exhibitions since 1960, the program was called "9 Evenings." Although this series received mixed reviews due to either technical failures or the press being bored by the deliberately low-key presentations, the events led to the founding of E.A.T. (Experiments in Art and Technology, Inc.) the following January.

Indebted to the cooperation and enthusiasm of the unlikely pair of Klüver and Robert Rauschenberg, E.A.T. created opportunities for collaborations between artists and engineers. Instead of merely using engineers to enact the ideas of artists, the program supported discussions that eventually led to truly collaborative works whereby each would learn from the other and both would be fully responsible for the new art that ensued. Soon after its inception, the E.A.T. concept was enthusiastically embraced by Los Angeles County Museum curator Maurice Tuchman, who undertook a four-year project of creating opportunities for artists and engineers to work together, using the vast resources of industrial firms in California. The project culminated in the exhibition *Art and Technology,* which opened at the Los Angeles County Museum in 1971. Concurrently, artist Gyorgy Kepes was able to convince MIT's Center for Advanced Visual Studies to sponsor a multimedia and interdisciplinary

program that brought in artists with the expressed goal of encouraging them to focus on new concepts in urban design and electronic art.

Today it might be hard to imagine the optimism that attended these collaborative investigations between artists and engineers, but they formed a distinct part of the late-1960s cultural landscape. Kinetic art in particular is an especially difficult component of this engineering paradigm to appreciate. Although this art form had received the imprimatur earlier in the century of such illustrious individuals as Marcel Duchamp, Naum Gabo, László Moholy-Nagy, and Alexander Calder, after this brief efflorescence kinetics ceased to be topical for several decades. It reemerged in the 1950s in the form of La Nouvelle Tendance, which counted adherents as well as audiences in almost the entire continent of Europe. One of its chief practitioners was Jean Tinguely, who has remained significant for his undermining of machines' presumed rationality by throwing them off balance and characterizing their ensuing movements as irrational. This approach enjoyed the prestige of both specialized and popular audiences in the late 1960s, when Aycock was first becoming engaged with the art world. Her early contacts with La Nouvelle Tendance may be one reason she revived aspects of kinetic art in the early 1980s when she was looking for a means to characterize the long ascendance and surprisingly brief waning of the industrial era, whose beginnings she dates to the late Middle Ages. Equally important to Aycock's work is kinetic art's ability to respond to her conviction that all life, from the simplest unicellular creatures to the most complex organisms, is evidenced by its dynamics.[5] Since kinetic art had reached a nadir in the early 1980s that was proportionate to its late 1960s zenith, its relegation to the void of the recent and not-yet-historic past made it a particularly apt means for characterizing industrialism's grand epoch as an antiquated form of modernism. Such a move required a willingness to break out of firmly established norms by

reassessing this denigrated art form, which Aycock in part undertook.[6]

Her exposure to kinetics was supplemented by her acquaintance with the ideas of Andy Warhol. In the spring of 1966, her school hosted an Andy Warhol film showing, a lecture by the artist, and a dance to music provided by the Velvet Underground. Although Aycock didn't attend the events, they were widely discussed on campus.[7] As reported in the student paper, Warhol told his Douglass College and Rutgers University audience that he intended to obliterate all vestiges of his personality in his art and to emulate a machine's capability to record aspects of the world directly and without sentiment. Instead of aggrandizing tape recorders and televisions as surrogate beings, his statement had the effect of reducing humanity to the level of mere adjuncts to this far more capable and highly disciplined equipment. For Aycock his message was evidently clear. Less an indictment of industrialism's pernicious effects than an endorsement of its continued relevance, Warhol's pronouncement made him a full-fledged member of the bygone age of industrialism and prevented his entry into the period of its critical aftermath, which became the subject of her art.

Two years later, in 1968, Aycock's first encounters with the artist-engineer prototype were sustained and developed by her visit to the grandiose exhibition *The Machine as Seen at the End of the Mechanical Age,* which K. G. Pontus Hultén curated for the Museum of Modern Art. In his introduction to the exhibition catalogue, Hultén acknowledged that while contemporary culture seemed to be fully imbued with a machine ethos and its benefits, the "mechanical machine" was being pushed aside by electronic and chemical discoveries patterned on the human brain and nervous system.[8] His peripatetic overview of the joys and frustrations of the waning machine age celebrated the few artists who, in his estimation, were still worthy of high praise, including the Russian constructivist Vladimir Tatlin. For Hultén,

Tatlin represented the epitome of the artist-engineer, who might "bring about the long-hoped-for integration of sculpture and architecture" and who was remarkable for his desire "to move from the abstract to the real and leave aesthetics behind."[9] For Aycock as well, Tatlin's work posed the yet unresolved dilemma of how one might move beyond traditional stylistic concerns and their limitations, approach reality on its own terms, and synthesize sculpture and architecture into a new and meaningful hybrid to reflect the world instead of the artist. To this list, one might add Aycock's need to make this art relevant to the approaching postmachine age.

From Minimalism to the Future

Minimalism had an effect on me, in that it was the prevailing ideology when I was a student, and I got to understand it a great deal better when I studied with Morris. It was a point of departure for me in that there were certain aspects of minimalism—it exists in the space of the viewer, it takes up real time and space, and you confront it with your body rather than [its] being an object on a pedestal—which I responded to very strongly. What I did not respond to as strongly is the idea that an object has no resonance . . . that it is divorced from a context, that it is divorced from association and from a content.

Alice Aycock
"An Interview with Alice Aycock," 1992

Hunter College and Minimalism

Pontus Hultén's exhibition at MoMA came at a propitious time for Aycock, since it coincided with her decision to move to New York in 1968 as a graduate studio student at Hunter College. Aycock's serendipitous choice of Hunter College placed her in daily contact with cutting-edge art and art history, as well as with the other obvious benefits that Manhattan provides aspiring artists. Among its illustrious faculty were the sculptors Robert Morris and Tony Smith, painter Ad Reinhardt, and art historians Konrad Hoffmann, Linda Nochlin, and Leo Steinberg. Although Rosalind Krauss was also a faculty member at Hunter, she was a young professor who had not yet established the preeminent position of major apologist for

minimalism that she would assume beginning in the 1970s. Two other faculty members were crucial to Aycock's development. One was Gregory Battcock, a lecturer in the department, whose *Minimal Art: A Critical Anthology* (1968) Aycock read even though she did not attend any of his classes. The other was the department chair E.C. Goossen, who curated the exhibition *The Art of the Real: USA 1948–1968*, focusing on minimalism, that was held the same year at MoMA. Both the Battcock book and the Goossen exhibition signified the canonization of minimalism in 1968 as a distinct and important movement. Because of the earlier and current work undertaken by Battcock, Goossen, Morris, and Smith, Hunter College was well on its way to becoming a major place for the creation and critical reception of this art.[1]

For Aycock, minimalism was thus a vein of rich ideas to be mined and assayed and also to be rejected and outdistanced. Soon after enrolling at Hunter, she inadvertently began heading in another direction when she encountered the street person Norman Bloom, who was most likely a schizophrenic. Aycock later related the episode of her first meeting with Bloom to critic Stuart Morgan:

One day in 1968, the year I came to New York, I was about to enter a bookstore on Eighth Street when I saw a grey-haired man standing behind a table with placards. He had a large quantity of printed matter and was hawking it with the words "All my works, all my writings, only 25 cents, won't you give it a try?" I bought what turned out to be a thin pamphlet in which the author, who lived in New Jersey, elaborated a system for decoding the Bible, which proved that he, Norman Bloom, was the Messiah.[2]

Three decades after this event, Aycock pointed out how Bloom's outlandish meditations instilled in her a deep respect for the rich eccentricities of the world, including a fascination with the genius evident in some schizophrenics' insights and a lack of patience with the minimalists' art-centered orientation:

I saw Norman Bloom as Jesus Christ willing to sell himself for 25 cents. I realized at that moment that for me the world could not be reduced to Minimalism. I believe that the world is too full and complex. I cannot deny content—meanings are always shifting and changing. I could not buy into a world without content. The shifting fiction had to be part of my art and the world.[3]

Though she may ultimately have relegated minimalism to a cultural dustbin for being unconcerned with content, Aycock's immediate minimalist forebear, Robert Morris, was being both celebrated and maligned in the 1960s for his inordinate attention to his works' meaning. As a consequence of her determined attitude to learn from minimalism and then move beyond it, Aycock a decade later dedicated her first full-scale catalogue, *Alice Aycock: Projects and Proposals 1971–1978*, to her recently deceased friend Gordon Matta-Clark and to Norman Bloom.

Notes from Aycock's personal papers refer to a course on minimalism that she took in 1969 with Goossen. Evidently created as a handout for an oral report given in this class, this typed sheet, with specific words underlined by Aycock, begins with the following statement by Dan Flavin that had been published in the December 1966 issue of *Artforum*:

I believe that <u>art</u> is shedding its vaunted <u>mystery</u> for a common sense of keenly realized <u>decoration.</u> Symbolizing is dwindling—becoming slight. We are pressing downward toward <u>no art</u>—<u>a mutual</u> sense of psychologically <u>indifferent</u> decoration—a <u>neutral pleasure</u> of <u>seeing</u> known to <u>everyone.</u>[4]

The statement and its underlined references were intended as a springboard to the following series of questions that Aycock posed to the class:

How does one discuss an art whose history is the attempt to become life-art; whose meaning is the elucidation of non-meaning?

How does one discuss an art whose existence is a contradiction—the synthesis of the Protestant ethic, Oriental mysticism, and Primitive sensualism?

What are the multi-meanings of the term "literal"?

Even as Aycock was learning about minimalism in Goossen's class, these notes indicate that she was already beginning to question its relevance outside a narrowly conceived set of principles and to attack the cool literalism for which her professor was known. At this point in her career, she began moving away from minimalism's famous "lack of affect" to an art that soon would be intentionally encumbered with too much effect, consisting, as we will see, of literal danger as well as an array of daunting, confusing, and competing meanings.

Robert Morris's Postminimalist Teaching

Strangely enough, Aycock's concern about minimalism's lack of pertinence was being voiced by her major professor, Morris, who at the time was still being honored as a preeminent minimalist even though he had gone beyond it to create antiform work. At the time, Morris would have seemed a particularly sympathetic choice for Aycock because he was writing a series of erudite essays on sculpture's new purview, which went far beyond the autonomy of the art object and often outside the museum and commercial art gallery context.[5] At about the same time that Aycock was spending a summer working on a Brancusi sculpture at the Guggenheim, Morris was completing an M.A. thesis at Hunter College entitled "Form-Classes in the Work of Constantine Brancusi," which used George Kubler's idea of "form-class" as a diagnostic tool. And when Aycock later searched for an art with a consequential aftereffect, she was able to rely on Morris's prior work in grounding the experience of art on a responsive subject.

During most of Aycock's time at Hunter, her husband, Mark Segal, attended Morris's classes with her. The subjects of these sessions were so intellectually provocative that the couple would later discuss and debate them. At this time Segal was enrolled in the master's program in film studies at the City University of New York and was taking courses with film critic Annette Michelson, who was convinced of Morris's singular importance. Thus Segal provided Aycock with an additional perspective on this artist's contributions and significance. (According to Segal, he and Aycock spent most of their time together during these formative years reading about modern art and theory and then discussing it. They prided themselves on trying to understand the most difficult topics and the most advanced theorists: "After dinner we would sit at our respective desks reading and making notes on the work of

Merleau-Ponty, Lévi-Strauss, Kuhn, Piaget, Barthes, Jakobson, and other assorted phenomenologists, structuralists, and semioticians. We didn't own a television during those years.")[6]

In order to understand the disparity between Morris's reputation as a minimalist and his teaching poststructuralist theory in the late '60s, it helps to look first at Aycock's assessment of his classes and then examine the first full-fledged apology of his art that Michelson wrote for his impressive 1969–1970 traveling exhibition.[7] In a 1992 interview, Aycock said she remained an extra year at Hunter so that she could audit Morris's classes. A major factor in her decision was his ability to question not only the relevance of art but also its direction beyond minimalism. "Morris," Aycock reflected, "was someone who at that point was going to go beyond minimalism in his thinking. . . . When I studied with him, he had already left that period."[8] In an earlier interview, she pointed out, "The questions he would frame were truly multidimensional, like 'How does the mind work and how can I probe it by using art?' He used art as a kind of probing device."[9] Aycock has referred to the dialectic between Morris's early phenomenologically oriented minimalism and conceptual art that she later forged in her art, primarily because "Conceptual Art and Conceptual artists address themselves to the world of ideas, rather than simply art ideas."[10]

Her initial response to Morris's teaching was a series of process-oriented pieces that are informed by the minimalists' use of industrial materials and disregard for the artiness of subtle compositional arrangements. Segal describes them as "big slabs of yellow wax, blocks of a hardened sugar-water mixture, mounds of sand, large sheets of plate glass. All the materials implied transformations from one state into another. Her straightforward presentation of the objects avoided compositional decisions based on personal taste and generated a tension between the things as static objects and as materials in flux."[11] This interest

in process, Segal recollected, led to an extended trip to the West to investigate "deserts, badlands, bubbling hot springs, geysers—to just about every site of erosion and upheaval you could find between New York and Death Valley."[12] After this trip, Aycock made *Electric Fence* (c. 1970), consisting of stretched and exposed electric wire that spanned the width of her 25-by-100-foot studio on Dutch and Fulton streets. The piece, which unfortunately was not photographed, was intended to place viewers in a quandary as to whether they wished to test its force by touching it, and in this way it extended minimalism's extrinsic aggressiveness into the realm of danger. Morris later used this approach in his 1970s installation *Hearing*, composed of a copper chair containing water heated almost to the boiling point and a zinc table, together with a lead bed, which were wired with thirty-six volts of electricity.[13] During this same time, Aycock moved five or six smudge pots into the studio and ignited them so that they would leave smoke on its walls. Although the danger of this piece did not approach that of *Electric Fence*, it still intrigued Aycock, who was not sure how risky the project would be, how much havoc it might create, or exactly what configuration the smudges would take.

Phenomenology and Minimalism

In recent years Rosalind Krauss's important 1973 essay "Sense and Sensibility: Reflection on Post-'60s Sculpture" has been credited with first comprehending the phenomenological basis for Morris's minimalism.[14] But the way had been paved for her substantial and important piece four years earlier by Annette Michelson, who later joined Krauss as founding coeditor of *October*. Michelson's essay for the 1969 *Robert Morris* exhibition is particularly germane to our analysis of Aycock's development because it demonstrates that, at the height of her involvement with Morris's teaching, his work was being publicly extolled for the ideas that he had initiated five years before but was no longer including in his courses. In addition, this essay supports Morris's phenomenological approach, which Aycock was to incorporate in her own work. In Michelson's excellent coverage of Morris's initial contributions to minimalist sculpture, she places him on a par with the originators of the New Dance, who include Merce Cunningham, Deborah Hay, Steve Paxton, Yvonne Rainer, and Simone (Forti) Whitman.[15] All these individuals, including Morris, aimed to rid their work of cumbersome artifices and find a way to make prosaic bodily movements eloquent and understated.

In addition to placing Morris in the context of New Dance, Michelson views his radical reconsideration of sculpture's objectivity bordering on objecthood as equivalent to the changes that French New Novelists had made over a decade earlier. Although she mentions this reference in passing as an evidently accepted truism of the time, its appearance merits our attention because it explains the low-key and antianthropomorphic view of this new revolutionary aesthetic that was to transform viewers and readers into art's new subjects. The primary apologist for this radical literary approach was Alain Robbe-Grillet.

In "A Fresh Start for Fiction," published in English in 1957 in the *Evergreen Review*, a widely read art and literary periodical at the time, Robbe-Grillet argues that new art should aim to avoid metaphor and other such poetic devices for colonizing and anthropomorphizing aspects of the world. In the 1950s and '60s his ideas were well known to members of the art world; his novels were usually translated into English as early as a year after being published in French.[16] In "A Fresh Start for Fiction," this former agronomist enjoins his readers to consider the merits of encountering a far more uncompromising empiricism than fiction had yet undertaken:

Instead of this universe of "signification" (psychological, social, functional), we must try to construct a world both more solid and more immediate. . . . In this future universe of the novel, gestures and objects will be "there" before being "something"; and they will still be there afterward, hard, unalterable, eternally present, mocking their own meaning, which tries in vain to reduce them to the role of precarious tools between a formless past and an indeterminate future.[17]

Here, indeed, is a crucial and now often ignored source for minimalism's emphasis on nonmetaphorical meaning.[18]

This plea for objectivity, however, is only part of the story that Michelson relates. A former student of Merleau-Ponty in the 1950s, she uses Morris's *Untitled (Mirrored Cubes)* of 1965 (fig. 4.1) as a model for explaining how viewers' physical presence might be anticipated by works of art. These cubes reflect not only the gallery around them but also observers coming within view of them. According to Michelson, these reflective boxes ensure that the envelope of space surrounding sculpture, which was formerly cordoned off from viewers because it was construed as virtual, now becomes part of their "'real' or operational space."[19]

43

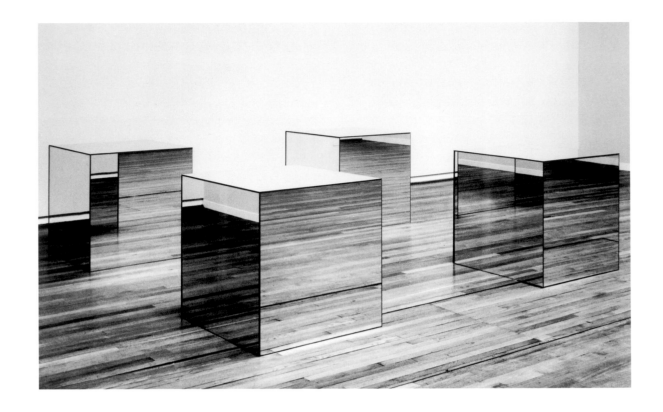

Robert Morris, *Untitled (Mirrored Cubes)*, 1965. Plexiglas
mirrors on wood, each 21″ × 21″ × 21″. Courtesy of
Sonnabend Gallery. © 2004 Robert Morris/Artists Rights
Society (ARS), New York.

In her discussion Michelson undermines the
authority of Susanne Langer's *Feeling and Form*,
then a canonical philosophical text in the United
States, in which Langer claims the "virtual space
[of sculpture] to be entirely distinct from the space
in which we live and act. It is, then, not an
operational space, nor the space of experience, but
of vision."[20] In addition, Michelson takes issue
with the central tenet of Clement Greenberg's essay
"The New Sculpture," which had first been
published in 1948 and was reprinted in 1958. This
essay was particularly timely in the late 1960s
because Greenberg used it, only two years before
Michelson's essay, as the basis for his widely
discussed "Recentness of Sculpture." (This later essay
had served as a key text for Tuchman's exhibition
catalogue for *American Sculpture of the Sixties*
at the Los Angeles County Museum of Art, which
had included two of Morris's sculptures.) In her

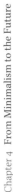

discussion of "The New Sculpture," Michelson intends to correct a mistaken attitude at odds with such recent phenomenologically based work as Morris's. She points out that Greenberg follows Langer's definition of virtuality when he explains, "The human body is no longer postulated as the agent of space in either pictorial or sculptural art; now it is eyesight alone, and eyesight has more freedom of movement and invention within three dimensions than two."[21] But Morris, according to Michelson, is no longer following either a Langerian or a Greenbergian formalist tradition; instead, he is involved in the more important project of looking for relevant and cogent frameworks in which to assess not art's essence but its parameters. This pursuit is both ontological and epistemological since it addresses not only the state of art but also the means by which it is approached and understood, i.e., the viewer's preeminent agency. Michelson points out that Morris enacts this distinct reorientation when he disputes "the distinction, the boundary instituted by traditional aesthetics between virtual and real space," and makes the work of art "in reality . . . transgressive."[22] This analysis intends to demonstrate that Morris's importance goes beyond the mere stylistics of minimalism, delineating a means for repositioning art in the real world rather than relegating it to a rarefied art world. This change is as radical as a move from the proscenium stage to street theater.

Michelson ends her analysis at the boundary separating art from the world. She permits Morris's mirrored cubes to remain semiautonomous modernist objects that interpolate observers as members of an art audience, while critiquing modernism for being far too insular and for not daring to project meaning outward from objects to viewers. At this point both Michelson and Morris are apparently content to remain at the great divide separating modernism from postmodernism—the divide that Aycock's art will later traverse.

While Michelson and Morris, in his minimalist phase, hoped to keep the terms of making and viewing this new phenomenologically based minimalist work carefully restricted to an art context—an approach that Krauss would later champion and sustain—Aycock was inspired to look farther afield (though she too in the end opted for art rather than life, as we will see). Crucial to her broader outlook were her conversations in the late 1960s with Morris, who was then eager to engage in new issues, and her study of art history.

Aycock's classes with Leo Steinberg placed her in the fortunate position of experiencing the first stages of a dramatic revolution in art history. Formalist analysis—long the mainstay of this discipline, which was predicated on the idea that style constitutes a special and distinct intelligibility—was being shunted aside by Steinberg and a number of other art historians who deemed content-oriented questions to be of greater significance. An early example of Steinberg's change of direction is his remarkable phenomenologically oriented essay on Jasper Johns that also recalls aspects of Wittgenstein's language games. In this piece Steinberg asks how one might explain to a blind person the characteristic way that painting functions, and he shows how Johns's art responds with disarming literalism.[23] This tactic no doubt results from Steinberg's early knowledge of the phenomenology of Merleau-Ponty, the philosopher whose ideas were crucial for Aycock's M.A. thesis. Steinberg writes, for example:

It is part of the fascination of Johns's work that many of his inventions are interpretable as meditations on the nature of painting pursued as if in dialogue with a questioner of ideal innocence and congenital blindness.

A picture, you see, is a piece of cotton duck nailed to stretcher.

Like this? *says the blindman, holding it up with its face to the wall.*

Then Johns makes a picture of that kind of picture to see whether it will make a picture.

Or: A picture is what a painter puts whatever he has into.

You mean like a drawer?[24]

Even when Aycock started working with Steinberg in the late 1960s, he was still asking provocative questions about traditional art. His instrumentalist view of modern art may have had an impact on Aycock's desire to understand the ramifications of science and to use her art to develop metaphors, predicated on such concepts as schizophrenia, that are capable of encompassing aspects of science, new computer technology, and modern life in general. However, she does not follow Steinberg when he wonders, in "The Eye Is a Part of the Mind," whether "the art of the last half-century may . . . be schooling our eyes to live at ease with the new concepts forced upon our credulity by scientific reasoning."[25] As we will see, art for Aycock does not just illustrate difficult concepts, it is a way to entice and even coerce viewers to experience the concepts directly for themselves and then wrangle with the difficulties of the work's overall import. In other words, she follows the questioning of the blind man in the essay on Johns rather than the reasoning of sighted individuals that Steinberg hypothesized in "The Eye Is a Part of the Mind." Being experiential, Aycock believes, art must be open to a range of interpretations and must even encourage them— an approach that Steinberg heartily endorses in "Objectivity and the Shrinking Self":

I am conscious of belonging to a generation brought up on Freud and James Joyce. Ulysses *and* Finnegans Wake *were the pabulum of my teens, and I am always ready to welcome another artist who conceives his symbolic forms multi-storied. This means that I am perpetually in danger of projecting my contemporary artistic experience upon the past—which every respectable art historian knows is reprehensible. But there is another way of putting the matter. If there ever were earlier artists who conceived multi-storied symbolic forms, then ours is the generation equipped to detect it, being trained, so to speak, in the reading of Joyce.*[26]

46

Aycock describes Steinberg's art history in terms of an insistent inquisitiveness coupled with an ability to delve into widely disparate realms of historical inquiry. On Steinberg's classes and her own learning, she has said:

He was all over the place. He would begin a lecture with the Parthenon and end up with Jasper Johns. He broke out of the walls of traditional art history, particularly with his theories about the sexuality of Christ. For Leo, I undertook a study of Bramante's Tempietto *by starting with the tumulus tombs in ancient Greece. . . . I loved the big schemes of Leo Steinberg even though some of them couldn't be proved. What was important to me was the notion of something transforming itself through time. Steinberg had been a student of Panofsky. Steinberg posited the work of art as a genie, a shape shifter. He could pick up on a thread and follow up on it through hundreds of years.*[27]

Steinberg's feat at tracing motifs and ideas through centuries is definitely crucial for Aycock's art. His approach had an enormous impact on her in conjunction with her employment at the time as head of the art history program's slide library. This position—a major coup for a fine arts major—provided Aycock with the concrete benefit of conversing daily with art historians in all the major fields represented at Hunter. While carrying out the duties of this position, Aycock familiarized herself with the thousands of images that she catalogued. This work provided her with a wonderful education in the history of art and the structuring of time that was to become so important for her work.

Konrad Hoffmann and the Year 1200

Hunter College thus provided Aycock the opportunity of taking classes with Goossen soon after his large show at MoMA, with Morris at the time of his impressive ten-year retrospective, and with Steinberg just before the publication in 1972 of *Other Criteria,* his collection of essays on modern art. She also was able to enroll in a course with Konrad Hoffmann while he was planning the great extravaganza *The Year 1200: A Centennial Exhibition at the Metropolitan Museum of Art.*[28] Although Aycock remembers Hoffmann's course as extremely dry, focusing solely on the iconographic issues of three manuscripts, she found the exhibition exciting. It highlighted international contacts that enabled the late Romanesque to become early Gothic; chronicled the cultural benefits of the Crusades, particularly in the areas of science and technology; and demonstrated how learning was becoming secularized with the growth of universities. The proto-renaissance occurring in Europe around the year 1200 led to many later profound inventions. From the exhibition Aycock gained a deep appreciation for incipient technological advances from this period that eventually culminated in the Industrial Revolution. She also acquired an understanding of how different worldviews have led to scientific discoveries and how paradigms have shifted radically over time. Seen in tandem with minimalism, which could be referred to as an art of the late industrial era (i.e., the end of the machine age), Hoffmann's rethinking of the Middle Ages provided a means for focusing her art and thought. It enabled her to form a picture of industrialism as including the long period of its anticipation, its two centuries of efflorescence, and the extremely brief time of closure represented by multinational capitalism, third-world industrialism, an economy predicated on service industries, and the coming of atomic power.

47

Although Morris's classes went far beyond his early phenomenological sculptures, seeing Bruce Nauman's *Performance Corridor* (fig. 4.2) in 1969 at the Whitney Museum of American Art opened a constellation of new possibilities for Aycock that Morris was in fact championing.[29] In particular, this piece made embodied perception compelling and coercive in a manner not anticipated by Morris's full-blown minimalist art of the mid-1960s, since it subjected viewers to Nauman's whims and the demanding process of apperception it entails.

4.2

Bruce Nauman, *Performance Corridor*, 1969. Wallboard and wood, 96″ × 240″ × 20″. Solomon R. Guggenheim Museum, New York, Panza Collection, 1972. Courtesy Sperone Westwater, New York. © 2004 Bruce Nauman/Artists Rights Society (ARS), New York.

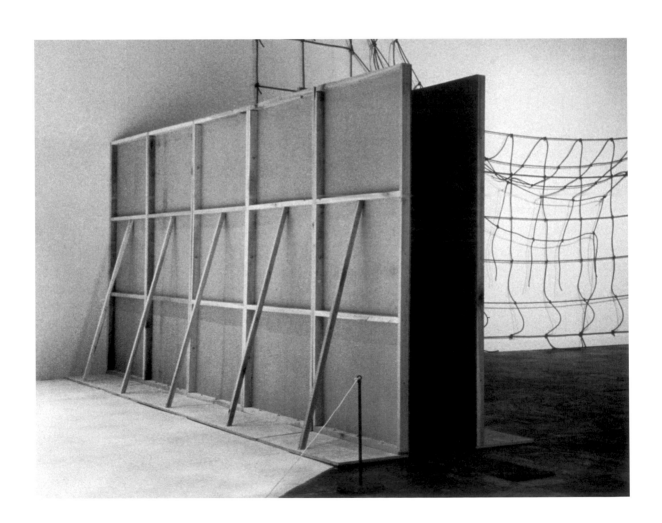

Aycock later acknowledged that her works of the early 1970s were inspired by Nauman's *Corridor* pieces, which often frustrate viewer's expectations. In one of his *Corridors,* viewers are encouraged to walk to the end of a closely framed alleyway to see a video monitor. Once there, they see the backs of their heads, relayed to the monitor by a camera behind them. When they turn around to see the camera, they cannot see themselves on the monitor. Thus the work of art gains the upper hand, and the viewer is subject to its demands. In these sculptures, Aycock cryptically recalls, "You were really confronted with yourself."[30] Even though these works appear in retrospect to have trumped minimalism, Nauman's discovery of *Performance Corridor,* by his own admission, was accidental. "Originally," he noted, "it was just a prop for a videotape I was making in my Southampton studio of me walking up and down the corridor."[31] Then he realized that rather than making himself both art's creator and its subject, he could let viewers undertake the latter role if they became sufficiently engaged with the work. While Nauman was content to permit viewers to become participants in his art, he did not wish to collaborate with them. "I have tried to make the situation sufficiently limiting, so that spectators can't display themselves very easily," he said.[32]

Besides Nauman's full-blown, phenomenologically oriented, postminimalist corridors of the late 1960s, one might adduce another influence: Robert Morris's then little known *Passageway* (1961). Created at Yoko Ono's loft in Manhattan, this piece consisted of a curved plywood walkway leading viewers to a dead end. Not content to reenact Nauman's rigid choreography or to plumb Morris's early research into the aesthetics of frustration, Aycock heightened the intensity of her audience's kinesthetic participation to the point of producing a state of panic among the viewers/participants — including at times even the artist herself.

Jumping ahead slightly to 1977, one piece that dramatizes this situation is the temporary work *The First National Bank Building, Dayton, Ohio, The 21st Floor: A Series of 21 Walls* (fig. 4.3), a unicursal labyrinth created for only a few thousand dollars in the raw space of a high-rise office building. According to Aycock, it is "a metaphor of the space [found] in this type of office building."[33] The work plays on both the austerity and the rigor of carpentering and drywall construction, which resist artiness in favor of straightforward efficacy. This confrontational experience panicked viewers in the course of exploring it. The piece required them to negotiate physically eccentric openings in twenty-one closely aligned Sheetrock walls, from which they were offered the questionable interim relief of a narrow corridor leading immediately to the next opening; reached by a ladder in the wall. No exit was provided until the entire daunting ensemble was explored in full as a loop of 42 walls, since participants reaching the end had to retrace their steps in order to get out. Aycock defended the aggressiveness of this type of work: "The point is to confront people with experiences they wouldn't ordinarily encounter, to lead them to reflect on their bodies and their psyches through physical and psychological discomfort." When told she could be describing a fun house, she countered, "That's ok. A good fun house is more interesting than bad art. The thing is, art's function has always been to challenge people's perceptions, to make them see in new ways. A lump of painted steel plunked down into an urban plaza doesn't do that anymore."[34]

Even though the art world has accorded Nauman's critically important *Corridors* all the benefits of a paradigm shift, the accolades showered on them should also be directed to the theories of Jack Burnham. The change in attitudes enacted by Nauman's *Performance Corridor* was anticipated in one of the most widely read texts on sculpture in the late 1960s, Burnham's *Beyond Modern Sculpture: The Effects of Science and*

4.3

Alice Aycock, *The First National Bank Building, Dayton, Ohio, The 21st Floor: A Series of 21 Walls*, 1977, under construction. (The finished work was walled off along each side.) Sheetrock and wood; overall depth of wall series 65′, each wall 16′ × 11′. Collection of the artist. Photo: artist.

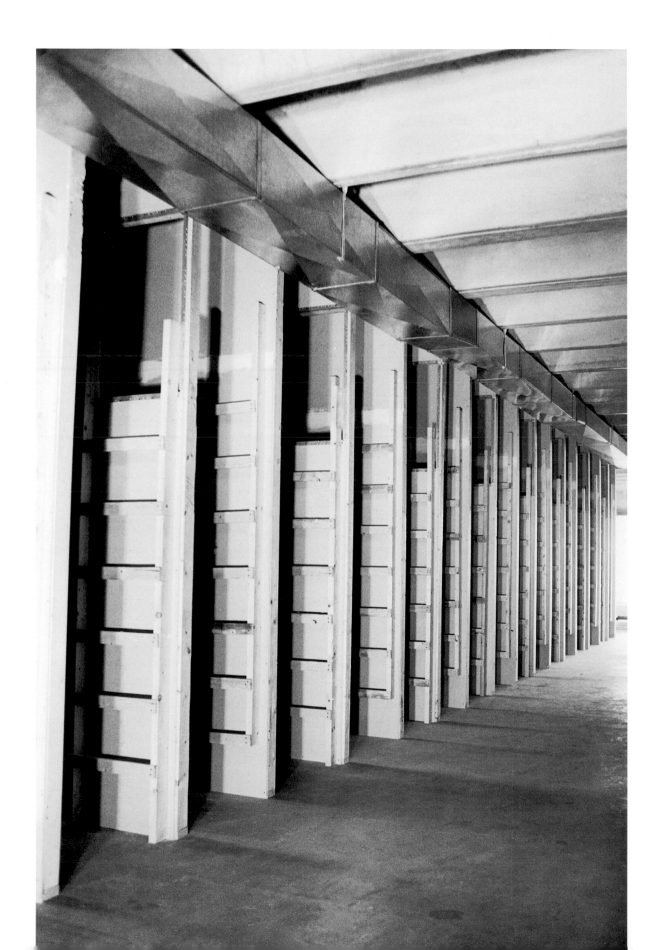

Technology on the Sculpture of This Century (1967). Although this study was regarded at the time as an indispensable source, it quickly fell out of favor and was almost forgotten a decade later when the accuracy of its predictions co-opted its prescience, making its import seem too obvious for further investigation. In this remarkable and still overlooked book, Burnham counters object-oriented sculpture with a new form of systems-guided work. While the former is traditional, the latter is related to life and to innovations already enacted by kinetic art, light sculpture, environmental art, and cybernetic art. According to Burnham, "systems-oriented art—dropping the term 'sculpture'—will deal less with artifacts contrived for their formal value, and increasingly with men enmeshed *with* and *within* purposeful responsive systems. . . . The system itself will be made intelligent and sensitive to the human invading its territorial and sensorial domain."[35] Whereas Burnham describes the ideal, Nauman creates work responsive to the wariness, coerciveness, and cynicism of modern life. The connections of Nauman's work with everyday life made it seem particularly apposite and original. The singularity of his unicursal structures removed them from the less insistent confrontations enacted by minimalist sculpture. They thwarted viewers' expectations of art because such participants could not manipulate their own images and instead could only succumb to the ones Nauman's art revealed to them, such as views of their backs, pictures of someone else, or upside-down presentations of themselves. These distinctive features also distanced Nauman's *Corridors* from the relatively tame, contemporaneous interactions with kinetic and cybernetic forms of art by forcing participants to respond to coercive installations.

The New York art world was fully prepared for the new sensibility represented by Burnham's systemic sculpture and Nauman's *Corridors*. Their attitudes were paralleled by the research of early conceptual artists who examined art's connections with language, philosophy, and systems. In January 1971, Adrian Piper corroborated this approach when she wrote:

I can no longer see discrete forms in art as viable reflections or expressions of what seems to be going on in this society. They refer back to conditions of separateness, order, exclusivity, and the stability or easily accepted functional identities which no longer exist. . . . I've been doing pieces the significance and experience of which are defined as completely as possible by the viewer's reaction and interpretation. Ideally the work has no meaning or independent existence outside of its function as a medium of change; it exists only as catalytic agent between myself and the viewer.[36]

Piper subscribes to a broad-based change in attitude affecting a number of prescient artists who believed that traditional sculpture's equation of art and commodity status was no longer relevant and that a new form of systems-oriented work should supplant it.

Sculpture in an Expanded Field: The NEA and GSA

In the realm of sculpture, this antimaterialistic and participatory attitude worked in concert with new funding sources offered in the 1960s by the National Endowment for the Arts (NEA) and the General Services Administration (GSA).[37] The NEA sponsored a program challenging cities with matching grants totaling as much as $45,000 per project. The first public sculpture funded through this program was Alexander Calder's *The Grand Vitesse*, which was dedicated in 1968. The NEA program not only provided needed funds for public sculpture, but it also had the effect of both creating and legitimizing the demand for art in the public domain. These federally appropriated moneys supported a new type of art whose content was moving away from the formerly sanctioned personal, intuitive, and idiosyncratic approaches to respond to the needs, tastes, and imaginations of a wide range of viewers. Beginning in 1963, the GSA's arts program mandated that 0.5 percent of moneys allocated for new federal buildings would be set aside for the purchase of works of art—an amount that was voluntarily increased to 1 percent in many places. This public program soon became the model for state and metropolitan agencies. So successful were these two federal programs that they changed the way people in the United States regarded sculpture. The dividend was as great for artists as for their audiences, because both began to contemplate art on a far grander scale than they had formerly permitted themselves. Because of NEA sponsorship, museums throughout the country could afford to invite artists to lend imposing works to thematic exhibitions and also to make challenging and monumental pieces for temporary shows.

The history of American sculpture beginning around 1970, when Alice Aycock was maturing as an artist, cannot be appreciated outside the models of public-spiritedness established by the federal government. Of particular importance to this work is its enlarged scale, its relationships with a newly found and broadly based audience, its openness to a variety of sites, and its general avoidance of the elitism and distance that had come to be associated with the virtual envelope of space separating traditional sculpture from the real world.

5

Cresting the Minimalist/ Postminimalist Divide

The movie recapitulates the scale of the Spiral Jetty. Disparate elements assume a coherence. Unlikely places and things were stuck between sections of film that show a stretch of dirt road rushing to and from the actual site in Utah. . . . The disjunction operating between reality and film drives one into a sense of cosmic rupture. Nevertheless, all the improbabilities would accommodate themselves to my cinematic universe. Adrift amid scraps of film, one is unable to infuse into them any meaning, they seem worn out, ossified views, degraded and pointless, yet they are powerful enough to hurl one into a lucid vertigo.

Robert Smithson
"The Spiral Jetty," 1970

Besides mining Nauman's imperatives in his *Corridors,* Aycock's art of this period was catalyzed by the challenging work of earth artist Robert Smithson. Aycock met Smithson briefly in 1968 when he was installing his "Nonsite" show at the Dwan Gallery in New York City and again in the summer of 1972, when she spent the evening with him and artist Nancy Holt at Max's Kansas City and showed them pictures of her recently completed *Maze.* Smithson's work has proved in retrospect to be far more important for the overall development of her art than that of Morris. According to Aycock, Smithson "cracked open minimalism" and thus enabled her "to get out of its prison house."[1] She saw Morris as "always strategically covering his tracks while Smithson, the poet and incorrigible romantic, was breaking

out of them."[2] Aycock read everything Smithson wrote and closely studied the posthumous exhibition of his drawings at the New York Cultural Center in 1974.[3] Her work began subscribing to his late-1960s strategies of creating supplementary works of art. These complements made their first appearance in his film and essay that highlighted different aspects of his enormous earthwork *The Spiral Jetty* in Utah's Great Salt Lake. In these discursive art forms, Smithson's voice invokes by turns the authoritative roles of scholar, artist, fabricator, and critic. He does this in order to enlarge upon the frames for viewing an individual piece and to stress how entropy in the form of information overload can overwhelm a sculpture, robbing it of its autonomy. This situation is akin to schizophrenia in a human. Instead of creating, as Smithson does, alternative works of art that reflect on a quasi-mythic earthwork far removed from the art world, Aycock's mature work combines interpretive and critical approaches with the traditionally preemptive role of the sculptor/creator and then directs both situations to viewers simultaneously, forcing them to come to terms with the ensuing contradictions. The art object and its presumed intellectual and cultural contexts are thus forced into an uneasy coexistence.

This type of sculpture-plus-text moves away from the model of inextricable union of disparate sources resulting in immediate acceptance and understanding, that formalist critics Clement Greenberg and Michael Fried discussed as one of the primary aspects of the visual arts. Aycock's decision to forsake the traditional autonomy of the art object enables her works to reinforce and critique the type of embodied perception dependent on the viewer's changing perspectival views that the phenomenological branch of minimalists (most notably Morris) advocated in their work. When asked if she considered her stories to be auxiliary to the art or part of it, Aycock's deadpan response—"Meshed into it"[4]—communicates the uneasy but forced contiguity

between form and script that her work necessitates, as well as the same contiguity between the work (what it "is") and its context of reception (art world, personal, idiosyncratic, etc.).

We might conceive Aycock's new hybridized form of art as a continuum extending beyond its status as a privileged object while still encompassing it. "The works are a synthesis," she explained. "They give me pleasure. They turn back on history and back on themselves. Like the example of Christianity outrunning the sign of the cross, the generative ideas/sources outrun the actual structures."[5] This approach represents an understanding of the necessarily schizophrenic condition of the postmodern work of art that spans the separate territories usually apportioned to art and its history. Aycock's new art sets up unnerving relays and notable breaks between phenomenologically oriented art objects, the viewers experiencing them, and the range of texts that might be summoned in the act of first creating them and later responding to them.

Between 1971 and 1986, Aycock transformed phenomenologically oriented minimalist objects and conceptualist texts into a new type of postontological art object. Although the art object remains a primary aspect of her art, its traditional ontology is split and dispersed. Thus Aycock deals with the lingering hegemony of a romantic belief in art as a surrogate being that was espoused by the abstract expressionists and bequeathed by them to later generations of New York artists, who in turn grappled with this anachronistic outlook and attempted to overturn it. In addition to subverting this abstract expressionist truism through schizophrenia, by empowering the surrogate as an alien force, Aycock's work advances beyond the minimalist/conceptual divide that bifurcated the visual arts in the late 1960s into phenomenologically orchestrated works and the thoughts generated about them. Her texts encumber her sculptures with frames and codes that not only enlarge our ways of understanding

them but also play one against another. While it is daunting to confront a great deal of text in relationship to a piece of sculpture, it is even more harrowing to begin speculating on the ramifications of the texts with which Aycock encumbers her art. Her work exaggerates conceptual art's purpose and multiplies its realms of possibilities. It constitutes a trek into the complex historical, intellectual, and fantastical spaces that affect our ability to generate meaning, at the same time underscoring the highly idiosyncratic ways in which works are interpreted. As Aycock has concluded, "If entropy can be construed as informational overload, my work collapses under the weight of meaning."[6] Then she extends Smithson's emphasis on entropy as subject matter into negentropy and the interpretive realms affecting and enriching art's reception.

Monroe Denton, one of Aycock's most perceptive critics, notes that "Alice Aycock's works propose a new kind of reading—one of disruption and denial rather than of sequence."[7] This new art resists almost all unilateral readings except its shape-shifting openness (its negentropy) and schizophrenic framework. This enlarged perspective has been difficult for many critics to accept; even such a prescient one as Lucy Lippard noted in 1979, when the art world was still coping with problems later characterized as postmodern, that Aycock "ties the generalized past (myths, historical sources and autobiographical fragments) to a specific present through accompanying texts which are perhaps unnecessary overlays on sculptural experiences, already sufficiently rich to produce a similar breadth of associations from the viewer without literary guidelines." As Lippard also points out, "[Aycock] might also be acknowledging the confusion of an artist today in her over-eclecticism, potentially validated by its roots in personal experience."[8] In the postmodern realm whose vast and permeable boundaries are suggested by the range of clues incorporated in Aycock's art, meaning must be considered a result of interpretation, not simply of the artist's prerogative and intent. Necessarily open to a range of meanings, art objects are capable of being extended well beyond the artist's private and personal insights at the time of their creation, which have traditionally been privileged in art history to the detriment of other approaches. Even if we read the texts accompanying Aycock's sculptures with a certain cynicism and question their relevance, we find ourselves caught in the disjunction between intent and reception that she underscores, thus producing a break in the inextricable unity that was considered essential to formalist art. The experience of her art is very much akin to traveling on a superhighway: the thoroughfare might be the same for each traveler and passenger, but each person's mode of responding to it will vary.

6

M.A. Thesis: The Highway Network

The highway is a path on which one moves through the heterogeneity of the world. When one drives along the highway the world goes by in all of its relatedness and unrelatedness like a movie. The highway is a theatre from which the spectators watch the world, a world which is itself a kind of stage set. Conversely, the highway is a set on which the actors/drivers move. No other experience I can think of, except for art, allows us to consider the world in all of its richness and contingency simply for its own sake. And in the art experience due to its finite nature the world has already been pre-selected, reformulated by someone else.

Alice Aycock
Project Entitled "The Beginnings of a Complex..."
(1976–77): Notes, Drawings, Photographs, 1977

In the spring of 1971 Aycock completed a master's thesis on the highway system that represents her concerted response to the changed attitude toward sculpture then taking place. Although Morris was her thesis director, the topic is in large part indebted to the former architect and acclaimed protominimalist sculptor Tony Smith, with whom Aycock also studied at Hunter College. Aycock remembers that Smith's warmth and humanism were important antidotes to the overbearing and almost fascistic orientation that she believed to exist in most minimalist art. His poetic and phenomenological description of a ride along the New Jersey Turnpike resonated with Aycock, who had often driven along this thoroughfare from Douglass College to New York City during her undergraduate years.[1] His description was so important to the overall sensibility of the late 1960s

that it was cited in its entirety by Michael Fried in his article "Art and Objecthood," which Battcock republished in *Minimal Art*. Smith recounted:

When I was teaching at Cooper Union in the first year or two of the fifties, someone told me how I could get onto the unfinished New Jersey Turnpike. I took three students and drove from somewhere in the Meadows to New Brunswick. It was a dark night and there were no lights or shoulder markers, lines, railings, or anything at all except the dark pavement moving through the landscape of the flats, rimmed by hills in the distance, but punctuated by stacks, towers, fumes, and colored lights. This drive was a revealing experience. The road and much of the landscape was artificial, and yet it couldn't be called a work of art. On the other hand, it did something for me that art had never done. At first I didn't know what it was, but its effect was to liberate me from many of the views I had had about art. It seemed that there had been a reality there that had not had any expression in art.

The experience on the road was something mapped out but not socially recognized. I thought to myself, it ought to be clear that's the end of art. Most painting looks pretty pictorial after that. There is no way you can frame it, you just have to experience it. Later I discovered some abandoned airstrips in Europe—abandoned works, Surrealist landscapes, something that had nothing to do with any function, created worlds without tradition. Artificial landscape without cultural precedent began to dawn on me.[2]

Finding Smith's discussion of highways haunting and challenging in its contemporaneity, and the topic ubiquitous enough to merit sustained attention, Aycock decided to make the highway the subject of her thesis.

Twelve years after completing this study, in a conversation with curators Tilman Osterwold and Andreas Vowinckel on the occasion of her retrospective at the Württembergisher Kunstverein

in Stuttgart, Aycock reflected on its origins. She recalled that after completing a paper for Steinberg on Bramante's *Tempietto* in the spring of 1970, she decided to travel to Greece and visit the tholos tombs that her paper had proposed as progenitors for Bramante's building. On this trip she took along Vincent Scully's recently published book *The Earth, the Temples, and the Gods*, which presents a structuralist analysis of ancient Greek strategies for siting temples, basing their location on the attributes of deities who personify the geological and geographic characteristics of the surrounding locales. Scully also provides an intelligible basis for the placement of particular buildings by situating these decisions in the mindset that, to him, constituted Greek culture. "As I was flying back from Greece," Aycock recalled, "I was trying to think of what was a contemporary example of that kind of phenomenon [described by Scully] and I looked down and saw the highway, this vast network."[3] Although she does not note a crucial analogy in Burnham's *Software* catalogue, the statement by the exhibition's technical advisor Theodor H. Nelson, who envisages highways together with their signage as hardware and the rules incumbent on drivers as software, was no doubt implicit in her decision to look at highways as cybernetic systems.[4]

In her thesis Aycock elaborates on the connection she found between the highway and the Greek temple. "In rural areas," she writes, "the road is similar to some forms of art such as early Greek architecture, specifically Mycenaean, and funerary monuments which use the landscape as their formative principle."[5] In her analysis, she intends to use "the highway experience as a point of view or reference on the world: ecologically, economically, geographically, geologically, politically, socially, structurally."[6]

Early in this study, she suggests that her analysis of systems theory enabled her to regard highways as open rather than closed systems. The latter category she equates with the Second Law

of Thermodynamics because the channeling of energy into unavailable forms creates conditions of increasing simplicity and uniformity. While this connection indicates her interest in Smithson's writings about modern superhighways as the entropic tar pits of the present,[7] it also suggests her desire to move beyond his work. Put in today's terms, we might conjecture that open systems are similar to Deleuze and Guattari's postmodern analogy of the rhizome as a form of biological maze.[8] Apropos this comparison, we might note that Aycock describes this highway configuration as "increasingly differentiated or complex."[9]

In addition to her interest in Scully and the Greek landscape, Aycock's thesis alludes to but does not acknowledge several art historical sources that no doubt were formative to it. Closely attuned to her interests is Sigfried Giedion's estimation of Chicago's contribution of an important school of urban architecture, which he equates with New York's equally important contribution of the parkway.[10] His understanding of the import of the latter is strikingly similar to Aycock's:

As with many other creations born out of the spirit of this age, the meaning and beauty of the parkway cannot be grasped from a single point of observation, as was possible when from a window of the chateau of Versailles the whole expanse of nature could be embraced in one view. It can be revealed only by movement, by going along in a steady flow as the rules of the traffic prescribe. The space-time feeling of our period can seldom be felt so keenly as when driving.[11]

In order to take full advantage of this new mode of perception, Aycock included as part of her thesis a three-part film that presents the same section of road straight on, obliquely, and perpendicularly. Although she does not cite Burnham's prescient insights, she has enthusiastically endorsed his systems-oriented analysis of this mode of travel, as indicated by his statement:

When we buy an automobile we no longer buy an object in the old sense of the word, but instead we purchase a three- to five-year lease for participation in the state-recognized private transportation system, a highway system, a traffic safety system, an industrial part-replacement system, a costly insurance system, an outdoor advertising system, a state park recreation system, a drive-in eating and entertainment system—and, not least of all, the general economic system. . . . Like the realistic portrait after the invention of photography, the object has been debased by its profusion.[12]

While Burnham found the entire set of overlapping systems exhausting, Aycock approached it as an exhilarating key to modern culture.[13]

Rather than analyzing the highway system structurally so that it and the culture from which it arises form a seamless net, Aycock wisely regards any single overarching definition as too confining and simplistic. She seeks to keep her terms open and ambiguous rather than closed and resolved. Therein lies the strength of her thesis and its continued relevance for her art. In her analysis of highways, she cites Merleau-Ponty's observation in *The Primacy of Perception* that "the individual and his or her relationship to events are in a process of perpetually 'becoming.'" She also quotes his definition of the maze constituting phenomenological perception, which can also describe the similarly circuitous pathways composing the modern superhighway system:

The idea of going straight to the essence of things is an inconsistent idea if one thinks about it. What is given is a route, an experience which gradually clarifies itself, which gradually rectifies itself and proceeds by dialogue with itself and with others. Thus what we tear away from the dispersion of instants is not an already-made reason; it is, as has always been said, a natural light our openness to some-thing. What saves us is the possibility of a new development.[14]

61

Aycock reinforces this approach by elucidating the twinned maze created by phenomenological viewing and driving along modern thoroughfares:

The experience of the articulated form of the road on which the users move is the experience of continual transition or passage from position to position. The experience is such that the whole of the articulated form of the road can never be seen at any one time. The portion traveled upon can only be remembered. Even from the air the whole of the highway network can not be seen, since it spreads in all directions across the country and connects with adjacent countries. . . .

The experience of the road as a segment in time is a kind of lived history. Instant by instant one is leaving a position in space and the phenomena that occupy that space, entering into that which lies immediately ahead, and anticipating or misjudging what can be seen in the distance.[15]

And she concludes by citing Merleau-Ponty's statement that "the perceived, by its nature, admits of the ambiguous, the shifting, and is shaped by its context."[16]

The openness of the highway network is the bedrock on which Aycock builds her art. At one point in her thesis she suggests that "the focus of highway-user changes to highway-user/perceiver" so that the experience changes with one's point of view. Working cybernetically, she compares highways to the body's circulatory system and to brain functions. She concludes that the first comparison is indeed close, but that any thorough comparison of highways and brain functions must consider the essential differences between the pathways of roads and the brain's mode of association. For a start, there is "the greater flexibility of the brain as compared with the highways system."[17] In addition, the brain reconstitutes itself, forming new routes as it acquires new connections. "Inherent in the brain's functioning," Aycock writes, "is a massive

reorganization of the neuron system with each 'new association.' Every new association is an initial condition, and every initial condition reorients the system."[18] This negentropic idea later leads her to a similar realization in her art—one that she never verbally articulates even though her works represent a clear comprehension of it. This determination is that her art, like the brain, is a dynamic maze that continually reconfigures itself as it grows and develops. New information has a direct impact on its development.

In her thesis Aycock moves from this analysis of the essentially fixed layout of highways to the user's fluid ways of reconceiving them. At this juncture she refers to Wolfgang Koehler's *Gestalt Psychology,* which she discusses as a "distinction between the static, topographical structure of a system and its processes which dynamically self-distribute themselves." She points out, however, that for highways and other open systems

the structure is only quasi-permanent. Structure is a fluid structural cycle. The goal of the system is movement, and the system itself is in motion. And although the structural processes form a new "more than" whole, it is not a whole which can be easily grasped. There is always something here and over there: the boundaries are always changing. The system is always ingesting parts of the environment and getting rid of parts of itself.[19]

At this point Aycock theorizes a space between the highway-user and highway-perceiver. This crucially important gap will become the basis of her mature art of the late 1970s and 1980s, in which differences between empiricism and rationalization place viewers in a quandary about how to respond to the information facing them. This approach parallels Burnham's conclusion in his *Software* catalogue that "*Software* regards the perceived appearance of the art object as a fraction of the entire communication structure surrounding any art,"[20] thus making thought a key factor in viewing the exhibition. Writing only a year before Aycock

completed her thesis, Burnham sets up a contrast between hardware and software that is an important underpinning of Aycock's entire thesis, which plays with differences between levels of perception.

If we replace the word "road" with "sculpture" in the following statement from Aycock's thesis, we can see how Burnham's reasoning provides a basis for looking at her subsequent work:

The experience of the articulated form of the [sculpture] on which the users move is the experience of continual transition or passage from position to position. . . . Thus no matter how many times a [sculpture] is traveled, it is never the same. And where continuity, balance, harmony, rhythm, and clarity exist at one moment, discontinuity, imbalance, disorientation, discord, and ambiguity exist at another.[21]

Taken as a guiding metaphor for her work, the road is a system that depends as much on the traveler/user/viewer as on the route traveled. Not an interloper, the participant in the system is woven into the system and his or her reactions are a crucial aspect of it, comprising the highway network just as they do the complex on which Aycock's works of the following decade are predicated. The work of art is both the object and the field of responses and experiences involved in confronting it. The problem facing viewers of some of Aycock's work is that one is not necessarily consistent with the other, particularly when the artist unhinges the traditional equation between signifier and signified—meaning and response— to suggest, in several texts accompanying these objects, a wide range of possible and even contradictory impressions that viewers might experience when confronting her sculptures. This openness in turn circumscribes the work of art and endows it with a new overarching meaning on a par with the shape-shifting complex that Aycock theorizes a few years later as the preferred arena for her work and its ultimate meaning.

63

7

Early Work: Projecting Art into Viewers' Spaces and the World, the Aesthetics of Danger, and the Synergy of 112 Greene Street

Radical states of imagination fascinated her, and she believed that the imagination of death forced people into the most extreme positions of all. I encouraged this, seeking out a screening of The Cabinet of Dr. Caligari *or tracking down an out-of-print biography of Gilles de Rais. My purpose wasn't the selfless one of furthering her work. Rather, I hoped that the infatuation with and research into the language and iconography of death would keep her own demons at bay.*

Mark Segal
on Alice Aycock, *Retrospective: A Novel*, 1987

Only a year after writing her master's thesis, Aycock began to understand how it could constitute a basis for her art. In this brief interim, during which she taught part-time at Hunter, she explored a range of ideas, some of which she soon discarded and others of which she continues to mine. One work based on ideas crucial to the evolution of her art is *Sand/Fans* (1971) (fig. 7.1). She returned again and again to this prescient early work, which can be considered at once a whirlwind, an incipient earthwork, and a maze. It was initially important to her art of the early and mid 1970s in terms of the frustration and incipient danger it poses to viewers.

Aycock's use of danger in her work is part of a new aesthetic view that moves beyond the theories of Immanuel Kant and Edmund Burke. While Kant

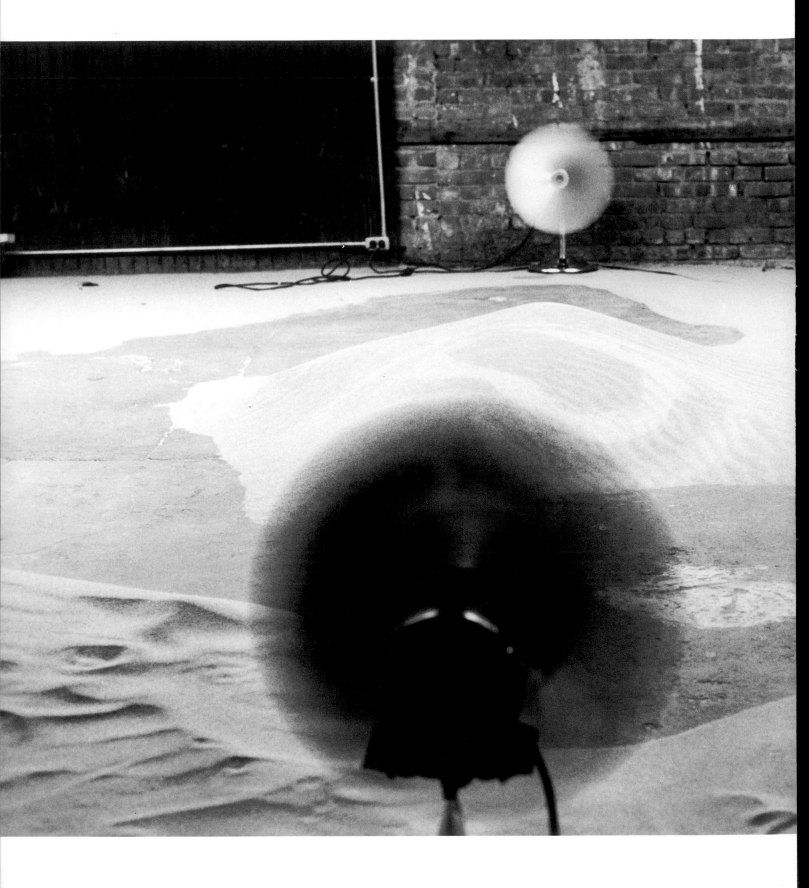

7.1
Alice Aycock, *Sand/Fans*, 1971. Approximately 20′ square.
Exhibited at 112 Greene Street Gallery, New York. Collection
of the artist. Photo: artist.

prescribed disinterestedness as a necessary precondition of beauty and reason as the ultimate response to the sublime, Burke defined the sublime as the strongest aesthetic emotion one can feel, even characterizing it as "danger at a distance." Differing entirely from Kant and going much further than Burke, Aycock's art demonstrates the belief that the immediacy and closeness of actual danger has been in general misunderstood by philosophers, who have failed to evaluate the type of aesthetic appreciation it can entail. Her concept of danger raises the ante of the already established aesthetic category of presence, which was of crucial importance in the 1960s as a Greenbergian formalist tenet, which Aycock, following in Morris's footsteps, reoriented away from opticality and in the direction of phenomenology. Danger heightens both presence and the Burkean sublime, compounding them with fear, anxiety, and closeness so that in a phenomenological sense observers' emotions deeply affect what they see and how they understand it.[1] Aycock manages to join physical and psychological forms of danger in blade machines that capitalize on people's fears and their fascination with these compelling instruments. The alternating forces of repulsion and attraction energize these works and keep them from becoming overly familiar and therefore no longer threatening; they also create a potent space that opens the work to viewers' individual experience. The fears they catalyze are both external and internal, pitting viewers against seemingly inexorable mechanical forces and against that part of themselves that is attracted to them.[2] As we will see, danger is a mainstay of Aycock's work, to which she returns periodically. Her aesthetics of danger, which places viewers in the center of irresolvable polarities, must be counted among her most important contributions. The situation is a both/and rather than an either/or proposition. In *Sand/Fans* Aycock placed sculpture on a new basis, creating work even more aggressive than

Nauman's most combative pieces; so that it keeps viewers both at hand and at bay.

Works such as *Sand/Fans* reflect a series of events that convinced Aycock that the world is dangerous. In the early 1970s she was literally blown out of bed in her living space, located between Fulton and John streets, when a nearby restaurant was firebombed for hiring only nonunion labor. Around the same time, there was a rumor that the street in front of her apartment was threatened with being dynamited. Both events reinforced a fear of knives which had developed in her childhood. The need to confront this deep-seated apprehension was one of her reasons for making *Sand/Fans*. Since Aycock's early works are part of the highly cathected period of the late 1960s and early '70s, they are subject to some of the same semiotic codes that together ensure the intelligibility of the world around them. We might look at *Sand/Fans* in terms of the omnipresence of brutality in the sixties that led black activist H. Rap Brown to state unequivocally that violence was "as American as apple pie"[3] and that contributed to Todd Gitlin's assessment of New Left insurgency during this same period that "there was a lingering sense of playing in overtime, wondering when the game was going to end in sudden death."[4] During this period, violence often assumed distinct political forms. Members of Aycock's generation and the audience at the artist's cooperative at 112 Greene Street where *Sand/Fans* was shown would have been familiar with the political subtext that informed so many individual actions as well as so much of the art of this period.

Aycock created two versions of *Sand/Fans*. Made in her loft, the first incorporated one industrial fan without guards that she placed on the edges of a sand pile weighing approximately 2,000 pounds. Soon thereafter, she set up a second version as an installation in the basement of 112 Greene Street. Measuring approximately 20 feet square, it included four similar industrial fans without guards. Because the configuration of the

sand pile positioned before one fan changed depending on the fan's direction, the first version of this piece served as the mechanical equivalent of a weathervane. For the second version Aycock redirected the fans so that they were all in opposition to one another. She expected the piece to create an image of low-level differentiation akin to entropy, but instead its air currents resulted in dramatic wind patterns similar to those occurring in desert sand. Only later did the forces of the individual fans begin to cancel one another out; at that point they reduced the sand to a relatively low and undifferentiated horizontal bed beneath the air currents.

Aycock remembers that sculptor Gordon Matta-Clark, a regular at 112 Greene Street, asked, "Without guards on the fans, this piece is about danger, isn't it?" Since then, she has free-associated about the work's incipient violence in words that recall Lewis Carroll's Alice who tumbles through the Rabbit's hole:

I want my work to have the sensation of a free fall, like falling into a well and not knowing the bottom, a quality of dislocation and disorientation. This is important for all my work. It is almost like instinct. This is the strong, nonverbal part of the work. It is almost like the urge to walk into the blades of a propeller, an urge to climb to a precipice and hurl oneself into the air.[5]

This uncanny approach can be related to the spinning blades of turbines found in her father's hydroelectric industry that she has known since childhood. This connection with danger also correlates with her early experience of riding the Comet, which had been installed in Hershey Park near Harrisburg in 1946. The Comet, a roller coaster with an elaborate wooden foundation, created quick turns and drops that briefly hurled people outside the force of gravity into a momentary sensation of weightlessness, which

they might have equated with falling or with transcendence.

Sand/Fans also correlates with Aycock's study of schizophrenia, which took a decided turn when she read Dr. Bruno Bettelheim's *The Empty Fortress* (1967). In this work Bettelheim discusses the so-called mechanical children—once thought to be schizophrenic but now diagnosed as autistic—whose bodily functions, including eating, defecating, and sleeping, seemed to function for them only when they were permitted the fantasy of plugging themselves into such imaginary circuits as motors, lights, propellers, and steering devices.[6] Bettelheim concludes that in the twentieth century "neither savior nor destroyer is cast in man's image any more"[7]—in its place is a mechanical being. Bettelheim's most compelling example of a child utterly subjected to this mechanical paradigm is his patient Joey, who at age one and a half became so preoccupied with electric fans that, incredible as it might seem, he could soon disassemble and then reassemble a fan again. Bettelheim conjectures that the fan assumed the portentous weight of a highly cathected symbol arising from Joey's early experiences of the airport due to his father's frequent business trips. Bettelheim theorizes that if a plane's propeller can excite so much fear, anxiety, and pleasure about his father's comings and goings, then Joey may have regarded it as a quasi-divine force capable of controlling his feelings and thus requiring his connection into an imaginary electric circuit in order to eat and sleep. He suggests that this condition is not limited to Joey alone, as "a preoccupation with rotating objects is typical of many autistic children," who either rock back and forth or walk around in circles when troubled.[8]

Sand/Fans's connection to "mechanical children" such as Joey is crucial to Aycock's overall work. Over the years she has made a number of statements testifying to the importance of schizophrenia and other mental disorders such as

autism for her art of the late 1970s. Her subsequent reading of Deleuze and Guattari's *Anti-Oedipus: Capitalism and Schizophrenia* in the 1980s confirmed her use of this dysfunctional condition as a metaphor for the fragmented human condition in the late twentieth century and for the infiltration of alien voices that erode one's sense of wholeness and integrity. This metaphor also parallels the erosion of the transcendent author as subject of the work of art that Barthes circumscribes in "The Death of the Author." And, as mentioned earlier, Aycock's reliance on schizophrenia elaborates Warhol's view of himself as the passive consort of his television and tape recorder. Because schizophrenia serves as a scientifically researched, if still little understood, form of fantasy in a world devoid of the flights of the imagination found in earlier periods, it has been crucial to Aycock's art.

In addition to Bettelheim's well-known example of Joey the autistic mechanical child, Aycock found in the little-known figure of N. N., whom she first encountered in the late 1970s, a number of references to the anxieties this diagnosed schizophrenic felt about the imploding power of speed and gravity. "There is too much *speed* or *gravity* in me," he told Róheim. "I feel as if the chair were falling over and throwing me out. It is like one of my dreams or fairy stories. It is like the time when I was crossing the field near my house, when I had the lion, and the *speed* took me away. I disappeared between the sun and the night, and I was not seen again for seven or eight years."[9] On another occasion, he refers to "the time I was walking or riding in a car or on horseback. My awful habit of going so fast made me go almost beyond myself or rush off the edge of the earth, like the sun when it sinks."[10] Róheim's reference to this experience as "the technique of projection or fission" connotes the type of internal/external breakup of boundaries that Aycock wanted the dangerous aspects of her work to effect in viewers

while it conditioned them to new ways of thinking about themselves and the world around them.

Although not as prescient as *Sand/Fans*, a number of other works Aycock created in the early 1970s merit consideration. These include photographs taken in 1971 of fair-weather cumulus clouds that would dissipate within five to fifteen minutes after formation (fig. 7.2). Although Aycock was unaware of Peter Hutchinson's 1970 claim that he could use the Hatha Yoga technique to dissolve clouds, such work testifies to the alliances then being forged by a number of artists between conceptual art, ecological thought, and hippy culture. Aycock's piece is notable for its dry scientific approach, which is entirely in sync with the formal constraints favored by conceptual artists. More germane to this piece than Hutchinson's works are the series of sky paintings created beginning in the mid 1960s by one of Aycock's favorite art instructors at Douglass College, Geoff Hendricks, who has been a life-long friend. Rather than perpetuating the work of this teacher, Aycock establishes a new blank slate for herself with each cloud dispersal. Another Aycock project consisted of marking shifts in magnetic north over the period of a year. And still another necessitated photographing seven rows of tilted glass plates in a field on a farm owned by her family in Pennsylvania. In these photographs Aycock documented the sun moving across the sky, producing an intense glare on some of the glass plates and thus making a visual record of solar power, which at the time constituted a significant ecological and political force. In 1973 Aycock created a conceptually oriented 16mm film together with a collection of still photographs documenting herself stepping across the abstract boundary of the Tropic of Cancer (fig. 7.3). Photo documentation of several of these pieces along with photographs of two important architectural pieces, *Maze* (1972) and *Low Building* (1973), and the architectural installation entitled *Stairs (These Stairs Can Be Climbed)* (1973–1974), were

introduced to New York audiences only in 1974 when her full-scale exhibition at 112 Greene Street took place.

Aycock's art of the early 1970s depended on the permissive environment of 112 Greene Street, an industrial space in Soho that was an important creative nexus for emerging artists. In the early 1970s, Manhattan's industrial district of nineteenth-century, iron-front buildings known as Soho (the acronym designating the area south of Houston Street, north of Canal Street, west of Lafayette, and east of Sixth Avenue) was ripe for artists' settlements. Loft spaces were plentiful and cheap because only some light industry was still being undertaken there. The building at 112 Greene Street was owned by impresario Jeffrey Lew, who encouraged selected artists and dancers to use his space freely, even to the point of removing walls and floors, as long as they later returned the space to the condition in which they had found it. Although 112 Greene Street was supposed to function as a gallery and was referred to as either the 112 Greene Street Gallery or 112 Workshop, Lew never seriously entertained the idea that he could sustain it or himself through commissions received on sales of the art shown there. Its distinguished review board included Metropolitan Museum of Art curator Henry Geldzahler, Whitney Museum of American Art curator Marcia Tucker, and artists Robert Rauschenberg and Andy Warhol. Its roster of artists reads like a who's who of the next generation, among them Vito Acconci, Carl Andre, Chris Burden, Louise Bourgeois, Philip Glass, Tina Girouard, Joan Jonas, Gordon Matta-Clark, Robert Morris, Dennis Oppenheim, Susan Rothenberg, Richard Serra, Carolee Schneemann, and George Trakas.[11] According to Girouard: "The way it worked [at 112 Greene Street] was, you had a project and went into the space and saw where you wanted to do it. If someone else was working there, you just said, tell me when you're going to be finished. The piece would come out and you could get to work."[12]

In addition to being highly cooperative, many projects at 112 Greene were interdisciplinary. Lew would organize what he termed "madness workshops" in which the space was open twenty-four hours a day for artists, dancers, musicians, and poets to join together and do whatever they wished. The atmosphere was highly permissive; the work gritty and industrial in approach; and even if the results proved to be unsaleable, the artists did not seem to care. At 112 Greene Street, artists made work for their peers so that compromises were discouraged and rigorous thinking was regularly upheld.

7.2
Alice Aycock, *Segment of a Cloud Piece*, 1971. One of four black-and-white contact
sheets, 15³/₄″ × 21³/₄″. Private collection. Photo: artist.

7.3

Alice Aycock, *Tropico de Cancer: Boundary Line 23½ degrees North, Tamaulipas, Mexico. Left (side): Torrid Zone; Right (side): North Temperate Zone*, 1974. Collection of the artist. Photo: Mark Segal.

8 *Maze*, 1972

Originally, I had hoped to create [in Maze*] a moment of absolute panic—when the only thing that mattered*
was to get out. Externalize the terror I had felt the time we got lost on a jeep trail in the desert in Utah
with a '66 Oldsmobile. I egged Mark on because of the landscape, a pink and gray crusty soil streaked with
mineral washouts and worn by erosion. And we expected to eventually join up with the main road.
The trail wound up and around the hills, switchback fashion, periodically branching off in separate directions.
Finally, the road ended at a dry riverbed. We could see no sign of people for miles.

Alice Aycock
"Work 1972–1974," 1977

While *Sand/Fans* suggests directions that Aycock's art would take, her *Maze* (1972) (figs. 8.1 and 8.2) determines them. Among all her early works, this piece is the most predictive of her future development, first because it joins the art with participants to create a rudimentary cybernetic system, and second because it breaks up the overall piece into the structural equivalents of hardware (the maze per se) and software (an ad hoc rationality incumbent on all participants as they negotiated the maze's alternative routes).[1] *Maze* was constructed on Gibney Farm near Carlisle, Pennsylvania, a property owned by Aycock's family. "I got the idea [for *Maze*]," Aycock reflected a few years later, "while paging through the *World Book* for the definition of *magnetic north*, and accidentally came across a circular plan for an Egyptian labyrinth. The labyrinth was designed as

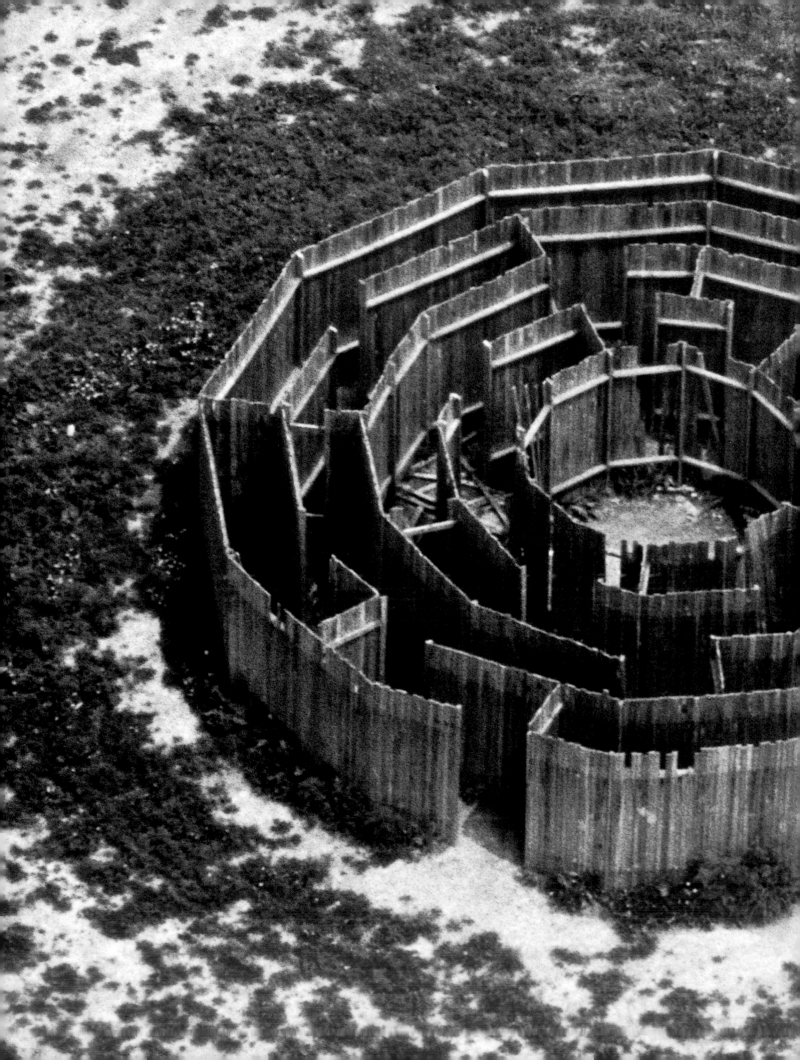

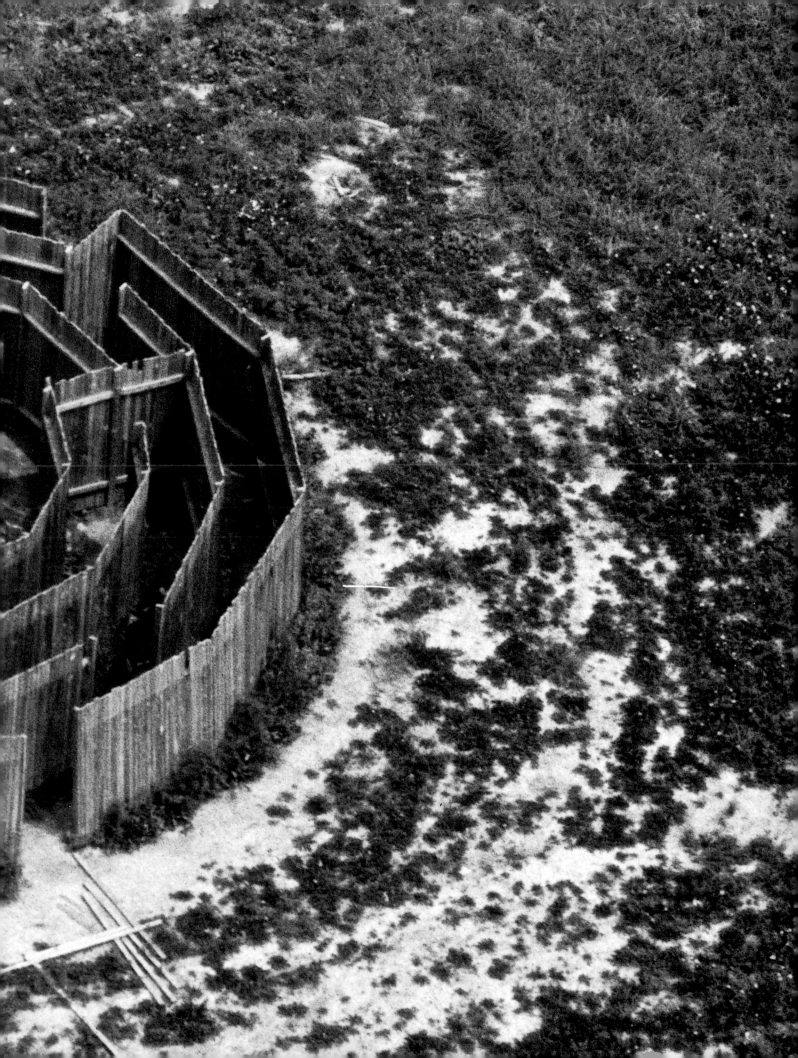

"Originally planned as a circular structure of 9 concentric rings, the actual maze was a 12-sided wooden structure of 5 concentric dodecagonal rings, broken by 19 points of entry and 17 barriers. These points of entry and barriers were constructed so that a passage through the maze involved a series of decisions and resulted in the loss of one's sense of direction. The diameter of the whole was approximately 32 ft. The height was 6 ft. and it was unroofed. While it was located in a semi-isolated area, the presence of the maze and speculations on its origin had been spread within a 30-mile radius by word of mouth. Its prolonged physical existence was tenuous; however, the maze has generally acquired a kind of local mythical existence like its predecessors, e.g. the Labyrinth of Minos on Crete." A. A.

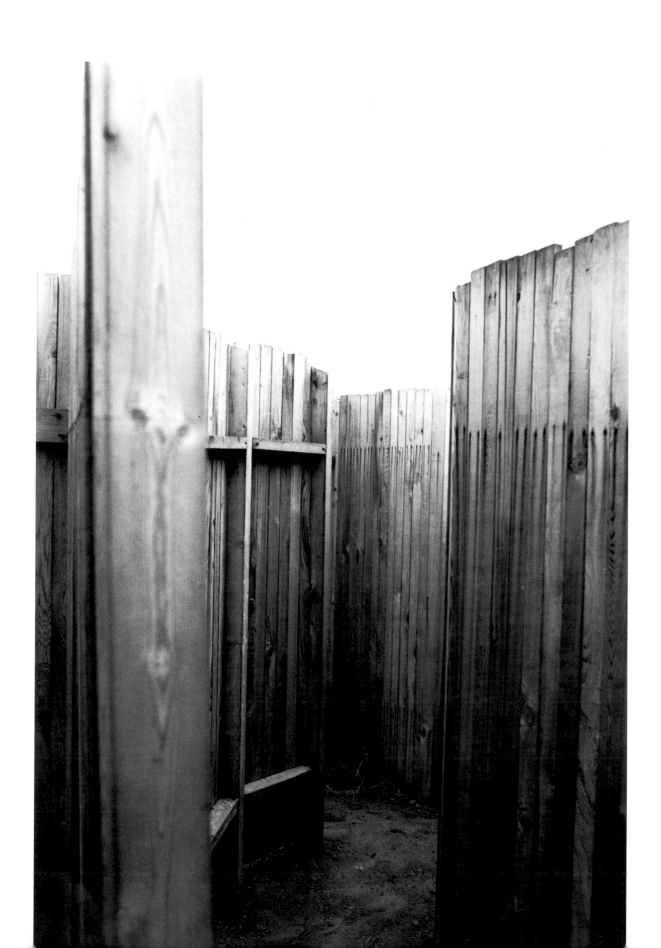

a prison."[2] As prisons, labyrinths can be considered models of ensconced ideologies that channel people along predetermined paths; only when viewers rise up to a bird's-eye view can they begin to perceive the artificiality of the labyrinth encompassing them. Aycock's use of this source anticipates by several years Foucault's research into the discourse of prisons and surveillance appearing in his *Discipline and Punish: The Birth of the Prison,* which was first published in English in 1977. But even before the English translation of this study, Aycock was familiar with the work of Foucault's teacher, Merleau-Ponty, concerning the body's effects on power and knowledge, which Foucault subsequently inverted. Thus, although her *Maze* is a catalyst for phenomenological looking that rethinks Merleau-Ponty's ideas in terms of Nauman's example so that knowledge and power are coercive factors determining the body's orientation, it could be considered Foucauldian in orientation if not in inspiration. In addition to associating this piece with an ancient Egyptian prototype, Aycock has likened it to Native American stockades. She also names Daedalus's famous labyrinth in Crete as one of its predecessors— significantly, a legendary architectural work, made to house the Minotaur, that was created by the first Greek sculptor to attain mythic status.

Aycock's choice of the term "maze" for the title of the work merits explanation, especially because she later often used the two terms, "maze" and "labyrinth," interchangeably in her various interpretations of the work. Although some writers do not differentiate between the two words and believe that they can be used indiscriminately, it is important to note that, for all their apparent complexity, labyrinths really only allow one to take a single path to achieve a predetermined goal. These configurations are predominant in art and literature before the Renaissance, when their inevitability symbolized the fate that preordains the route one must follow. Far more modern is the maze, which made its initial appearance in the

Renaissance when the responsibility for one's destiny was thought to be a matter of individual choice. Therefore, mazes, unlike labyrinths, contain intersecting paths representing the discriminations that each person must make.[3] As Aycock herself noted, "I took the relationship between my point of entry and the surrounding land for granted, but often lost my sense of direction when I came back out [of the maze]." She added, "I forgot the interconnections between the pathways and kept rediscovering new sections."[4] Because of the differences between labyrinths and mazes, Hermann Kern in *Through the Labyrinth: Designs and Meaning over 5,000 Years* concludes, "Taken one step further, one could accordingly regard the clearly laid-out labyrinth as 'Catholic' and the emancipated, profane idea of the maze, with its strong emphasis on the responsibility of the seeker, as 'Protestant.'"[5]

While creating *Maze,* Aycock felt that at last she had found a means for synthesizing her M.A. thesis on highways into her art:

Like the experience of the highway, I thought of the maze as a sequence of body/eye movements from position to position. The whole cannot be comprehended at once. It can only be remembered as a sequence.

I was asked if I thought a maze was a basic form like the circle and the square. No, not exactly. But it seems to be a recurrent need—an elaboration of the basic concept of the path. I certainly intended to tap into the tradition. And what about Borges's reference to that "one Greek labyrinth which is a single, straight line . . . invisible and unceasing"?[6]

She has also pointed out, "I see my work [referring specifically to *Maze*] as a shift from Morris and Nauman to architecture."[7] In relation to Morris's prior work, this assessment was particularly apt, because he dispensed in the mid 1960s with architecture as too grand in scale and too competitive with his phenomenologically

oriented works. He turned to architecture again only in 1974, when he created his *Labyrinths* and *In the Realm of the Carceral* series, which suggest a working knowledge of both Aycock's and Nauman's art.[8]

For Aycock, one of the attractions of her *Maze* is that "people in the Harrisburg area who happened onto the piece would not know it was intended to be a work of art: they would have had to assume it was art in order for it to become so."[9] This unclassified experience is appropriate to Aycock's later and wider project for sculpture. Soon after the completion of *Maze*, it became popular with the high school and college-age crowd in the area, who invaded it at night for impromptu gatherings. These escapades culminated in the piece's destruction when one of the groups' many fires ignited a section of it.

Because it comprises several points of entry and a number of alternative routes and dead ends, Aycock's *Maze* could be said to symbolize the hazards of modern life, particularly its complexities and ambiguities as well as its contingencies, frustrations, doubts, and blind alleys. Unlike unicursal labyrinths popular in the Middle Ages that implied a master plan foreordained by God, Aycock's multicursal piece forces viewers to make difficult choices and to come to terms with their inability to predict outcomes in this disorienting structure.[10]

This three-dimensional puzzle also affords the possibility of two distinctly different vantage points: one is experienced inside the structure and is chaotic and confusing; while the other, which is attained through the artist's photograph from a vantage point outside the maze and slightly above it, provides an overview of the exciting visual complexity the piece offers.[11] These two basic modes of looking at and understanding mazes and the mazelike world beyond them—which Merleau-Ponty viewed in terms of a phenomenological/Cartesian or body/mind split—have furnished Aycock with a model for her later work. Only a few years after

creating *Maze*, she posited polarities between it and its various histories in the form of architectural sculpture and the libretto-like text augmenting it, which also represents the perspectival divide between the body and the mind. Later she takes this split further in her machine sculptures, which play with a schizophrenic displacement of mental capacity analogous to the data-processing capabilities of personal computers.

Although Aycock has wondered if the revival of the maze might be one of her most important contributions to seventies art,[12] a number of artist-originated mazes both preceded and came after hers. Among them are Tony Smith's several forays in the genre in the 1960s, Patrick Ireland's 1967 mirrored labyrinth without an entrance, John Willenbecher's labyrinths of 1969, and Dennis Oppenheim's field *Maze* of 1970, which was constructed of bales of hay. These works, together with Richard Fleischner's well-known *Sod Maze* of 1974 and Morris's labyrinth, indicate the enthusiastic response to this art form that occurred in the late 1960s and early 1970s.

Though Aycock cannot be awarded the honor of resuscitating this genre, she has mined it more fully as a structural paradigm for art than have many of her contemporaries, who were only occasional creators of actual labyrinths and mazes. Aycock has considered the maze formally as a sculptural/architectural hybrid and also as an elaborately wrought intellectual puzzle that exhibits difficulty, intricacy, elaborateness, tortuousness, and affectation. In addition, she has looked at mazes critically as a means for interpreting art though unlimited semiosis.

Her understanding of mazes as elaborate and ingenious intellectual frameworks, whose beauty lies more in their complexity than in their clarity, was no doubt catalyzed by her reading of Jorge Luis Borges's intricate descriptions of architectural puzzles in his short stories, which were themselves intellectual mazes. The idea that a maze can be figurative rather than literal is the raison d'être of

8.3
Saul Steinberg, untitled drawing, 1957. Ink on paper.
Originally published in *The New Yorker*, June 1, 1957.
© The Saul Steinberg Foundation/Artists Rights Society
(ARS), New York.

his "The Garden of Forking Paths." This story presents a narrative about Ts'ui Pên's confused novel of that name, which is itself the maze on which the story focuses. In his denouement Borges explains:

The Garden of Forking Paths *is a picture, incomplete yet not false, of the universe such as Ts'ui Pên conceived it to be. Differing from Newton and Schopenhauer, your ancestor did not think of time as absolute and uniform. He believed in an infinite series of times, in a dizzily growing, ever spreading network of diverging, converging and parallel times. This web of time—the strands of which approach one another, bifurcate, intersect or ignore each other through the centuries—embraces* every *possibility.*[13]

Later, we will see that Aycock's own elaborate narratives form intellectual mazes of interpenetrating, overlapping, and incongruent times in the manner of Borges.

Her *Maze* can also be connected to Saul Steinberg's popular book *The Labyrinth.*[14] One of the book's early segments is a vignette on language in which each individual speaks in a specialized form of script. These scripts include a cubist construction, a maze, a constructivist drawing, a dot-to-dot configuration, a baroque arabesque sprouting foliate shapes, a cursive script that surrounds its speaker, smudged halting writing, and an elaborate nineteenth-century folly. On one page Steinberg parodies the difficulty, if not the impossibility, of communication by showing three individuals who each crystallize a visual equivalent of language in a different style (fig. 8.3). The little girl joins botanical forms with her relief-like speech that looks like fairground architecture, while the man's speech is solidly three-dimensional and constructivist and the woman's assumes the polite patois of delicately drawn Victorian rococo. Taken together, the three create an impenetrable maze on the order of Aycock's late '70s writings and her drawings both during this time and later.

The maze had also been thematized in Anthony Shaffer's successful Broadway production *Sleuth: A Play,* which was made into the classic British film *Sleuth* by Joseph L. Mankiewicz, released in December 1972, several months after Aycock completed *Maze.* Although the maze in this film comes at too late a date to be considered an influence on Aycock's work, its importance to both the play and the film, where it is literally and figuratively represented as an actual maze and as the plot's structure, indicates the fascination that this subject was then eliciting in both popular and fine arts. One of the leitmotifs of the film is the garden maze that constitutes the set for the opening scene and then becomes the key narrative device through which the intertwined plot with its false leads, disguises, and feigned plots are all articulated.[15] While we might speculate on reasons for the popularity of this type of mystery, which emphasizes the resourcefulness and surprising connivances of its characters, such analogies as the interminable war in Vietnam with its convoluted military tactics seem perhaps too reductive. It may be sufficient to surmise that changes in all areas of society at the time—including the explosion of information, the escalation of popular culture, annual announcements of new competing vanguard schools, the sexual revolution, the full-fledged development of the women's movement, and the assassination of key political figures in the United States—all culminated in the need for artistic symbols capable of registering the new complexity and relativity that seemed to be invalidating old ways of thinking and standard modes of reacting without providing clear and viable alternatives. As restatements of the problem, mazes would help to resolve these complexities by realizing them playfully, encouraging individuals to enter into the game and forcing them to assume responsibility for their own choices and arrive at their own solutions.

In light of the changes from late modernism to postmodernism that Aycock's work helped to enact, it is tempting to view the maze as a leitmotif of the dilemma facing artists who could no longer take comfort in the Greenbergian certainty of medium specificity as the goal and content of serious new work. The 1960s in New York had constituted modernism's last efflorescence. At the end of this heady period of almost constant change, the force behind modernism suddenly petered out. It was soon replaced by more freewheeling and less clearly identifiable currents. The new postmodern realm of possibilities confronting artists in the late 1960s and early '70s began to seem like a maze, with blind alleys, alternative routes, and unknown goals. This approach became a modus operandi for Alice Aycock's *Maze* (1972) and later for much of her work in the second half of the '70s, when she figuratively reconstrued the maze in terms of alternative and often conflicting readings of her art that she appended to her fantastic architectural sculptures.

9

Low Building with Dirt Roof (for Mary), 1973

There exists for each one of us an oneiric house, a house of dream-memory, that is lost in the shadow of a beyond of the real past. I called this oneiric house the crypt of the house that we were born in. . . . It is on the plane of the daydream and not on that of fact that childhood remains alive and poetically useful within us. . . . To inhabit oneirically the house we were born in means more than to inhabit it in memory; it means living in this house that is gone, the way we used to dream in it.

Gaston Bachelard
The Poetics of Space, 1958

The summer after creating *Maze,* Aycock undertook another major project on Gibney Farm that she called *Low Building with Dirt Roof (for Mary)* (fig. 9.1), which has at times been incorrectly referred to as "Buried House." Like *Maze,* this piece was made with the artist's full knowledge that members of the New York art world would not travel to see it and that her contemporaries at 112 Greene Street would be able to view only photographs of it. Even so, Aycock wanted to create an actual load-bearing structure and not just a stage set. For the load-bearing portion of this building she employed twelve-by-twelve timbers. The non-load-bearing walls consisted of uncut fieldstone joined with mortar. The fieldstone was found either in the immediate locale where *Low Building* was constructed or at the site of an old, partially ruined house nearby on the Gibney property.

The work represented a reconsideration of Robert Smithson's *Partially Buried Woodshed* (fig. 9.2).

87

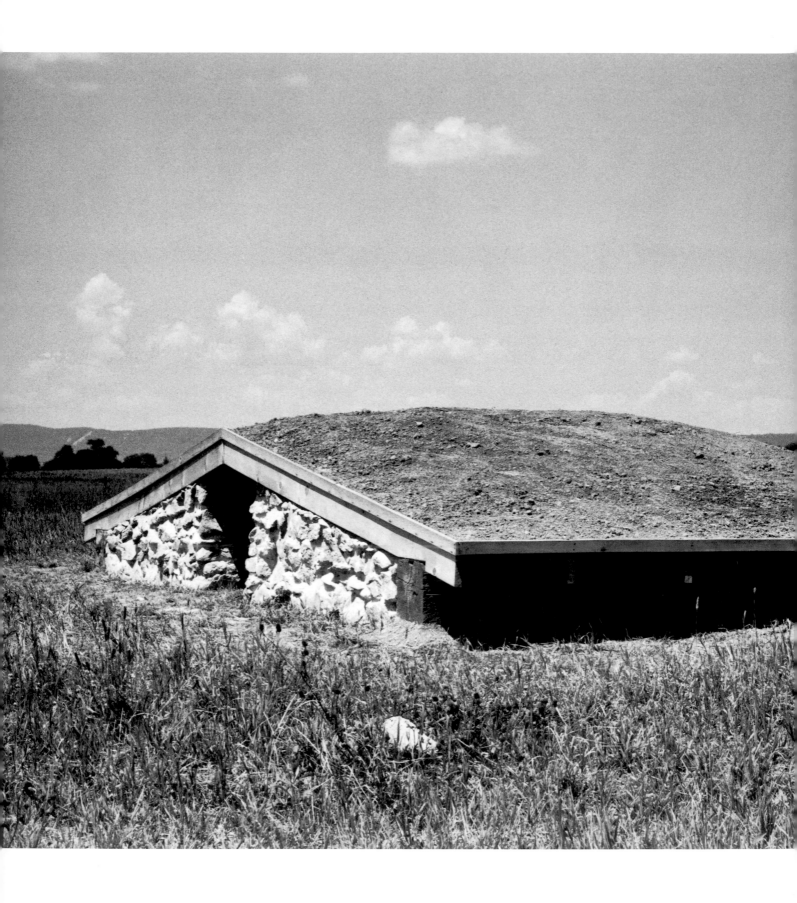

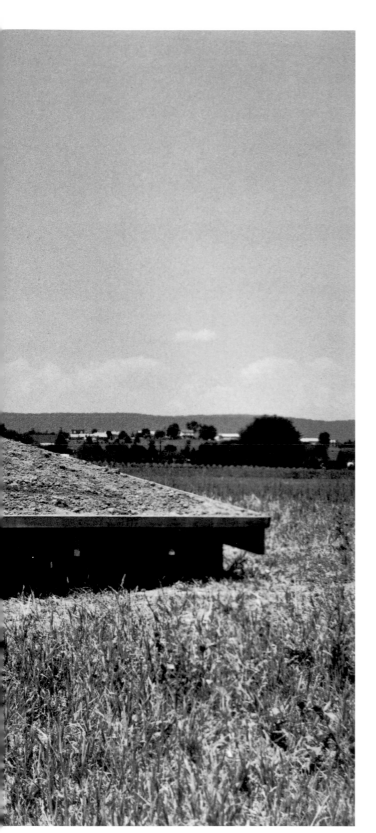

9.1

Alice Aycock, *Low Building with Dirt Roof (for Mary)*, 1973.
Wood, stone, and earth, 30″ high × 20′ wide × 12′ deep.
Gibney Farm near New Kingston, Pennsylvania. Collection
of the artist. Photo: artist.

"The basic structure of the building consists of a
pitched roof supported by two (12″ × 12″) timber walls
12′ long and two interior posts (6″ × 6″ × 30″ high). Uncut,
mortared Weldstone walls (16′ long), which bear no
weight, enclose the front and back of the building. The
stone was gathered on the site. From its lowest
interior height of 12″ the pitched roof rises to a height
of 30″ at the ridge beam where the entrance is located.
The body posture of anyone moving into the building
ranges from a crouched hand-and-knees to a flat
horizontal position on the ground. The sense of
claustrophobia inside is increased by the knowledge
that the exterior surface of the roof is covered by a
mound of earth (approximately 7 tons). The decisive
factor in the selection of the site and orientation of the
building was the horizon. The building is located
on a rise in the landscape so that from slightly below
the entrance the earth mound of the roof forms an
artificial horizon beyond which no other objects are
visible. Built in July 1973, on the Gibney Farm near New
Kingston, Pennsylvania, the building has exterior
dimensions of 12′ × 20′ (including roof eaves) and a
roof slope of 1/6." A. A.

9.2

Robert Smithson, *Partially Buried Woodshed*, 1970, Kent
State University, Ohio. One woodshed and twenty truckloads
of earth, 18′ 6″ × 10′ 2″ × 45′. Estate of Robert Smithson.
Courtesy of James Cohan Gallery, New York. © Estate of
Robert Smithson/Licensed by VAGA, New York, NY.

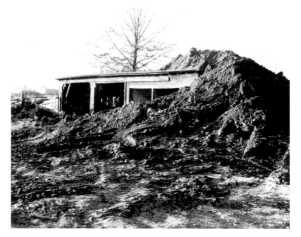

The summer before she constructed *Low Building*, Aycock had seen near the Gibney Farm some abandoned and partially destroyed greenhouses with pitched roofs that reminded her of Smithson's work. Instead of being a planned industrial accident like *Partially Buried Woodshed*—in which earth was piled on an abandoned outbuilding located on the margin of the Kent State University campus until its center beam cracked—*Low Building* was a constructed memorial relying on local building materials and time-honored carpentering. Because Aycock built the piece with some help from her relatives, it could be seen in terms of 1960s counterculture movements that advocated a return to basics coupled with an emphasis on individual integrity and resourcefulness. *Low Building*'s references reached back to distant times rather than the nonhistoric recent past that fascinated Smithson, and its sources include the pitched roof forming the entryway of the Tomb of Aegisthus in Mycenae.

Aycock wanted this structure to recall sod-covered houses built in the Neolithic period as well as in the nineteenth century on the great prairies of the United States. Early in her career she developed a fascination for ancient and third-world vernacular architecture. One of her favorite sources was Bernard Rudofsky's *Architecture without Architects: A Short Introduction to Non-Pedigreed Architecture*. She agreed with Rudofsky that Western architectural historians had ignored vast sectors of indigenous building forms and contented themselves with the relatively narrow tradition that glosses over the first fifty centuries of building.[1]

Low Building, which Aycock calls "nonfunctional architecture" rather than sculpture,[2] served as a low screen rising slightly above the horizon on which seasonal changes and crop rotations could be projected. If wheat or alfalfa was planted in the adjoining fields, its seed covered the ample sod roof of *Low Building*. Aycock built the piece mainly to take full advantage of its frontal

view. She wanted the piece firmly embedded in the landscape, and at the same time she intended its pitched roof to form a distinct break in the horizon. This work has important personal associations for Aycock, to the extent that she felt "exposed and vulnerable, even a little silly" when she exhibited photographs of it.[3] However, it also draws upon the artist's reading. The truncated building recalls the form of architecture advocated by one of the inventive architects in Jonathan Swift's Lagado who "contrived a new method for building houses, by beginning at the roof, and working downward to the foundation."[4] *Low Building* also resonates with ideas found in Gaston Bachelard's *The Poetics of Space* and Vincent Scully's *The Earth, the Temple, and the Gods*.

Aycock's description of *Low Building* includes a revelation of both familial and historical sources for it:

About fifteen years ago I visited the house in which my great-great-grandparents Benjamin and Serena lived and where my great-grandfather Francis was born. It was a small wood-frame house. I climbed up alone into the attic where they slept and stood under the rafters. In the yard was the family cemetery. I remember the tombstone of Catherine, who died at age three. Years later, I dreamt that my brother Billy came for me and took me to that same wooden house set into the hills of Greece like a tholos tomb. I climbed the stairs again and behind a screen, a young girl, whose face I could not see, lay dead.[5]

The connection between house and cemetery reflects the impact that Joseph Rykwert's book *On Adam's House in Paradise* (1972) had on Aycock's thinking about humankind's first houses, which served the dual functions of dwellings for the living and tombs for dead ancestors. As Aycock's Soho neighbor James Wines, the architect who masterminded the Sites projects, later explained, "Her early works, like *Low Building . . .*

were more explicitly archaeological in feeling and based on vernacular archetypes for shed structures. This particular enclosure recalled an Iron Age dwelling or part of an early agrarian settlement."[6] In an interview with art historian Jonathan Fineberg, Aycock connected Rykwert's concept of the first house to the building belonging to her great-great-grandparents in North Carolina. In addition, she pointed to the significance of Bachelard's *The Poetics of Space* and noted that its first chapter is entitled "The House, from Cellar to Garret."[7]

If one moves from Aycock's reference to Bachelard to the book itself, it is possible to understand why she empathized with his analysis of one's first house. Bachelard joins Merleau-Ponty's phenomenology with C.G. Jung's archetypes to create images that can be personalized and also considered universally. He undertakes in this book a "topo-analysis," a mixture of descriptive psychology, depth psychology, psychoanalysis, and phenomenology that he terms "the systematic psychological study of the sites of our intimate lives."[8] Bachelard's phenomenology assumes a psychological orientation, using tombs as archaeological metaphors for the preobjective experiences harbored throughout one's life. Merleau-Ponty regarded these encounters as formative to an individual's later experience of the world.

Although Bachelard's entire first chapter can be related to Aycock's piece, two sections are worthy of special note. The first is structuralist in intent, since it states that we internalize the house of our childhood and later become "the diagram of the functions of inhabiting that particular house."[9] Our first house forms the architecture of our dreams. Bachelard writes, "I called this oneiric house the crypt of the house that we were born in."[10] In a later passage he suggests two spaces that are particularly cathected: the cellar and the attic. These, he says, occupy "a phenomenology of the imagination." "Near the roof," he continues, "all our thoughts are clear. . . . As for the cellar . . . it is

first and foremost the *dark entity* of the house, the one that partakes of subterranean forces. When we dream there, we are in harmony with the irrationality of the depths."[11] Bachelard tries to portray this phenomenological and archetypal architecture in positive terms and describes this early structure as one's "cradle,"[12] even though such a structure can also be considered one's crypt.

In her Stuttgart interview, Aycock free-associated about the Bachelardian first house, which represented to her the dualities of human existence, becoming by turns "a shelter and a tomb, a bunker and a prison. When you are underground in these tombs [referring to the rock-cut Mycenaean graves buried in the ground that she had visited], you feel at once very protected and you also feel the crush of the earth on top of you. And you move back and forth between these sensations."[13] These contradictory feelings occurred in relation to *Low Building* because, even at its highest point, its interior space was so confining that it barely permitted anyone to sit upright (fig. 9.3). Aycock commented on both the confinement of this work and the strong and particularly ambivalent feelings it engendered in her in a piece of free-associational writing:

You, Margaret, knowing the story [of the Aycocks' family home in North Carolina], said it reminded you of an attic on the ground. And you, Perrine [Martin, a witch from the Middle Ages], said it reminded you of the houses which the poor people in the Midwest built. First, they built the basements, covered them with an A-frame, and lived underground for a few years until they had the money to build the first story. You said you used to go to their houses and play with their children and eat tomato soup. I remember the night you had to use the men's room in the gas station. You said you hated that toilet. The smell of piss was like thick soup. Like in those pissoirs in Europe, it had been gathering for years. You said when they piss they get it all over the sides of the toilet.[14]

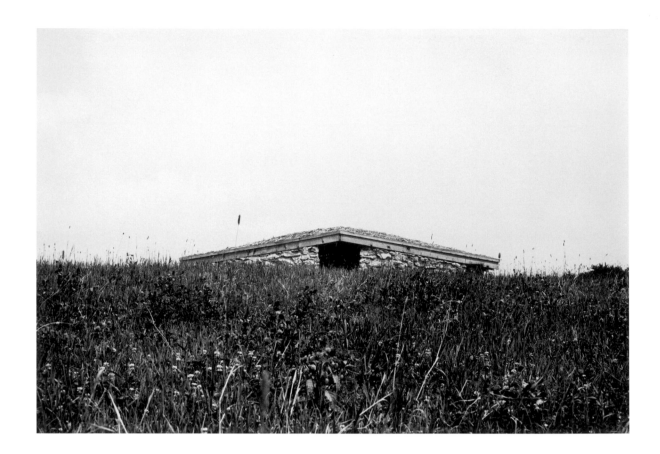

In an interview with Grace Glueck for a *New York Times* review, Aycock summarized some sources for *Low Building* already enumerated in her interview with Fineberg and even added a few. "A whole lot of things had worked in me," she told Glueck, "frontier homes, the tunnels and tombs of Mycenae, the myth of Clytemnestra and Agamemnon, dreams, the memory of my grandparents' attic. I also have a shelter concept— a sort of physiological need for a 'first house.' . . . The heaps of burning garbage toward the outskirts of Cairo in which people have tunneled rooms and which they pop in and out of like prairie dogs."[15]

Aycock refers either to Greek tholos tombs or to such members of the tragically fated House of Atreus as Clytemnestra and Agamemnon in most of her discussions of *Low Building*. Such an exploration is in part justified when one recalls that Aycock's tour guide for her trip to Greece in 1970

was Scully's *The Earth, the Temple, and the Gods.*[16] In his book, Scully advances the questionable yet still intriguing hypothesis that Greek architecture is specifically sited so that it stands—like Greek deities and like the House of Atreus—in direct opposition to the landscape that it symbolically dominates, an approach that Aycock found reasonable and useful.

9.3 (previous pages)
Low Building with Dirt Roof (for Mary), interior. Photo: artist.

9.4
Low Building with Dirt Roof (for Mary). Photo: artist.

10 Feminism

Otherwise titled "This Is MY Opening Farewell": I see you there, you filthy, imbecilic child with your adult face, with that hole in your adult face, that hole between your mouth and your nose with the snot running out of it; with your dirty, filthy hands grasping at me, pulling me into your face—sticking it out, pushing it into my face. "Hey mister! Madame! Hey mister monsieur! Madame! Hey monsieur! Here's to you, my friend, monsieur! Yeh! Here's to you, my friend, monsieur! Yeh! Here's to you! Your health, madame, your health! In the dry desert over which I had to travel, here's to you!" I said, "In the dry desert over which I'm traveling still, here's to you! Here's to you and why not! Hey mister! And why not! Why not, mister? Why not? Why not, madame? Why not? Oh mister monsieur, here's to you! Your health!" I said, "Mister, why not! Oh mister—not a peep out of me. Oh no, they won't get a peep out of me in the dry desert over which I'm traveling still. Here's to you!" I said, "Here's to you. Thanks, thanks a million, madame! Thanks a million times over." I said, "Thanks and here's to you!" I said, "If I allowed myself to hate you in the dry desert over which I'm traveling, mister monsieur, every rock in the dry desert, every rock would lose its shadow." I said, "Hey mister monsieur! Hey mister! In the dry desert I will wear you out. I will wear you out by thinking about you. In the dry desert, in the dark desert, in the vast desert, in the dry, dark, vast desert of existence I will wear you out."

Alice Aycock
Project Entitled "The Beginning of a Complex…"
(1976–77): Notes, Drawings, Photographs, 1977

It seems to me making art is almost prior to everything. . . . A long time ago I saw the cave paintings. You journey deep into the earth, sometimes on little electric trains. It seemed to me then that art felt very prior, felt like the first act, before the written word, before legal systems before everything. . . . An artist who creates is tied very much to invention. And I wanted to know what the relation between making a tool and invention was and how art related to that.

Alice Aycock
from Leo Van Damme, "Alice A. in Wonderland: The
Investigations of Alice Aycock," 1984

Aycock readily acknowledges how fortunate she was to enter the art world at a time when the women's movement was fighting for equal opportunity in all areas of life. However, she strongly believes that her art should speak for itself and be on its own terms. Although gender, race, age, and personal experience have certainly affected and enriched the discourse on art and will continue to do so, to define art made by women—an enormously large category of people—solely based on their gender is for Aycock an extreme position that she calls "ridiculous."[1] On this matter she has often said she is happy that she "doesn't look the way she thinks, and think the way she looks."[2] She believes artists should be "ambidextrous, androgynous, and ambivalent," at least initially.[3] Despite her resistance to a feminist tag, Aycock's approach can be correlated with art historian Linda Nochlin's retrospective view of the movement: Nochlin questions the legitimacy of "'woman' as a fixed category" and suggests instead that feminism be considered "as something more fluid, constructed, and variable."[4] As this overall study of Aycock's art will demonstrate, her art—despite her statements to the contrary—is clearly in line with many of the "feminist models of fragmentation, pluralism, diversity, subjectivity, activism —all leitmotivs of postmodernity" that critic Jan Avgikos hypothesizes as feminism's great and enduring legacy.[5]

Lucy Lippard included Aycock in one of her earliest feminist exhibitions, *Twenty-Six Contemporary Women Artists,* which opened at the Aldrich Museum in Ridgefield, Connecticut, in April 1971. Besides Aycock, some of the women included in this important show were Cecile Abish, Cynthia Carlson, Mary Heilmann, Sylvia Mangold, Mary Miss, Howardena Pindell, Adrian Piper, and Jacqueline Winsor. At the time there seemed to be some justification for considering Aycock's work feminist because it relied on the embodied experiences of both herself and her viewers as they explored the interiors of spaces.

Such experiences, which are the basis for Merleau-Ponty's brand of phenomenology, were a mainstay of most feminist groups in the 1960s, whose members individually and in concert began trying to make sense of their experiences as women. They tended either to adopt ideological modernist and engendered views in the belief that women are distinctly different from men, or to acknowledge most gendered conventions as long-held pernicious views that must be brought to consciousness before being discarded. The consciousness-raising activities of many women's liberation groups were devoted to discussions of the participants' experiences as women, with special emphases on encouraging them to express their personal frustrations and injustices. Once their personal feelings were vented, participants in these often wrenching discussion sessions believed they would be empowered to direct their energies to the specific problems they had articulated and thus begin to transform personal feelings into political consciousness.

For Lippard's exhibition, her first appearance in a group show, Aycock made a mud piece that Mark Segal helped her build (fig. 10.1). He describes it as a reification of its own construction. "We had built a six-foot square, foot-high plywood box," he recalled, "and filled it with 2,000 pounds of clay powder mixed with water to make a muddy liquid. Over a period of weeks the mud slowly dried out and then cracked, so that it came to resemble the mud flats we had seen in Death Valley in 1969. It was an elegant dialectic between process and product, with the object arresting as an image in itself, containing within its imagery the process of its formation."[6] The work was so heavy that it had to be taken out of the studio by a crane. After the exhibition, the piece was sunk into the ground and left permanently at the Aldrich. Although its appearance in an exhibition of women artists suggested a feminist reading (for example, as an incarnation of mother earth), the work is remarkable for its closeness to some of Robert Smithson's

early pieces, such as his 1966 proposal for a Philadelphia earthwork entitled *Tar Pool and Gravel Pit*. It also recalls Iranian artist Marcos Gregorian's paintings constructed of soil that often looked like fields of parched earth.

Seven years after Lippard's landmark exhibition, critic April Kingsley made Aycock the centerpiece of a study that included Cecile Abish, Nancy Holt, Mary Miss, Mary Shaffer, and Michelle Stuart. Kingsley's questionable goal was to articulate differences between female and male earthworks. "Male 'earthworks,'" she argues, "are public objects that externalize the values of society in the traditional ways art has always done, whereas the women's works are private places made for interiorizing values and universal experiences."[7] In her effort to develop a criterion for a feminist site-specific aesthetic, Kingsley relies on contemporary truisms that naturalized women as homemakers emotionally in touch with the world around them. Consequently, she thinks that female site-specific artists wish to create congenial spaces that they themselves would like to occupy. She proposes the highly speculative and idealistic argument that since women prefer working with their hands, they establish a connection with their sites and materials, unlike men who attempt to dominate them. Furthermore, she argues that female site-specific artists remain intuitive in their responses and maintain in their work an emotional kinship with expressionism and surrealism.

In response to Kingsley's piece and the remarkable amount of work in the landscape that women were creating in the 1970s, Lippard wrote "Complexes: Architectural Sculpture in Nature," which was published in 1979. In this article Lippard develops the new term "shelter sculpture" for the current work that women were undertaking and projects her ideas about possible inherent connections between the female body, architecture ("called 'the mother of the arts' and . . . probably invented by women"), and the earth.

10.1 (following pages)
Alice Aycock, *Clay #1*, 1971. 2,000 pounds of clay mixed with water in wood frame, 6′ × 6′ × 12″. Photo: artist.

97

One of the claims of "shelter sculpture" to a new reality might be based on its assumption of a knowledge or at least an awareness of the roots of a sculpture and architecture in matter, in the earth and in the female body. . . . It may even be that since women in modern Western cultures have not been discouraged to be architects, much "shelter sculpture" is in fact the architectural impulse "feminized." [8]

Among the artists included in this initiative is Aycock, whom Lippard commends for keeping "the center . . . inviolable." [9]

This inclusion of Aycock's work in discussions of feminism necessitates a closer look. At the outset, we need to assess the range of feminism in the 1970s, when the four major tendencies of conservative, radical, social, and liberal feminists were fighting for supremacy, and to consider these competing modes in relationship to Aycock's work. Conservative feminists sought to perpetuate differences between the sexes; radical feminists proclaimed patriarchy the enemy; social feminists intended to establish group solidarity with other oppressed groups and classes; and liberal feminists looked to legislative reform such as the equal rights amendment to overturn a bankrupt system because they viewed men and women as essentially alike in their mental abilities even if they might assume different procreative roles. Judy Chicago belongs to the first and second group; Lippard to the first and third; while a great many women artists such as Yvonne Rainer, Susan Rothenberg, and Aycock are in accord with the fourth group. All are feminists, but each represents a different division.

Feminism in its various manifestations during the 1970s was thus considered part of the vanguard mainstream—to use an oxymoron then suitable to conditions of the avant-garde—so that it was part of the discussion among advanced artists at the time. Since Aycock was maturing as an artist during this time of intense consciousness-raising,

proselytism, and open debate, it would have been impossible for her to avoid some contact with the movement, even though she agrees with many liberal feminists in considering herself and her work to be far removed from it.

Because Aycock's art can be grouped within liberal feminism, her status vis-à-vis other types of feminism is highly problematic. She is neither a full-fledged conservative feminist artist wishing to discern essential differences between the sexes, nor a woman unmindful of the feminist project or untouched by the changes it enacted. She wishes to reform the system and level the playing field so that she can compete fairly. Moreover, the differences between conservative/radical and liberal feminists may help us to understand the coincidental fact that the temporary exhibition space Womanhouse, organized by conservative/radical feminists such as Chicago and Miriam Schapiro, opened on the West Coast in spring 1973, just months before Aycock created *Low Building with Dirt Roof.* In light of the differences between these two camps of feminists, one wonders if Aycock's work should be taken as a direct or implicit critique of Womanhouse—or whether she even knew of this event at the time she made *Low Building,* since she no longer remembers.

As late as the 1990s, Aycock still experienced difficulties in reconciling herself and her work with conservative, radical, and social types of feminism and did not recognize her affinities with the liberal and unaffiliated branch of this group. In 1990 she told Grace Glueck, "We [women artists] were young and we didn't have a lot of preconceptions about gender. . . . The art did a good deal to break down conventional stereotypes of what men did and what women did." [10] The following year she appears to countermand this pro-feminist observation by stating flatly, "Art is androgynous. I rarely thought, 'They're not letting me do this because I'm a woman.' It might have been true, it might still be true, but I don't allow myself that rationalization. Ego survival is

hard enough for an artist."[11] Despite their differences, both positions can be grouped under a liberal feminist rubric. Equally liberal feminist are Aycock's remarks seven years later: "I have been fascinated with male culture and would not retreat into some notion of feminism to defend myself. I walked the thin line. I am driven by the aspect of so-called male culture where they have no trouble going for something they want—playing to win."[12]

If we move back in time to Aycock's years at Hunter College, we find that she was in contact with the social/liberal feminist Linda Nochlin when the latter was working on her landmark essay "Why Are There No Great Women Artists?" Not only did Aycock sit in on several of Nochlin's art history lectures at Hunter, but she was also the slide librarian there and was in daily contact with its art history faculty. She remembers that Nochlin's version of art history demonstrated the importance of a social-political context and helped her move beyond minimalism.[13] Because Nochlin's essay is so important to the women's movement and affected how work by women was then being regarded, it is essential for understanding Aycock's art.[14]

While many of the specifics of Nochlin's argument relate to earlier historical periods, her indirect reliance on phenomenology to reinforce her social history is important for Aycock's work. Nochlin cites Piaget's work on children to fortify the interactions between children and social situations in the formulation of genius, which she terms "a dynamic activity, rather than a static essence, and an activity of a subject *in a situation.*"[15] This situational approach, in which social forces are a major factor in determining results, is implicit in the following discussion:

The question "Why are there no great women artists?" has so far led to the conclusion that art is not a free, autonomous activity of a superendowed individual, "influenced" by previous artists, and more vaguely and superficially, by "social forces," but rather, that art making, both in terms of the development of the art maker and the nature and quality of the work of art itself occurs in a social situation, is an integral element of the social structure, and is mediated and determined by specific and definable social institutions, be they art academies, systems of patronage, mythologies of the divine creator and artist as he-man or social outcast.[16]

Nochlin concludes that the autonomy of the individual artist has been undermined by geography and suggests, in the manner of Foucault, that priority be given to the social field that makes actions possible rather than to the individuals enacting them. A brief look at Foucault's importance for social/liberal feminism is thus in order. In his writings Foucault rejects phenomenology's emphasis on the absolute priority of an observing subject, since this subject is already embedded in a number of discourses and power relations of which he or she may be only partially or unconsciously aware—an approach crucial for social/liberal feminism. Moreover his development of the concept of the archive—which differs from a collection of empirical data in that it represents the a priori conditions enabling one to establish a point of view—depends on Merleau-Ponty's notion of preobjective experience as underlying and characterizing an individual's receptivity to later encounters. In consideration of culture's impact on empiricism, we might say that Foucault historicizes Merleau-Ponty; and we might go even further and state that Nochlin in turn critiques the engendering cultural archive by detailing a historical perspective toward women and providing a rationale for the then-current feminist slogan "the personal is political." Thus women's acculturated gender traits, according to Nochlin, have predetermined both what is seen and how it is viewed.

Aycock remembers thinking that the title of Nochlin's essay was extremely provocative and frightening because she asked the core question on everyone's mind, especially women's. If few women had distinguished themselves from the mass of humanity as exceptional in any discipline, maybe women were condemned to silence or at best mediocrity. She reflected,

My classes with Linda Nochlin helped me to better understand the political and social context that allows for the exceptional person to arise within a society. This distinguishing quality is rare in either sex, but the notion of a sense of entitlement in terms of access to knowledge and opportunities should not be. Because I was born in a family where the intelligence of a woman was never in doubt, I had the good fortune to be able to identify from my childhood with the historical pantheon of remarkable people that certainly includes women.[17]

Although Aycock did not recognize this approach as liberal feminist since all such tactics were conflated at that time, her statement reveals this type of orientation.

Aycock later added that being an artist means being true to feelings of a radical sense of oneness that goes beyond gender differentiation, even though the feelings may be "infantile and narcissistic." Apropos of this observation, she cited N. N.'s assertion, "I got my name at the beginning of the world, when I began to live,"[18] as corroboration for these intense feelings and then pointed to the following passage by him as further support:

My father and mother wanted me to go to a place beyond the earth. But the house where I was born is mine, and nobody can take it away from me. I once found an entrance to the Garden of Eden. It was a hole or a ditch in the earth and I nearly fell through. This is the place where I came out, the place where I was born—in the Garden of Eden. It is as if you are driving a car through a dark forest and suddenly

you go through a tunnel and fall forward, head first, with great speed.

Once upon a time I came out of a place where there was no door. That was before I had a name. Some people thought that I was born like that—in the desert or in the woods, like a wild animal. Or maybe I was born in the Garden of Eden and had no mother. I came right up through the earth, somewhere near the Mississippi, and there was a great mountain there to stop me. I had no name for some time, and then my father fought with me and would not let me stay at home.[19]

Reaffirming her birthright through her art was of crucial importance to Aycock. Even as this feeling caused her to subscribe to traditional forms of individuality, it also reinforced a mythic anonymity and an openness outside current ideological constraints compatible with aspects of 1970s liberal feminism that emphasized art more than its maker.

Besides reinforcing her own sense of destiny and her doubts about the ideological nature of male artists' priority, Aycock's reading of Nochlin's essay and her concurrent conversations with this feminist scholar reinforced the formative role of both Foucauldian and Merleau-Pontian perspectives for her work. These philosophic approaches helped to undermine not only the authority of the artwork but also that of the artist, transforming both the making and the reception of art into knowledge that is dependent on power relations as well as one's place in the social network and one's particular view of it. Consequently, one of the ways to deemphasize the cultural stereotypes that have prejudiced both society's attributes and women's acculturated views is to force viewers to become conscious of their role in determining a given work's meaning, a tactic Aycock has used in her art.

While Merleau-Ponty did not focus on the specifics of gender and race, his thought could be interpreted in these terms and actually was in the late 1960s and '70s by a range of feminists (though

such a reading proved most useful to the movement's liberal wing). In order to use Merleau-Ponty, feminists had to transform his natural view of perception into a constructed one—similar to the approach Foucault used—so that current definitions of femininity could be seen as ideological. They used Merleau-Ponty as part of a twofold critique, in which they first attempted to comprehend their orientation to the world as women before assessing it ideologically to understand its artificiality. Their reconstitution of Merleau-Ponty's form of phenomenology enabled them also to rework Robert Morris's art-for-art's-sake brand of phenomenological minimalism. Even though Morris was known as the preeminent phenomenologist among the minimalists, his brand of minimalism was geared to universal viewers without sexual, racial, and political affiliations.[20] Moreover his works of art employed devices such as mirrors and the different placement of the same primary forms, such as the two L-shaped pieces of fiberglass making up *Untitled* (1965), to tease detached viewers into acknowledging their embodied presence in relation to a work of art. At the same time, this reciprocity encouraged viewers to dispense with long-cherished ideas about the sacredness and separateness of art objects that had depended on their virtuality for this effect. While feminists were rethinking Morris's contributions from a sexual perspective, Aycock was reconsidering them mainly from historical, literary, and scientific points of view. Thus, due to her reconstitution of the art object and the specificity of its viewers, she can generally be categorized as a liberal feminist.

Differing from some first-generation, self-conscious feminists and acting in accord with other members of this group, Aycock views gender roles as historically determined and socially constructed narratives that can be manipulated at will. In her art she relies on both male and female trickster figures—a reliance that indicates her unwillingness to identify her art with the type of set gender patterns that less perceptive artists have embraced. Aycock's many heroes and heroines—which include such males and females as Death, Sadie of the City of the Dead, Gilles de Rais, Franz Ferdinand, Windbag Man, Elizabeth, the Hangman of the World, the Pig of Knowledge, and the nongendered ghosts haunting machines—are all tricksters or shape-shifters whose shenanigans are intended to be open-ended. Employed as protagonists in Aycock's art, they ward off romanticized concepts of women and men as stable entities and function similarly to the schizophrenic N. N., who dramatizes the self's many disparate roles and inability to maintain over time a monolithic sense of self.

11 Drawing on Patriarchal Order while Deflecting It

The painter who draws by practice and judgment of the eye without the use of reason is like the mirror that reproduces within itself all the objects which are set opposite to it without knowledge of the same.

Leonardo da Vinci
Notebooks

Aycock's work has moved beyond Linda Nochlin's general assessment of drawing as an engendered and therefore highly ideological medium that has been directed in different ways by men and women. In "Why Are There No Great Women Artists?" Nochlin concludes that the type of drawing permitted to women in the nineteenth century constituted a compromised activity. To prove her point Nochlin cites a passage from Mrs. Ellis's *The Family Monitor and Domestic Guide*, which was widely read in both England and the United States before the mid nineteenth century. According to Mrs. Ellis, "Drawing is of all other occupations, the one most calculated to keep the mind from brooding upon itself, and to maintain that general cheerfulness which is a part of social and domestic duty. . . . It can also be laid down and resumed, as circumstance or inclination may direct, and that without any serious loss."[1] Nochlin accepts at face value this nineteenth-century woman's conclusion that drawing has become for her the artistic equivalent of embroidery and crochet: it is a harmless

form of busywork guaranteed to keep women usefully occupied.

Nochlin's attitude toward drawing in her article is part of a much larger attack on this mode of working as the basis of an academic hierarchy that had been codified in the Renaissance. She may have cited the nineteenth-century attitude toward drawing both because it portrays the plight of women at that time and because it differs substantially from the Renaissance conception of drawing as *disegno,* the foundation of art and the mode that the sixteenth-century artist, chronicler, and critic Vasari most recommended for the realization of genius. Mrs. Ellis's comments would have formed yet another way for Nochlin to buttress the strengths of the realist tradition that she attempted later in her career to reinforce through both careful analysis and by rebutting its principal adversary, the idealist Renaissance emphasis on drawing. A proponent of this august attitude, Vasari refers to *disegno* as "the parent of our three arts, Architecture, Sculpture, and Painting, having its origin in the intellect."[2] He then elaborates:

From this knowledge there arises a certain conception and judgment, so that there is formed in the mind that something which afterwards, when expressed by the hands, is called design, we may conclude that design is not other than a visible expression and declaration of our inner conception and of that which others have imagined and given form to in their ideas. Some believe that accident was the father of design and of the arts, and that use and experience as foster-mother and schoolmaster, nourished it with the help of knowledge and of reasoning, but I think that, with more truth, accident may be said rather to have given the occasion for design, than to be its father.[3]

Vasari's engendered vision of drawing as male is made explicit in this passage, and it is an approach that has continued to be generally upheld. Because of its continued force, Nochlin made this vision one of the objects of her ongoing, adversarial program in the 1970s.

Nochlin's ironic engendered reference to drawing as an appropriate form of women's busywork differs from the Renaissance understanding of it as patriarchal and idealist. As a social/liberal feminist, Nochlin assumes a tactical advantage in her fight against this male prejudice, implying that their long-extolled masculine feats might be as prosaic as an ordinary bourgeois woman's needlework. She also casts doubt on the received wisdom that the realist tradition, beginning with northern European Renaissance painters, constitutes mere replications of nature whereas idealist art reasons, abstracts, and distills nature, as the Leonardo epigraph suggests.

In the 1970s Aycock began making drawings not just as an adjunct to her sculpture but as a distinct mode of thought. Since she has established drawing as a mainstay of her art by developing a low-key, almost deadpan style that emulates the work of architects and engineers, one must assume that she is also trying to refute the trivialization of the genre as women's busywork and also to deflect Vasari's glorification of it by reconsidering it from the perspective of a fully engaged, erudite human being who happens to be female. Even if she was not thinking of Nochlin's essay, the long-embedded prejudice that women are able colorists while men are thinkers capable of the rigors of *disegno* may have encouraged her to redirect architectural draftsmanship and engineering drawings so that they might bespeak a new role for artists that goes against the grain of essentialism. Such an attempt at discourse reformation has to be considered feminist in intent even if it is far removed from the stylistic simplicities that Chicago and Schapiro among others advocated, because its incisiveness demonstrates that women can compete equally with men and can usurp the prerogatives of a patriarchal tradition by disproving their truisms. As part of Aycock's transformation of this highly regarded genre, she

also assumes a distinctively ironic attitude worthy of Lewis Carroll's deliberately miscast forms of rationality when she couches highly fanciful architectural and sculptural schemes in the guise of austere mechanical drawings.

Aycock often manifests her thoughts in the form of isometric or axonometric projections.[4] This style of drawing has a long history stretching back to the sixteenth century, when it was used by military engineers and consequently was called *cavaliere* (referring to the elevated perspective of one on horseback). Leonardo is known to have employed parallel projections, for example. The oblique views of axonometric or paraline drawings offer artists a distinct advantage in clarifying depth perception in their works. Only in the early nineteenth century did axonometric projections become popular, when their clarity of presentation made them an excellent descriptive formula for solid geometric forms, mechanical drawings for engineers, and archaeological reconstructions. These associations with engineering, architecture, geometry, and science also made the paraline mode an expedient style for such early modernists as El Lissitzky and Theo van Doesburg, who wished to avoid the preciousness of traditional architectural rendering and to emphasize instead the kinship of their art with a machine aesthetic. Their use of axonometry has in turn influenced late-twentieth-century architects, who have made paraline drawings a primary medium for their design ideas and a standard that has become virtually synonymous with postmodern developments beginning in the mid 1970s. Axonometric drawings have appealed internationally to such leading figures as Aldo Rossi in Italy, Oswald Mathias Ungers in Germany, Leon Krier in Great Britain, and Michael Graves, Peter Eisenman, Richard Meier, and Bernard Tschumi in the United States.

Because parallel lines in axonometric projections do not converge in a vanishing point as they would in one-point perspective drawings, no specific viewer's stance is privileged by these works even though a bird's-eye view and three-dimensional solidarity of structure are indicated. "I didn't know how to draw," Aycock has admitted, "and so I taught myself isometrics in order to see pieces ahead of time, to see what they were *going* to look like. I just bought myself a book and taught myself the whole thing."[5] The ambiguity about observer's location in axonometric projections works to Aycock's advantage, as she wishes to present viewers with a number of possible interpretive means and points of view. Taken in tandem with her sculptures, axonometric drawings dispel the certainty of a distinct observer's position that her early sculptures necessitate, thus contradicting their phenomenological space. This tactic, which became increasingly important as Aycock's works advanced in the 1970s, involves setting up viewer situations that her carefully drafted texts undermine. As Aycock explained when referring not to a technical drawing but to the performance set up by the sculptures themselves:

What I'm trying to do is to take a normal architectural situation and make it disjunctive, and the only way to do that is to take the normal situation and put it somewhere that it wouldn't be. A parallel for this can be found in the structure of a sentence. There is the good sentence, it is grammatically correct and it also generates a set of directions which make sense, i.e., which elicit a clear response. Then there is the bad sentence. It may or may not be grammatically correct but it generates a set of directions for which a clear response is impossible. It is disjunctive, one set of direction responses is contradicted by another.[6]

We might conclude that Aycock's mature works—both her objects and their implied histories and ramifications—follow this model of the disjunctive sentence.

Because the dry mechanical plans favored by engineers since the nineteenth century and by

architects since the twentieth have been viewed as masculine, Aycock's appropriation of them for her own aesthetic and highly fanciful ends flies in the face of historically conditioned and essentialized gender roles and thus can be construed as a liberal feminist gesture. This approach is consistent with her general strategy to upset naturalized categories of thought. Both her drawing style and her sculpture are affected by this strong desire for a rigorous, authentic manner of working. "I spend a lot of time before I draw at all, just thinking," the artist has remarked. "I have to see a piece in my head first—it has to emerge, this image—and I don't even do little sketches. It really has to come right from my head, and then I'll sit down and do the whole thing."[7] In her drawings Aycock regularly challenges herself to deal with complex and thought-provoking ideas. Consequently, she has looked to recent research in philosophy, critical theory, schizophrenia, and quantum mechanics as subjects for her work.

108

12 Architectural Sculpture

Up, down, left, right, backwards, forwards—these are the six dimensions of space as defined by the writer Borges. These dimensions comprise a set of sensorimotor directions which the body must comprehend in order to orient itself in the world. These dimensions/directions are naturally operational during one's experience of the highway. They are also operational when one experiences architecture or more simply enclosed spaces. The most basic enclosure is the hut or windscreen. The cellar and the attic belong to the complex or fleshed out hut. They are the most non-functional aspects of the house. On a conventional or metaphorical level, up and down correspond to the cellar and the attic. From the cellar and the attic one can derive four behavioral responses represented in the form of continua: from claustrophobia to claustrophilia, from acrophobia to acrophilia. On a more general level the continuum from phobia to philia can be seen as a movement from disorientation to orientation and back to disorientation.

Alice Aycock
Project Entitled "The Beginning of a Complex..."
(1976–77): Notes, Drawings, Photographs, 1977

Minimalist artists and their critics often referred to architecture, even though they were loath to credit it with inspiring their primary forms. Their rhetoric on occasion treads the precarious boundaries separating art and architecture, at times appearing to be using architecture to sanction a new way of thinking. Phenomenology enabled some minimalists to secure new laurels by developing innovative sculpture that incorporated actual space as opposed to virtual space (as seen in Michelson's discussion of Morris) without trespassing on the domain of architecture. The situation was heightened in the case of both Sol LeWitt, who had earlier been employed as a graphic designer in

109

the architectural firms of I. M. Pei, and Tony Smith, an architect who had worked with Frank Lloyd Wright. "Architecture and three-dimensional art are of completely opposite natures," LeWitt stated unequivocally. "The former is concerned with making an area with a specific function. Architecture, whether it is a work of art or not, must be utilitarian or else fails completely. Art is not utilitarian."[1]

Tensions between architecture and sculpture resulted in ongoing contradictions. When he discussed his Black paintings, Stella with one hand credited the role architecture played and then with the other withdrew the idea of such an influence:

I enjoy and find it fruitful to think about many organizational or spatial concepts in architectural terms, because when you think about them strictly in design terms, they become flat and very boring problems. So I guess I use a little bit of the outside world by bringing in architecture as another way of looking at the problems, as a way of expanding them. But I think my painting remains a distinctly pictorial experience—it's not finally an architectural one.[2]

Far less generous than Stella, Robert Morris writes of the architectural component of some late-sixties sculpture as a reactionary representation of latent romanticism. "At the extreme end of the size range," he writes in "Notes on Sculpture, Part 3," "are works on a monumental scale. Often these have a quasi-architectural focus: they can be walked through or looked up at. Some are simple in form, but most are baroque in feeling beneath a certain superficial somberness. They share a romantic attitude of domination and burdening impressiveness. They often seem to loom with a certain humanitarian sentimentality."[3] No doubt he is alluding to works by Ronald Bladen and Tony Smith. Still a confirmed phenomenologist in this essay, Morris prefers sculpture that is human-scaled so that the presence of the body in

conjunction with his fabricated forms will represent a one-on-one confrontation. When he creates architectural sculpture, he makes certain that the scale of his lintels, columns, plinths, and labyrinths does not dwarf his viewers. In these situations architectural scale is summoned on stage, given a nod, and politely and quickly urged to beat a hasty retreat. No doubt this situation arose because the architecture under consideration was modern, and this type of building was so monolithic and forceful that it could easily overwhelm its recently developed hybrid, minimalism. Modern architecture transcends the virtual/real divide central to Morris's art and also serves as an important aesthetic component of LeWitt's and Smith's work, despite their statements to the contrary.

A truly hybridized form of architectural sculpture could only develop in tandem with a dramatic rethinking of the modern architectural paradigm. And the first step of this new approach happened in 1968 when Aycock read Robert Venturi and Denise Scott Brown's *Architectural Forum* essay "A Significance for A&P Parking Lots or Learning from Las Vegas,"[4] an early version of the thinking that would be developed in their book *Learning from Las Vegas.*

Aycock was inspired the following year to include this island of urban glitz and semiotic sleaze on a trip whose itinerary was to have included important recent earthworks by Walter De Maria, Michael Heizer, and Robert Smithson. Although she visited only national parks on this trip instead of earthworks, she did stay in Las Vegas. Touring this city and reading Venturi's writings encouraged her to go back to his earlier study *Complexity and Contradiction in Architecture* (1966), which had the added distinction of MoMA's imprimatur as the first volume in its new series on architecture. Aycock later said, "Venturi is a great theorist. I responded strongly to his ideas."[5] Railing against the continued hegemony of modernism in the early and mid 1960s, Venturi

noted that, unlike architectural studies, most humanistic and scientific endeavors have understood the creative potentials of "complexity and contradiction."[6] To corroborate this, he cited work by Kurt Gödel, T. S. Eliot, and Josef Albers and referred to criticism by Cleanth Brooks, Kenneth Burke, and William Empson. Then with the full-blown rhetoric of a manifesto, he declared:

Architects can no longer afford to be intimidated by the puritanically moral language of orthodox Modern architecture. I like elements which are hybrid rather than "pure," compromising rather than "clean," distorted rather than "straightforward," ambiguous rather than "articulated," perverse as well as impersonal, boring as well as "interesting," conventional rather than "designed," accommodating rather than excluding, redundant rather than simple, vestigial as well as innovating, inconsistent and equivocal rather than direct and clear. I am for messy vitality over obvious unity. I include the non sequitur and proclaim the duality.

I am for richness of meaning rather than clarity of meaning; for the implicit function as well as the explicit function. I prefer "both-and" to "either-or," black and white, and sometimes gray to black or white.[7]

This statement was liberating for young architects in the late 1960s and early '70s wishing to avoid the limitations of the reified quasi-historic, decorative approach later ratified as "postmodern" and wanting to be less orthodox, more open, and certainly more critical. Venturi provided these architects—and Aycock—with a basis for rethinking architecture.

Bernard Tschumi's essays on architecture summarize key changes in the 1970s that have also proven to be important for Aycock's art.[8] Having read Venturi's *Complexity and Contradiction in Architecture,* Tschumi wished to find a way out of the impasse of modernism. Fluent in the new French critical theory, he undertook in the mid

1970s a deconstruction of one of modern architecture's central truisms, the idea that "form follows function," which had received its most cogent launching in Louis Sullivan's writings. Tschumi based his argument on examples from the work of Italian and Austrian architectural groups and individuals coming of age in the late 1960s, such as Superstudio, Archizoom, Hans Hollein, Walter Pichler, and Raimund Abraham, who paralleled conceptual art in their efforts to dematerialize architecture. Tschumi hoped to accomplish this deconstruction by questioning any individual's ability to experience simultaneously actual space and the concept of it. Going against the grain of modernism, he points out that there is "no simple relation between the building of spaces and the programs within them."[9] Since neither activity can incorporate the other, each involves a lack that destabilizes architecture's presumed solidity, transforming it into a series of ongoing disjunctions between the concept and the event that Tschumi analogizes in terms of the pyramid and the labyrinth. "As opposed to the previously described Pyramid of reason," he writes, "the dark corners of experience are not unlike a Labyrinth where all sensations, all feelings are enhanced . . . for perception in the Labyrinth presupposes immediacy. . . . The metaphorical Labyrinth implies that the first moment of perception carries the experience itself."[10] This passage sounds as if it has been informed by conversations with Aycock and was actually written with an awareness of her *Maze,* which was shown at 112 Greene Street the year before. But since labyrinths and mazes had been created by a number of sculptors during this period, Tschumi's ideas should be considered part of a period response to differences between ontology and epistemology as well as between empiricism and rationality that were also crucially important for Aycock's art.

In the 1970s architecture was being redefined as a conceptual mode rather than just a builder's art, as Tschumi explains in the following passage:

"What is architecture?" asked Boullée. "Will I define it with Vitruvius as the art of building? No. This definition contains a crass effort. Vitruvius takes the effect for the cause. One must conceive in order to make. Our forefathers only built their hut after they had conceived its image. This production of the mind, this creation is what constitutes architecture, that which we now can define as the art to produce any building and bring it to perfection. The art of building is thus only a secondary art that it seems appropriate to call the scientific part of architecture." At a time when architectural memory rediscovers its role, architectural history, with its treatises and manifestos, has been conveniently confirming to architects that spatial concepts were made by the writings and drawings of space as much as by their built translations.[11]

Tschumi concludes that architecture has become cerebral and that the work involved in erecting structures has been relegated to craft. Several years before Tschumi's essay, the globe-trotting Italian curator/critic Germano Celant posed a similarly disarming question in the catalogue for *The New Italian Landscape*, a MoMA exhibition. "If architectural work consists of questioning the nature of architecture," he asked, "what prevents us from making this questioning a work of architecture in itself?"[12] According to Tschumi, there is indeed nothing that prevents us from doing so. A conceptualist, he regards built form as nonessential—a rarefied and Cartesian view. Unlike Tschumi, however, Aycock was not ready to give sole priority to her drawings and statements and to dispense with constructed pieces as cumbersome nonessentials. Her architectural sculpture must be placed precariously on the cusp separating ideas and space that Tschumi so eloquently describes. In addition it needs to maintain the dialectical tension between the two in order to problematize the very different activities of thinking about objects in the world and directly experiencing built versions of them,

similar to her childhood experiences of playing with the model of the home her father designed while living in the built-out version of it.

Some historians would see Aycock's resistance to architecture as a purely conceptual activity, and her incorporation of building as one of the central components of her new hybrid "nonfunctional architecture," as suggesting an alliance with the approach of Charles Moore, particularly since he paralleled her interest in vernacular forms. But the differences between the two are far greater than their similarities. First, Aycock did not view conceptual architecture and construction as mutually exclusive. Second, unlike Moore, her concerns were far less stylistic than structural. Rather than celebrating vernacular adornments as key signs of regional styles, as Moore did, she was concerned with vernacularism as a basic and broad approach. Consequently, she favored in her works of the early and mid 1970s such common building materials as ordinary concrete blocks, reinforced concrete culverts, and balloon frames, without the benefit of art historical overlays. As she admitted to Fineberg, lumber was readily available wherever she traveled, and carpentry is a "general sort of skill that people in a gallery have."[13]

Wood should be considered either a proto- or early-industrial material, according to A. C. Crombie, the distinguished historian of science whose book *Medieval and Early Modern Science* was an important source for Aycock:

Until the end of the 18th century the most important material for machinery and construction generally was wood. Most of the parts of watermills and windmills, spinning wheels, looms, presses, ships and vehicles were of wood, and wood was used for geared wheels in much machinery as late as the 19th century. Thus it was that the first machine tools were developed for working wood, and even in the tools themselves only the cutting edge was of metal. . . . Wood, as Lewis Mumford has

vividly pointed out, "provided the finger exercises for the new industrialism."[14]

Not only were wooden machines and tools formative for industrialism, but industrialism itself transformed carpentry; the balloon frame, first known in the nineteenth century as Chicago construction, was made possible because of machine-made nails and improved sawmill machines. These advances created a situation in which "a man and a boy can now [in 1865] attain the same results, with ease that twenty men could on an old-fashioned frame [joined by mortise and tenon]," as G. E. Woodward explained in *Woodward's Country Homes* of 1869.[15] In addition, this man and child could be relatively unskilled and would not require intensive training in the refinements of carpentry demanded of old-style builders. The lightness of this style of building and its ubiquity in post–World War II America, where it was used for the acres of tract houses making up the many Levittowns built in the Northeast, were important considerations for Aycock's incorporation of the balloon frame in her work. In addition, its associations with Russian constructivist stage design—particularly Liubov S. Popova's austere, innovative concept for Vsevolod Meyerhold's production of Fernand Crommelynck's *Magnificent Cuckold* in 1922—provided this approach with a respected artistic precedent. As Aycock later said of Russian constructivist theater design, "That was some of the best sculpture ever made. . . . They were working with space in a way that defied gravity. I was very attracted to it."[16] Her early preference for the balloon frame over other forms of construction poses a fascinating critique of the combined discourse of modern sculpture and architecture, particularly the mid-twentieth-century bricolaged bits of Victorian gingerbread that had catapulted Louise Nevelson—one of Aycock's favored role models at this time—into the position of the country's greatest woman sculptor.

Aycock was not alone in her desire to rethink architecture by putting aside function so that she could focus on form and meaning. Gordon Matta-Clark organized a yearlong discussion at 112 Greene Street in anticipation of *The Anarchitecture Show*, presented in this space in March 1974, one month before Aycock's exhibition there. Aycock did not participate in these conversations, but she was clearly aware of them since she talked frequently to Matta-Clark. Among the participants of both the discussions and the exhibition that followed them were Laurie Anderson, Tina Girouard, Suzanne Harris, Jene Highstein, Bernard Kirschenbaum, Richard Landry, Matta-Clark, and Richard Nonas. Several members of this group, including Matta-Clark and Kirschenbaum, had received training in architecture, so they felt even more keenly the need to rethink it. As Girouard later reflected, "We met virtually through our exposure at 112 Greene Street, and we started meeting to talk about 'architecture and architorture and artic-vector and anartdeflector." Matta-Clark acknowledged, "We were thinking more about metaphoric voids, gaps, leftover spaces, places that were not developed. . . . For example, the places where you stop to tie your shoelaces, places that are just interruptions in your own daily movements. These places are also perceptually significant because they make a reference to movement in space."[17] As this statement indicates, architecture became equivalent to the envelope of space surrounding individuals. This group's researches were largely phenomenological investigations intending not only to ferret out the meaning of this space but to see how their perceptions of it transformed it. Although she was not a participant in this group, Aycock recognized that, as a nonfunctional architect making sculpture, she could look at building in a radically new way as a set of forms that could be transformed at will: she could design an upside-down stair if she wished or suspend a door in midair, while traditional architects had to

worry about making habitable buildings and meeting code.

For her first solo exhibition at 112 Greene Street in 1974, Aycock constructed *Stairs (These Stairs Can Be Climbed)* (1974; fig 12.1). Because she was still in the process of teaching herself carpentry, *Stairs* was overbuilt, as were many of her works at the time. She spent four months working on the piece. During this period, she pored over books on carpentry and sought professional advice when unclear about solutions. Near the end of the process of building *Stairs,* she decided to employ a professional carpenter to help her.

When conceiving the piece the artist reflected on her trip to Mexico in 1973, when she had visited all the major Aztec sites and was particularly intrigued with pyramids scaled by vast staircases, which frightened her as she came down them. The culture itself also interested her, as she has indicated:

It is in part the neurotic quality of pre-Columbian [culture] which I respond to. It is obsessive, brutal, angry, extravagant, aggressive, fearful. Motivated by an incredible need to pacify the universe, to eliminate uncertainty, the pyramids with their solar and astronomical orientations are mere bases for the temples on top, which are reached by staircases inclined at angles of forty-five degrees or greater. These staircases are intended to establish a system of correspondences between the position of the priest as he climbed and the position of the sun as it moved across the sky. I always think of the title of a book, The Design of Inquiring Systems. . . .

The pyramid of Tenayuca consists of eight superimposed pyramids, each preserved within the other. The pyramid at Tlatelolco had fourteen superimpositions. All that remains is a succession of fourteen double staircases leading nowhere, each one larger than the one behind it.[18]

Aycock wanted people to actually climb to the top of the piece and to be confined by the space there. Consequently she came up with the second part of the title, informing viewers that these stairs are exactly what they purport to be. As she has remarked, "I intend my architectural elements to be taken literally. If there are stairs in a piece, they are intended to be stairs."[19] In addition to climbing the stairs, people are supposed to play a key role in turning the event into knowledge, as the artist's reference to C. West Churchman's *The Design of Inquiring Systems: Basic Concepts of Systems and Organization* strongly suggests. In this book Churchman, a pragmatist and one of the best-known apologists of the systems approach to management, interprets the viewpoints of various philosophers, such as Leibniz, Locke, Kant, and Hegel, in relationship to the ongoing role humans play in creating knowledge, which can never be simply equated with facts. His book sets out to demonstrate the type of goals vital to Aycock's program. For example, he proposes, "Knowledge resides in the user and not in the collection. It is how the user reacts to a collection of information that matters."[20]

Besides the conscious influence of the Aztec pyramids, *Stairs* was also associated in Aycock's dreams with the myth of Sisyphus. Throughout her involvement with building such pieces, she remembers having dreams in which, as she was working on a piece, it would repeatedly fall apart, and she would have to begin building it once again. She also had recurrent euphoric dreams in which she wandered through rooms in endless houses; sometimes she levitated through atriums located in these buildings.

In analyzing *Stairs,* we should consider the phenomenological significance of embodied perception that the piece thrusts in each viewer's path. We should also be mindful of the ways that Aycock has rethought Morris's project to eradicate sculpture's presumed virtuality by creating such a preposterous set of actual steps that they can be seen through literal and virtual lenses.

Bruce Nauman's description of the experience of climbing stairs is especially relevant to Aycock's piece:

. . . going up the stairs in the dark when you think there is one more step and you take the step, but you are already at the top . . . or going down the stairs and expecting there to be another step, but you are already at the bottom. It seems that you always have that jolt and it really throws you off. I think that when these pieces work they do that, too. Something happens that you didn't expect, and it happens every time. You know why, and what's going on, but you just keep doing the same thing. It is very curious.[21]

The surprise that Nauman describes in this passage can be considered a prosaic and low-key form of satori, the enlightenment sought by Zen adherents, in which one is not so much shocked into awareness as slightly jolted into it. In *Stairs (These Stairs Can Be Climbed)*, Aycock creates an analogous situation without the built-in jolt. She projects an occasion for an everyday experience and then finds a way to make viewers self-conscious about it, thus transforming perception into apperception. As critic Roberta Smith noted in an *Artforum* review:

With the staircase, the decision to climb is simple, but neither visual nor esthetic. It involves a whole history of your own responses, of what you know you can or cannot do. Thus Aycock's earlier concern with movement through time and space, previously of herself across abstract boundaries, or of the sun across the sky, has become at once more direct and more mysterious. These structures demarcate a special site and space and provide an opportunity to relate our own physical size, scale and weight to theirs.[22]

As understood by Smith, the activity involved in traversing *Stairs* is phenomenological. Self-realization is primary; in performing this piece,

viewers assume the role of one of Yvonne Rainer's or Simone (Forti) Whitman's dancers who enact on the stage common events from daily life.

Probably as a response to Aycock's exhibition at 112 Greene Street, Nancy D. Rosen and Edward F. Fry asked her to participate in their exhibition *Projects in Nature: Eleven Environmental Works Executed at Merriewold West, Far Hills, New Jersey,* which took place in the fall of 1975. Participants included such notable figures in land art as Carl Andre, Richard Fleischner, Roelof Louw, Alan Sondheim, and George Trakas. Going literally underground, Aycock's contribution extensively reworked a piece that she had constructed the year before at Gibney Farm entitled *Walled Trench/ Earth Platform/Center Pit* (fig. 12.2). For the later version, *Project for a Simple Network of Underground Wells and Tunnels* (fig. 12.3), Aycock created an elaborate series of underground tunnels that are 32 inches wide and 28 inches high, making travel through them a claustrophobic and disconcerting experience (figs. 12.4, 12.5, 12.6).[23]

At the time, Aycock's conversations about early films with Mark Segal had led to fascination with a series of haunting film stills.[24] While working on *Project for a Simple Network*, Aycock was thinking about the scene from F. W. Murnau's *Nosferatu* that takes place in the hold of the ship bringing to Bremen the vampire Count Orlock, who is buried in a coffin (since vampires need to travel with the soil in which they have been interred), along with the many rats that accompanied him. The moment that is crucial for Aycock's piece is the one in which a number of the plague-carrying rats scurry out of this hold. Aycock remembers that the image of proletarians leaping out of barrels in one of Eisenstein's films was also germane to this piece.

But when she provided an accompanying statement for this work, Aycock chose not to reference these early films and instead listed the following associations:

12.1
Alice Aycock, *Stairs (These Stairs Can Be Climbed),* 1974.
Wood, 14′ 2″ high × 9′ 8″ wide × 14′ 2″ deep. Installed at 112 Greene Street Gallery,
New York. Collection of the artist. Photo: artist.

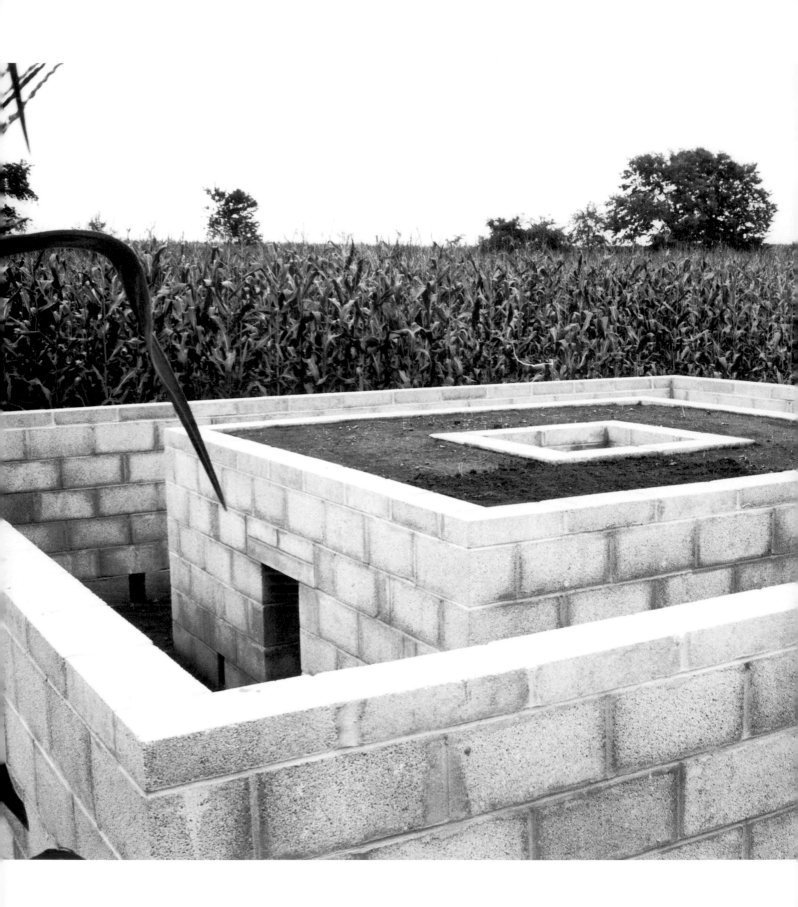

12.2

Alice Aycock, *Walled Trench/Earth Platform/Center Pit*, 1974. Concrete block wall, 5′ high × 21′ 4″ square. Gibney Farm near New Kingston, Pennsylvania. Collection of the artist. Photo: artist.

"The structure consists of three concentric quadrilateral concrete block walls—a solid masonry wall 21' 4" square, a retaining wall 11' 4" square, and a center well or pit 4' square. The outside solid masonry wall rises 3' above the existing grade of the land and encloses a trench 52" wide and 16" below grade (i.e. on the trench side the height of the wall is 4' 4"). The walled trench is defined on the inside by a masonry retaining wall 4' 4" high. This enclosure, backfilled with earth excavated from the site, forms a kind of earth platform which surrounds a square masonry pit 5' deep. A tunnel 18" wide × 52" long × 30" high, of post and lintel construction, runs underneath the earth platform and connects the center pit with the walled trench. The project as a whole is situated in a low, flat area between two rises in the elevation of the land. With no point of entry, the outside wall presents a barrier which must be climbed. In order to reach the inside earth platform one can jump over the trench or one can lower one's body into the trench and then scale the inside retaining wall. However, this is more difficult to scale than the outside wall because the height has increased from waist high to shoulder high. There are no footholds in the walls. From the platform one can lower oneself into the center pit, which at 24" below grade is the lowest point in the surrounding area, or alternately one can enter the pit by the underground passage." A. A.

12.3 (following pages)

Alice Aycock, *Project for a Simple Network of Underground Wells and Tunnels*, 1975. Concrete block, wood, and earth, approx. 28′ wide × 50′ long × 9′ deep. Merriewold West, Far Hills, New Jersey. Collection of the artist. Photo: artist.

"An area approximately 20' × 40' was excavated and a series of six concrete block wells 5' 4" square, connected by tunnels, were built. Three of the wells are open entry wells 7' deep. Three of the wells, 7' 8" deep, are indicated above ground but capped with permanent covers and a layer of earth. One can crawl from entry well to entry well through narrow tunnels 32" wide and 28" high interrupted by vertical 'relieving' wells which are closed and are completely surrounded by earth. The underground structure is demarcated by a 4" wall 28' × 50'." A. A.

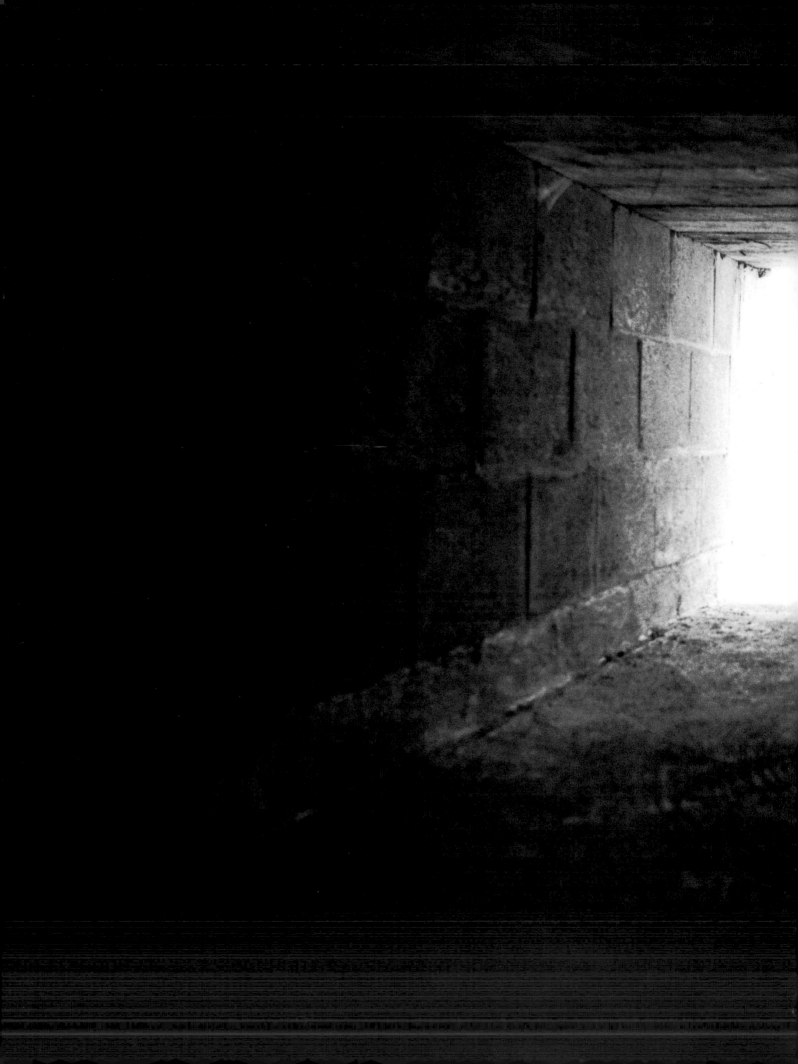

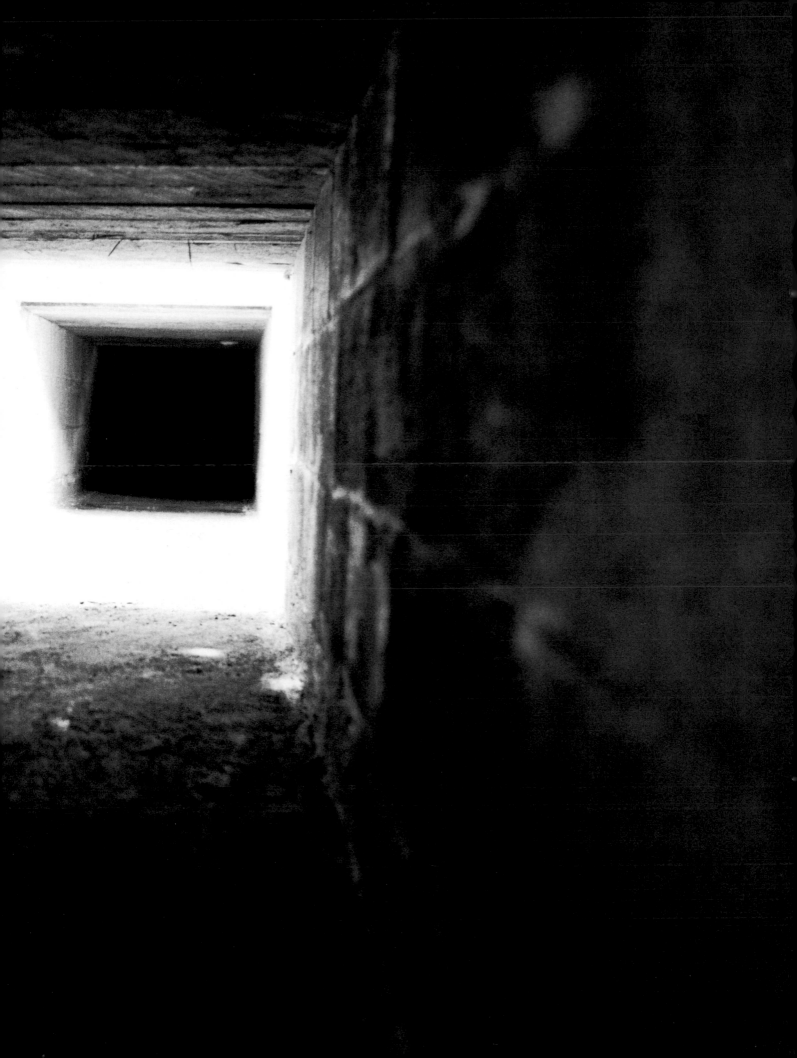

12.4 (previous pages)
Project for a Simple Network of Underground Wells and Tunnels, interior.
Photo: artist.

12.5
Project for a Simple Network of Underground Wells and Tunnels, open entry well
with ladder. Photo: artist.

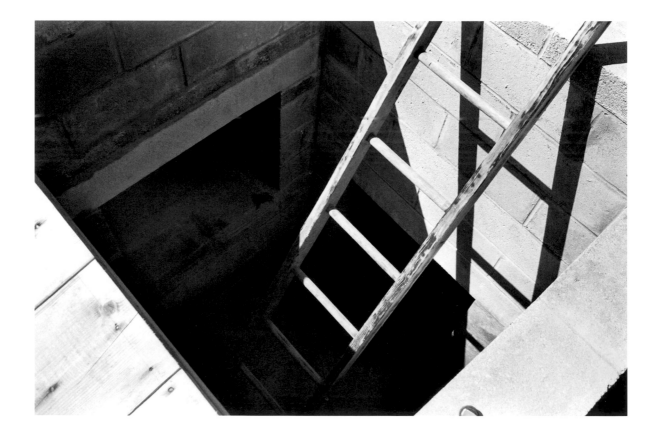

A subterranean network of passages set up for the purpose of operating below the surface of the earth; Gaston Bachelard's reference to "underground maneuvers" and childhood fears of the cellar and attic (see Bachelard, Gaston. The Poetics of Space. *"The house, from cellar to attic, the significance of the hut.")*

The circular pits of the Matmatis people who live beneath the Tunisian desert; square courtyards extending 30 feet below the earth which are light wells for underground dwellings in the loess belt of China [fig. 12.7]; burial holes now inhabited by the living in Siwa, Egypt; tunnels to underground bunkers (Mallory, Keith, and Arvid Ottar, The Architecture of War, *p. 118); The Federal Reserve Bank of New York—subterranean vaults five stories deep; dugouts, cellars, sarcophagi.*[25]

While she wished to seed the work with a wide range of references, the image of witches is particularly memorable, as Aycock's inclusion of the following passage indicates:

Second Hag:
 Come hither.
[She (to the young woman)]:
 O my darling don't stand by, and see this
 creature drag me [down]!
Second Hag:
 'Tis the law drags you.
[She]:
 'Tis a hellish vampire, clothed all about with
 blood, and boils and blisters.

adapted from Aristophanes, Ecclesiazusae[26]

In addition to the copy included in the catalogue, Aycock's own notes on the piece cite the following sources:

Vincent Scully's reference to Greek mystery cults whose architectural sites generally "invoke interior, cave experience," e.g., the underground caves dedicated to the goddess Rhea where castration rites were celebrated; Rider Haggard's character, She, who lived for 2000 years attended by deaf mutes with her dead lover in the caves of Kor, a charnel house containing the embalmed bodies of a mysterious civilization. Edgar Allan Poe, "The Pit and the Pendulum": "At the intersection of the tunnel and the closed vertical wells there is a drop-off where one reaches out into dark empty space: 'my chin rested upon the floor of the prison but my lips, and the upper portion of my head, although seemingly at a less elevation than the chin, touched nothing . . . I put forward my arms and shuddered.'"[27]

Aycock incorporates in this work enough references to ensure a wealth of possible interpretations. But one is left with the impression that *A Simple Network of Underground Wells and Tunnels,* and such related pieces as *Project for Elevation with Obstructed Sight Lines* (fig. 12.8), *Study for a Hexagonal Building* (fig. 12.9), and *Project for a Vertical Maze: Four Superimposed Cruciform Buildings* (fig. 12.10), were intended to be anything but simple: they have much in common with the complexities and contradictions that Venturi found in modern architecture. Moreover, her references to mysterious and confining spaces all connect with the dark and forbidding structure she constructed. Seen in tandem with Rider Haggard's character She, these images constitute an elaborate panoply of associations with witches and similarly transgressive figures capable of making an impact on both life and death.

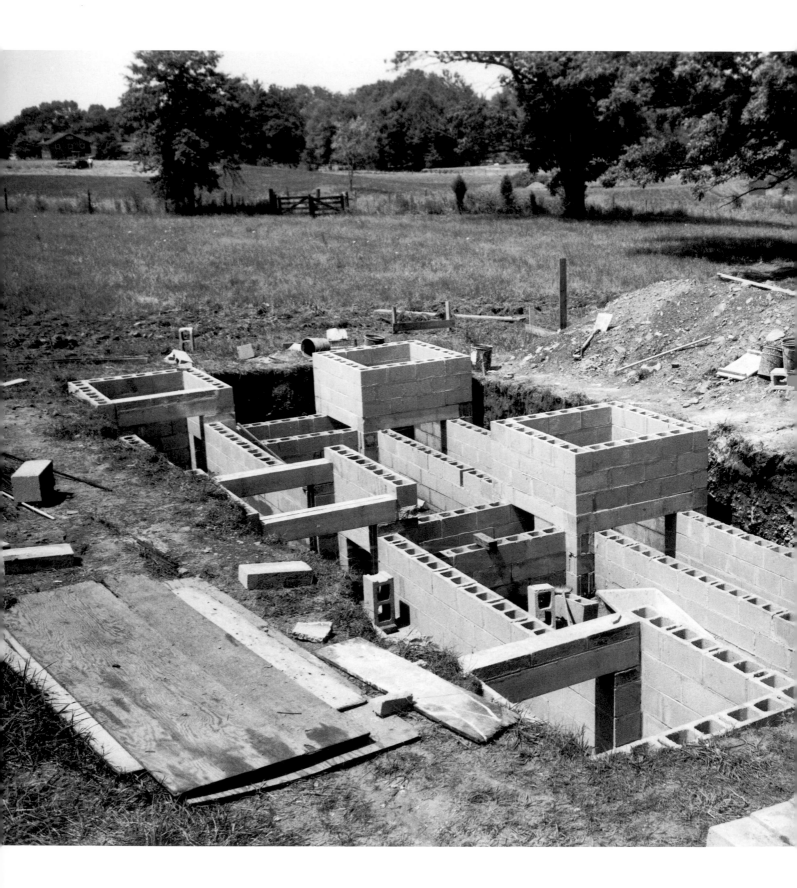

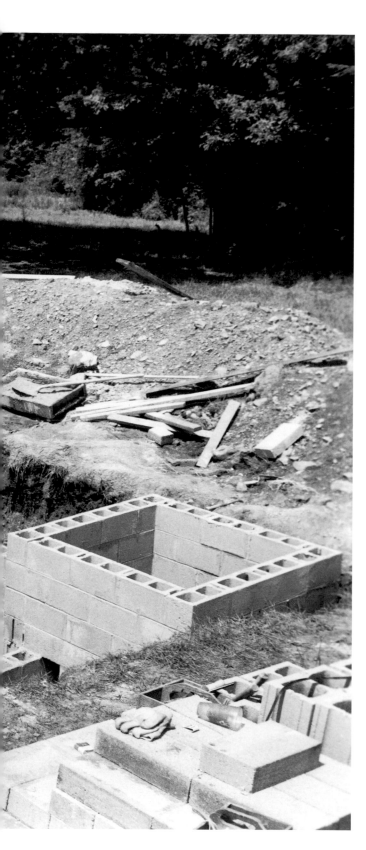

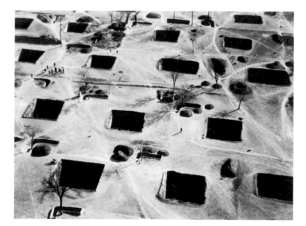

12.6

Project for a Simple Network of Underground Wells and Tunnels, under construction. Photo: artist.

12.7

Underground dwellings in the loess belt of China. Photo: Wulf-Diether Graf zu Castell. Deutsches Museum, Munich.

12.8

Alice Aycock, *Project for Elevation with Obstructed Sight Lines,* elevation, 1972. Pencil on vellum, 15″ × 45³⁄₄″. Private collection. Photo: John Ferrari.

"Cut, fill, and compact an already existing earth formation according to the specifications on the plans. The length of the elevation is approximately 792 feet. Only one side of the resulting structure can be climbed. All other side slopes are steep enough to deter climbing. The elevation of each successive climbing slope is determined by the sight lines of a 6-foot observer so that only as the observer completes the ascent of a given slope does the next slope become visible." A. A.

12.9

Alice Aycock, *Study for a Hexagonal Building,* isometric section, 1975. Pencil on vellum, 21″ × 38″. Solomon R. Guggenheim Museum, New York. Photo: John Ferrari.

"Construct a hexagonal building which encloses a sunken courtyard. The building has two levels. The exterior of the upper level has three openings, only one of which leads inside. The other two openings lead to a space between the outer and inner walls from which one can see inside through the eye slots but not get inside. Conversely, on the inside there are four openings, only one of which leads out. The lower level can be entered from the interior courtyard. This level, a narrow, low passageway, is a cul-de-sac with an eye slot at its terminus so that one can see into the courtyard. In the center of the courtyard is an entrance to an underground pit." A. A.

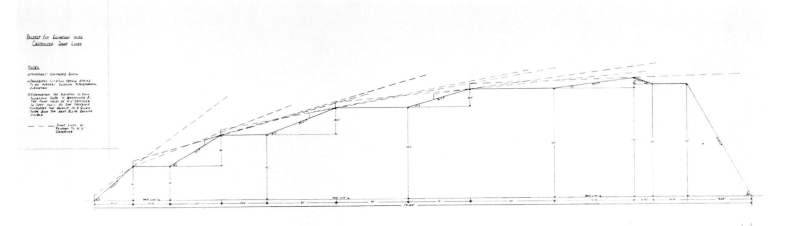

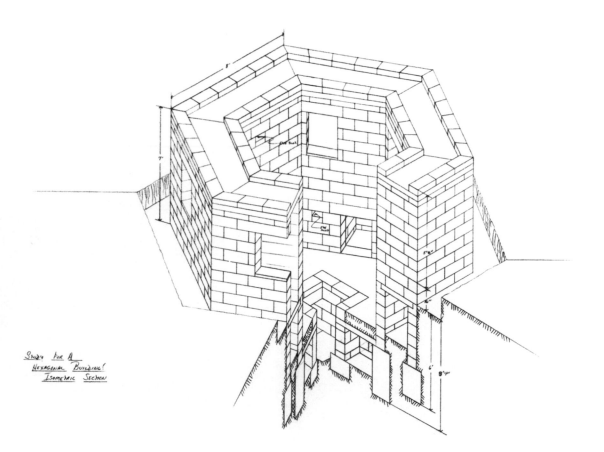

Study for a
Hexagonal Building:
Isometric Section

12.10

Alice Aycock, *Project for a Vertical Maze: Four Superimposed Cruciform Buildings,* oblique section, 1975. Pencil on vellum, 21″ × 38″. Private collection. Photo: John Ferrari.

"Construct four concrete buildings one inside the other so that the floor of building no. 1 is the roof of building no. 2, and so on. All four buildings share a common wall on four sides. They diminish in height and in width at the corners from a maximum of 12' high and 18' wide to a minimum of 6' high and 56" wide. The crawl space between floors and corner walls is 16" wide on the plans but may be widened to 20". Small openings in the walls will let in light from the outside. The structure is entered through an opening in the roof of building no. 1. One then crawls across the roof of building no. 2, and climbs down the four corners searching for the entrance to building no. 2. This procedure of climbing down the corners of each building and across the roofs is repeated until the innermost building has been reached." A. A.

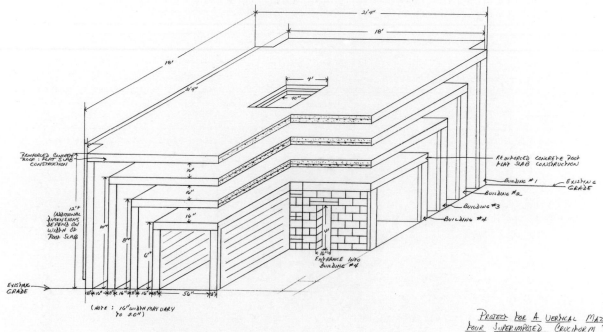

21'4"

18'

18'

21'4"

4'

40"

Reinforced Concrete
Roof : Flat Slab
Construction

Reinforced Concrete Roof
Flat Slab Construction

Building #1

Existing
Grade

Building #2

Building #3

Building #4

10"

10"

16"

16"

12'+
(Additional
Dimensions
Depend on
Width of
Roof Slab

10"

8"

6"

4'

16"φ
Entrance Into
Building #4

Existing
Grade

18" 16" 8" 16" 8" 16" 8" 56' 18"

(NOTE : 16" width may vary
to 20")

Project for a Vertical Maze
Four Superimposed Cruciform Buildings
— Interior : Oblique Section

Alice Aycock '75

Project for Five Wells Descending a Hillside

12.11

Alice Aycock, *Project for Five Wells Descending a Hillside*, oblique exterior view, 1975. Pencil on vellum, 21″ × 38″. Collection of Lauren Ewing, New York. Photo: John Ferrari.

"Build five concrete block structures 6' 8" square and 7' 8", 9', 11' 8", 15' 8", and 21' high respectively. Each well is lower than the one above it but deeper overall. The wells are connected by a series of doorways 4' high. The first doorway is level with the floor of well no. 1 but 4' above the floor of well no. 2; the second doorway is level with the floor of well no. 2 but 5' 4" above the floor of well no. 3, and so on. As one climbs through the interconnected series of wells, terminating at the base of a 21' well, one climbs down the hillside." A. A.

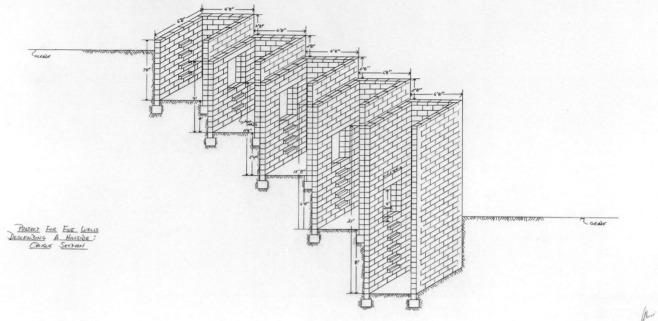

12.12

Project for Five Wells Descending a Hillside, oblique section, 1975. Pencil on vellum, 21″ × 38″. Private collection. Photo: John Ferrari.

12.13

Alice Aycock, *Masonry Enclosure: Project for a Doorway,* exterior, 1976. Pencil on vellum, 36½″ × 52½″. National Gallery of Art, Washington, D.C. Photo: John Ferrari.

"Build a series of masonry walls as shown on the plain which surround a solid masonry structure 24' square × 42' high. In the center is a doorway approximately 24' from the ground. The doorway is inaccessible. If access to the doorway is gained, one would encounter an interior stairway. As one descends the stairway, the risers increase in height as follows: 9", 18", 27", 36", 45", 54", 63", 72", 81", 90". Anyone moving down would gradually entomb him/herself." A. A.

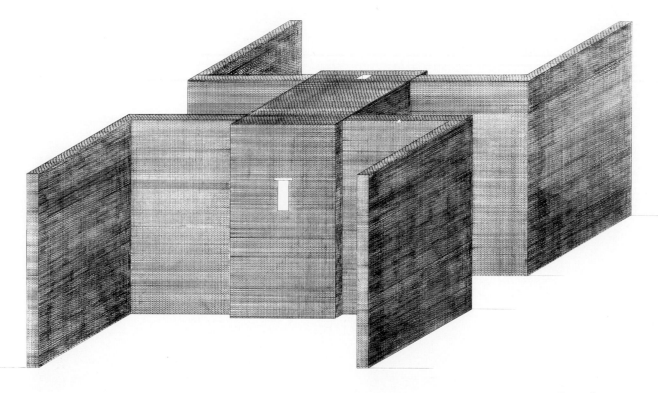

MASONRY ENCLOSURE:
PROJECT FOR A DOORWAY

12.14

Masonry Enclosure: Project for a Doorway, interior of central section of fig. 12.13, isometric section, 1976. Pencil on vellum, $36\frac{1}{2}'' \times 52\frac{1}{2}''$. National Gallery of Art, Washington, D.C. Photo: John Ferrari.

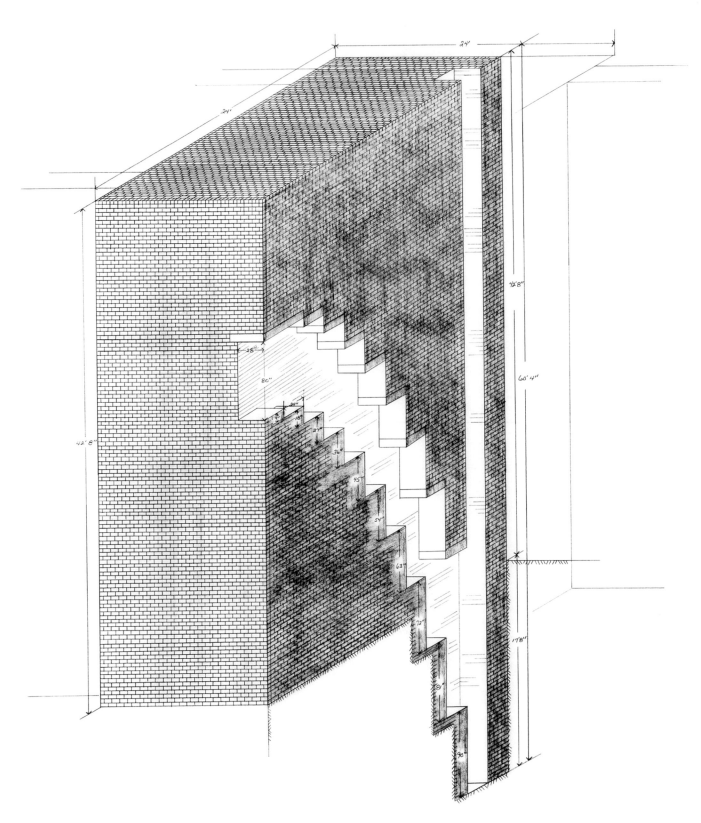

24'

42'8"

42'8"

42'8"

60'4"

17'8"

28"

80"

24"

18"

27"

36"

45"

54"

63"

72"

81"

90"

MASONRY ENCLOSURE:
PROJECT FOR A DOORWAY
—SECTION

13 Site Specificity

Site specificity used to imply something grounded, bound to the laws of physics. . . . Site-specific art, whether interruptive or assimilative, gave itself up to its environmental context, being formally determined or directed by it.

Miwon Kwon
One Place after Another, 2002

During the 1970s artists making quasi-architectural sculptures outdoors were tempted to respond to the romance and history of the sites in which their works were located rather than examining them critically. Grounding art in specific locales became the vanguard equivalent to the counterculture movement: such an approach invoked continuity and tradition and was at odds with the mobility and change that typified so much postwar culture. This traditional approach soothed people's anxieties about the sweeping transformations that the world was then undergoing. These changes on the one hand were so tremendous that Robert Smithson announced at the end of the '60s that strip mining, suburbanization, pollution, and other aspects of industrialization had the power to wreak havoc on planet earth equal to the devastating effects of former geologic epochs. On the other hand, artists such as Mary Miss, daughter of a former army soldier, whose migratory childhood evidently created a great need to make a pact with distinct places, made works that are sanctuaries, testifying

139

to the illuminating and soothing permanence exuded by specific locales.[1]

While Aycock usually avoided such romantic and sentimental overtones in her earth-sited pieces, instead emphasizing the frustrations of embodied perception in *Maze* and claustrophobia in *Low Building,* she did succumb to a period reading in *Wooden Posts Surrounded by Fire Pits* (1976). This piece was located at the Nassau County Museum on the former Frick property in Roslyn, Long Island. Rather than establishing a dialectic with its locale that would acknowledge change and problematize an easy nostalgia, this piece evoked and even aggrandized vestiges of a past Native American presence. The work consisted of 160 posts placed in concentric rings that were then surrounded by 12 round pits composed of fire brick. According to Lippard, "Aycock doesn't consider the piece complete until the fires are lit, underlining its ritual level and relating it to Haitian voodoo ceremonies, an Iron Age camp, the Hall of Mysteries at Eleusis, and so forth."[2] Aycock has admitted that the piece is one of her least favorite works because it "is a lie with Long Island."[3] No doubt she is referring to the fact that this anthropologically oriented work ignores the centuries of change that have affected Long Island, romanticizing the distant past and implying that aspects of it are somehow still accessible.

At the time, *Wooden Posts Surrounded by Fire Pits* (fig. 13.1) was a critical success because it played into the archaistic and reactionary genre of land art called "site-specific" work. But it did not satisfy Aycock, probably because it did not exhibit the raw edge of physical discomfort bordering on danger that she had maintained in *Maze* and *Low Building*. As she told Fineberg, "A work of art should have aspects in it that the world has, and living in the world is risky. . . . There were things that were made out of tremendous need and they did force you to physically put yourself in some sort of state—not dire risk."[4] She found this quality exciting in some of Vito Acconci's performances,

Dennis Oppenheim's body art, and Richard Serra's precariously balanced lead pieces and wished to maintain this edge in her own work. Creating mere sanctuaries and gardens would not accomplish this goal.

After concluding that *Wooden Posts Surrounded by Fire Pits* was a failure, Aycock reclaimed an edge crucial for her work in *Circular Building with Narrow Ledges for Walking* (summer 1976) (fig. 13.2) and in a series of concrete-block sculptures and installations such as *Heavy Roofed Building* (1976), shown in Los Angeles, which anticipates the sculpture that former conceptual artist Sol LeWitt began making in the late 1980s. *Circular Building with Narrow Ledges for Walking* was situated in the center of a corn field on the Fry Farm, but because it could have been created in a number of places it cannot be considered truly site-specific. Although she built the ladder and all structural forms by herself, Aycock sought technical help with the concrete pour. The work consists of reinforced concrete poured in place into wooden forms, with a height of seventeen feet (thirteen feet above grade and four feet below); one must scale a tall ladder to enter it. Inside are two ledges each precariously approached by two eight-inch-wide wooden stairs with twelve-inch risers, with each set of stairs moving along the ledge in a direction opposite the one preceding it (figs. 13.3, 13.4). At the lowest eight-inch shelf, Aycock conceived a drop-off of four feet, making a climb back onto the ledge extremely difficult.[5] She later reflected, "I think that movement is only one aspect [of my work]. Sometimes it's possible to simply look at a work, for instance *Circular Building with Narrow Ledges for Walking*, and to fantasize what it would be without actually doing it."[6]

As in a number of Aycock's works, her dreams played an important role in the generation of this piece. She told Maurice Poirier: "About the time I was six or seven years old, I would be terrified of going to sleep at night for fear of falling into this

13.1

Alice Aycock, *Wooden Posts Surrounded by Fire Pits,* 1976. Pencil on vellum,
35½″ × 49″. Private collection. Photo: John Ferrari.

**"One hundred sixty posts, approximately 8½" in diameter, set in the ground
and aligned in six concentric rings with the following radii on center: 14' 8",
11' 8", 9' 7", 8' 1", 5' 10", 3' 1". As one moves toward the center the approximate
distance between the posts in each ring diminishes as follows: 22", 16", 36", 11",
9", 6". The inner ring is inaccessible to the average person. The diameter of
the outer ring is 30'. It is surrounded by twelve fire pits with an overall
diameter of 111'." A. A.**

13.2

Alice Aycock, *Circular Building with Narrow Ledges for Walking,* 1976. Reinforced cast-in-place concrete and wood, total height 17′, 13′ above grade. Silver Springs Township, Pennsylvania. Collection of the artist. Photo: artist.

"**Reinforced concrete cast in place; overall height 17′— 13' above grade, 4' below; exterior diameter 12'; interior— a series of three concentric ledges approximately 8" wide with the following diameters; 10' 8", 9' 4", 8'; two sets of wooden stairs (12" riser to 8" tread) 7' and 6' high respectively; center shallow pit 56" square. The concentric ledges are connected by a set of steep stairs so that one must walk around each ledge before climbing to the ledge below. The deepest level, sunk 4' below the earth, has no connecting stairs." A. A.**

13.3 and **13.4**

Circular Building with Narrow Ledges for Walking, interior. Photos: artist.

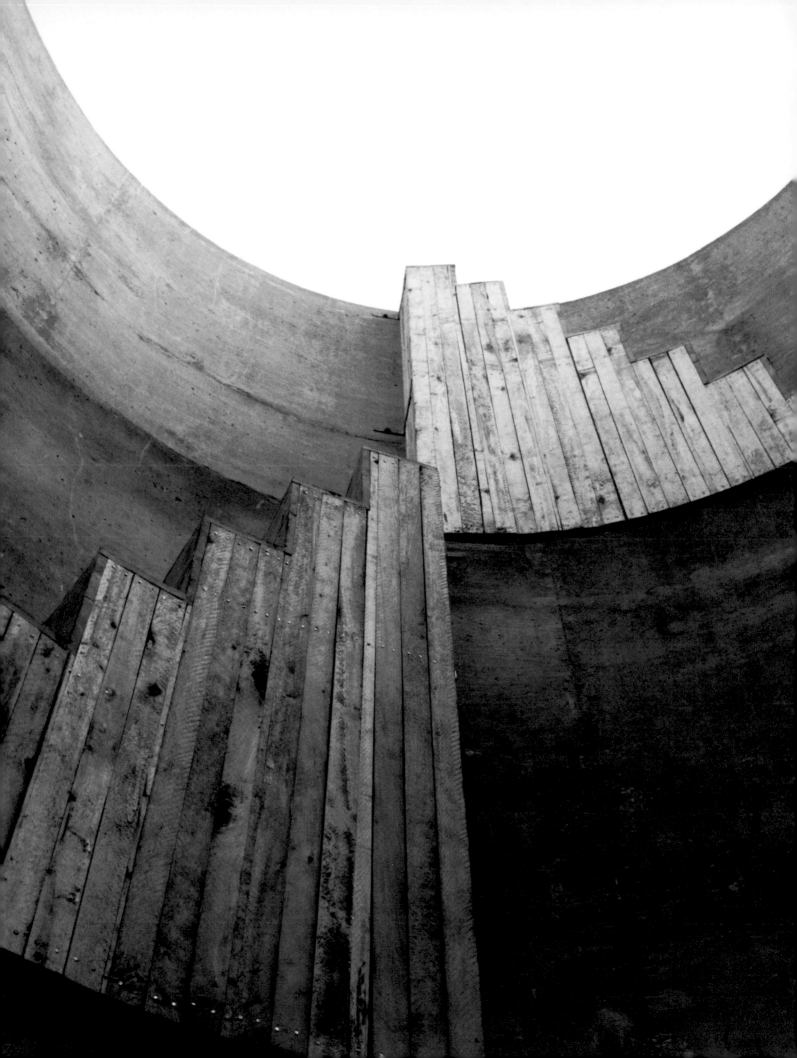

void of blackness. It was a fear of death, and I remember it as being extremely intense. I also have a memory of falling into a well."[7] Rather than succumbing to these anxieties, Aycock used them in her art. "This sense of the precariousness of myself in the world that I have had since I was very young has never gone away," she admitted.[8] In addition to these recurring fears, the artist has equated works such as *Circular Building* with a related feeling "almost like a free fall—jumping off and not knowing where the bottom is, the sensation of falling into that night." She elaborated, "This is the deep well that the work comes from, being afraid to close your eyes in the night because you will not wake up, or falling into outer space, for instance, the fantasy of being ejected into space and never finding another solid body there."[9]

In addition to these personal anxieties, Aycock has connected *Circular Building* with Native American kivas, World War I concrete bunkers, and empty graves. But the images that were most important to its creation were Hieronymus Bosch's paintings. She relied on Walter S. Gibson's monograph on Bosch, looking especially at this artist's representation of a tower in the right wing of the triptych *The Haywain* (fig. 13.5) and at the circular building in his *Temptations of St. Anthony*. In the text describing *The Haywain*, Gibson notes that Sigüenza explained in 1605 that towers in the nether regions were intended to house the damned and that the stones of which they are made are the "souls of the wretched damned." Besides this interpretation, Gibson acknowledges that the location of Bosch's tower in Hell might be an ironic play on the biblical Tower of Babel, which demonstrates the hopelessness of any human attempt to storm the gates of heaven.[10] Such futility, as we will see, seems to have been literalized by Aycock as a modus operandi of her art.[11] Dante conceived the Tower of Babel's creation as an affront to God, the reason that language's integrity has been forever shattered and the rationale for placing this tower's creator in frozen ground close

to Satan, where he was condemned to babble incomprehensibly. However, later thinkers began to appreciate the chorus of different voices that followed from Babel and permitted a range of approaches. Aycock is sympathetic with this latter group and consequently hails the Tower of Babel as a giant step forward for humanity.

13.5

Hieronymus Bosch, *The Haywain*. Right wing, "Hell," c. 1485–1490. Oil on panel, 53″ × 17³/₄″. Museo Nacional del Prado, Madrid.

14
Architectural Sculpture as Suprastruction

Prefix: supra, meaning over or beyond; suffix, struction, which is an amalgam of the words structure and construction.

Michael Hall
"High Time for a Christening," 1979

In 1979, a statement by sculptor and noted folk art collector Michael Hall linked Aycock and himself together with their contemporaries Siah Armajani, Richard Fleischner, Mary Miss, Robert Stackhouse, and George Trakas in a new movement that differed markedly from site-specific work. Hall's essay proposes the term "Suprastructionists" as a label for this group.[1] This term never gained any currency, probably because Hall's piece was not published until 1988, when the art world as well as the work of several of the artists involved had developed in new directions. In addition, the essay's publication in a UMI Press volume ensured it at best a restricted audience of scholars, graduate students, and perhaps a few critics. But if we look back to the 1970s when it was originally conceived, many of Hall's propositions are helpful, even if some remain overly speculative.

Hall sees the suprastructionists as a group coming of age after minimalism, earth art, and postminimalism. He contends that conceptual art imbued this work with a desire for content and new meaning, and he discerns that the suprastructionists

149

translated the highbrow language of architecture into the lowbrow practice of building evident on most construction sites, where such materials as concrete, steel, rough-cut timbers, corrugated metal siding, plywood, and wallboard are found in ready supply.[2] A particularly apposite example of Aycock's use of such prosaic material is *Heavy Roofed Building* (1976), created entirely of concrete blocks.[3] In discounting the relevance of site-specific work for these artists, he neglects to consider some projects by Mary Miss and George Trakas that relate to either the mood or the dynamics of a particular place. Hall is on firmer ground when he points to their theatrical interest in making their pieces platforms or stages on which viewers can act. However, he overstates the romantic program of these sculptures when he connects them with an archaistic revival of Neolithic forms, since it would be better to view this so-called neoprimitivism (actually an art zero aesthetic) as a means for critiquing the excesses of the present. Hall correctly points out that this work eschews art for art's sake in favor of the larger world. And he astutely attributes this renewed interest in the world to the fact that these artists were among the first to benefit from being educated in college art programs. Although he errs in seeing this group's overall goal as the "revitalization and reification of the art of sculpture,"[4] since many of them were not as formalist as he apparently was, he accurately assesses their ongoing interest in early-twentieth-century constructivism. Toward the end of his essay Hall astutely emphasizes the group's "new formal and intellectual complexity" and wholesale rejection of "the idea that either form or content in art need be holistic or self-referred," and notes that "instead, these things were expressed as fragmented and fragmentary."[5] Hall is particularly prescient when he observes, "Suprastructions function most like a set of clues to be combined by viewers into sets of assumptions and presumptions. These responses in turn must be filtered through the viewer's memory, experience and bias, finally to align into active patterns of meaning."[6]

Overall, Hall's essay on suprastruction is a remarkable analysis of a group of sculptors who never viewed themselves as a cohesive entity. In retrospect, these sculptors deserve stylistic recognition for their common goals and accomplishments. Though cumbersome, the term "suprastruction" usefully characterizes some of Aycock's works of the early and mid 1970s.

Both *Wooden Shacks on Stilts with Platform* (fig. 19.6), made in 1976 for the Hartford Art School, and *The True and the False Project Entitled "The World Is So Full of a Number of Things"* (fig. 16.1) can be referred to as suprastructions. The second piece, incorporating steps, ladders, interior spaces, and towers, was shown at 112 Greene Street in 1977. In 1975 Aycock and her husband had purchased a spacious loft on the same street as this gallery. At the time she designed and built this work, Aycock was reading Foucault's *Discipline and Punish: The Birth of the Prison*, which had been published in English translation that year.[7] This book reinforced her ideas about architectural structure as a machine—a set of directions for a performance. In addition to Foucault, Aycock drew on her experiences during a trip to Hollywood in the fall of 1976, when she toured the set for *Hello Dolly!* and was amazed at how plywood was being made to look like asphalt, concrete, and a variety of other materials. Although she chose to leave her structures in their raw, unpainted state, the concept of the stage set was important to her. That same fall she also visited Rome, a kind of historical stage set culminating thousands of years of culture, and an excellent example of Venturi's view of scenographic and symbolic architecture.[8]

150

15 Borges's Tear and Aycock's Rip

I keep remembering the Borges story "The Aleph," in which the narrator finds a tear in the universe that allowed him to see everything that was and is and will be. He is thus able to pull himself away from the "now" by understanding what came before him, living in the world that is, and envisioning another one. I'd be happy if I could just find a tiny rip.

Alice Aycock
from Grace Glueck, "A Sculptor Whose Imagery Is
Encyclopedic," 1990

I'm interested for the most part in what's not happening, that area between events which could be called the gap. This gap exists in the blank and void regions or setting that we never look at.

Robert Smithson
"What Is a Museum?," 1967

Actuality is when the lighthouse is dark between flashes: it is the instant between past and future: the gap at the poles of the revolving magnetic field, infinitesimally small but ultimately real. It is the interchronic pause when nothing is happening. It is the void between events.

George Kubler
The Shape of Time, 1962

To appreciate the vast range of interpretations a work of art might suggest to Alice Aycock, one needs to look, as she repeatedly does, at Jorge Luis Borges's sublime passage in "The Aleph" delineating the discovery of a glitch in our time-space continuum that affords a view beyond it. In his description of this gap, Borges conjoins the ecstatic vision of a religious mystic with the precision of a science fiction writer:

151

In that gigantic instant I saw millions of delightful and atrocious acts; none astonished me more than the fact that all of them together occupied the same point, without superposition and without transparency. . . . In the lower part of the step [in the basement of my associate], toward the right, I saw a small iridescent sphere, of almost intolerable brilliance. At first I thought it rotary; then I understood that this movement was an illusion produced by the vertiginous sights it enclosed. The Aleph's diameter must have been about two or three centimeters, but cosmic Space was in it, without diminution of size. Each object (the mirror's glass, for instance) was infinite objects, for I clearly saw it from all points in the universe. I saw the heavy-laden sea; I saw the dawn and the dusk; I saw the multitudes of America; I saw a silver-plated cobweb at the center of a black pyramid; I saw a tattered labyrinth (it was London); I saw all the mirrors in the planet and none reflected me. . . . I saw the Aleph from all points; I saw the earth in the Aleph and in the earth the Aleph once more and the earth in the Aleph; I saw my face and my viscera; I saw your face and felt vertigo and cried because my eyes had seen that conjectural and secret object whose name men usurp but which no man has gazed on: the inconceivable universe.[1]

After relating this extraordinary vision, the narrator wonders why Carlos Argentino, the keeper of the Aleph, might have settled on the first letter of the Hebrew alphabet when deciding on a name for this rent in the world's assumed seamless fabric. He conjectures that its reference to En-Sof, meaning "the limitless and pure divinity," is the probable reason.[2] Then, with a wonderfully malicious sleight of hand, Borges deconstructs the promise offered by his incredible tale when his narrator concludes, "I believe there is (or was) another Aleph, I believe that the Aleph in the Calle Garay was a false Aleph."[3]

In my opinion Borges's Aleph accords with Martin Heidegger's concept of the rift or opening developed in one of his major statements on

aesthetics, "The Origin of the Work of Art."[4] The two writers' mutual interest in positing a perspective capable of opening viewers to greater insights impacts our understanding of Aycock's aesthetic. While Borges's Aleph reaches far afield, Heidegger focuses on specific cultures and works of art. This German philosopher believes that art is far less important as a material object than as a metaphysical realization, or event, whose truth is to open a world, even to establish a world, a human dwelling place. The work of art implants us in history even though it remains outside the world it institutes. It should be construed as an essentially ambiguous essence that provides human beings access to that which is, as well as to themselves as beings rooted in time. Heidegger's description of the function of the ancient Greek temple succinctly summarizes these ideas:

It is the temple-work that first fits together and at the same time gathers around itself the unity of those paths and relations in which birth and death, disaster and blessing, victory and disgrace, endurance and decline acquire the shape of destiny for human beings. The all-governing expanse of this open relational context is the world of this historical people. Only from and in this expanse does the nation first return to itself for the fulfillment of its vocation.[5]

Besides proposing the work of art's ability to collect subliminal desires and shared associations in a form so arresting that it is capable of inspiring unity, Heidegger posits that great works of art manifest inherent conflicts: "In the creation of a work, the conflict, as a rift, must be set back into the earth, and the earth itself must be set forth and used as the self-closing factor."[6] He later concludes that while the function of art is to provide this opening, it does not need to resolve it—a concept that will prove to be central to Aycock's work in general and to her blade machines and other works focusing on danger in particular. "The foregoing reflections," he notes, "are concerned with the

riddle of art, the riddle that art itself is. They are far from claiming to solve the riddle. The task is to see the riddle."[7] Art, in other words, should not be required to resolve the major debates or ideological views of its age; instead, it is enough to frame them in terms of the rift and to give them the prominence and distance that is a consequence of their aesthetic form. This idea, as we shall see, is of ever more far-ranging significance for Aycock's art than even she had suspected. For example, the polarities established by the blade machines between seduction and fear constitute a crucially important aesthetic arena in which viewers might act and react. Rather than resolving polarities, Aycock's work extends them so that viewers have the space, or the rift, in which to respond to an entire continuum of disparate feelings. This response is consistent with Aycock's negentropic goal of expanding rather than constraining responses to the work. Moreover her art undertakes the important task of ideological reformation by puncturing established views—setting up a rift in them—in order to create spaces where new insights might become possible.

I would further contend that Jacques Lacan's category of the Real can be viewed as the psychological counterpart of Borges's Aleph, particularly when one considers the disjunction that separates it from the Symbolic—another Lacanian category—which impoverishes and transforms the Real into socially accepted terms. Seen in this way, the Real represents the void, the gap, or the wound that occurs when a symbolic self based on accepted prototypes is developed. The Aleph as a glitch in the universe can also be construed in terms of Lacan's infamous *objet petit a* which bears witness to its failure to communicate, thus providing an opening by casting doubt on itself like the purported "false Aleph" in Borges's story. According to philosopher Slavoj Žižek, one of Lacan's most important disciples, "Taking an analogy from art, this intangible Real could be said to function like the 'vanishing point': i.e. something that cannot be represented but which is nonetheless constitutive of representation."[8] In this sense, the Real as Aleph is the void that is no longer nature and certainly not culture, but is the gap between the two. Its emptiness can sometimes begin to become apparent in a traumatic situation, and it can often be intuited in terms of the breaks making up our personalities that are configured and reconfigured through unlimited semiosis. These breaks both large and small appear sometimes as the inconvenient junctures making up our necessarily multiple selves. These cracks and fissures, as we will see, can be symbolized—as Aycock has chosen to do—in terms of the dispersal of the self that is part of the schizophrenic condition, the unlimited semiosis that is part of Derrida's poststructuralist revolution, and the concept of cyberspace that is part of the digital divide, becoming in all three situations a void, i.e., the Real, that is usually camouflaged by outer Symbolic shells.

Like Borges with his Aleph, Heidegger with his rift, and Lacan with the Real, Aycock imagines an opening discernible in the fissures among the far-flung fantastic references and possible meanings for her art.[9] She found a living prototype for this "tiny rip" in her paternal grandmother's mind, which both fascinated and scared her as her grandmother grew senile and lost touch with reality, becoming a conduit for no-longer-cloistered memories and unrestrained thoughts. Aycock flatly stated, "It is the death of consciousness that most frightens me."[10] But, as so often in Aycock's work, her fears become her muse, guiding her in new and perilous directions. "I want my art to be as fluid and fantastical as my grandmother's mind," she said. "Now that she's one hundred, she voyages in time. One minute she believes it is thirty years ago, the next it is tomorrow. She sometimes knows it's me. Then I become her sister, or the daughter that she never had. Her life is fueled by dreams."[11] This observation helps to explain Aycock's fascination with Milton's attempt to describe the indescribable, Death,

in *Paradise Lost*.[12] Aycock has also discussed the fluidity of interpretations that can significantly transform an object. "If you look at the CBS logo," she explained, "it's an Egyptian hieroglyph. To that degree, yes [we can ground perception in a specific experience]. But they mean different things in different situations. Meaning is always arbitrary, but the sign [i.e., the work of art] stays there and floats until some other arbitrary meaning flows into it."[13] As this example implies, Aycock does not intend to link her sculptures and statements into a univocal relationship that might provide definitive keys for their explication. In her work, language plays a leading role in questioning both the sculptures' authority per se and the series of conflicting statements she makes about them. Although Aycock's fascination with Borges's Aleph might suggest a desire to unravel the mysteries of the universe, she actually wished to do the opposite. "If I really did begin to decode something," she reflected, "I would also want once again to make it mysterious."[14]

Borges is also crucial for Aycock's work because he provides her with an ambiance of erudite and esoteric learning that is both far-ranging in its interests and specific in its effects. His sensibility is precious, sinister, and highly intellectual. Through his intermingling of factual, arcane, and fictitious references, Borges creates a distinct sense of the marvelous. For Aycock the challenge lies in transforming consciousness into a sculptural medium unfettered by the traditional and mundane materials that might militate against the imaginative flights occasioned by Borges's prose. Beginning in the late 1970s, she does this by first setting up a phenomenological situation of a hybridized architectural sculpture that viewers are encouraged to experience through their senses. Then she provides factual and fantastic prose that circulates around her sculptures, endowing them with an aura of the marvelous and at the same time challenging viewers to resolve them into a coherent meaning. Instead of merely permitting

the sculptures to serve as illustrations of her prose or the prose to explicate her art, her texts function as both illuminations and obfuscations of her sculpture—a type of Aleph—by establishing a series of alternative and often contradictory readings. Later in her career she makes elaborate machines to capture ineffable ghosts (similar to her grandmother's wafting thoughts) referred to in several of her titles. Often she alludes to cosmological forms, medieval prototypes, fairground architecture, and quantum mechanics, with the intended effect of destabilizing all her references as well as those imagined by the viewers of her art so that no one element is able to maintain for any length of time the unassailed position of transcendental signified. We might think of her many references as a transparent overlapping of disparate times and cultures, arranged so that we might savor the similarities and differences comprising her sculptures while participating in the Aleph's, rift's, or Real's potential for greater understanding. Her approach demotes even the most cogent interpretation to at best a temporary stopgap on a par with Merleau-Ponty's assessment, "There is finality only in the sense in which Heidegger defined it when he said approximately that finality is the trembling of a unity exposed to contingency and tirelessly recreating itself."[15]

The Aycock work that most directly demonstrates the enchantment of Borges's Aleph was never made. It is a projected drawing of her palm—the proverbial artist's hand—that she compares to seeing fantastic shapes in clouds. Her description of this intended work underscores the constraints she places on foreclosure:

What I did was to look into my hand and see different sorts of magic signs to start off with and then to see. . . . Well, this one has palindromes; Solomon's seals; Mesopotamian devils' whirls which have bits of Mesopotamian writing on them [fig. 15.1]; another Cabalistic sign, Cleopatra's sign;

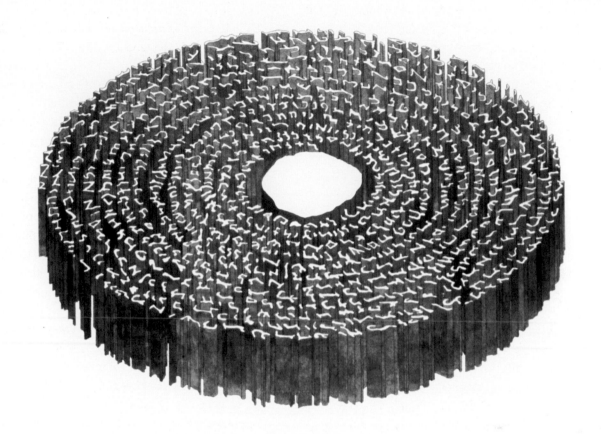

15.1
Alice Aycock, *Babylonian Devil's Trap*, 1987. Watercolor, pastel, and ink on paper, 38″ × 50″. Private collection. Photo: Fred Scruton.

*the angel Gabriel's handwriting. That's the
Pythagorean Theorem. That's the trench system in
World War I. That's the organ of Corti. This is the
I-Ching three-dimensionalized. This is a diagram of
how the doges are elected in Venice. There is the Big
Bang theory and there is Tic-Tac-Toe. I keep
throwing more and more in, as if I was going to see
the entire universe in my hand.*[16]

As we will see, this approach toward migrating
symbols becomes a modus operandi in most of
Aycock's sculptures. Meanings are elaborated rather
than curtailed, and Derrida's slipping signifiers,
which she favors over transcendental signifieds, are
accepted and relished rather than precluded.

16

The True and the False Project: Embodied and Disembodied Seeing; Phenomenology and Schizophrenia

For the last few centuries, people have lacked confidence in themselves. This period is characterized by metaphysical divisions and rationalistic inventions. Man's synthetic powers failed him and he placed his faith in the explanations that proceeded from his disembodied reasoning. Mind was divided from sense, art from science, and god from man.

David Lee
"A Systematic Revery from Abstraction to Now," 1966

In her text accompanying *The True and the False Project Entitled "The World Is So Full of a Number of Things"* (figs. 16.1, 16.2, 16.3), Aycock not only acknowledges sources and ideas important for her but also concedes that her culture comes at the end of an era. This conclusion is also reached by literary critic Harold Bloom in his 1975 book *A Map of Misreading*. "We, in fact, *are* latecomers," Bloom writes, "and we are better off for consciously knowing it, at least right now. . . . Nietzsche insisted that nothing was more pernicious than the sense of being a latecomer, but I want to insist upon the contrary: nothing is now more salutary than such a sense. . . . All of us now have been pre-empted, as I think we are all quite uneasily aware."[1] George Kubler similarly concludes in *The Shape of Time* that invention depends, in semiotic fashion, on the tacit accord of a given culture regarding the general use of certain symbols and on the

157

16.1 (previous pages)
Alice Aycock, *The True and the False Project Entitled "The World Is So Full of a Number of Things,"* 1977. Wood and Sheetrock, rectangular section: 6′ wide × 12′ long × 13′ high. Exhibited at 112 Greene Street Gallery, New York. Collection of the artist. Photo: artist.

16.2 (facing page) and **16.3** (following page)
The True and the False Project Entitled "The World Is So Full of a Number of Things," details. Photos: artist.

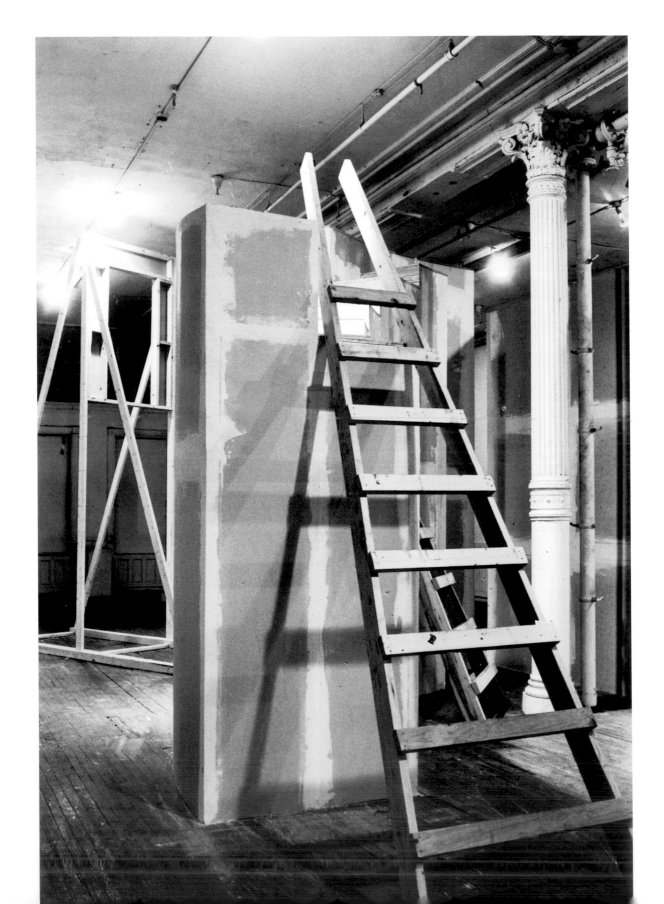

recognition that future inventions must necessarily be limited "since prior positions are part of the invention."[2]

Recognizing the impossibility of creating ex nihilo, Aycock in her text for *The True and the False Project* underscores the idea of being a latecomer through the following citations, which play with the arbitrariness of truth and the absurdity of appending tags to events after their occurrence. The contradictions provide a series of breaks in rationality that Aycock on other occasions has analogized in terms of Borges's Aleph, as we have seen. Her list of ambivalent attitudes toward truth and fiction affirms one of her favored analogies, that knowledge in the late twentieth century is as plentiful as meat in a well-stocked deli:[3]

The false project after the catacombs of St. Sebastian.

The true project after the astronomer Lord Rosse's telescoped construction

"The Leviathan of Parsonstown."[4]

The false project after a Piranesi engraving of the Thermae of Titus.

The true project after the circular building in Bosch's painting The Temptations of St. Anthony.

The false project after Georgy Yakulov's 1922 stage design for Girofle-Girofla.

This lineup of true and false propositions ostensibly relates to the necropolises Aycock had discovered in Rome and Egypt, which housed not only the dead but also the living— a real-life counterpart of Milton's shape-shifting Death. Her list for *The True and the False Project* demonstrates that she roams through both time and place in search of undeniable truths—but finds instead simulations of reality and series of associations that defer meaning, so that the authenticity and undeniable power of the present is destabilized and transformed

into a series of ongoing referents. Similarly in *Project Entitled "The Beginnings of a Complex . . . ,"* she writes:

And there is the Twentieth-Century-Fox set for Hello Dolly which I accidentally came upon one day finding it situated amidst the city of Los Angeles, finding that inversion in which the false city on the scale of the true city uses the true city as a backdrop for its falseness. And undermining and underpinning it all there is my Low Building with Dirt Roof (for Mary) *and undermining and underpinning it all there is the* Partially Buried Woodshed *by Robert Smithson. (And before that there is the Tomb of Aegisthus at Mycenae. But that's another, earlier story.)*

But there is still more to it than that. There are the crates which some children pushed together like "Spanky and Our Gang" in a deserted lot landscaped with brick and broken bottles on Delancey Street in New York City. There are the heaps of burning garbage towards the outskirts of Cairo in which people have tunneled rooms and which they pop in and out of like prairie dogs. And undermining and underpinning it all there is the image of the single shack on the plain over which a cool breeze blew soothing me and reminding me of you. And undermining and underpinning it all there is the image of the single hut or tent or wind screen on the prairie or desert over which a warm breeze blew, a desert wind searing me and reminding me of you, reminding me of the words from The Egyptian Book of the Dead, *"Today death stands before me like a cure for an illness, like a walk after suffering. Today death stands before me like the perfume of myrrh, like repose beneath a sail on a day of high wind. . . . Today death stands before me like the desire of seeing home again after long years passed in captivity. . . ." Of course, I know what those Egyptian sails look like, I can still see the Nile, feel the desert wind and the way it blew at the mud brick pyramid of Hawara, the site of the original labyrinth. But I knew what it all would be*

163

like even before I went. The thing is I knew that I had traveled to the right place—found the true source—because every night at dinner after having spent the day crawling into tombs, I would eat potatoes that tasted like they had been stored in the drawer of a desk which was in the hall of my mother's house in a Pennsylvania coal-mining town settled by Irish immigrants. The thing is I knew I had traveled to the right place—found the true source—because the other day as I crossed Lafayette Street for a brief, very brief moment the smell of Egypt wafted toward me reminding me of you and the image of you alone on the plain, reminding me of the image of the single wooden shack in the city of the Dead [fig. 16.4], reminding me of you and The Family of Pascal Duarte, *reminding me of you, Pascal, who became so accustomed to the smell of death that when you left the family hovel for the city you grew lonesome and could not sleep unless you curled up with your face in the crotch of your pants, your pants having the familiar sweet smell, the familiar acrid odor of carrion.*[5]

Aycock embellishes these descriptions of necropolises cum makeshift metropolises in Italy and Egypt by pointing out that they "functioned in a metalinguistic way. It was a structural system/ city that could be used to describe or analyze

another actual system/city. The words true and false are applicable, the true and the false city."[6] Although this statement suggests a belief in ascertaining differences between the two cities, the text for *The True and the False Project* mocks such efforts. Aycock commented two decades later that this work, like her later Documenta piece and the project at Artpark, "is a meta-city for the world we live in with all its commercialism, fantasy, its razz-ma-tazz."[7] Here she retrospectively approaches the realm of simulacra—the collusion occurring between so-called reality and the signs for it—that French sociologist Jean Baudrillard was then analyzing. Such encounters between metametropolises and actual cities allude to a far more ambitious undertaking for this work. Placing truth under erasure, like Derrida, so that each term in the list of cited polarities loses its force—and thus makes truth relative, and perspectival viewing no longer a condition of embodiment—signifies Aycock's effort to underscore the permeability between metropolises and necropolises, life and death, being and nonbeing, as well as meaning and nonsense.

In *The True and the False Project* Aycock enacts a paradigm shift of enormous consequence to her work, one that she sustains in subsequent pieces. Other artists have placed truth under erasure and made it a factor of seeing from a new

16.4

The City of the Dead, Cairo, Egypt. Photo: Alice Aycock.

and ambiguous though still specific point of view; we might think, for example, of Robert Rauschenberg's literally erased de Kooning drawing and Robert Smithson's essay and film on his *Spiral Jetty*. However, I contend that none before Aycock both choreographed and simultaneously scripted a host of polarities for the experiential and interpretive roles that viewers must assume when confronting works of art.[8] Although one overarching interpretive key to her work might be Borges's Aleph, Heidegger's rift, and Lacan's Real—that is, the universe in its awesome multiplicity that is punctuated by occasional breaks or tears—on a specific level the works offer viewers conundrums and contradictions that they are invited to consider and perhaps resolve. One might say that the metropolis/necropolis reference in *The True and the False Project* is a way for the artist to posit differences between the actual experience of art and its history in this piece. The work begins with viewers' embodied relationships to the installation housed at 112 Greene Street (the metropolis) as a series of solid empirical experiences. These experiences are then subjected to doubt by the artist's list of competing claims regarding the validity of the work's art historical sources (the necropolis). At this point, embodied seeing is disembodied and redirected away from the piece in the gallery, and the overall work, including its architecturally fabricated jungle gym and the artist's truth claims regarding it, begins to approach a schizophrenic condition.[9]

The structural divide enacted in this and subsequent Aycock works develops from a selective reading of Roland Barthes's essay "Rhetoric of the Image," which was written in 1964 and published in English in the collection of essays *Image—Music—Text*[10] in 1977, the year *The True and the False Project* was created. For this essay Barthes undertakes an analysis of a Panzani pasta advertisement focusing on contrasts between denotation and connotation that begin to be

apparent in the distinct roles words and photography play in the ad. He begins by exploring differences between texts and images and notes that "the intelligible [linguistic description] is reputed [to be] antipathetic to lived experience [visual perception]."[11] Thus he provides a basis for Aycock's separation of cultural (written) and perceptual (sculptural per se) messages in *The True and the False Project* and in a number of subsequent works. Instead of anchoring text to image, which Barthes indicates is the usual practice, or allowing them to be mutually supportive fragments, which he terms "relays," Aycock exaggerates the polysemous nature of her sculpture. She unleashes a "floating chain" of signifiers in her writings so that a virtual "terror of uncertain signs" occurs between her writing and the sculpture that it seems to be denominating. The poetic characterization that she provides for this separation of art into cultural and perceptual components is schizophrenia, which is not surprising since she had discovered Róheim's *Magic and Schizophrenia* the same year she created *The True and the False Project*.

In Aycock's schizophrenic works like *The True and the False Project*, phenomenological seeing is set up as a series of contradictions in order to heighten and frustrate viewers' experiences. Then these frustrations are compounded in a distinctly different second phase when attention is directed away from the object and toward the artist's statement with its germinative ideas that multiply viewers' potential responses. In raw unpainted Sheetrock sculptures, viewers' bodies are first put through their paces when they are encouraged to climb ladders, mount stairs, crawl through tunnels, and stand atop towers. In this architectural sculpture, however, rationality is eschewed for irrationality. Paradox reigns supreme in the form of arbitrary openings, staircases ending in blank walls, a range of triangulated ladders including some impossible to climb, and platforms too close to the ceiling to traverse. The situation

recalls the images of Giovanni Battista Piranesi, particularly his prisons, and the writings of Italo Calvino, especially *t zero*.[12] It is also strikingly similar to the following description of the city of the Immortals in Borges's story:

In the palace [of the city of the Immortals] I imperfectly explored, the architecture lacked any such finality [of a maze]. It abounded in dead end corridors, high unattainable windows, portentous doors which led to a cell or pit, incredible inverted stairways, whose steps and balustrades hung downwards. Other stairways, clinging airily to the side of a monumental wall, would die without leading anywhere, after making two or three turns in the lofty darkness of the cupolas. . . .

Everything was elucidated for me that day. The troglodytes were the Immortals. . . . As for the city whose renown had spread as far as the Ganges, it was some nine centuries since the Immortals had razed it. With the relics of its ruins they erected, in the same place, the made city I had traversed: a kind of parody or inversion and also temple of the irrational gods who govern the world and of whom we know nothing, save that they do not resemble man.[13]

This passage is informative not only for *The True and the False Project* but also for others by Aycock, including *The Angels Continue Turning the Wheels of the Universe Despite Their Ugly Souls, Part II* (1978) and *Flights of Fancy, States of Desire, Part I* (1979), which incorporates a similar upside-down staircase. The reference to "the irrational gods" suggests Aycock's way of dramatically inverting and permuting architecture's presumed rationality, so that viewers assume the role of interlopers in the hybridized architectural traps in which she ensnares them.

As if this state of complexity and contradiction were not enough, Aycock's statement problematizes these experiences even more by distancing them through a series of truth claims about images from the past. As she is clearly aware, words become

things to schizophrenics: "If they say the word 'shoe,' it's as good as the shoe being there."[14] Thus, as the language that forms part of the maze comprising *The True and the False Project* is privileged, the art object at 112 Greene Street is decentered: it is made a function of a set of scripted meanings initially chosen by the artist but placed in the public domain and subject to the whims and orientations of its various publics. Meaning is no longer lodged within the art object per se, and the parity between thought and form that Sol LeWitt sought for conceptual art is retired for its simplicity. For Aycock, art's status is similar to the mental disposition of schizophrenics who turn their destructive impulses onto themselves. Their projective identification with external objects is so strong that they feel depleted and as a result often become incoherent. Similarly, the schizophrenic work of art loses its coherence as meaning moves outward from the object. Just as there is no true self with whom the schizophrenic wishes to identify, so there is no cohesive and autonomous work of art in this new schema that Aycock offers. She alluded to this situation when she insisted on citing in an interview a passage from Foucault's *Madness and Civilization*:

[A] proliferation of meaning, . . . a self-multiplication of significance, weaving relationships so numerous, so intertwined, so rich that they can no longer be deciphered except in the esoterism of knowledge. Things themselves become so burdened with attributes, signs, allusions that they finally lose their own form . . . a theatre of theatre, situating the play, from the start, in the interacting illusions of madness. One group of actors takes the part of spectators, another that of actors. The former must pretend to take the decor for reality, the play for life, while in reality these actors are performing in a real decor; on the other hand, the latter must pretend to play the part of actors, while in fact they are actors acting. A double impersonation in which each element is doubled, thus forming that

renewed exchange of the real and the illusory which is itself the dramatic meaning of madness.[15]

Foucault's "theatre of theatre" could be construed in terms of Aycock's notes and in relationship to the actual stages she builds. And spectators, assuming the position of improvisational actors playing the role of observers, are readily apparent in the different physical and intellectual positions assumed by viewers surveying her work.

As noted earlier, Aycock became intrigued with schizophrenics through reading *Magic and Schizophrenia,* which she viewed as a collection of inspired messages that Róheim calls "imagination magic" and a "fantasy [that] is generally a substitute for action."[16] She explains, "the language of the schizophrenic was extremely poetic. The way he [N.N.] put words together, punned on them and changed them around led me to think of putting sculpture together like a sentence; but it wouldn't be 'grammatically' correct and the meaning or context wouldn't be logical. Causality would play no part."[17]

The schizoid art object had actually been anticipated by minimalist art. Rosalind Krauss explains this situation most clearly in her essay "Sense and Sensibility," even though she does not use the term "schizophrenia" and does not seem aware of Aycock's insight that minimalism actually encourages this type of disassociation, which is in fact endemic to it. Krauss opines that traditional art—which is supposedly an index of the intentionality of individual artists and thus thought to define a private space formative to it and inclusive of it—has been transformed by the minimalists, who have effectively separated it from any residual claims that a traditional creator might make.[18] Minimalism eschews the privacy of past art and opts instead for meanings that occur in the public arena. Choosing Frank Stella's paintings as exemplary, Krauss writes: "The real achievement of these paintings is to have fully immersed themselves in meaning, but to have made meaning itself a

function of surface—*of the external, the public, or a space that is in no way of a signifier of the a priori, or of the privacy of intention.*"[19] One of Krauss's goals in this essay is to establish a new ontological understanding of the work of art in which its formal elements remain autonomous—a legacy, no doubt, of her earlier work with Clement Greenberg—while its potential meanings become a condition of its spectators.

The dispersal of minimalist art into a public arena as well as its loss of both privacy and an analogical relationship with the artist's separate self enable us to characterize this condition as inherently schizophrenic. Although the schizophrenic work of art was implied in minimalism's propulsion of meaning outward to viewers, the psychotic nature of this enterprise becomes explicit in Aycock's pieces. She forces an even greater scission between the work of art, its purported meanings, and the physical presence of viewers passing through it than was even imagined possible before her. Imagination is crucial to Aycock's work and involves not only her activities but also those of her audience: her work challenges viewers to break out of familiar constraints by positing a new ambiguous and unfamiliar space. The relative inaccessibility of her architectural sculptures even when viewers attempt to traverse them, coupled with the seeming accessibility of her texts, has been a contradiction Aycock has long appreciated as a key to unlock one's imagination. Her understanding of the essential fragmentary and ideological nature of our world, which ties us to an impoverished reality and precludes us from conceiving greater wholes or alternative perspectives, can be documented as early as her graduate school days when she used a statement by Erwin W. Straus as an epigraph for her M.A. thesis: "In our physical existence, we are confined to fragments; we can exchange only one part for another, move from place to place, from day to day. The whole as such is inaccessible. We

get hold of it through the mediation of language or other means of symbolic representation."[20]

The schizoid work of art, which is given its first cogent manifestation in Aycock's work, represents a particularly rich development in the realm of postontological art objects, a subcategory of postmodern art.[21] The major characteristic of this schizophrenic condition is an internal division of the work of art into object and text[22] concomitant with a proliferation of possible meanings so that no one particular interpretation can be considered transcendent and definitive. As Aycock has remarked, "I tried not to be deciphered by loading a range of meanings onto my works. . . . You change partners in the middle of the dance. My stories were intended to be impenetrable fictions so that I could not be found out."[23]

This mention of stories suggests a connection between Aycock's work and a contemporary development that curator Paul Schimmel crystallized in his important 1978 exhibition for the Contemporary Art Museum, Houston, on American narrative art, which surveyed work of the preceding decade.[24] The similarities between Aycock's work and narrative art are as important as their differences. In his introduction to the exhibition catalogue, Schimmel recognizes that artists participating in a great range of styles are allied by their common interest in storytelling. Among these many overlapping styles and interests, Schimmel lists practitioners of funk, conceptualists, postconceptualists, earth artists, postmodernists, performance artists, video artists, and diaristic artists.[25] Similarities between narrative art and Aycock's work include forcing observers to cope with images, texts, and the overarching frameworks defining them and establishing major forms of disjunction between them. Schimmel acknowledges the difficulties that ensue when language competes with images. "The relationship between the art and its consequences as information becomes as complex as life itself," he concludes, "that is, duplistic,

prismatic." He continues, "Just as words (text) arise from images in narrative, so do images (imaginary) arise directly from text. Visual symbols which take on direct verbal/written connotations direct movement, stretch the viewer between image, text and the total work. The artists create images with a language of movement, a space that goes beyond/between words. The artists 'tell' the viewer how to perceive the art by ordering the space and time of perception."[26] Aycock exacerbates the situation even beyond this dialectic because her most rigorous work subjects both the text and the object to serious doubt.

In his preface to Schimmel's catalogue, Contemporary Art Museum director James Harithas conjectures that Marcel Duchamp's writings may have constituted a basis for the widespread interest in narrative art. He writes, "Only in the seventies has Duchamp received academic acceptance through his major exhibitions at the Museum of Modern Art and the Philadelphia Museum of Art."[27] Certainly, for Aycock as for Robert Morris, who was one of the first artists to incorporate Duchamp's ideas in his work, the example of Duchamp has been of paramount importance. But whereas Morris looked at this artist's works, Aycock was also studying his notes. She stated, "I think Duchamp's notes read like those of a schizophrenic." She sets out to prove this in a talk in which she cites Duchamp's description of a "headlight child" that outdistances the vehicle driving it (from a note for *The Bride Stripped Bare by Her Bachelors, Even*), and then imagines what this child might say by furnishing him with lines from N. N.'s fantasies. The three characters in this performance piece are Aycock, Duchamp, and the Headlight Child. The passage she takes from Duchamp is as follows:

The headlight child will be the instrument conquering the Jura-Paris road. The headlight child could, graphically, be a comet, which would have its tail in front, this tail being an appendage of the headlight child, appendage which absorbs by

crushing (gold dust, graphically) this Jura-Paris road. The Jura-Paris road, having to be infinite only humanly, will lose none of its character of infinity in finding a termination at one end in the chief of the 5 nudes, at the other in the headlight child. The term indefinite, seems to be more accurate than infinite. The road will begin in the chief of the 5 nudes, and will not end in the headlight child . . . in the beginning (in the chief of the 5 nudes the road) will be very finite in width, thickness, etc. in order little by little, to become without topographical form in coming close to this ideal straight line which finds its opening towards the infinite in the headlight child.[28]

According to Aycock, "Duchamp invented his own language to talk about his art; he created a transformational grammar. I relate it to the Kaballah."[29] Burnham made the same connection in *Great Western Salt Works,* which was probably the most direct source that enabled Aycock to come to terms with this particular type of reading (which was also advanced by Arturo Schwarz). The Kaballah, as Aycock explains, has been crucial to her because "I like the notion of writings to confuse, to keep meaning hidden, to tell about the work without giving it away."[30] Her comments on Duchamp sounds remarkably like an assessment of her own position when she remarks, "I think that Duchamp's visual signs can be arbitrary. He forged his own visual language. It is intentionally visually obscure."[31]

Over the years Aycock has analyzed Duchamp's notes time and again. She has also no doubt relied on conclusions drawn by British artist and Duchamp specialist Richard Hamilton, who pointed out in the publication of the first English translation of Duchamp's *Green Box:* "It was his [Duchamp's] intention that the 'Large Glass' should embody the realization of a written text which had assisted the generation of plastic ideas and which also carried layers of meaning beyond the scope of pictorial expression. The text exists beside the glass as a commentary and within it as a literary component of its structure."[32] In the 1970s Aycock was certainly aware of the high esteem in which Duchamp's work was held by Morris and many other prominent cutting-edge artists.

She has conceded that Duchamp's ability "to show us that an object is in the process of transformation" was important for her own work. "It is anything that Duchamp says it is,"[33] she emphasized, obviously intrigued with the ability of art objects to absorb in a chameleon-like fashion the coloring of references attributed to them. She has complimented Duchamp's "use of language to obfuscate—the shifting sands of transformation—changing the meaning of things, lying a lot to throw viewers off course."[34] Continuing in this vein, she noted: "I did not want the Readymade to remain a bicycle wheel. I wanted it to be all Duchamp said it could be. Not just a Campbell's Soup can but all the flavors and labels. Warhol was part of the tradition of American pragmatism; I am more interested in the way that the Europeans [meaning members of the Arte Povera], Beuys, Broodthaers, and others have mined Duchamp in the surrealist/Dada vein."[35]

The schizoid situation that Aycock initiates in *The True and the False Project* is akin to the operations of allegory, in that some but not all of its meanings are external to the traditionally conceived art object and a result of the codes superintending it. But unlike allegories' dependence on such master codes as the Bible, which partially redeems the impoverishment of *Pilgrim's Progress,* for example, the schizophrenic object cannot subscribe wholeheartedly to an official narrative. In his discussion of *Trauerspiel,* or mourning plays, which he regarded as preeminently allegorical works of art, Walter Benjamin pointed out, "This play [similar to *Pilgrim's Progress*] is ennobled by the distance which everywhere separates image and mirror-image, the signifier and the signified. Thus, the mourning play presents us not with the image of a higher existence but only with one of two mirror-images."[36] However, instead of clearly being

"one of two mirror-images," the schizophrenic work of art is decentered. Because of the disruptive nature of this condition, it does not so much mirror the world as refract aspects of it.[37]

Aycock holds in high esteem schizophrenics' belief in transcending the limits of empiricism. N. N. exemplifies these imaginative leaps for her. "I have a photographic machine that takes pictures of people eating," N. N. recalled to Róheim, "This machine is like the one in the movies. The doctors built it—to see who was putting his head inside me and eating my food. When I ate a cereal it would thin down to coffee, and when I drank coffee it would evaporate into smoke."[38] Aycock envisions a model for the workings of artistic imagination in terms of N. N.'s world of fantasy and illusion in which one's mind is capable of constructing the universe one inhabits. "It's very close to the way I see an artist being able to wander," she says.[39] One of the aspects of N. N. that most intrigues her is his belief in the incredible power of language. As an example, she cites his statement: "One Sunday I was trying to eat a beef stew and could not eat it, and I could not make anybody understand what I was trying to say, and consequently the world war broke out."[40] While some of his remarks are like modernist metaphors—such as his statement, "People thought I was acting funny. I am like a compass without marks"—other aspects of his fantasy realm are closer to poststructuralism's lack of closure. An example of this approach is evident in N. N.'s observation:

This was the trouble with the sun-dial. Once I looked at the sky. I saw the sun rising suddenly and then going down in flames. This was as if I had been driving a car on the curve of a racetrack. I am the sun. The sun is speeding too fast. It will disappear from the sky, and I will disappear from the earth.

Once I went out into the street and it felt as if I had stepped into hot glass—it scorched my body. Once I was looking up into the sky with one eye closed,

and I saw an eagle near the sun. It was huge—like an airplane. From that distance it looked about as big as my tooth. It was as if I was looking at myself. This is not Alaska, and the sundial is not sun-dying, but I am afraid that the sun will die. This means that I will die or disappear.[41]

Besides differing from allegorical works of art, schizophrenic objects are removed from the ongoing tug-of-war familiar in appropriation art, in which new and former meanings vie for supremacy and yet depend on ongoing tensions of both present and past associations for their effects. The range and permeability of schizophrenic art objects is far greater than the dialectics central to the type of appropriation found in Andy Warhol's many raids on mass media imagery or the proliferation of references occurring in David Salle's work.

A third contender for the banner of schizophrenic object might be Robert Smithson's set of sites/nonsites. These pieces establish a pun on "sites" and "sights" and an inverse dialectic between a piece of sculpture containing ore (making it a dislocated boundary marker), which is seen in the gallery (the nonsite), and its reference in a locale far removed from it (the site). But this complex dialectic, in which those aspects that are unseen are referenced in their component—either the site or nonsite—that is on view, does not approach the breakup found in Aycock's schizophrenic art.

In this art, being, which is subjected to doubt, is a consequence of a coercive otherness. The strictures that usually cohere the work of art into a unified whole are unleashed so that codes are scrambled and flow freely in many different directions. These works resemble itinerant modifiers: because they have lost the stability of a distinct noun anchoring them, they are capable of meandering in many different directions. Unlike works of art generically considered postmodern, these schizoid pieces are genuinely phantasmagoric effigies capable of referring back to a number of possible referents, each of which governs a different set of readings.

17

"The Beginnings of a Complex...": For Documenta

The problem seems to be how to set up the conditions which would generate the beginnings of a complex.

Alice Aycock
Project Entitled "The Beginnings of a Complex..."
(1976–77): Notes, Drawings, Photographs, 1977

In 1976 Aycock was invited to participate in the international German exhibition Documenta, which is held every five years in Kassel. For this exhibition, which took place the following year, she created an elaborate piece called *Project Entitled "The Beginnings of a Complex...": For Documenta*[1] (figs. 17.1, 17.2, 17.3). In order to enact this plan, she went to Kassel several months in advance of Documenta's opening.

In *Project Entitled "The Beginnings of a Complex...": For Documenta,* Aycock plays with a number of the ideas that contributed to the first stage of the schizophrenic work of art, that is, the initial breaking apart of the art object and the fragmentation of an overriding phenomenological view so that no one perspective prevails. The second stage that she creates—the development of competing narratives akin to Roland Barthes's definition of writerly prose—will be discussed later. In conversation with British critic Stuart Morgan, Aycock acknowledged using the word "complex" as a pun, referring to a group of buildings as well as to a mental condition.[2] Thus,

171

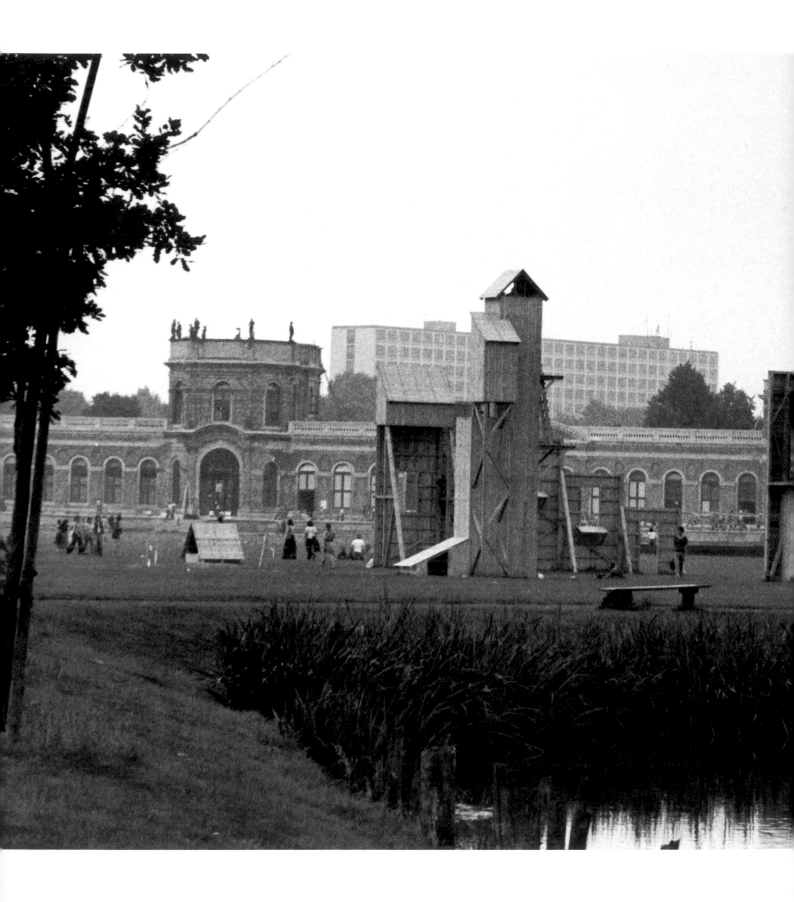

17.1

Alice Aycock, *Project Entitled "The Beginnings of a Complex...": For Documenta*, 1977. Wood and concrete; wall facade 40′ long; 8′, 12′, 16′, 20′, 24′ high, respectively; square tower 24′ high × 8′ square; tall tower group 32′ high. Exhibited at Documenta 6, Kassel, Germany. Collection of the artist. Photo: artist.

"And Gilles, that medieval sadist who wallowed in the intestines of children—I have worn him out by thinking about him. Now when I think of Gilles, I think of that great stone chimney standing in the forest among the towers of Tiffauges. Attached to that chimney, they say there is one remaining wall with a door high up. Along the wall one can ascend a staircase which leads to the room long ago fallen away where he cut the throats of peasant children and threw them in the fireplace." A. A.

"I'll never forget it. One day Nita came by and she said to me 'Miss Matty, would you like to go on another trip?' And I said, 'I sure would if I could just scrape together the money.' And Nita said, 'Well Miss Matty, find the money.' And so a few months later there we were, and you know how people get when they're overawed by things. Well, all the people around us kept trying to find the words to express their feelings. And I'll never forget it. Nita looks up at me and she says, 'On the Nile, Miss Matty, here I am on the Nile.'"

"So this was to be the story of the Middle Ages and possibly World War I, and you ask me how I got around to Egypt and the desert and I have to tell you I simply don't know." A. A.

17.2 (facing page) and **17.3** (following pages)
Project Entitled "The Beginnings of a Complex . . .": For Documenta, details.

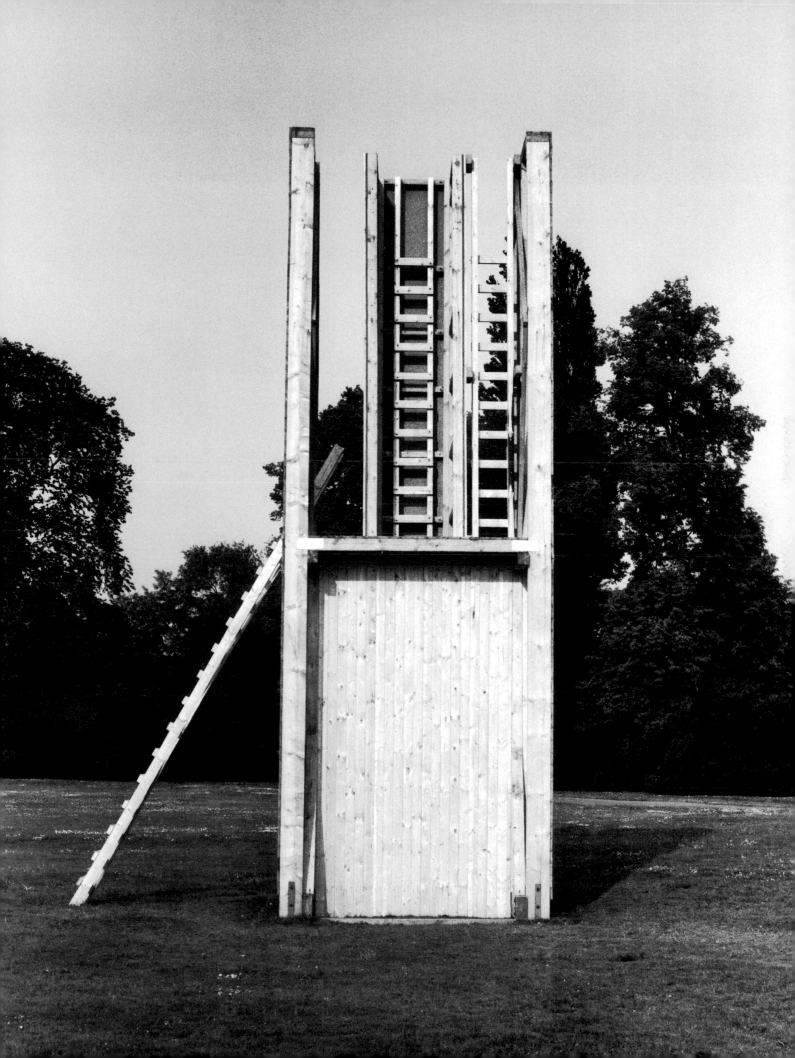

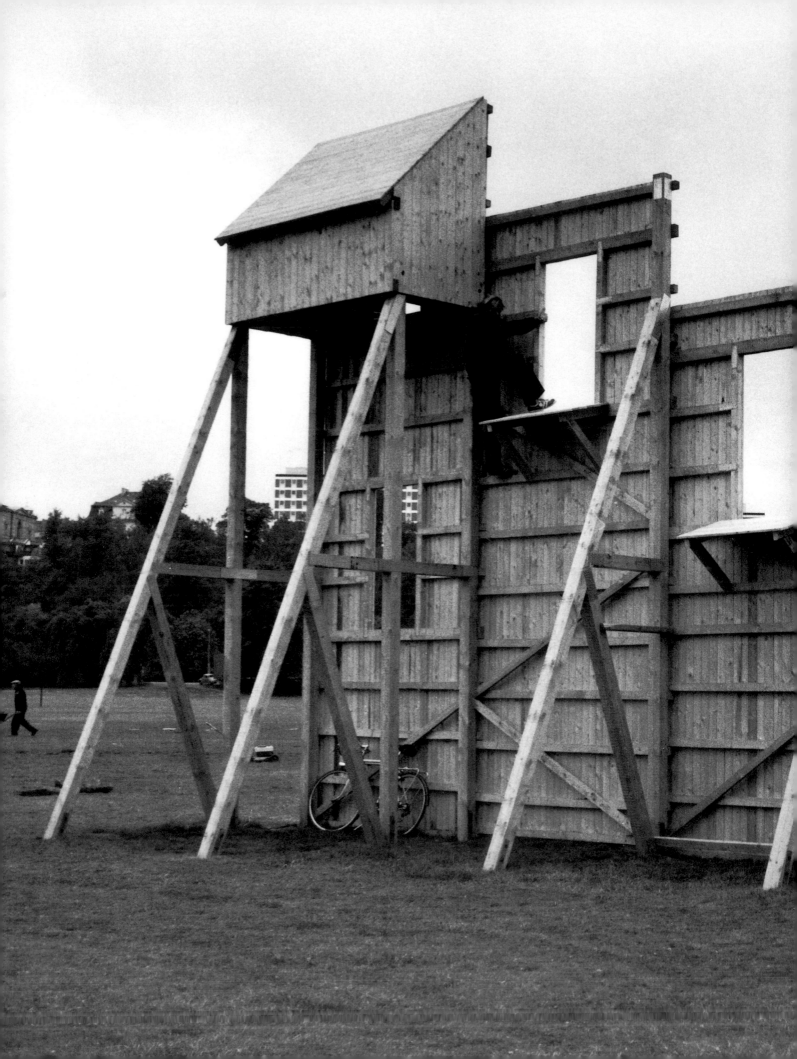

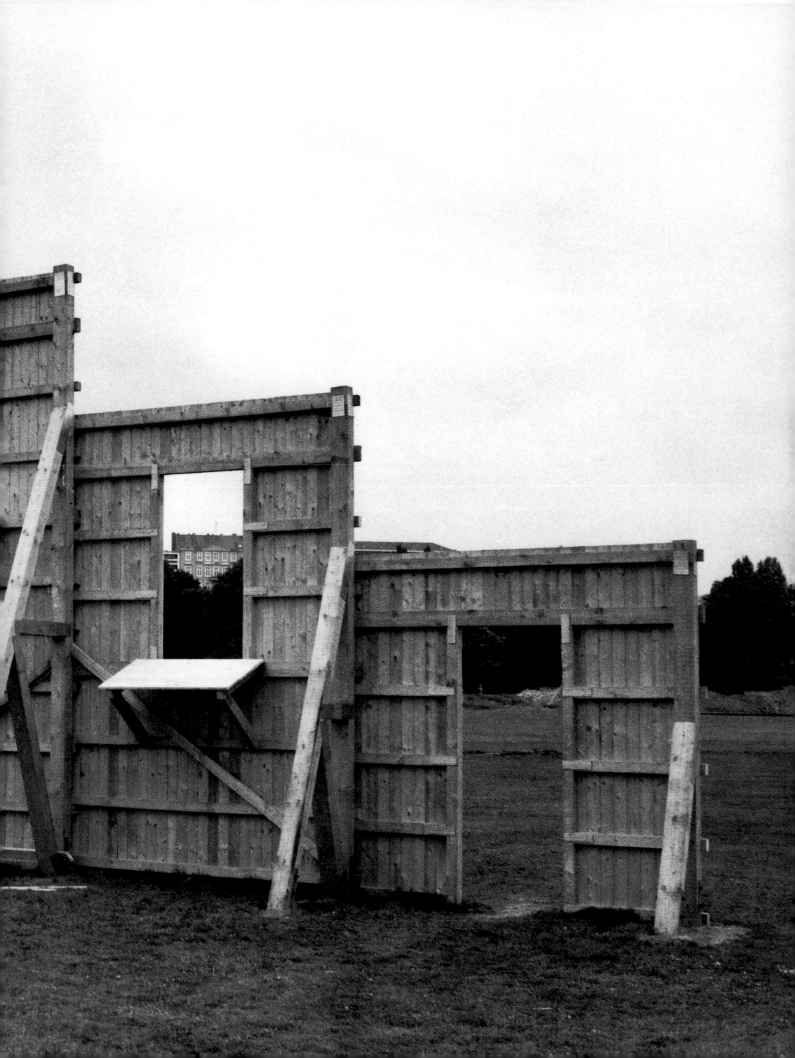

she understood when first generating this work some of the psychotic ideas that would later inform its written complement.

Although Morgan mentions Aycock's visit to the *Hello Dolly!* set as a reason for her makeshift architecture, in retrospect this piece appears to have far more to do with her earlier reading of Venturi's *Complexity and Contradiction in Architecture*. Particularly germane is Venturi's reference to the false fronts in old Western towns, which he describes as "an impure architecture of communication."[3] He notes that their twentieth-century counterparts have undergone an internal splitting apart, with the result that these buildings are small and insignificant while their still-grand false fronts have been perpendicularly repositioned to make them into highway billboards. Earlier in his discussion, Venturi had extolled the merits of such highway signs:

They make verbal and symbolic connections through space, communicating a complexity of meanings through hundreds of associations in a few seconds from far away. Symbol dominates space. Architecture is not enough. Because the spatial relationships are made by symbols more than by forms, architecture in this landscape becomes symbol in space rather than form in space. Architecture defines very little: The big sign and the little building is the rule of Route 66.[4]

In Aycock's schema, this breaking apart and subsequent dispersal would be termed "schizophrenic." When thinking of *The Beginnings of a Complex . . .": For Documenta*, we need to take note of the fact that several definitions of the word "complex" apply to Aycock's piece, as implied above: it is both intricate and highly cathected, representing a number of related and competing personal, familial, and psychotic ideas important to her, as well as a set of buildings. Aycock also compounds the associations with the word "build" to connote construction of ideas as well as objects. In the following passage, she plays with these

meanings to suggest that reality itself is only a construction or a simulation:

This complex would exist in the world while at the same time running parallel to it. Using the concept of the metalanguage, this complex would be a metacomplex setting up the conditions of a city and acting as a model for a city on the scale of an actual city. And if one agrees with Joseph Rykwert in The Idea of a Town *when he states that "every act of building is necessarily an act against nature; it is an unnatural act in the sense . . . of the development of consciousness of being unnatural. When you choose a site you set it apart from nature." If one agrees with Rykwert, as I do, then one accepts the inherent artifice behind every act of building. It then seems possible to imagine a complex which exists in the world as a thing in itself, generating the conditions of its own becoming, and which exists apart from the world as a model for it, exposing the conditions of its own artifice, a complex which undercuts its own logic by exposing the premise on which it was built, underpinning and undermining, drawing in and then distancing the spectator from the work in a theatre of theatre which is both true and false.*[5]

The phrase "a theatre of theatre which is both true and false" is a definite giveaway that Aycock has moved from Foucault, who was responsible for the first part of the statement. She now clearly anticipates Baudrillard's concepts of simulation and hyperreality, in which one's understanding of reality breaks down when the so-called real world mimics the signs used to describe it—a breakdown that is both schizoid and postmodern.

Central to the development of Aycock's art is this aggrandizement of the signified into narratives, which in turn become new signifiers, and the demotion of a building into sets of permeable and disconcerting signifiers. She has at times inverted this situation and created architecture from hieroglyphs by imagining how letters and writing might look if they were made three-dimensional

and placed in a landscape. A number of monumental drawings from the mid 1980s, such as *Rosetta Stone City* (fig. 17.4), *Garden of Scripts* (fig. 17.5), and *The Great Watchtower of the East* (fig. 17.6), are based on this concept.

Such an approach as Venturi's had the net effect of encouraging Aycock in the direction of *The True and the False Project,* in which both the piece of architectural sculpture and her text compete for center stage. Although the texts appear to be the meanings connoted by her pieces, they are actually competitive signifiers. The situation is analogous to Popova's constructivist set for Crommelynck's *Magnificent Cuckold* (fig. 17.7)— one of Aycock's favorite ensembles—which vied for attention in Meyerhold's 1922 production, and undermined the play's unity by presenting competing signs with different connotations.

Aycock intensified her tendency to attach antagonistic signifiers to her artwork when she created *Project Entitled "The Beginnings of a Complex...": For Documenta,* an impressive piece comprising a series of towers. Inside the two tallest towers—the tallest was almost forty feet tall and another was almost twenty-five feet—ladders led adventurous viewers to lookouts at the top. The original idea had been to locate tunnels underground, but Aycock reworked the piece after a core sample of the site revealed that the area was in fact a floodplain. "There were just thousands of people climbing all over this thing," Aycock recalls, discussing the finished piece, "like some kind of Olympic event, and it horrified me. I thought of these things as being kind of contemplative, and I immediately retreated. I felt violated by it all. It all seemed like a gymnastic event with no self-reflection."[6] However, she had encouraged this type of play because she had "become enamored [abstractly and theatrically] with the play within the play within the play" that her Documenta piece represented.[7] In conceiving this piece, she had recognized that the Orangerie and its grounds where the piece was situated had been

a rococo theatrical setting for German royalty and that postwar Kassel, which had been almost decimated during World War II, had been almost entirely rebuilt in the years thereafter. This layering of artifice and reality, in which the so-called real world could be regarded as an elaborate stage set, reminded her of two historical events that have intrigued her over the years:

One was hearing that at Hadrian's villa in Tivoli, Hadrian had recreated all his favorite landscapes in the Roman Empire. Another was the reenactment of the storming of the Winter Palace right where it happened three years later, with a cast of thousands, some of whom had been there before as participants returning as actors. The idea of being there on the original site with the original scale, original excitement, but the event being re-enacted, really intrigued me.[8]

These elaborate stage sets, which replicate scenes and events, function in much the same way as Borges's fabled map that is identical to the borders of the country it represents. Playing with these simulations that conflate the real and the fictive, Aycock wished to contribute her own, and she thought of her Documenta piece as reenacting aspects of "a circus, a fairground, an amusement park, a gypsy camp, a hog farm, a Hollywood movie set, a 'ghost' town, a rundown country estate, the ruins of a medieval castle, just some shacks and shanties somewhere on an industrial spoils pile, a squatter settlement, a market place."[9]

To Aycock the Documenta piece seemed initially to be desecrated by the participants' climbing up and down its false fronts. Thinking that viewers seemed to appreciate the work as little more than a wonderfully conceived playground or a "Disneyland," Aycock wanted to redeem both it and the future direction of her work. Given the multiplicity of interpretations she sought, her reaction to this "misinterpretation" is most informative. It suggests that a range of

17.4
Alice Aycock, *The Rosetta Stone City Intersected by the Celestial Alphabet*, detail,
1985. White pencil and pastel on black paper, 60″ × 85″. Collection of Henry S.
McNeil, Jr., Philadelphia. Photo: Gregory Benson.

17.5
Alice Aycock, *Garden of Scripts (Villandry)*, 1986. Ink on paper, 78½″ × 60″.
Collection of Sarah-Ann and Werner H. Kramarsky, New York. Photo: Fred Scruton.

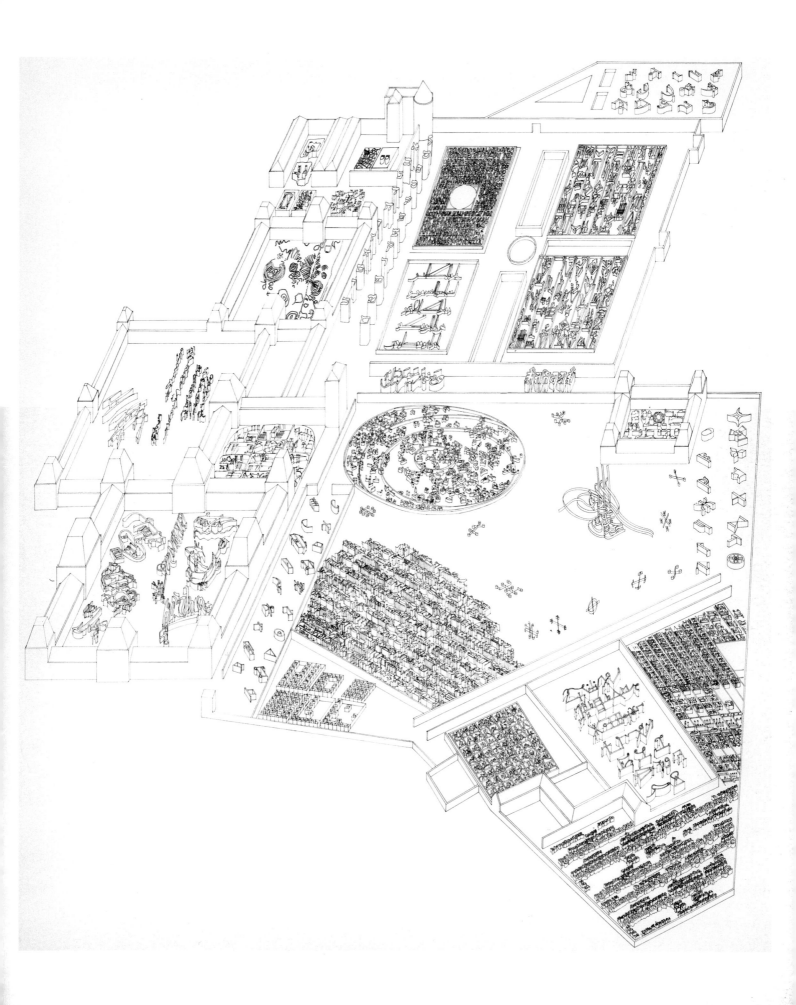

17.6

Alice Aycock, *The Great Watchtower of the East*, 1988. Ink, pastel, and watercolor on paper, 60″ × 83¾″. Collection of Sean Kelley, Kansas City, Missouri. Photo: Fred Scruton. (also plate 1)

17.7

Liubov Popova, stage model for Fernand Crommelynck's *The Magnificent Cuckold*, directed by Vsevolod Meyerhold for the State Higher Theater, Moscow, 1922. Wood and metal, 30″ × 44½″ × 27″. Institut für Theaterwissenschaft der Universität Köln, Cologne.

182

interpretations was acceptable as long as the work of art was assumed to be serious and treated accordingly. Although Aycock extended a great deal of latitude to her work, allowing it to function in the "expanded field" that Krauss so eloquently described,[10] she, like Krauss, unequivocally demanded that it be taken as high art. At that point she determined, whether rightly or wrongly, that if people were too preoccupied with having fun, they would not be capable of the reflections that she wanted her work to inspire. From this, we must conclude that the fun-house metaphor at the basis of much of Aycock's art both freed her to make a new type of work that dominated sculpture's expanded field at the same time as it conflicted with the type of receptive behavior that she deemed acceptable. Evidently Aycock wished to emulate the free-wheeling nature of sideshow attractions without enticing viewers into the mirthful glee and wild shenanigans such concessions can inspire. Her long schooling in art viewing had inculcated in her a certain sense of decorum that was deeply offended by the no-holds-barred attitude of the art crowd at Documenta. Instead of being observers, members of this art public became far more active participants than Aycock herself had dreamed possible.[11]

"I wanted to give credibility to what I did at Documenta,"[12] she later reminisced. But to do so would take a little time. Her first work after Documenta was *Project Entitled "The Beginnings of a Complex . . .": Excerpt Shaft #4/Five Walls* (figs. 17.8, 17.9), which recaps a number of aspects of the Kassel piece and seems to be an extension of it. The work was made for Artpark, a new type of outdoor *Kunsthalle* in Lewiston, New York, featuring cutting-edge installation art. Representative of the spirit of the 1970s, when advanced artistic thought actively competed with enduring forms, Artpark was a summer program featuring temporary work. It was placed under the National Heritage Trust and administered through the New York State Office of Parks and

Recreation. Initiated in 1974, Artpark could accommodate approximately twenty-five artists each session, who were permitted to create and construct pieces on the two hundred acres of land along the gorge of the Niagara River. During the summer of 1977 when Aycock built *Five Walls*, other Artpark participants included Laurie Anderson, Agnes Denes, Sam Gilliam Jr., Newton and Helen Harrison and their son Joshua, Martin Puryear, and Robert Stackhouse. Although this designated park for land art became enormously popular and attracted 330,000 visitors in its fourth season, the audience during the summer of 1977 when Aycock was working at this site was, in her words, "respectful of the art situated there and treated it deferentially," that is, as art. Aycock remembers that her efforts that summer resulted in a deliberately rough piece that looked as if it were in the process of being either built or torn down. In this work, she wanted to create a feeling of "jumping out into space" rather than surmounting and violating actual spaces. "I wanted to take viewers' breath away!" she explained.[13] This state of breathlessness was caused by the notable gaps between walls that viewers were challenged to bridge at a height involving actual risk. Because of the potential danger, few elected to climb the piece, most viewers preferring to think about the very real possibility of bodily harm if one failed to maneuver successfully through the spaces separating the five piece's walls and, conversely, the exhilarating feeling if one were able to do so.

Aycock's personal act of contrition for the recreational diversion that Documenta had become was the recondite artist's book *Project Entitled "The Beginnings of a Complex..." (1976–77): Notes, Drawings, Photographs*, published the following year. Considered in the terms provided by Jack Burnham in his essay "Real Time Systems," the book can be considered the software that relates to the hardware constituting the architectural sculpture itself.[14] Burnham wrote,

Electronics have taught us that we often confuse software with its physical transducer. In other words, if we extend the meaning of software to cover the entire art information processing cycle, then art books, catalogues, interviews, reviews, advertisements, sales, and contracts are all software extensions of art, and as such legitimately embody the work of art. The art object is, in effect, an information "trigger" for mobilizing the information cycle.[15]

The artist's book of the 1970s was a descendant of Fluxus boxes and pieces of printed ephemera in the 1960s as well as the commercially printed art booklets spearheaded by California pop artist Edward Ruscha, who was also the designer of *Artforum*. Because it was both democratic in its affordability and smart in its tactics of placing art under the aegis of information, the artist's book became a widely practiced new genre. It stressed the look and standards of commercial printing and the pluralistic postconceptual idea that art could take the form of objects and text as well as aesthetics and information. *Project Entitled "The Beginnings of a Complex...": Notes, Drawings, Photographs*, Aycock's single contribution to this genre, is so central to her thought that I have already cited a number of its key passages above. This artist's book elaborates on the method established in *The True and the False Project* by diverting the possible significance of the Documenta piece into an assemblage of texts: a brief essay called "A Play in One Act after *Modern Times* by Charlie Chaplin" and a piece entitled "For Granny (1881–) Whose Lamps Are Going Out: A Short Lecture on the Effects of Afterimages" (itself an investigation of late-coming), which had been published in *Tracks* the spring before. The lecture in particular enabled Aycock to invest her false fronts with far more than the abbreviated set of guidelines created for *The True and the False Project*. In it she associated her fragmentary architectural forms with the following peripatetic

17.8
Alice Aycock at Artpark working with drill on *Project Entitled "The Beginnings of a Complex . . .": Excerpt Shaft #4/ Five Walls,* 1977.

17.9
Alice Aycock, *Project Entitled "The Beginnings of a Complex . . .": Excerpt Shaft #4/Five Walls,* 1977. Wood, 28′ high × 8′ wide × 16′ deep. Exhibited at Artpark, Lewiston, New York. Collection of the artist. Photo: artist.

"Five wood frame walls, 28′ high × 8′ wide, situated on an artificial hill. The distance between each wall was approximately 42". The walls could be scaled by entering an underground tunnel which, in turn, led to an enclosed ladder above ground and a series of doors high up on each of the walls. In the foreground was a shed, a false entrance, behind which was a serpentine mound." A. A.

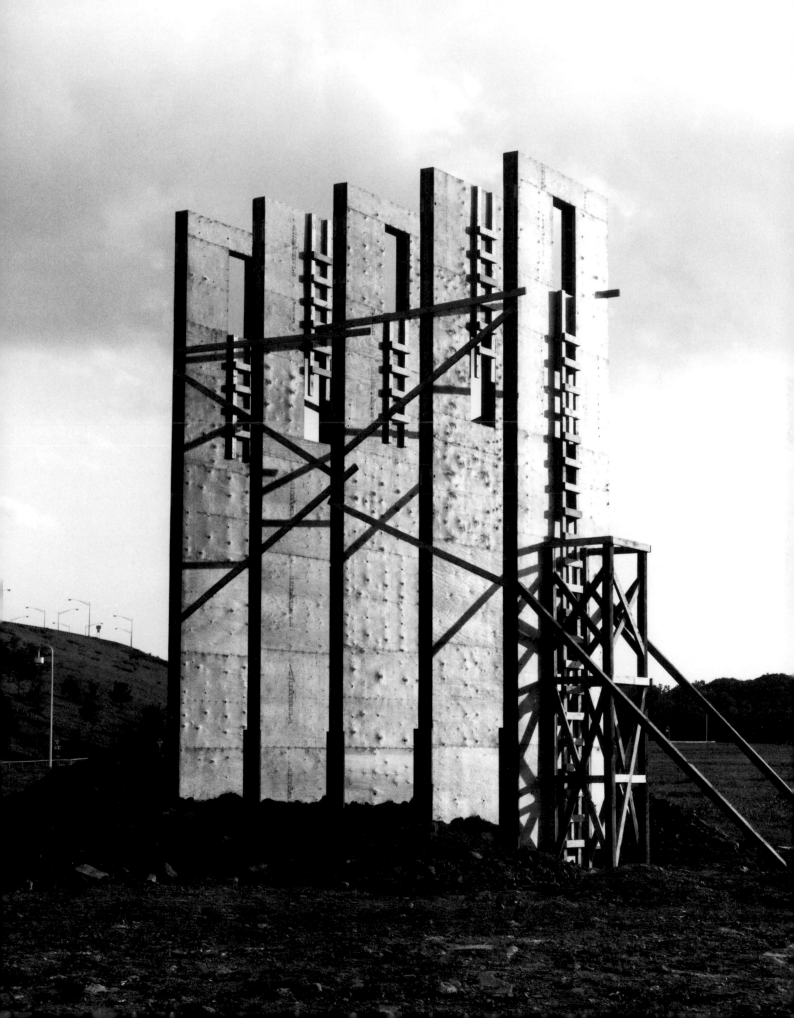

and dark narrative, involving the destruction of Oscar Wilde's persona, the deadly machinations of Apuleius's sorceress, and the panic invoked by the witch Perrine Martin, who worked for the monstrous Gilles de Rais. The sequencing of associations approaches Aycock's understanding of the layered and far-flung references constituting the Aleph:

And later, poor, destitute masochistic Wilde writing Alfred from prison, "in less than three years you had entirely ruined me from every point of view. For my own sake there was nothing for me to do but to love you. I knew, if I allowed my self to hate you, that in the dry desert of existence over which I had to travel, and am traveling still, every rock would lose its shadow, every palm tree be withered, every well of water prove poisoned at its source." I like that passage—it's all that nature imagery. It reminds me of that sorceress referred to by Apuleius "whose powerful charms . . . will harden running waters to cold marble . . . will extinguish the light of the stars. . . ." It reminds me of you with your wild black hair, Perrine Martin, nicknamed "la Meffraye" (the Terror) because you procured children for Gilles de Rais to disembowel. And Gilles, that Medieval sadist who wallowed in the intestines of children—I have worn him out by thinking about him. Now when I think of Gilles, I think of that great stone chimney standing in the forest among the towers of the castle at Tiffauges. Attached to the chimney, they say there is one remaining wall with a door high up. Along the wall one can ascend a staircase which leads to the room long ago fallen away where he cut the throats of peasant children and threw them in the fireplace.[16]

In addition to these narratives, the artist's book contains photographs and drawings of the Documenta piece as well as other images, suggesting powerful and disturbing relationships but leaving the connections open so that readers can become accomplices in the interpretations they choose.

Though originated by Aycock, this new schizophrenic form of art, which first appears in *The True and the False Project* and is elaborated in *Project Entitled "The Beginnings of a Complex . . .": For Documenta,* soon became important for other artists. Aspects of it are evident in Sherrie Levine's freely composed copies of famous reproductions of works of art (usually considered appropriations) that not only refer back to their dissemination through the mass media but also indicate the range of misunderstandings that attend such incarnations. The schizoid condition is also evident in many of Cindy Sherman's photographs, in which the reality of the artist is suspended, held suspect, and even jeopardized by her assumed masks that in turn reference the many incarnations to which that ambiguous signifier, "woman," refers. This splintering apart of mimetic fidelity so that it no longer resembles a known element in the world is heightened in Yasumasa Morimura's work when he photographs himself in the guise of famous actresses for the series entitled *The Sickness unto Beauty.* He leaves viewers wondering whether his images are to be considered pictures of a transvestite, representations of the media's power to transform the world around it, or critiques of his fellow Japanese and their ability to expropriate foreign cultures. With each of these interpretations, the work of art's identity is changed. Each interpretation makes the preceding one suspect, causing the lineage of artifacts to be seen as a series of surrogates. And certainly Lorna Simpson's use of masks together with a collection of alternative labels to append to them is indebted both to Derridean slipping signifiers and to the schizoid framework for art in the age of criticism that Aycock's sculptures realize.

Aycock's development of the schizophrenic work of art has also had an impact on her former Yale student Matthew Barney. The series of films constituting Barney's *Cremaster* cycle, as well as the separate objects originating from them, might at first appear to be allegorical since they seem to

depend on the external mythos of the cremaster muscle that determines the gender of a fetus. But this work follows more clearly the schizophrenic model that Aycock originated than an allegorical one, because it breaks the entire saga into a series of discrete entities that appear to support an overarching grand narrative but in actuality dissipate its focus. Instead of embodying meaning, these complex works transfer it by lodging signification in any of a number of subtexts, which might become claimants for the series's transcendent cause. Such subtexts include in *Cremaster 2* the state logo for Utah with its reference to a beehive, Norman Mailer's novel about Gary Gilmore, the legend of Harry Houdini including Mailer's portrayal of him in the film, and prison rodeos and their intertextual relationship to the genre of Western film.

Differing from mediated identities and simulated selves, the schizoid work of art implodes from within before sending out its fragments to incarnate a disparate welter of beings and things. This schizophrenic method of rigorously displacing the center onto a series of surrogates, so that a clear identity is masked and even denied, is evident in the way that Barney has demoted photography to the level of film stills that appear to reinforce the narrative from which they are excised. Instead of supporting the cohesiveness of their origins, however, they memorialize the film's openness to other narratives and meanings than those embedded in the sequences giving rise to them. While one might argue that the distribution of meaning outside the work is true of almost all art, most pieces steadfastly try to maintain at least a residual sense of their autonomy: their meanings and identity are not permitted to behave like pieces of scattered confetti but are cemented to a superintending form that tries to behave as if it were still complete and monolithic.

18 Writerly Texts and Schizophrenia

When we noted a moment ago that the schizo is at the very limit of the decoded flows of desire, we meant that he was at the very limit of the social codes, where a despotic Signifier destroys all the chains, linearizes them, univocalizes them, and uses the bricks as so many immobile units for the construction of an imperial Great Wall of China. But the schizo continually detaches them, continually works them loose and carries them off in every direction in order to create a new polyvocity that is the very code of desire.

Gilles Deleuze and Félix Guattari
Anti-Oedipus: Capitalism and Schizophrenia, 1983

The schizophrenic work of art cannot be fully appreciated without understanding its complicity in Roland Barthes's "death of the author" theory and his concept of writerly as opposed to readerly texts. The brilliance of Barthes's prescient essay "The Death of the Author," written in 1968 and translated into English in 1977,[1] is its ability to remain on the cusp of a paradigm shift from readerly to writerly texts—a cusp, as we will see in the discussion that follows, on which many of Aycock's works are poised. This essay transposes the variables of the structuralist/poststructuralist divide so that one no longer depends entirely on the ontology of an artwork but on the epistemology it provokes. This approach was championed by conceptual artists, who emphasized the viewer's role in assessing how art functions in its various contexts. In Barthes's essay the hegemony of the work of art is broken up, the artist is exonerated of full responsibility, and

the burden is now shifted to the interactive process of reading—which is reconceived as a playful and self-reflexive activity no longer dependent on the discernment of codes and systems that reveal a given text's immanent meaning. This shift occurs when the work of art becomes permeable to one's mode of responding to it even though it is still held partially accountable for the way in which it is seen. Looked at in conjunction with Barthes's later criticism, this approach appears to be far more open-ended than it actually is, for these writings contribute to the theory of a perpetual signifier that depends on continued reliance on the partially responsible text.[2] When Barthes declares prophetically at the end of his essay that "the birth of the reader must be at the cost of the death of the Author,"[3] he gives priority to reception over generation and to the creative role of reading over writing. At the same time that he elevates the reader, he demotes the *auteur*—the autonomous, unique, and private personality responsible for originating a work of art—by replacing him or her with the *scripteur,* the scribe who simply writes.

Barthes's characterization of what he calls the writerly implies that the work of art and the interpretation can be considered a continuum and that any reading is contingent on both the position taken and the person undertaking the analysis. The writerly approach and the work it investigates might be spatially mapped out as a traveler on a modern highway, analogous to the comparison that sculptor Carl Andre made between his works and roads: "A road doesn't reveal itself at any particular point or from any particular point. Roads appear and disappear. We have to travel on them or beside them. But we don't have a single point of view for a road at all, except a moving one, moving along it. Most of my works . . . cause you to make your way along them or around them or to move the spectator over them."[4] Even more than Andre's works, Aycock's pieces function like roads. I have often visualized her works as two sets of overlapping thoroughfares: one is created by the work itself, the other by the texts appended to them. Although the ensuing conjunction of the two thoroughfares produces few correspondences between artist and work as well as observer and work, it does create intrusions and fractures that point to a vast and complex manifold. Such a pairing privileges outer views (i.e., reader) rather than inner views (i.e., *auteur*) so that essential identities are pried open and found to be specious, inherent realities are shown to be dichotomous, and the integrity of art is presented as an outworn convention.

Two years after "The Death of the Author," Barthes's complex study *s/z* provided a model for the complexities of reading. Because it was published in English in 1974, several years before Aycock's development of the schizophrenic work of art, and was widely read and discussed at the time, *s/z* may be considered a factor in the origination of her concept. In *s/z*, a condensation of his course notes on Balzac's novella *Sarrasine*, Barthes divides reading into *lisible* (readerly) and *scriptible* (writerly) functions. In the former, the text almost entirely anticipates and substantiates the reader's reactions, which are assumed to be seamlessly in accord with it. Readerly texts avoid contradiction, rely whenever possible on master codes, and fill in gaps, creating a sense of inevitability. This type of reading is most apparent in popular fiction, in which viewers' reactions are assumed and woven into a given text so that they smoothly acquiesce to its presumptive and privileged views of reality. In writerly prose, however—and here the same can be assumed true of "writerly" works of art—clarity is held suspect, and readers are forced to devise their own interpretations because meanings are not self-evident. In writerly works there are many competing codes rather than a hegemonic one that might provide easy answers. Though Barthes does not specifically invoke this metaphor, his characterization of apprehending writerly texts as an "entrance into a network with a thousand

entrances"[5] parallels the contingency, difficulty, and lack of a clear resolution that might be experienced in a complex maze. The process of comprehending writerly prose is akin to interpreting an involved and subtle poem: the communiqué is thrown back at the reader, transforming reading into a creative activity, "a perpetual present,"[6] in which texts are rewritten by recipients rather than by the sender. According to Barthes, coming to terms with a writerly text "does not consist in stopping the chain of systems, in establishing a truth, a legality of the text, and consequently in leading its reader into 'errors'; it consists in coupling these systems, not according to their finite quantity, but according to their plurality."[7]

Barthes looks at the readerly and writerly perspectives in a different way in the brief essay "From Work to Text," written the following year. Here he reconfigures the readerly process when he equates it with the work of art per se, which he describes as "a fragment of substance" that is only "*moderately* symbolic," while the text is viewed as "a methodological field" that is "*radically* symbolic" and also "off-centered, without closure."[8] In other words, the work of art is as limited as the discrete object constituting it, while its interpretation is open-ended. In a wonderfully poetic statement, Barthes compares the text to the intoxicating aromas and flavors arising from wine that go far beyond merely drinking it, while the work of art is the firmly corked bottle. "The Text (if only by its frequent 'unreadability')," he speculates, "decants the work (the work permitting) from its consumption and gathers it up as play, activity, production, practice."[9]

Going beyond Barthes, Deleuze and Guattari's *Anti-Oedipus* provides an understanding of the fluid and open-ended role of the signifier in schizophrenia. Their work clarifies how Aycock's poetic evocations of this psychotic condition are similar to Barthes's writerly text. Deleuze and Guattari contrast the signifier's role in so-called normal (i.e., capitalist) situations with its

appearance in schizophrenic ones. They characterize paranoia as totalizing, while they understand schizophrenia in terms of its lack of a center and openness to flows. The theorists are careful to point out that they are not using schizophrenia to name a social illness; instead, they are employing it to define an ongoing process of deterritorialization in which individuals can prevent themselves from being hailed as subjects, even rebellious ones, by scrambling codes and channeling desire without challenging it.[10] Implicit in Deleuze and Guattari's study is the idea that interpellation transforms viewers and readers into distinct types that conform to the social programs dictated by works of art. The condition is particularly pronounced in popular cinema, where the viewer is standardized into a conforming member of the middle class. Schizophrenics are useful for Deleuze and Guattari because they diverge from their charted response and enact instead a continuous process of creating and recreating mazes of new and unconnected meanings in the social realm. This innovative interpretation dethrones the traditional priority Ferdinand de Saussure placed on the signifier, in favor of a free play of signifiers. In Barthes's terms, "the temporary wandering of the predicate can be described in terms of a game."[11] For this reason Deleuze and Guattari cite Louis Hjelmslev's abandonment of the signifier's identity in the 1930s in favor of its partial dismemberment to make it permeable to flows of desire. In writerly terms, this transfer of allegiances is tantamount to making the work of art (the signifier) available to readers' improvisations and transforming their activities (their proposed signifieds that in turn become signifiers) into creative forms of play, or as Barthes stated, it enables readers "to appreciate what *plural* constitutes."[12] The schizoid/writerly process is a type of fissuring, a continually open bifurcating maze—an Aleph, a rift, an opening onto the Real—that is both exhibited by the work of art and enacted on it,

so that it no longer has a foreseeable beginning or end.

This process and Aycock's sculpture enact a reversal on recent ways of seeing, so that she overcomes both the empirical self-enclosure of the modernist work that dictates the terms and limits by which it is to be understood and the provisions of the stated generative idea around which conceptual art devolves. In order to dramatize the proportions of this change, we might point to Laurence Sterne's novel *The Life and Opinions of Tristram Shandy, Gentleman,* which was important to Aycock in the early 1970s. She was especially interested in the character of Uncle Toby, who constructs in his backyard a series of scaled-down earthworks recreating the battle in which he was wounded. Whereas Sterne steadfastly maintains the intelligibility and presence of his characters even to the point of minimizing his descriptions of these model battlefields, Aycock foregrounds her architectural sculptures and then makes their raison d'être suspect in her allusive descriptions of their possible importance.

An example of her writerly prose is the playlet *I Have Tried to Imagine the Kind of City You and I Could Live in as King and Queen* (appendix A), which was conceived in 1978 to accompany an elaborate set of drawings (fig. 18.1). Aycock's drawings feature the Queen's Complex, which comprises the following structures: *The House of the Stoics* (fig. 18.2), *The Pavilion above the Vale of Tempe, The Hundred Small Rooms* (figs. 18.3, 18.4), *Canopus,* and *The Wood of Tempe, The Nymphaeum.* In addition, the adjacent King's precinct is intended to include an equally intricate complex of buildings coupled with earthworks and a thirty-two-foot-high wall with a rose window emulating the one at Notre-Dame. The confusion of the text begins with The Character Elizabeth, who may be one person or several people with the same name. Her separate speeches to clouds, her parents, and the stars resemble the ramblings of a schizophrenic, as do the disparate and

quixotic descriptions and events making up the rest of this playlet.

The entire sculptural complex resembles a maze, and two of its buildings, *The Hundred Small Rooms* and *The House of the Stoics,* constitute labyrinths. The first house actually consists of sixty-three rooms rather than the hundred listed in its title, since each of the seven floors has nine compartments. This disparity already clues viewers in to the difficulty of sorting out information about this piece and the entire project. *The Hundred Small Rooms* is a vertical labyrinth that takes about forty-five minutes to traverse and leads to a dead end, so that participants find themselves on the roof and then are forced to retrace the labyrinth's pathway in order to get out. Each floor is four and a half feet high, and the total height of the building is about thirty-two feet. Instead of being framed by a picket fence, this one is built from picket fences. In addition to its vernacular American reference this piece was inspired by drawings of Roman attack towers that were designed so that they could be rolled into position. *The Hundred Small Rooms* was first constructed in 1984 for the Houston Arts Festival; several months later it was relocated to Laumeier Sculpture Park in St. Louis County, Missouri, on a grassy knoll among tall pine trees that once had graced the home of Mrs. Detrick Hedenkamp.

That same year another building in the Queen's Complex, *The House of the Stoics,* was built on Lake Biwa, Japan. While *The One Hundred Small Rooms* suggests a Victorian cottage with its picket fence transformed into a tower, *The House of the Stoics* is reminiscent of a far grander Victorian structure, replete with gingerbread filigree that reinforces the grandeur of a central structure comprised of ten towers. Ladders inside these towers enable viewers to move up and down, but the balconies and central building space are inaccessible. In conversation with Fineberg, Aycock remarked on the claustrophobic quality of this building, which she compared to a prison and a

vertical tomb and described as an inversion of her *Low Building*.[13] Seen in conjunction with Aycock's disjunctive playlet, both buildings from the Queen's Complex can be construed as variations on the biblical Tower of Babel, which has symbolized for millennia the difficulty and futility of achieving a single language capable of scaling the heavens of transcendent meaning. One might say that the quest to create the Tower of Babel is a desire to ordain the readerly text as the preemptive one, and that the divine act of confounding this unitary goal by establishing competing languages is an actualization of reality in the form of writerly texts.

18.1

Alice Aycock, *Project Entitled "I Have Tried to Imagine the Kind of City You and I Could Live in as King and Queen,"* isometric view, 1987. Black ink on paper, 54½″ × 73″. Collection of Laumeier Sculpture Park, St. Louis, Missouri.

18.2

Alice Aycock, *The House of the Stoics Structure A*, 1984.
Wood painted white, 32′ high × 13′ 6″ wide × 11′ 9″ deep.
Exhibited at Lake Biwa, Miyazaki-Mura, Japan. Collection
of the artist. (also plate 2)

18.3

Alice Aycock, *The Hundred Small Rooms*, 1984. Wood
painted white, 28′ high × 12′ 4″ long × 12′ 4″ deep. Exhibited
at Laumeier Sculpture Park, St. Louis, Missouri. Collection
of the artist. Photo: Robert Pettus.

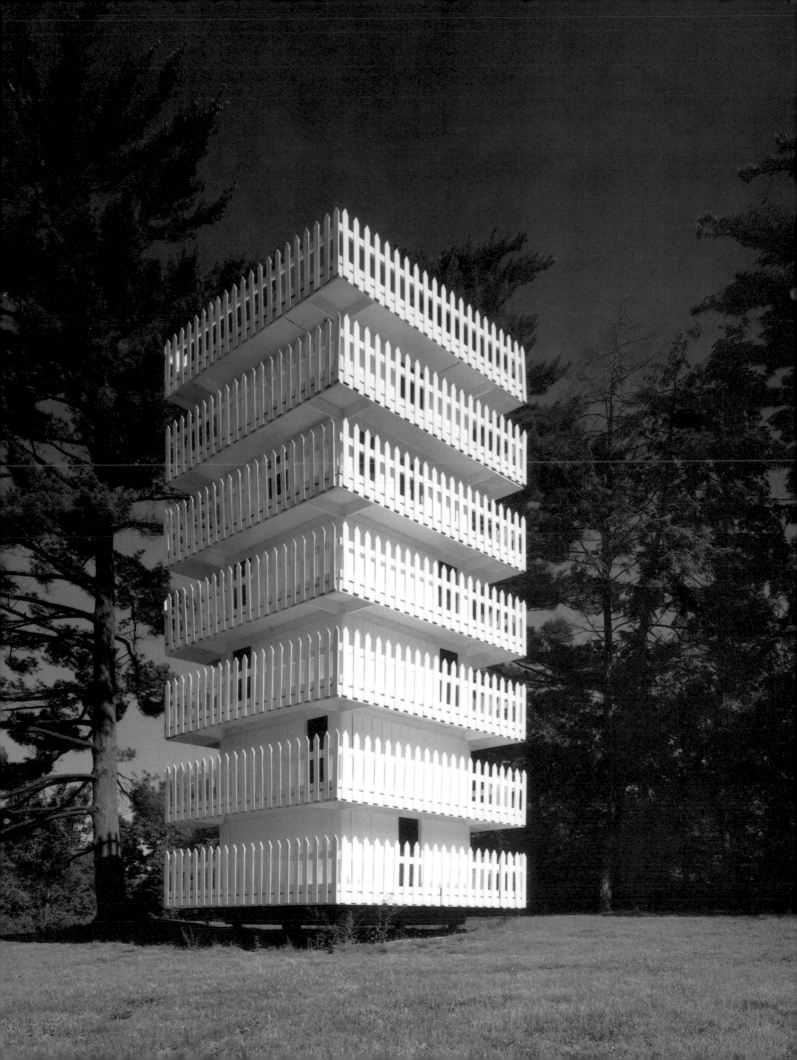

18.4

Alice Aycock, *The Hundred Small Rooms (Another Tower of Babel) on the Eve of the Industrial Revolution (A Pictorial Re-creation of the Raising of an Egyptian Obelisk in the Piazza di San Pietro, Rome, 1586) with Turning, Cranking . . .*, 1984. Pencil on Mylar, 36″ × 54″. Collection of Richard Kahan. Photo: Fred Scruton.

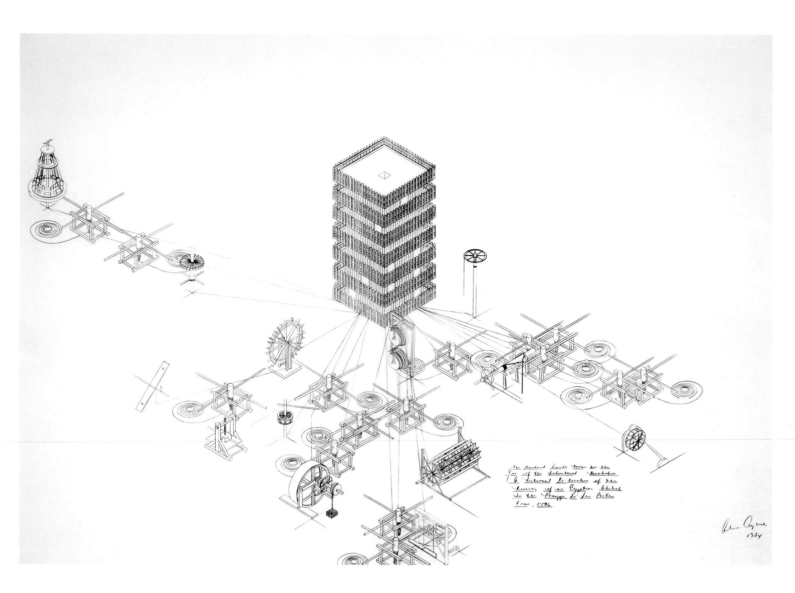

One Hundred Small Rooms on the
Plan of the Redundant Revolution.
(In Reverent Re-erection of the
Raising of an Egyptian Obelisk
in the Piazza di San Pietro
Rome, 1586)

19

Virtual Space, Medieval Legacies, and Architectural Sculpture

Don Quixote *is the first modern work of literature, because in it we see that the cruel reason of identities and differences make endless sport of signs and similitudes; because in it language breaks off its old kinship with things and enters into that lonely sovereignty from which it will reappear, in its separated state, only as literature; because it marks the point where resemblance enters an age which is, from the point of view of resemblance, one of madness and imagination. . . . The madman, understood not as one who is sick but as an established and maintained deviant, as an indispensable cultural function, has become, in Western experience, the man of primitive resemblance. . . . The madman fulfils the function of* homosemanticism: *he groups all signs together and leads them with a resemblance that never ceases to proliferate.*

Michel Foucault
Les mots et les choses, 1966

The phenomenological/epistemological process that Aycock initiated in *The True and the False Project* in 1977 and continued with both her Documenta work and *I Have Tried to Imagine* proved to be not only cumbersome but also alarming when her sculpture at Documenta became a fun house for children. Participatory art was also becoming a concern for the museums commissioning these pieces in the late 1970s because of the pragmatics of increasing insurance restrictions and rising costs. For these reasons Aycock decided that in her next sculptures she would no longer try to break down traditional barriers between virtual and real spaces. Instead she would focus on virtual space but handle it in a new way that was informed by an

architecture discernible in terms of models and drawings. Her first experiment with partially impeding viewers' entry to her work was *Project Entitled "Studies for a Town"* (fig. 19.1), a wood and plywood piece created for a showing at MoMA in late 1977 and subsequently purchased by this institution. According to Aycock, its sources include "references to medieval walled towns, Roman amphitheaters, military bunkers, Egyptian shanty towns and desert citadels, and an eighteenth-century Indian observatory [at Jaipur]."[1] She also included references in the piece to people living in the walls of Rome and to the oblique perspectival views found in medieval woodcuts.[2] *"Studies for a Town"* was purposefully situated at MoMA in a room entirely too small for it, making the piece itself enormously imposing and its viewing proximate and difficult. This constrained space rhymed well with its almost claustrophobic interior, causing the two to seem part of the same overall installation comprising the gallery itself, an observation that Aycock heightened by the inclusion of photographs and information on the walls of the adjoining room. The ladders, wells, roofs, shafts, and alleyways of this piece all bespeak the variety of spaces found in urban settings as well as the vocabulary of forms appearing in many of Aycock's works.

In the late 1970s Aycock created a number of stage-set drawings and sculptures that viewers could not physically traverse, including *Project Entitled "A Shanty Town Which Has a Lunatic Charm That Is Quite Engaging" or Rather "A Shanty Town Inhabited by Two Lunatics Whose Charms Are Quite Engaging"* (1978), which was never built (fig. 19.4), *Untitled Shanty (Medieval Wheel House)* (1978) (fig. 19.5); *Wooden Shacks on Stilts with Platform* (1976) (fig. 19.6); and the elaborate *History of a Beautiful May Rose Garden in the Month of January* (figs. 19.7, 19.8), constructed in late 1978 for the Philadelphia College of Art. This last piece consists of two main parts, which the artist listed on the accompanying label:

200

19.1

Alice Aycock, *Project Entitled "Studies for a Town,"* 1977. Wood, 3′ to 10′ high, variable diameter 11′ to 12½′. Museum of Modern Art, New York. Photo: artist. (also plate 3)

"An elliptical wooden structure cut on a skew to provide a bird's-eye view of the whole and to reveal its interior components: steps, walls, doorways, windows, ladders, roofs, shafts, and alleys, some of which may be reached by the spectator, others only seen, remaining inaccessible. . . . The work incorporates references to medieval walled towns, Roman amphitheaters, military bunkers, Egyptian shanty towns and desert citadels, and an eighteenth-century Indian observatory." A. A.

Part 1: The Ascension Scene (Weapons) in which there appears a huge funnel-shaped pit situated beneath the Northern Hemisphere and running down to the center of the Earth.
Part 2: The Coronation Scene (Planets) in which there can be found a Book of Knowledge of Mechanical Devices *as illustrated by the Elephant Clock.*

Made smaller than life-size yet still imposing enough to dominate the gallery's space, this project, which secularized the religious themes of the Coronation and Ascension of Christ, enabled Aycock to experiment with an ambitious range of connected spaces that also inform the Queen's and King's precincts in *I Have Tried to Imagine*. The contradiction suggested by its title signals the work's writerly nature. And the constellation of garden imagery, the titular references to the seasons winter and spring that traditionally connote death and resurrection (which are reversed in this carpentered structure), suggest a break, paralleling personal and biographical circumstances in the artist's life, making it also a readerly text. In conversation, Aycock has acknowledged that *History of a Beautiful May Rose Garden in the Month of January* reflects the breakup of her ten-year marriage with Mark Segal.[3] In light of this information, the work's smaller scale and lack of entry assume a psychological dimension, suggestive of the dissolved marriage that no longer permits either the artist or her estranged spouse a viable route.

After her separation from Segal, Aycock retreated into a hallucinatory space that she equated with flying. During the summer of 1977, she had spent time with Matta-Clark, and they had become close friends. Then he died the following year, before she made *Rose Garden*. In retrospect these painful breaks signal on a personal level the type of tears in the universe that Aycock has associated with Borges's Aleph. The strange emotional hiatus that followed these two events was formative to her new work, including the *Rose Garden* installation.

Around this time, Aycock had begun to build a collection of reproduced images about levitation and flight that were to prove crucially important to her art, since each in its own way transgresses norms and provides an opening that in my opinion is a physical manifestation of Borges's Aleph. In the initial group were four postcards referenced in her notes for the *Rose Garden* installation with the cryptic preface "Ways to get to heaven, ways to climb there, August, 1978," which connects death, resurrection, and heaven with the break or hiatus each of these images enacts. Aycock regarded these postcards as a ready-made visual currency and as a shorthand for past experiences largely because of the famous scene in Jean-Luc Godard's antiwar film *Les carabiniers* (1963) in which two naive peasants, Ulysse and Michel-Ange, bring back postcards with images of war experiences, including raping and pillaging. (Besides the use of postcards to commemorate such loathsome acts, Aycock was also interested in these two characters, who appear as tricksters in her text for *Project Entitled "The City of the Walls"* of 1978 [figs. 19.2, 19.3]; see appendix B.) In this important text and drawings, the in-between is the modus operandi of the work. It begins with a character named Sadie, who used to live in the City of the Dead outside Cairo and now lives in a city in the Middle Ages, a change that mixes up time and place into a conflated world that characterizes the rest of the text and also the city of the walls referenced in Aycock's title.

While collecting her postcard series, Aycock began musing about the frustration that people must have experienced before the age of airplanes when they wished to represent or realize the desire to fly. The first postcard in this collection is a reproduction of Sano di Pietro's *Annunciation to the Shepherds* (fig. 19.9). Aycock was intrigued with this painting because of its representation of an angel who is levitating. The second image features the sideshow challenger Eunice Winkless and is dated July 4, 1905 (fig. 19.10). As Aycock described the image, Winkless "is diving from a scaffolding,

19.2 and **19.3**

Alice Aycock, *Project Entitled "The City of the Walls,"* plan and isometric section, 1978. Pencil on vellum, 42″ × 72½″. Museum of Modern Art, New York. Photos: John Ferrari.

19.4 (following page)
Alice Aycock, *Project Entitled "A Shanty Town Which Has
a Lunatic Charm That Is Quite Engaging" or Rather
"A Shanty Town Inhabited by Two Lunatics Whose Charms
Are Quite Engaging,"* 1978. Pencil on vellum, 96″ × 42″.
University of Massachusetts Fine Arts Center, Amherst,
Massachusetts. Photo: John Ferrari.

**"Construct fifteen rows of 'shanties' similar to those
shown on the drawing. Some of the 'shanties' are
locked; some have false doors; some lead underground.
Above ground the rows are not linked in any way. The
streets simply end. The paths which appear have been
worn by people walking. Underground, the 'shanties'
are connected by rows of tunnels. Many rows lead to one
long tunnel which runs perpendicular to the rows.
Some of the 'shanties' dead-end underground." A. A.**

19.5 (page 205)
Alice Aycock, *Untitled Shanty (Medieval Wheel House),* 1978.
Wood, house 8′ × 4′ × 4′; wheel 8′ diameter. Whitney
Museum of American Art, New York. Photo: John Ferrari.

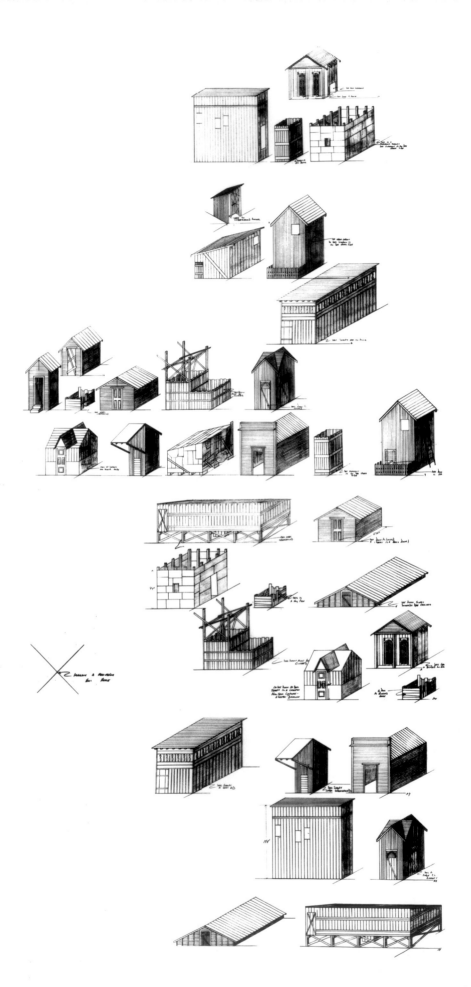

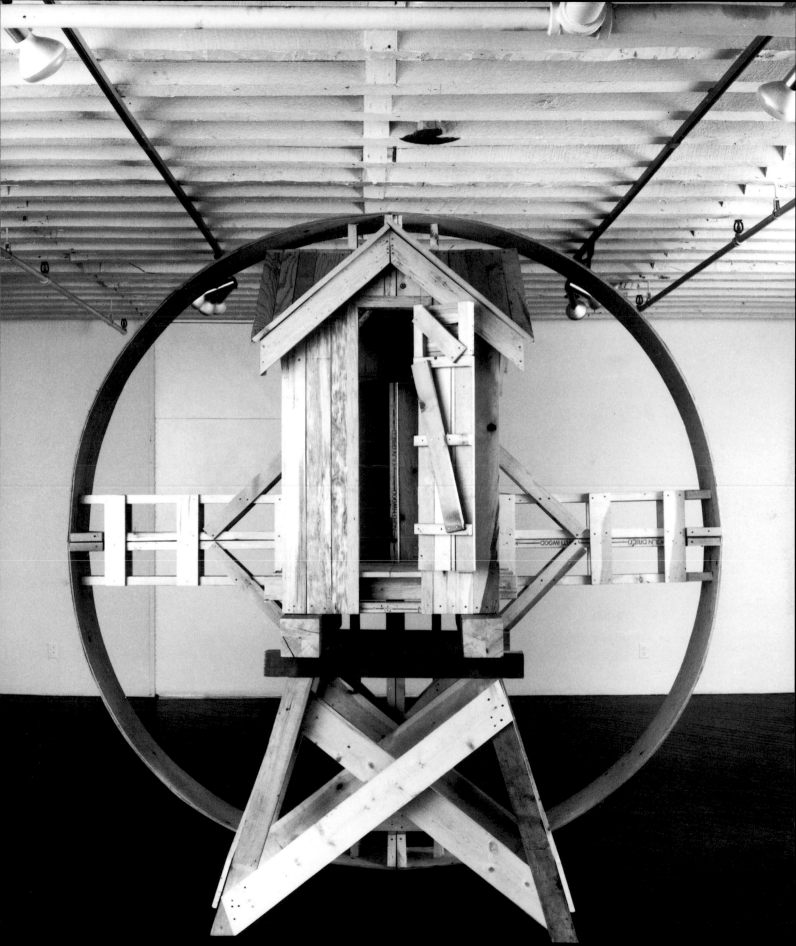

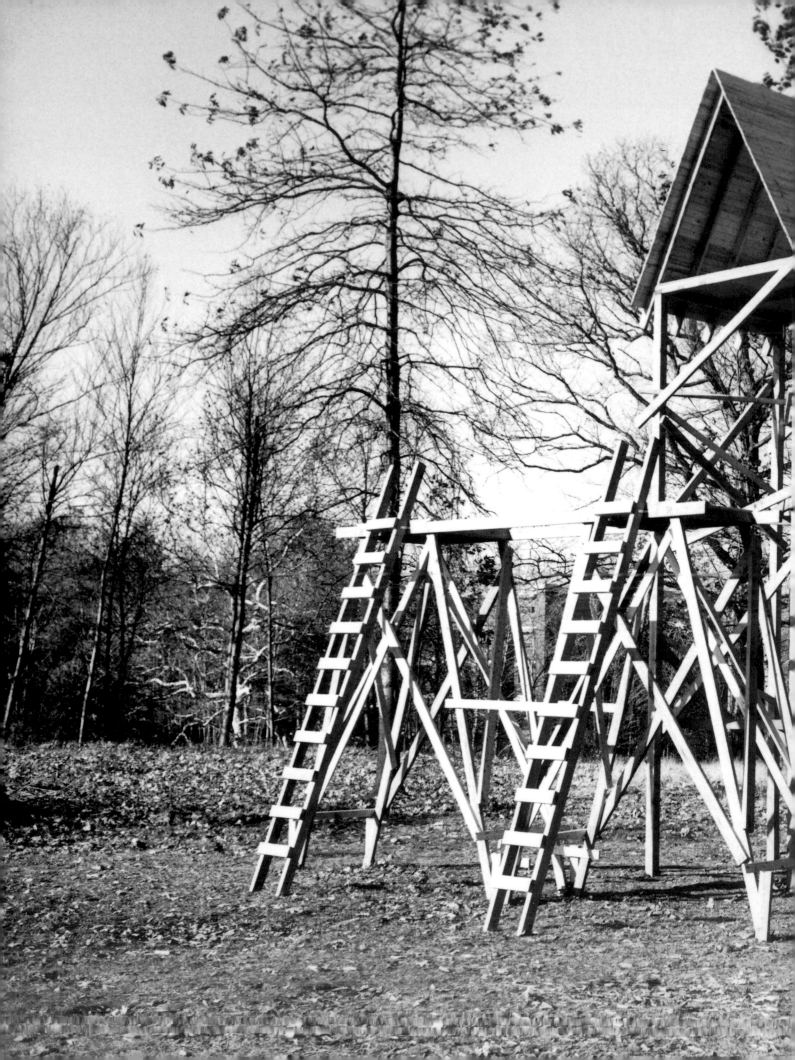

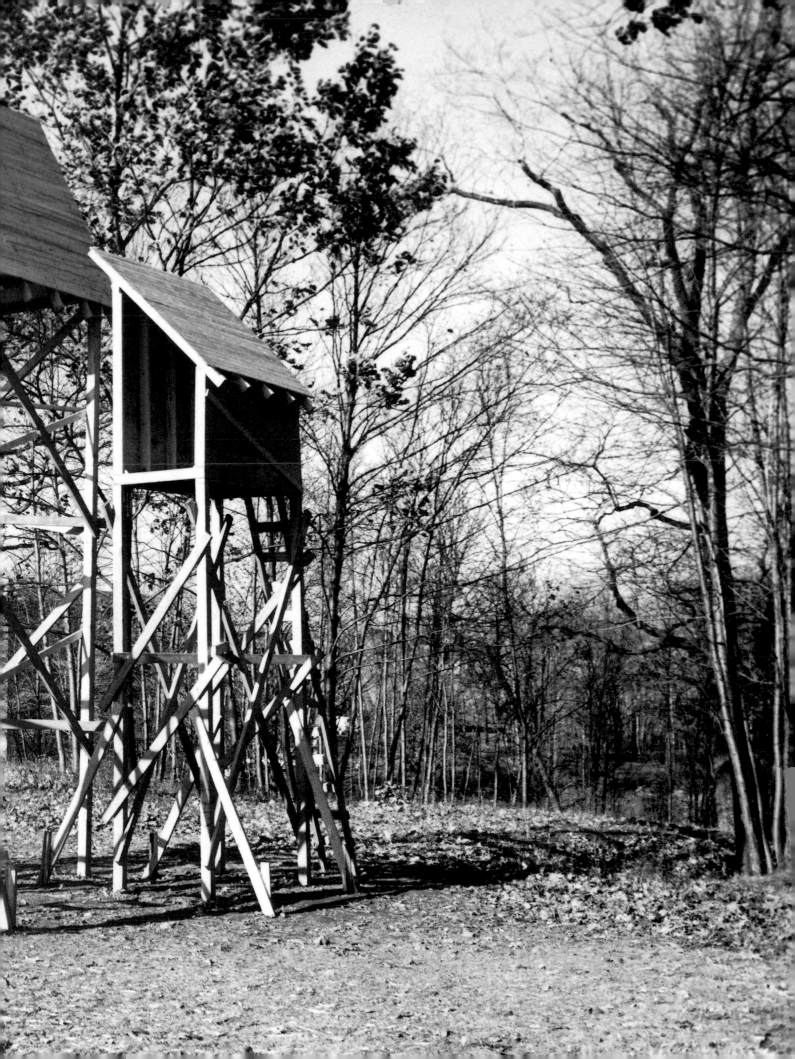

19.6 (previous pages)
Alice Aycock, *Wooden Shacks on Stilts with Platform,* 1976. Wood, dimensions variable. Exhibited at Hartford Art School, University of Hartford, West Hartford, Connecticut. Collection of the artist. Photo: artist.

19.7
Alice Aycock, *History of a Beautiful May Rose Garden in the Month of January,* 1978. Wood, dimensions variable. "Projects for PCA 4," Philadelphia College of Art. Collection of the artist. Photo: artist.

19.8
Alice Aycock, *History of a Beautiful May Rose Garden in the Month of January,* 1978. Pencil on vellum, 24″ × 68″. Private collection. Photo: John Ferrari.

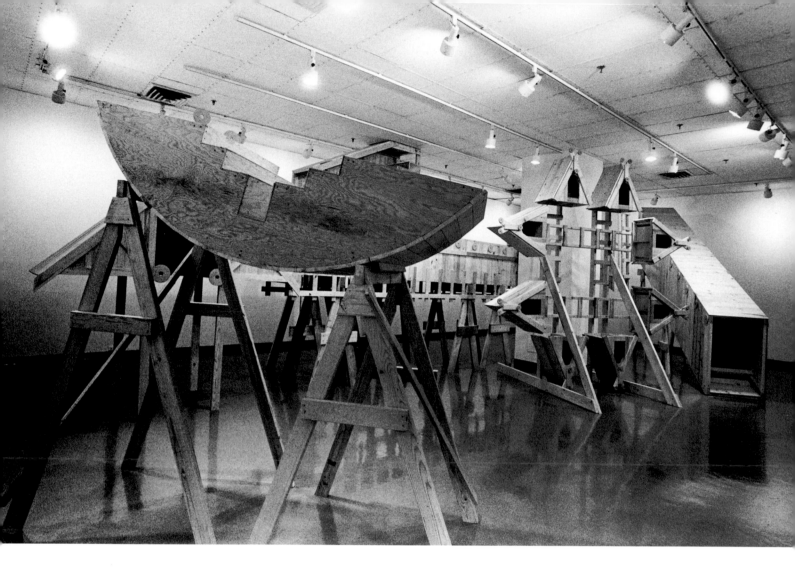

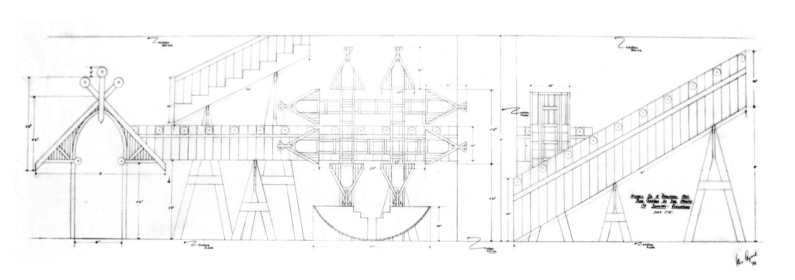

almost like a roller-coaster ramp. She's on her horse. She was a Victorian lady, and she's in full Victorian dress and she's diving into a pool of water. The post card shows her in mid-air."[5] This image is particularly prescient for Aycock because Winkless appears to be momentarily defying gravity when she makes a grand, public dive for a prize of one hundred dollars. This momentary state of levitation symbolizes the crossing of boundaries and the temporary yet ultimately futile achievement of transcendence. Winkless thus becomes the Victorian counterpart to the angel. Aycock's fascination with this postcard image may also derive in part from the approximately forty-foot-high wooden diving platform that resembles some of her sculptures.

The remaining two postcards in this series also represent states of human levitation. The third presents another figure in midair, this time a man jumping across the chasm at Standing Rock in the Wisconsin Dells in the summer of 1887 (fig. 19.11). The space between rocks in which this figure is momentarily suspended poignantly signifies the type of tear in the universe that Borges describes and the hazards such breaks entail. The fourth image documents Wilbur Wright testing a glider at Kitty Hawk, North Carolina, on October 10, 1902 before making his first historic flight the next year (fig. 19.12). Aycock explains her preference for this image: "It seemed to me that there was a strong relationship between the position of Wilbur's body on that glider and the position of the angel's body in the air."[6] In other words, Wright finds a way to realize physically the sublimated aspirations that the angel's image embodies.

In the spring and summer of 1978, while working in Italy for the Venice Biennale and an exhibition in Milan, Aycock began looking in earnest at medieval and early Renaissance paintings and manuscripts. As she studied these images, she pondered the relationship between the long sleep of the Middle Ages—its retreat from the physical experimentation of the Romans and

movement into the linguistic proofs of Scholasticism—and the empiricism and rationalism that followed it. She started wondering whether the apparitional effects of flying angels and celestial scenes in medieval art might indicate a great longing for the type of inventions developed during the Industrial Revolution. This insight enables Aycock to collapse traditional definitions of time into a new four-dimensional framework, in which she imputes to medieval artists a tremendous nostalgia for the future and then retrofits their fantasies to accord with later developments. If the distant past is contemplating the future, she reasoned, it will see it imperfectly through its own blinders, turning rationality into fantasies and engineered designs into beautifully crafted, jewel-like apparatuses that look more like science-fictional reliquaries than streamlined machines. Aycock's complex use of these ideas in her art anticipates the elaborate scenarios of the *Terminator* films and *12 Monkeys*. It is also connected with Kurt Vonnegut's hero Billy Pilgrim in *Slaughterhouse-Five* who "has come unstuck in time."[7] All these works play with a postmodern effort to understand the chimerical nature of reality that occurs when nature has lost its priority so that signs, which displace and exclude it, reduce it to their own reflection. In this new simulacral realm that develops from Guy Debord and anticipates Baudrillard, Aycock's sensation of vertigo or flying is an entirely appropriate response, akin to coming in contact with Borges's opening in the universe or Heidegger's rift, when reality no longer provides a firm anchor. Instead, culture becomes a key means of understanding this unhinging of one's world, and reality is reduced to one of culture's effects rather than one of its causes.

In order to realize this strange state of affairs, Aycock characterizes the present as a reified fantasy of the most bizarre medieval and early Renaissance visionaries. "It seems," she conjectured about the medieval paintings and

19.9 (previous page)
Sano di Pietro (1406–1481), *Annunciation to the Shepherds*.
Pinacoteca Nazionale, Siena. Photo: Scala/Art Resource, NY.

19.10 (previous page)
Eunice Winkless's dive into a pool of water, Pueblo, Colorado,
July 4, 1905, for a prize of $100. Postcard. Photo: Fotofolio.

19.11
Leaping the chasm at Standing Rock in the Wisconsin Dells,
1887. Postcard. Photograph by Henry Hamilton Bennett.

19.12
Wilbur Wright's glider test flight, Kitty Hawk, North Carolina,
October 10, 1902. Postcard. Photographer unidentified.

manuscript illuminations that were the basis for her free associations, "that they noted all the signs for electricity, magnetism, nuclear energy by hand.... It was as though they couldn't do it in reality at that moment, so they dreamed it. It seems they were obsessed by flying. You have the fluttering angels' wings, these emanations that come from the halos, the orbs, which are like electrical wheels, sparkling."[8] In light of her interest in Kuhn's *The Structure of Scientific Revolutions*, I should point out that this reference to electricity— one of many in her writings—is noteworthy because Kuhn used the prehistory of the paradigm of electricity throughout his book to explain the dynamics of scientific investigation and the competing claims and often strange ideas that have been put forth in the name of science. At this same time, Kubler privileged electrodynamics in his theoretical investigation of art history when he suggested that it might have served material culture as a better structural metaphor than botany.[9] When Aycock was reflecting on these ideas in the 1970s, one of her favorite traditional works of art was Giovanni di Paolo's *The Creation and the Expulsion of Adam and Eve from Paradise* (fig. 19.13), in which a schematic of the earth is surrounded by circles of light culminating in a penultimate ring punctuated by zodiac signs. This fifteenth-century configuration seemed to her to be predictive of discoveries in the field of electrodynamics that would be made many centuries later.

Looking at such manuscripts and later at paintings, Aycock mused that there are certain enduring human desires and ideas dating from the beginning of time that assume different forms depending on the dominant ideologies of the period in which they are manifested. For example, she views medieval alchemists' desire to turn mercury into gold as an earlier manifestation of the quest to unlock the atom and then realign its constituent particles to make new elements. The alchemical myth of the philosopher's stone is related to the Greek myth of Pandora whose insatiable

19.13

Giovanni di Paolo (active by 1417, d. 1482), *The Creation and the Expulsion of Adam and Eve from Paradise*.
Tempera and gold on wood, 18¼″ × 20½″. The Metropolitan Museum of Art, New York, Robert Lehman Collection, 1975 (1975.1.31).

curiosity symbolizes an enduring human need to know, even if that knowledge is always channeled through each age's ideological blinders.[10] In Adam and Eve's desire for knowledge in spite of the consequences, Aycock has sometimes seen an overriding need to know that is equivalent to the drive to create an atomic bomb and, more recently, to clone humans. People who approach this knowledge, which really is like a portion of Pandora's box, know there are real consequences to their discoveries, but they have to know regardless of the cost. In this way their pursuit of knowledge precludes an Edenic existence.[11]

Not content to look only at European cosmological concepts, Aycock has also studied views of the conformation of the universe developed by Babylonian, Roman, and pre-Columbian cultures. But during this period she focused mainly on the Middle Ages, both because of her graduate work with Hoffmann, including his exhibition *The Year 1200* at the Met, and because it had not been used by her contemporaries, who had already mined aspects of the Neolithic period and Iron Age for their art.

A work that developed out of her fascination with flight and the medieval passion for it was *The Angels Continue Turning the Wheels of the Universe despite Their Ugly Souls: Part II, in Which the Angel in the Red Dress Returns to the Center on a Yellow Cloud above a Group of Swineherds (It Was a Pseudo-World of Love-Philters and Death-Philters)* (fig. 19.14). It was created in 1978 for the Stedelijk Museum in Amsterdam. Pursuant to her new goal of separating her sculpture from the viewer's actual space and playing off divergent views, Aycock delimited this piece with a square frame indented at each corner on the floor and a series of trenches that came from an Islamic diagram demonstrating how a rainbow could be created, thus pitting aspects of Christian iconography against New Eastern concepts to dramatize not only the eclecticism of our world but also the breaks in it. "I asked myself," Aycock recalled, "to try to design a

series of structures that one could inhabit if one were in a weightless state, if one could walk upside down and didn't have to conform to the laws of gravity."[12] Describing the upended staircase in this piece (discussed earlier in relation to Borges's tale of the Immortals), Aycock notes that it "was a metaphor for what I was trying to get at."[13] As she later reflected, "One is moving through the world in a normal way and suddenly something intervenes and one has to jump over space as if it were a new space/time continuum and walk upside down in order to continue."[14] No doubt she was thinking of the absurdity of the irrational gods known as "the Immortals" whom Borges described. The initial part of the lengthy title of this work refers to a French manuscript illumination that depicts two angels turning the wheel that guides the universe. Discussing this image, the artist has speculated, "there's a correlation between the wheels of the universe and the wheels that resulted in the Machine Age, the Industrial Revolution. . . . Right now, I'm involved in false speculations, concocting various world views."[15]

Aycock's purposefully misguided fantasies, resembling discredited histories that pseudosciences such as alchemy had examined centuries before the development of the scientific method, were a mainstay of Michel Foucault's *The Birth of the Clinic: An Archaeology of Medical Perception* and *Discipline and Punish: The Birth of the Prison,* books crucially important to her thought and work at this time, as were a number of his other studies, including *The Order of Things: An Archaeology of the Human Sciences.* Also formative to this mindset were Kubler's structuralist admonishments about "formal sequences" that extended far beyond a given stylistic period and presented a given feature or motif from dramatically different positions, leading to a new type of "serial appreciation."[16] Kubler's description of the historian's rightful purview as "the discovery of the manifold shapes of time"[17] might also be ascribed to Aycock's

art historical leanings, which go back to her undergraduate and graduate studies.

Not only did Foucault and Kubler prepare Aycock for her so-called "false speculations" on the imaginative flights of medieval mystics and artists, but Hoffmann's exhibition at the Met had also enabled her to grasp the importance of inventions during the Middle Ages and the consequent mindset that led to the Industrial Revolution. Although I have connected Aycock's ruminations with a postmodernist view of the world, her speculations constructing new and imaginative historical narratives have a basis in historical fact. One of the scholars Hoffmann cited in class was A. C. Crombie, who demonstrated how hundreds of superstitions, eccentric beliefs, and alchemical approaches in the Middle Ages anticipated rationalist science.[18] The following passage by Roger Bacon (1214–1294) illustrates this mindset:

We can construct for navigation machines without oarsmen, so that the largest ships on rivers and seas will be moved by a single man. . . . We can construct vehicles, which, although without horses, will move with incredible speed. We can also construct flying machines of such a kind that a man sitting in the middle of the machine turns a motor to activate artificial wings that beat the air like a bird in flight. Also a machine of small dimensions to raise and lower enormous weights, of unequalled usefulness in emergency. . . . We can also make machines to move through the sea and the watercourses, even to the bottom, without danger. . . . These machines were constructed in ancient times and they have certainly been achieved in our time, except, perhaps the flying machine, which I have not seen and I do not know any person who has seen it, but I know an expert who has perfected the means of making one. And it is possible to build such things almost without limit, for example bridges across rivers without cords or supports and unheard of mechanisms and engines.[19]

Crombie's contemporary Lynn White Jr., whose work Aycock had read, also researched the prehistory of science during this fecund period from 1000 to 1400 A.D. and found it a definitive time for harnessing nature's forces for human use. He commented that people during this period "were power-conscious to the point of fantasy." And he added the codicil, "But without such fantasy, such soaring imagination, the power technology of the Western world would not have been developed."[20] A popular source for this type of thinking that Aycock also used is James Burke's *Connections*, which accompanied a BBC series of the same title aired in the late 1970s.[21]

Aycock's familiarity with the research of Crombie and White is a source for her free associations in the following observation:

The Middle Ages and religious artists made literal what was invisible. These illuminations have to be languages for interpreting the world. Whereas we see radiation, they would see God. I think we can reconsider manuscript illuminations in terms of subatomic theory.

The Holy Spirit became rays of light; later scientists found ways of harnessing the invisible force of electricity into light. In the same way Bernini's rays of divine light later became radiation. I often look at works in the past as predicting energy states common to us in the nineteenth and twentieth centuries. The manuscripts present ecstatic, crazy, mad, pathological, and dumb images that the Industrial Revolution harnessed. Because of my academic training, I go back to the Middle Ages.[22]

Aycock was also intrigued with the twelfth-century visions of Hildegard von Bingen, who corresponded with such important ecclesiastics as St. Bernard of Clairvaux. Like a number of medieval thinkers whose Neoplatonic outlook was channeled through Aristotle's theory of the predictability of the connections between the

19.14

Alice Aycock, *The Angels Continue Turning the Wheels of the Universe despite Their Ugly Souls: Part II, in Which the Angel in the Red Dress Returns to the Center on a Yellow Cloud above a Group of Swineherds (It Was a Pseudo-World of Love-Philters and Death-Philters)*, 1978. Wood, 16′ high × 23′ wide × 23′ deep. Exhibited at the Stedelijk Museum, Amsterdam, The Netherlands. Collection of the artist. Photo: courtesy of the Stedelijk.

"FIRST: The emperor maintains his connection with the dome of heaven by devising a lunar calendar. The emperor speaks: 'When a moon creature is unwise enough to allow itself to be caught in the open air near midday its outer fur is singed by the intense heat.'
SECOND: The comet of 240 B.C. reappears on the sail of a small boat. Peter speaks: 'What is this unknown pushing force?'
THIRD: The windbag man uses his wings to fan the fire with which to kill his enemies, the French doves. The windbag man speaks: 'Anyone who for so long has owned a horse or a dog or a cat has felt its uncanny sense of trouble in the air.'
FOURTH: The emperor, trying unsuccessfully to hide a noisy fart, speaks again: 'Is it a circle or an ellipse?'" A.A.

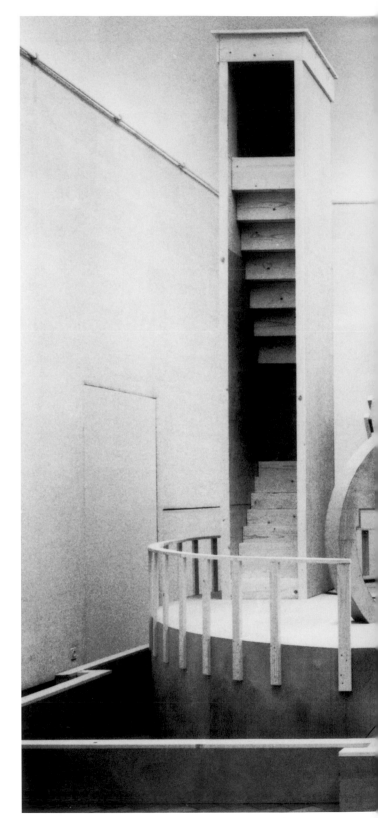

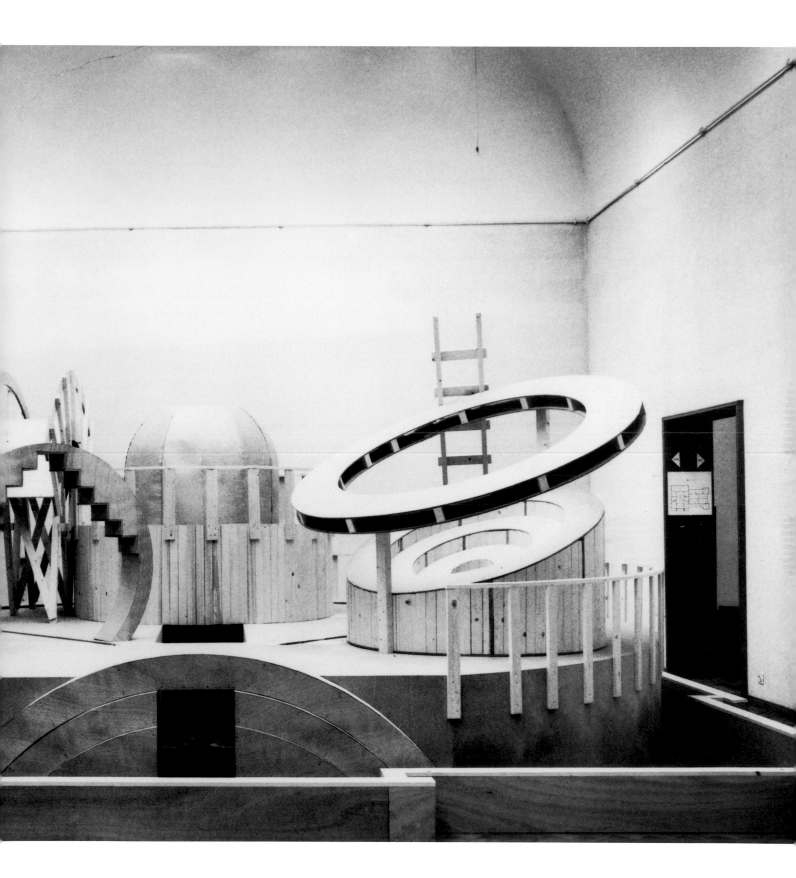

cosmic macrocosm and the unreliable microcosm in which they lived, Hildegard joined scientific, theological, and philosophical ideas in elaborate visions based on a belief in life's basic interconnectedness. An example is her testimony "I saw that the upper fiery firmament was stirred, so that as it were ashes were cast from there to earth, and they produced rashes and ulcers in men and animals and fruits."[23] For Aycock this undifferentiated realm that joined spiritual and scientific yearnings on the order of Bacon's visions offered undeniable proof that people in the Middle Ages were thinking about the future in organic terms foreign to our categorical way of organizing concepts. At the same time, she appreciated their extraordinary visions as poetic excursions on the order of N. N.'s imaginary travels, which sometimes join science and imagination, as in his reminiscence:

When after birth I became conscious, I found myself in a locality, in which I gave light and warmth to myself and to others. The bigger the Universe, the more predominant the sun-giving becomes. I started sunshine. At my birth I produced it, along with atoms, light and warmth. At the beginning the Universe was a canoe, in which I alone had a place. This was the first building. The caul was the canoe and this was also the first Universe.[24]

Taking Hildegard's integrated cosmology as a cue, Aycock set to work mentally reconstructing medieval manuscript illuminations with an eye to their modern ramifications: free-associating in this vein, she found that the twisted branches of the tree of life might have anticipated the double helix of DNA.

The Angels Continue Turning was also influenced by the postcard of Sano di Pietro's *Annunciation to the Shepherds* with its hovering angel. No doubt for Aycock this resonated with many of N. N.'s descriptions of out-of-body experiences. This similarity with schizophrenic

hallucinations furnished her with a contemporary, medical rationale for earlier ecstatic visions that have traditionally been ascribed to religious insight. For example, N. N. reminisces:

Once a priest took me up into the air. I just flew through the sky and disappeared from home, and was away for eight or nine years. Up in the sky I found an angel, a woman called Angel Love. She had yellow hair, a body of gold, and wings made of feathers that covered her completely. She wanted me to go to her house and marry her, but I was detained by other women. . . . These other women were similar to the first one. . . . It was an island floating in the air, and I came up there, like the time when I crashed through the stained glass.[25]

Strict iconographic studies are often useful only in the initial stages of comprehending Aycock's work, since she used these references to the past as catalysts for viewers. Besides enabling us to make the images accessible to new interpretations and other worldviews, these studies also point to the work's function as an Aleph. In *The Angels Continue Turning*, residual ties to an Islamic diagram appear in the rainbow-shaped configuration in the foreground, while associations with a French manuscript illumination are implied by the wheels, which take the form of various circular configurations in the work. Despite these references, the overall piece looks more like the marriage of a Russian constructivist stage set with a Rube Goldberg drawing[26] than a realization of Eastern and medieval concepts. Even though these iconographic sources inspired Aycock, she did not feel compelled to list all of them in the text accompanying this work (see extended caption for fig. 19.14), which she intended to be approached as a writerly text.

At this point in her career, Aycock was in great demand by museum curators, who wanted her to create temporary works for exhibitions. Her projects, which would be presented at exhibitions

for a period of a month to six weeks before being dismantled, were an enormous boost to her artistic development because they provided her with tremendous freedom for experimentation with a minimum of accountability. Lumber was cheap at the time; carpentry skills were readily available; museums liked the idea of commissioning works for temporary exhibitions; and the resulting photographs were the only remaining tangible legacy of the process. If an idea didn't work, an artist need not be haunted by it. As she admitted to museum curator Howard N. Fox, "At first it was a good thing, and I almost enjoyed having my history wiped away."[27]

The Cranbrook Academy of Art commissioned her to design and build a series of temporary projects in Bloomfield Hills, Michigan. With a budget of a few thousand dollars and three weeks of construction time, Aycock created a series of works that she listed in an ad hoc manner under the general title *Project Entitled "On the Eve of the Industrial Revolution, a City Engaged in the Production of False Miracles."* They include *A Structure Called "An Explanation for the Rainbow"* (fig. 19.15), *The Rabbit Story House, The Treadmill* (fig. 19.16), and *A Structure Called "The Ups and the Downs" or "Hanging and Oscillating,"* among others. Perhaps because of the brief time in which this piece was conceived and built, Aycock wished to make her points as clearly and concisely as possible. Instead of providing a writerly text that heightened the ambiguities of the project, she established a set of brief guidelines that functioned like footnotes. In them she cited as her major source David Braithwaite's important *Fairground Architecture*, which includes a history of the St. Bartholomew's Fair held on a crossroads to London. Aycock included a history of this famous medieval festival in her text:

St. Bartholomew's Fair was the site of miracles. The Fair's charter was issued in 1133. The production of miracles drew large crowds. The site of the Fair was associated with the city playground, the city gallows, the Friday market, the burial ground of the "plague smitten." The Fair was also the site of tournaments and jousts. The derivation of the word "carousel" comes from the Italian garosello meaning "little war." Fairs also originated in funeral games, which were held near ancient tumuli, i.e., dancing in the cemeteries.[28]

Originally established in 1120 by a grant from Henry I to his former court jester, who had become a monk, the St. Bartholomew's Fair at first was held in a priory churchyard. Feats of skill were performed there for money: they included such acts as a woman balancing herself by the palms of her hands on two sword points, whom Aycock cryptically called "a lady on swords." In addition, religious miracles were regularly performed. Twenty to fifty years after the establishment of this fair, it became known primarily for its diversions and consequently was moved to the marketplace. Two centuries after it began, men and women were put up for sale, and three centuries later crowds were regaled with tournaments and acts of public torture, sometimes euphemistically called "martyrdoms." Elaborate pieces of wooden machinery such as the windmill, the rack, and the roundabout (fig. 19.17) were developed as spectacles for this type of fair. They performed a number of tasks, such as harnessing power, torturing victims, and entertaining people with vertiginous rides that would briefly throw them off balance by providing them with a different view of the world.

Aycock's pieces for Cranbrook, as well as her later *The Game of Flyers* (1980; figs. 19.18, 19.19, 19.20), remind us that, together with the development of steam and later electricity, early wooden machines gave rise to a number of joyrides, including roundabouts, gondolas, and switchbacks, which were among the most typical vernacular architectural sculptures of the Industrial Revolution. Aycock kept these pieces austere and permitted

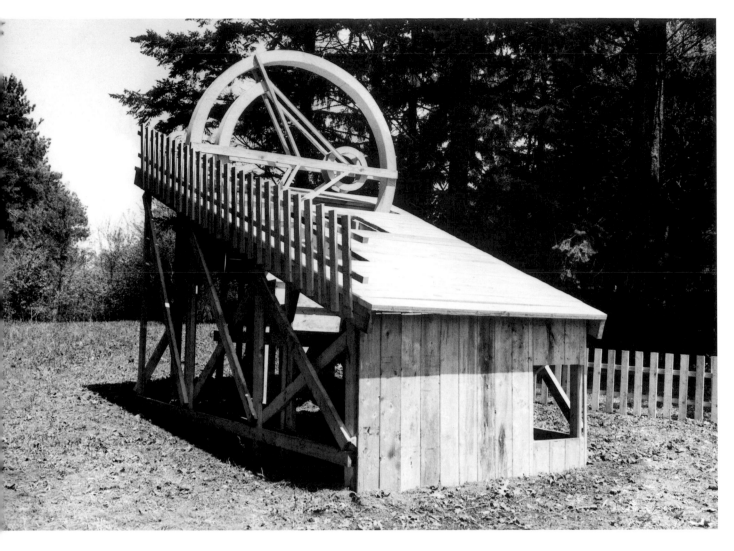

19.15

Alice Aycock, *A Structure Called "An Explanation for the Rainbow,"* from *Project Entitled "On the Eve of the Industrial Revolution, a City Engaged in the Production of False Miracles,"* Wood, dimensions variable. Exhibited at the Cranbrook Academy of Art, Bloomfield Hills, Michigan. Collection of the artist. Photo: artist.

"Five structures were built in the wooded area across from the Jonah Pool at the end of Academy Way. These structures were located in terms of the existing system of 'labyrinthean' paths which have been worn by people walking through the woods. The structures were designed as a complex.

Notes

—**What is the generating story behind these structures?**
—**See David Braithwaite, *Fairground Architecture*. Research St. Bartholomew's Fair.**
—**Build things on an isometric skew like the medieval bird's-eye view. Construct a viewing and performing platform, a closed-off stagelike structure.**
—**St. Bartholomew's Fair was the site of miracles. The Fair's charter was issued in 1133. The production of miracles drew large crowds. The site of the Fair was associated with the city playground, the city gallows, the Friday market, the burial ground of the 'plague smitten.' The Fair was also the site of tournaments and jousts. The derivation of the word 'carousel' comes from the Italian *garosello* meaning 'little war.' Fairs also originated in funeral games which were held near ancient tumuli, *i.e.* dancing in the cemeteries.**

—Organize the complex as a competition between various structures; take advantage of crossroads and dead ends; make a small mound with rocks and flowers beside The Rabbit Story House; put fences around things.
—Imagine the site as a place where children burn mysterious things.
—A man on stilts, a lady on swords.
—In 1305 'traders, pleasure seekers, friars, jesters, clothiers, tumblers, walkers on stilts' hurried to the gallows under the trees for the execution of a national hero who was 'dragged bruised and bleeding and polluted with the city filth.' Afterward they all returned to the fair where the priest continued to rehearse for the day's miracle." A. A.

19.16
Alice Aycock, *The Treadmill,* from *Project Entitled "On the Eve of the Industrial Revolution, a City Engaged In the Production of False Miracles,"* 1978. Wood, dimensions variable. Exhibited at the Cranbrook Academy of Art, Bloomfield Hills, Michigan. Collection of the artist. Photo: artist.

19.17

"Three Several Sorts of Swingings: Roundabout, Wheel, and Swing," an illustration from *The Travels of Peter Mundy in Europe and Asia, 1608-67* (London: Hakluyt Society, 1936).

19.18

Alice Aycock, *The Game of Flyers*, 1980. Wood, steel, fire, water, birds, pulleys, and trenches; 40′ high × 25′ wide × 100′ long. Exhibited at Washington Public Arts (WPA), Washington, D.C. Collection of the artist. Photo: artist.

"*The Game of Flyers* is a large wooden construction 25′ by 100′ which is composed of wheels, ladders, platforms, trenches, a tower, a column, and a carousel, reminiscent of a fantasy medieval carnival crossed with a battleground. *The Game of Flyers'* fanciful machines, wheels, pulley, buckets, and handmade devices are intended to be instruments of flight that would propel one upward into the sky. The large metal troughs that are half sunk into the earth are derived from ancient Tantric drawings of a cross section of the earth; they are filled with water and fire. The combination of allegorical architecture elements and fantastic machinations suggests a vision of multiple activities including battle, play, and flight." A. A.

Hello Great
Hello Cackler
Hello Crown Prince
Hello Property Gate
Hello Girl Dummy
Hello Little Depth Koda
Hello Delicate Monster
Hello Ethiopia
Hello May
Hello Clare
Hello Archangel Michael
Hello Flatman
Hello Honey Ball
Pigeons
—the trenches are subversive evil ones
—lines of fire
—air attack
—behind the shifting balance between attacker and defender
—sick pens
—burning buried things
—squares of dense spikes
—surround w/ trenches
Dear Mr. Flatman,
This is the story of the speed in me, and of Property Gate, and of the Giant Flywheel, & of the Crown Prince, & of the Great Cackler, & of the small teethies, the Twin Big Wheels, the Silent Death, the Big Pot. In this story I "evanesced" them (that's the way I put them offstage). Like the Crown Prince "kings should disdain to die & only disappear. They should abscond, that is, into the other world."

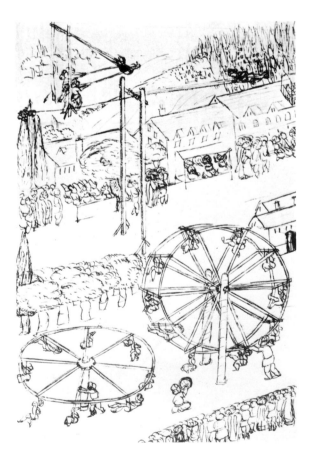

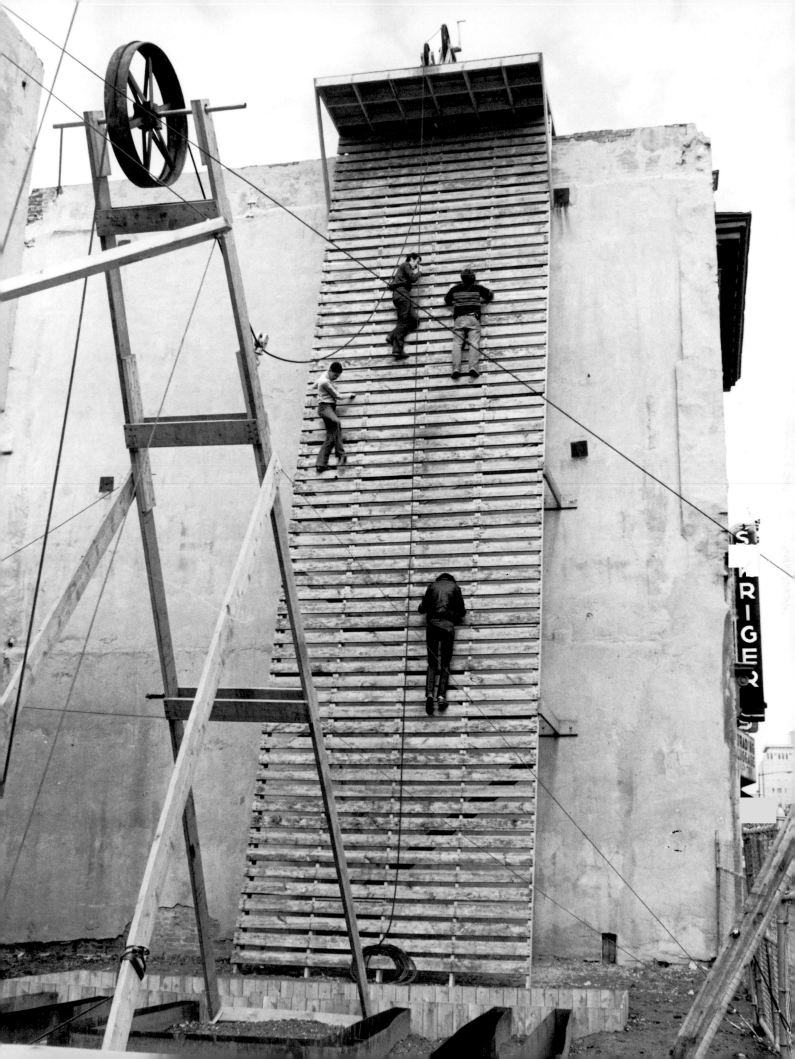

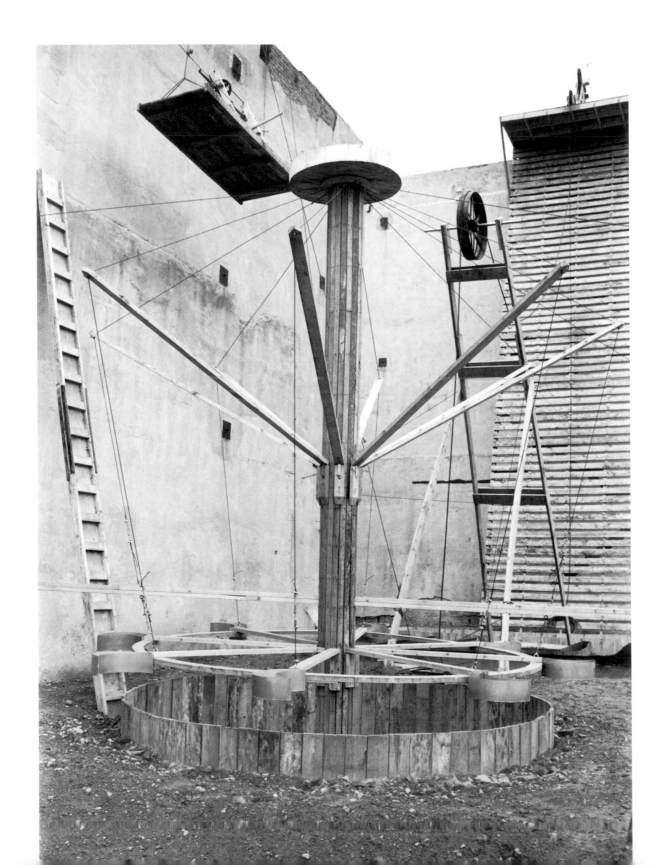

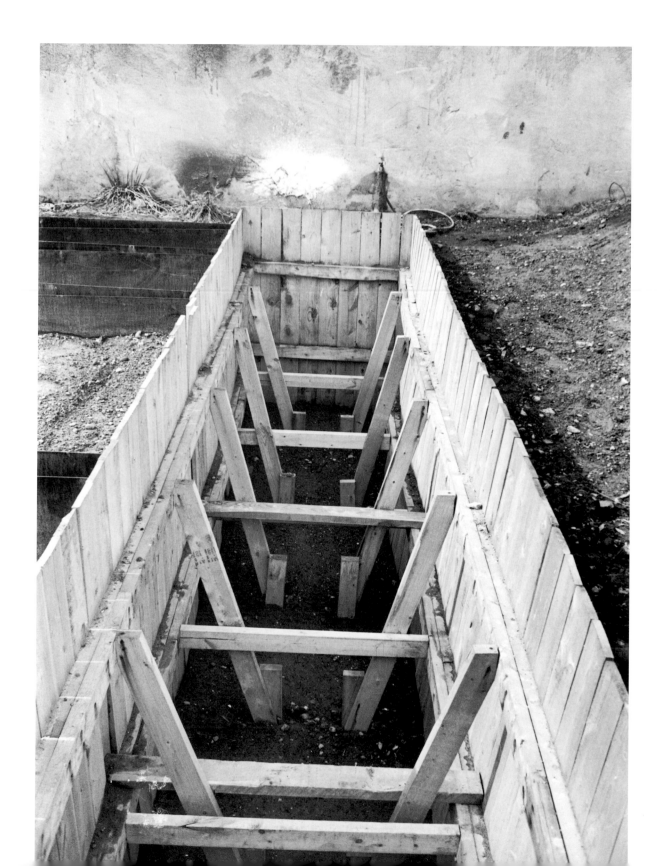

her carpentered machines only the most minimal decoration, formed of rhythmic uprights and patterns developed from diagonal bracing. She carefully avoided allusions to later roundabouts with the favored Louis xv–style garnitures, which were customarily used as a thin veneer of culture to cover structures similar to the ones Aycock built. Several pieces at Cranbrook make direct references to such amusement park elements as wheels and the underlying structures of rides, so that aspects of this traditional recreational architecture become the basis for Aycock's own fantasies. More allusive are the associations conjured by *The Treadmill,* which the artist connects with machines, torture devices, sewing machines, and a wheel rocket ship:[29]

I think of the piece as a series of three-dimensional sketches or mock-ups. I was especially interested in the site—a wooded area with meandering paths along which I could place these various structures, which were interconnected visually, contentwise and by the pathway system. This made for a journey by the viewer discovering mysterious structures in the woods.[30]

20

From Architectural Sculpture to *The Machine That Makes the World*

Subjectivity is a plenary image ... whose deceptive plenitude is merely the wake of all the codes which constitute me, so that my subjectivity has ultimately the generality of stereotypes.

Roland Barthes
s/z, 1970

1979 was an ebullient and trying year for Aycock, during which she created some of her most important works to date. The year represented the type of general stocktaking that occurs after an overview exhibition, and in 1978 Aycock's work had been subjected to an early-career review, coupled with a catalogue that presented a retrospective view of her work, when Monroe Denton put together the show *After Years of Rumination on the Events That Led Up to This Misfortune ... Alice Aycock: Projects and Proposals 1971-1978* for Muhlenberg College in Allentown, Pennsylvania. In addition to being encouraged to look critically at her first seven to eight years of work, Aycock entered in February 1979 into an intense relationship with artist Dennis Oppenheim that led several years later to a brief marriage. During this time Oppenheim, Aycock, and Vito Acconci were highly energized by their mutual interests and even greater differences, and their discussions reinforced their separate directions even though they shared for a brief time a common visual repertoire. Language remained

Acconci's starting point, and a number of his works were elaborate visual manifestations of wry jokes. An heir to the romantic tradition, Oppenheim was still convinced of artists' ability to inseminate materials directly with ideas so that artists could be seamlessly united with their art, which would serve as their surrogates. Differing from the two men, Aycock wanted her works to be separated from herself so that they could exhibit the complexities of writerly prose and thus force readers to formulate their own interpretations and not rely on the privatization of art that the romantic ego represented. Although Aycock had regularly hired carpenters, masons, and crane operators to help her with her art, the major lasting impact that Oppenheim had on her work was to encourage her to enter the arena of high technology and to turn over to specialists the fabrication of needed components for her sculpture. Oppenheim's example first affected Aycock in the fall of 1979 when she began to tire of wood and looked for other materials and means. As a result she created the transitional works *The Central Machine, The Machine That Makes the World,* and *How to Catch and Manufacture Ghosts* that inaugurate her series of machine works.

1979 was also an ominous time for Aycock because on March 28 of that year a partial meltdown occurred at the Three Mile Island Unit 2 Nuclear Generating Station on the Susquehanna River about ten miles from Harrisburg, Pennsylvania—approximately fifteen miles from her childhood home. Played out in the international news media, headlines focused on government engineers' fear that the reactor's nuclear fuel might melt its thick steel-and-cement encasement or that a hydrogen gas bubble in the core would explode. During this disaster Pennsylvania Governor Richard Thornburgh ordered the evacuation of preschool children and pregnant women from within a five-mile radius of the plant, and recommended that people within ten miles of Reactor 2 stay inside and keep their windows closed.

The episode terrified people throughout the country as it jeopardized the Northeast and Mid-Atlantic region, including New York City and Washington, D.C. Occurring only two weeks after the release of the film *The China Syndrome,* which described a similar meltdown, the Three Mile Island nuclear disaster became a watershed that substantially changed the general public's attitude toward nuclear energy.

Because the Three Mile Island disaster occurred so close to her childhood home, Aycock was jolted by the experience.[1] In its aftermath she began investigating the problem of how the same object could be regarded at different times as benevolent and horrendous. She was especially interested in the atomic bomb, which some scientific theorists regard as a reenactment in miniature of the Big Bang that inaugurated time's beginning. As part of her investigation, Aycock reconsidered the way the film *Dr. Strangelove* addressed both the beauty and absurdity of the bomb.[2] Her researches after Three Mile Island soon took her into the realm of mythology with its emphasis on the dual nature of divine power and its often whimsical attitudes. She was captivated by such potentially related images as the cracking of the philosopher's stone, the opening of Pandora's box, and the way that the wind can be benign, beneficial, and also thoroughly destructive when it assumes the form and force of whirlwinds, tornadoes, and hurricanes.[3] The potential dangers of Three Mile Island stimulated Aycock to focus in yet a new way on the discredited prehistory of scientific beliefs and to find new means to manifest the mythos of the "ghost in the machine" to symbolize the mysteries of subatomic particles, quantum mechanics, and electricity.

Explanation, An. Of Spring and the Weight of Air (figs. 20.1, 20.2, 20.3), constructed in the spring of 1979 for the Contemporary Arts Center in Cincinnati, was Aycock's most direct response to Three Mile Island. In it she played off the domed space of the Arts Center with a structure that

appeared to be a giant balloon and could also be read more obliquely as the infamous type of mushroom cloud created by an atomic explosion. She also incorporated into the piece a reference to her longtime interest in earlier manifestations of modern scientific inventions and the Aleph, here as an allusion to Eunice Winkless.

Although Winkless, the daredevil leaping into the unknown, is the protagonist of Aycock's *Explanation, An. Of Spring and the Weight of Air*, the most direct inspiration for this piece comes from Bramante's Tempietto (fig. 20.4), which was the subject of her graduate paper for Leo Steinberg. The small structure (its interior only fifteen feet in diameter) was built on the spot where St. Peter was supposed to be buried. In her paper, Aycock hypothesized that "it must be understood not only as a descendant of the classical circular building, but as a Renaissance martyrium, having its roots in the Roman funerary mausoleum, the Etruscan tumulus tombs, and the Cretan/Mycenaean tholos tombs."[4]

Moving to an entirely different culture, Aycock based the platform that supported this Bramante inspiration in *Explanation, An* on Tantric diagrams. These schemas provided her imagined protagonist with a base from which to dive and a pool in which to plunge. Although the Tantras were then popular among members of the counterculture, this currency does not explain Aycock's repeated use of them as basic plans for a number of her sculptures during the late 1970s and early 1980s. In addition to their formal intricacy and great beauty, the drawings are hypnotic and meditative perhaps because they were intended to affect some neurological function in the brain without the use of drugs. Moreover, many of the particular types of Tantric images important to Aycock are cosmological and pseudoscientific.

Playing with the domed space in the Cincinnati nonprofit in which *Explanation, An* was to be housed, Aycock created a large balloonlike shape—an inflation of Bramante's dome—surmounted with a scaffolding resembling stairs, perhaps a play on water towers or, more simply, a way to climb into and around the dome-within-the-dome comprising this work. The structure may also have been inspired by an early amusement park ride, consisting of a globe attached to a roundabout, that was known as the waltzing balloon (fig. 20.5)—an allusion again to Winkless's performance at a fair. The ebulliency of this balloon, its association with sideshows, and the connection with Winkless's dive are all highly ironic allusions when one reflects that Aycock considered the piece a response to Three Mile Island.[5] If one analyzes the piece in a readerly more than a writerly mode, many of its components change accordingly: the balloon begins to assume the look of nuclear pollutants or a mushroom cloud, the amusement park references critique the sideshow that this accident had spawned, and Winkless's dive resembles a suicidal plunge. Of course, this interpretation is only one of many that can be offered. Its primary function here is to demonstrate how readerly and straightforward an iconographic interpretation can be and to suggest the rich potentials of meaning that can occur through the simple conjunction of elements from distinctly different realities. Aycock's text accompanying this work illustrates the many layers of meaning that it encompasses:

He who travels in the early morning shall look carefully to the east. He will see there something like letters marching in the sky, some rising, some descending. These brilliant characters are the letters with which God has formed heaven and earth . . .
The Zohar
REPEAT AFTER ME
 A *is for Hoop-La*
 B *is for Razzle-Dazzle*
 C *is for Over-the-Tops*
 D *is for Hanging and Oscillating*
 E *is for Wheel-'em-In*

20.1

Alice Aycock, *Explanation, An. Of Spring and the Weight of Air. An Account of the Substances Which Have Been Used to Describe the Events up to and Including Eunice Winkless's Dive into a Pool of Water (from the Angels Continue Turning the Wheels of the Universe Part III)*, 1979. Wood, 19′ high × 18′ wide × 36′ deep. Exhibited at Contemporary Arts Center, Cincinnati, Ohio. Collection of the artist. Photo: Ron Forth.

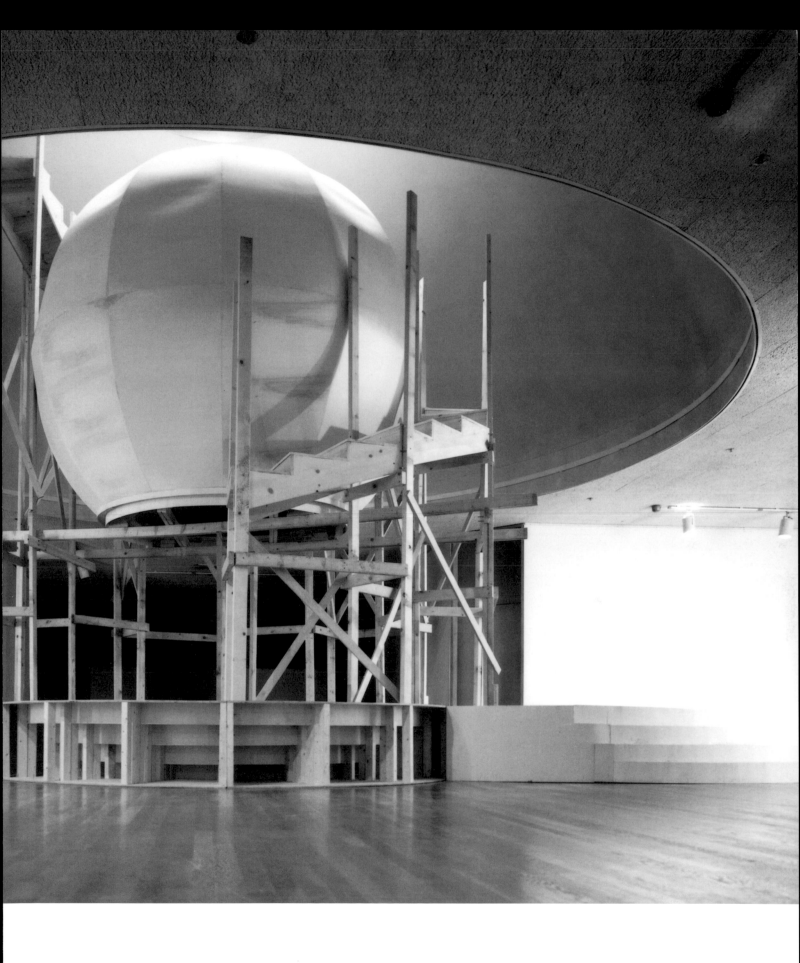

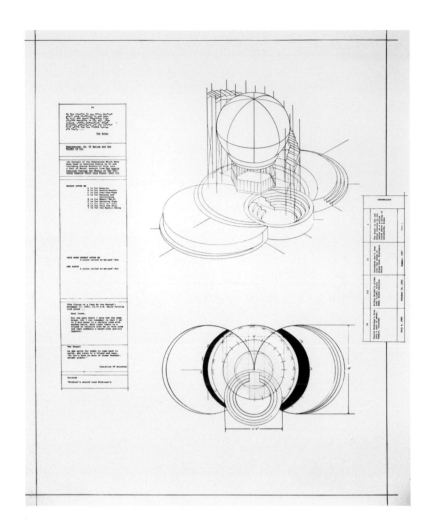

20.2

Alice Aycock, *Explanation, An. Of Spring and the Weight of Air*, 1979. Pencil on vellum, 47³/₄″ × 36¹/₄″. Private collection. Photo: Nathan Rabin.

20.3

Explanation, An. Of Spring and the Weight of Air, detail. Photo: Ron Forth.

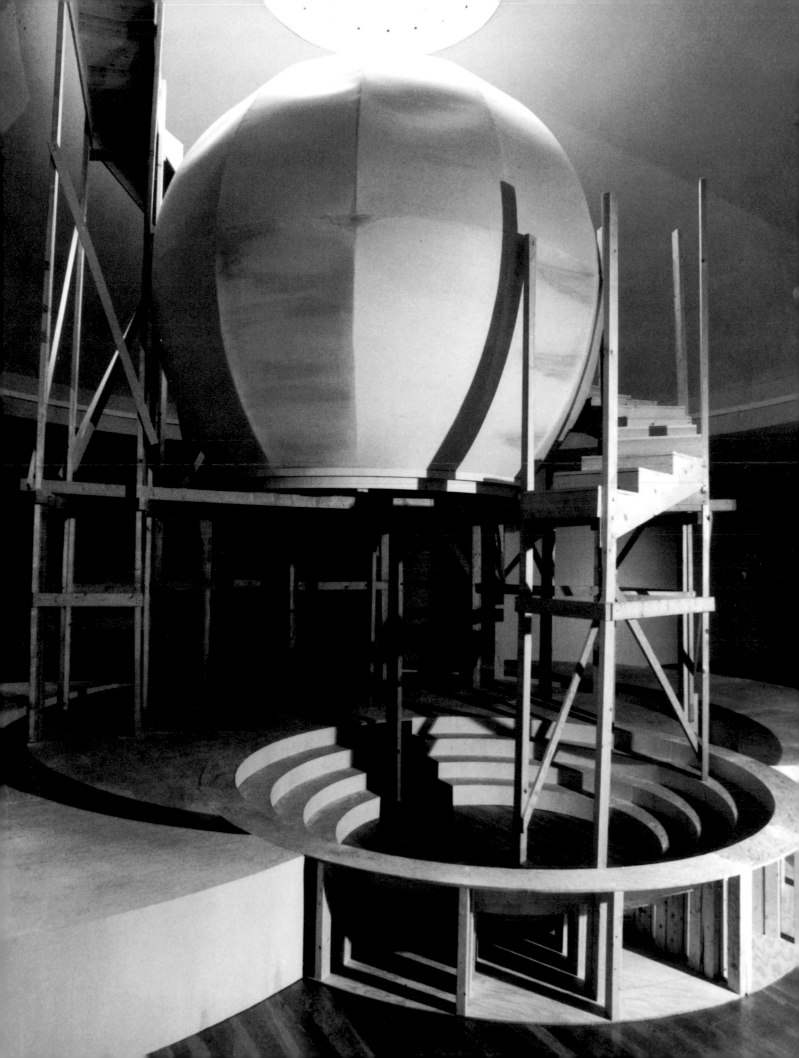

20.4
Donato Bramante, plan for San Pietro in Montorio
(Tempietto), Rome, c. 1504. $26\frac{1}{4}'' \times 42\frac{1}{2}''$. Photo: Geremy
Butler, courtesy The Trustees of Sir John Soane's Museum.

20.5
C. W. Parker, *Patent Plan for Balloon Roundabout*, 1888.
Courtesy Her Majesty's Stationery Office and Greenwood
Publishing Group.

F *is for Spinning Tops*
G *is for Rock an' Roll*
H *is for Slip the Slip*
I *is for the Mystic Swing*

ONCE MORE REPEAT AFTER ME
A place called Ar-ma-ged'-don

AND AGAIN
A place called Ar-ma-ged'-don

During the summer of 1979 Aycock was invited to create an indoor piece at the San Francisco Art Institute, where she had accepted a brief teaching assignment. Perhaps because of the serendipitous nature of the project, Aycock moved in a different direction and created a more open-ended project that can only tangentially be related to her current interest in the positive/negative aspects of nuclear power. The resultant work, *Flights of Fancy, States of Desire, Part 1* (figs. 20.6, 20.7, 20.8, 20.9, 20.10), which was made in only two weeks, pushes to an extreme the direction of aberrant architectural spaces and disparate and separated elements established in *The True and the False Project*. However, its subject matter relates more to *The Angels Continue Turning the Wheels of the Universe* in the desire to transcend boundaries and achieve a state consonant with flight, even though those limits may be the traditional barriers separating sanity from insanity. The fictional protagonist for this piece is a female religious fanatic who assumes the prerogatives of a ghostly spirit and hops about erratically on church altars, much like an electron following its unpredictable path. An old photograph of an Apulian hysteric bitten by a tarantula and hopping onto the cornice of an altar was the source for this work (fig. 20.11).

In *The Central Machine,* a September 1979 installation for the Protetch-McIntosh Gallery in Washington, D.C., Aycock's texts present a young woman obsessed with the goal of catching supernatural blue rain—possibly a reference to nuclear fallout:

CASE 131: *X., daughter of a general. She was raised in the country. At the age of 34 she began to spend hours staring at the sky. Eventually she became convinced that it was going to rain supernatural blue showers. She began to build a machine in which she could sit and scan the sky. She thought she could catch the blue rain, draw it off, and evaporate it before it fell. She built the machine on the ground. It became necessary to raise it up. She had seen some turning and cranking devices in books. She didn't understand how these devices worked. She thought that perhaps if she assembled as many of these devices as possible, if she brought as many inventions as possible to bear on the problem, and attached them by ropes to the scanning machine that she could raise it into the air. She was not aware that the site that she had chosen for the machine was over an underground lake.[6]*

In the fall of 1979 Aycock exhibited at the John Weber Gallery in Soho *The Machine That Makes the World* (fig. 20.12) and *How to Catch and Manufacture Ghosts* (figs. 20.13, 20.14), which transposed the dangers and mysteries of the Three Mile Island nuclear disaster into a historical and mythic mode that focused on a relentless and mindless destructive/constructive activity. According to the artist, "To give the guillotine doors to *The Machine That Makes the World* was to make it a great destroyer and also a great creator."[7] The second work is a type of time machine intended to catch and harness aspects of the ineffable.[8] The two pieces exist in a dialectical relationship with each other: while *The Machine That Makes the World* is concise and focused, forming a good albeit lumbering gestalt, *How to Catch and Manufacture Ghosts* is purposefully disparate and evocative, as if to suggest that its contents can only be alluded to and not manifested. *The Machine That Makes the World* implicitly compares the bombardment of neutrons to a gauntlet of guillotines, thus analogizing the nuclear age in terms of a reign of

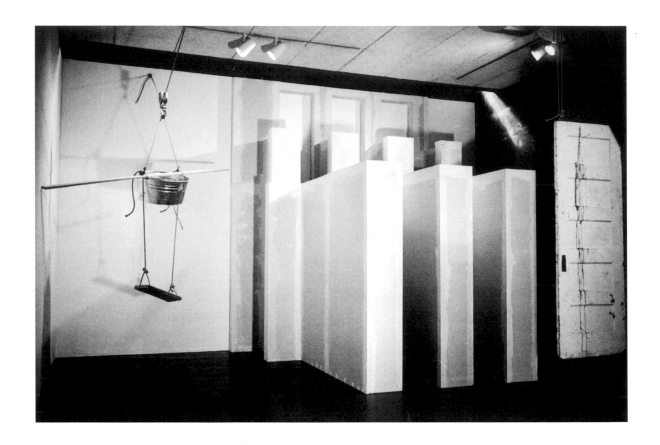

20.6 (previous pages)
Alice Aycock, *Flights of Fancy, States of Desire, Part I, Cell/Ramp Section*, 1979.
Wood, metal, rope, Sheetrock, water, and rocks; dimensions variable. Exhibited at
San Francisco Art Institute, San Francisco, California. Collection of the artist.
Photo: artist.

20.7 and **20.8**
Flights of Fancy, States of Desire, Part I, details.

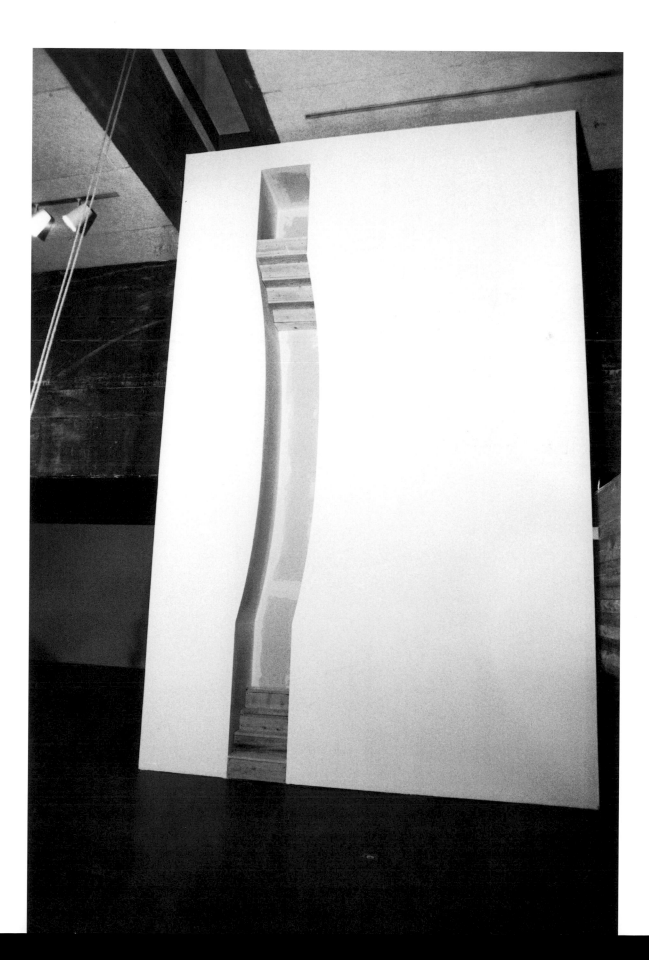

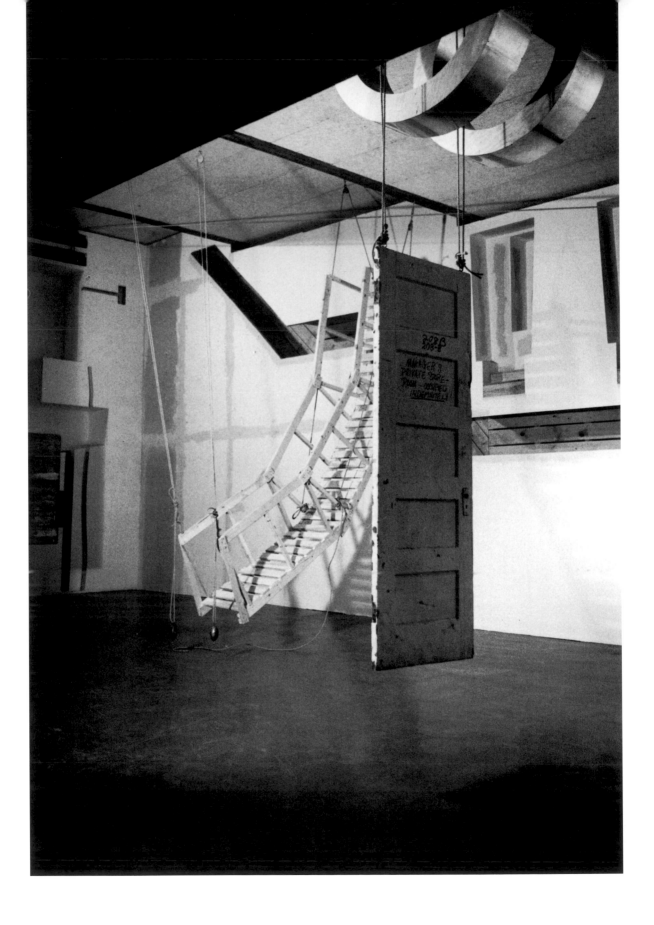

20.9 and **20.10**

Flights of Fancy, States of Desire, Part 1, details.

20.11

Apulian Woman, under a Spell Following a Bite from a Tarantula Spider, Jumps about on the Cornice of the Altar. Photograph from Maurice Bessy, *A Pictorial History of Magic and the Supernatural*, p. 314.

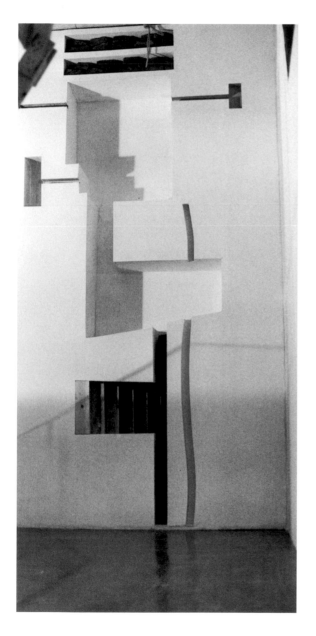

20.12

Alice Aycock, *The Machine That Makes the World*, 1979. Steel, wood, steel doors, pulleys, and revolving drum; 8′ high × 12′ 1½″ wide × 38′ deep. Sheldon Memorial Art Gallery and Sculpture Garden, University of Nebraska-Lincoln, Gift of the artist and Klein Gallery. Photo: Musée des Beaux-Arts, Montréal, Canada.

"***The Machine That Makes the World*** is a roughly constructed large wooden structure. In order to enter the sculpture, it is necessary to hoist into the air a series of metal doors which are located along three 'avenues.' The machine contains a wheel composed of three concentric rings which manually rotate one notch per hour. Over a long period of time, it is possible to enter the innermost ring." A. A.

"For three hundred years they let me eat that beef stew . . . or corn soup undisturbed. And then, suddenly, when I wanted to eat a whole restaurant full of food, I was told I couldn't because other people might get hungry or might be hungry. . . . I myself was Adam years ago, or perhaps a crown prince. We were sitting at home at the table. . . . Then somebody—maybe me— would think that the food on my father's plate or my brother's looked better and would try to exchange it . . . but perhaps all these stories are the same story. That somebody was starved . . . and then when he ate the corn, all was well again." A. A.

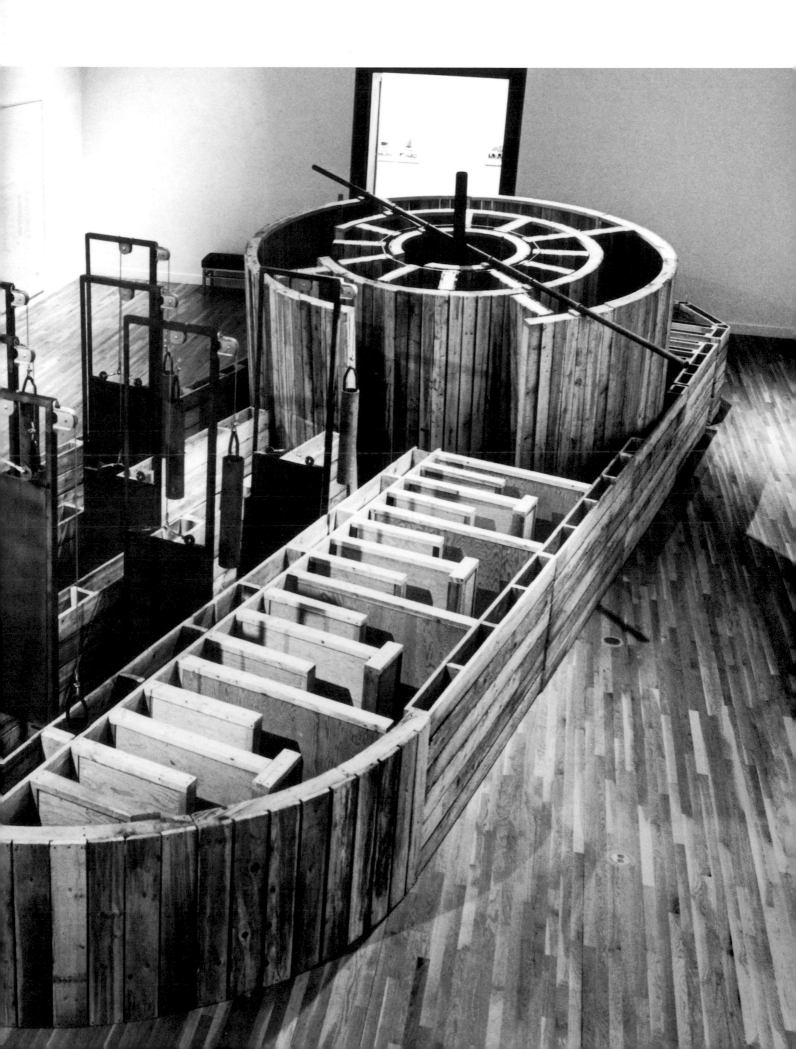

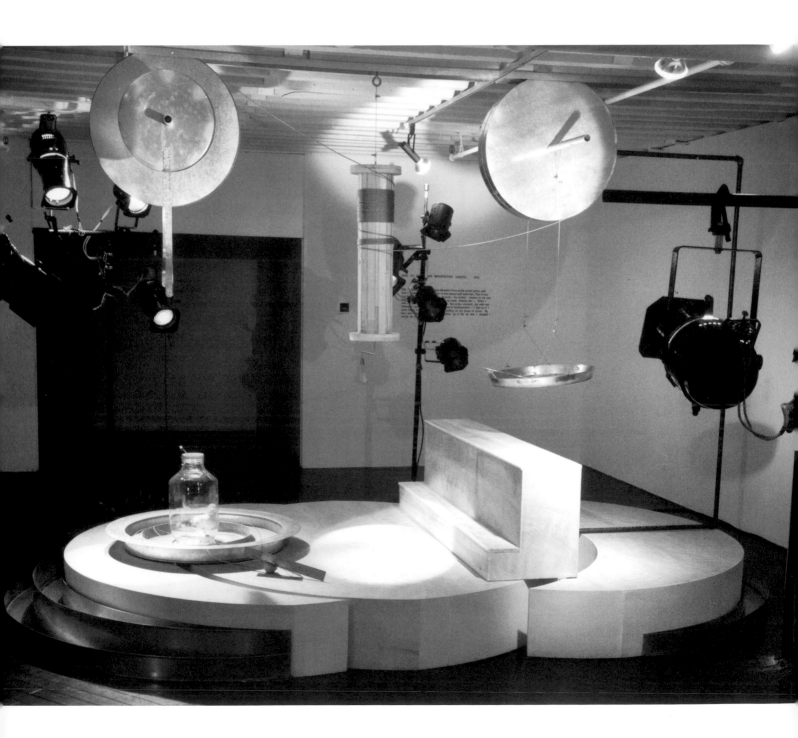

20.13

Alice Aycock, *How to Catch and Manufacture Ghosts,* 1979. Wood, glass, water, lights, galvanized steel containers, birds, performer with bubbles and pipe, copper, zinc, and lemon battery connected to a bird in a glass bottle; approx. 10′ high × 8′ wide × 15′ deep. Collection of the artist. Photo: John Ferrari.

20.14

How to Catch and Manufacture Ghosts, detail.

terror, while at the same time enlarging on this concept, as the wall label suggests. It reads, with heavy irony definitely intended, "An amusement park, a lunatic asylum, a prison-house, a market-place, a battlefield, paradise—now they're really all the same thing, aren't they?" In *How to Catch and Manufacture Ghosts,* Aycock tacitly compares the hydrogen bubble in the core of the Three Mile Island nuclear reactor to the mysterious conjunction of a rudimentary wet-cell battery for producing electricity and a girl who would come to the gallery at set times and blow bubbles. In these two works, allusions to the past and to science's prehistory, respectively, transform the Three Mile Island episode into a broad meditation on time, terror, power, mystery, and the viewer's relationship to them. We might consider both Three Mile Island and these two works Alephs that resemble a Heideggerian rift in their capacity to open up the present to disparate and even contradictory views without resolving them.

The Machine That Makes the World is an impressive forty-foot-long piece with steel doors, which was intended to be seen indoors. After keeping audiences mostly at bay for several years after Documenta (*The Game of Flyers* is an exception), Aycock decided in this piece to allow them once again to enter her art, but only if they were strictly marshaled by the clearly established system of constraints she provided. At preestablished times during the exhibition a guide would lead small groups through a series of guillotine-like steel doors that would be raised for them to move underneath. Once inside the sculpture, participants had to negotiate their way through three circular rings that would first confine them and then release them from the sculpture. The circular rings were connected to wheels so that spectators were literally turned into and out of the sculpture: they were forced to wait until the turning walls revealed a doorway that permitted them to enter into the next ring. A labyrinth, *The Machine That Makes the World* is a highly articulated and coercive

refinement of Aycock's early *Maze;* moreover it extends the idea of Duchamp's *Chocolate Grinder,* one of Aycock's favorite works by this artist.[9] She views the piece as a cooking pot, a mixer, or a grinder similar to the salt grinder at the bottom of the sea in a story she was often told as a child. It is worth noting that the noun "machine" has the same root as "might," meaning "power"; also it refers to "machinations," which are elaborate maneuvers and intrigues. Critic Kay Larsen thought of the work as an outgrowth of the artist's childhood Catholicism and suggested that the artist "remembers visits to the vast cathedral where gold orbs swung in mid-air and miracles were preached."[10] In accordance with Larsen's insight, we might conjecture that Aycock's early Catholicism may have predisposed her to the theatrics of ritual and the mysteries of transubstantiation that were definitely secularized in the series of her works focusing on the ghostlike qualities of electricity and the unknown but inexorable machines that move society forward in both positive and negative ways.

In many respects, Aycock's exhibition of *The Machine That Makes the World* and *How to Catch and Manufacture Ghosts* was a two-pronged affair. It was both the beginning of this artist's machine works period, in *The Machine That Makes the World,* and an inauguration, in *How to Catch and Manufacture Ghosts,* of the apparitions haunting these machine works. Aycock has equated the title of this second piece with eighteenth-century ideas on magnetism and electricity. This work merits a careful investigation, since it initiates a group of similarly oriented pieces. *How to Catch and Manufacture Ghosts* launches a highly original, new constellation of ideas that joins together early superstitions about electricity with both mesmerism and the hallucinations of hysterics as well as with schizophrenia, quantum mechanics, and phenom-enology. As we will see, this ghostlike personification also relates to the mind/body problem important to Cartesianism and its twentieth-century nemesis, Merleau-Pontian phenomenology.

21

How to Catch and Manufacture Ghosts

I do not know whether any human being has ever lifted that veil . . . the ancients knew what lifting the veil means. They called it seeing the god Pan. . . . [It can be accomplished with] a slight lesion in the grey matter, that is all; a trifling rearrangement of certain cells, a microscopical alteration that would escape the attention of ninety-nine specialists out of a hundred. . . . The great truth burst upon me, and I saw, mapped out in lines of light, a whole world, a sphere unknown; continents and islands, and great oceans in which no ship has sailed (to my belief) since Man first lifted up his eyes and beheld the sun, and the stars of heaven, and the quiet earth beneath. . . . A presence, that was neither man nor beast, neither the living nor the dead, but all things mingled, the form of all things but devoid of all form. And in that moment the sacrament of body and soul was dissolved.

Arthur Machen
"The Great God Pan," 1894

Like her other installations, *How to Catch and Manufacture Ghosts* holds together a wildly eclectic assemblage of ideas spanning more than eight centuries and encompassing both Eastern and Western cultures to give sculptural form to the fantastic images and perspectives of Borges's Aleph. Its plywood and galvanized metal base conflates Tantric schemas delineating the position of stars with medieval designs dividing the planet into areas of wood (earth) and water. Placed on these abstracted cosmological systems are components for making an early form of wet-cell battery, consisting of a lemon with pieces of copper and zinc, that Aycock could activate by following instructions in a children's science book

247

she had found describing the creation of Franz Anton Mesmer's rudimentary example. In this experiment, in which the two metals are placed in a container of water, free electrons break away from the zinc—the negative terminal—and form ions as they migrate across the water. Accepting these ions is the positive terminal, represented by the piece of copper. Both negative and positive forces work together to constitute a battery capable of generating one volt of electricity. This type of battery inaugurated a historical investigation over several centuries that led to nuclear reactors as the most elaborate and sophisticated means of generating electricity. Also in this sculpture, Aycock assembles a pan of water and a glass vessel that looks like a Leyden jar, the type of glass container that scientists at the University of Leyden used, beginning in 1746, as an early type of capacitor, or condenser for storing electric charge. A significant component of this sculpture is a birdcage holding a small white pigeon that recalls a famous eighteenth-century painting by Joseph Wright of Derby, *An Experiment on a Bird in the Air Pump* (fig. 21.1), that dramatizes science's means and mystery. Constituting the remaining part of *How to Catch and Manufacture Ghosts* is an overhead system of rotating pulleys and cylinders that are linked to the components for the Mesmer-type battery. In the center of the sculpture's base is a bench where an attendant is supposed to sit at prescribed times and blow bubbles. The bubbles are meant to materialize like ghostly apparitions as they float over to the glass jar that holds the bird during these sessions, thus heightening the piece's magical aura and suggesting, according to the artist, that the whole affair is as whimsical as a stream of bubbles bursting in the air.[1]

The sense of mystery conveyed by this sculpture is fully complicit with Mesmer's own eighteenth-century pseudoscience, a far-distant and discredited ancestor of Freudian psychology (particularly in terms of his emphasis on energy). His highly specious techniques—named "mesmerism"—relied mainly on hypnotism but also employed electricity at times. Electricity was then thought to be an invisible potion that could conquer disease by ensuring the unrestricted circulation of magnetic fluids within the body, and has in fact become so when it is channeled through pacemakers to regulate erratic heartbeats.

Since electricity is invisible but its effects are not, people in the eighteenth and nineteenth centuries associated it with ghosts, a connection enhanced by the fact that any object touching an electrically charged body will itself become electrified through conduction. Considered the mysterious force par excellence for life itself, electric signals were recognized at that time as life's most necessary condition. Later scientists have realized that brain functions operate on the same electrical impulses.

That electricity was generally accepted as life's elixir in the early nineteenth century is confirmed by Mary Shelley's description of how Dr. Frankenstein employed the electric shock of a lightning bolt to jolt into life his composite monster, made of sewn-together parts of dead bodies. When Hollywood made a film of this horror story in the 1930s, it replaced the more traditional bolt of lightning in Shelley's story with sparks from an electrostatic generator. The effect of both the novel and the film was not lost on Aycock, who remembers thinking of Shelley's tale when she was initiating *How to Catch and Manufacture Ghosts*. "At the time," she recalled, "I was also reading eighteenth-century accounts about how electricity was used to cure madness or bring back the dead."[2] To her way of thinking, this force is still miraculous, almost like alchemy.[3] "We really don't understand it," she says. "We just plug into it and take it for granted."[4]

Although Aycock does not refer specifically to Eliphas Lévi in her statements about this piece, his late-nineteenth-century belief that astral light was the equivalent of electricity and magnetism in the form of mesmerism and physical force is entirely consistent with the prescientific and

discredited type of knowledge she was assessing. Lévi's sense of wonder about the elemental force emitted by the godlike power of astral light and its modern equivalent, electricity, is evident in the following passage from his book *Dogme et rituel de la haute magie:*

There exists in nature a force infinitely exceeding that of steam, a force that would enable the man capable of seizing and directing it to change the face of the world. The ancients knew this force: it consists in a universal agent whose supreme law is equilibrium and whose direction is directly related to the great arcanum of transcendental magic. Through the use of this agent one can change the very order of the seasons, produce the phenomenon of day in the middle of the night, enter

instantaneously into contacts with the farthest ends of the earth, see events on the other side of the world, as Apollonius did, heal or attack at a distance, and confer on one's speech universal success and influence. This agent, barely glimpsed by the groping disciples of Mesmer, is nothing other than the first matter of the great work of the medieval adepts.[5]

Lévi may have called this force "astral light," but it is the same type of "ghost in the machine" that Aycock's sculptures reference.

Although Aycock used the term "ghost in the machine" for an entire group of sculptures, she has, strangely, forgotten its origins; on a number of occasions, she has mistakenly attributed it to a book about eighteenth-century mesmerism. Her forgetting may have been a precondition for her "re-remembering" in a creative fashion, so that the term colludes with the mystery it originally attempted to unveil. The term "ghost in the machine" has a source in the work of the Oxford University philosopher Gilbert Ryle, who coined it for use in his behaviorist critique of Cartesian dualism. Describing Descartes's thoughts on this subject with utter contempt, Ryle refers to dualism as the "official doctrine" in which

a person . . . lives through two collateral histories, one consisting of what happens in and to his body, the other consisting of what happens in and to his mind. The first is public, the second is private. . . . Underlying this partly metaphorical representation of the bifurcation of a person's two lives there is a seemingly more profound and philosophical assumption. It is assumed that there are two different kinds of existence or status.[6]

The concept of a phantasm haunting this human machine, which Ryle calls "a category-mistake,"[7] is a misconception that has plagued the branch of philosophy known as the philosophy of mind. Descartes's spiritual mind, which probably should

be equated with the soul, was again the subject of discussion in the 1960s when the metaphors provided by cybernetics were beginning to pervade the language and affect ways in which the mind/body problem was being reconstrued by functionalists. Rather than taking sides in discussions about mind/body problems, Aycock uses the theory of the ghost in the machine as an updated form of mesmerism that continues to haunt twentieth-century technology. She particularly applied the theory to early film, which she views as a development in part by illusionists who wanted to find ways to represent images of ghostly figures.[8] She also adjudicates LeWitt's claim that the mechanization of thought was becoming the generative construct for art by reinscribing traces of humanity as ghosts haunting the machinery of the modern world.

No longer limited to the past, the concept of the ghost in the machine is directly applicable to computers. Proponents of digital computers in the late 1970s, when the PC revolution was being inaugurated, were fond of pointing to the defects of mainframe analog machines (fig. 21.2) that had begun to be obsolete as early as the late 1940s.

21.2
John von Neumann in front of the Institute (analog) computer, 1952. Photo: Alan Richards. Courtesy of the Archives of the Institute for Advanced Study, Princeton, New Jersey.

Among the reasons given for this obsolescence is the fact that analog calculators can function only within a certain range. Large voltages saturating their transistors regularly upset their normal way of working, and low voltages channeled through them caused them to become extraordinarily sensitive to the random effects of noise,[9] which is in effect a type of specter haunting these machines. The enormous and far-reaching ramifications of the PC revolution had not yet been felt in 1977 when the Apple II became the first commercially viable personal computer. Still, Aycock's art of that time indicates a ready understanding of the PC's capability for generating and communicating information in such a way that knowledge is reconstrued in terms of systems, networks, and established modes of apprehending the world. For this reason PCs reconstitute information as innumerable series of mazes, thus extending Aycock's architectural metaphor into a data-processing analogy. This reconstitution of knowledge, which began with the mainframe computer and reached dizzying proportions with the proliferation of the PC, was to be exacerbated even more with the establishment of the Internet, which could be considered a never-ending and ever-proliferating maze.

Looking at Aycock's work in terms of the PC enables us to extend the metaphor of the schizophrenic work of art into the realm of mainstream society, where intelligence is directed outward to machines that appear to think and respond to people's thoughts in the process of recording them. The PC is a perfect tool for a postmodern and schizophrenic culture in which the autonomy of the individual is eroded, the self is seen as permeable, and the sense that someone or something is taking control of one's life—the proverbial ghost in the machine—is reinforced daily by this surrogate and sometimes alien form of artificial intelligence at one's fingertips. Not only do personal computers act as typewriters, filing systems, calculators, accounting systems, libraries, telephones, drafting boards, tutors, toys, and theaters, but they also become both psychological prosthetics when responsive to their users and alien beings when they show themselves to be discrete forms of artificial intelligence operating under the strict rules of given programs. Besides being seen as representatives of the dispersal associated with schizophrenia, computers themselves are vulnerable to the invasive tactics of hackers and thus could be diagnosed as potentially second-order schizophrenics, susceptible to being haunted by outside forces.

The PC revolution in data processing is part of an even larger transformation in understanding that can be grouped under a number of headings, beginning with the tremendous move from the space age to the information age. In the 1960s, when some of the tensions of the cold war were being channeled into the space race, the thematic of outer space was paralleled by a tremendous interest in phenomenological or actual space, in which the observer's distinct orientation directly impacts what is observed. As we have seen, this interest in phenomenology was crucially important to Aycock's M.A. thesis as well as to her architectural sculpture of the 1970s, starting with *Maze* (1972). Her interest in phenomenology continued until the end of the decade, when the ghost in the machine metaphor represented a change from experiential space to virtual space, or cyberspace, the neologism created by science fiction writer William Gibson. In his 1984 cyberpunk tale of the twenty-first century, *Neuromancer*, Gibson offers a definition of the term:

Cyberspace. A consensual hallucination experienced daily by billions of legitimate operators, in every nation, by children being taught mathematical concepts. . . . A graphic representation of data abstracted from the banks of every computer in the human system. Unthinkable complexity. Lines of light ranged in the nonspace of the mind, clusters and constellations of data. Like city light, receding.[10]

Working in the grand tradition of advanced science fiction that combines dense prose, deliberately alienating terms, an environment of otherness, and vividly developed adventures, Gibson unfortunately derails the radicalness of his term, as he needs to place his narrative in specific settings that are at least in part recognizable to his readers. In his novel, cyberspace's "unthinkable complexity" becomes readily perceptible, virtual space assumes some of the coordinates of everyday space, and the expelled bodies of his characters continue to race through their adventures in the matrix as if they were actual three-dimensional beings, even though their corporal selves supposedly remain seated before their terminals. Gibson obviously understands the radical nature of the new medium of PCs, but he is unwilling to forgo the many anchors that tie his story to his readers' reality.

Although Gibson's own fiction partially invalidates the relevance of his term, it provides us with perspective on the important new understanding of space that Aycock's art enacts in the late 1970s and early '80s by underscoring the schizophrenic culture attending the creation of the PC and its ghostly emanations. The concept of cyberspace does this specifically through its participation in the hyperreality of the spectacle that philosopher, sociologist, and poet Guy Debord so brilliantly analyzes. In Theses One and Four of his *The Society of the Spectacle*, Debord lays out the terms of this new world:

1. The whole life of those societies in which modern conditions of production prevail presents itself as an immense accumulation of spectacles. *All that once was directly lived has become mere representation. . . .*
4. The spectacle is not a collection of images; rather, it is a social relationship between people that is mediated by images.[11]

Unraveling the relationship between reality and illusion, in which the latter supplants the former, is the legacy of the spectacle, a condition similar to the loss of perspective and colonization of the self by outside forces that characterizes persons diagnosed as schizophrenic. In spectacular culture, the self is severely dislocated, a condition that film studies specialist Scott Bukatman calls "terminal identity" and describes as "an unmistakably doubled articulation in which we find both the end of the subject and a new subjectivity constructed at the computer station or television screen."[12] Bukatman follows this observation with a statement that initially sounds too pat and convenient, claiming that "the explosion of the Space Age has yielded to the implosion of the Information Age."[13] Yet one can look at Aycock's art in terms of a new post-space-age phenomenology that allows it to move out to its viewers and condition their perspectives. One can also think about her art in terms of information-age technologies that have provided her with instant accessibility to vast ranges of knowledge, including such superannuated techniques and devices as mnemonics and medieval prototypes for analog computers. Within the confines of a single art object, which we might refer to as a text, there are innumerable possible meanings and references moving inward, unseating its autonomy, upsetting its boundaries, and precluding its sureties. As we have seen, Aycock's writings aid this implosion, even to the point of presenting her viewers with competing models for interpretation that show them how to continue the project themselves.

Since they operate on electricity and attempt to exist as separate functioning entities, PCs seem to have become the most modern candidates for the romantic-era discourse on the ghost in the machine. However, they go far beyond Dr. Frankenstein's collaged fragments. Aycock tacitly acknowledged this fact when she moved beyond Shelley's tragic monster to the realm of schizophrenia and found a compassionate protagonist in N.N. She consequently mounted several of his statements on the wall of the

252

John Weber Gallery installation during the exhibition of *How to Capture and Manufacture Ghosts*. Two of these quotations follow:

For three hundred years they let me eat that beef stew ... or corn soup undisturbed. And then suddenly, when I wanted a whole restaurant full of food, I was told I couldn't because other people might get hungry. ... I myself was Adam years ago, or perhaps a crown prince. We were sitting at home at the table. ... Then somebody—maybe me— would think that the food on my father's plate or my brother's looked better and would try to exchange it ... [but] perhaps all these stories are the same story. That somebody was starved ... and then when he ate the corn, all was well again.

and

Somebody else might have dreamed of me as the crown prince, and then I would appear in the dream of that other person and wake him. That is how I go home sometimes. Somebody at home—my mother—dreams of me and then I am at home with a broom in my hand, helping her.

Aycock associated the first N. N. statement with *The Machine That Makes the World* and the second with *How to Catch and Manufacture Ghosts*. Taken together, the two citations refer to an obsession with always having more and with understanding the chimerical quality of modern existence in which one's life increasingly assumes a dreamlike quality. Both are legitimate responses to the perpetually escalating demand in the United States for energy and the shock of the mediated virtual world we now inhabit.

To Aycock, N. N.'s observations seemed to conjure up both the magic and the madness of the early electric experiments that initiated a process of investigation leading to the splitting of the atom and nuclear energy. In addition, N. N. furnished her with a living equivalent of Duchamp's enigmatic and illogical Headlight Child. As she reflected, "Duchamp's child [like N. N.] would not listen to reason. He is a muse, and he plays a game of marbles with the stars and wreaks havoc on the universe."[14] One of N. N.'s insights that she chose to accompany *How to Catch and Manufacture Ghosts* captures the apparitional state of being that some schizophrenics experience. "Once I was putting on my shoes at home," N. N. related. "My feet and shoes began to lift themselves up in the air and I thought I would be lifted off the ground."[15] N. N.'s somatic delusions about his ability to transcend limits serves as a fitting metaphor for the ghosts in the title, which refers to the conjunction of magic and electricity and the invisible forces linking the two. His descriptions provided Aycock with a series of images on a par with the medieval manuscripts and Tantric configurations that enabled her to suggest breaks in this universe similar to Borges's Aleph or springboards to future ones. "There is no way we are going to make these long space journeys to the stars," Aycock conjectured, "unless we can change our material form. It is something we are going to do someday: to dematerialize ourselves and materialize again somewhere else."[16]

Aycock was particularly intrigued with N. N.'s ability to describe his experiences so that they seem to be related to quantum mechanics, particularly its magic and unpredictability. At one point N. N. admitted: "At the same time I moved the sundial. I wanted to take the sun off its course. They did not like that. It was as if I had eaten the stew and accidentally splashed it on someone else. I thought that there was something wrong with time. I was not born at the time people said I was born. That is why I tried to take the sun out of the sky."[17] N. N.'s confession is as ingenuous as those of Freud's Dr. Schreber, who claimed the ability to defecate beams of light.[18]

To Aycock, the new theoretical physics of quarks and charms seemed to sustain the fantasies experienced by religious artists and others during

the Middle Ages and the special perceptions of schizophrenics in the twentieth century.[19] As she has put it, physics has had "to posit totally illogical concepts in order to understand microscopic events."[20] Among its insights, quantum mechanics has focused on energy bundles called "quanta," which are the contemporary world's most likely candidates for Aycock's ghosts. Its achievements include overturning both the reliance of classical physics on direct observation and its belief that the universe operates in the manner of a gigantic machine whose smooth workings are guaranteed by the absolute synchronicity of time and space. Aycock's recognition that physicists had debunked this established industrial metaphor may be one reason that she began to focus on machines and the magical ghosts emanating from them as superannuated images still capable of evoking fantasies and catalyzing viewer's reactions. After the early-twentieth-century discoveries of Albert Einstein, Niels Bohr, Max Planck, and Werner Heisenberg, postclassical physics would depend on probabilities and statistics to determine the constituencies and behavior of subatomic particles too small to be seen and too erratic to be easily charted. Thus, the pioneers of theoretical physics ushered in a new era of faith far different from the Middle Ages but sharing with it a similar belief in the efficacy of unseen forces. A strange form of circular reasoning was enacted in which scientific predispositions correlate with flights of the imagination, and these fantasies in turn corroborate scientific knowledge. In place of the certainty of classical physics, specialists in quantum mechanics have posited an uncertain universe in which light behaves as either particles or waves, depending on the questions asked and conditions used for analysis. Sounding like phenomenology, Heisenberg's Uncertainty Principle states that we disturb or change what we seek to observe. The situation is akin to Merleau-Ponty's discovery that observant individuals are key factors in the knowledge accrued through their observations. Both phenomenology and quantum mechanics create an intellectual landscape for the relativity of writerly prose in which the meanings of works of art depend on the people who are looking at them and the types of inquiries they are undertaking.

Aycock's inspired choice of a schizophrenic's erratic visions as metaphors for ghosts haunting antiquated machines ultimately relates to quantum mechanics in ways that she did not anticipate. In brief, her work demonstrates that quantum mechanics can be characterized in terms of schizophrenia. The breakup of light into either particles or waves depending upon one's perspective is akin to the breakdown of the self into incommensurable entities in schizophrenia. For example, Bohr's first postulate, stating that an electron can exist in any one of several special orbits with no emission of radiation, is analogous to schizophrenics' fragmenting aggression against themselves in which they split up their capacity to identify with one integral self and disperse themselves abroad into other orbits. Moreover, his concept of the discontinuous quantum jumps occurring within an atom is in itself a type of schizoid behavior resulting from this diffusion. This discovery allows us to see Aycock's work as a schema for symbolizing the alienation of the modern world in terms of theoretical physics. Put in the context of her art, the quantum jump is akin to Eunice Winkless's leap and Borges's tear in the universe—an existential void that is characterized as a grand adventure. By developing mechanistic sculptures still haunted by the nonbeing of schizophrenic ghosts, Aycock's work is able to undermine and derail the machine analogy that had proved such a useful tool for classical physicists and that would later become an enormous stumbling block for theoretical ventures.

The full spectrum of ideas in *How to Catch and Manufacture Ghosts* so intrigued Aycock that she used it as the series title for a number of works,

including *Collected Ghost Stories from the Workhouse* (spring and summer of 1980), at the University of South Florida, and *The Rotary Lightning Express (An Apparatus for Determining the Effects of Mesmerism on Terrestrial Currents)* (1979–1980), first proposed for Roanoke College's Olin Hall (figs. 21.3, 21.4) and later built indoors in 1980 at P.S. 1 in New York (fig. 21.5). She ultimately built *The Solar Wind*, a vertical blade machine, out of doors on Roanoke College's campus; and *Hoodoo (Laura): Vertical and Horizontal Cross Section of the Ether Wind* (1981), first created for *Metaphor*, an exhibition at the Hirshhorn Museum and Sculpture Garden curated by Howard Fox, and later acquired by the Los Angeles County Museum of Art, where it was placed on permanent view in the director's garden. Aycock did not designate *Ghosts* (fig. 21.6), a work playing on the look of sewing and textile industry machinery—no doubt an oblique reference to Jacquard looms as a distant progenitor of the computer that Burke described in *Connections*—as part of this series.[21] But this piece, which was constructed for the Laica exhibition *Architectural References* and executed at the University of California, Irvine in the fall of 1980, can easily be related to this group in terms of its subject and components. Also connected with this series is *The Miraculating Machine in the Garden* (figs. 21.7, 21.8, 21.9, 21.10) commissioned in 1980 by Douglass College. The constellation of associations important to *How to Capture and Manufacture Ghosts* also provided the raison d'être for *The Savage Sparkler*, commissioned in 1981 by the State University of New York at Plattsburgh.

Besides creating works that join electricity, schizophrenia, and quantum mechanics into perceptive if highly complex and erudite metaphors of late-twentieth-century estrangement, Aycock extended them in the direction of automata, which Burnham in the 1960s had labeled "subsculpture."[22] As revamped automata or deconstructed cybernetics, these sculptures look backward as well as forward. In the process, these pieces participate in a phantasmagoric rather than a figurative realm when they transform nostalgia into a liminal concept so that one can yearn for a far distant future as well as for a nonexistent past. Working in concert with this idea, these sculptures signal a new and yet archaistic brand of kinetic art. Rather than joining the ranks of futurists who are forever proclaiming the inexorable march of progress, Aycock queries the underlying progressive ideology of automata and kinetic art. Several works in *How to Catch and Manufacture Ghosts* present electricity in terms of the rudimentary eighteenth- and nineteenth-century experiments that helped people to understand and later harness it. Movement and technology in this group of works generally take the antimodern position of great lumbering machines and slamming pieces of metal. When light appears in them, it usually assumes either the mystery of spotlighted stages or the stridency of neon. Thus Aycock's sculptures of the late 1970s and early '80s reject even a tacit acceptance of modernist form by engaging in an antiquated formal vocabulary that alludes to both early laboratory experiments and superannuated industrial processes. Unlike in the early twentieth century, when the inside of machines— particularly car engines and factory mechanisms— seemed to represent the most modern and unabashed force then available, in the digital age in which Aycock was working this type of rigorously modern machinery seemed old-fashioned and even quaint.

The Rotary Lightning Express (An Apparatus for Determining the Effects of Mesmerism on the Terrestrial Currents) initially stakes claim to a number of components that will recur in other pieces in the series, including a collection pan, spinning cylinders, slamming plates, hot coils, a glass jar, and pulleys. The artist's succinct description details how these elements are joined together in this piece:

21.3

Alice Aycock, *The Rotary Lightning Express (An Apparatus for Determining the Effects of Mesmerism on Terrestrial Currents)*, from the series *How to Catch and Manufacture Ghosts*, 1980. Model. Collection of Roanoke College. Photo: E. Mopsik.

21.4

Alice Aycock, *Proposal for Olin Hall, Roanoke College: The Rotary Lightning Express (An Apparatus for Determining the Effects of Mesmerism on Terrestrial Currents)*, from the series *How to Catch and Manufacture Ghosts*, 1980. Pencil on vellum, 36″ × 41″. Collection of Henry S. McNeil Jr., Philadelphia. Photo: John Ferrari.

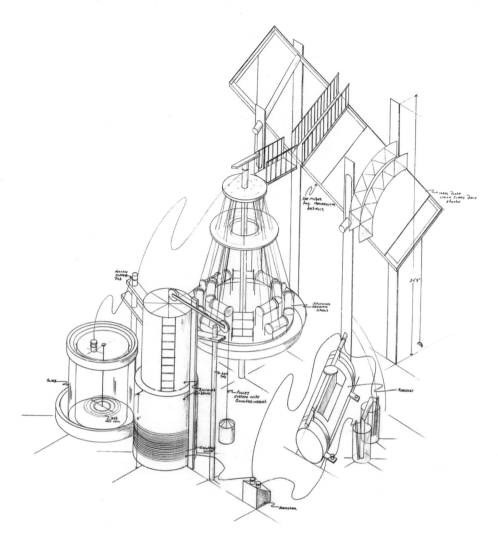

PROPOSAL FOR OLIN HALL,
ROANOKE COLLEGE: THE ROTARY
LIGHTNING EXPRESS (AN
APPARATUS FOR DETERMINING
THE EFFECTS OF MESMERISM
ON TERRESTRIAL CURRENTS

SCALE: ½"=1'

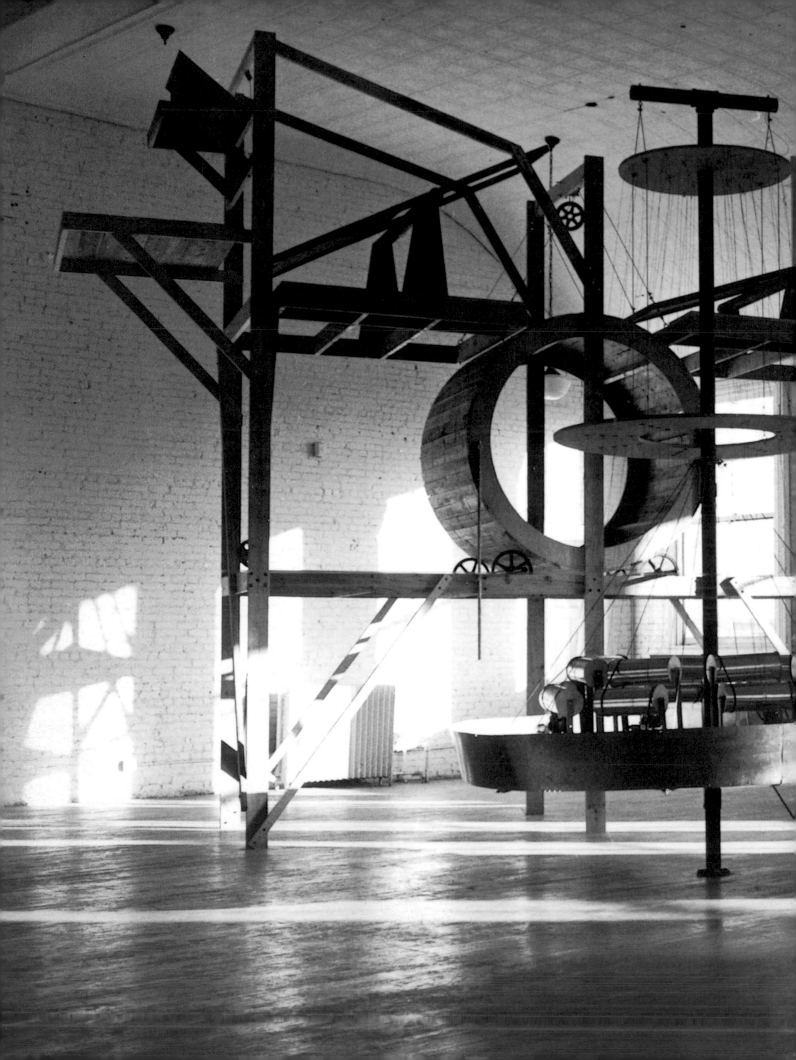

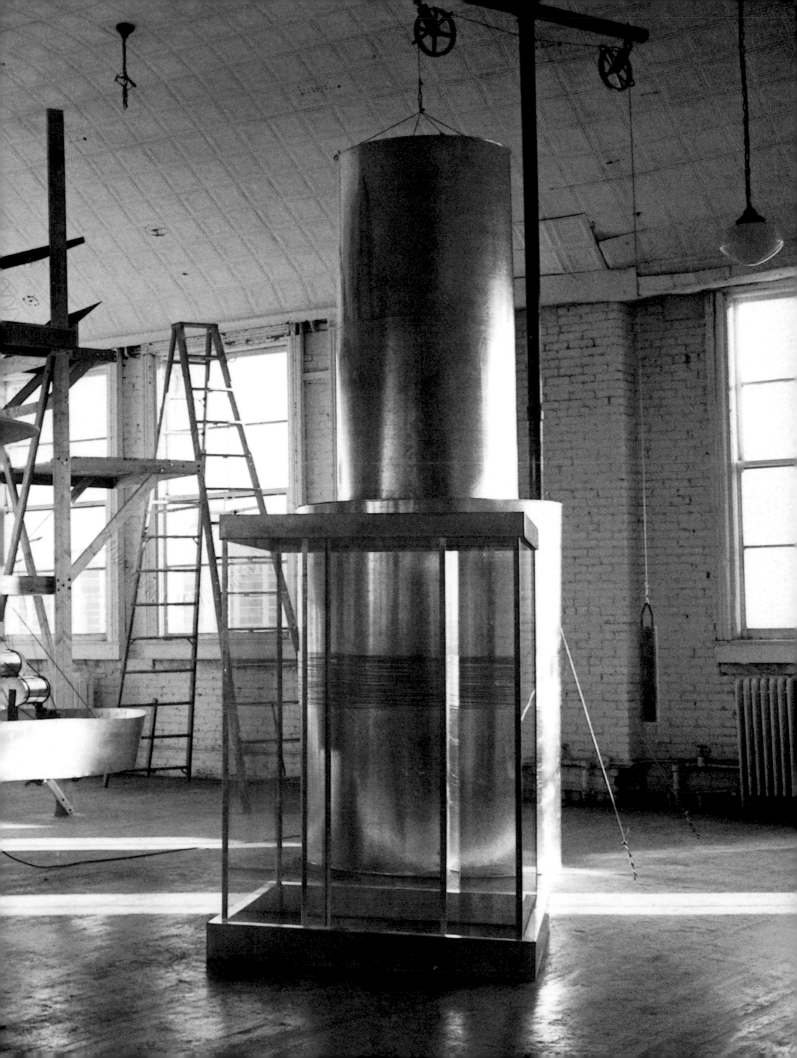

21.5 (previous pages)
Alice Aycock, *The Rotary Lightning Express (An Apparatus for Determining the Effects of Mesmerism on Terrestrial Currents),* from the series *How to Catch and Manufacture Ghosts,* 1980. Galvanized steel pan, glass jars, spool, steel cable, steel drum, steel plates, and wooden platform; 18′ × 30′, variable width. Exhibited at P.S. 1, Long Island City, New York. Collection of the artist. Photo: artist.

21.6
Alice Aycock, *Ghosts,* 1980. Wood, belts, cables, clamps, pulleys, and steel; approx. 16′ high × 11′ wide × 15′ deep. The Orange County Museum, California. Photo: Bruce Williams.

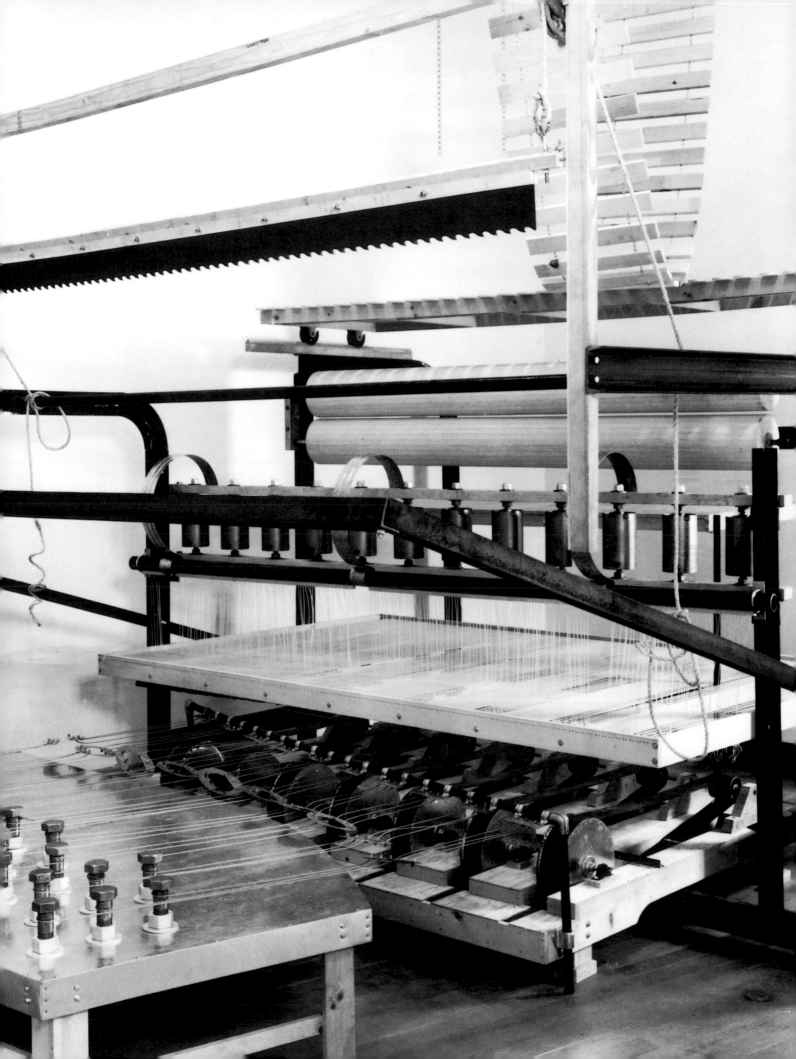

21.7
Alice Aycock in front of *The Miraculating Machine in the Garden (Tower of the Winds)*, c. late 1980s.

21.8
Alice Aycock, *The Miraculating Machine in the Garden (Tower of the Winds)*, 1980–1982. Glass, concrete, steel, sheet metal, copper, neon light, and vegetation; 30′ high × 30′ wide × 20′ deep. Douglass College, Rutgers University, New Brunswick, New Jersey. Photo: Wenda Habenicht.

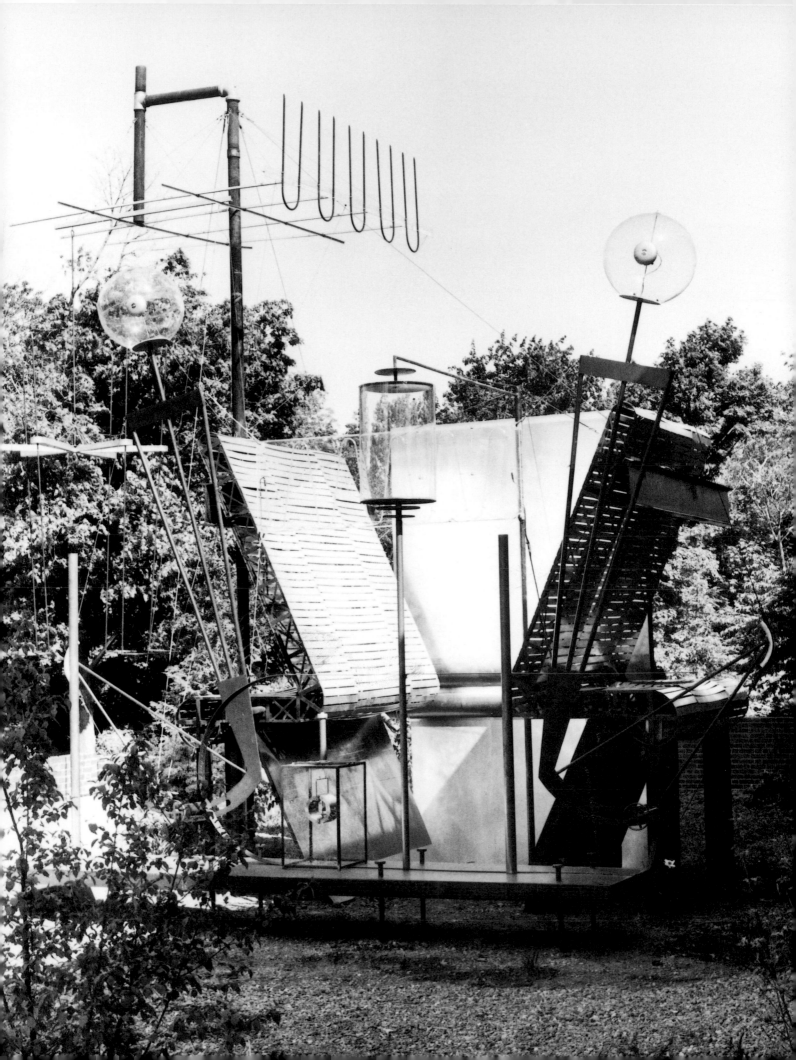

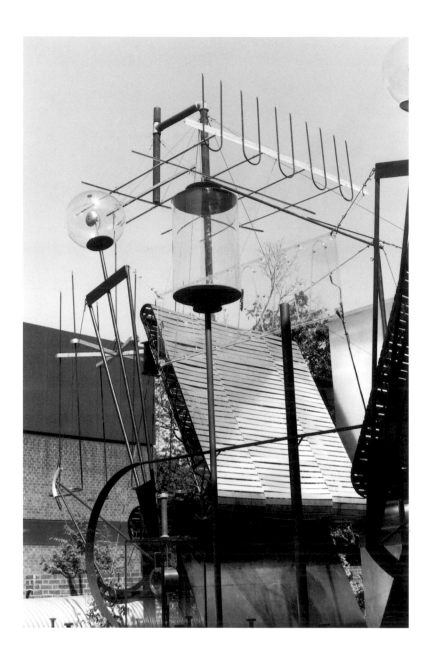

21.9
The Miraculating Machine in the Garden (Tower of the Winds), detail.

21.10
Alice Aycock, *The Miraculating Machine in the Garden (Tower of the Winds),*
proposal for Douglass College, 1980. Pencil on Mylar, 39⅝″ × 42″. Collection of
Henry S. McNeil Jr., Philadelphia. Photo: Jon Abbott.

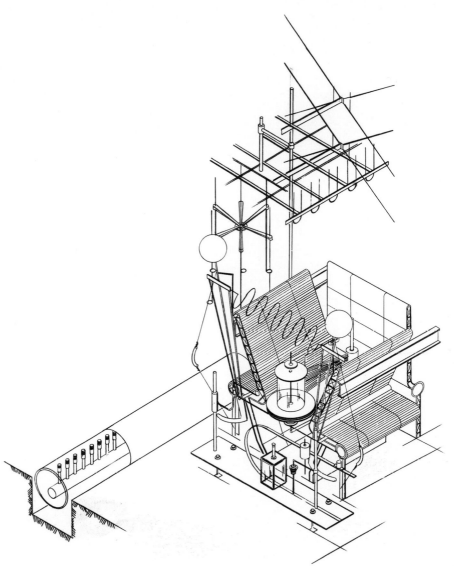

The Miraculating Machine In
The Garden
Proposal For Douglass College
(A 16' High Structure With
Moving Walls On A Conveyor
System, Sounding Devices,
Organs, Bells Ringing In
A Vacuum & A Cylindrical
Box Built For Sending
Vibrations

The Rotary Lightning Express *is composed of a steel platform approximately 25 feet high × 5 feet wide. This platform frames a steel plate which slams back and forth in a see-saw fashion. Immediately in front of this platform is a suspended galvanized steel pan, 10 feet in diameter, containing galvanized spools which are threaded with steel cable. These spools spin. The spinning spool construction is suspended from a center pole and connected to a rectangular glass jar containing another smaller jar, water, and a hot coil. This is in turn connected to a galvanized steel drum, 5 feet in diameter and 7 feet high, containing a smaller steel drum which can be hoisted up and down on pulleys. The project also contains a specially made rheostat in which a person can lie and be mechanically turned around. . . . This specific project is intended to be a machine or instrument for retrieving and recharging the mind of a 100-year-old woman.*[23]

While the threading devices allude to the textile industry and thus replace sewing with its industrial counterpart, the reference to the old woman at the end of this passage strikes a personal note. It is directed to Aycock's paternal grandmother, then almost one hundred years old and suffering from dementia. As the descriptive title of this work indicates, Aycock plays Dr. Frankenstein to her grandmother's loss of memory; she thereby inserts her grandmother in place of both the lightning that invigorated the monster in Mary Shelley's book and N. N., who appears in the accompanying text for the premier sculpture in the series, *How to Capture and Manufacture Ghosts*. The work's complete title makes a seemingly far-fetched connection between mesmerism and terrestrial currents that reflects an awareness of Edward Lorenz's innovative work in the early 1960s on chaos theory and the butterfly effect. Aycock's linkage of the two gently parodies Lorenz's findings even as it perpetuates his discovery of the profound ramifications of seemingly accidental and inconsequential behavior.

The Rotary Lightning Express *and other such* machine works in this series can be understood in terms of Alice Aycock's and Dennis Oppenheim's at times fierce debates about sculpture. Oppenheim personified this relationship in his mechanomorphic prose poem accompanying *Final Stroke—Project for a Glass Factory* (1980):[24]

He could read her mind as if it was a glass factory. Crystal cams spun thoughts down connection rods into multi-shaped pistons digging deep into cylindrical wells. Her thoughts began under vacuum pressure near the piston. The release would spin the cams and urge them towards clarity, converting motion into forces of pure mental pressure. Thoughts would push then swell up inside the receptacles, only to contract to a ribbon bending and reshaping the perimeter walls. As these vents and troughs meshed with his desires, he would wish himself into them. By inhaling and exhaling, his thoughts joined hers and were pulled down into the vacuum, swirling inside the metal cylinder where facets pushed out diamond-shaped openings and exiting produced sparks. Crystalline slivers pierced the chamber walls, scraping past reflector blades, swinging, ricocheting into liquid charms, showering into the air like water forced to travel through electric cables, flooding tunnels of atmospheric circuit breakers. At these moments he would imagine himself a tree or another single image while pushing through channels. Then he would switch, dodge in and out of subjects, always colliding them into hers. At other times he would envisage a rock crashing into his head, how that would interfere with his present thoughts, swelling even more now into petrified impulse, blocking the exhaust channels. These obstructions increased the vacuum pressure in her mind, which in turn caused a vortex of wind to swirl through him at greater and greater speeds. Gales would sweep through the mental corridors, diamond chambers and liquid cooling bins, then flood her many receptacles, filling this glass factory with his

*thoughts. He noticed the cams moving faster and
faster, the metallic pistons vibrating until almost
invisible. The chamber walls began to glow. Then
everything stopped, freezing his mind into her
many chambers, vents, cylindrical cells,
imprisoning him under still cams haunted by the
ghost of a pressure, a missing mental vacuum. Over
the years he would occasionally guide his thoughts
toward the assembly of pistons overhead and follow
the main lines through to the lifters above the cams,
hanging there, some up, some down. Those cams
that once spun a collective force outward now
merely signaled a memory of that final stroke. The
shape created by overload alone became his grave.*[25]

While Oppenheim's prose poem responds to the
intricacies of their relationship by conflating
machine imagery with thoughts and thinly veiled
sexuality, Aycock's hypnotic blade machines that
slowly and menacingly cut wide swathes represent
among many other things, according to the artist,
the fascination and danger of their being together.
The assertiveness of these machines creates both
a space in which to act and also a barrier to any
interloper, even perhaps Oppenheim.

As curator of *Machineworks*, held at the
Institute of Contemporary Art, Janet Kardon
states in her introduction:

Machineworks, *by these artists [Acconci, Aycock,
and Oppenheim] and others, can be viewed as a
segment of the art and technology continuum, an
extension of assemblage acquisitiveness, an
aspect of '70s large scale site-specific work—or as
all three. Diverse objects and machine parts are
combined with the passion of the* bricoleur, *the pure
fantasy of a Mary Shelley and the conceptual
playfulness of a Jorge Luis Borges. Machineworks may
resemble actual machinery, or even a Rube Goldberg
contraption, but an artist's machine remains a
handy metaphorical conveyance, manipulated by
each artist's idiosyncratic sensibility, which is*

*unquestionably maintained, although these artists
may share personal histories.*[26]

Seen as a continuum by Kardon, the works of these
artists could also be viewed as both a formal
leave-taking and an elegiac farewell to the
hegemony of a machine age dominated by gears,
ball bearings, crankshafts, and pistons. Less than
half a decade before this exhibition, Apple
Computer had already inaugurated the era of the
personal computer, thus ushering in the digital
age of microscopic circuitry and information
technology—a realm that Aycock was already
beginning to mine.

Even as Aycock was beginning to explore ideas
initiated specifically for *How to Catch and
Manufacture Ghosts*, she viewed some of its concepts
as still intermingled with *The Machine That
Makes the World*. From this intermeshing of thought
came the proposal and subsequent model for *The
Great God Pan* (fig. 21.11), named after an early-
twentieth-century story by Welsh writer Arthur
Machen, which had intrigued her as a child:

*When I was a child, I had this big thick book of
gothic tales which I would read before I went
to sleep at night and I would always save the story
"The Great God Pan" as a treat and never read it,
just fantasized about it. As a child, when I began to
think about the Biblical story of Genesis, what
God needed to know to make the world, how would
he collect the information, I thought of that story,
and I envisioned this big pan like a pizza pan, a
kind of collector that would extend into the sky and
the information would fall into that pan and it
would move through the system below and it would
be used to make the world.*[27]

Often represented with the legs, horns, and ears
of a goat, this Greek mythological god, whose
dominion included the natural terrain of wild
animals and shepherds with their herds, was
associated in Aycock's fancies with an ordinary

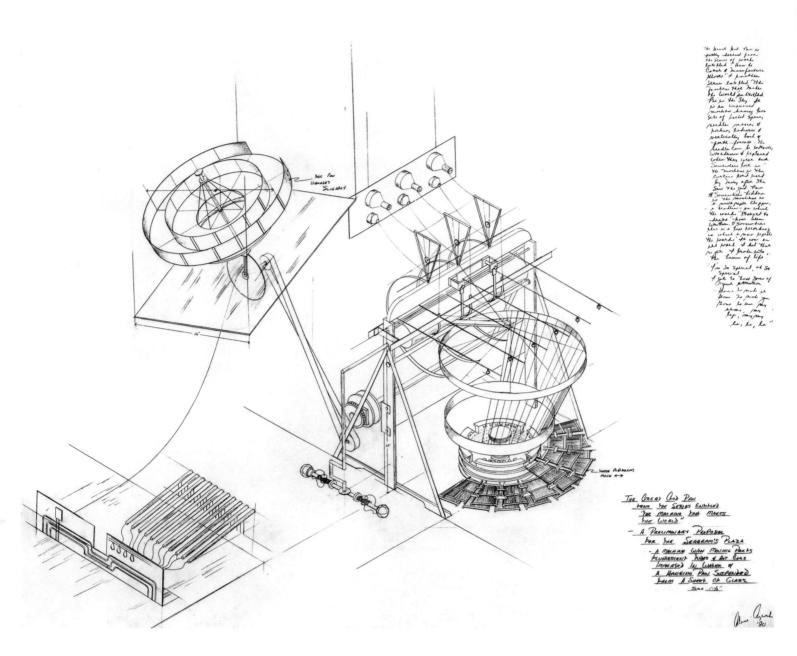

21.11

Alice Aycock, *The Great God Pan, from the Series Entitled "The Machine That Makes the World" subtitled "Pie in the Sky,"* 1980. Pencil on Mylar, 42″ × 52″. Private collection. Photo: John Ferrari.

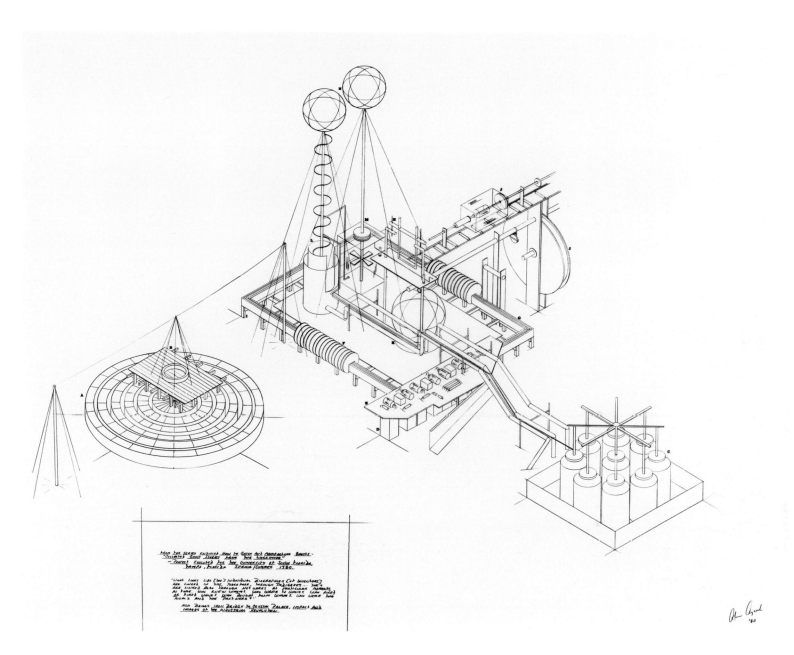

21.12

Alice Aycock, *From the Series Entitled How to Catch and Manufacture Ghosts,*
"Collected Ghost Stories from the Workhouse," 1980. Pencil on Mylar, 36″ × 42″.
Private collection.

pizza pan. In her reveries, his domain was transposed from nature to culture, particularly civilization in its traditionally historical function of collecting and retrieving information.

Aycock's correlation is evident in the drawing proposing this sculpture for the Seagrams Plaza in New York City. (Unfortunately, it was never built as intended, but the artist constructed a three-dimensional model of it and also created a version of the piece in Salisbury, Maryland.) The work was to include moving parts, fluorescent tubes, hot coils immersed in water, and a hanging pan suspended from the Seagrams Building over a sheet of glass. Subtitled *Pie in the Sky,* in obvious reference to the pizza pan of her daydreams, the piece was intended to work in the following manner:

It is an improved machine having two sets of barbed spring needles moving and rocking endwise and vertically back and forth forever. The needles can be instantly withdrawn and replaced when they wear out. Somewhere in the machine is the improved curtain cord used by Mary after she saw the God Pan. Somewhere hidden in the machine is a newspaper clipping headline on which the words "starved to death" have been written. Somewhere else is a tape recording in which a man repeats the words "It was an ill work I did that night. I broke into the house of life." [28]

Aycock describes the lower section of *The Great God Pan* "as a carousel structure combined with a particle accelerator, literally big electro-magnets that move around a center." Additionally she notes, "Things heat up down there and ascend back up or something comes from the sky and moves back down. And then ultimately, it's just *Pie in the Sky,* a dream, a joke. I intend to undercut the seriousness of the idea." [29] Rather than considering the classical figure of Pan as a benevolent flutist, she recognizes his malevolence, which might seem strange when one thinks of her pizza pan analogy. But she is adamant on this point and refers to

the earth deity as "another Frankenstein," [30] in reference to Shelley's doctor, not the monster he created. Later she picks up on Milton's description of Death and declares that "Pan is a god who can make himself take any shape. He is a shape shifter." [31]

If one goes back to Machen's novella "The Great God Pan," included in his *Tales of Horror and the Supernatural,* Aycock's understanding of this deity's dark side becomes clear. In this tale Pan is equated in symbolist fashion with the unspeakable terror at the core of existence—a type of tear in the universe that maintains its mystery, becoming all the more terrible and foreboding for doing so. Machen refers to him as the ineffable force that veils "the most awful, most secret forces which lie at the heart of all things; forces before which the souls of men must wither and die and blacken, as their bodies blacken under the electric current." [32] After describing the misfortunes resulting from acquaintance with Pan, Machen characterizes the effect of this terrible deity in terms compatible with Borges's later description of the vision facilitated by the Aleph, as seen in the epigraph to this chapter. The Great God Pan's ability to transmute his form and to elude description reinforces his role as a signifier equivalent to Milton's ultimate signified, Death, but Aycock's work conceives his function somewhat differently. Although she herself made the Machen connection, her sculpture reconceives his view of Pan as a symbol of the earth's ultimate corruption; Aycock instead casts Pan as a new iconographic figure commensurate with the electricity that haunts living matter and machines as well as with the quanta that have subjected classical physics to a new indeterminacy. Instead of signifying the multifarious inevitability of Death, Aycock's Great God Pan connotes the shape-shifting capabilities of scientific knowledge that has become as mysterious, invisible, and deadly as the biogenetic revolution that seeks power over both life and death.

The commission for *Collected Ghost Stories from the Workhouse* was in large part due to the

efforts of art historian and former Guggenheim curator Edward Fry, who had become a faculty member at the University of Southern Florida. Designed and built in mid 1980 and dedicated in February 1981, the piece was unfortunately dismantled in 1985 and since then has not been reerected. Situated behind the art department building and within view of this institution's physical plant, *Collected Ghost Stories from the Workhouse* (fig. 21.13) played off the countering interests of art and technology. Although the piece no doubt was intended to resonate with the dynamics of its locale, its references are not limited to them. The piece also bespeaks the artist's long-term fascination with the architecture of the Standard Oil refinery alongside the New Jersey Turnpike (near New York City), which was Aycock's route to Douglass College and the subject of Tony Smith's epiphanic car ride. Explaining her interest in the refinery, Aycock has said, "I've looked at it for years and always loved it—especially at night with all the lights and smoke. It's like a giant chemistry lab, almost like a city."[33] The refinery's dispersal in the landscape helps to explain why the artist was still waging war with the assaultive unitary forms of the minimalists but not with their industrial subtext. "I wanted to break apart the gestalt in *Collected Ghost Stories from the Workhouse*," she recalled, "to make something equivalent to Barry Le Va's Scatter Art. I could make a good gestalt and often did, but I wanted to break it up in this work."[34] As part of her effort to undermine a holistic approach, she included fourteen propositions (see appendix c) that describe individual components while simultaneously directing the work away from a strictly readerly approach and encouraging viewers to undertake writerly interpretations.

Part of the inspiration for this piece came from the large glass containers found on Canal Street that reminded Aycock of Leyden jars. These Leyden-type jars became one of the symbolic repositories for the ghost tales in her title. To reinforce the theme of electricity's mysterious force, she situated the central and main section of this piece on a platform whose plan was inspired by a diagram for an electric circuit panel. Placed high above is a pair of spheres that resembles Van de Graaff electrostatic generators, which scientists have used mainly as research tools for breaking up atoms and studying their constituent particles. Seen in conjunction with the electric circuitry that forms a stage for them, these generators underscore the mysterious force of electric charges making up matter and the even greater force issuing from their breakup. To one side of this configuration, the artist has placed concentric rings rotating in different directions like an amusement park carousel (fig. 21.14). Directly above the rings is a rectangular wooden platform called a montgolfier platform that was used for launching hot-air balloons beginning in the eighteenth century. It looks as if it is levitating, and it references "puffing Billy—the first successful manned flight," according to the statement accompanying this piece. On the other side of the central electric circuitry platform is a group of nine metal canisters with agitators inside them that make noises similar to those of washing machines (fig. 21.15). These canisters are yet another possible repository for the ghosts or mental emanations that might inhabit the recent past represented by the electric circuit and the Van de Graaff generators—and that might also haunt the distant eighteenth century denoted by the spinning rings and carousel supporting the hot-air balloon's launching pad. An additional historical connection would have been established by Aycock's original intent to include live birds in the lower portion of the central section containing the Van de Graaff generators; these creatures would have alluded to the Wright of Derby painting mentioned earlier. The agitators contained in the canisters derive their significance from the artist's own childhood connection of the human soul with the inside of washing machines. "As a child," she reminisced, "I

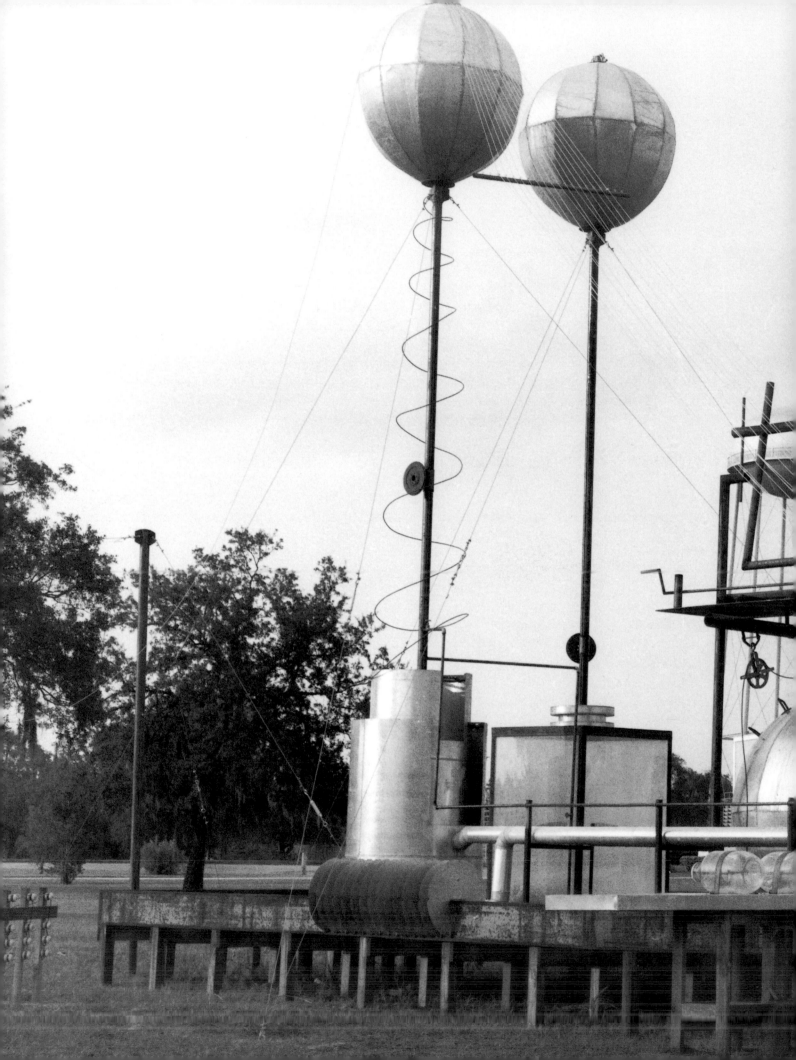

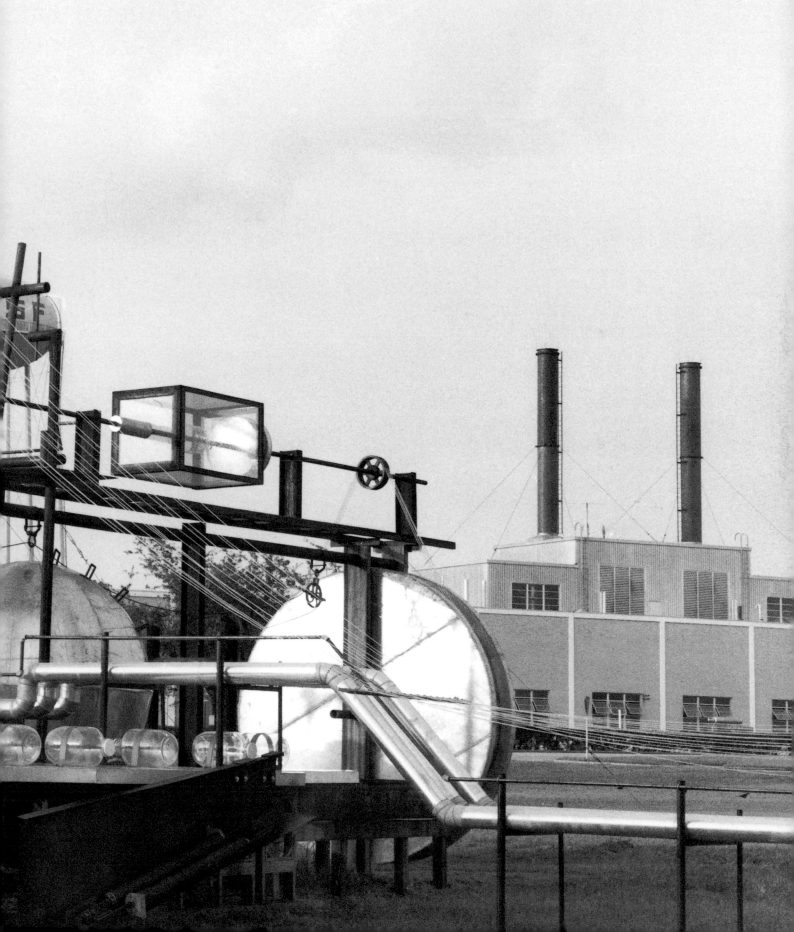

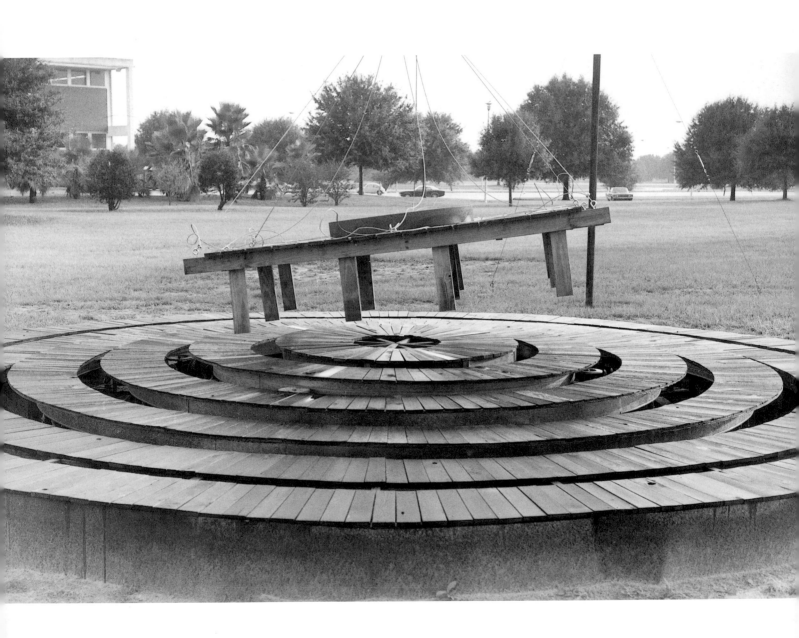

21.13 (previous pages)
Alice Aycock, *From the Series Entitled How to Catch and Manufacture Ghosts,*
"Collected Ghost Stories from the Workhouse," 1980. Cable, copper, galvanized steel,
glass piping, steel, wire, and wood; 30′ highest point × 75′ wide × 120′ deep. Installed
at University of South Florida, Tampa. Collection of the artist. Photo: artist.

21.14
From the Series Entitled How to Catch and Manufacture Ghosts, "Collected Ghost
Stories from the Workhouse," detail of spinning rings. Steel, wood, and motorized
parts, 20′ diameter. Photo: artist.

21.15
From the Series Entitled How to Catch and Manufacture Ghosts, "Collected Ghost
Stories from the Workhouse," detail of agitation canisters. Galvanized steel and
motors, 20′ square. Photo: artist.

thought my soul looked like an agitation device in a washing machine. I thought I could throw it in and get it cleansed."[35]

While her childhood recollection of agitation devices in washing machines served as a basis for the agitators in the canisters in *Collected Ghost Stories,* a more frightening episode from her youth—when Aycock was trapped in a gyrating amusement park fun house—became the basis for *The Savage Sparkler* (fig. 21.16) of the following year:

The floor was becoming the wall and the walls were becoming the ceiling, and I was supposed to walk through it. I couldn't. So I just got down on the ground and started screaming, "Turn the machine off!" I remember that experience as being really scary. But I also remember that the scary part was fun. So I tried to make work that was equivalent to the feeling of being in a tumbling world where you can't stand up straight because everything keeps changing.[36]

The mixture of fear, amazement, exhilaration, and vertigo that made up this experience, which the artist equates with the changes affecting the world at large, was no doubt also a source for her 1971 *Sand/Fans.* Aycock's entrapment in the rotating fun house suggests a similar albeit far more dramatic means for accomplishing the same task as absolving sins in a washing machine for the soul. However, instead of a metonymic association between one's self, one's clothes, and one's soul, this whirling space operated directly on her own body. Over the years she has supplemented this dramatic episode with a growing awareness of nuclear reactors, particle accelerators, wind tunnels, and cement mixers on trucks. She has also described jet turbines as being alternately repelling and attracting, so that they become hypnotically sublime forces capable of transfixing one's vision and interest.[37] To transpose this experience into sculpture, Aycock worked with a team of assistants to construct *The Savage Sparkler* out of a series of

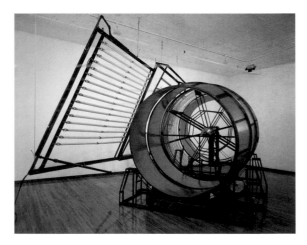

21.16

Alice Aycock, *The Savage Sparkler,* 1981. A series of large revolving drums with a rapidly spinning section, a suspended rack of hot coils, fluorescent lights, steel, anodized aluminum, fans, motors, copper tubes, and sheet metal; approx. 10′ high × 10′ diameter × 20′ long. Collection of Myers/Kent Gallery, State University College, Plattsburgh, New York. Photo: Jon Abbott. (also plate 5)

large revolving drums that spun rapidly and in different directions, a suspended rack of hot coils, and other components, including a highly theatrical green fluorescent light that reminded her of "the hot cobalt-blue water that is associated with reactors."[38]

The source for this piece's title helps to gauge the quality and range of Aycock's thought at this time. The original Savage Sparkler was the ingenious creation of Frederic Savage, who wished in the early nineteenth century to find a means for converting electricity to fairground use. A portable electric-light engine, Savage's Sparkler depended on a reciprocating steam engine joined by a belt-drive to a dynamo. Savage's highly original machine weighed seven tons and was extremely temperamental, making it far too cumbersome and erratic ever to become popular. As a type of steam engine, Savage's machine resonates with the "Analytical Engine" that the British mathematician, astronomer, and inventor Charles Babbage—the real-life Dr. Frankenstein, according to many of his contemporaries— planned to design beginning in the 1830s. Babbage hoped that his elaborate steam-driven mechanism would be able to execute calculations so that people would no longer need to engage in repetitive mental exertions, making it a proto-computer.

In Aycock's sculpture, this early "jerry-rigged" generator serves as a metaphor for the unwieldy and inexact tools used over the past two centuries to harness first the mysterious forces of electricity and more recently those of nuclear power. Circulating around nuclear reactors and atom smashers, these phantoms—that is, atoms— are as elusive today as electricity was earlier. Rather than being harnessed by these machines, they taunt them with glimmers of understanding as well as schizophrenic dislocations. Whereas Aycock needed a writerly prose to reinforce this form of dislocation in her sculptures of the mid and late 1970s (and even continued this approach on occasion in the early 1980s), the allusions to the

conundrums of theoretical physics that are created by *The Savage Sparkler* are sufficient to haunt her sculptural forms by reminding viewers of their inadequacy. In her art she establishes intentional deficiencies that oppose many of the simple-minded self-satisfactions of futuristically oriented sculpture; she also opts for delaying the signified, which might be construed as yet another form of ghost haunting her postmodern machines.

In *Hoodoo (Laura): Vertical and Horizontal Cross Section of the Ether Wind* (figs. 21.17, 21.18, 21.20), also from the series *How to Catch and Manufacture Ghosts,* Aycock was encouraged by her readings of Foucault to appropriate segments of discredited histories similar to Savage's Sparkler. In this piece she plays with hoodoo, a variant on voodoo, a syncretic religion joining African folk medicine with aspects of Christianity that has traditionally been important in the American South. The name "Laura" was taken from the haunting 1944 Otto Preminger film about a presumably murdered socialite played by Gene Tierney whose ghostlike absence propels the story. And the reference to the ether wind in this work's title signals the no longer viable scientific belief that light's medium of travel is a rigid medium called "luminiferous ether."

More closely attuned to Duchamp's *Large Glass* (fig. 21.19) than any of Aycock's other sculptures, *Hoodoo (Laura)* documents her careful reading of his notes, her fascination with his ability to create enduring conundrums, and her intrigue with his mechanomorphic forms, which she sees as superannuated, bordering on quaint. Situated in the center of this work is the type of vent commonly used for circulating air in barns and stables and employed in commercial and industrial contexts in urban areas. The association of this object with its prosaic function is a semiotic that enables Aycock to characterize the ether wind as an antiquated idea, yet still valid for art. The artist has confirmed that this object is intended to be both the equivalent of Duchamp's Bride in *The Large*

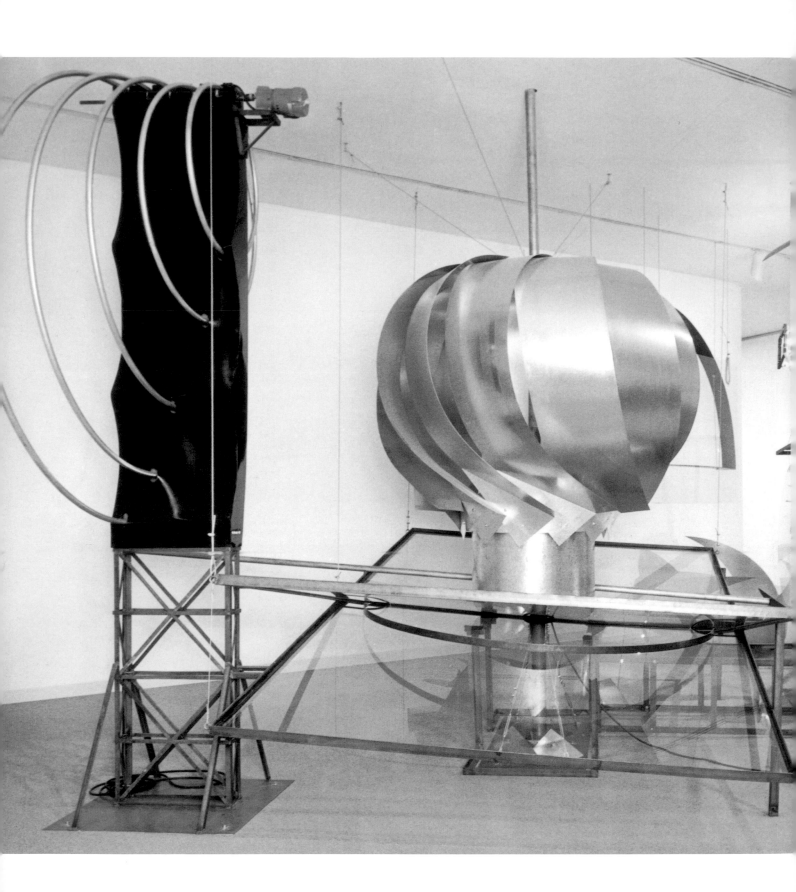

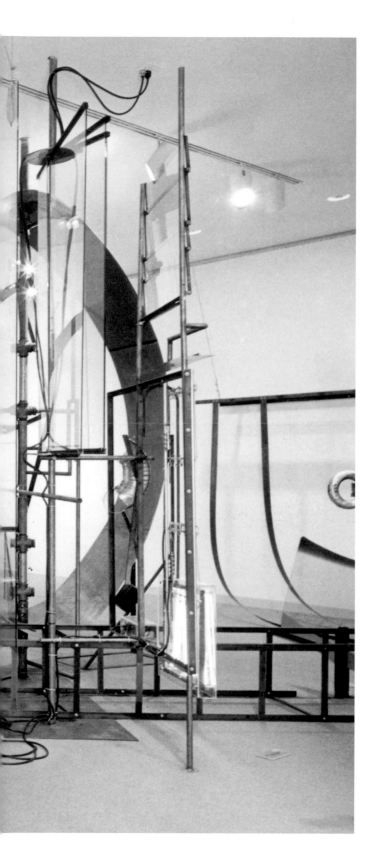

21.17
Alice Aycock, *Hoodoo (Laura): Vertical and Horizontal Cross Section of the Ether Wind*, from the series *How to Catch and Manufacture Ghosts*, 1981. Plexiglas, glass, steel (also galvanized), motors, and neon; approx. 10′ high × 34′ wide × 30′ deep. Los Angeles County Museum of Art, Los Angeles, California. Photo courtesy Hirshhorn Museum and Sculpture Garden.

21.18
Hoodoo (Laura): Vertical and Horizontal Cross Section of the Ether Wind. Photo: artist.

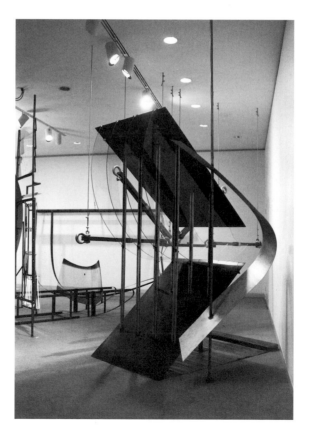

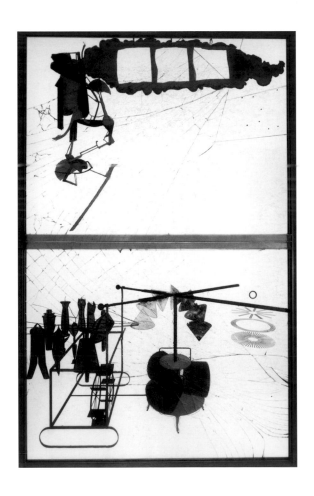

21.19
Marcel Duchamp, *The Bride Stripped Bare by Her Bachelors, Even (The Large Glass),* 1915–1923. Oil, lead, wire foil, dust, and varnish on glass, 8′ 11″ × 5′ 7″. The Philadelphia Museum of Art. © 2004 Artists Rights Society (ARS), New York/ADAGP, Paris/Succession Marcel Duchamp.

21.20
Hoodoo (Laura): Vertical and Horizontal Cross Section of the Ether Wind, detail. Photo: artist.

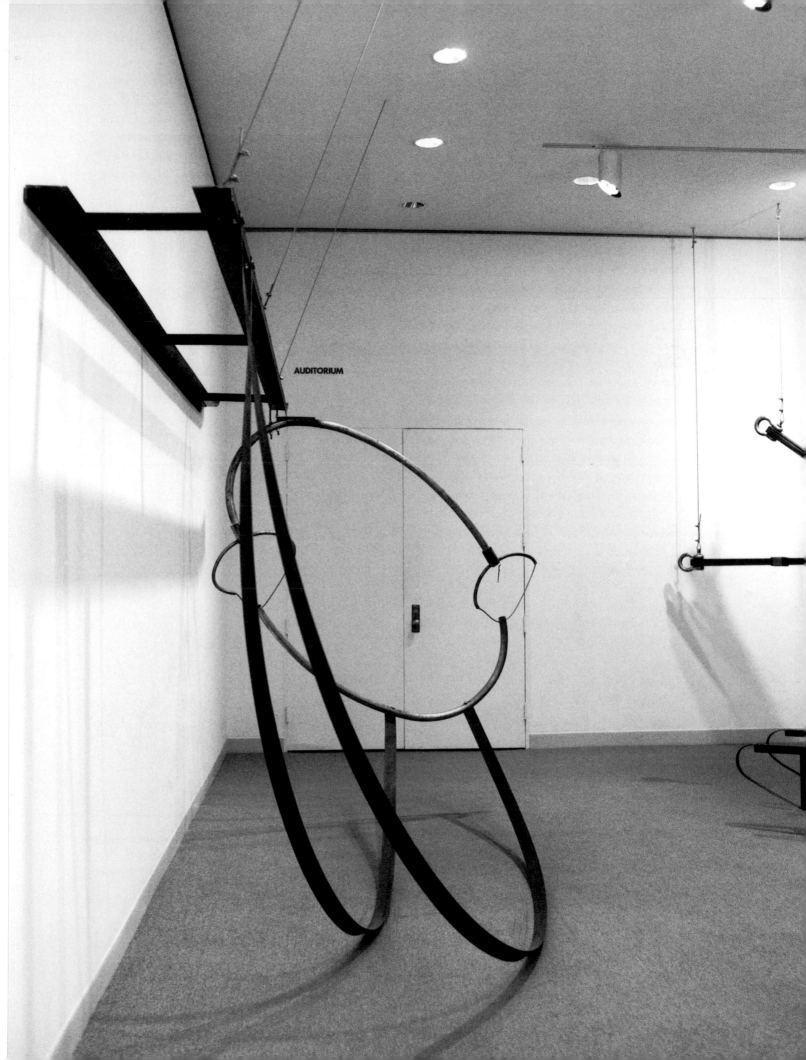

entirely different project of looking at its prehistory in the extraordinarily rich area of mnemonics, in which human beings commit to memory daunting amounts of information in record times. Her aim has little to do with the glorification of machines. In fact, she only intended to ferret out the history of human memory techniques and to appreciate their workings in the era antedating digital technology and thereby understand the relationship between memory and forgetfulness. Witnessing the loss of memory in her family's greatest storyteller increased Aycock's desire to comprehend both the miraculous workings of anamnesis and the traditional historical modes and formulas for enhancing it.

Soon after she began creating the wonderfully implausible piece *The Rotary Lightning Express*, which enabled her to fantasize about curing her grandmother's dementia through the quasi-divine intervention of a bolt of lightning, Aycock constructed *Large Scale Dis/Integration of Micro-Electronic Memories (A Newly Revised Shantytown)* (figs. 22.1, 22.2, 22.3, 22.4, 22.5, 22.6), a piece that refers, among other things, to the artist's overloaded situation at the time.[1] Situated on Manhattan's Battery Park City landfill next to the West Side Highway, the piece was begun in the summer of 1980 but was never completed, though it was allowed to remain at this site for several seasons. Although its incomplete state and consequent emphasis on process were unintentional, the quality of being *in medias res* endowed this work with a special poetic resonance, as if the artist herself had come under the sway of her subject of memory (integration) and forgetting (disintegration). Similar to a number of Aycock's sculptures of this period, *Large Scale Dis/Integration* depended on diagrams for microelectronic circuitry and on Tantric beliefs that, in the words of Edward Fry, "express[ed] the multi-layered density of the human mind."[2] Originally Aycock wanted the piece to function like an elaborate maze punctuated with empty spaces that would

require viewers to find a way to bridge them in order to enter the next space.[3] Consisting of three major parts that look as if they are simultaneously being constructed and deconstructed, this piece includes a wheel recalling either an amusement park carousel or a roulette wheel,[4] an extensive latticework made of a balloon frame on stilts, and motley painted walls or false fronts constructed of salvaged doors from New York's Lower East Side. The doors no doubt functioned as metonyms for Aycock's grandmother's house, since they called to mind the fictive story included in *Project Entitled "The Beginnings of a Complex..."* about the locked doors in the side of the house that her grandmother no longer used. Each of the three divisions of the Battery landfill piece can be related to a specific character, as the artist has enumerated:

A child who had big boxes of crayons and drawing paper was in my mind. And there's a streetwalker. She wants to remember all the rooms she's been in; she wants to lay out the patterns of her rooms so that she can remember her life. And there's an old woman who assigns doors to different parts of her life, to different weeks of her life, and when she can't remember, there's a blank door.[5]

The three figures are evidently intended to represent the three ages of a person's life—childhood, maturity, and old age. Aycock said, "I imagined the child as the Headlight Child—a boy unknowingly crayoning over the drawings or 'playing a game of draughts' with the world."[6] In addition, the three respectively point to phases of dreaming, remembering, and partially forgetting.

The framed doors leading nowhere that form the final segment of this piece provide a clue to the mnemonics crucial to memory. At the time, Aycock was reading Jonathan D. Spence's *The Memory Palace of Matteo Ricci*.[7] Spence's book examines the memory techniques that this Jesuit priest taught the Chinese governor of Jiangxi and his three sons in the late sixteenth century.

Ricci's formula depends on lessons he learned at the Jesuit College in Rome that sustain a long tradition going back to Cicero. To begin this process, Ricci points out that one must devise a system for storing concepts. He recommends architecture as the most obvious vehicle for doing this and indicates that palaces, because they are the most commodious of all buildings, are extremely useful analogies for lodging all the objects one might wish to recall. Whether or not architecture is one's repository for facts, Ricci advises that one choose some type of known locale by using one of the following strategies: (1) develop, if possible from life, a series of loci; (2) elaborate a series of spaces from one's imagination; or (3) mix fictive and actual spaces in one's search for an apt mnemonics. After deciding on a system, Ricci's pupils were instructed to proceed as follows:

Once your palaces are all fixed in order, then you can walk through the door and make your start. Turn to the right and proceed from there. As with the practice of calligraphy, in which you move from the beginning to the end, as with fish who swim along in ordered schools, so is everything arranged in your brain, and all the images are ready for whatever you seek to remember. If you are going to use a great many [images], then let the buildings be hundreds or thousands of units in extent; if you only want a few, then take a single reception hall and just divide it up by its corners.[8]

So prodigious were Ricci's own mnemonic feats that he was able to run through a random list of five hundred Chinese ideograms and then enumerate them in reverse order. In addition, he could repeat volumes of Chinese literature after having perused them once.[9] Ricci's art of memory can be thought of as a pre-digital computer algorithmic symbol manipulator, because his algorithms follow the method of specifying each step in a given procedure without ambiguity so that there is no question about the next stage, and working within

an overall system that guarantees that if each phase is correctly taken, the desired result can be produced in a finite number of moves. This connection between mnemotechnics and computers is central to Aycock's works focusing on memory. In them the subject of individual and collective knowledge as well as its retrieval and loss is of crucial importance.

Ricci's example provided Aycock with a diagram for positing mnemotechnics as a series of brightly colored doors in *Large Scale Dis/Integration of Micro-Electronic Memories*. However, it is my contention that because these salvaged doors had layers of chipped and peeling paint, they refer not just to one set of reminiscences but to generations of them. And since they have been removed from the houses and apartments whose interiors they protected, they symbolize in this installation dislocated and thereby schizoid memories, not established ones.[10] Lined up beside one another, these doors signal the many routes taken in a life as well as the ones not ventured, those lives remembered and those as easily forgotten. In their fragility and vulnerability, they appear to leave open the possibility of whether memories have been integrated or disintegrated, as Aycock's title indicates.

In addition to their familial and social ramifications, these doors provide an intriguing codicil to Robert Morris's 1978 essay "The Present Tense of Space." Morris distinguishes between involved experiences that he labels with the personal pronoun "I" and recollected ones that he counters with the objective case, "me." As he points out, "The distinction is a thoroughgoing one dividing consciousness into binary modes: the temporal and the static."[11] One might hypothesize that in this piece Morris at long last counters, albeit unsuccessfully, Michael Fried's famous essay "Art and Objecthood," which took Morris's phenomenological minimalism to task by pitting the theatricality of minimalism with the presentness of modernist art. In his polarity, Morris's "I"

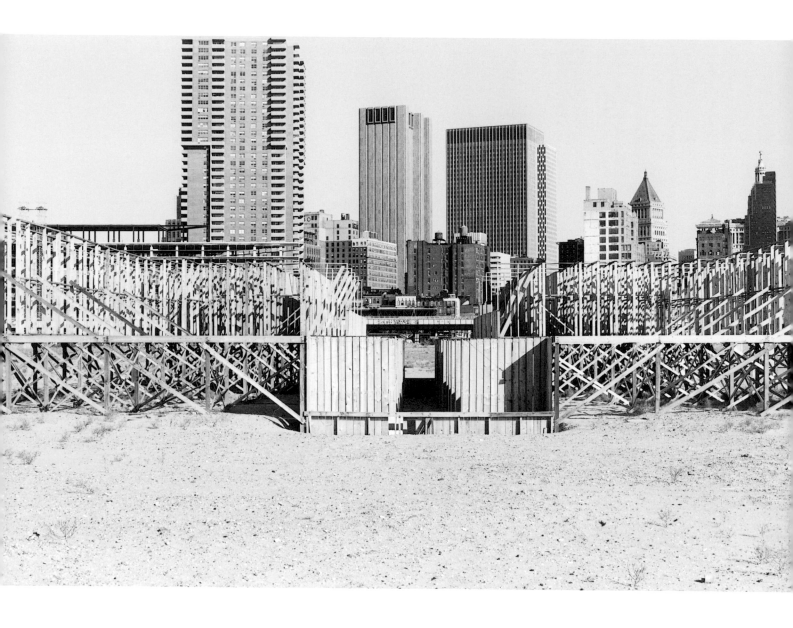

22.1

Alice Aycock at Battery Park City landfill while working on *Large Scale
Dis/Integration of Micro-Electronic Memories (A Newly Revised Shantytown)*, 1980.
Photo: Allan Tannenbaum.

22.2

Alice Aycock, *Large Scale Dis/Integration of Micro-Electronic Memories (A Newly
Revised Shantytown)*, 1980. Wood and used doors; ramp 75′ × 105′, five walls of doors
of varying lengths, 8′ high, carousel 14′ × 15′ × 30′. Exhibited for Creative Time at
Battery Park City landfill, New York City. Collection of the artist. Photo: artist.

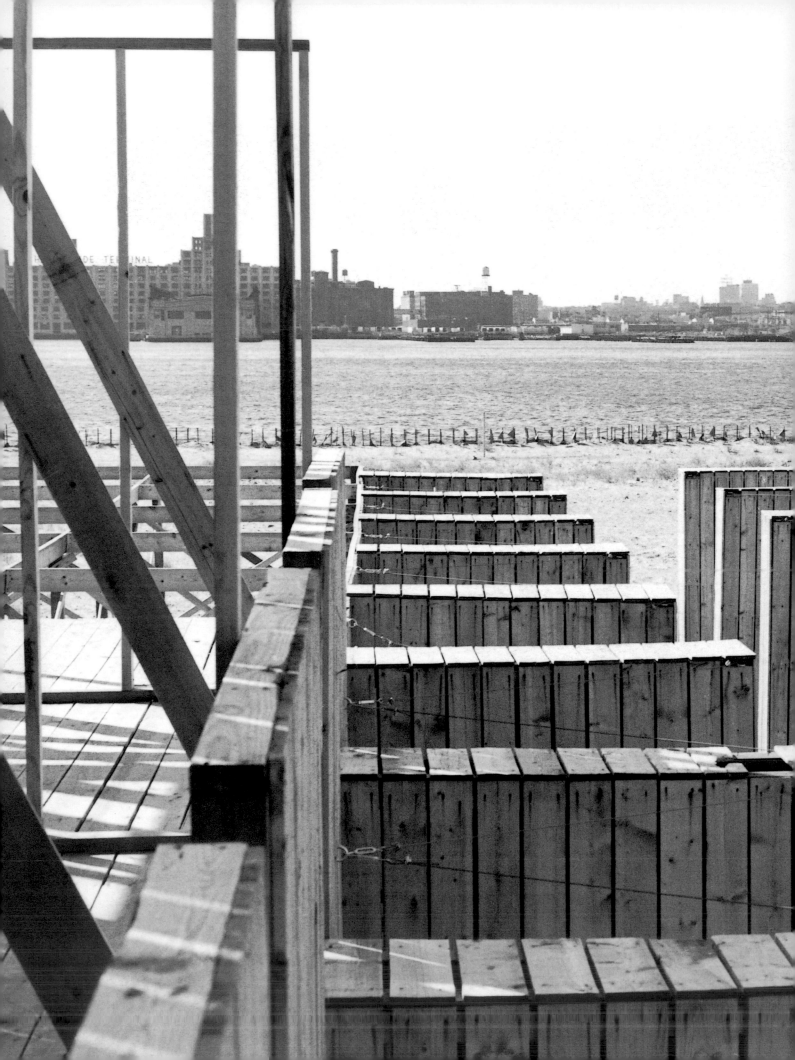

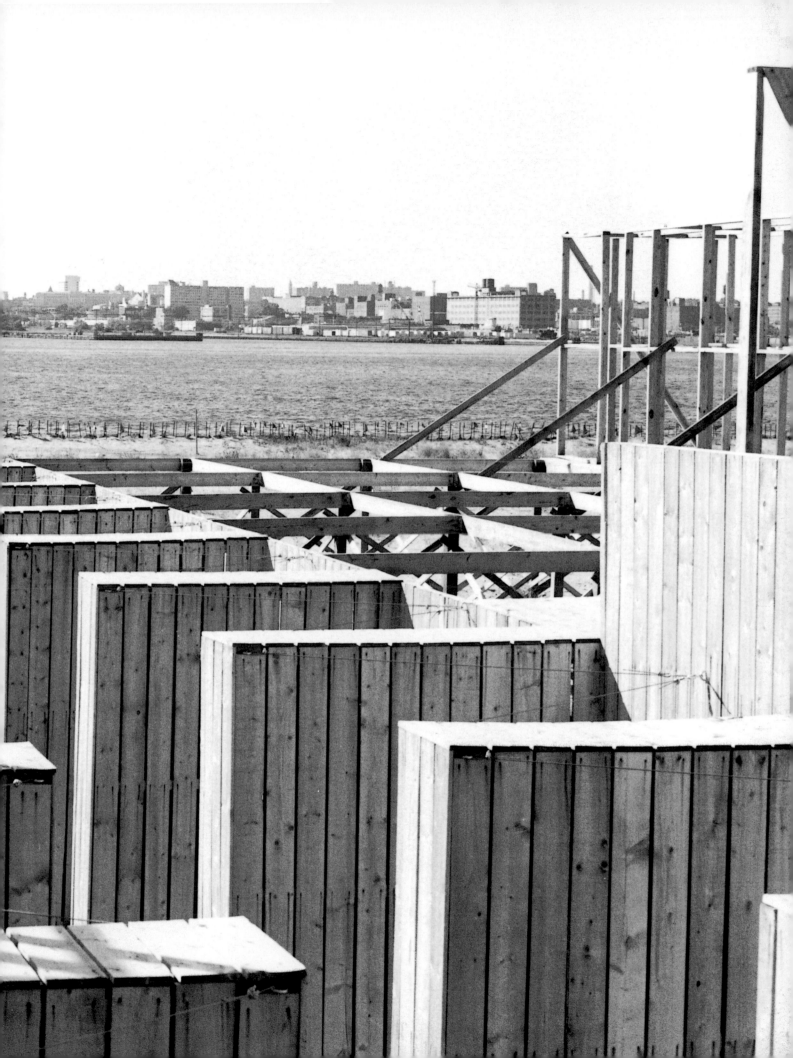

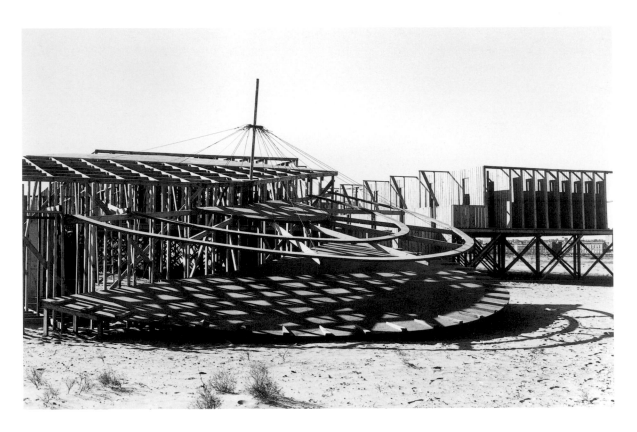

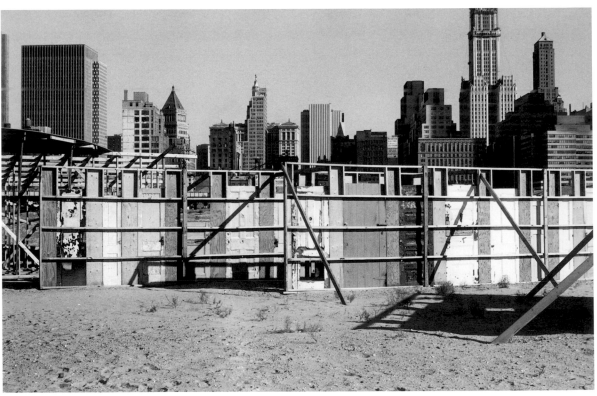

stands for the theatrical approach and his "me" represents "the self reconstituted from various remembered indices."[12] While the "me" appears to be the formalist viewer, one suspects that Fried would find in this severed and dislocated self an unacceptable characterization for the universal spectator he has in mind. When Morris couches this divided self in a philosophic framework in this article, he states, "The 'I' is phenomenological époché—bracketing the me—the results— perception of object—I—perception of architecture me."[13] Later in a footnote he concludes, "With [my] mirror works the 'I' and the 'me' come face to face,"[14] thus indicating a reliance on the Lacanian mirror state, known as the Imaginary, when ego identity is formed as an act of alienation in which the "me" is grasped in terms of the "I" or some equally available image of wholeness. In *Large Scale Dis/Integration* Aycock places Morris's "I" of direct spatial apprehension in direct opposition with the "me" of dreams, reflection, and memory to accentuate not only their differences but also their overlapping interests and shared concerns. Differing from Morris, we might conjecture that the "me" is the creation of the "I" and venture the idea that the "I" is in turn influenced by its creation so that the two are inextricably intertwined, as Aycock's piece indicates.

That the subjects of mnemotechnics and her grandmother Martha Morgan Aycock continue to be important for Aycock is confirmed by her 1984 *The New China Drawing (The World Above, the World Below)* (fig. 22.8). This monumental drawing describes a woman who made doors for each week of her life, and each door in turn opened onto streets that constituted special remembered worlds. There are three versions of this drawing. The first, which is particularly elegiac, attempts to provide each important memory with a door so that Aycock's grandmother could walk through her memories and reminisce about her life, whose overall configuration resembles a giant teapot. For each memory, Aycock provides a sign as a symbol for

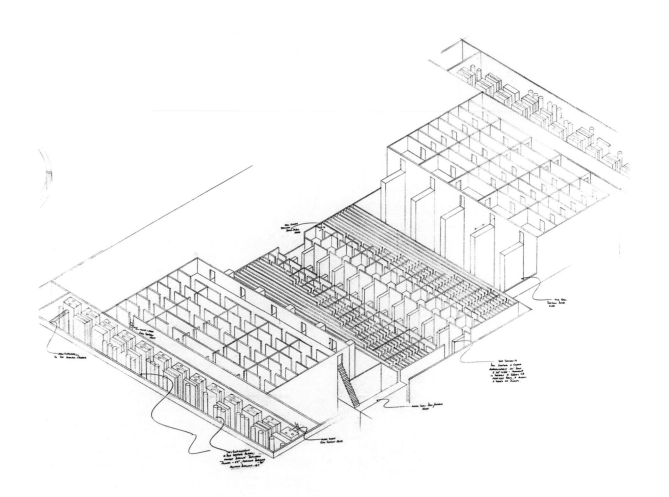

the memory that her grandmother has lost. The direct antecedent for this work is the 1665 town plan of Canton published in Jan Nieuhof's *L'ambassade de la Compagnie orientale* (fig. 22.9), which is reproduced in Rudofsky's *Architecture without Architects,* one of Aycock's long-term, favorite sources. An ironic aspect of this work is its reference to China rather than Japan, where her grandmother lived as a young woman. This substitution implies that her grandmother is so out of touch with her own past that she can only recall once visiting the Far East. Since China has long been an apt sign for the population explosion, it is a useful sign for communicating the teeming nature of proliferating memories and one's inability to access all of them. In addition, the Chinese reference and the work's date allude to Ricci's extended stay there in the seventeenth century.

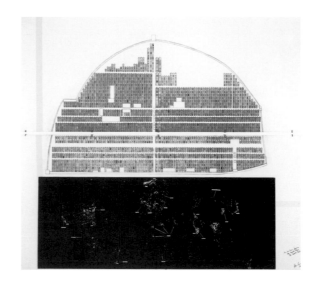

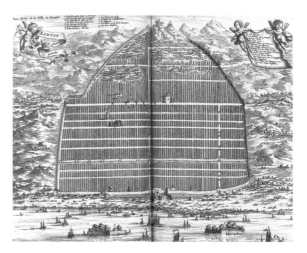

22.7
Alice Aycock, *The Paradise Romance #3: Leaping the Chasm, a Mayan Manuscript Concerning the Motions of Venus,* 1979. Pencil on vellum, 96″ × 61½″. Private collection. Photo: John Ferrari.

22.8
Alice Aycock, *The New China Drawing (The World Above, the World Below),* 1984. Ink, pencil, and crayon on Mylar, 96″ × 108″. Museum of Modern Art, New York, fractional and promised gift of Sarah-Ann and Werner H. Kramarsky. Photo: Fred Scruton. (also plate 9)

22.9
Town plan of Canton, China, from Jan Nieuhof, *L'ambassade de la Compagnie orientale . . . ,* 1665. Courtesy of the New York Public Library.

293

23 Enmeshed in Wisdom's Nets

The demons-blacksmiths appeared to Solomon in a dream and brought him to their Demon-King, who was struck with fear upon seeing Solomon, and asked him what he had in his belly. Solomon answered that he was full of the grace of God, and that this grace protected him against evil spells. Then he spoke some words of power. The King of the demon-blacksmiths was angered and ordered his servants to kill the offender. Solomon said the following words: "Lofham, lofham. . . ." The executioner's mouth was stopped up, some of his followers were drowned, others were reduced to ashes. The King alone survived. Solomon seized him by the throat, struck him, and commanded him to give up his secrets. The King revealed the evil spells for provoking miscarriages, or stealing a victim's heart, for making monks and nuns sin, for making princesses have bastards, for appearing in many forms (with the face of an ass, a horse, a dog, a lion, a leopard, and so on). Solomon struck him again and said a prayer.

Jacques Mercier
Ethiopian Magic Scrolls, 1979

In 1982 the prospect of a mid-career retrospective exhibition of Aycock's work created since 1972 raised the ante in the already high-stakes game she was then playing with science and industry in her sculpture. The retrospective show would open in Stuttgart in 1983 and then tour to museums in West Germany, the Netherlands, and Switzerland. Also encouraging Aycock to look even further afield were a show scheduled for 1983 at Chicago's Museum of Contemporary Art and a summer in 1982 spent working in the innovative sculpture park at the Fattoria di Celle near Pistoia, Italy, where Morris, Oppenheim, Anne and Patrick Poirier, Richard Serra, and George Trakas were all creating major

permanent pieces. Specifically, Aycock began to search for historical sources that could represent the discredited forms of rationality she had found so intriguing in her readings of Foucault. In her words, "I am more interested in wrong-headed than right-headed schemes."[1] This interest in altering prescribed ways of thinking by challenging viewers to new and even disorienting systems of thought also has a basis in Morse Peckham's *Man's Rage for Chaos*. Peckham's book which Aycock had read in the late 1960s, proposes an instrumental theory for art as a primary means for enabling societies to grow.[2] No doubt Peckham's ideas had prepared Aycock to expect that a significant and innovative work of art would explode conventional patterns of thought even if its destructive wake did not replace these patterns with new models. "Art," according to Peckham, "is a rehearsal for those real situations in which it is vital for our survival to endure cognitive tension, to refuse the comforts of validation by affective congruence when such validation is inappropriate because too vital interests are at stake."[3]

In her efforts to confront models of reality radically different from those embraced by the contemporary world, Aycock discovered a treasure trove in early scientific and engineering diagrams that included the alchemical plans of the sixteenth-century mystic Robert Fludd.[4] She also visited the Institute and Museum of the History of Science in Florence, whose incredible collection comprised an impressive array of exquisite scientific instruments. Aycock was especially interested in the instruments employed by Galileo in Padua, such as his monumental astrolabe (fig. 23.1), as well as mechanisms made under his direction to be sold or used as important gifts for dignitaries and even royalty.[5] No doubt her excitement about these early instruments had been fueled in part by her careful reading of Kubler's *The Shape of Time*, which begins by considering art as part of a class of objects that includes tools and writing as well as the objects commonly deemed art.[6] The museum

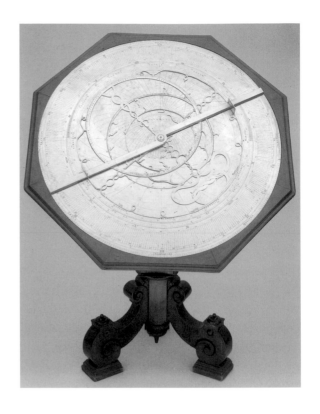

23.1
Egnazio Danti or Giovanni Battista Giusti, astrolabe, 16th-century Florence, called "Galileo's astrolabe." Brass and wood, 33″ × 33″. Courtesy of Istituto e Museo di Storia della Scienza, Florence.

296

in Florence permitted her to think of machine art in terms of a much longer trajectory that extended back to the Middle Ages and to contemplate fabricating instruments with a similar delicacy and refinement. At the time she turned away from her usual practice of relying mainly on written texts and started to free-associate with diagrams. "Diagrams," she emphasized, "enable me to attempt to understand how the human mind functions. Diagrams enable me to come to terms with not just the look of something but its very structure. In the early 1980s I stopped reading so intensely and started putting together an image bank. I just looked and looked and looked. At a certain point I did not want to follow the chain of more and more thinkers."[7] Instead of following established lines of thought, she wished to create openings—tears in the ideological universes that she had inherited. In an interview constituting part of the text for the Stuttgart retrospective, Aycock recollected the process of obtaining worthwhile images and the equally important process of free-associating about them:

My assistant, Wendy Habenicht, goes to the library and she brings back diagram after diagram.... I have a book called the Encyclopedia of Illustration *which I look at constantly. Initially there are line drawings that form a schemata that gives me a clue to organizing things. And then in that schemata— which is not filled in—I begin to see an alphabet and that alphabet connects to a thought and that thought connects to the brain and so on. For me that's the conceptual part, that's the bait that makes it more than just a kind of exercise.*[8]

These plans as well as Colin Ronan's *Science: Its History and Development among the World's Cultures* and *Asher & Adams' Pictorial Album of American Industry 1876*, in addition to her acquaintance with antique scientific instruments, supplied Aycock with new sources for her art and with distinctly different sensibilities.[9] Foucault's

ideas had impressed on her the importance of studying no-longer-useful schemes; and she viewed diagrams of these esoteric systems not as illustrations of reality but as testaments of belief and radical constructions of the world that had since been discarded. In addition diagrams have fascinated her because viewers can regard them alternately as information and art and can oscillate between the very different activities of reading and viewing. Referring to the superannuated information of interest to her, Aycock exclaimed to Fineberg, "They're all wrong; there's never been one that was really accurate, and that also fascinated me, the fact that these schemes are really works of the imagination."[10] An early foray in this realm is her free association about Leonardo's *Study of the Flow of Water* (fig. 23.2), a series of drawings of turbulent water flow that led to Aycock's sculpture *Leonardo's Swirl* (1982) (fig. 23.3). These Renaissance drawings can be considered part of the prehistory of chaos theory, which was attracting a great deal of attention in the early 1980s.

Aycock found that many antique pieces at the Florentine museum were created with such subtlety and refinement that they looked like masterpieces of the jeweler's art, as in fact a number of medieval, Renaissance, and baroque examples were intended to be. Recent research has disclosed that, rather than representing workaday tools, the most spectacular pieces in the Institute and Museum of the History of Science were made for educative purposes or, more simply, to dramatize the allurements of scientific quests.[11] These finely crafted and elaborately articulated antique instruments served as the inspiration for a number of Aycock's works over the next decade. Among them are *The Paradise Romance* (1979) (fig. 23.5), *Greased Lightning* (1984), *The Universal Stirrer* (1984), *The Dice Game for Diverse Visions* (1986) (fig. 23.7), *The Six of Pentacles: To Know All Matter of Things, Past & Future* (1987) (fig. 23.6), *Three-Fold Manifestation III* (1988), and *The Descent and Re-ascent of the Soul II* (1988). Most of

23.2

Leonardo da Vinci, *The Study of the Flow of Water,* c. 1505. The Royal Collection. © 2003 Her Majesty Queen Elizabeth II.

23.3

Alice Aycock, *Leonardo's Swirl,* 1982. Galvanized sheet metal, 5′ diameter × 3′ high. Collection of Camille Hoffman, Chicago. Photo: Fred Scruton.

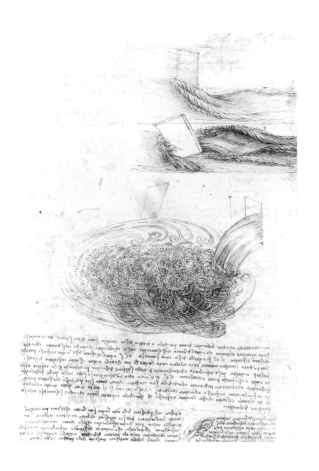

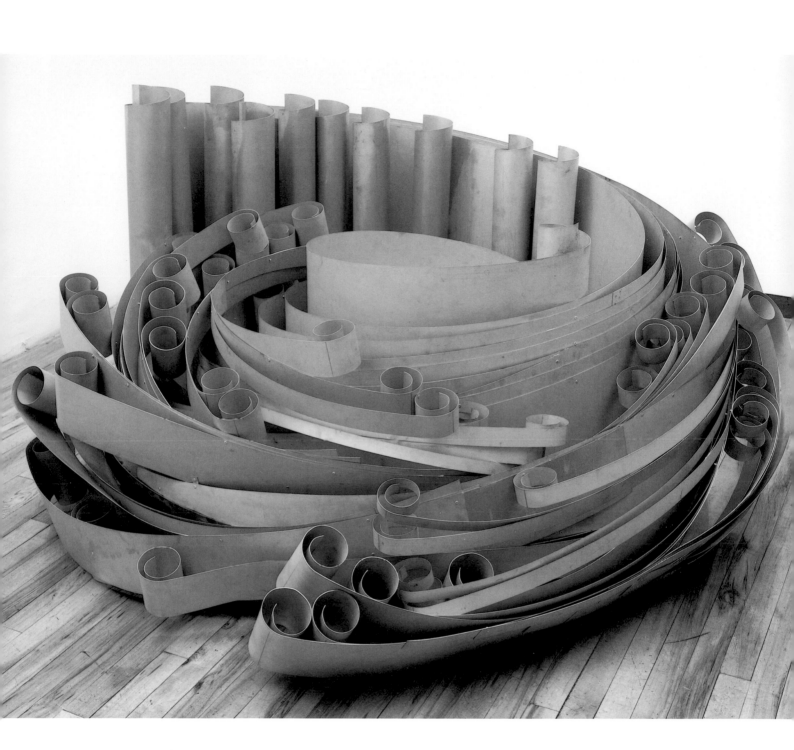

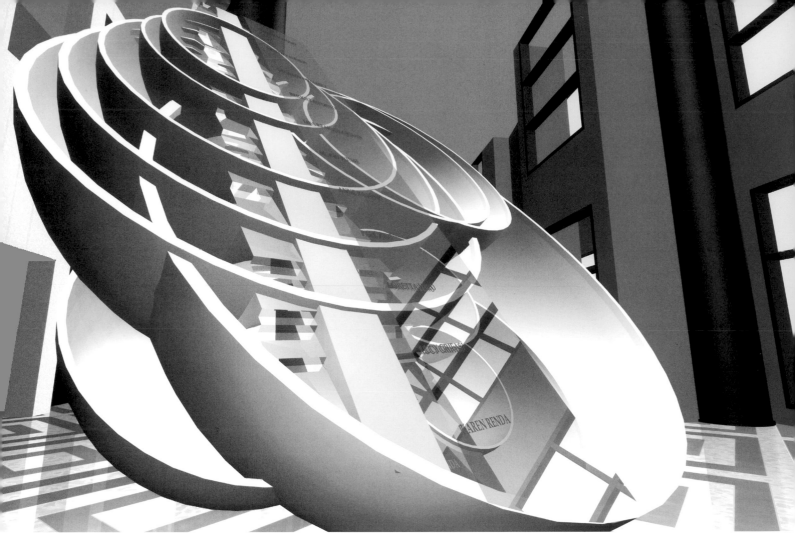

23.4

Alice Aycock, *Proposal for a 9/11 Memorial to 11 American Express Employees,* for the American Express Headquarters, New York City, 2002. Unbuilt. Computer graphic: Mark Watkins.

23.5

Alice Aycock, *The Paradise Romance (after Kepler's Mysterious Cosmography for Ptolemy),* second proposal for De Oosterpoort Cultural Center, Groningen, Holland, isometric, 1979. Pencil on vellum, 24″ × 30″. Private collection. Photo: John Abbott.

DREAM 1

1634
Dear Irene,

Many years ago I had a dream about traveling to
the moon. "The initial shock is the worst part
of it for [one] is thrown upward as if by an ex-
plosion of gunpowder....When the first part of
the journey is completed, it becomes easier
because on such a long journey the body...es-
capes the magnetic force of the earth....At
this point we set the travelers free and leave
them to their own devices: like spiders they
will stretch out and contract, and propel
themselves forward by their own force....
[Moon creatures] have no fixed and safe habit-
ations; they traverse in hordes, in a single
day, the whole of their world, following the
receding waters either on legs that are longer
than those of our camels, or on wings, or in
ships....

 --Johannes Kepler, Somnium

DREAM 2

September 19, 1947
Dear Irene,

Several months ago I dreamt that I was walking
along a road. Suddenly I saw a "sphere approach
the earth at high velocity....It became pos-
sible to discern the maritimes on its surface
which were lines of longitude.... As we gazed,
another and yet another sphere emerged from the
horizon and sped towards the earth. Each sphere
did in turn crash work as a bomb would crash....
These spheres, then, were falling at intervals
all around, but all of them ...well beyond the
point at which they might annihilate us. There
appeared to be a danger of shrapnel."

 --C.G. Jung, Flying Saucers

DREAM 3

September 19, 1957
Dear Irene,

Last week I dreamt that "a flying saucer floated
into view, passed at eye-level before us and
lay there, clear and shining in the sunlight.
It did not look like a maritime but like a deep
sea fish, round and flat."

 --C.G. Jung, Flying Saucers

DREAM 4

June 7, 1979
Dear Irene,

Last night I dreamt that I was coming up out of
the underpass with a friend and my dog, Jack, as
we walked along the highway we came to an opening
in a fence in an abandoned lot. We were on a
hill and could see the whole city below. I recog-
nized the color of the night sky as Giotto blue,
the color in the fresco in which Halley's Comet
appears. Suddenly a silver plane came across the
sky trailing an old car painted white. The car
was tied to the plane with a rope. My friend
turned and said to me, "You're the kind of person
that would try to fly a kite at night."

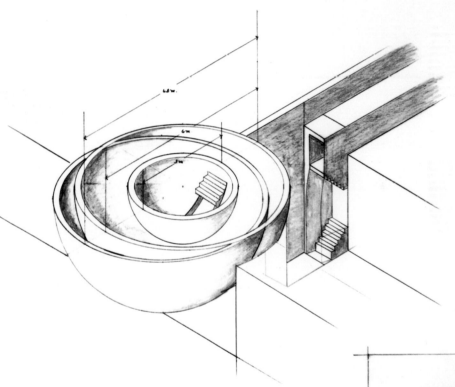

scale 1:33 1/3

23.6

Alice Aycock, *The Six of Pentacles: To Know All Matter of Things, Past & Future*, 1987. Wood, paint, and fiberglass, 26′ diameter, high point 6′ 4″. Exhibited at Kunstforum, Städtische Galerie im Lenbachhaus, Munich, Germany. Photo: Philippe Schonborn.

23.7

Alice Aycock, *The Dice Game for Diverse Visions*, 1986. Brass, mirror, Plexiglas, plaster, wood, motor, and dice; 45″ high × 36″ wide × 88½″ deep. Collection of Martin Sklar, New York. Photo: Fred Scruton. (also plate 6)

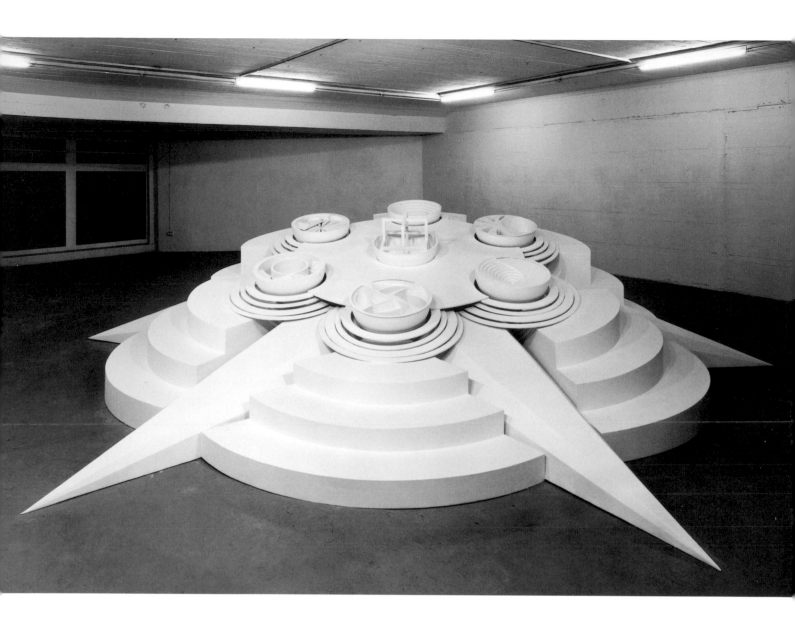

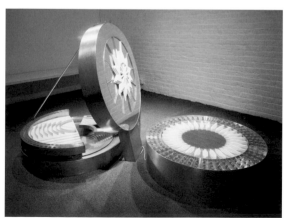

these works court the earlier art of the goldsmith instead of the industrial fabricator: they are precious, highly refined, and provocatively esoteric. Moreover, they seek a perspective far removed from that of the present day to comment on the highly refined new area of digital circuitry that resulted in jewel-like thoroughfares of increasing intricacy. But before Aycock initiated this series, she continued for the next two years to work within an industrial framework that constitutes in many ways an extended farewell to a far different, more cumbersome, and already superannuated form of mechanics.

Entitled *The Nets of Solomon,* her piece at the Fattoria di Celle documents the beginnings of a change from a machine-oriented metaphor stemming from the Industrial Revolution to an evocation of its prehistory. *The Nets of Solomon* comprises five separate pieces, each standing for a distinct intellectual sphere, and is placed on a hillside in the midst of a grand 1840s romantic garden that includes artificial waterfalls and lakes as well as gothic, classical, and fanciful Near Eastern artificial ruins. The individual pieces are arranged so that visitors to the park can't see them all at once, even though they might be able to frame three and sometimes even four of the individual segments within the scope of their vision (fig. 23.12). The five components are *The Astrolabe* (fig. 23.8), named after the early scientific instrument for celestial navigation, which in its planespheric incarnation became a rudimentary analog computer; *The Neutrino Ramps* (fig. 23.13), which refers to the diagram of the jet path of smashed protons and the particles that issue from it (fig. 23.14); *The Philosopher's Stone* (fig. 23.9), referring to "the stone that is not a stone," as alchemists fondly called it, because it was used for correcting "base" and "sick" metals as well as for dealing with human complaints; *Atlantic Hurricane and Gulf Stream Ramps* (fig. 23.10), which charts the movement of a hurricane; and

Hyperbola/Horizon (fig. 23.11), a schematic sketch of our universe.

With such an auspicious and ambitious set of linked subtitles reinforcing the general title, one might expect *The Nets of Solomon* to refer to several manifestations of accrued wisdom represented by these five separate spheres and to celebrate humans' ability to garner knowledge in so many different ways. But considered in light of Aycock's oeuvre, the piece suggests that wisdom entraps as well as illuminates. The title *Nets of Solomon* comes from a book of Ethiopian magic scrolls that Aycock owns. In it, the net was employed by an Ethiopian quasi-mythic, Old Testament King Solomon "for calling up devils, making them reveal their secrets, and employing them for the construction of the Temple."[12] As an artist Aycock has rejected her Catholic upbringing as well as religion in general and has looked instead to such cultures as the early Christians in Ethiopia, who mixed fact with fantasy and sacred texts with indigenous myths grounded in magic.[13]

Solomon's net assumed the form of an often-invoked Ethiopian prayer intended to save believers from the host of spells cited in the epigraph to this chapter. Seen in terms of Aycock's overall work, which plays repeatedly with the semiotic richness theorized by postmodernism, this prayer and Solomon's net represent quaint, no longer viable forms of belief incapable of capturing the shape-shifting devils that in some cultures have often assumed the guise of wisdom. Instead of pointing to efficacy and enchantment, the nets in Aycock's title underscore the ways wisdom becomes enmeshed in ideological biases. At the same time as Aycock was working on *The Nets of Solomon,* she made a drawing of nets, a subject that fascinated her for its flexibility and pliability since nets are systems capable of changing their shape depending on their function.

The name of this piece was so important to Aycock that she used it as the title for a linked series of installations called *The Nets of Solomon,*

Phase II (figs. 23.16, 23.17), which was shown at the Museum of Contemporary Art (MCA), Chicago, in the winter of 1983. She also gave the same name to a separate component of this work, thus confusing an easy and clear-cut rationality in which titles are one-time handles guaranteed to safeguard the uniqueness of individual works. This series of sculptures was occasioned by the donation of her piece *The Celestial Alphabet* to the MCA by noted collectors Paul and Camille Hoffmann (fig. 23.15). A steel ramp, *The Celestial Alphabet* is strikingly similar to *The Neutrino Ramps* in *The Nets of Solomon* at Fattoria di Celle, which is similarly based on schematic diagrams of particles passing through accelerators. The entire work at the MCA was loosely assembled in a linear fashion that calls to mind the Fattoria di Celle piece as well as the form a three-dimensional sentence might take. The component called *The Nets of Solomon* in the MCA installation records the elliptical trajectories of comets moving in and out of the solar system; it even simulates their paths in terms of a spring called a solenoid that is timed so that it will eject steel balls every nine seconds through steel channels, thus comprising a never-ending barrage of two comets. The remaining two parts of *The Nets of Solomon, Phase II,* called *The Game Assembly* and *The Spinning Top,* point to the precariousness of the universe, which can be construed as an elaborate game of chance.

Only a few months after the creation of this work, a new discrete piece also known as *The Nets of Solomon* was incorporated in an entirely different linked sequence of sculptures entitled *The Thousand and One Nights in the Mansion of Bliss* (fig. 23.18). This sequence was first exhibited at the Protetch-McNeil Gallery in New York City and then was shown in a substantially altered form in Stuttgart, where only its first two parts formed the basis for one of the major works in Aycock's traveling European retrospective exhibition, which she changed throughout the tour (figs. 23.19, 23.20). For the Stuttgart showing she added the designation "Part II" and the subtitle "The Fortress of Utopia." The main title for this piece has obvious connections to the bride of the legendary Near Eastern king Shahriyār in the collection of stories making up the *Arabian Nights,* also known as *One Thousand and One Nights.*[14] The framing narrative, employed since the tenth century to cohere this eclectic mixture of Islamic folklore with locales in Baghdad, Basra, and Cairo, is the tale of the condemned bride Scheherazade who manages to escape death by beguiling her husband with a host of cliff-hanging tales. Her stories can be seen as shape-shifting evocations in the face of death and as a means of forestalling its presence. The tactic of using stories to reinvent and delay difficulties has personal resonance for Aycock, going back to her grandmother's tales. In an *Artnews* interview, she acknowledged that the reference to the collection of Near Eastern stories was intentionally ironic because of her "emotionally charged life,"[15] thus marking herself a modern Scheherazade. Instead of composing a verbal narrative to allay difficult circumstances, Aycock constructs an elaborate installation piece in several segments with distinct breaks between each component.

Although *The Thousand and One Nights in the Mansion of Bliss* is not her first blade piece— *Sand/Fans* merits pride of place in this category— it is the work in which Aycock's aggressiveness and vulnerability are most apparent. Art critic Sanford Kwinter tantalizingly describes this type of machine: "Two scimitarlike forms spin menacingly and cause the entire structure to shiver and wobble sadistically. This is a decidedly mean work, essentially psychological in effect, suggesting some kind of oriental guillotine, abstract castration apparatus or ecstatic bachelor machine."[16] Aycock initiated such blade machines soon after seeing Cuisinart blades in action; they seemed to her to be latter-day descendants of Duchamp's chocolate grinder. In her opinion Duchamp was particularly French in his obsession with the kitchen. Responding to this artist and to her interest in

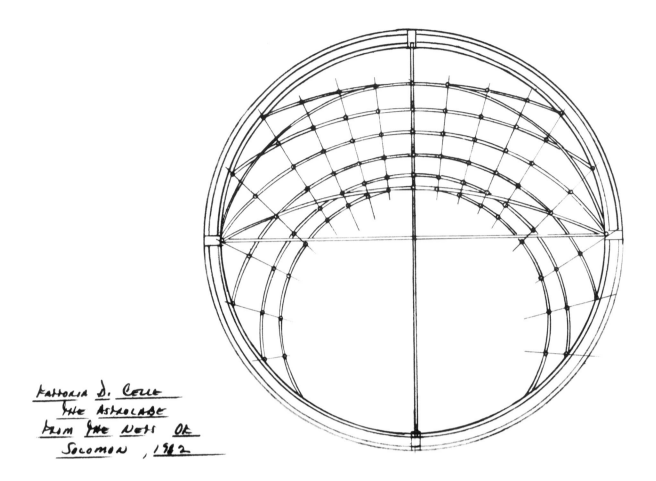

Fattoria d. Celle
The Astrolabe
from the Nets of
Solomon, 1982

23.8

Alice Aycock, *Fattoria di Celle: The Astrolabe from the Nets of Solomon*, 1982. Pencil on vellum, 11³/₄″ × 19″. Collection of Giuliano Gori, Fattoria di Celle, Pistoia, Italy.

23.9

Alice Aycock, *Fattoria di Celle: The Philosopher's Stone from the Nets of Solomon*, 1982. Pencil on vellum, 19″ × 12″. Collection of Giuliano Gori, Fattoria di Celle, Pistoia, Italy.

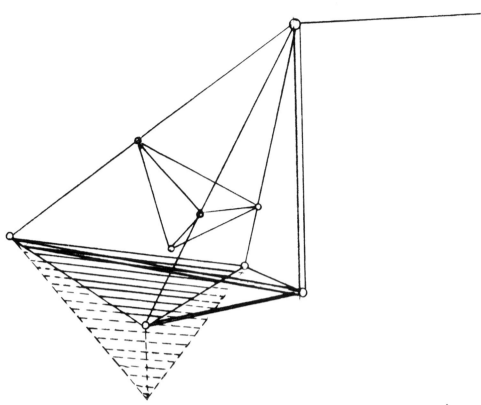

Fattoria di Celle
the Philosopher's
Stone from the Nets
of Solomon, 1982

Fattoria D. Colle
Atlantic Hurricane &
Gulf Stream Ramps
From the Nets of Solomon
1982

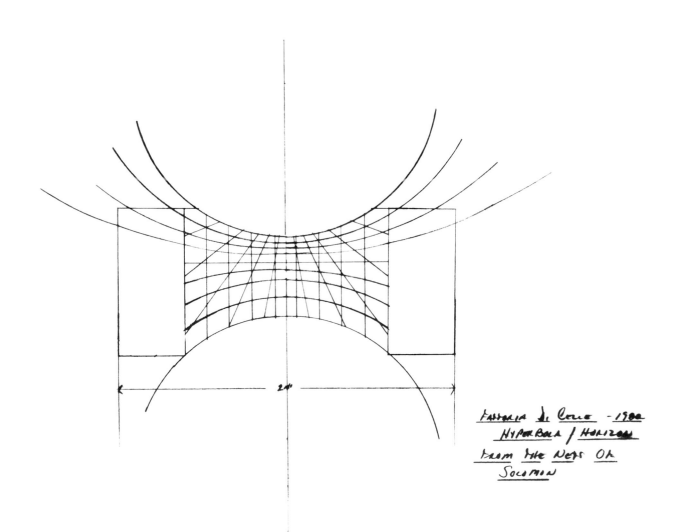

Fattoria di Colle - 1982
Hyperbola / Horizon
from the Nets of
Solomon

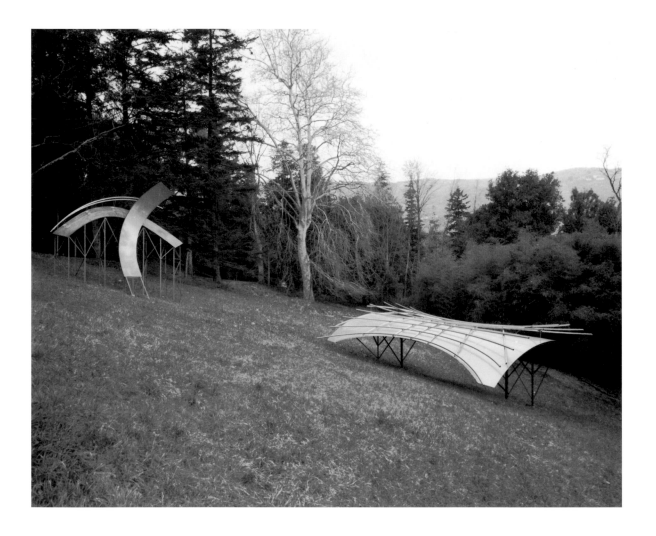

23.10

Alice Aycock, *Fattoria di Celle: Atlantic Hurricane and Gulf Stream Ramps from the Nets of Solomon*, 1982. Pencil on vellum. Collection of Giuliano Gori, Fattoria di Celle, Pistoia, Italy.

23.11

Alice Aycock, *Fattoria di Celle: Hyperbola/Horizon from the Nets of Solomon*, 1982. Pencil on vellum. Collection of Giuliano Gori, Fattoria di Celle, Pistoia, Italy.

23.12

Alice Aycock, *The Nets of Solomon*, 1982, detail. Steel, marble, and assorted metals, dimensions variable. Fattoria di Celle, Pistoia, Italy. Collection of Giuliano Gori, Fattoria di Celle. Photo: Aurelio Amendola.

"***The Nets of Solomon*** consists of five individual structures, each being a diagrammatic sketch of an imaginary object (a spaceship, perhaps) having come from one of five different schematic universes." A. A.

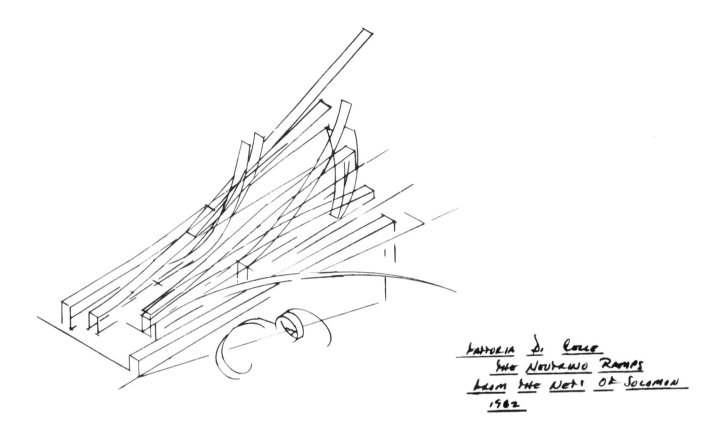

Fattoria di Colle
the Neutrino Ramps
from the Nets of Solomon
1982

POSITRON POSITRON

POSITRON

POSITRON

POSITIVELY
CHARGED
HADRONS

NEUTRINO

ELECTRON

NEGATIVELY CHARGED
HADRON

NEGATIVE MUON

ELECTRON

NEGATIVELY CHARGED HADRON

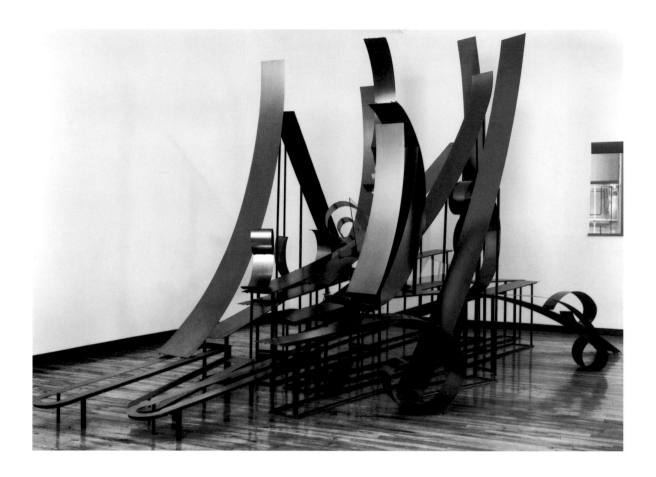

23.13

Alice Aycock, *Fattoria di Celle: The Neutrino Ramps from the Nets of Solomon*, 1982. Pencil on vellum. Collection of Giuliano Gori, Fattoria di Celle, Pistoia, Italy.

23.14

Diagram of jet of particles emerging from a proton struck by a high-energy neutrino, from Jacob and Landshoff, "The Inner Structure of the Proton," *Scientific American* 242 (March 1980). Courtesy Gabor Kiss.

23.15

Alice Aycock, *The Celestial Alphabet (Ramps)*, 1983, at the John Weber Gallery. Steel, cold-rolled sheet metal, glass, grinding wheel, and motor, 16′ long × 10$\frac{1}{2}$′ high × 9′ wide. Museum of Contemporary Art, Chicago, Gift of Paul and Camille Hoffmann. Photo: Fred Scruton.

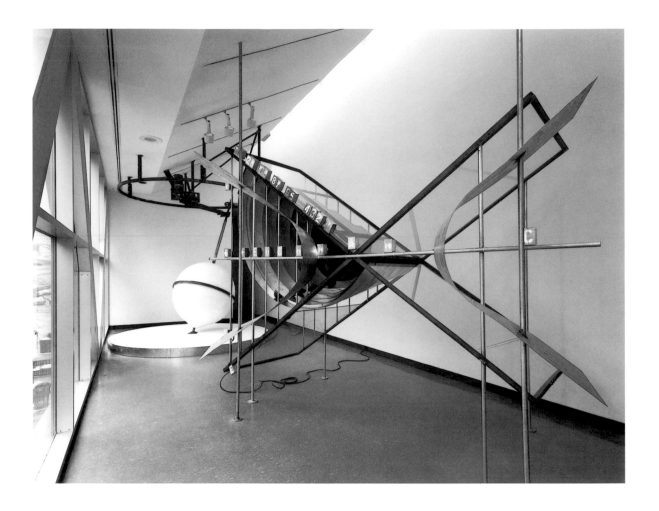

23.16 and **23.17**

Alice Aycock, *The Nets of Solomon, Phase II,* 1983, details. Steel, glass, and electrical
lights; room-size installation, approx. 13′ × 75′. Constructed for the Museum of
Contemporary Art, Chicago. Collection of the artist. Photos: Tom Van Eynde.

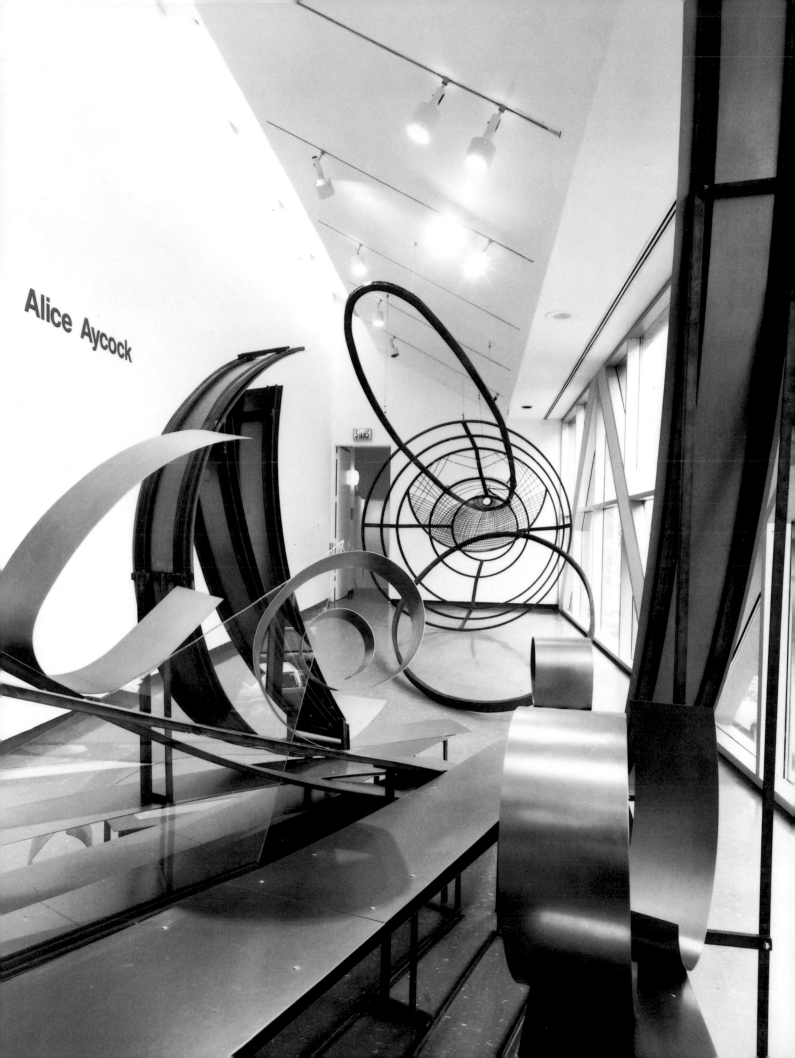

Cuisinart blades, she bought Susan Campbell's *Cook's Tools: The Complete Manual of Kitchen Implements and How to Use Them* and made several pieces based on images found in it, as well as drawings presenting fantasies of kitchen tools engaged in combat (fig. 23.21).[17] Overall she found Cuisinart blades mesmerizing and conjectured that, enlarged in a piece of sculpture, they might prove hypnotic traps for viewers. Important antecedents for this blade machine include Aycock's *Sand/Fans* and her continued fascination with the mechanical child Joey in Bettelheim's *The Empty Fortress,* who was obsessed with the rotary blades of propellers, engine planes, and fans.

The first component of *The Thousand and One Nights in the Mansion of Bliss* is evocatively titled *The Glance of Eternity,* a term she had picked up somewhere in conversation and later recalled.[18] To her the phrase represented a close call with death, such as standing by a street and almost getting run over. As she commented, "Blades are scary. . . . I feel they are both beautiful and terrifying." She then elaborated, "The experience [of this work] is like leaning over a table saw, a deep ravine in the ground, or the propellers of a plane."[19] The reference to the terror a table saw might evoke goes back to the artist's own graduate school experiences when she was working with such equipment and to her later efforts to bolster her self-confidence in using this tool to make sculpture in wood.[20] Throughout the many changes

to which Aycock subjected *The Thousand and One Nights in the Mansion of Bliss, The Glance of Eternity* continued to be this work's central focus. The slowly moving and hypnotic blades making up this segment of the sculpture are both unsettling and captivating. The artist takes note of its hypnotic factor, commenting, "There is the implication [in the blade machines] of being literally sliced."[21] On another occasion, she explained that in the early 1980s she attempted "to deal with that explicit moment in which you come face to face with a mindless force, which I think of as a whirling that moves through the universe, almost like a vortex."[22] Certainly the fifteen-foot-long blade machine, which appears to have been enlarged to a scale capable of accommodating human victims, accords with this reading.

But no matter how intimidating blades might be, Aycock regards their danger as only part of the story.[23] For example, she envisions arrowheads as weapons for obtaining food that are part of a destructive and creative cycle necessary to sustain life. Throughout her work Aycock has searched for a generic image capable of communicating both sides of the story, an image capable of containing in embryo the basic operation of civilizations past, present, and future, a tear in the universe on the order of Borges's Aleph that provides a view of its essential structure. She believes this to be an impossible goal, yet a venture worth undertaking and continuing. We might view this quest as an attempt to develop visual forms akin to James

23.18

Alice Aycock, *The Thousand and One Nights in the Mansion of Bliss,* 1983. Steel, aluminum, lights, sheet metal, Plexiglas, motorized parts, and steel mesh; approx. 30′ high × 22′ wide × 80′ deep. Installed at Protetch-McNeil Gallery, New York. Collection of the artist. Photo: Wolfgang Staehle.

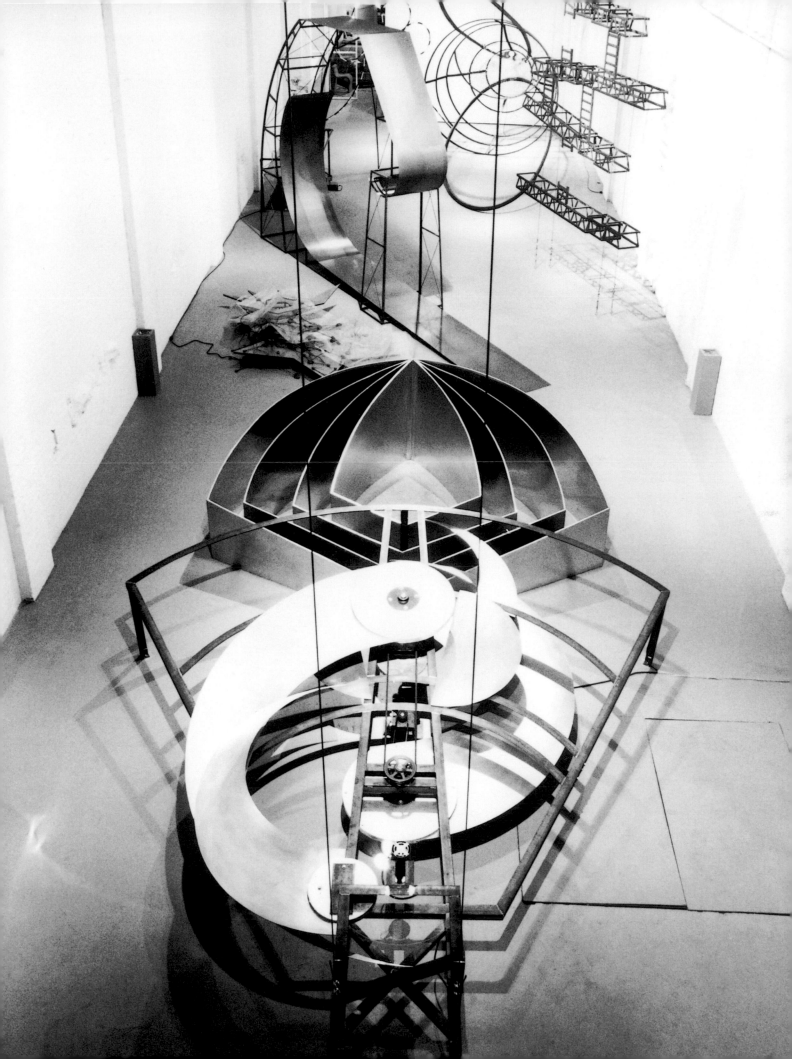

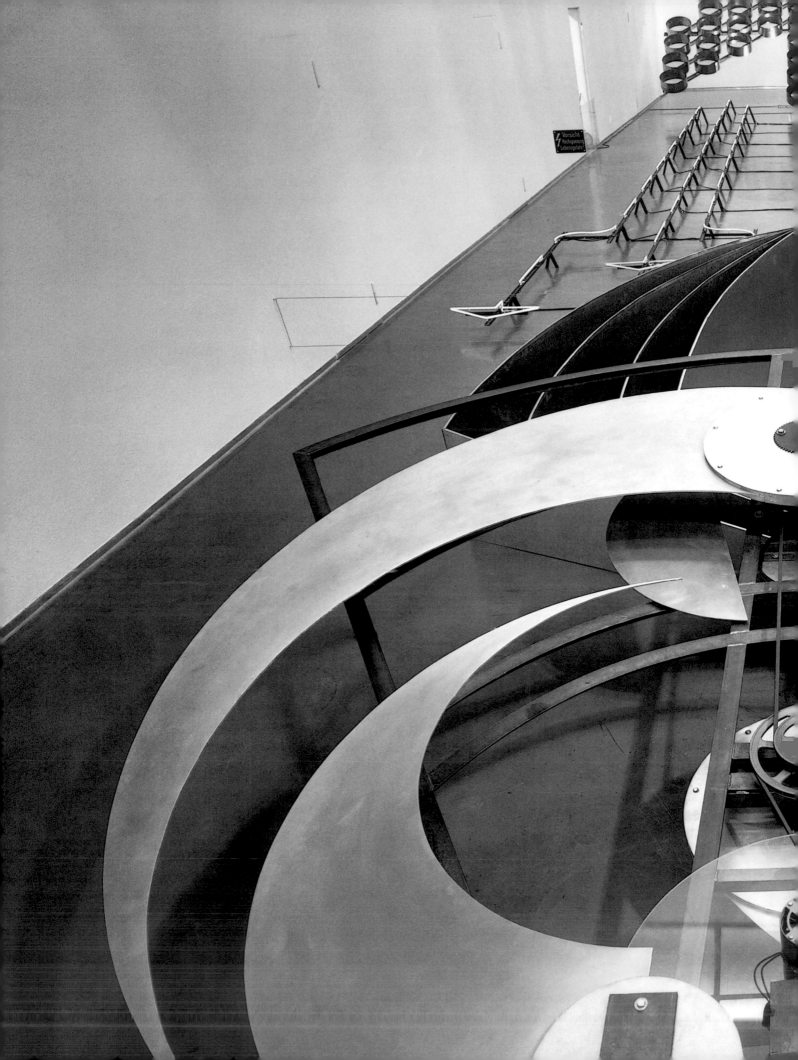

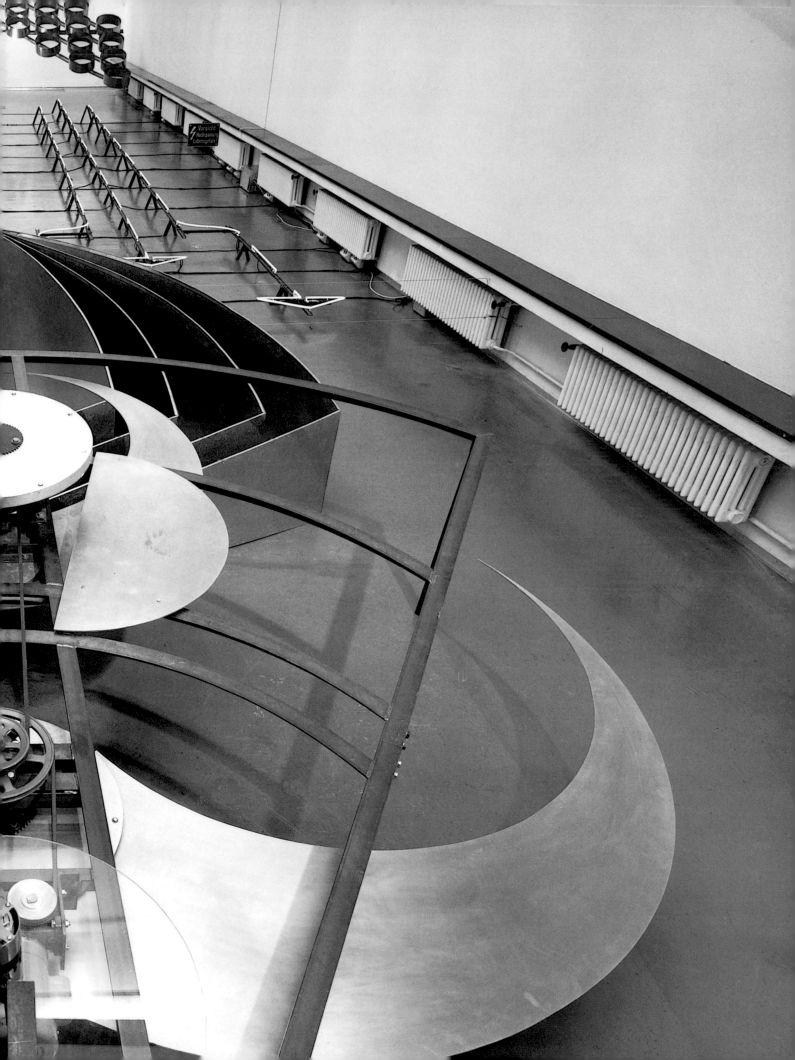

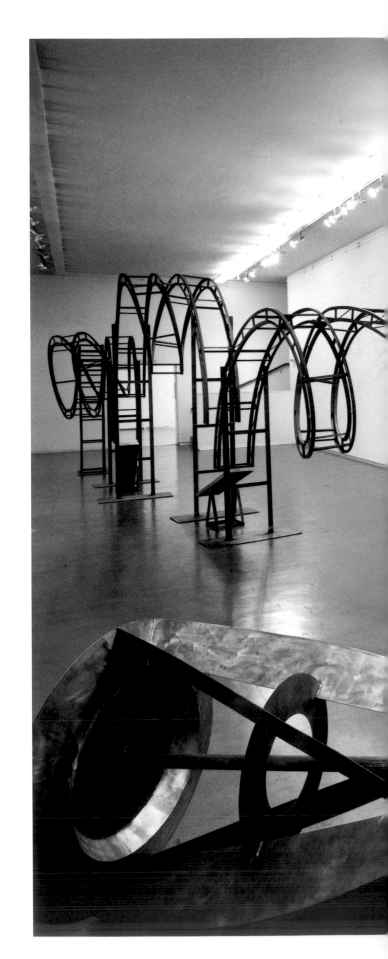

23.19 (previous pages) and **23.20**
Alice Aycock, *The Thousand and One Nights in the Mansion of Bliss, Part II: The Fortress of Utopia*, 1983–1984, details. Structural steel and galvanized sheet metal, dimensions variable. Installed at Kunstmuseum Luzern, Luzern, Switzerland. Collection of the artist. Photos: Kunstmuseum Luzern.

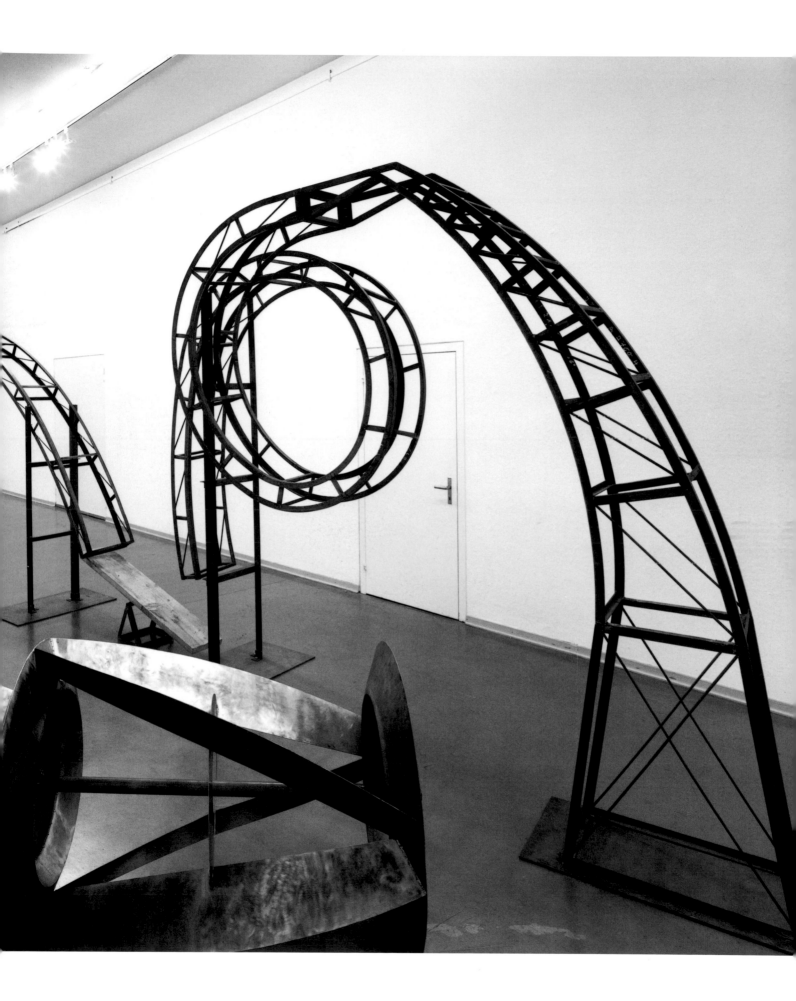

23.21

Alice Aycock, *The Fourth War Maneuver: Attack in Oblique Order (from War
Maps—the Seven Basic Maneuvers of War)*, 1984. Pencil on Mylar, 36″ × 48″.
Collection of Jonathan Fineberg, Urbana-Champaign, Illinois. Photo: Fred Scruton.

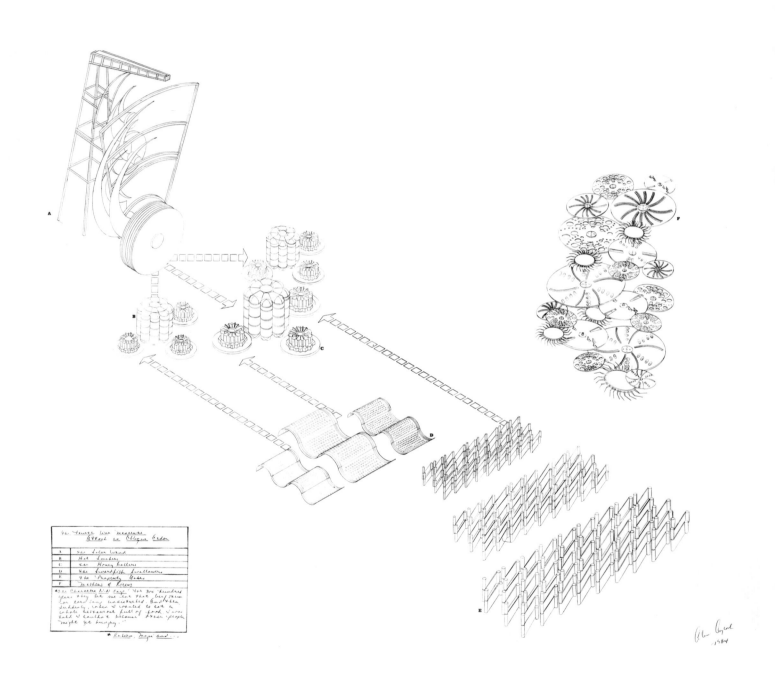

Joyce's particularly cogent portmanteau words, those concise literary compounds resembling German nouns that consider both the diachronic and synchronic aspects of words, both past and present usage.

The blade machine that initiates *The Thousand and One Nights in the Mansion of Bliss* adjoins a twelve-foot-long segment entitled *The Cookie Cutter.* The latter, which continued to be the second component of the work during its tour (1982 through 1983), consists of a set of four monumental graduated cookie cutters modeled after kitchen tools and conflated with shorthand designs found on pinball machines for such words as "wham" and "bam," making one think of the slang expression for a one-night sexual encounter. Next to it is a small improvisational floor piece, *Stars,* made of blinking lights, wire mesh, and a star cut from galvanized sheet metal. One might say *The Thousand and One Nights* takes whatever subject one chooses—it might be an imaginary entity, perhaps a fictional character or an intellectual subject—and cuts it into pieces, with the menacing saw blades placed like part of a monstrous Cuisinart that will mix it together before subjecting it to the predetermined pattern of the cookie cutters. As Randy Rosen and Catherine C. Brawer have pointed out, "Aycock acquired a

Cuisinart [around this time] and was acutely impressed with its Shiva-like role as 'both a creator and destroyer.'"[24]

After undergoing these changes, the imaginary subject being channeled through *The Thousand and One Nights,* which is now reduced to an undifferentiated substance, is moved to a pair of neutrino ramps, entitled *Loop to Loop* after a 360-degree-loop roller coaster like the Sooperdooperlooper (fig. 23.22), so that its molecular particles can be blasted and precious protons released, thereby reconstituting its essence. Subsequent to this section is *Quadruple Summersault,* consisting of yellow blinking lights that move sequentially to imply tumbling. After these trials, this now mangled and totally reconfigured imaginary entity assumes the role of the hunted monkey in an untitled component of the sculpture who must surmount ladder after ladder, in a hanging bridge system of trusses. In its efforts to stay alive, the monkey resembles the figure in the 1981 video game Donkey Kong for which it is named (itself a play on the film character King Kong). Not only does this video-game reference ensure the contemporaneity of Aycock's piece, but it also points to the high-density computer chips used for these games and to the fact that these forms of dislocated

23.22
Sooperdooperlooper. Designer: Anton Schwarzkopf, West Germany; installed 1977. Track length 2614′; loop height 57′; maximum speed 45 mph; ride duration one minute. Courtesy of Coasterimage.com.

intelligence, representing yet another type of cultural schizophrenia, were important early market incentives for the development of the personal computer. After this exhaustive set of vicissitudes comes *The Nets of Solomon,* which subjects this already transformed and exhausted subject to the trajectories of its circling comets.

To recapitulate this complex and daunting gauntlet, we might conclude that the first two segments of *The Thousand and One Nights*—*The Glance of Eternity* and *The Cookie Cutter*—can be connected with the radical transformations that cooking necessitates; the third segment, *Stars,* with an ersatz, almost sideshow type of transcendence; the fourth, *Loop to Loop,* with a cyclotron; the fifth, *Quadruple Summersault,* with acrobatic feats worthy of a circus performer; the sixth, *Donkey Kong,* with a sadistic video game; and the last, *The Nets of Solomon,* with a cosmic pinball machine. As this extended narrative suggests, a mechanistic Scheherazade—Aycock's equivalent to Duchamp's bride—who might be identified with the heroine of *The Arabian Nights* but does not have to be limited to her, exhibits the potential to undertake a series of ritualistic and ferocious acts that would make most forms of torture pale by comparison. While this piece might be interpreted in terms of the artist's own life, it can also be construed as a wry and even cruel comment on the elaborate machinations of our culture, which changes, transforms, and ultimately mediates everything that comes under its purview. "I didn't want my art to be a dead thing people walked by and intellectualized about," Aycock later reflected. "I wanted to create an intense psychological response, to force people to confront themselves. It depressed me if they simply had fun. I wanted them to get scared."[25] And "scared," "beguiled," "entertained," and "confused" are certainly adjectives one might use in relation to this confrontational sculpture.

Sometime before beginning *The Thousand and One Nights,* Aycock had discovered in an East

Village shop a 1948 reprint of a book on sacred magic that dates back to 1458. Bearing the extraordinarily long title *The Book of the Sacred Magic of Abra-Melin the Mage as Delivered by Abraham the Jew unto his Son Lamech: A Grimoire of the Fifteenth Century from an Old and Rare French Manuscript in the Bibliothèque de l'Arsenal at Paris,* this publication represents the advice that Abraham the Jew, a resident of Würzburg, bequeathed to his younger son, Lamech, who would not be eligible to receive the wisdom of the Kaballah, which is customarily handed down to the oldest son. Instead of the transcending gifts of mysticism bequeathed to the firstborn, Lamech received the pragmatics of magic squares, which have long been reputed to convey special powers to their users. Magic squares are palindromes—closed universes of language—which can be read in many directions. Aycock loved the idea that this book plays with the Jewish tradition of sacred words and their presumed capacity for creating universes. She found the specific instructive erudition in this volume on magic particularly appealing.[26] Each of the palindromes in the book refers to particular powers bestowed on one who is versed in the esoteric lore of a particular magic square. Among them are the ability to fly in the air, feed oneself at will, find gold, and transform oneself by moving back and forth in time. Some of these abilities—such as flight, food on demand, and knowing where to prospect for gold—are now commonplace legacies of the Industrial Revolution, whereas others, such as moving through time, remain in the realm of the magical.

When Aycock was working on this sculpture, New York graffiti artists such as Keith Haring were making names for themselves by creating shorthand notations in the form of a discrete number of signs. This broad-based interest in sign systems, shared even by urban vernacular artists, encouraged Aycock to study signs by looking at them both synchronically and diachronically. This research enabled her to discover theories hypothesizing the origin of writing in terms of

footprints that became magic forms of identity. At the dawn of history, writing enabled people to move away from a perpetual present called "Eden" in the Old Testament and to enter the realm of linear time. During the Inquisition of the Counter-Reformation, suspected witches and heretics were tortured into making confessions that were then signed by the devils possessing them, who often had their own private language. To Aycock this belief in a sign's ability to control destinies indicates a hegemonic and closed system that human beings have been unable to bridge. This understanding of humanity's limits is a basis for the artist's later drawing *The Dance Garden Containing Magic Diagrams* (1988), in which nature is so acculturated that it is seen in terms of formal gardens whose parterres assume the form of magic designs. Among the many sources that Aycock perused during this time, none fascinated her as much as Abraham the Jew's legacy to his younger son.

Contained in this book is the best-known lettered square in the Western world, composed of the Latin words SATOR, AREPO, TENET, OPERA, and ROTAS. When the words are arranged vertically and horizontally, this lettered square has at its center the word TENET appearing twice and forming the two arms of a cross. This square has appeared in many places, including the first-century A.D. ruins of Pompeii. Although some mystics contend that the words in the square are nonsensical, one can connect SATOR with "creator," AREPO with "slow-moving," TENET with "maintains," OPERA with "his creation," and ROTAS with "vortices." Read together, these words make up the sentence, "The creator slow-moving maintains his creations as vortices."[27] To Aycock this statement had the force of a revelation since it seemed to anticipate and sanction the power of vortices found in her work, beginning with *Sand/Fans* and including her blade machines that intrigue, repulse, and ultimately remain hypnotic and mysterious. Since this magic square is one of the pentacles known as the "Key of

Solomon," its significance is certainly noteworthy for *The Thousand and One Nights* with its one component named *The Nets of Solomon*, which becomes a snare for wisdom's power.

In most of her work Aycock wanted to achieve the double edge of entertaining and disturbing viewers as well as enticing and repelling them. As she explained in 1989 to Fineberg:

You can follow this image of a [flint, arrowhead, plow] blade or knife in my work as it transforms itself into a waterwheel and a windmill and a turbine and a Cuisinart and also into the crescents of the moon. It starts with something early. . . . This image of the large blade machine moving very slowly is incredibly seductive and it is also very, very sinister, terrifying. I wanted that double edge, like the Low Building.[28]

Perhaps because she was six years removed from the creation of *The Thousand and One Nights in the Mansion of Bliss* at the time of this statement, she described this duality and its importance in her work with the impartiality of a bird's-eye perspective.

The contrast between the relative equanimity of this later assessment and the heightened involvement of the one she made a year after the creation of this piece is remarkable:

There's a duality with the architectural work I did in the past. You could feel very secure, as if you were in a bunker, and you could also feel as if you were in a prison. It had this dual aspect, depending upon the situation. My present work still has this kind of ambiguity. One of my fantasies, which I find extremely important, is that kind of duality between the ecstatic and something that's awful, and the combination of the two. There's this series of historic Chinese photographs, "The 1000 Cuts," in which this criminal is being tortured and given opium at the same time. I know I shouldn't be talking about this, maybe, but it's a perverse part of

my personality that's got to be in my art, or else it doesn't feel right.[29]

The conjunctions of pain and pleasure, horror and ecstasy, hell and heaven, approach and withdrawal, and destruction and transcendence suggested by this passage are all part of Aycock's work during this period. Regarding these polarities as ongoing and irresolvable, she works to create spaces where such encompassing and seductive conjunctions could be felt. The sensibility is akin to the sensations willingly experienced by riders of an amusement park's loop-the-loop, where one can count on being subjected to incredible speeds, deliciously perilous descents, and wonderfully frightening turns. She recognized that the ride's breathless brushes with heightened emotional states—even to the point of courting, within strictly defined parameters, the awesome and sublime feeling of approaching death—paralleled the psychological emphasis of her blade machines. These instruments enchant even as they threaten and hold one in suspension. In the amusement park humans are allowed to enter the machine, which becomes architecture on a par with Charlie Chaplin's ride through the turning cogs of a factory in *Modern Times* (fig. 23.23). In conversation Aycock has frequently referred to all her blade machines as "glances of eternity."[30] The power of these works lies in their ability to attain strong emotional effects, even a sense of wonder, within the constraints of industrial forms and thereby to humanize and often demonize the presumably inhuman machinery. It is as if an assembly line was reconfigured as an eloquent, particularly tragic, and even sadomasochistic gauntlet capable of dramatizing the human condition.

Of inestimable value to Aycock's works at this time were the many publications of the 1960s and 1970s on Russian constructivist art that illustrate utopian projects by Vladimir Tatlin and pared-down stages used for proletarian theatrical events. Such images are indirectly responsible for

the industrial components Aycock was using, because they gave her permission to break out of the minimalist straitjacket that in the 1960s had transformed most industrial allusions into rigid gestalts. Unlike the rigidity of modernist architecture, Russian constructivist architecture—particularly Tatlin's *Monument to the Third International* (1919)—had long ago jettisoned gravity and approached a new euphoria that was most evident in amusement rides such as the Superdooperlooper.

While Aycock's acquisition of Cuisinart blades may have played a pivotal role in the development of her blade machines and certainly provides a worthy Duchampian subtext to these works, a rationale for these machines can be found in her studies of the esoteric drawings of the Elizabethan hermetic philosopher Robert Fludd, who lived at a time when magic and science overlapped. Aycock viewed Fludd as part of the larger trajectory that Duchamp dramatized. "I often saw Duchamp," she reflected, "as a transitional figure—one foot in the alchemy of the Middle Ages and one foot in quantum mechanics."[31] Fludd's drawings (figs. 23.24, 23.25) reminded her of diagrams of hurricanes, whirlpools, and Cuisinart blades, and therefore they attracted her in the same way as did El Lissitzky's and G. G. Klucis's drawings. While Fludd was investigating his own esoteric theories, he was also acquainted with his friend William Harvey's discovery of the circulation of blood. For Aycock's purposes, Fludd's historic nexus as a transitional figure living between the diametrically different worldviews of magic and science was extremely useful, constituting a type of Aleph, as were his many hermetic diagrams that summarize a soon-to-be obsolete body of knowledge. She was not interested in his texts and purposefully did not read them, but she did use his extraordinarily beautiful drawings as catalysts for her own intensive imaginative free associations, which create a series of new perspectives (though in scrutinizing these images

23.23

Film still, *Modern Times,* United Artists, 1936. Courtesy of the Academy of Motion Picture Arts and Sciences.

23.24

Robert Fludd, *The Macrocosm as Universal Man,* from Robert Fludd *Utriusque cosmi . . . historia* (Frankfurt, 1624), vol. 1, p. 254. Courtesy of College of Physicians of Philadelphia. Photo: Louis W. Meehan.

23.25

Robert Fludd, *The Descent and Reascent of the Soul,* from *Utriusque cosmi . . . historia,* vol. 2, p. 45. Courtesy of College of Physicians of Philadelphia. Photo: Louis W. Meehan.

she unwittingly digested information from their captions). The drawings of the Jesuit Athanasius Kircher, who was also a contemporary of Fludd, have been another important source of ideas for Aycock. Because she spent hours and days studying Fludd's schemes and because her works suggest a sophisticated understanding of the concepts they illustrate, we can assume that over time she came to understand many of the concepts that his drawings were intended to illustrate, and therefore I will reference both his ideas and her deviations from them.

There is ample historical justification for believing Fludd to be a Rosicrucian, as he defended the ideas of this sect in his *Apologia compendiaria* of 1616.[32] His highly esoteric cosmology begins with an unassailable and ineffable unified godhead beyond human understanding. But this absolute principle manifests itself as the duality that Fludd refers to as the Light and the Dark Aleph, employing the first letter of the Hebrew alphabet as Borges was later to do. While Fludd connects the light side with activity and goodness, the dark side is chaotic and evil. But he cautions his readers to remember that, since the two aspects are part of this absolute force, they must both be considered good.

In relation to Aycock's blade machines we might conjecture the importance of Fludd's theory—originated in his drawing—that the absolute principle "creates by limiting its own infinity,"[33] that is, by cutting or slicing itself so that a duality is manifested. He connects angels with the Light Aleph, devils with the dark one, and points out that the two are pitted against each other in eternal conflict.[34] Accepting duality as a both/and situation, Aycock's art straddles it, creating an ongoing duel between attraction and repulsion as well as between creation and destruction similar to the one envisioned by Fludd.

Fludd's exegesis of the division of the absolute's oneness into subsequent dualities makes both the separation and the tools used for enacting it sacred

326

and revered instruments. To understand this point, we should look at his discussion of monochords as an analogous realization of this overarching principle. For Fludd the monochord is emblematic of life because it consists of a series of sliced and overlapping triangles that connect the oppositions of darkness and light.

A source for Aycock's blade machine, Fludd's diagrams of pyramids and monochords present hierarchies and essential dualities that separate levels of being from one another and also reconnect them to the original principle of unity. The purportedly divine attributes of the blades in his drawings, which symbolically break apart the primary oneness of the world and substitute preordained dualities, make them privileged liturgical instruments that are as sacred as the contents they cut asunder. In this way the blades function as signs of liminality, mediating between an original unity and a preordained duality, thus connecting light and darkness, goodness and evil, ecstasy and horror, transcendence and dismemberment. In other words they constitute breaks similar to Borges's Aleph and Heidegger's rift.

For Aycock, liminality—the privileged position of the perpetual in-between, akin to Borges's Aleph—is precisely the realm that her sculptures at this time delimit and heighten. When looking at Fludd's drawings, she would fantasize about the presence of nothing and the relationship of the abyss to the nonabyss that his cosmological devices attempted to represent. This fantasy is reflected in her sculpture *The Silent Speakers* (1984) (fig. 24.2).

The important question for someone as skeptical as Aycock is, What is nothing? And the next question is, How do blade machines separate this inconceivable nothing? The answer is, of course, that they don't separate so much as momentarily and then eternally dislodge elements of the universe in order to reconnect them. The nothing that Aycock tried to envision may go back to the apocalyptic void of the cold war bomb scares that were omnipresent during her

adolescence.[35] Aycock's blade machines are potent symbols of unity and division on a par with the Tower of Babel, which several years later would become the subject of a drawing and sculpture. Extending the indifferent power of the blade machines to other works, Aycock remarked apropos of *The Solar Wind* (1983) (fig. 23.26), "I was thinking of all the potential power we have right now, and it dawned on me, what if there was this force that was neither bad nor good, but mindless, a kind of raw source of power, much like the sun, and as it moved it created all sorts of things?"[36]

Fludd's visual meditations on the metaphysical properties of blades provided Aycock with a set of hermetic diagrams enabling her to view her early *Sand/Fans* as extremely prescient and far more cosmological than she had originally thought when she was working under the aegis of phenomenology. A piece documenting her high regard for Fludd's concepts is *The DNA Cutter* (1984) (fig. 23.27), an approximation in three dimensions of Fludd's two-dimensional rendering and an intriguing, if violent, updating of the separation of an essential and initial unity at life's core and its subsequent reconnection to reestablish new life. Besides examining Fludd's work, Aycock was looking at medieval manuscripts, particularly tree-of-life patterns. In the beginning phase of planning this sculpture she had morphed their twisting knots into the double helixes of DNA, and the two in tandem with Fludd's diagrams provided a syncretic basis for this sculpture's representation of a genetically encoded tree of life. The completed piece that employs a column rather than a tree of life is a reification of the destructive/creative division of the world—and perhaps a skeptical view of the burgeoning field of biogenetics that relates to the Aycock family's experience with cystic fibrosis, since a cure for the disease would most likely be discovered only through DNA research. Mixing a classical column with curved steel blades, *The DNA Cutter* also merges architecture with technology or industry.

In September 1987 Alice Aycock's brother died of cystic fibrosis. At the time of his final illness, his sister was completing a work for Western Washington University's impressive park of site-specific sculpture. The piece is entitled *The Island of the Rose Apple Tree Surrounded by the Oceans of the World for You O' My Darling.*[37] She said, "In the summer of 1987, Billy began to die. I was finishing *The Island of the Rose Apple Tree* . . . in Bellingham, Washington, when word came that it was time to go home. He waited for me to come and died the next day."[37]

Paying homage to Billy, the piece was inspired by Tantric drawings and Islamic water gardens carved in stone. A source for it was the following observation by N. N., which assumes the magic of a fairy tale in its beginning and the promise of a permanent refuge as it develops:

Once upon a time I ate an apple that was growing near a farmhouse. It was not like the other apples that one gets in the market, and the doctors thought it might make my chest broad. I ate the apple. That is why the food would slip right through me.

I saw the Garden of Eden once. It was like an island with trees, but the water around it was not really water. It was like looking at the other shore of an ocean, or like a cemetery with a gate. Nobody could go in and take things away—not even God or Satan. I had been in there once. It was the same thing as Alaska, a place I discovered where I lived with my grandfather at the beginning of the world.[39]

Aycock recalled that after her brother's death, "he just evaporated," and added, "I do not believe in the human soul or in God. It seems to me that this belief system is an endless series of reflections and illusions of one's self and one's wishful thinking and one's narcissism. If you look at a mirror, you only see what is reflected in it. It has no depth, only the illusion of it."[40] She made this statement in reference to *The Descent and Re-ascent of the Soul II* (fig. 23.28), which she created in 1988. She said,

23.26
Alice Aycock, *The Solar Wind, from the Series Entitled A Theory of Universal Causality (Time/Creation Machines)*, 1983. Painted steel, aluminum, galvanized sheet metal, Plexiglas, cable, and blue neon light; 40′ high × 40′ wide × 31′ deep. Collection of Roanoke College, Salem, Virginia. Photo: David O. Garcia.

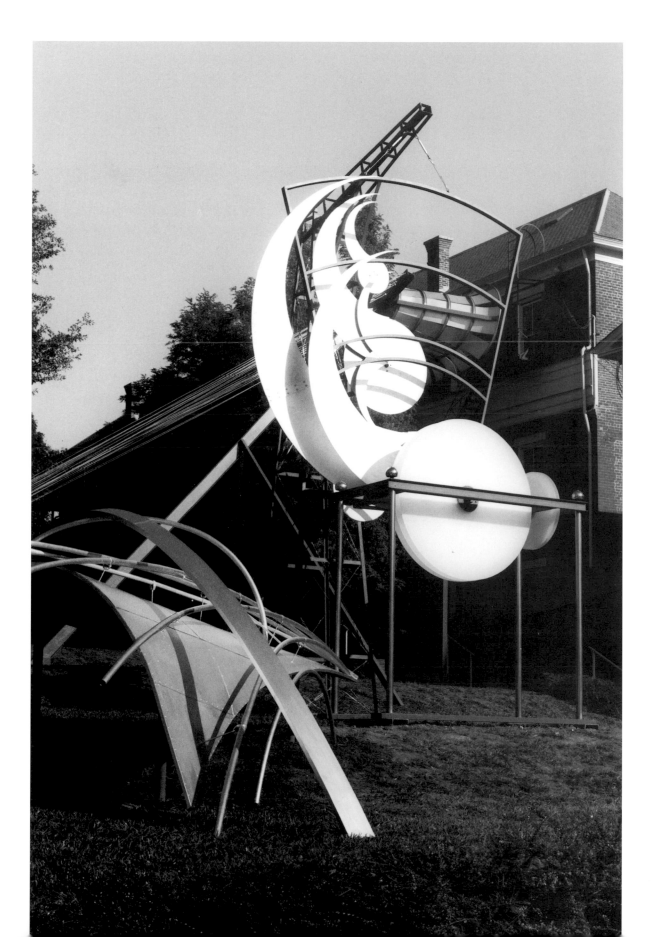

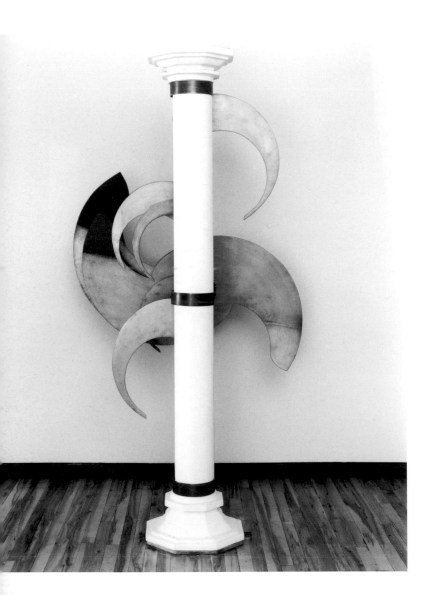

23.27
Alice Aycock, *The DNA Cutter*, 1984. Plaster, wood, and steel,
85″ high × 48″ wide × 36″ deep. Collection of the artist.
Photo: Fred Scruton.

23.28
Alice Aycock, *The Descent and Re-ascent of the Soul II*,
1988. Mirror, Plexiglas, aluminum, brass, and wood;
11′ high × 7′ wide × 4′ 8″ deep. Collection of the artist.
Photo: Mark America.

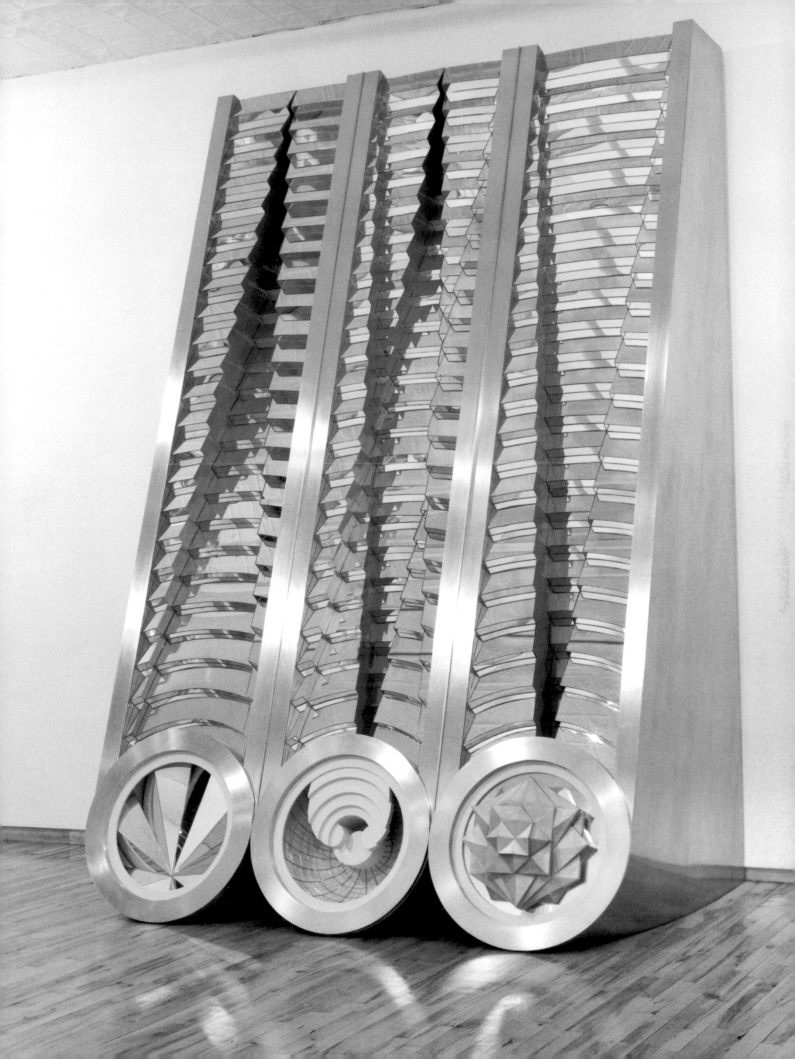

"If you can imagine a soul, then that soul is only a mirror of what is in front of it. The piece is about that nothing. I saw the piece as an endless series of ascents and descents not unlike the palindromes in the book of magic that I found in that the work exists in this enclosed universe."[41] Aycock's references to mirrors reflecting nothing parallels the superstitious practice of using a mirror to ascertain whether someone still has a soul, since only humans with souls are supposed to be capable of being reflected in mirrors. The Fludd diagram that Aycock employs for this sculpture and first thought of as a slot machine[42] schematizes the concept of the three octaves, which is one of Fludd's extended analogies comparing the cosmological order with music. Representing humanity's three major regions, these octaves comprise the "supercelestial and spiritual," the "celestial and Middle," and the "elemental and corporeal."[43]

Fludd's plan delineating this path functions mostly as an armature for Aycock's stepped sculpture, which seems to be predicated on mirrors as indicators of a Lacanian mirror phase at the basis of the ego's formation. She confirms the role of Lacan's theory: "The mirror image establishes boundaries between the imaginary and the symbolic. It is a threshold phenomena whereby the reflected ego is transformed into the social ego. It also is an example of the double operating at the point where the self disassociates itself from the self to become the other."[44] Instead of revealing an integral soul and thereby establishing an inextricable unity that continues even beyond death, *The Descent and Re-ascent of the Soul II* does the opposite. Through its stepped mirrors that fragment anyone coming within view of them, this work dramatizes the disjunction that is at the basis of ego formation and alludes to the paranoia that Lacan regarded as crucial to this process, which he calls "the mirror stage." We might well conclude that this piece denies Billy after his death an essential being, suggesting instead, as does Lacan, that the self is divided in the process of being

formed. This view postulates that fundamental nature is a social construct predicated on the faulty sense of wholeness intuited during the mirror phase, thus precluding at the outset the development of an integrated ego capable of transcending death.[45] Instead of revealing a self in sync with our symbolic universe, Death—the great shape-shifter according to Milton and a metaphor for a break in our ideological universe capable of undermining its network of beliefs according to Aycock—provides, in my opinion, an inkling of the void that constitutes the Lacanian Real. And her sculpture *The Descent and Re-ascent of the Soul II* accordingly mocks the futility of ever coming to terms with this gap when its stepped patterns assume the guise of a fun-house mirror that distorts everything coming within its purview.

24 Sophistry and Postmodernism

[Sophistry] is indeed the ancient game of wits which, starting in the remotest cultures, vacillates between solemn ritual and mere amusement, sometimes touching the heights of wisdom, sometimes sinking to playful rivalry.

Johan Huizinga
Homo Ludens, 1938

Alice Aycock's transformation of personal anxieties into erudition of a particularly complex sort is part of an ongoing game of raising the stakes exponentially by multiplying meanings and references—similar to a reckless gambler who keeps all winnings riding on each additional roll of the dice. Although Martha Morgan Aycock may have taught her granddaughter how to transmute reversals through stories, Aycock taught herself the practice of increasing the art game's overall difficulty by increasing her sources and looking both to magic and to science's most theoretical discoveries as means for her metaphors. This tactic, which occurs often in her work, may have been sanctioned early in her career by the many references Kubler makes in *The Shape of Time* to art as an ongoing game.[1] Aycock's procedure, which has the incidental therapeutic benefit of sometimes distancing personal problems, is the basis for increasingly elaborate operations that are as playful as they are perplexing and that sometimes become their sole justification for being enacted. Often the sheer arduousness of her act is its overriding rule as well as the goal of the complex

333

divertissement she has chosen. Her art is remarkable not only for the range and involvement of its erudition but also for its ability to couch extremely fanciful concepts in terms of the austerity of engineering drawings and industrially fabricated components, thereby creating such oxymora as dry whimsy, laconic fantasy, and machined absurdity.

It is my contention that the pyrotechnics of her art, which often appears to indulge in virtuosity for its own sake, allies it with the long-denigrated tradition of sophistry that was initiated by the Greek pre-Socratics who influenced Socrates and Plato, even though the latter cast aspersions on their methods. In *Homo Ludens: A Study of the Play Element in Culture,* social historian Johan Huizinga helps to resurrect this group of denigrated itinerant lecturers, writers, and even craftsmen who were repeatedly drawn to exhibit their expertise in Athens. Adhering strictly to the Greek word *sophos,* meaning "wise," "clever," or "expert," Huizinga aligns sophist eloquence with noble play of the most serious type and points out that one of the leading members of this group of independents, Protagoras, "goes to the heart of the matter."[2] Despite its parallels with this philosophic school, Aycock's art does not share its ideas of revolting against science and opposing nature and culture. However, her work's thoughtful and playful extravagance is definitely in sync with sophistry, as are her dazzling displays of knowledge and her appreciation of the impressive workings of antilogic, which is predicated on understanding truth in terms of arguments and their counterarguments. Similar to the ideas of the sophists, her art also appeals to learned audiences rather than to the mainstream. Often, it resembles sophist debates in its predilection for intellectual jousting and investigating the nature of language.

Aycock's introduction to sophistry's possible benefits for contemporary art may have been Jack Burnham's *Structure of Art* (1971), which opens with a description of Hermann Hesse's *The Glass Bead Game,* a book that first appeared in Switzerland in 1943 and therefore has been interpreted by some as an allegory on Nazism's evils. Although she has only read portions of Hesse's book, Aycock acknowledges being well acquainted with its overall approach.[3] The game that provides the name for Hesse's novel plays with ancient symbols and rituals as well as with national ones, transforming them in the process so that their original meanings are redirected to new imperatives. Set in a mythic twenty-fifth century, the story indicates the type of culture that might develop if a sophistic approach to knowledge were to be continued. Its protagonist, Joseph Knecht, known as Ludi Magister Josephus III in the game's official archives, begins to experience the painful separation of reality and its models that Baudrillard would designate "simulation." Inspiring almost religious devotion, the yearly tournament is a competition among highly skilled sophists. Burnham's epigraph, a quotation from Hesse's book, explains this competition in unbridled sophistry and alludes to the problems arising from its favored form of disputation, antilogic:

Experts and Masters of the Game freely wove the initial themes into unlimited combinations. For a long time one school of players favored the technique of starting side by side, developing in counterpoint, and finally harmoniously combining two hostile themes or ideas, such as law and freedom, individual and community. In such a Game the goal was to develop both themes or theses with complete equality and impartiality, to evolve out of thesis and antithesis the purest possible synthesis.[4]

The story is set in the highly decadent country of Castalia where the life of the mind assumes an unheralded aestheticism based on interplays of intellectual wit undertaken with the expressed goal of winning the game. Hesse assumes the hyperbolic tone of a propagandist:

All the insights, noble thoughts, and works of art that the human race has produced in its creative eras, all that subsequent periods of scholarly study have reduced to concepts and converted into intellectual property—on all this immense body of intellectual values the Glass Bead Game player plays like the organist on an organ. And this organ has attained an almost unimaginable perfection; its manuals and pedals range over the entire intellectual cosmos; its stops are almost beyond number. Theoretically this instrument is capable of reproducing in the Game the entire intellectual content of the universe.[5]

Because neither ethical responsibility nor intellectual accountability is anywhere to be found in this sport, Burnham uses it as a straw figure to represent the ills of the modern critical and art historical world that should be overturned. His primary *bête noire* is the current hegemony of formalism, which encourages mere descriptions rather than cogent analyses. "The most impeccable scholarship," he opines, "only succeeds in further indoctrinating us into the art mystique."[6]

Since Aycock had already decided in the 1970s on a career as an artist rather than an art historian, she would have been partially immune to Burnham's dire warnings. In fact, her art demonstrates that she has found the Glass Bead Game an exhilarating form of negentropy that continues to open works to vital new meanings. For her the game no doubt was a variant on Borges's Aleph. She has envisioned the Glass Bead Game spatially as a situation in which everything is transparently layered on top of everything else so that one could look through innumerable levels and discern differences. Aycock imagines that its crystal-clear glass marbles represent the Platonic geometric solids. She thinks that the paradox of this sport is that one must play it even though there are no rules. In this respect it resembles the art game with its few rules, as well as the game of life with its dynamic changing ones.[7]

Considered historically, the negentropy resulting from effectively playing this sport anticipates the vast inflation of readily available information initiated by the development of the World Wide Web in 1992. Moreover, Aycock's reading of Morse Peckham, who assessed the game metaphor as "reveal[ing] the presence in artistic behavior of the artist as challenger and the perceiver as respondent,"[8] places primary emphasis on the artist as an agent provocateur par excellence of the specific contents of whatever forms of chaos he or she is able to engender. In Aycock's case this chaos is the Borgesian Aleph. Being able to race through history and relish with impunity civilization's intellectual and artistic delights since its beginnings is akin to being left alone in the Vatican Library for several days—just long enough to enjoy its temptations and sample its many censored volumes without having to assess their ethics and ramifications. Such an approach has been encouraged by modern museum culture, which has often settled for sound bites of knowledge peripatetically gleaned rather than striving for true understanding. For an artist wishing to reflect the times rather than to change or denounce them and wishing to set up rifts between different ideological views, Burnham's censures could be reframed as injunctions guaranteed to ensure unabashed contemporaneity, and his pronouncements against the type of sophistry exhibited by masters of the Glass Bead Game could be understood as inducements to cultivate such proficiency. Recently Aycock reflected on her continued delight in being able to roll back knowledge to the dawn of civilization and then to jump forward to the last ten seconds of existence. She views this opportunity as a distinctly recent phenomenon that has been commercially truncated into ads and condensed into video spots on MTV.[9]

In 1985, fourteen years after the publication of Burnham's book, Aycock reflected on Hesse's contest in an impressive drawing entitled *The Glass*

24.1
Alice Aycock, *The Glass Bead Game: Circling 'Round the Ka'ba*, 1985. Pencil and pastel on paper, 57½″ × 83″. Collection of Stephen Kramarsky. Photo: Peter Muscato. (also plate 7)

336

Bead Game: Circling 'Round the Ka'ba (fig. 24.1). The work combines a board game with navigational and astronomical elements. This type of divertissement is a wonderful metaphor for Aycock's art and no doubt was catalyzed by Duchamp's penchant for playing chess and her own regard for art's machinations as an elaborate, ongoing form of amusement. The metaphor of art as the game board's playing field allows Aycock to represent many concepts that have long been important to her, ranging from Wittgenstein's language games that explore the implicit rules by which cultures organize intelligibility to Barthes's concept that interpreting writerly texts is an amusement whereby one plays with a text "in all its polysemy."[10] Moreover, the game board is an antiquated correlative for video games, which assumed an important role in the development of PCs while also foreshadowing the sophistry that would ensue from the widespread Glass Bead Games represented by surfing the Internet.

In the center of Aycock's drawing is a vortex in the form of a whirlpool that replaces the two-story arcade and displaces many of the concentric sets of steps surrounding the actual black stone at Mecca called the Ka'ba. On top of this central whirlpool in Aycock's drawing is a wooden house resembling the domiciles of the dead that the artist had seen years ago in Cairo. At that time she had been shocked to discover that these structures for the dead mirrored the residences of the living. This parallel between houses of the living and the dead conflates the liminal role of Milton's Death, who mirrors life while heralding its end. In Cairo Aycock noticed that one old black wooden structure among the mainly stone and stucco buildings resembled shacks she had seen in the American South during her family's visits to her father's home in North Carolina. Because this building made her feel strangely at home in this ancient spot, it is the edifice that she chose to replace the Ka'ba. And because this magnificent stone is the most sacred site for Moslems, who

believe they will receive great spiritual blessings if they visit it, its replacement by a shack resembling a house for the dead is exceedingly ironic. The extent of Aycock's irony can be fully appreciated when one realizes that this black rock symbolizes the point at which humans are able to make contact with their divine counterpart and to plant their spirit at last in its eternal firmament. In place of such spiritual nurturance, Aycock presents a southern shack that looks like a wooden tomb, a succinct and undeniable image of death. As she explains, the purpose of the game depicted in this drawing is to use the crystal marbles, in particular their transparency, to try to enter the house.[11] Considering the shack's historic background, the artist's personal and cultural associations with it, one might assume that the drawing portrays the Glass Bead Game as a transparent game of life and death.

What makes this conclusion even more intriguing is Aycock's creation the year before of the sculpture *The Silent Speakers—Every Day I'm Born, Every Night I Die* (fig. 24.2). On one side of this sculpture a windshield wiper placed over a funnel-shaped music speaker keeps scraping away the symbolic world. On the other side, a wiper blackens the world and thereby affirms it. In one way or the other, sign systems are being revealed and wiped away, making this a profoundly pessimistic piece. Among other things, *The Silent Speakers* is concerned with the terrifying issue of ultimate nothingness after death that has troubled and fascinated Aycock for decades. Both this sculpture and the drawing *The Glass Bead Game: Circling 'Round the Ka'ba* imply that a wide gap separates secular and divine worlds. Death— the ultimate shape-shifter—is the primary goal and barrier in the drawing, and obsolescence is the major focus of the sculpture, with its wipers that either blacken and define or scrape away one of Fludd's elaborate cosmological schemes. Seen in light of Hesse's protagonist who wants to find an orthodoxy that he can completely embrace, Aycock's pieces side with the Master, who advised the young player: "There is truth, my boy. But the doctrine you desire, absolute, perfect dogma that alone provides wisdom, does not exist. Nor should you long for a perfect doctrine, my friend." However, her attitudes are dramatically opposed to the rest of his advice that "you should long for the perfection of yourself. The deity is within you, not in ideas and books, Truth is lived not taught."[12] The first part of his advice could be considered a wonderful description of the writerly and shape-shifting ability of Aycock's complexes and *Nets of Solomon* to set up conflicts that viewers must activate and resolve for themselves. This quality makes the art both instructive and instrumental without becoming moralistic, since its ultimate goal is to put viewers in touch with aspects of themselves at the same time as it reinforces the quixotic nature of the universe and the fact that life is full of partial truths.

In the mid 1980s, drawing became an increasingly important mode of expression for Aycock, and she made a number of majestic ones such as *The Celestial City Game* (fig. 24.3), *The Wishbone Years* (fig. 24.4), and *The Great Watchtower of the East* (fig. 17.6) (all 1988). These wonderfully extravagant renditions exhibit a disciplined, almost mechanical approach to line while using it to realize elaborate fantasies. The drawings also enabled Aycock to take stock of her own development.

This grand retrospective view culminated in *The New & Favorite Game of the Universe and the Golden Goose Egg* (fig. 24.5), which was ostensibly created for the 1987 Documenta where it was exhibited. According to Aycock, the interpretation of this drawing depends on "understanding a more universal illusion, the tension between memory and forgetfulness, and the fact that no matter how you might play this game you always get a goose egg at the end, not knowledge."[13] At this point the player who wins by reaching the goal first is required to return to the beginning, so that *The Universe and the Golden Goose Egg* characterizes

Alice Aycock, *The Silent Speakers—Every Day I'm Born,*
Every Night I Die, 1984. Mixed-media installation,
87″ high × 60″ long × 30″ wide. Destroyed by fire; formerly
collection of History Museum, Geneva, Switzerland.
Photo: Fred Scruton.

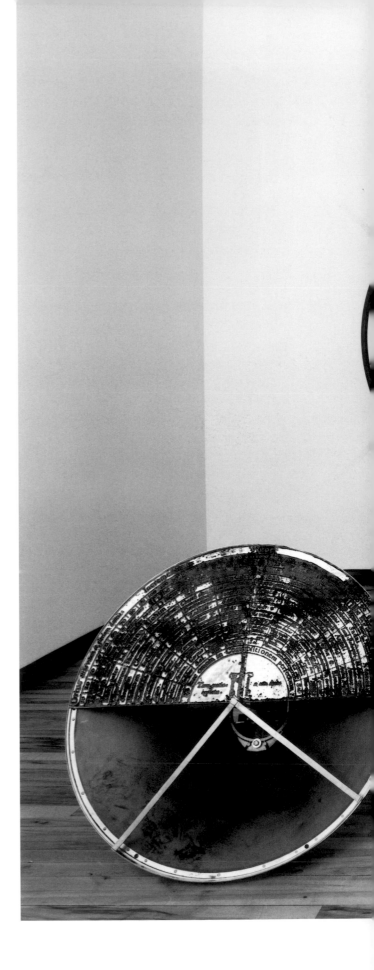

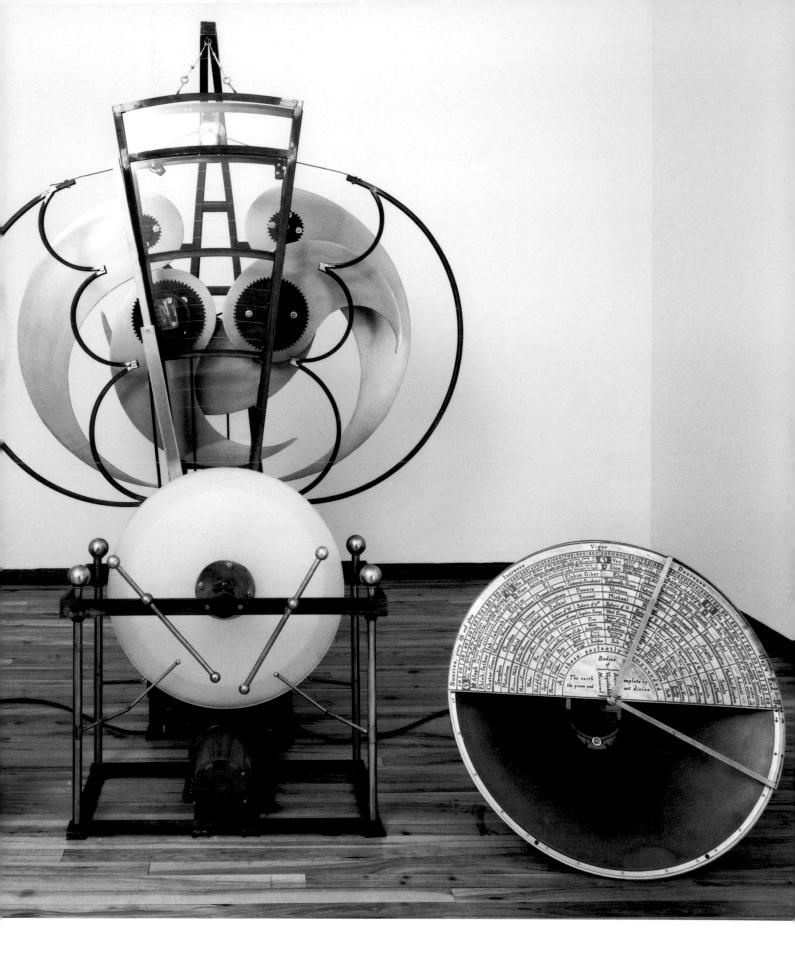

24.3

Alice Aycock, *The Celestial City Game*, 1988. Ink and watercolor on paper, 60″ × 90″. Private collection. Photo: Fred Scruton. (also plate 8)

24.4

Alice Aycock, *The Wishbone Years*, 1988. Black ink on paper, 60″ × 102″. Private collection. Photo: Fred Scruton.

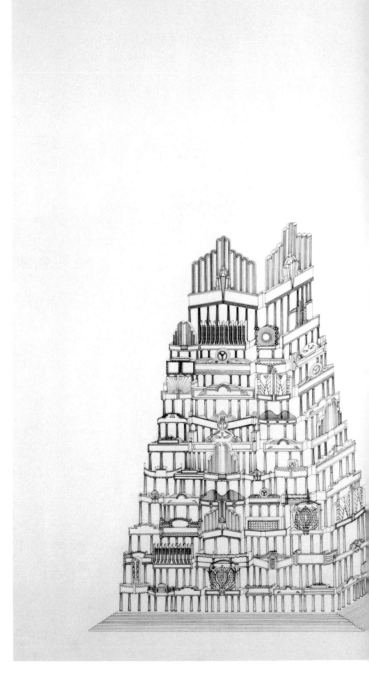

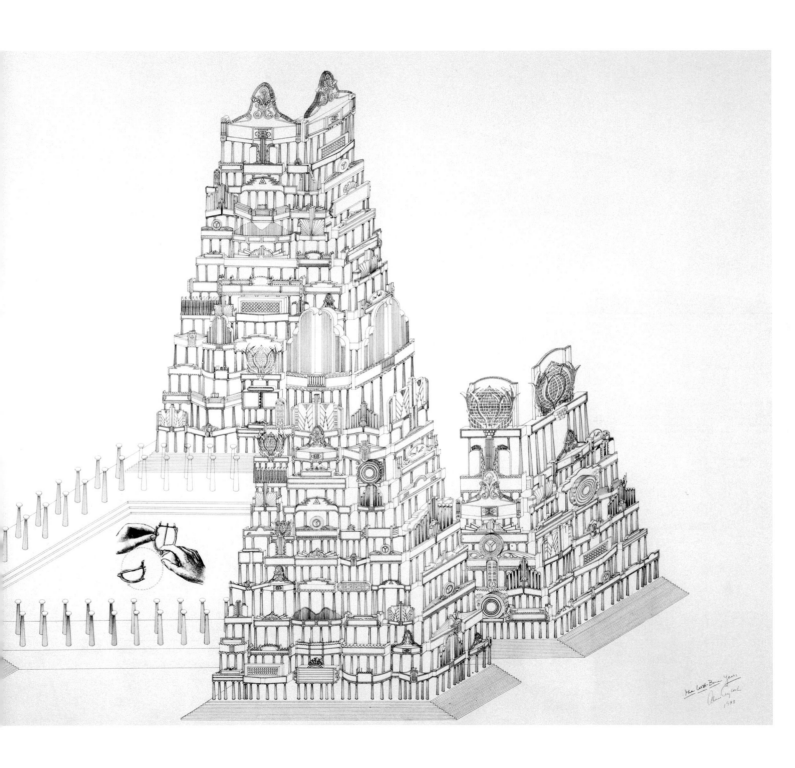

24.5

Alice Aycock, *The New & Favorite Game of the Universe and the Golden Goose Egg*, 1987. Ink, pastel, and watercolor on paper, 102″ × 60″. Private collection. Photo: Fred Scruton. (also plate 10)

life as a Sisyphean project both cosmologically and historically. Like Solomon's nets, which attempt to cope with shape-shifting forms, wisdom in this elaborate cosmological game ultimately remains unfixed and indeterminate.

In this drawing Aycock literalizes the metaphor of life as a board game by reconceiving an archetypal race game known as Goose, which may have been played in ancient times.[14] The earliest known modern version of Goose is Francesco dei Medici's sixteenth-century *Giuoco dell'Oca* (Game of Goose), which became the source for other popular variations such as the French *Jeu* or *Jardin de l'Oie* with its unicursal labyrinth in the form of a snail shell pattern or chambered nautilus shape that ultimately became this game's definitive form.[15] Such illustrious figures as King Louis XIII of France played this board game as children, and the Grande Dauphine at Versailles employed it for gambling. In England the Duchess of Norfolk was so enamored of this game of progression that its overall configuration became the design for her garden. During the nineteenth century, interpretations of the game of Goose included everything from standard characters found in comedy and pantomime to satirical and political figures.

Following this tradition, Aycock has inserted between the standard images of goose eggs alternating cells that depict sculptural images from a variety of cultures. "Through the years," she explained, "I noticed that I would take a cosmology, say a Babylonian cosmology, a Hindu cosmology, and I would then invent structures that would supposedly illustrate and/or architecturalize those cosmologies."[16] Placed in approximate chronological order on the game board are visual interpretations of these schemes. Some derive from historical early visual sources, while the artist imagined others based on verbal descriptions she found in ancient sources collected over the years. The cosmological orders are paradigms in the Kuhnian sense of the word, and this drawing may

be Aycock's clearest realization of ideas contained in his *Structure of Scientific Revolutions*. Her schemes are associated with Anaximander, Philolaus, Plato, Isidore of Seville, Dante, Cosmos of Alexandria, Fludd, Kepler, and Copernicus. Her interest in mapping these diverse intellectual terrains as discrete spaces on a game board is not as whimsical as it might appear; many early publishers of board games in such cities as London mostly sold maps and prints with cosmological references and only delved into board games as a sideline. In *The New & Favorite Game of the Universe and the Golden Goose Egg,* Aycock included among the luminary cultures the fourteenth century of Charles V of France as well as cultures of antiquity, China, India, Thailand, and Islam.

Although a few of these cosmological schemes relate to worldviews that Aycock had already translated into sculpture, thus transforming this drawing into a retrospective key of these pieces, the majority of them do not. For this reason, this work is not just an overview of her past accomplishments but also indicates future ideas that she has mined in her work. A year after she made this drawing, Stephen W. Hawking in his book *A Brief History of Time* reproduced illustrations by Ron Miller of early cosmological systems that closely resembled her work. Hawking used these images, made expressly for this book, to demonstrate that the contemporary universe with its black holes may be as strange to contemporary readers as distant cosmological schemes were to their citizenries.[17]

Aycock's inclusion of historical worldviews as discrete spaces on the game board supports a reading of this drawing's organizational metaphor as a variation on the Glass Bead Game. And its reification of these overarching schemes into sculptural diagrams is compatible with the type of dislocated forms of intelligence that Aycock has associated in her art with schizophrenia.

In one part of her legend for this drawing she differentiates between the two objectives of detecting a new universe and returning to the universe to which one rightfully belongs (see appendix D). Of course, determining one's rightful universe is part of the problematics underscored in this involved drawing, since it reconfigures these august goals in terms of a board game. Essentially it presents the conundrum of received versus personally intuited truth that Hesse made a central factor of *The Glass Bead Game.* The spiral making up Aycock's Goose game begins on the outside and moves toward the center, where our universe is posited as a giant egg already demarcated with the major constellations of stars making up the zodiac. Although astrology is a discredited science, the zodiac is still a viable shorthand for the cosmos that star-gazing charts and the *New York Times* regularly reproduce—demonstrating how this colonized and acculturated realm still constitutes the image that most people identify as the night sky. The culminating space in Aycock's drawing resembles the ending of Stanley Kubrick's film *2001* where the main character merges with the cosmos, and is a fitting symbol for an artist caught in a Janus-faced situation who might well be wondering how next to proceed. Aycock labels this central space that is the winner's goal as "The Starry Night: The House of the Hangman of the World." While the "Starry Night" obviously references the night sky and Vincent van Gogh's famous idiosyncratic painting in New York's Museum of Modern Art, the "House of the Hangman" directs us to the tarot figure who symbolizes alignment with the laws of the universe and higher principles. Because he is presented upside down, this figure enjoins tarot readers to look at the world from his point of view—that is, from a new perspective—thus encouraging them, according to the artist, "to achieve the game's contradictory objectives of discovering a new universe while trying to return to their own proper domain, thus setting up the type of impossible conditions for discovering

Borges's Aleph, Heidegger's rift, and Lacan's Real." Aycock has added, "I also imagine this Hangman as sinister and identify it with the abyss and the terror of the unknown. The Hangman is a trickster, the ultimate delusion—a figure who says, 'Ha! Ha! You're dead. You went the wrong way,'"[18] making this figure equivalent to Milton's shape-shifting Death or at least the gap in a perceived reality that undermines it.

The Universe and the Golden Goose Egg and other drawings similar to it effect a formal redundancy through superimposition. Both the game board and its legend are drawings of themselves, producing exact reenactments that join an object and its representation in a twinning or doubling of forms. Their union appears inevitable and inextricable except when each of the elements is read, and here the difference between writerly and readerly modes of apprehension parallels traditional differences between poetry and prose. When we read through these hand-drawn letters to decipher their meaning, we transform the text into readerly prose. In his marvelously layered analysis of Magritte's *This Is Not a Pipe*, Foucault betrays his familiarity with Barthes's thought and style of writing: "As soon as he [the gazing subject] begins to read, in fact, shape dissipates. All around the recognized word and the comprehended sentence, the other graphisms take flight, carrying with them the visible plenitude of shape and leaving only the linear, successive unfurling of meaning."[19] Unlike words in art, poetry is presumed to be both the statement and its representation or reflection: although it can achieve moments of the uncanny, it tends to complicate the process of reading by opening it up to numerous entrances and in the process transforms it from a mere labyrinth into a complex maze. The manifestation of the writerly mode in *The Universe and the Golden Goose Egg* assumes at times the radical lapses of a schizophrenic's text and transforms Foucault's mapping of "a calligram where are found, simultaneously present and

visible, image, text, resemblance, affirmation, and their common ground"[20] into a poetic mode that allows images to be seen and simultaneously read without impoverishing either approach.

In 1993 Aycock returned to the theme of the starry night, which lay at the center of the game board in *The Universe and the Golden Goose Egg*. In a series of drawings subtitled *The Eaters of the Night (A Continuing Series)* (figs. 26.8–26.14), she portrayed constellations of stars in terms of the conventions humans have already used to colonize planet earth. The seven white-ink hand-drawn and silkscreen drawings on black paper making up this series ironically depict wars, mechanical movements, games, "universe schemes," languages, cities, and dances.

Besides anthropomorphizing outer space so that it conforms to human desires and structures, Aycock poetically evokes in her 1998 *The Star Sifter, Proposal for Terminal One, JFK Airport, New York* (fig. 26.22) the winnowing of nature involved in the exploration of outer space. Harnessing the known and unknown worlds to our algorithms— our recipes, in fact—we sift through space for the elements that reinforce human views, particularly those reenacting the type of implicit proscriptions against worldviews that do not accord humanity a dominant place, a position similar to the one in which the Catholic church placed Galileo. In the late 1990s Aycock ceases to problematize levels of reading in her work by pitting written texts against viewers' own experiences. Instead, the ambiguities in this work are more straightforward and are inherent in the work proper, not in any adjunct material that disrupts its directness.

In the late 1980s, Aycock created another set of monumental drawings called *The Dance Garden Containing Magic Diagrams* (1988) (fig. 24.6), whose ostensible motivation was her dream about dancing. She recounted both the circumstances giving rise to this dream and the dream's contents to curator Donna Stein, who reports:

344

24.6
Alice Aycock, *The Dance Garden Containing Magic Diagrams*, 1988, detail. Sepia and gold ink on cream paper with watercolor; top section: 36″ × 118″, bottom section 48″ × 118″. Private collection. Photo: Fred Scruton.

In the early 1980s, a time when Aycock was baffled by her own romance with history, particularly when she was trying to relate her process to the period in which she lived, an archetypal dream became a great resource for her subsequent artistic inspiration. She had been traveling between Europe and the U.S. on a monthly basis, and had become extremely conscious of the separation between cultures. One night, the artist went out dancing, which since childhood she always had found exhilarating and liberating. When she got home she fell into a deep sleep, jet-lagged and exhausted. Aycock dreamt she was dancing across history and as the music changed she moved through space in a time machine, changing centuries and world views from the Middle Ages to the 1930's of Fred Astaire. This highly condensed narrative was a visceral experience of a compositional system and became a prevailing metaphor for her life and work.[21]

Stein's wonderfully apt description does not mention how Aycock's dream of a dance through time was catalyzed by the disco she attended the evening after returning from a transcontinental flight. The DJ kept shifting music so that it jumped from one period to another, all the while staying within the framework of popular music of the preceding four decades. With each change of music, Aycock felt that time—a proverbial shape-shifter—had been altered and that she, like Vonnegut's Billy Pilgrim, was entering into a new continuum, demanding different movements and rhythms, thus enacting physically a series of pop culture Alephs.

In order to remain true to the dream rather than to her real experience at the disco, Aycock embraced the subject of historical dances in this drawing rather than the relatively recent ones she had enjoyed. To convey a sense of the wizardry of her imagined flight, she drew a series of parterres outlining ancient kabbalistic emblems that she had found in a sixteenth-century text. These emblems have been reinterpreted as magic signs and considered capable of generating such forces as

invincibility. An ardent gardener, Aycock no doubt relished the prospect of joining magic emblems and dance notations into elaborate formal topiary as the setting for a love garden.

This conflation of kabbalistic symbols and dance notations into a new language appears to be fully in line with the thought of German Enlightenment writer Christian Wolff. A popularizer of Enlightenment concepts, Wolff explained the mechanisms of language in terms of its ability to provide clear mental pictures of the world's more nebulous aspects, and cited dance notations as easily comprehensible examples of this process.[22] His example, which demonstrates language's ability to coalesce time into intelligible signs, correlates well with Aycock's idea that drawing and dance both spatialize and concretize time, thereby making it understandable, if not static. This concept is particularly apposite to the subject of this drawing, which situates contredanses within the confines of the highly structured framework of a fenced-in and elaborately planned formal garden, which in turn underscores the universal and cyclical aspects of movement (dance) and nature (gardens). The building in the drawing comes from an illustration of the Marquis de Sade's theater for his sadomasochistic love rites. And this reference heightens and concentrates the drawing's overriding thematic of darkness and light.

The dance theme is extended nine years later in Aycock's installation *Waltzing Matilda* of 1997 (fig. 26.15), featuring a stage backdrop of the night sky. In front of this background is a spinning top—perhaps a metaphor of the earth wobbling on its axis—whose movement is confined to a template outlining eighteenth-century contredanse diagrams. *The Eaters of the Night* series and *Waltzing Matilda* were shown together in 1997 at East Hampton's Guild Hall. The installation also contained a zoetrope of monkeys jumping through hoops in outer space—certainly an ironic view of human efforts to conquer and colonize space—that

had made an appearance in *Sculpture Installation, Sacramento Convention Center* (1996) (fig. 26.17). Shortly after the terrorist attacks of September 11, 2001, Aycock returned to the thematic of the top rotating on its axis. She opted for a more readerly approach in a computer drawing of two abutted tops precariously balanced on a shifting world stage to signify the abrupt conjunction of Islamic fundamentalist terrorism and Western worldviews that the assaults on New York's World Trade Towers and the Pentagon represented (fig. 26.23).

Despite her own enormous curiosity, deep commitment to learning, and valorization of the knowledge game that I have characterized as sophistry, Aycock agonizes about being too easily understood and therefore "found out, perhaps because some of her pieces, as we have seen, crest the readerly/writerly divide and can be interpreted as belonging to either one of these sides or both of them."[23] Her statement echoes Nietzsche's ironic sentiment, "Every profound thinker is more afraid of being understood than of being misunderstood."[24] "Being found out" can be construed as a fear of being discovered as a fraud or of being thought simple-minded, but both suppositions have to be discounted when one considers this artist's vast knowledge and exceptional ability to synthesize diverse and complex scientific and philosophical material in her most writerly works. A more apposite reading of her overall fear might be her worry that her work will be reduced to an official, impoverished interpretation that does not acknowledge its deliberate contradictions and ambiguities—a writerly tack that gives her most notable work a resilient open-endedness. A more limited view would have the net effect of reconstituting and ultimately incarcerating her art by substituting its readerly criteria for her usual writerly approach. Just as importantly, a readerly interpretation—whether her own or her viewer's—would insinuate its biases, thus affecting an individual work so stringently that it might

determine the standards that future viewers might project on it. Aycock might also fear being found out because her relatively unconventional multitextual approach might make her work appear less serious to those accustomed to established forms of interpretation involving the obviousness of transcendental signifieds.

In her 1984 blade sculpture *A Salutation to the Wonderful Pig of Knowledge* (fig. 24.7), Aycock resolves her fear of being "found out," as she has on numerous other occasions, through the stylistic that she has called "schizophrenic." A figure found in Edwin A. Dawes's *The Great Illusionists*,[25] the "Wonderful Pig of Knowledge" is also one of the twenty characters listed in *The New & Favorite Game of the Universe and the Golden Goose Egg*. In creating this sculpture, Aycock speculated about the peacock image in the *Combat of the Bird and the Serpent* (fig. 24.8), an illustration in the Gerona Beatus of 975, which she found in John Williams's *Early Spanish Manuscript Illumination*.[26] According to Williams, the bird is a personification of Christ defeating the devil.[27] In terms of Aycock's work, it might be construed as an allegory of Faustian life confronting shape-shifting Death, which here takes the form of a serpent. Aycock considered the reproduced manuscript page with its image of the bird's head in profile to be so marvelously insane that it had to have been made by a person in "a mad hallucinatory state."[28] She imagined that this bird of paradise was suffering enormous pain because its head had been bisected and spread open to show how electric impulses from its brain might extend to the furthest reaches of the universe. Aycock's conversation with critic Stuart Morgan about this sculpture is indicative of the chimerical nature of her free associations, her continued need to escape the confines of official interpretations, and her sheer delight in the disjunctive flights of the imagination as well as the metamorphoses such processes can effect. The discussion between Aycock and Morgan sounds at

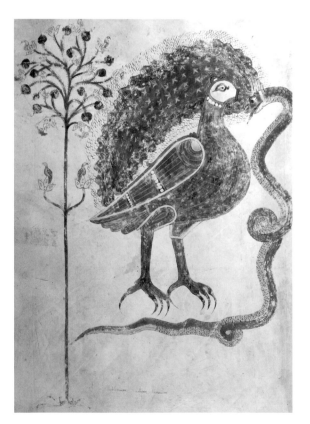

24.7

Alice Aycock, *A Salutation to the Wonderful Pig of Knowledge (Oh! Great Jellyfish, Great Waterspouter . . . There's a Hole in the Bucket, and There's a Hole in My Head . . .)*, 1984. Steel, copper, brass, aluminum, Formica, wood, Plexiglas, LEDs, and motorized parts; 6′ 9″ high × 9′ 3″ wide × 11′ 6″ deep. Private collection. Photo: Fred Scruton. (also plate 11)

24.8

Combat of the Bird and the Serpent in the Gerona Beatus of 975. Illuminated manuscript page, 15³/₄″ × 10¹/₄″. Collection of Gerona Cathedral. Image courtesy of George Braziller, Inc.

times almost like a performance piece between a straight man and a schizophrenic:

MORGAN: *Who or what is the Pig of Knowledge?*
AYCOCK: *He's the diagram of how Doges are elected in Venice—he's got that crest on his head; he's an attack system for a medieval fortress in Europe, he's a fan, he's the 52 decks of cards, he's the chicken story. Especially the chicken story.*
MORGAN: *He can't be all those things.*
AYCOCK: *He is. He and Corti [the organ of Corti—part of the inner ear] discuss the whole situation. The Pig is fluttering in the corner like birds do when they're in a room and they knock themselves against a wall.*
MORGAN: *Pigs don't flutter.*
AYCOCK: *He's not a pig; he's a bird. He's really a bird. But he's a pig because he's so hungry. When you're ravenous for information you're a Pig of Knowledge. Einstein was a Pig of Knowledge—he wanted it so bad. And what people say about that someone says about the Pig. You know how birds keep knocking themselves against walls when they're inside a room and they want to get out? Someone walks in and says, "I want to hear the vast fluttering, the vast flapping of the soon-to-be-belated bird."*[29]

Historically, according to Dawes, there was not one Pig of Knowledge but a number of them that could be called "clever." Among them are The Wonderful Pig, which Thomas Rowlandson caricatured in 1785; Toby, the Swinish Philosopher and Ladies Fortune Teller, who appeared at London's Bartholomew Fair in 1825; the Unrivalled Chinese Swinish philosopher, Toby the Real Learned Pig, who is recorded as being at this same fair in 1833; and his rival, the Amazing Pig of Knowledge, who was shown at the George Inn that same year. In addition to these British examples, an American Pig of Knowledge appeared at the end of the eighteenth century and the beginning of the nineteenth. All of these animals could perform for audiences, some could play card tricks, several could spell, and the Amazing Pig of Knowledge, according to Dawes's sources, "could tell the number of pence in a shilling, the shillings in a pound, count the spectators, divine their thoughts, distinguish colours and, as if this were not enough, 'do many other wonderful things.'"[30] For Aycock this ready-made, historical image of sleight-of-hand illusionism and gluttony was a particularly apt way to characterize the late twentieth century's romance with virtual reality and its rapacious information binge that the PC revolution was beginning to permit.

"The chicken story" that Aycock mentions in her interview with Morgan refers to a particularly dramatic incident from her childhood when her menagerie of Easter chicks and bunnies were left overnight in the same cage. The bunnies licked the chickens so much that they removed their feathers and skin, revealing the organs underneath. The cuddly bunnies literally loving the birds to death and the combination of pain and pleasure that the artist imagined these creatures feeling have remained a powerful image that she has superimposed on the Pig of Knowledge, whose flayed wing reveals the sun. For Aycock this story bespeaks the great anguish and joy that can come from living life with maximum intensity. Her image of a bird/pig without its feathers—an image of stymied transcendence—coupled with a deep physical desire for knowledge—evidenced by the obstruction of the new life that Easter chicks are supposed to represent—can be regarded, using Aycock's preference for Derridean slipping signifiers, as a reconsideration of the Greek myth of Marsyas who challenged Apollo to a musical contest, which Marsyas as an ordinary mortal then lost. Subsequently, he was flayed alive by the sun god for his temerity, and thus was linked throughout time with Apollo, his victor and executioner. The reference also suggests a connection with the impertinent Icarus, who flew too close to the sun and thus fell to his death when the wax adhering feathers to his body melted.

349

Although these allusions recommend viewing Aycock's *Wonderful Pig of Knowledge* as an updated allegory of humanity's hubris on a par with Marsyas's challenge and Icarus's flight, Aycock's work moves beyond such clear-cut interpretations. The Pig's greed for knowledge and loss of autonomy assume the far reaches of Faust's pact with the Devil, which can yield the ready delights of sophistry rather than the rigors of wisdom. Not at all satisfied with art's ability to help ratify distinct ideologies, Aycock's most trenchant work dramatizes the contradictions developing from a plethora of information. The result is a jostling of worldviews with distinct limits and breaks between them that incite viewers to come to terms with those rifts in the universe where one ideological view breaks off and another commences.

Conclusion

Because the archaeological sites I have visited are like empty theatres for past events, I try to fabricate dramas for my buildings, to fill them with events that never happened, to allude to function, a function they never had.

Alice Aycock
"Mystery under Construction," 1977

During an intense period from the early 1970s to the late '80s, Alice Aycock moved with astonishing speed through the intellectual landscapes of Duchamp's work, minimalism, conceptual art, performance, and site specificity, as well as medieval manuscript illuminations, kinetic art, and architectural history. She has repeatedly visited a number of these sites, particularly Duchamp's, as she has thought of ways to extend art's epistemological range. Extended analysis of her work reveals significant connections with cybernetics and systems theory, feminism, esotericism, the prescientific world, amusement parks, engineering, and mazes, in addition to quantum mechanics, chaos theory, and mnemonics as the antecedent of artificial intelligence. The number of topics literally and figuratively embraced by this work is truly daunting, and its potential resonances are many: on the one hand, this art suggests how mediated our culture has become, since most thoughts are echoes of already formulated ideas; on the other, it testifies to a vast inflation of information and

351

visual imagery making up our negentropic contemporary world.

During the two-decade period when Aycock was first a student at Douglass and Hunter colleges and later became an artist, she developed a means for coping with the Glass Bead Game distinguishing our culture. Instead of making moral judgments about the chaotic state of our culture or recoiling from it to create ascetic pieces, she has embraced its encyclopedic vastness with the enthusiasm of a sophist who contemplates knowledge's grand edifices in terms of ever-changing complexes. In doing so she has reveled in our culture's contradictions, played with its most serious and profound discoveries, and been utterly delighted with its challenges. Her unabashed indulgence in intellectual games tantamount to sophistry ensures her work historical cogency because it dramatizes the tremendous desire for easily accessible, widely disparate forms of knowledge and multitudinous perspectives that characterize the beginnings of our information age as schizophrenic.

Maturing as an artist in the transitional period of incipient postmodernism, Aycock is similar to a number of other members of her generation who experienced a profound distaste for the reductive purity of Clement Greenberg's modernism. In place of this autonomous art that aimed at becoming a transcending aesthetic distillate, Aycock wished to keep her work firmly grounded and open to people as well as to contemporaneous social, historical, and cultural contexts. To accomplish this goal, she had to move beyond making mere pronouncements about the meaning of her art and present a number of possible perceptual and interpretive spaces in which viewers were free to imagine. Her goal has been to analogize Borges's Aleph so that art can be seen as an opening on both known and unknown worlds. Creating at a time when formal art was considered bankrupt, Aycock has initiated a new type of shape-shifting work that aims to keep polarities open in a manner consistent with Heidegger's rift. In one of her often-cited phrases, she encourages her work "to take a walk in the world." I should add that this type of open-ended exercise permits art to participate fully in the complexities of a dynamic world that not only has affected the artist while working on her pieces but also has an impact on viewers coming in contact with them.

352

Plates

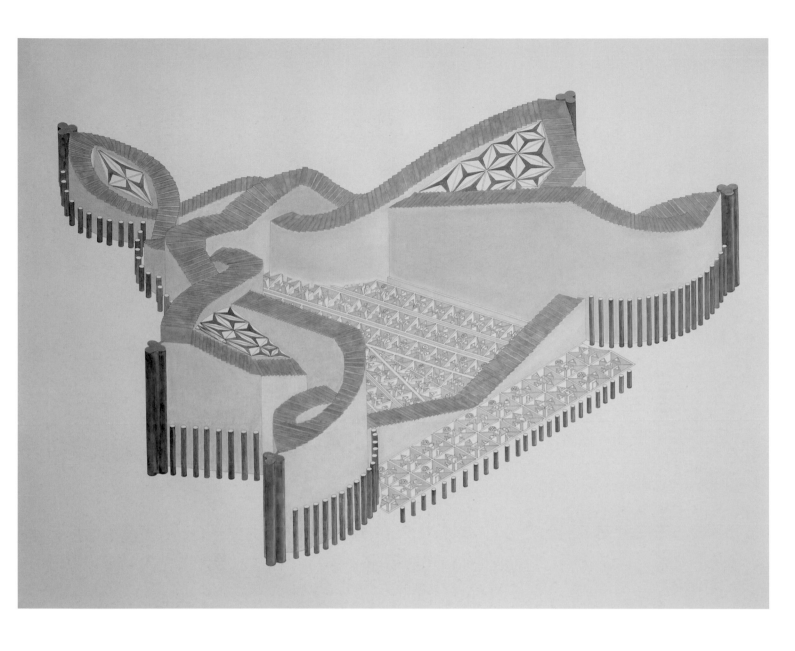

Plate 1
Alice Aycock, *The Great Watchtower of the East*, 1988.
Ink, pastel, and watercolor on paper, 60″ × 83³/₄″. Collection
of Sean Kelley, Kansas City, Missouri. Photo: Fred Scruton.

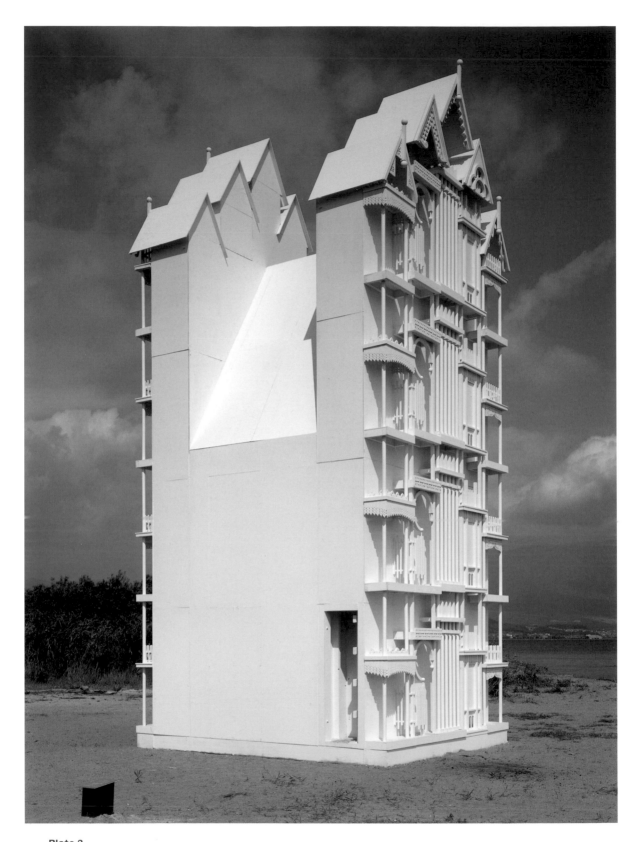

Plate 2

Alice Aycock, *The House of the Stoics Structure A*, 1984.
Wood painted white, 32′ high × 13′ 6″ wide × 11′ 9″ deep.
Exhibited at Lake Biwa, Miyazaki-Mura, Japan. Collection
of the artist.

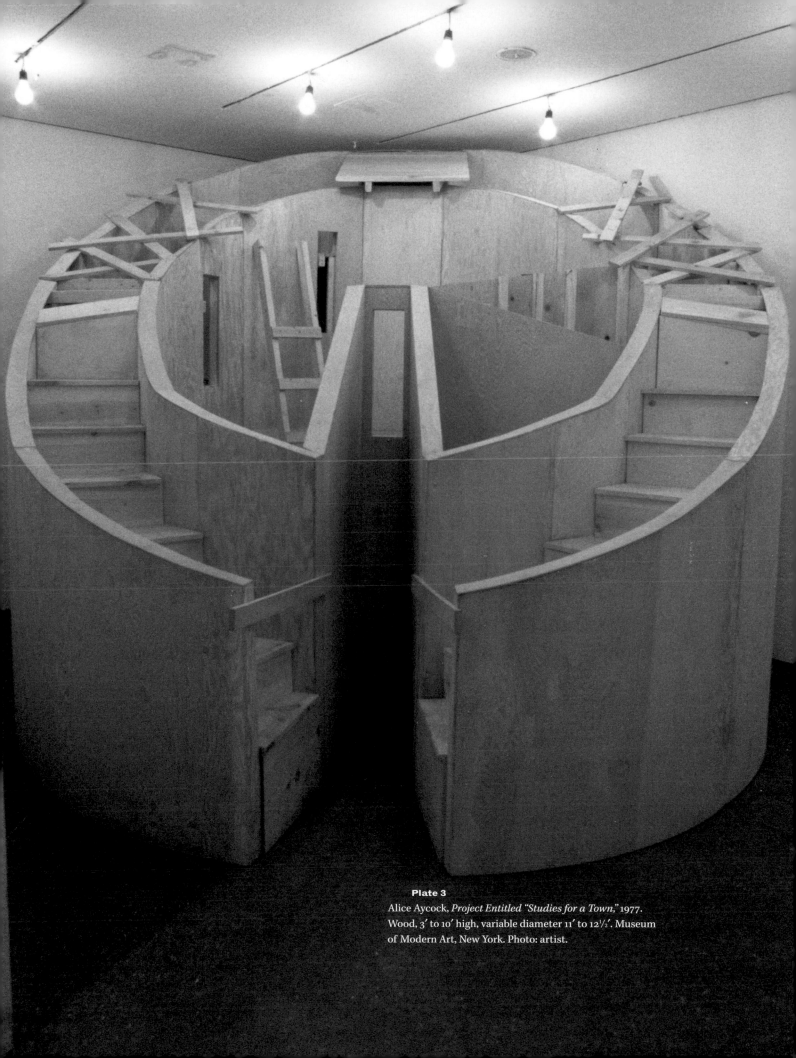

Plate 3
Alice Aycock, *Project Entitled "Studies for a Town,"* 1977.
Wood, 3′ to 10′ high, variable diameter 11′ to 12½′. Museum
of Modern Art, New York. Photo: artist.

Plate 4
Alice Aycock, *Large Scale Dis/Integration of Micro-
Electronic Memories, The Storyboard*, 1980. Pencil and ink on
Mylar, 42″ × 54″. Collection of J.P. Morgan Chase Bank.
Photo: Nathan Rabin.

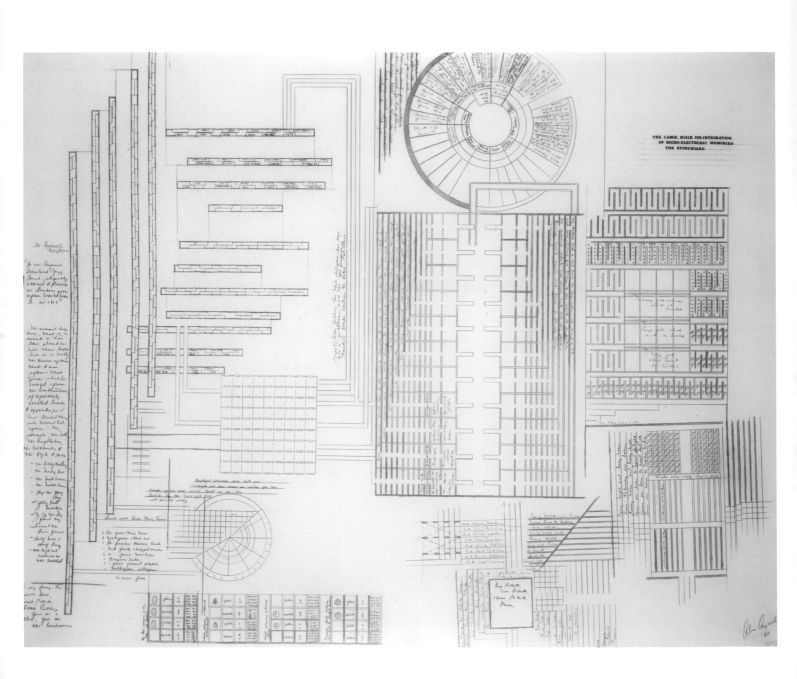

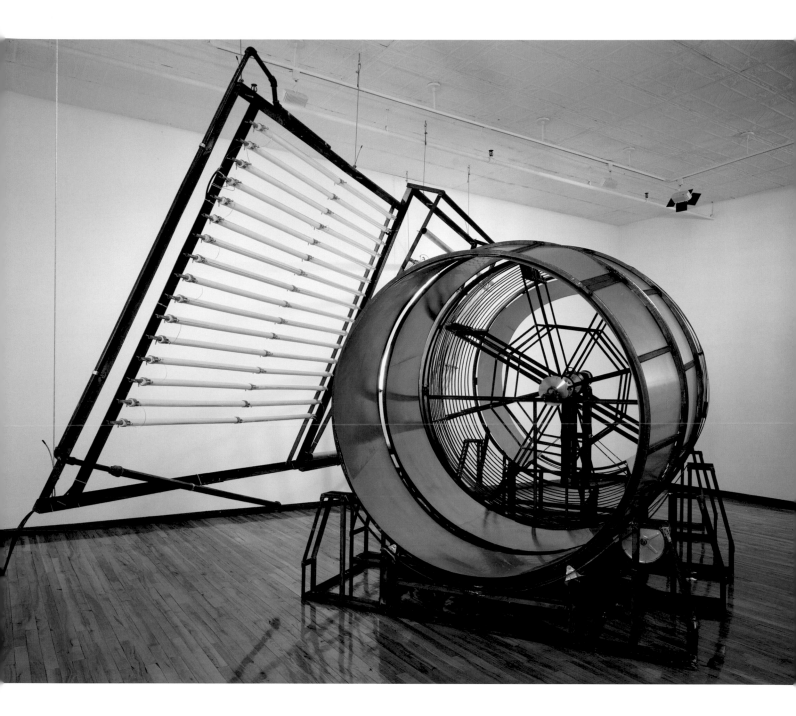

Plate 5

Alice Aycock, *The Savage Sparkler*, 1981. A series of large
revolving drums with a rapidly spinning section, a suspended
rack of hot coils, fluorescent lights, steel, anodized
aluminum, fans, motors, copper tubes, and sheet metal;
approx. 10′ high × 10′ diameter × 20′ long. Collection of
Myers/Kent Gallery, State University College, Plattsburgh,
New York. Photo: Jon Abbott.

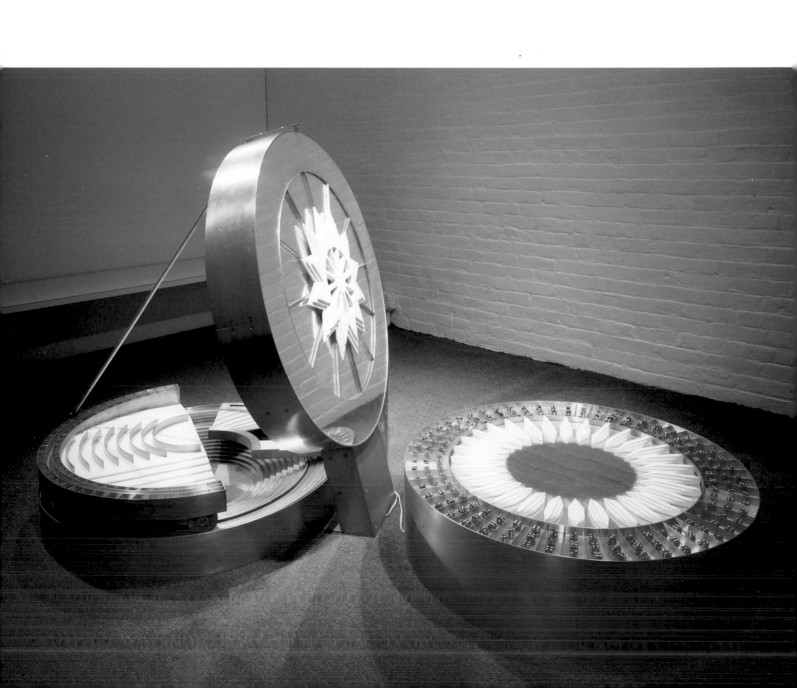

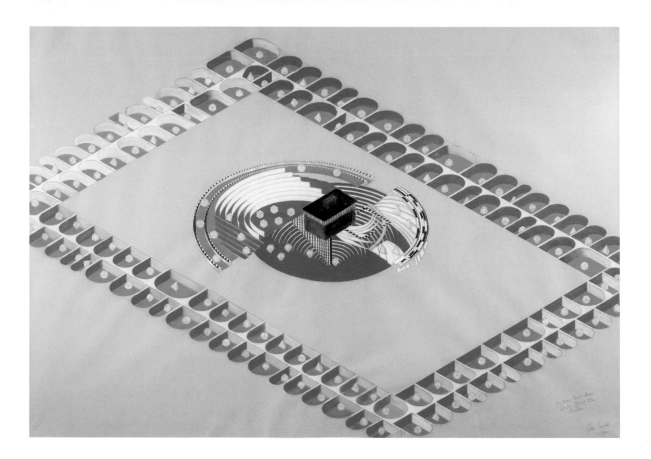

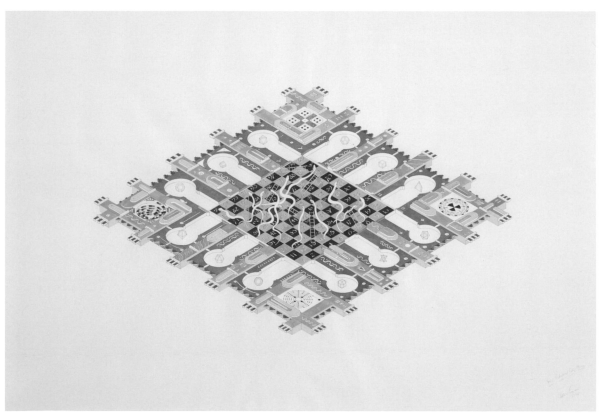

Plate 7
Alice Aycock, *The Glass Bead Game: Circling 'Round the Ka'ba*, 1985. Pencil and pastel on paper, 57½″ × 83″. Collection of Stephen Kramarsky. Photo: Peter Muscato.

Plate 8
Alice Aycock, *The Celestial City Game*, 1988. Ink and watercolor on paper, 60″ × 90″. Private collection. Photo: Fred Scruton.

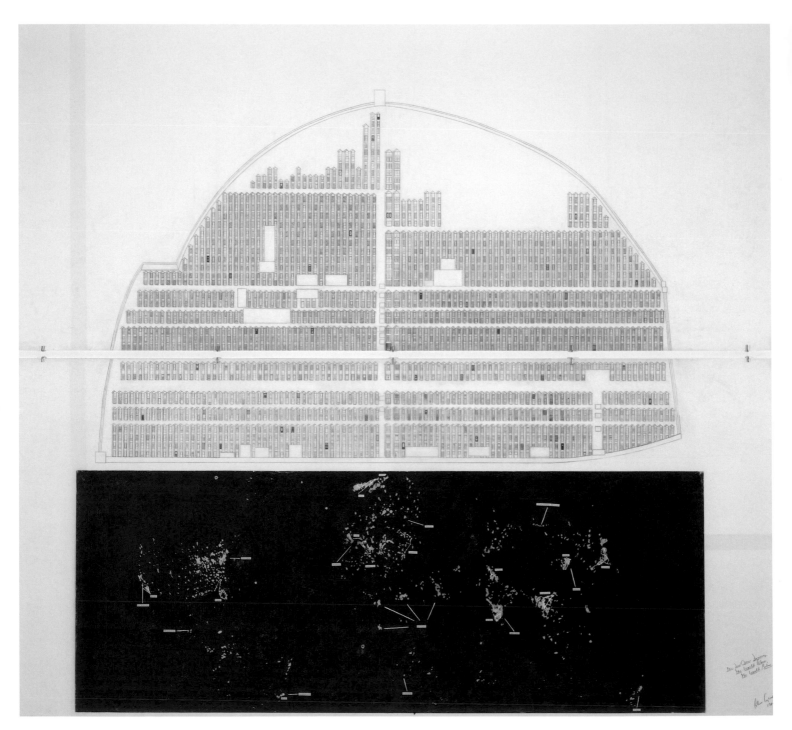

Plate 9
Alice Aycock, *The New China Drawing (The World Above, the World Below)*, 1984. Ink, pencil, and crayon on Mylar, 96″×108″. Museum of Modern Art, New York, fractional and promised gift of Sarah-Ann and Werner H. Kramarsky. Photo: Fred Scruton.

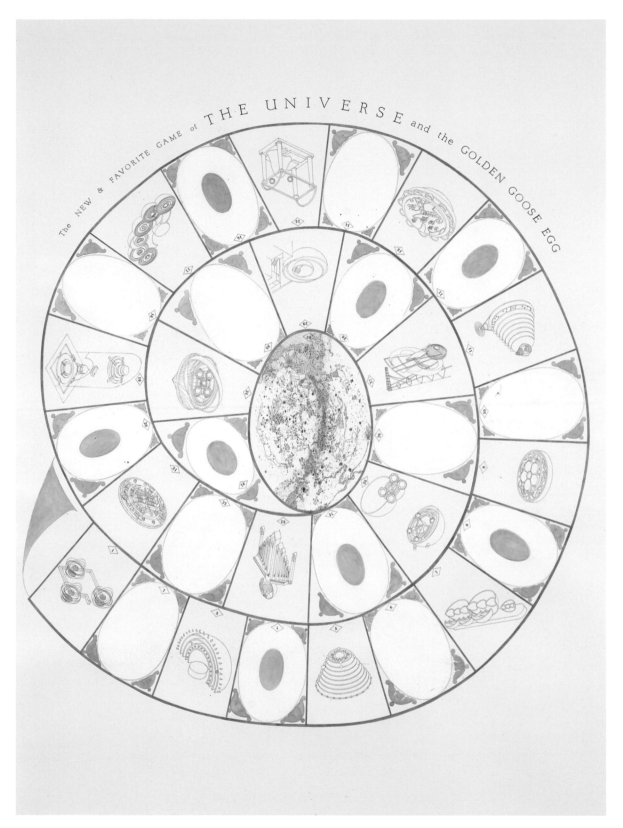

Plate 10
Alice Aycock, *The New & Favorite Game of the Universe and the Golden Goose Egg*, detail, 1987. Ink, pastel, and watercolor on paper, 102″ × 60″. Private collection. Photo: Fred Scruton.

Plate 11

Alice Aycock, *A Salutation to the Wonderful Pig of Knowledge (Oh! Great Jellyfish, Great Waterspouter ... There's a Hole in the Bucket, and There's a Hole in My Head ...)*, 1984. Steel, copper, brass, aluminum, Formica, wood, Plexiglas, LEDs, and motorized parts; 6′ 9″ high × 9′ 3″ wide × 11′ 6″ deep. Private collection. Photo: Fred Scruton.

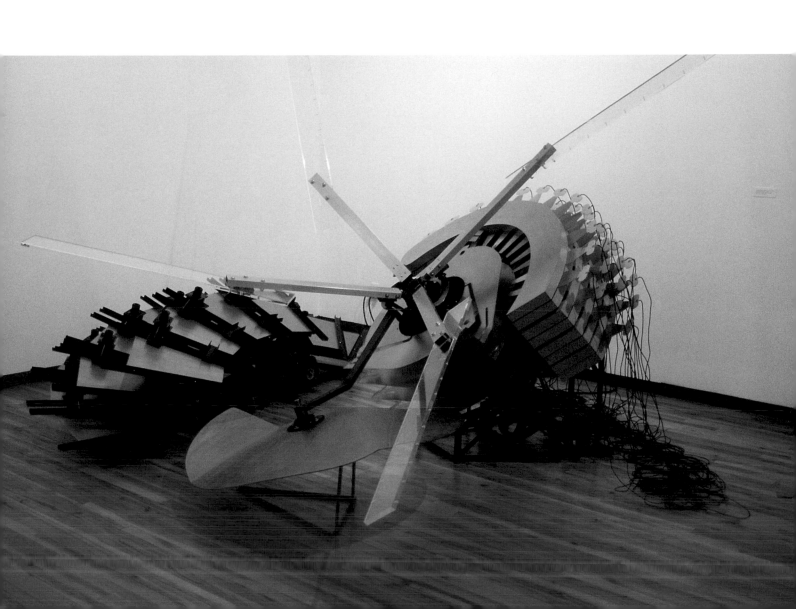

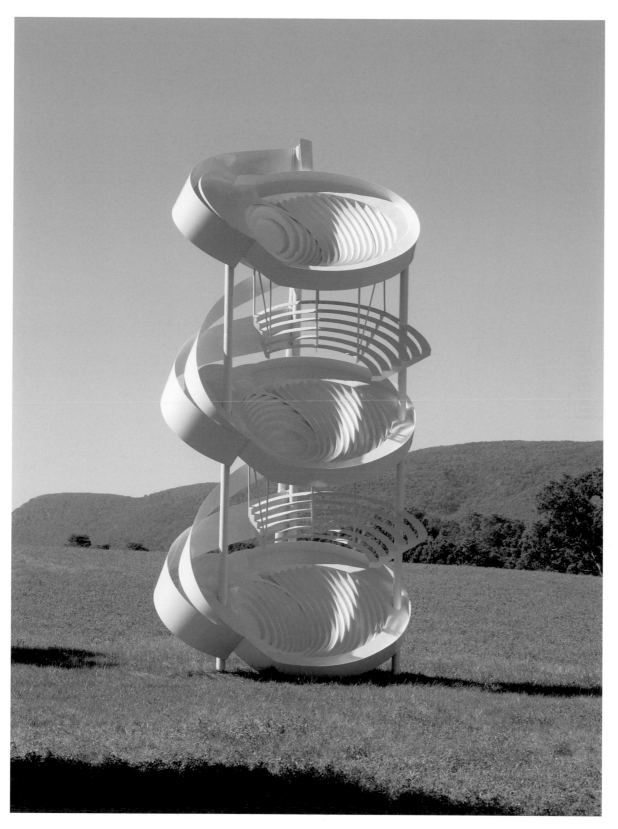

Plate 12

Alice Aycock, *Three-Fold Manifestation II*, 1987. Steel
painted white, 32′ high × 12′ wide × 14′ deep. Collection of
Storm King Art Center, Mountainville, New York.
Photo: Jerry L. Thompson.

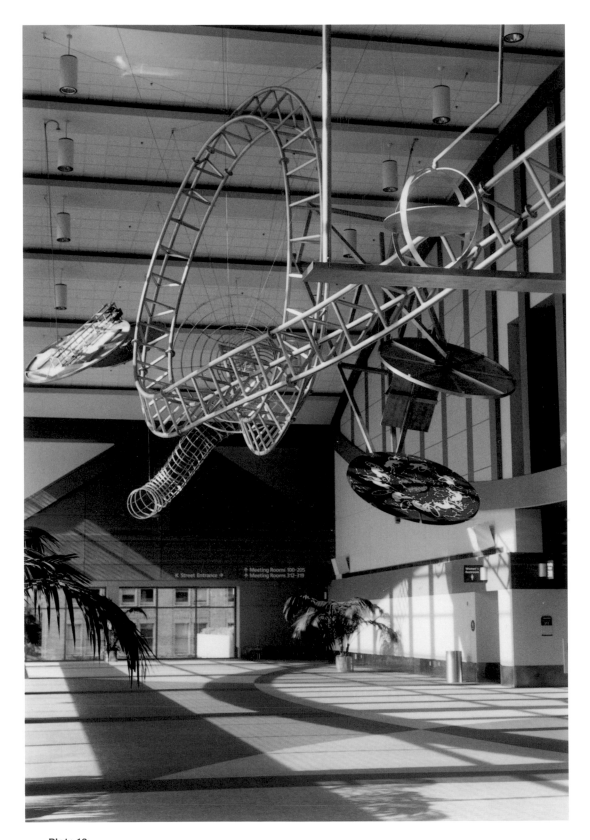

Plate 13

Alice Aycock, *Sculpture Installation, Sacramento Convention Center*, 1996. Aluminum, mirrored Plexiglas, motorized parts, and vinyl; 28′ high × 30′ wide × 110′ deep, 18′ above ground. Collection of City of Sacramento, California. Photo: artist.

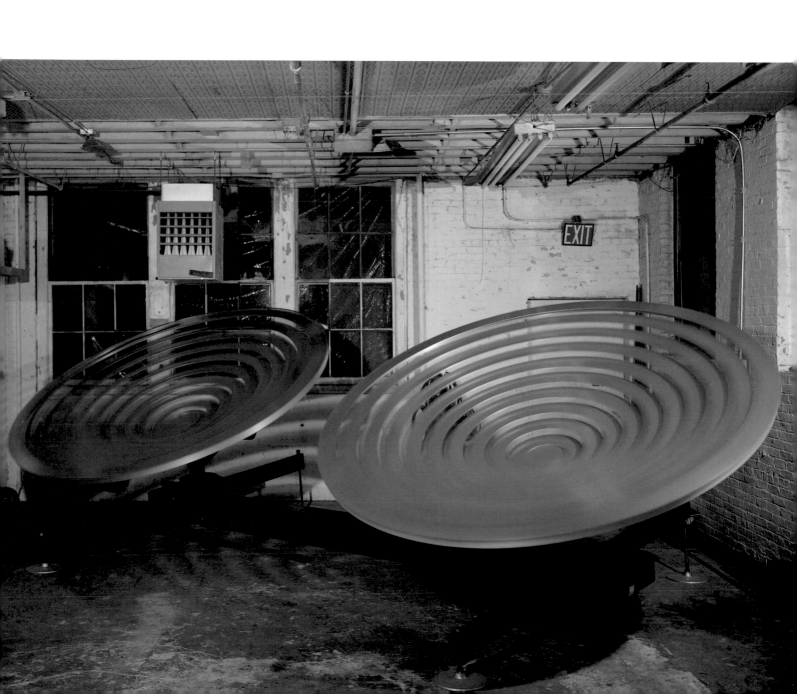

Plate 15

Alice Aycock, *Maze 2000,* 2002. Aluminum, 17′ high × 26′
wide × 30′ deep. Installed at University of South Florida,
Psychology/CSD Building, Tampa, Florida. Collection of
University of South Florida. Photo: Vincent Ahern.

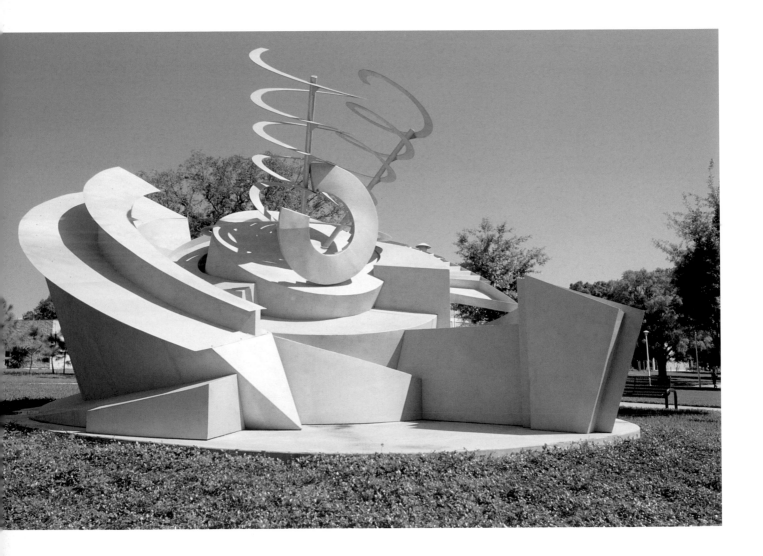

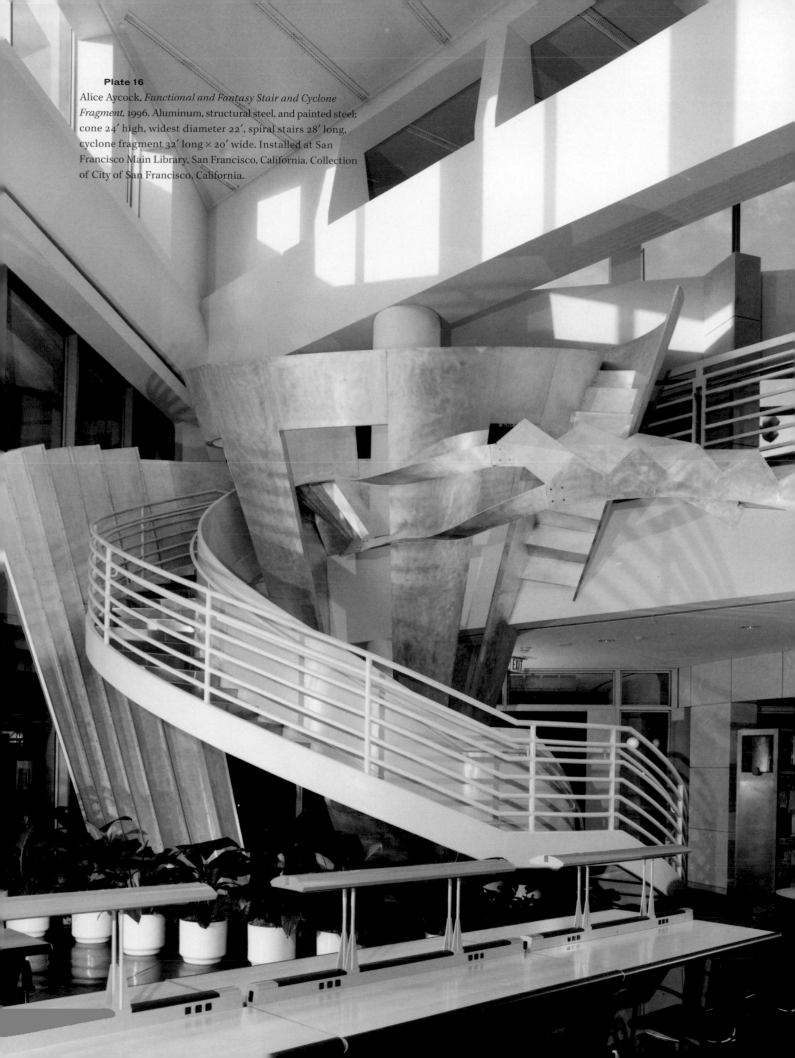

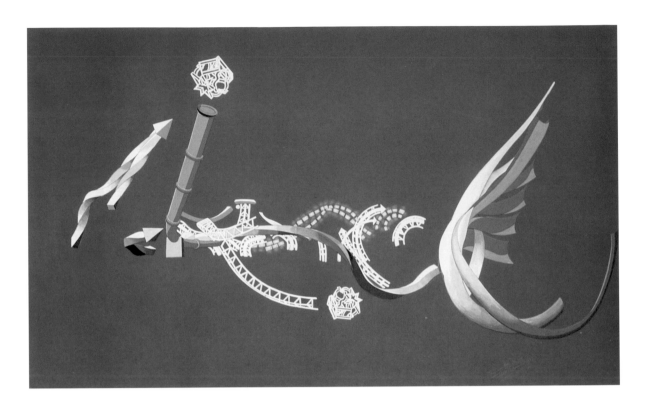

Plate 17

Alice Aycock, *Proposal for Miami Heat Arena,* isometric, 1998. Ink, pencil, and marker on orange handmade paper, 39½″ × 59″. Collection of Sarah-Ann and Werner H. Kramarsky, New York. Photo: Peter Muscato.

Plate 18

Alice Aycock, *The Star Sifter, Proposal for Terminal One, JFK Airport, New York,* 1998. Ink and colored pencil on paper, 48″ × 71″. Collection of Hugh Freund, New York. Photo: Fred Scruton.

Postscript

[Christos Ioannis] Yessios spelled out a significant notion for his approach to 3D modeling: the space enclosure as the primary primitive. To put an end to the historical division between drafting and designs, he sustains [in Form-z] an approach where drafting was going to be a subsystem of 3D modeling. . . . All the software available were designed to fit the needs of mechanical engineering and drafting, hardly accommodating the operational logic of architectural design. The mechanical engineer deals primarily with solids, hence solid modeling; the architect deals with voids, for instance a room is a void. It follows that void modeling [Form-z] would better fit the thought process propelling architectural design.

Pierluigi Serraino
History of Form-z, 2002

Although this book has focused specifically on Alice Aycock's work that questions sculpture's traditional status and mode of communicating, it would be unfair to leave readers without at least a glimpse of her more recent endeavors. At the same time that she was summing up her early style in magisterial drawings of the 1980s, Aycock was already initiating a new phase. This development is oriented toward making monumental and permanent pieces, as her 1987 *Three-Fold Manifestation II* (fig. 26.1) clearly demonstrates.

Similar to her earlier endeavors, this piece draws on a number of sources that the artist transforms and distorts. She references a Walter Gropius design for three theaters, and then tiers and encloses it to resemble a DNA spiral, which also appears to update the image of the stairway to the heavens

353

that appears in medieval and Renaissance art. In addition to this type of far-ranging iconography, *Three-Fold Manifestation II* and a number of other such sculptures from this period recall predominantly white constructivist pieces of the early twentieth century. The predominance of white in Aycock's work at this time implies the self-consciousness of a classic phase, as if she were comparing her art to color-stripped Greek and Roman marble sculptures as well as to early modern International Style architecture. Rather than consolidating these references into one single cohesive idea, Aycock invites the many associations of her pieces to question the simplicity of the classic white integument she has chosen for them.

In 1992 Aycock discovered a dramatically new way of virtually modeling forms on the computer before having them built, thus moving from the PC as the implicit subject matter of her earlier art to virtual imaging as a means for realizing innovative forms in her new work. At the recommendation of two young architects, graduates of the architecture program at Columbia and Parsons School of Design, she experimented with the new software called Form-z, which was being taught in a great number of architectural programs worldwide. Released in February 1991, this program was widely used by architects and designers because it allowed them to move immediately from concept to three-dimensional model without making interim two-dimensional drawings. Almost overnight Form-z and its corollary Auto-CAD enabled large architectural firms to dispense with scores of draftsmen and to hire in their place architects equipped to make design choices. This and other software tools for molding space on computers have contributed to the new fluidity in contemporary architecture exemplified by the designs of Santiago Calatrava, Frank Gehry, and Zaha Hadid, among others. For Aycock, who over the years has assembled an image file of movement, including such trajectories as the flight patterns of hummingbirds, the new

Alice Aycock, *Three-Fold Manifestation II*, 1987. Steel painted white, 32′ high × 12′ wide × 14′ deep. Collection of Storm King Art Center, Mountainville, New York. Photo: Jerry L. Thompson. (also plate 12)

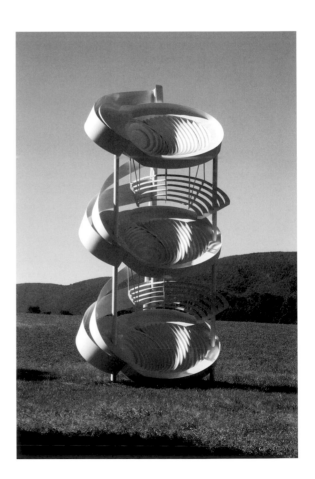

354

software program has been a boon for realizing a host of dynamic shapes in three dimensions.

One of her first works to incorporate an extensive use of Form-z is *East River Roundabout* (fig. 26.2), located in Waterfront Park, New York City, near the Queensborough Bridge. Working with the New York landscape architecture firm of Quennell Rothschild Associates, Aycock conceived an architectural sculpture that transforms a former Sanitation Department garage into a park pavilion by removing its sheathing to reveal a skeletal steel armature, which serves as a platform for her piece. Consisting of a looping spiral truss, a raised rectangular grid, a stairway thrust through the armature, and a fan-shaped wave, this roof sculpture was inspired by particle diagrams in quantum mechanics, Fred Astaire's gravity-defying dance in the 1951 film *Royal Wedding*, and the pathways of gigantic roller coasters like the Sooperdooperlooper. These forms of ascent, together with the sculpture's momentary thrust and propulsion, constitute a seemingly weightless movement through space that harks back to the cyberspace models giving rise to it and the hypertext-like links that join the work's many visual references.

Since the completion of this piece, Aycock has made many more works that rely on Form-z software as a sculpting tool. One of the most recent is *Maze 2000* (figs. 26.3, 26.4) for the University of South Florida, which rethinks constructivism in terms of a series of dynamic overlapping and interpenetrating curves intended to recall whirlwinds, vortices of hurricanes, spiral staircases, and amphitheaters. Not only do the effects of such ephemeral forces become discernible in *Maze 2000*, but elements of cyberspace also are made tangible. The work makes a compelling comparison with Aycock's *Leonardo's Swirl* (1982) (fig. 23.3), which attempted to realize in three dimensions this Renaissance artist's insights into the behavior of eddies of water. Two decades later, the empirical has become virtual, and movement around voids has been reconfigured as static envelopes of space encasing and defining them. Rather than depicting velocity in terms of a series of concentric forms representing dynamic currents as she did in *Leonardo's Swirl*, Aycock now contemplates its effects as a solid, thus making her sculpture an occasion for seeing how movement can activate space and how architecture can encase voids as if they were solid forms.

26.2
Alice Aycock, *East River Roundabout*, 1995. Aluminum, approx. 50′ high × 100′ wide × 100′ deep. Installed at East River Pavilion, East 60th Street and York Avenue, New York. Collection of New York City Department of Parks and Recreation. Photo: Warner Wada.

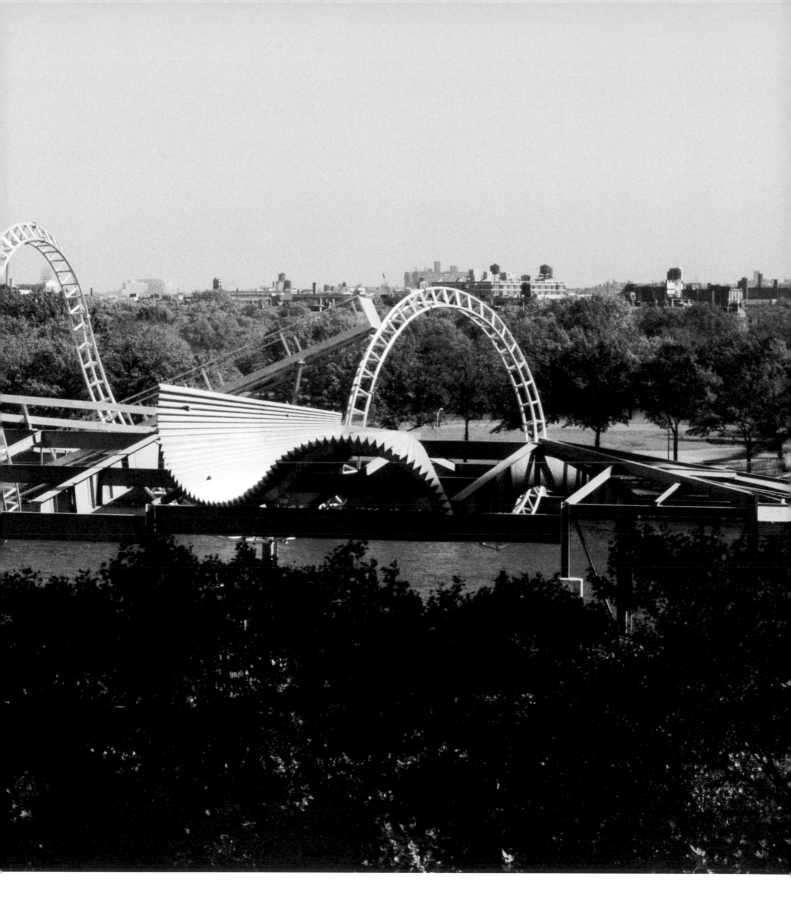

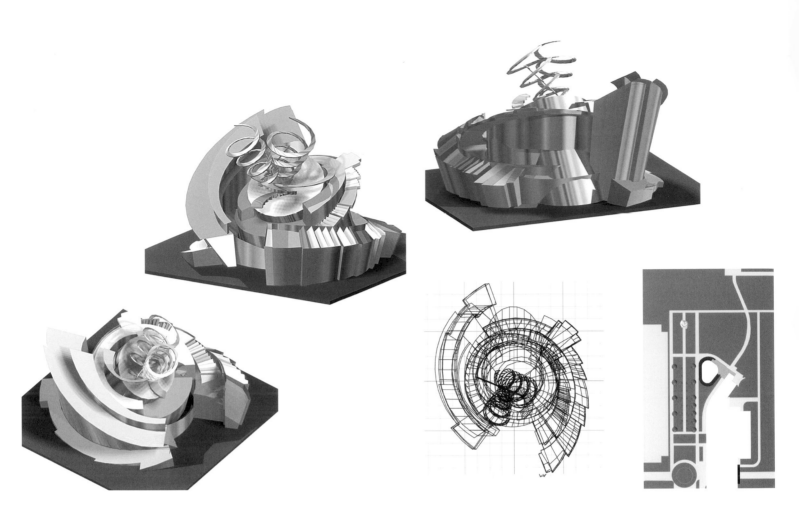

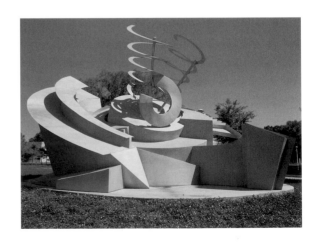

26.3
Alice Aycock, *Maze 2000, Proposal for University of South Florida, Tampa, Florida*, 2000. Computer-rendered image, variable sizes. Photo: Jacek Malinowski.

26.4
Alice Aycock, *Maze 2000*, 2002. Aluminum, 17′ high × 26′ wide × 30′ deep. Installed at University of South Florida, Psychology/CSD Building, Tampa, Florida. Collection of University of South Florida. Photo: Vincent Ahern.
(also plate 15)

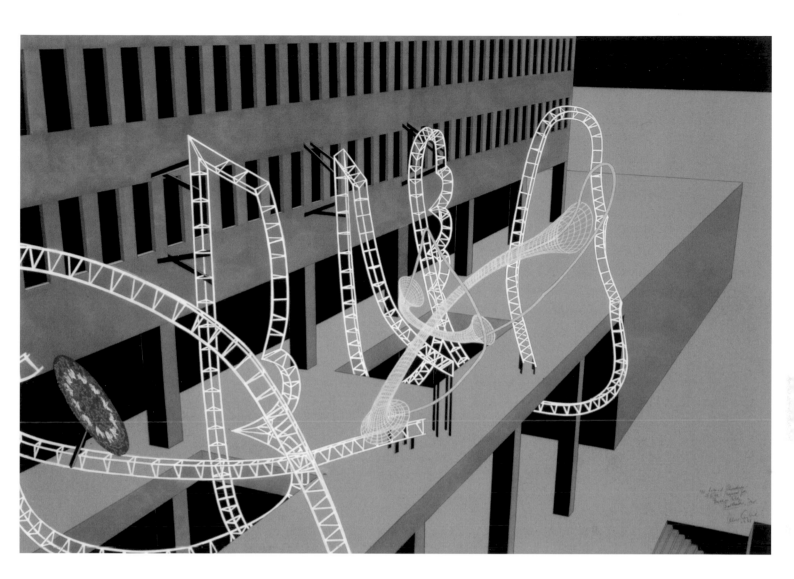

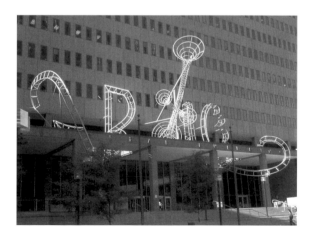

26.5
Alice Aycock, *The Second Adventure, Flight*, 1998, ink and colored pencil on paper (set of 5), 44″ × 64″. Collection of the artist. Photo: Fred Scruton.

26.6
Alice Aycock, *Swing Over,* George H. Fallon Office Building, Baltimore, Maryland, 2004. Aluminum, approximately 40′ high × 400 linear feet wide × 30′ deep. Photo: Karen Mauch.

26.7
Alice Aycock, *Waterworks Installation, University of Nebraska Medical Center,* 1993. Aluminum, steel, concrete, plumbing system, and water; 28′ high × 41′ long × variable width. Collection of University of Nebraska, Omaha. Photo: artist.

"This fountain enlarges on children's experiments found in Arthur Good's *Magical Experiments or Science in Play* (1894). Called 'Russian Mountains,' the experiment is supposed to create 'the spectacle . . . of drops of water ascending and descending, one after the other, on the miniature mountains and looking as if they were trying to catch up to one another' (p. 219)." A. A.

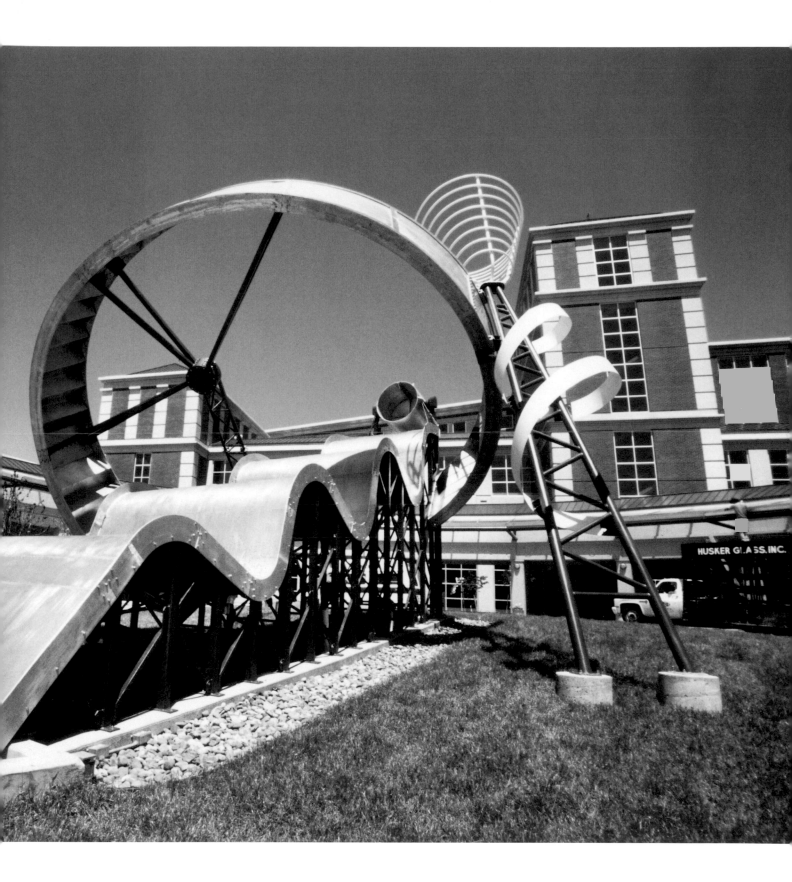

Language

Alan Cycok
1953

(previous seven pages)

26.8

Alice Aycock, *Dances on the Starry Night, from The Eaters of the Night
(A Continuing Series)*, 1993. White ink and silkscreen on black paper, $45\frac{1}{2}'' \times 31'' \times 1\frac{3}{4}''$
framed. Collection of Berger, Stern & Webb, LLP. Photo: Fred Scruton.

26.9

Alice Aycock, *Wars on the Starry Night, from The Eaters of the Night
(A Continuing Series)*, 1993. White ink and silkscreen on black paper, $45\frac{1}{2}'' \times 31''$.
Private collection.

26.10

Alice Aycock, *Mechanical Movements on the Starry Night, from The Eaters
of the Night (A Continuing Series)*, 1993. White ink and silkscreen on black paper,
$45\frac{1}{2}'' \times 31''$. Collection of Agnes Gund, New York.

26.11

Alice Aycock, *Games on the Starry Night, from The Eaters of the Night
(A Continuing Series)*, 1993. White ink and silkscreen on black paper, $45\frac{1}{2}'' \times 31''$.
Collection of Wachtell, Lipton, Rosen, Katz, New York.

26.12

Alice Aycock, *Universe Schemes on the Starry Night, from The Eaters of the Night
(A Continuing Series)*, 1993. White ink and silkscreen on black paper, $45\frac{1}{2}'' \times 31''$.
Collection of Wachtell, Lipton, Rosen, Katz, New York.

26.13

Alice Aycock, *Languages on the Starry Night, from The Eaters of the Night
(A Continuing Series)*, 1993. White ink and silkscreen on black paper, $45\frac{1}{2}'' \times 31''$.
Collection of Wachtell, Lipton, Rosen, Katz, New York.

26.14

Alice Aycock, *Cities on the Starry Night, from The Eaters of the Night
(A Continuing Series)*, 1993. White ink and silkscreen on black paper, $45\frac{1}{2}'' \times 31''$.
Collection of Pat Hall, Santa Fe, New Mexico.

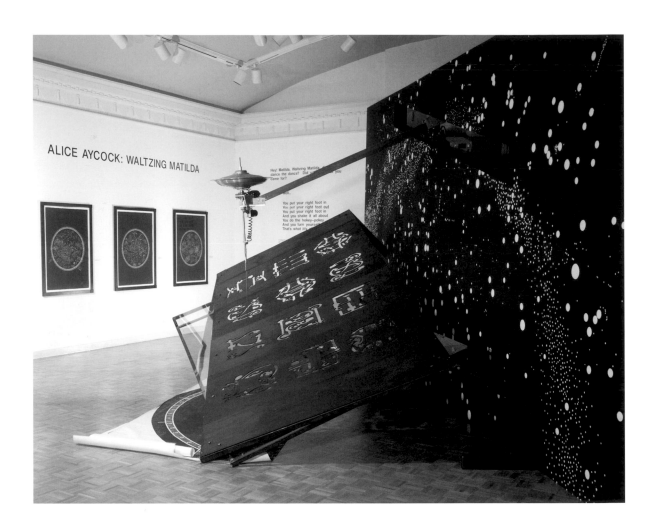

26.15

Alice Aycock, *Waltzing Matilda,* 1997. Steel, Plexiglas, motors, wood, and electronics. Collection of the artist. Photo: Noel Rowe.

26.16 (top)
Alice Aycock, *Whirlpools,* 1995. Aluminum, steel, and motorized parts, approx. 6′ × 20′ × 20′. Collection of the artist. (also plate 14)

26.17 (bottom, left)
Alice Aycock, *Sculpture Installation, Sacramento Convention Center,* 1996. Aluminum, mirrored Plexiglas, motorized parts, and vinyl; 28′ high × 30′ wide × 110′ deep, 18′ above ground. Collection of City of Sacramento, California. Photo: artist. (also plate 13)

26.18 (bottom, right)
Alice Aycock, *Functional and Fantasy Stair and Cyclone Fragment,* 1996. Aluminum, structural steel, and painted steel; cone 24′ high, widest diameter 22′, spiral stairs 28′ long, cyclone fragment 32′ long × 20′ wide. Installed at San Francisco Main Library, San Francisco, California. Collection of City of San Francisco, California. (also plate 16)

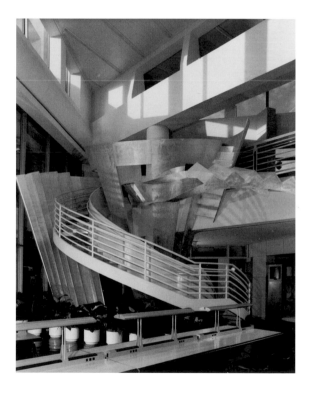

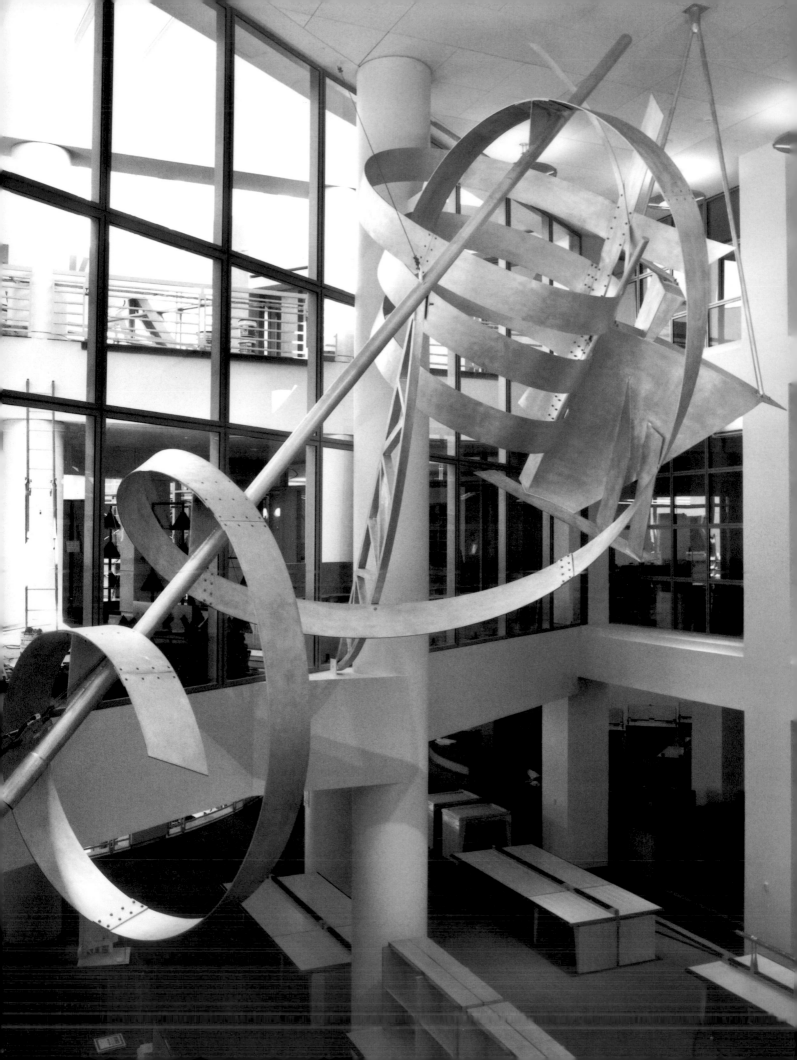

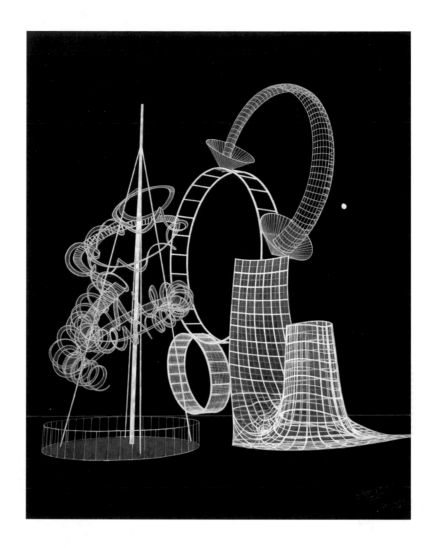

26.19

Functional and Fantasy Stair and Cyclone Fragment, detail of cyclone fragment.

26.20

Alice Aycock, *The Fallacy of the Great Water Spouter,* 1998. White ink and colored pencil on blue paper, 70 × 59″. Collection of the artist.

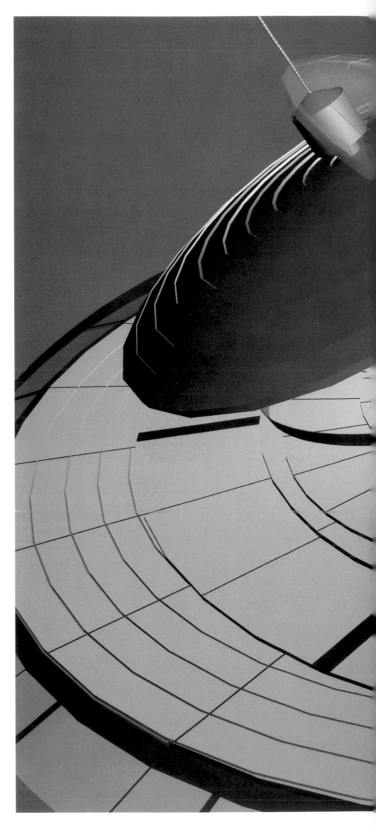

26.21
Alice Aycock, *Proposal for Miami Heat Arena,* isometric, 1998. Ink, pencil, and marker on orange handmade paper, 39¹/₂″ × 59″. Collection of Sarah-Ann and Werner H. Kramarsky, New York. Photo: Peter Muscato. (also plate 17)

26.22
Alice Aycock, *The Star Sifter, Proposal for Terminal One,* JFK *Airport, New York,* 1998. Ink and colored pencil on paper, 48″ × 71″. Collection of Hugh Freund, New York. Photo: Fred Scruton. (also plate 18)

26.23
Alice Aycock, untitled proposal, October 2001, dimensions variable. Computer graphics by Mark Watkins.

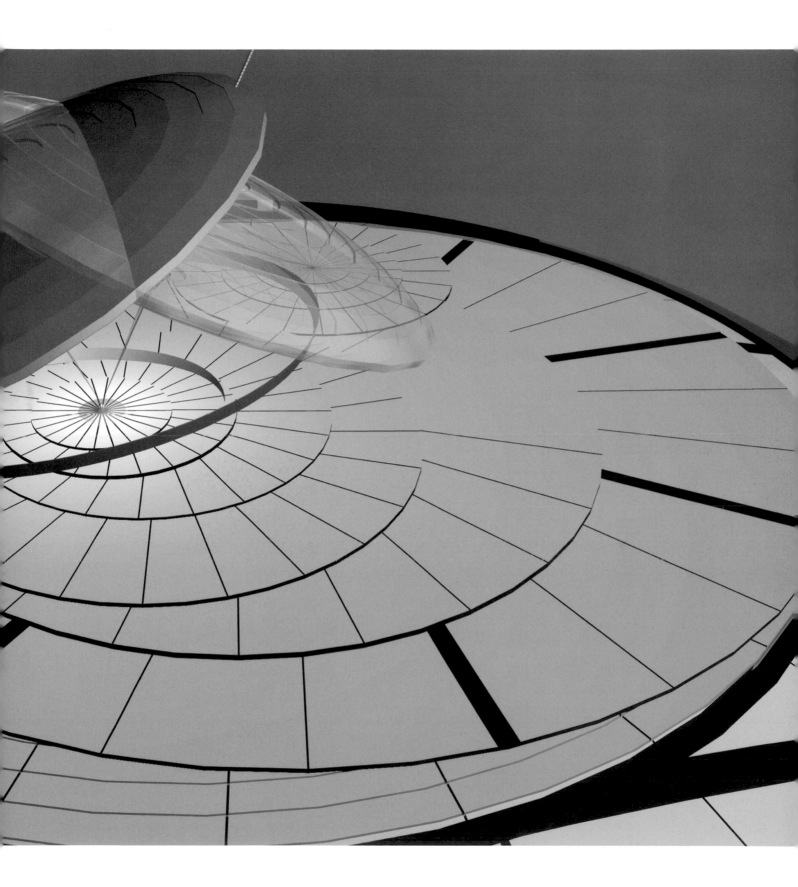

During the process of creating her art, Alice Aycock frequently fantasizes about the completed works and their possible meanings. These fantasies have taken the form of elaborate playlets and far-ranging stage directions (appendixes A and B); free-associated musings, resembling cheerleading yells or dance routines (appendix C); and, on one occasion, detailed instructions for a board game (appendix D).

Appendix A

Text Accompanying *Project Entitled "I Have Tried to Imagine the Kind of City You and I Could Live in as King and Queen"*

THE SCENE. A brewery and soft drink bottle manufacturing plant on the Eve of the Industrial Revolution named Yantra. It is a star castle.

THE ACTION. She wore the same black linen dress, cut low on the shoulder with a long white cotton lace petticoat and bright red arm-length gloves and a white cotton veil draped over a stiff bonnet that stood out from her head in a great triangle. A leafy vine wound around the headdress. She watched the young men who worked for her bathe naked in the pond and catch frogs and put them between their legs. And one of the young men who was working a small plot of wheat that grew on the island appeared to be allowing the red and purple flowers that grew randomly among the wheat to remain. His sweat smelled a little like sweet unsalted butter that had just begun to turn.

"Ficko confessed to having thrown five girls . . . into a wheat silo, interred two girls in the kitchen by the channel and two others at Lezeticze churchyard at night."

He, the king, wore a brilliant royal blue robe flecked with gold fleurs-de-lys and a black feathered cap. A leafy green vine wound around his cap. They, the king and the queen, were connected by long strands of a leafy, green vine which wound through their red-blue-grey-white-yellow heads.

A DESCRIPTION OF THE CITY. The walls are irregular. They enclose everything, square plots of land with perfect rows of trees and square gardens of asparagus, broccoli, strawberries, yellow summer squash, sweet peas.

"You are like a wild animal. You do not deserve to breathe the air on Earth, nor to see the light of the Lord. You shall disappear from this world and shall never appear in it again. The shadows will envelop you . . ."[2]

THE CHARACTER ELIZABETH. Twinkle, twinkle little star how I wonder where you are.

A DESCRIPTION OF THE CITY. On one side there was a forest in the shape of a crescent with a clearing in the center. From that side

377

the nine towers of her compound appeared over the tops of trees. It was the miles of rose gardens ringing her chimneys that she loved. They were mostly blue, some pink and yellow.

THE CLIMAX. He permits himself only one diversion now. Occasionally when his supply runs out, he travels with two assistants to her compound and has her brought down. He inserts a large needle in the corner of her eye and draws a small quantity of blood. He then returns to his chimney keep and stares out from the single cutglass window that faces in her direction. He dips his left small finger in her blood, which is contained in a vial with a red circular stem, and flicks a tiny speck onto the glass. Then he returns to his reading.

THE REFRAIN

Alas my love, you do me wrong to cast me off discourteously,
And I have loved you oh, so long,
Delighting in your company.
Greensleeves was all my joy
Greensleeves was my delight . . .
But still thou hadst it readily
Thy music still to play and sing
And yet thou wouldst not love me

THE CHARACTER ELIZABETH

Widow of the Count died at the castle on August 14 suddenly and without a crucifix and without light.

THE CHARACTER ELIZABETH

I. Sphere of the Moon
II. Sphere of Mercury
III. Sphere of Venus
IV. Sphere of the Sun
V. Sphere of Mars
VI. Sphere of Jupiter
VII. Sphere of Saturn
VIII. Sphere of the Fixed Stars
IX. Crystalline Sphere The Primum Mobile

Appendix B

Text Accompanying *Project Entitled "The City of the Walls"*

The City of the Walls: a Narrow City; a Thin City, Out of Walls, Thin Houses Grow, an Italian Version of Midsummer Night's Dream.

THE CHARACTERS. The main character is Sadie who used to live in the City of the Dead outside of Cairo. About six months ago she traded out of there for a city in the Middle Ages where she runs wind and water machines in the courtyard daily from 9 to 5. Sometimes, she longs for Mugattam City which is now beyond the blue horizon. Sadie is approximately six years old, wears a striped pair of pajamas, and carries a white flannel blanket. Three days ago she was hit by a stone on the inside of her forearm just across the wrist. She now has a blue bruise with small cuts around it. It is very tender.

THE SCENE: Paris, Tokyo, Munich, Athens, New York, Buenos Aires, Los Angeles, Cairo, London. Manila, Baghdad, Canton, Addis Ababa, Moscow, Toronto, Marseilles, Havana, Warsaw, Johannesburg, Lisbon, Venice, Cordoba, Zanzibar, Adelaide, Reykjavik, Istanbul, Calcutta, Sarajevo.

THE CHARACTERS. Five progenitors named Ulysse, Michel-Ange, Venus, Cleopatre, and Cusanus. They loved one another, that is, as one turned to another one who in turn moved in the direction of the fourth one who was in turn moving toward the fifth . . . or rather just as #1 began to have a deep Neolithic longing for #3, the presence of #5 shifted/sated that longing and this in turned roused #5's passion for #2 who had for the time being sought oblivion by sucking on her left thumb. By the way, it is Cleopatre who is fond of running a smooth cool cloth between her fingers.

FROM THE PLAN OF THE CITY it is apparent that there are no curves, no circles, only angles, sharp turns of every degree. And so Cusanus becomes obsessed with moving circles, circles without centers, circles whose circumferences are here and there and everywhere. He thinks once again of Sadie and her wheel-like machines. He thinks that just this morning as he bent down to erase a line in Cleopatre's plan and the blood rushed to his head that he had dreamed Sadie in the courtyards the night before. But then he thinks that perhaps he is only now this morning because of some accidental physio-chemical action, his bending and the blood rushing and a cell being triggered, that perhaps he is only now remembering a dream he had ten years ago. And then he thinks that perhaps he has dreamed Sadie every night since that hot day in 1908 in the top story of the cotton mill when he and Venus were fucking behind the cotton bales and turned to watch as Sadie turned impatiently from her machines and posed for the photograph.

For Sadie there is no question. Cusanus is a dream. She remembers the day he appeared in the empty streets of the City of the Dead and

stood for hours watching behind his telescope as she watched her father spinning on his wheel.

THE REST OF THE SCENE. Etamin, Castor, Alpha Centauri, Arneb, Alhena, Betelgeuse, Hamalm Markab, Gienah, Antares, Denebola, Rastaban, Sadr, Naos, Canopus, Beta Corvi.

THE PLAN OF THE CITY. The city has been generated by five people who loved one another. They wore the paths, that is the outline of the wall as they moved each in turn from one to the other. When they realized what they had done, they tried each in turn to draw the pattern they had made, that is, to construct a city in which the "measurements of its space" developed out of the "events of the past." And so there were five separate plans, each superimposed on the other. In some places one plan obliterated the other, in many places the plan changed while the city was under construction. For instance, the day after he finished his plan, Ulysse gave Michel-Ange a rubdown in the men's room in a suburb of La Paz.

THE ACTION. Most of the action is a secret. However, they did squabble about who did what, where, and when. There were erasures on each other's drawings, and some old grievances were relived, like the time Venus was abandoned by Ulysse at a dance party in Bloomfield, Indiana, or the time Venus begged Cleopatre to come to Sarajevo and when Cleopatre finally arrived having paid an excess baggage charge . . . But never mind about that. Basically the walls are red herrings.

Appendix C

Text Accompanying *From the Series Entitled How to Catch and Manufacture Ghosts*, *"Collected Ghost Stories from the Workhouse"*

"What Looks Like [The] Individual Biographies [Of Inventors] Are Linked In Time, Therefore, Through Pedigrees . . . They Are Linked Also Through Networks At Particular Moments In Time. Who Knew Whom? Who Wrote To Whom? Who Hired Or Fired Whom? Who Bought From Whom? Who Were The Rivals And The Partners?"

ASA BRIGGS. IRON BRIDGE TO CRYSTAL PALACE, IMPACT AND IMAGES OF THE INDUSTRIAL REVOLUTION

A the french bicycle track from the rainfall speed trails: it is the source of muliplication and increase for dancing a high dance

B a montgolfier platform (also called puffing Billy)—the first successful manned flight

C the agitation cannisters (also called an electric battery)

D the bird cages (a rhythmical screaming of vast flocks of unnaturally belated birds—whipperwills, no pigeons)

E the bird table

F windings with exciting table

G a generator; o/o/ ripple, zero adjustment

H life on the footplate (also called the ampere experiment on electromagnetism); one of five tuning forks for the universe

I timber sleepers—the source of the nightmare

J another of Wauksbee's electrical machines in which two glass vessels . . . with the inner exhausted and stationary. this engine is unusual in that it has been adapted from reciprocal to rotary motion in order to produce subliminal uprushes of memory

K a disinfecting chamber for noxious fumes which have seeped up

L two coils of insulated wire submerged in water

M a nightjar which contains a long strand of iron-grey hair for Daisy who is skating on thin ice

N a climbing indicator (also called an apparatus for determining the specific heat of gases

Appendix D

Text Accompanying *The New & Favorite Game of the Universe and the Golden Goose Egg*

This is an endless tale . . . "It was a dark and stormy night. The robbers were sitting around the fire." It began with a simple game of marbles and the six ancient wonders of the world that did not survive. It began with an offhand remark, "I'm going to pretend you're dead. I'm going to use that feeling to get somewhere else." It began with a very clear sentence spoken at dawn on May 12, 1881, "No matter what happens this cannot be erased. No one can erase this."

RULES FOR PLAYING

1. This Game is played with a Tetotum, marked on 6 sides, and any number of persons can play at it.
2. Spin for the first player, and whoever spins the highest number must begin the Game.

THE PLAYERS

Numskull	Sugar Daddy
Fata Morgana	Mary Jane
Jelly-fish Man	First is Best
Star Noodle	First Foot
Mr. Softee	Dead Smell Bad Child
Dirty Boy	Dead Smell Bad Boy
Dirty Girl	Dead Smell Bad Girl
Thrown Away Boy	Franz Ferdinand I
Thrown Away Girl	Sally Hemmings
Bead Spitter	Pig of Knowledge

THE OBJECT OF THE GAME

1. The obvious object of the Game is to discover a new universe scheme. The winner gets the Starry Night, the Hangman of the World. The losers get a Golden Goose Egg.
2. The true object of the game is for the players to go home to the universe where they belong. All the players have found that the door to their particular universe has been shut and locked and it has become necessary for them to jump over space in order to get inside.

REFERENCES TO THE GAME

1. The representation of the world according to the Babylonians times three:
The Earth (upper world) and The Earth (lower world)
The Sky. The celestial ocean, The terrestrial ocean,
Evening (west); the two mountains of the sunset,
Morning (east); the two mountains of the dawn,

The Dike of the Sky,

The seven walls surrounding the Palace of the Kingdom of the Dead.

3. Anaximander's Universe divided into a number of heavens, the lowest for air and stars, a higher heaven for the moon, a still higher one for the sun, and a region of fire, the lightest on top.

5. Philolaus's central fire and its spheres, one each for the earth and antichthon—the counterearth— (each shown in four positions), the moon, the sun, and the planets, indicated by circles, and finally the stars.

7. Plato's Music of the Spheres.

9. Isidore's five climatic zones.

11. Dante's universe with nine spheres indicating the Crystalline Sphere of the Primum Mobile.

13. Map of the world, surrounded by twelve winds, made in the time of Charles v, 14th Century.

15. The rectangular universe according to Cosmas of Alexandria: four walls carry the vault of Heaven, the hump in the center is the earth, washed by rectilinear oceans, the two disks re-present the summer and winter sun.

17. Creation Myths: medieval schemes of planetary motion.

19. The Peking Temple of Heaven group.

21. The Indian world view with Mount Meru at the center from which all the rivers of the world flow.

23. The Thai manuscript of the universe.

25. Two Islamic models for planetary motion.

27. The Elemental Pyramids according to Robert Fludd.

29. The Paradise Romance, after Kepler's Mysterious Cosmology for Ptolemy.

31. The world system of Copernicus: the various circles denote the Zodiac and circle of fixed stars and the orbits of the planets. The four positions of the earth are shown at vernal equinox, summer solstice, autumnal equinox, and winter solstice; the sun is at the center.

33. The Starry Night: the House of the Hangman of the World.

Notes

1. John Milton, *Complete Poems and Major Prose*, ed. Merritt Y. Hughes (Indianapolis: Bobbs-Merrill, 1957), p. 248. Milton's description of Death is

> *The other Shape—*
> *If shape it might be called that shape*
> *had none*
> *Distinguishable in member, joint, or*
> *limb;*
> *Or substance might be called that*
> *shadow seemed,*
> *For each seemed either—black it stood*
> *as Night,*
> *Fierce as ten Furies, terrible as Hell,*
> *And shook a dreadful dart: what*
> *seemed his head*
> *The likeness of a kingly crown had on.*

2. Viktor Shklovsky, "Art as Technique," in L. T. Lemon and M. J. Reis, eds., *Russian Formalist Criticism: Four Essays* (Lincoln: University of Nebraska Press, 1965), p. 12.

3. Michael Fried, "Three American Painters: Kenneth Noland, Jules Olitski, Frank Stella," in Michael Fried, *Art and Objecthood* (Chicago: University of Chicago Press, 1998), p. 233. On page 232, Fried writes of "the difficulty of conceiving of a space to which eyesight gives access but which somehow denies even the possibility of literal, physical penetration of it by the beholder."

4. Frank Stellar, quoted in Bruce Glaser, "Questions to Stella and Judd," ed. Lucy Lippard, in Gregory Battcock, ed., *Minimal Art: A Critical Anthology* (New York: E. P. Dutton, 1968), p. 158.

5. Alice Aycock, conversation with author, 7 October 2003.

6. Sol LeWitt, "Paragraphs on Conceptual Art," *Artforum* 5, no. 10 (Summer 1967), p. 80.

7. Joseph Kosuth, *Art after Philosophy and After: Collected Writings, 1966–1990*, ed. Gabriele Guercio (Cambridge, Mass.: MIT Press, 1991), pp. 37, 91. The first statement was "Introductory Note to *Art-Language* by the American Editor" (1970), and the second is from an unpublished lecture delivered to art students in 1971 at the University of Chile, Santiago; Cleveland Art Institute; and Coventry College of Art, Coventry, England. Although this lecture was not published, it presents in a concise form Kosuth's ideas that were widely available elsewhere. It is cited here because of its precision.

8. Jack Burnham, *Software: Information Technology: Its New Meaning for Art* (New York: Jewish Museum, 1970), p. 35.

9. Donna DeSalvo, conversation with author, 27 February 2002.

10. Roland Barthes, "The Death of the Author," in *Image—Music—Text*, trans. Stephen Heath (New York: Hill and Wang, 1977), pp. 142–148.

11. Ibid, p. 148.

12. Lucy R. Lippard, "Complexes: Architectural Sculpture in Nature," *Art in America* 67 (January 1979), p. 89. In addition to Aycock's work which initiates the artists' section, Lippard discusses the work of Harriet Feigenbaum, Richard Fleischner, Suzanne Harris, Audrey Hemenway, Nancy Holt, Jody Pinto, Keiko Prince, Alan Saret, Charles Simonds, and Susana Torre. Lippard suggests that some of the work by these artists and others parallels "the conservative yearnings of artists (and members of the so-called counterculture) to regain contact with the earth and with the rhythms of a seasonal cosmology" (88). This art "might be read as a call to 're-feminize' society" (88). However, when she discusses Aycock's art, Lippard states that "her ambivalent shelters often turn out not to be sanctuaries after all; entrances lead to coldly bunker-like tunnels of stone, claustrophobic crawl spaces and other nightmarish spatial surprises" (89).

13. Rosalind Krauss, "Sculpture in the Expanded Field," *October* 8 (Spring 1979), pp. 30–44.

14. Ibid., p. 38.

15. Jack Burnham, "Systems Esthetics," in *Great Western Salt Works: Essays on the Meaning of Post-Formalist Art* (New York: George Braziller, 1974), p. 15. The essay was originally published in *Artforum* in 1968.

16. Thomas Kuhn, *The Structure of Scientific Revolutions* (Chicago: University of Chicago Press, 1962). Much of my analysis of the discourse to which Kuhn's book belongs is indebted to Ziauddin Sardar, *Thomas Kuhn and the Science Wars* (New York: Totem Books, 2000).

17. Mark Segal reports that he and Alice Aycock read this book together and discussed its significance. Mark Segal, interview with author, 20 November 2001.

18. Alice Aycock, conversation with author, 25 July 2000.

19. Kuhn, *Structure of Scientific Revolutions,* p. 3.

20. Claude Lévi-Strauss, *The Savage Mind* (Chicago: University of Chicago Press, 1962), p. 11.

21. Ibid., p. 15. This attitude soon became mainstream, as is indicated by Colin A. Ronan's general history of science, which notes in its first chapter, "It is impossible to discuss the history or theory of science without coming face to face with magic. This was a way of looking at the world which was a complex amalgam of spiritism and arcane knowledge." Colin A. Ronan, *Science: Its History and Development among the World's Cultures* (New York: Facts on File Publications, 1982).

22. Jean de Menasce, "The Mysteries and the Religion of Iran," in Joseph Campbell, ed., *The Mysteries: Papers from the Eranos Yearbooks*, trans. Ralph Manheim, Bollingen Series, vol. 30, no. 2 (Princeton: Princeton University Press, 1955), p. 136.

23. Kurt Seligmann, *The History of Magic* (New York: Pantheon Books, 1948), p. 21.

24. Lévi-Strauss, *The Savage Mind,* p. 22.

25. Alice Aycock, "For Granny (1881–) Whose Lamps Are Going Out: A Short Lecture on the Effects of Afterimages," in Aycock, *Project Entitled "The Beginnings of a Complex..."* *(1976–77): Notes, Drawings, Photographs*, ed. Amy Baker (New York: Lapp Princess Press, in association with Printed Matter, 1977), n.p. The piece was also published in *Tracks: A Journal of Artists' Writings* 3, nos. 1 and 2 (Spring 1977), pp. 141–144.

26. George Kubler, *The Shape of Time: Remarks on the History of Things* (New Haven: Yale University Press, 1962), p. 39.

27. Alice [Aycock] Segal, "An Incomplete Examination of the Highway Network/User/Perceiver Systems(s)" (M.A. thesis, Hunter College of the City University of New York, 13 May 1971), p. 2. Her faculty advisor was Robert Morris.

28. Both essays are reproduced in Burnham, *Great Western Salt Works*, pp. 15–38.

29. Jack Burnham, "Real Time Systems," in *Great Western Salt Works*, p. 27.

30. Quoted in ibid., pp. 30–33.

31. Aycock., "An Incomplete Examination," p. 12. Aycock goes on to differentiate between negative and regulatory feedback: "Regulatory feedback is closely connected to negative feedback, but whereas the latter informs the system of events, regulatory feedback controls and counteracts events which might disturb the system" (14).

32. Ibid., pp. 18ff.

33. Burnham, *Software*, p. 11.

34. Ibid., p. 12.

35. Les Levine, "Systems Burn-off x Residual Software" (1969), in ibid., pp. 60–61.

36. Burnham, *Software*, p. 12.

37. Ibid., p. 14. Burnham concludes his essay by noting, "Many of the finest works in the *Software* exhibition are in no way connected with machines. In a sense they represent the programs of artists who have chosen not to make paintings or sculptures, but to express ideas or art propositions" (14).

38. Although Burnham concludes that this exhibition represents "the second Age of Machines" which updates the first one presented at the Museum of Modern Art only two years earlier, it actually comprises the third machine age since the second focusing mostly on the space age was inaugurated in the 1950s.

39. Maurice Bessy, *A Pictorial History of Magic and the Supernatural* (1964; reprint, London: Spring Books, 1972), p. 316.

40. This notion has a precedent in the writings of French nineteenth-century poet, mystic, and radical socialist Alphonse Louis Constant, called Eliphas Lévi, who had a major impact on the occult aspect of symbolism, thereby influencing such writers as Joris-Karl Huysmans, Charles Baudelaire, Victor Hugo, Stéphane Mallarmé, and William Butler Yeats. See Thomas A. Williams, *Eliphas Lévi: Master of Occultism* (Tuscaloosa: University of Alabama Press, 1975).

41. Curtis Crawford, ed., *Civil Disobedience: A Casebook* (New York: Thomas Y. Crowell, 1973), p. 238. In the following commentary, Crawford describes the range of popular dissent taking place in the 1960s and early 1970s, when Aycock was in her formative years:

By 1968 the use of civil disobedience by substantial numbers in the United States had spread from the movement for racial equality to the struggle against the Vietnam war, and included a growing student revolt. Some of the tactics of protest were: refusing to be

drafted, refusing to pay war taxes, desertion from the armed forces, emigration to avoid imprisonment, sitting-in at government offices, blocking traffic, refusal by students to attend classes, occupying buildings, breaking windows and furniture, taunting the police, and occasional bombings and sniping; numerous ghetto riots occurred which the protest movement sometimes encouraged, but apparently did not instigate. Resistence [sic] now meant not only disobeying the law, but evading punishment; not only violating "unjust" laws, but others as well; not only boycotting an activity, but disrupting its performance by others; not only risking harm to oneself, but destroying property and occasionally other persons.

42. Cf. Guy Debord, *The Society of the Spectacle*, trans. Donald Nicholson-Smith (New York: Zone Books, 1995).

43. In the early 1960s, the majority of Merleau-Ponty's writings were published in English by Northwestern University Press as part of its Studies in Phenomenology and Existential Philosophy. The availability of his thought in English had a major impact on minimalism, installation art, and performance art. An analysis of Merleau-Ponty's importance for the 1950s via his close friend Harold Rosenberg is found in Robert Hobbs, "Merleau-Ponty's Phenomenology and Installation Art," in Claudia Giannini, ed., *Mattress Factory 1990/1999* (Pittsburgh: University of Pittsburgh Press, 2001), pp. 18–23, and in Robert Hobbs, "Rosenberg's 'The American Action Painters' and Merleau-Ponty's Phenomenology" (paper presented at the annual meeting of the College Art Association, New York City, 1999).

44. Maurice Merleau-Ponty, *Phenomenology of Perception*, trans. Colin Smith (London: Routledge & Kegan Paul, 1962; reprint, New York: Routledge, 1989), pp. xvi–xvii.

45. Michel Foucault, *The Order of Things: An Archaeology of the Human Sciences* (London: Tavistock, 1970), pp. xx–xxi.

46. Alice Aycock, conversation with author, 5 May 2003.

47. Alice Aycock, correspondence with author, 2 July 2001.

48. Jane Howard, "You Don't Have a Body. You Are Your Body," *Mademoiselle* 71 (May 1970), p. 211. In 1970 the human potential movement became mainstream. This issue of *Mademoiselle* included two additional pieces on the topic: Amy Gross, "Getting Together," and John D. Black, "An Opinion: Encounter Groups '. . . May Look at a Potential Source of Salvation.'" *Life* magazine weighed in on the topic with a book review by Robert L. Schwartz entitled "New Hope for the Dull," *Life* 68 (12 June 1970), p. 16. Editor Robert Claiborne wrote "The Potential of Human Potential" for "Books & The Arts" in the *Nation* 211 (19 October 1970), pp. 373–375. And senior editor Leon Jaroff of *Time* drafted the piece "A Weekend Encounter: Strength from the Group," *Time* (9 November 1970).

49. A negative characteristic of schizophrenia is catatonia, which does not relate to the symbolic system Aycock references.

50. Géza Róheim, *Magic and Schizophrenia* (New York: International Universities Press, 1955), p. 121.

51. Ibid., pp. 160–161.

52. Alice Aycock, correspondence with author, 20 March 2001.

53. Róheim, *Magic and Schizophrenia*, pp. 152–153. In correspondence with author (20 March 2001), Aycock indicated the importance of this passage for her.

54. Ibid., p. 128.

55. Ibid., pp. 146–147.

56. Alice Aycock, "Introduction to a Short Untitled Work of Fiction in Five Chapters (Work in Progress)," in Donna Stein, *Alice Aycock: Waltzing Matilda* (East Hampton, N.Y.: Guild Hall Museum, 1997), p. 15. This passage was part of the script for the artist's Duchamp talk.

57. The author thanks Joshua Poteat for this observation.

58. Burnham, "Real Time Systems," p. 30.

59. Ibid., p. 28.

Chapter 2

1. Alice Aycock, interviews with the author, 21–24 November 1996 and 11–15 July 1997.

2. Ibid.

3. This situation of feeling that she was both inside and outside at the same time might help explain Aycock's later fascination with schizophrenia and N. N. The author thanks Joshua Poteat for this observation.

4. Aycock, interviews with author, 21–24 November 1996 and 11–15 July 1997.

5. Aycock, *Project Entitled "The Beginnings of a Complex . . . ,"* n.p.

6. Alice Aycock, "Notes," in *Tracks: A Journal of Artists' Writings* 2, no. 2 (Spring 1976): 24.

7. Aycock, interviews with author, 21–24 November 1996 and 11–15 July 1997.

Chapter 3

1. Aycock's "Melange" columns were occasional thought pieces, not regular features, that were published in the Douglass College newspaper, *The Caellian,* beginning in the spring of 1966. The dates for Aycock's columns are 11 March 1966; 8 April 1966; 29 April 1966; 30 September 1966; 9 December 1966; and 10 February 1967.

2. An excellent source on the artists/instructors at Rutgers is Joan Marter, ed., *Off Limits: Rutgers University and*

the *Avant-Garde, 1957–1963* (Newark: Newark Museum; New Brunswick: Rutgers University Press, 1999).

3. Allan Kaprow, "The Legacy of Jackson Pollock," *Artnews* 57, no. 6 (October 1968), p. 55.

4. Aycock, interview with the author, 21 November 1996.

5. The standard source on this topic is D'Arcy Wentworth Thompson, *On Growth and Form,* 2nd ed., 2 vols. (1942; reprint, Cambridge: Cambridge University Press, 1979). Thompson bases his theories on the idea that physical forces give unicellular life its distinctive shapes. His research into the morphology of organic form suggests physics as its basis.

6. Later, it became natural for an artist to use movement without receiving special notice; movement simply became one of the many materials at an artist's disposal.

7. Alice Aycock, interview with the author, 20 March 2001.

8. K.G. Pontus Hultén, introduction to *The Machine as Seen at the End of the Mechanical Age* (New York: Museum of Modern Art, 1968), p. 3. This catalogue was distributed by the New York Graphic Society, Greenwich, Connecticut.

9. Ibid., 108.

Chapter 4

1. Cf. Anna C. Chave, "Minimalism and Biography," *Art Bulletin* 82, no. 1 (March 2000), p. 159, n. 4. In addition to the critics I have listed, Chave mentions Maurice Berger and Phyllis Tuchman, who were later interested in minimalist art.

2. Quoted in Stuart Morgan, "Alice Aycock: A House for the Self," in Monroe Denton, ed., *After Years of Rumination on the Events That Led Up to This Misfortune . . . Alice Aycock: Projects and Proposals 1971–*

1978 (Allentown, Pa.: Muhlenberg College, 1978), n.p.

3. Alice Aycock, interview with author, 11 September 1996.

4. Aycock archives.

5. Cf. Robert Morris, *Continuous Project Altered Daily: The Writings of Robert Morris* (Cambridge, Mass.: MIT Press; New York: Solomon R. Guggenheim Museum, 1993).

6. Mark Segal, "Retrospective: A Novel" (1987), unpublished manuscript, Segal's papers, East Hampton, New York, p. 187. This *roman à clef* is based on Segal's life with Aycock. It contains a number of perceptive views of her work and thought during her early years. Aycock has confirmed that the passages cited in this study are entirely in character with her thinking and often appear to contain verbatim comments.

7. Annette Michelson, "Robert Morris: An Aesthetics of Transgression," in *Robert Morris* (Washington, D.C.: Corcoran Gallery of Art, 1969), pp. 77–79.

8. Carole Campbell and Phylis Floyd, "An Interview with Alice Aycock," *Kresge Art Museum Bulletin* 7 (Michigan State University, 1992), p. 50.

9. Quoted in Maurice Poirier, "The Ghost in the Machine," *Artnews* 85, no. 8 (October 1986), p. 50.

10. Aycock, interview with Campbell and Floyd, p. 50.

11. Segal, "Retrospective," p. 151.

12. Ibid., p. 153.

13. Both Aycock's and Morris's use of danger anticipated the later investigations of Mona Hatoum that used live electricity, as did Chris Burden's several pieces of the early 1970s.

14. Rosalind Krauss, "Sense and Sensibility: Reflection on Post '60s Sculpture," *Artforum* 12, no. 3 (November 1973); reprinted in Amy Baker Sandback, ed., *Looking Critically: 21 Years of Artforum Magazine* (Ann Arbor: UMI Research Press, 1984), pp. 149–156.

15. For clarification on the role New Dance played in the formation of minimalism, see Chave, "Minimalism and Biography," pp. 149ff.

16. Mark Segal relates that he had read Robbe-Grillet's work and was intrigued with his theories. He remembers in particular discussing with Alice Aycock the ideas contained in Robbe-Grillet's *For a New Novel.* Mark Segal, interview with author, 20 February 2001.

17. Alain Robbe-Grillet, "A Fresh Start for Fiction," in Barney Rosset, ed., *Evergreen Review Reader: A Ten-Year Anthology* (New York: Castle Books, 1968), p. 59.

18. Over the years, this type of nonmetaphorical thinking has become a mainstay of Rosalind Krauss's critical approach.

19. Michelson, "Robert Morris," p. 35.

20. Ibid.

21. Clement Greenberg, quoted in ibid.

22. Ibid., pp. 35ff.

23. Leo Steinberg, "Jasper Johns: The First Seven Years of His Art," in Leo Steinberg, *Other Criteria: Confrontations with Twentieth-Century Art* (New York: Oxford University Press, 1972), p. 48. Steinberg's note on page 17 details the publication history and revisions he made to this piece: "First published in *Metro,* nos. 4/5, 1962, and, with revisions, by George Wittenborn, New York, 1963. In the present version the survey of previous critical literature has been again somewhat revised and expanded. Otherwise the piece stands essentially as completed by the end of 1961, the terminus for all references to 'recent' work."

24. Ibid., p. 48.

25. Leo Steinberg, "The Eye Is a Part of the Mind," in *Other Criteria,* p. 305. Steinberg enumerates the publication history of this piece: "First published in *Partisan Review,* no. 2 (March-April 1953); revised and reprinted in Susanne K. Langer, ed.,

Reflections on Art, Johns Hopkins, Baltimore, 1958, and Oxford University Press, New York, 1961" (289).

26. Leo Steinberg, "Objectivity and the Shrinking Self," in *Other Criteria,* p. 320. The piece was completed in October 1967, as Steinberg explains, "in response to an invitation from Professor James Ackerman, Harvard University, to participate in a conference, held 1967–68 at the American Academy of Arts and Sciences, on 'The Condition of the Humanities.'" He adds, "For the results of the conference see *Daedalus,* Summer 1969."

27. Aycock, conversation with author, 21 November 1996.

28. Konrad Hoffmann, *The Year 1200: A Centennial Exhibition at the Metropolitan Museum of Art* (New York: Metropolitan Museum of Art, distributed by New York Graphic Society, 1970). The catalogue was so enormous that it was published in two volumes. Thomas Hoving had been trained as a medievalist and had worked at the Cloisters before becoming director of the Met, so this exhibition was no doubt undertaken with his full blessing. Its intent was to revise radically the ways that the Middle Ages are viewed so that their "dark age" associations would be dispelled, as would their assumed monolithic lugubriousness. Hoffmann's exhibition was crucial to retelling the story of the Middle Ages.

29. *Performance Corridor* was part of an exhibition at the Whitney entitled *Anti-Illusion: Procedures/ Materials,* organized by Marcia Tucker and James Monte. In "The Art of Existence: Three Extra-Visual Artists: Works in Process" (*Artforum* 9 [January 1971], p. 28), Robert Morris describes strategies that he attributes to several West Coast artists:

Characteristic of the work of these artists is the total negation of any

process that can be located within the source of stimuli. This does not mean that the process is not very much part of the work. It is, but it is located within the one who participates in the experience of this art. That is, one is thrown back onto one's awareness of such things as the duration of acclimation to a dark room (to take Bell for example) during which a certain piece of specific visual information gradually becomes sensate. A certain duration of time is necessary for the experience of much designated outdoor art. Unless one is satisfied with the instantaneous photograph, one is required to be there and to walk around in the work. But it is not the physical necessity of duration in order to experience—either walking, adjusting to the dark, listening carefully, etc.—that seems basic to either the outdoor or indoor mode of art in question. Rather I think it marks itself off in another way from art so obviously involved in presenting itself as "action" taken in the world and revealed in retrospect by objects and residual or implied processes of transformation. It does this by presenting situations which elicit strong experiences of "behaving," rather than the implied actions of the "having done" common to much "thing" art that is now available.

30. Quoted in Poirier, "The Ghost in the Machine," pp. 78ff.

31. Willoughby Sharp, "Nauman Interview," *Arts Magazine* 44, no. 5 (March 1970), p. 23.

32. Ibid.

33. Aycock, interview with author, 11 September 1996.

34. Quoted in Mark Segal, "Retrospective," p. 383.

35. Jack Burnham, *Beyond Modern Sculpture: The Effects of Science and Technology on the Sculpture of This Century* (New York: George Braziller, n.d. [1967]), p. 363.

36. Adrian Piper, "section of an on-going essay," January 1971; from *26 Contemporary Women Artists,* Aldrich Museum, April 1971, in Lucy Lippard, *Six Years: The Dematerialization of the Art Object from 1966 to 1972* (New York: Praeger, 1973; reprint, Berkeley: University of California Press, 1997), pp. 234–235.

37. Joyce Pomeroy Schwartz, "Public Art," in Joseph A. Wilkes, ed., *Encyclopedia of Architecture,* vol. 4 (New York: John Wiley & Sons, 1989), pp. 112–139. Schwartz provides an excellent and clear summary of this period, including a useful chronology of federally supported art projects.

Chapter 5

1. Alice Aycock, interview with author, 13 December 2000.

2. Ibid.

3. See Susan Ginsburg, *Robert Smithson: Drawings* (New York: New York Cultural Center, 1974).

4. Quoted in Stuart Morgan, "Alice Aycock: A Certain Image of Something I Like Very Much," *Arts Magazine* 52 (March 1978), p. 118.

5. Alice Aycock, "Work 1972–1974," in Alan Sondheim, ed., *Individuals: Post-Movement Art in America* (New York: E. P. Dutton, 1977), p. 105.

6. Aycock, interview with author, 11 September 1996.

7. Monroe Denton, "Reading Alice Aycock: Systematic Anarchy," *Sculpture* 9, no. 4 (July/August 1990), p. 48.

8. Lippard, "Complexes," p. 89.

Chapter 6

1. Aycock, conversation with author, 17 March 2001.

2. Cited in Michael Fried, "Art and Objecthood," in Battcock, *Minimal Art: A Critical Anthology,* pp. 130–131.

3. Alice Aycock, in "Talk with Alice Aycock, Tilman Osterwold, and Andreas Vowinckel in July 1983 in Stuttgart," in *Alice Aycock: Retrospektive der Projekte und Ideen 1972–1983, Installation und Zeichnungen* (Stuttgart: Württembergisher Kunstverein, 1983), n.p.

4. Burnham, *Software*, p. 11.

5. Aycock, "An Incomplete Examination of the Highway Network," p. 27.

6. Ibid., p. 34.

7. Cf. Robert Hobbs, *Robert Smithson: Sculpture* (Ithaca: Cornell University Press, 1981).

8. Gilles Deleuze and Félix Guattari, "Introduction: Rhizome," in Gilles Deleuze and Félix Guattari, *A Thousand Plateaus: Capitalism and Schizophrenia,* trans. Brian Massumi (Minneapolis: University of Minnesota Press, 1987), pp. 3–25.

9. Ibid., p. 10.

10. Sigfried Giedion, *Space, Time and Architecture: The Growth of a New Tradition* (1941; Cambridge, Mass.: Harvard University Press, 1967), p. 831.

11. Ibid., p. 826.

12. Burnham, *Beyond Modern Sculpture*, p. 11.

13. Now, far less sanguine about highways, Aycock thinks of them as cancerous growths.

14. Quoted in Aycock, "An Incomplete Examination of the Highway Network," pp. 30, 24.

15. Ibid., pp. 28, 30.

16. Quoted in ibid., p. 32.

17. Ibid, p. 20.

18. Ibid., p. 21.

19. Ibid., pp. 22–23. The sources for Wolfgang Koehler that Aycock cites are his *Gestalt Psychology: An Introduction to New Concepts in Modern Psychology* (New York: Mentor Books, 1947) and "Closed and Open Systems," in F.E. Emery, ed., *Systems Thinking: Selected Readings* (Harmondsworth: Penguin, 1969).

20. Burnham, *Software*, p. 12.

21. Ibid., pp. 28 and 29.

Chapter 7

1. Certainly no discussion of danger in twentieth-century sculpture can leave out the work of Richard Serra, who played with the precariousness of lead antimony plates in *One Ton Prop (House of Cards)* (1969), which literally depends on the precarious balance of four square sheets of metal. Unlike the attraction/repulsion polarities of Aycock's works, Serra's works impress viewers with their force and precariousness. Instead of emphasizing viewers' inability to take control of a tentative house of cards that might topple at any moment, Aycock sets up situations where viewers must cope psychologically with their own relationship to the blade machine's beguiling lure.

2. At present, far too little analysis of the potent role of danger in art has been undertaken. In March 2001, Exit Art, a New York City gallery, opened the exhibition *Danger,* curated by Jeanette Ingberman and Papo Colo. It included works by Robert Chambers, Gregory Green, Chico MacMurtrie, Yucef Merhi, Arnaldo Morales, and Susan Seubert. Among the dangers it surveyed were physical danger, psychological fear, and anxiety created by transgressing norms. Unfortunately no catalogue was produced for the exhibition.

3. Quoted in Todd Gitlin, *The Sixties: Years of Hope, Days of Rage* (Toronto: Bantam Books, 1987), p. 316.

4. Ibid., p. 317.

5. Aycock, interview with author, 21 November 1996.

6. Bruno Bettelheim, *The Empty Fortress: Infantile Autism and the Birth of the Self* (New York: Free Press, 1967), pp. 233ff. At the time autism was regarded as childhood schizophrenia; it only began to be diagnosed as a

distinct disorder in the 1970s. Among the differences between the two conditions: autism occurs before a child is thirty months of age, whereas the onset of schizophrenia occurs from adolescence through middle adulthood. In addition, children with autism are not psychotic and do not exhibit a disintegration of personality.

7. Ibid., p. 234.

8. Ibid., p. 248.

9. Róheim, *Magic and Schizophrenia,* p. 157.

10. Ibid., p. 159.

11. Among the many other creative individuals and groups who showed or performed at 112 Greene Street were Laurie Anderson, Billy Apple, Bill Beckley, Connie Beckley, Kathy Bigelow, Trisha Brown, Rosemarie Castoro, Agnes Denes, Stefan Eins, Bob Fiore, Joel Fisher, Grand Union with Yvonne Rainer, Harmony Hammond, Suzanne Harris, Mary Heilman, Alex Hay, Geoff Hendricks, Jene Highstein, Patrick Ireland, John Jesurun, Richard Landry, Barry LeVa, Ana Mendieta, Martha Wilson, Richard Nonas, Alan Saret, Italo Scanga, Charles Simmonds, Alan Sonfist, Keith Sonnier, Marjorie Strider, Francesc Torres, William Wegman, and Roger Welsh.

12. Robyn Bretano and Mark Savitt, eds., *112 Workshop/112 Greene Street: History, Artists & Artworks* (New York: New York University Press, 1981), p. viii.

Chapter 8

1. This concept was introduced in chapter 1 of this text in my discussion of Burnham's catalogue text for his *Software* exhibition; cf. the section "Systems Theory and Cybernetics."

2. Aycock, "Work 1972–1974," p. 106.

3. W.H. Matthews, *Mazes and Labyrinths: Their History and Development* (New York: Dover Publications, 1970), p. 1. Helmut

Jaskolski, *The Labyrinth: Symbol of Fear, Rebirth, and Liberation,* trans. Michael H. Kohn (Boston: Shambhala, 1997), p. 11. Hermann Kern, *Through the Labyrinth: Designs and Meaning over 5,000 Years,* trans. Abigail Clay (Munich: Prestel, 2000), p. 23. Kern writes, "By comparison the earliest *depiction* of a maze dates from about 1420 CE; in curious contrast to the literary tradition widely accepted in antiquity and in the Middle Ages, all depictions of labyrinths up to the Renaissance show only one path; therefore, there is no possibility of going astray."

4. Aycock, "Work 1972–74," p. 108.

5. Kern, *Through the Labyrinth,* p. 305.

6. Aycock, "Work 1972–74," p. 108.

7. Aycock, interview with author, 21 November 1996.

8. Perhaps inspired by the mystery of the great labyrinth of king Minos in Crete with its mythic Minotaur, Morris evoked the dark side of this ancient configuration. For his Castelli-Sonnabend Gallery showing, which featured a labyrinth with eight-foot-high walls closely aligned to create claustrophobic corridors, he created an infamous poster of himself wearing the sadomasochistic paraphernalia of storm trooper's helmet and chains. Used to advertise this exhibition in *Artforum,* the image was so controversial that it upstaged Morris's exhibition. This poster had the beneficial collateral effect of naturalizing the labyrinth, thereby removing it sources from critical debate. In the process, the controversy made Morris's labyrinth appear to be unquestionably his own invention.

9. Aycock, interview with author, 21 November 1996.

10. Penelope Reed Doob, *The Idea of the Labyrinth: From Classical Antiquity through the Middle Ages* (Ithaca: Cornell University Press, 1990). This book contains an excellent discussion of unicursal and multicursal labyrinths, together with an analysis of their possible meanings. My discussion is indebted to Doob's excellent insights.

11. Ibid., p. 18.

12. Aycock, interview with author, 21 November 1996.

13. Jorge Luis Borges, "The Garden of Forking Paths," in Jorge Luis Borges, *Ficciones,* ed. Anthony Kerrigan, trans. Emecé Editores (New York: Grove Press, 1962), p. 100. In addition to being the title of one of Borges's short stories, "The Garden of Forking Paths" is the name of part one of *Ficciones.*

14. Saul Steinberg, *The Labyrinth* (1954; reprint, New York: Harper & Brothers, Publishers, 1960).

15. The mazelike complexity of this film even extended to its credits, which list such names as Margo Channing, the name of the aging actress played by Bette Davis in another Mankiewicz film, *All about Eve* (1950) that is about Channing's understudy Eve Harrington (played by Anne Baxter, who together with Davis was nominated for an Oscar in the Best Actress category). In *Sleuth* Margo Channing's character appears only as a painted portrait of actress Joanne Woodward, which is certainly an elaborate and arcane joke since this actress won the Academy award for her role as a person suffering from a multiple personality disorder in *The Three Faces of Eve,* directed by Nunnally Johnson in 1957. Another deliberate false lead also appears in the credits: Inspector Doppler is supposedly played by Alec Cawthorne, but cinema goers discover that this character is played by Michael Caine wearing an effective disguise.

Chapter 9

1. Bernard Rudofsky, *Architecture without Architects: A Short Introduction to Non-Pedigreed Architecture* (New York: Museum of Modern Art, 1965), n.p.

2. Alice Aycock, conversation with author, 18 September 2003. Since the 1970s Aycock has referred to her work informally as "nonfunctional" architecture.

3. Aycock, interview with author, 21 November 1996.

4. Jonathan Swift, *Travels into Several Remote Nations of the World. By Lemuel Gulliver, First a Surgeon, and then a Captain of Several Ships,* ed. Michael Hulse (Köhn Verlagsgesellschaft mbH, 1995), p. 187.

5. Aycock, *Project Entitled "The Beginnings of a Complex ,"* n.p.

6. James Wines, *De-Architecture* (New York: Rizzoli International, 1987), p. 100.

7. Fineberg, "Alice Aycock, Reflections on Her Work," p. 18.

8. Gaston Bachelard, *The Poetics of Space,* trans. Maria Jolas (Boston: Beacon Press, 1969), pp. xxxi, 8.

9. Ibid., p. 14.

10. Ibid.

11. Ibid., p. 17.

12. Ibid., p. 6.

13. Aycock in "Talk with Alice Aycock, Tilman Osterwold and Andreas Vowinckel," n.p.

14. Aycock, *Project Entitled "The Beginnings of a Complex ,"* n.p.

15. Grace Glueck, "Art People," *New York Times,* 6 January 1978, C14: 5.

16. Vincent Scully, *The Earth, the Temple, and the Gods: Greek Sacred Architecture* (New York: Frederick A. Praeger, 1969).

Chapter 10

1. Alice Aycock, conversation with author, 7 October 2003.

2. Ibid.

3. Ibid.

4. Linda Nochlin, statement in "Feminism & Art [9 Views]," *Artforum* 42, no. 2 (October 2003), p. 141.

5. Jan Avgikos, statement in "Feminism & Art [9 Views]," p. 146.

6. Segal, "Retrospective," p. 205.

7. April Kingsley, "Six Women at Work in the Landscape," *Arts Magazine* 52 (April 1978), p. 108.

8. Lippard, "Complexes: Architectural Sculpture in Nature," p. 88.

9. Ibid., p. 89.

10. Grace Glueck, "A Sculptor Whose Imagery Is Encyclopedic," *New York Times,* 15 August 1990, p. C14.

11. Quoted in Judith March Davis, "Sculpture Shock," *Rutgers Magazine* 70, no. 1 (Spring 1991), p. 34.

12. Alice Aycock, interview with author, 17 July 1997.

13. Aycock, conversation with author, 13 December 2000.

14. Ibid.

15. Linda Nochlin, "Why Are There No Great Women Artists?," in Vivian Gornick and Barbara Moran, eds., *Woman in Sexist Society: Studies in Power and Powerlessness* (New York: Basic Books, 1971), p. 353.

16. Ibid., p. 354.

17. Aycock, conversation with author, 7 October 2003.

18. Róheim, *Magic and Schizophrenia,* p. 173.

19. Ibid., pp. 180–181.

20. A clear indication of Morris's firmly entrenched phenomenology is his text for "Notes on Sculpture," republished in Battcock, ed., *Minimal Art.* Apropos his affinity for this approach is his observation: "The object is but one of the terms in the newer aesthetic. It is in some ways more reflexive because one's awareness of oneself existing in the same space as the work is stronger than in previous work, with its many internal relationships. One is more aware than before that he himself is establishing relationships as he apprehends the object from various positions and under varying conditions of light and spatial context" (232).

Chapter 11

1. Nochlin, "Why Are There No Great Women Artists?," p. 358.

2. Giorgio Vasari, *Vasari on Technique,* trans. Louisa S. Maclehose, ed. G. Baldwin Brown (New York: Dover Publications, 1960), p. 205.

3. Ibid., pp. 205–206. The author thanks Professor Fredricka Jacobs for suggesting Vasari as a critical source for demonstrating the high regard in which drawing was held in the Renaissance.

4. The following discussion of axonometry has been informed by two excellent analyses of this genre: M. Saleh Uddin, *Axonometric and Oblique Drawings: A 3-D Construction, Rendering, and Design Guide* (New York: McGraw-Hill, 1997), and Yve-Alain Bois, "From –Infinity to 0 to +Infinity: Axonometry, or Lissitzky's Mathematical Paradigm," in *El Lissitzky: Architect, Painter, Photographer, Typographer* (Eindhoven: Municipal Van Abbemuseum, 1990).

5. Alice Aycock, in "Round Table Discussions," in Hugh M. Davies and Ronald J. Onorato, *Sitings: Alice Aycock, Richard Fleischner, Mary Miss, George Trakas,* ed. Sally Yard (La Jolla: La Jolla Museum of Contemporary Art, 1986), p. 105. Later Aycock noted that these drawings were a crucial means for finding out how she was going to build the pieces delineated in them (Alice Aycock, conversation with author, 19 August 2003).

6. Quoted in Ruth K. Meyer, "Interview with Alice Aycock," *D.A.A. Journal* (January 1980), pp. 7, 8.

7. Aycock, in "Round Table Discussions," p. 106.

Chapter 12

1. Sol LeWitt, "Paragraphs on Conceptual Art," *Artforum* 5, no. 10 (June 1967), p. 83.

2. Frank Stella, as told to William Rubin, cited in Kenneth Baker, *Minimalism: Art of Circumstance* (New York: Abbeville Press, 1988), p. 141.

3. Robert Morris, "Notes on Sculpture, Part III: Notes and Nonsequiturs," *Artforum* 5, no. 10 (June 1967), p. 26.

4. Robert Venturi and Denise Scott Brown, "A Significance for A&P Parking Lots or Learning from Las Vegas," *Architectural Forum* 28, no. 2 (March 1968), pp. 37–43, 89, 91.

5. Aycock, correspondence with author, 20 March 2001.

6. Robert Venturi, *Complexity and Contradiction in Architecture* (New York: Museum of Modern Art, in association with the Graham Foundation for Advanced Studies in the Fine Arts, Chicago, 1966). This book is volume 1 in The Museum of Modern Art Papers on Architecture.

7. Ibid., pp. 22, 23.

8. Aycock briefly became associated with Bernard Tschumi later in the 1970s through a casual friendship with his wife, Kate Linker, an editor of *Tracks: A Journal of Artists' Writings* and an art critic for *Artforum.*

9. Bernard Tschumi, *Architecture and Disjunction* (Cambridge, Mass.: MIT Press, 1994), p. 20. For Aycock's work and this discussion, the most pertinent essays by Tschumi are "The Architectural Paradox" and "Questions of Space," which originally appeared in a different form as "Questions of Space: The Pyramid and the Labyrinth (or the Architectural Paradox)," in *Studio International* (September-October 1975).

10. Ibid., p. 39.

11. Ibid., p. 34.

12. Germano Celant, quoted in Tschumi, *Architecture and Disjunction,* p. 34.

13. Quoted in Fineberg, "Alice Aycock, Reflections on Her Work," pp. 17ff.

14. A. C. Crombie, *Medieval and Early Modern Science*, vol. 1 of *Science in the Middle Ages: v–xiii Centuries* (Cambridge, Mass.: Harvard University Press, 1963), pp. 209, 213.

15. Cited in Sigfried Giedion, *Mechanization Takes Command: A Contribution to Anonymous History* (New York: W. W. Norton, 1969), pp. 347, 349, 250.

16. Quoted in Fineberg, "Alice Aycock, Reflections on her Work," p. 18.

17. Bretano and Savitt, *112 Workshop/ 112 Greene Street*, p. xi.

18. Aycock, "Work 1972–1974," p. 115.

19. Aycock, interview with author, 23 November 1996.

20. C. West Churchman, *The Design of Inquiring Systems: Basic Concepts of Systems and Organizations* (New York: Basic Books, 1971), p. 10.

21. Bruce Nauman, "Bruce Nauman Interviewed by Willoughby Sharp," *Avalanche* (Winter 1971), p. 30.

22. Roberta Smith, "Reviews: Alice Aycock at 112 Greene Street," *Artforum* 13 (September 1974), p. 71.

23. One wonders if Kubler's extended metaphor in *The Shape of Time* regarding the history of art might also relate to this piece, since throughout her work Aycock has been attuned to art history and its impact on recent art. Kubler writes, "The history of art is like a vast mining enterprise, with innumerable shafts, most of them closed down long ago. Each artist works on in the dark, guided only by the tunnels and shafts of earlier work, following the vein and hoping for a bonanza, and fearing that the lode may play out tomorrow" (p. 125).

24. A writer and assistant curator employed in the film and video department at the Whitney Museum of American Art from 1975 to 1979, Segal was passionate about early-twentieth-century film. When he was working in the department of public information at MoMA from 1970 to 1975, he frequently talked with members of the film department and would bring home stills of Meyerhof's sets, Fritz Lang's German expressionist architectural fantasies, and scenes from Murnau's *Nosferatu*.

25. Quoted in Edward F. Fry, introduction to Nancy D. Rosen and Edward F. Fry, *Projects in Nature: Eleven Environmental Works Executed at Merriewold West, Far Hills, New Jersey* (Far Hills, N.J.: Merriewold West, 1975), n.p.

26. Ibid.

27. Aycock notes, artist's archives, New York City.

Chapter 13

1. Deborah Nevins, "An Interview with Mary Miss," *Princeton Journal: Thematic Studies in Architecture* 2 (1985), pp. 96, 98, 99. Miss told Nevins:

I think one of the reasons that I decided to start thinking about the landscape was my desire to integrate sculpture with its context.... My interest has always been in the direct experience of the place by the viewer.... I'd say that two of the strongest influences visually have been fortifications and gardens.... But while I was developing Field Rotation *I was doing a lot of reading about early Persian gardens: what interested me was the kind of protection and sense of enclosure they provide within a vast, open landscape.... So in a way a garden provides protection like a fortification does.*

Unlike Miss, with whom she has often been compared, Aycock has not looked at her pieces as refuges, and except for *Wooden Posts Surrounded by Fire Pits* she has not attempted to create works that evoke the sense of a specific place.

2. Lucy R. Lippard, "Sculpture Sited at the Nassau County Museum," *Art in America* 65 (March 1977), p. 120.

3. Aycock, interview with author, 14 July 1997.

4. Quoted in Fineberg, "Alice Aycock, Reflections on Her Work," p. 14.

5. This type of physical difficulty became important for Aycock's student Matthew Barney, who used it as a basis for his drawing restraint series, in which he tried to create a work of art as direct as a drawing while his body was encumbered by restraints.

6. Quoted in "Talk with Alice Aycock, Tilman Osterwold and Andreas Vowinckel in July 1983," n.p.

7. Poirier, "The Ghost in the Machine," p. 80.

8. Ibid.

9. Quoted in "Talk with Alice Aycock, Tilman Osterwold and Andreas Vowinckel in July 1983," n.p.

10. Walter S. Gibson, *Hieronymus Bosch* (New York: Praeger Publishers, 1973), p. 76.

11. Such associations demonstrate how far removed her work is from conventional site-specific art.

Chapter 14

1. Michael D. Hall, "High Time for a Christening," in *Stereoscopic Perspective: Reflections on American Fine and Folk Art* (Ann Arbor, Mich.: UMI Research Press, 1988). Written in 1979, this essay was intended as an introduction to a book on site sculpture that was never completed. The essay was presented a number of times as a paper in a revised and edited form.

2. Ibid., pp. 19–20.

3. In retrospect, this work appears amazingly prescient because it seems to be the forerunner of the late

sculptures of Sol Lewitt, which are also made of concrete blocks.

4. Hall, "High Time for a Christening," p. 34.

5. Ibid., p. 33.

6. Ibid.

7. Aycock, interview with author, 15 July 1997.

8. During this trip Aycock was impressed with the catacombs of St. Sebastian, which became the source for the little niches in *The True and the False Project.*

Chapter 15

1. Jorge Luis Borges, "The Aleph," in *A Personal Anthology,* ed. Anthony Kerrigan (New York: Grove Press, 1967), pp. 149, 151.

2. Cf. Joscelyn Godwin, *Robert Fludd: Hermetic Philosopher and Surveyor of Two Worlds* (Boulder, Colo.: Shambhala, 1979). In her analysis of the sixteenth-century mystic Robert Fludd, Godwin elaborates on his presentation of the Lesser and Greater Alephs: "God (alpha), or the Lesser Aleph of the uncreated darkness, or potency, reveals itself for the world's creation by changing to light or act. God (omega), or the Greater Aleph, emerging from dark earth or the created darkness, reveals itself to men for the world's salvation" (p. 52). In this pantheon, the Lesser Aleph appears closer to Borges's Aleph, while the Greater Aleph seems to be Christological. Elsewhere Godwin points to the Dark Aleph, which is defined as "the ultimate void before creation." According to kabbalistic interpretations, Yod, God the Father, is manifested through the two Alephs of Son and Spirit, which represent the positive, light element and the dark, negative one (p. 39).

3. Borges, "The Aleph," p. 153.

4. Martin Heidegger, "The Origin of the Work of Art," in *Poetry, Language,* *Thought,* trans. Albert Hofstadter (New York: Harper & Row, 1971), pp. 17–87.

5. Ibid., p. 42.

6. Ibid., p. 64.

7. Ibid., p. 79.

8. Slavoj Žižek and Glyn Daly, *Conversations with Žižek* (Cambridge: Polity Press, 2004), p. 8.

9. Apropos the Aleph, it is worth pointing out that in Róheim's book, N.N. describes his birth in terms strangely similar to Borges's concept of a hole in the universe and Lewis Carroll's description of the rabbit hole. "I once found an entrance to the Garden of Eden," N.N. announced. "It was a hole or a ditch in the earth and I nearly fell through. This is the place where I came out, the place where I was born—in the Garden of Eden. It is as if you are driving a car through a dark forest and suddenly you go through a tunnel and fall forward, head first, with great speed." Róheim, *Magic and Schizophrenia,* p. 181.

10. Alice Aycock, "Alice Aycock: The Wonderful Pig of Knowledge, an Interview with Morgan," in *Alice Aycock* (London: Serpentine Gallery, 1985), n.p.

11. Quoted in Paul Richard, "Prop Art: Alice Aycock's Stagy Tower at 12th and G," *Washington Post,* February 23, 1980, B 1.

12. "Talk with Alice Aycock, Tilman Osterwold and Andreas Vowinckel in July 1983," n.p. In this interview Aycock referred to her interest in this passage by Milton and stated that her fascination with the "system which you can't quite grasp" was one of the primary reasons for her interest in medieval and Islamic art.

13. Campbell and Floyd, "An Interview with Alice Aycock," p. 58.

14. Ibid.

15. Maurice Merleau-Ponty, *Signs,* trans. Richard C. McCleary (Evanston, Ill.: Northwestern University Press, 1964), p. 97.

16. Aycock in "Alice Aycock: The Wonderful Pig of Knowledge," n.p.

Chapter 16

1. Harold Bloom, *A Map of Misreading* (Oxford: Oxford University Press, 1975), pp. 27, 29, 30.

2. Kubler, *The Shape of Time,* p. 64.

3. Alice Aycock, conversation with author, 17 May 2001.

4. The Leviathan of Parsonstown, according to the artist, is a crucial source for this piece. It is a structure built around a large early telescope erected in Ireland. Alice Aycock, conversation with author, 21 August 2003.

5. Aycock, *Project Entitled "The Beginnings of a Complex . . . ,* n.p.

6. Quoted in Meyer, "Interview with Aycock," p. 9.

7. Aycock, conversation with author, 17 July 1997.

8. John Baldessari might seem to come close in such a piece as *If It Is* A.M.*; If It Is* P.M. (1972–73). But he actually plays a delightful game of possibilities, all of which are dependent on the different experiences viewers might have if they follow the scenario outlined for them. The first part of the work is a photograph presenting a section of a windowsill. It is accompanied by two additional panels on which the artist writes, "If it is A.M., the man who lives in the house opposite this window will water his garden. If it is P.M., the couple living in the apartment next door will probably argue."

9. Aycock, conversation with author, 17 July 1997.

10. Roland Barthes, *Image—Music— Text,* trans. Stephen Heath (New York: Hill and Wang, 1977), pp. 32–51.

11. Ibid., p. 32.

12. In *Project Entitled "The Beginnings of a Complex . . ."* Aycock includes the following passage from Calvino's *t zero:*

The walls and vaults have been pierced in every direction by the Abbe's pick, but his itineraries continue to wind around themselves like a ball of yarn, and he constantly goes through my cell as he follows, each time a different course. He has long since lost his sense of scratching at the ceiling: a rain of plaster falls on me; a breach opens; Faria's head appears, upside down. Upside down for me, not for the walls like a fly, he sinks his pick into a certain spot, a hole opens; he disappears He has hardly slipped into his tunnel when I hear him make the sound of a long aspiration I wait for a week, for a month, for a year All of a sudden the wall opposite trembles as if shaken by an earthquake; from the shower of stones Faria looks out, completing his sneeze.

13. Jorge Luis Borges, "The Immortal," in *Labyrinths: Selected Stories & Other Writings,* ed. Donald A. Yates and James E. Irby (New York: New Directions, 1964), pp. 110, 113.

14. Quoted in Poirier, "The Ghost in the Machine," p. 82.

15. Ibid., pp. 6, 7. Nine years earlier Aycock had used this passage as an epigraph for the section of her artist's book *Project Entitled "The Beginnings of a Complex . . ."* that was designated simply "An Essay."

16. Róheim, *Magic and Schizophrenia,* p. 3.

17. Quoted in Alan Artner, "Alice Aycock Sculpture: A Roller Coaster Ride through the Middle Ages," *Chicago Tribune,* 6 February 1983. This news clipping comes from the artist's papers, New York City.

18. In light of this observation, it is of interest to note Jack Burnham's thoughts on the subject in his chapter "Art History as a Mythic Form," in *The Structure of Art* (New York: George Braziller, 1971), p. 34. Burnham describes "Conrad Fiedler's doctrine of 'pure visibility' [as] a forerunner of Formalism at the end of the nineteenth century. Fiedler justified his reduction of art to formal knowledge on the basis that subjective responses to art should be identified with the expressiveness of the artist, not the viewer; this he proposed as a hard-headed alternative to esthetic idealism." He also quotes from Wilhelm Worringer's doctoral dissertation *Abstraction and Empathy:* "To enjoy esthetically means to enjoy myself in a sensuous object diverse of myself, to emphathize myself into it. Through empathy the intentions of the artist are recognized and received, if only with the aid of a verbal ideology, as in the case of abstract or nonobjective art."

19. Krauss, "Sense and Sensibility," p. 47.

20. Erwin W. Straus, "Norm and Pathology of I-World Relations," in Paul Tibbetts, ed., *Perception: Selected Readings in Science and Phenomenology* (Chicago: Quadrangle Books, 1969), as cited in Aycock (Segal), "An Incomplete Examination of the Highway Network," p. 1.

21. Stuart Morgan terms Aycock's work "deliberately overworked" and views Smithson and Morris as crucial progenitors for her approach because of their penchant for "ontological overload." He states, "Smithson placed his sculptures under such a heavy burden of meaning that they broke under the strain." Although Morgan's observations regarding Aycock's art are among the most perceptive, I would argue that the term "ontological overload" places Aycock's work in too traditional a perspective and does not account for the type of disinterested fragmentation analogous to schizophrenia that her art objects exhibit. Cf. Morgan, "Alice Aycock: A House for the Self," n.p.

22. Here, the term "text" is intended in the structuralist sense of a set of implicit rules or conditions for reading. It might be a verbal text, as seen in Aycock's work, but does not have to be. Text in the schizoid work of art needs to provide alternative or contradictory readings to an art object. It works best when these differences become a focus.

23. Aycock, interview with author, 13 July 1997.

24. Paul Schimmel, ed., *American Narrative/Story Art: 1967–1977* (Houston: Contemporary Arts Museum, Houston, 1978).

25. Paul Schimmel, introduction to *American Narrative/Story Art,* p. 4.

26. Ibid.

27. James Harithas, preface to Schimmel, *American Narrative/Story Art,* p. 3.

28. Alice Aycock, "Script for Duchamp Talk," typescript, artist's papers, New York City. The statement appropriates sections of one of Duchamp's 1912 notes for *The Bride Stripped Bare by Her Bachelors, Even.* Cf. Richard Hamilton, "The Green Book," in Marcel Duchamp, *The Bride Stripped Bare by Her Bachelors, Even: A Typographic Version by Richard Hamilton of Marcel Duchamp's Green Box,* trans. George Heard Hamilton (London: Percy Lund, Humphries & Co., 1960), n.p. In considering this figure, which Aycock views as male, it is worth noting that she named her son Halley after the comet that came close to earth in the 1980s, thus making him a headlight child.

29. Aycock, interview with author, 16 July 1997.

30. Ibid.

31. Ibid.

32. Hamilton, "The Green Book," n.p.

33. Aycock, interview with author, 16 July 1997.

34. Ibid.

35. Ibid.

36. Walter Benjamin, "*Trauerspiel and Tragedy,*" in *Walter Benjamin: Selected Writings, Volume 1, 1913–1926,* ed. Marcus Bullock and Michael W. Jennings (Cambridge, Mass.: Belknap Press of Harvard University Press, 1996), p. 57.

37. The potential for looking at all works of art as schizophrenic is a legacy of Jacques Derrida's deconstruction, which looks for contradictions in texts and elaborates on the ways that they often communicate differently than they intend.

38. Róheim, *Magic and Schizophrenia,* p. 165.

39. Quoted in Poirier, "The Ghost in the Machine," p. 82.

40. Róheim, *Magic and Schizophrenia,* p. 128.

41. Ibid., p. 178.

Chapter 17

1. One of James Wines's assistants made the drawings for Documenta. Wines was a neighbor of Aycock in Soho at the time. Aycock, interview with author, 16 July 1997.

2. Stuart Morgan, "The Skateboard on Middle Ground: 'Looking' at Documenta 6," *Artscribe* 9 (November 1977), p. 32.

3. Venturi, *Complexity and Contradiction in Architecture,* p. 18.

4. Ibid., p. 13.

5. Aycock, *Project Entitled "The Beginnings of a Complex ,"* n.p.

6. Aycock, in Campbell and Floyd, "An Interview with Alice Aycock," p. 57.

7. Aycock, interview with author, 16 July 1997.

8. Meyer, "Interview with Aycock," p. 6. *The Storming of the Winter Palace,* which was a mass theatrical production, was performed in Petrograd in November 1920.

9. Aycock, interview with author, 16 July 1997.

10. Krauss, "Sculpture in the Expanded Field." This idea is implicit throughout Krauss's essay.

11. In light of Aycock's conclusion that her Documenta piece had become too much a sideshow attraction, it is worth noting that in 1977 her father and his construction firm finished retooling and reinstalling the first 360-degree looping roller coaster on the East Coast for Hershey Park in Pennsylvania. It was named the Sooperdooperlooper, no doubt because this string of words enhanced the brand name's onomatopoeic associations with the perilous flow of its 2,614-foot continuous steel track. Created by renowned German designer Anton Schwarzkopf, the 77-foot-high ride required Aycock Construction's on-site precision overhaul before it could be safely operated. The completed Sooperdooperlooper achieved a maximum speed of forty-five miles per hour and dropped a heart–stopping, precipitous fifty-seven feet. Soon after its completion, this phenomenal ride achieved legendary status among roller-coaster riders, who were awarded large buttons at the end of their escapade to verify their intrepidness. Aycock and her father were both aficionados of such rides, and several years before he undertook work on the Sooperdooperlooper, she had already begun to research fairground architecture. While Aycock deemed the Documenta piece too interactive, she continued to be intrigued with amusement parks and their rides, which have provided her with a generative metaphor for a number of her major pieces.

12. Aycock, interview with author, 16 July 1997.

13. Ibid.

14. Burnham, "Real Time Systems," p. 28.

15. Ibid.

16. Alice Aycock, "For Granny (1881–) Whose Lamps Are Going Out," n.p.

Chapter 18

1. Barthes, "The Death of the Author," in *Image—Music—Text.*

2. Umberto Eco, *The Role of the Reader: Explorations in the Semiotics of Texts* (Bloomington: Indiana University Press, 1979). By positing a model reader, Eco embellishes, adumbrates, and systemizes Barthes's ideas appearing in this essay and in his subsequent writings. This hypothetical reader is the creation of an empirical author who does not need to be identified with the individual credited with writing a specific text. According to Eco, the empirical reader must attempt to become the model reader that a given text foreordains. Although Eco's system is deterministic, it does have the advantage of displacing the author's intention or function onto the text. While I am certainly indebted to Eco's analysis, I prefer Barthes for his stylistics—his fluid and easy understanding of the topic at hand— and most importantly for the fact that both Aycock and Segal read him. While not the inventor of the poststructuralist system that he uses in the late 1960s (many of the advances he describes must be attributed to Jacques Derrida), Barthes is an urbane stylist who is capable of involving readers, while Derrida, for all his delightful puns and wonderful reverses, often alienates them. These are the probable reasons that Barthes was the French poststructuralist of choice for both Aycock and Segal.

3. Barthes, "The Death of the Author," p. 148.

4. Quoted in Phyllis Tuchman, "An Interview with Carl Andre," *Artforum* 8, no. 10 (June 1970), p. 56.

5. Roland Barthes, *s/z,* trans. Richard Miller (New York: Hill and Wang, 1974), p. 12.

6. Ibid., p. 5.

7. Ibid., p. 10.

8. Roland Barthes, "From Work to Text," in *Image—Music—Text*, pp. 156–159.

9. Ibid., p. 162.

10. Gilles Deleuze and Félix Guattari, *Anti-Oedipus: Capitalism and Schizophrenia,* trans. Robert Hurley, Mark Seem, and Helen R. Lane (Minneapolis: University of Minnesota Press, 1983).

11. Barthes, *s/z*, p. 188.

12. Ibid., p. 5.

13. Fineberg, "Alice Aycock, Reflections on Her Work," p. 21.

Chapter 19

1. Denton, ed., *After Years of Rumination on the Events That Led Up to This Misfortune,* n.p.

2. Quoted in Grace Glueck, "Art People," *New York Times,* 6 January 1978, c14: 5.

3. Aycock, conversation with author, 2 July 2001.

4. Aycock, conversation with author, 7 October 2003.

5. Quoted in Meyer, "Interview with Aycock," p. 8.

6. Quoted in Fineberg, "Alice Aycock, Reflections on Her Work," p. 7.

7. Kurt Vonnegut, *Slaughterhouse-Five or The Children's Crusade: A Duty-Dance with Death* (New York: Dell Publishing, 1969), p. 29. The publication date of 1969 suggests the importance of this high-profile book for Aycock and others of her generation. The primary difference between Vonnegut's novel and Aycock's artwork is that Pilgrim's fragmented world consists of his own lifetime whereas Aycock's ranges over history. As Vonnegut tells us, "Billy has gone to sleep a senile widower and awakened on his wedding day. He has walked through a door in 1955 and come out another one in 1941. He has gone back through that door to find himself in 1963. He has seen his birth and death many times, he says, and

pays random visits to all the events in between. . . . Billy is spastic in time, has no control over where he is going next, and the trips aren't necessarily fun. He is in a constant state of stage fright, he says, because he never knows what part of his life he is going to have to act in next."

8. Quoted in Leo van Damme, "Alice in Wonderland, the Investigation of Alice Aycock," *Arte Factum* (April/May 1984), p. 20.

9. Kubler, *The Shape of Time,* p. 9.

10. Aycock, conversation with author, 8 August 2003.

11. Aycock, conversation with author, 25 March 2005.

12. Quoted in Fineberg, "Alice Aycock, Reflections on Her Work," p. 8.

13. Ibid., p. 9.

14. Aycock, conversation with author, 7 October 2003.

15. Quoted in Meyer, "Interview with Aycock," p. 8.

16. Kubler, *The Shape of Time,* pp. 37, 35.

17. Ibid., p. 12.

18. Cf. Crombie, *Medieval and Early Modern Science.*

19. Quoted in K. G. Pontus Hultén, *The Machine as Seen at the End of the Mechanical Age* (New York: Museum of Modern Art, 1968), p. 9.

20. Lynn White Jr., *Medieval Technology and Social Change* (Oxford: Clarendon Press, 1962), p. 134.

21. James Burke, *Connections* (Boston: Little, Brown, 1978).

22. Aycock, conversation with author, 22 November 1996.

23. Quoted in Charles Singer, *From Magic to Science: Essays on the Scientific Twilight* (London: Ernest Benn, 1928), p. 219.

24. Róheim, *Magic and Schizophrenia,* p. 179.

25. Ibid., p. 137.

26. Although this reference to Rube Goldberg is presented casually, this source may actually be indirectly important to Aycock's work.

Duchamp, one of her long-time heroes, was a great admirer of this cartoonist's work. In April 1921, he published a drawing by Goldberg in *New York Dada.* At the time, Goldberg, whose full name was Reuben Lucius Goldberg, was a cartoonist syndicated in newspapers throughout the United States. Soon after this time he became one of the highest-paid artists in the country.

27. Quoted in Howard N. Fox, "The Thorny Issues of Temporary Art," *Museum News* 57, no. 6 (July/August 1979), p. 45. This article summarizes a panel, "Temporary Art Projects in the Museum Context," organized and chaired by Howard N. Fox and sponsored by the American Association of Museum Curators Committee, at the annual meeting of the College Art Association in Washington, D.C., 1 February 1979. In addition to Aycock, the panelists included RoseLee Goldberg, Patrick Ireland, Gerry McAllister, Rae Tyson, and John Willenbecher. Quoted statements are from this session.

28. Denton, ed., *After Years of Rumination on the Events That Led Up to This Misfortune,* n.p.

29. Aycock, interview with author, 12 July 1997.

30. Aycock, conversation with author, 7 October 2003.

Chapter 20

1. Because of Aycock, Inc.'s prior experience working with nuclear reactors, it was one of a number of companies enlisted for the cleanup. Over the years Aycock, Inc. worked on a number of atomic reactors, including Peach Bottom, Peco Energy Co. (Lancaster, Pennsylvania), Pilgrim Nuclear Power Station (Plymouth, Massachusetts), and Seabrook Power Plant (Seabrook, New Hampshire).

2. Aycock, conversation with author, 8 August 2003.

3. Aycock, conversation with author, 11 August 2003.

4. Alice [Aycock] Segal, "The Tempietto: A Study of Tradition," unpublished paper for Leo Steinberg's graduate class in Renaissance art, 20 May 1970, p. 2. Later she refers to "the crypt beneath, [where] a marker stands over the place where St. Peter's cross was said to be fixed to the ground" (p. 3).

5. Aycock, conversation with author, 8 August 2003.

6. Alice Aycock, text for *The Central Machine*, in Edward F. Fry, *Alice Aycock Projects 1979–1981* (Tampa: University of South Florida, 1981), p. 32.

7. Quoted in "Talk with Alice Aycock, Tilman Osterwold and Andreas Vowinckel in July 1983," n.p.

8. Aycock, conversation with author, 7 October 2003.

9. Aycock, conversation with author, 8 August 2003.

10. Kay Larson, "Machineworks," in Janet Kardon, *Machineworks: Vito Acconci, Alice Aycock, Dennis Oppenheim* (Philadelphia: Institute of Contemporary Art, 1981), p. 26.

Chapter 21

1. Aycock, conversation with author, 7 October 2003.

2. Aycock, interview with author, 22 November 1996.

3. Kay Larson, "Alice in Duchamp-Land," *New York* 14, no. 21 (May 25, 1981), p. 66.

4. Quoted in Poirier, "The Ghost in the Machine," p. 82.

5. Quoted in Williams, *Eliphas Lévi*, p. 101.

6. Gilbert Ryle, *The Concept of Mind* (1949; reprint, London: Hutchinson, 1969), pp. 12, 13.

7. Ibid, p. 16.

8. Alice Aycock, conversation with author, 10 September 2003. One of the books related to this idea, which Aycock studied, is Maurice Bessy's *A Pictorial History of Magic and the Supernatural* (London and New York: Spring Books, 1964), p. 238. Figure 776, which presents a picture taken from a doctoral thesis by a Professor Frank (1783), illustrates a means for using mechanical illusionist tricks for conjuring up images of ghosts. In addition, Bessy notes, "In his book 'Le Fantôme des Vivants' (The Ghost of the Living), H. Durville states that as he sees it, the 'fluid masses' surrounding a subject to a radius of nearly ten feet can suddenly be condensed beneath the influence of magnetization and finally assume the shape of what we call a ghost." This hopeful connection of ghosts with science was later elaborated by illusionists, who hoped to be able to conjure up such apparitions on film.

9. Georges Ifrah, *The Universal History of Computing from the Abacus to the Quantum Computer*, trans. E. F. Harding (New York: John Wiley & Sons, 2001), p. 161.

10. William Gibson, *Neuromancer* (New York: Ace Books, 1984), p. 51.

11. Debord, *The Society of the Spectacle*, p. 12.

12. Scott Bukatman, *Terminal Identity: The Virtual Subject in Postmodern Science Fiction* (Durham: Duke University Press, 1993), p. 9.

13. Ibid.

14. Aycock, interview with author, 22 November 1996.

15. Róheim, *Magic and Schizophrenia*, p. 159.

16. Poirier, "The Ghost in the Machine," p. 82.

17. Róheim, *Magic and Schizophrenia*, p. 180.

18. This reference calls to mind one of Aycock's favored theories that whenever paradigms shift, so do human beings' relationship to the sun. In her courses at Yale she used to point to the Russian constructivist play *Victory over the Sun* as exemplary of this attitude. She related it to the constructivists' belief that they could overthrow antiquated, nineteenth-century ways of thinking by creating an antigravitational architecture in which the stability of the post and lintel system was overturned for oblique and skewed forms. According to Aycock, this new order represented their recognition of their ability to change the world. Aycock, conversation with author, 10 July 2001.

19. Aycock, conversation with author, 23 November 1996.

20. Aycock, conversation with author, 7 October 2003.

21. Burke, *Connections*, pp. 111ff.

22. Burnham, *Beyond Modern Sculpture*, p. 185.

23. In Fry, *Alice Aycock Projects 1979–1981*, p. 17.

24. Aycock, conversation with author, 7 October 2003.

25. Dennis Oppenheim, description for *Final Stroke—Project for a Glass Factory* (1980), in Kardon, *Machineworks*, p. 32.

26. Janet Kardon, "Metaphorical Machinery," in *Machineworks*, p. 8.

27. *Alice Aycock: Retrospektive der Projekte und Ideen 1972–1983*, n.p. The statement was slightly edited by Aycock in September 2003. Aycock, conversation with author, 7 October 2003.

28. Aycock, in Fry, *Alice Aycock Projects 1979–1981*, p. 20.

29. *Alice Aycock: Retrospektive der Projekte und Ideen 1972–1983*, n.p.

30. Aycock, conversation with author, 23 November 1996.

31. Aycock, conversation with author, 13 July 1997.

32. Arthur Macher, "The Great God Pan," in *Tales of Horror and the Supernatural*, ed. Philip Van Doren Stern (New York: Alfred A. Knopf, 1998), p. 107.

33. Poirier, "The Ghost in the Machine," p. 82.

34. Aycock, interview with author, 22 November 1996.

35. Ibid.

36. Quoted in Jamie Diamond, "Heavy Metal: Sculptor Alice Aycock's Outside Vision," *Lears* 4, no. 8 (October 1991), p. 86.

37. Aycock, interview with author, 22 November 1996.

38. Fineberg, "Alice Aycock, Reflections on Her Work," p. 14. This observation may refer to the thousands of gallons of water in one of the nuclear power plants at Three Mile Island that had poured from an accidentally opened valve. As a result, the plant was only hours away from an uncontrolled meltdown of the reactor's core that would have resulted in devastation similar to that which occurred a few years later in Chernobyl, Ukraine.

39. Marey's experiments were later important to both futurism and kinetic art, as Giacomo Balla's images of birds in flight relied on this French physiologist's graphic images. Since Aycock was impressed in the 1960s by kinetic art, her reference to Marey brings this tradition into a full and complete cycle.

40. Weston La Barre, *The Ghost Dance: Origins of Religion* (New York: Dell, 1970), p. 229.

41. Poirier, "The Ghost in the Machine," p. 86.

Chapter 22

1. Aycock, conversation with author, 7 October 2003.

2. Fry, *Alice Aycock Projects 1979–1981*, p. 5

3. Aycock, conversation with author, 14 July 1997.

4. Eugenie Tsai, "A Tale of (at Least) Two Cities: Alice Aycock's 'Large Scale Dis/Integration of Microelectronic Memories (A Newly Revised Shantytown),'" *Arts Magazine* 56 (June 1982).

5. Aycock, conversation with author, 14 July 1997.

6. Aycock, conversation with author, 7 October 2003.

7. Jonathan D. Spence, *The Memory Palace of Matteo Ricci* (New York: Viking, 1984). Although the English Renaissance hermetic philosopher Robert Fludd, whose thought was to be important to Aycock's work in so many ways, developed a compelling memory system, Aycock has preferred Matteo Ricci's. For an elaboration of Fludd's mnemotechnics, see Frances A. Yates, *The Art of Memory* (Chicago: University of Chicago Press, 1966).

8. Ibid., p. 9.

9. Ibid. In first-world cultures, feats of memory have assumed far less significance than they have in second and third worlds, probably because memory is less in demand. In the eighteenth century the origination of the French encyclopedia went far to deprecate memory in favor of codified knowledge, and the process continues to this day, perhaps even more so in the new age of globalism that erases boundaries between first, second, and third worlds. On a personal note, a Chinese acupuncturist whom I have visited boasts an ability to remember vast quantities of information. He has encouraged his children in this direction and makes similar claims for them. It is tempting to think that he and similar memory experts are heirs to the mnemotechnics that Ricci taught the Chinese over four centuries ago.

10. In this situation schizophrenia also functions as a metaphor for the artistic and romantic process of dislocating and separating feelings by conveying them to works of art. Instead of romanticism's manifestation of an integral connection between artist and work, this stylistic can be interpreted as a schizophrenic splintering of the self into surrogate and ultimately alienating forms because they compete with their creators for legitimization and self-definition.

11. Robert Morris, "The Present Tense of Space," *Art in America* 66 (January/February 1978), p. 72.

12. Ibid., p. 70.

13. Ibid., p. 72.

14. Ibid., p. 80, n 9.

Chapter 23

1. Aycock, interview with author, 11 July 1997.

2. Morse Peckham, *Man's Rage for Chaos: Biology, Behavior, and the Arts* (New York: Schocken Books, 1967).

3. Ibid., p. 314.

4. Another early scientist from this period is Athanasius Kircher (1602–1680), a Jesuit scholar and philosopher, whose ideas have been a source for a number of Aycock's works. Professor of mathematics and Oriental languages at the Collegium Romanum, Kircher later studied hieroglyphics and other archaeological problems.

5. The French artists Anne and Patrick Poirier, who were working at Fattoria di Celle at the same time as Aycock, introduced her to this important collection. The Institute and Museum of the History of Science is located in the Palazzo Castellani near the Uffizi Gallery.

6. Kubler, *The Shape of Time*, p. 1.

7. Aycock, interview with author, 22 November 1996.

8. "Talk with Alice Aycock, Tilman Osterwold and Andreas Wowinckel in July 1983," n.p. The book of illustration Aycock refers to is J. G. Heck, *The Complete Encyclopedia of Illustration*, trans. Spencer F. Baird (New York: Park Lane, 1979). This is a republication of the 1851 *Iconographic Encyclopedia of Science, Literature, and Art.*

9. Colin A. Ronan, *Science: Its History and Development among the World's*

Cultures (New York: Facts on File Publications, 1982), and *Asher & Adams' Pictorial Album of American Industry 1876* (New York: Routledge Books, 1976).

10. Fineberg, "Alice Aycock, Reflections on Her Work," p. 9.

11. Cf. Jim Bennett and Stephen Johnston, *The Geometry of War 1500–1750* (Oxford: Museum of the History of Science, University of Oxford, 1996):

The ingenuity and precision of the instruments on display, and the elegance, poise and delicacy of many of them, contrast with the harsh and uncompromising conditions of the battlefield. A review of such instruments is bound to raise the question of how useful they could really have been in practice. They were supposed to be employed in battle, but it is clear that their purported military value also had other functions—in justifying textbook geometrical problems, for example, and in attracting patronage. (p. 9)

These authors note that when some examples are particularly large, they "would have served primarily for study and practice rather than for more active exertions" (p. 80). I thank Richard Drayton for guiding me to this source.

12. Jacques Mercier, *Ethiopian Magic Scrolls* (New York: George Braziller, 1979), p. 8.

13. Aycock emphatically stated that the only biblical texts that intrigue her are writings like the book of Revelation, which appears to her to have been written by a schizophrenic and partakes of the same type of magic systems found in so-called pagan texts. Alice Aycock, interview with author, 8 August 2003.

14. The best-known translation of this story is Richard F. Burton, *The Book of the Thousand Nights and a Night* (London: Burton Club, 1900), which is influenced by John Payne's edition.

15. Quoted in Poirier, "The Ghost in the Machine," p. 85. In an interview

with the author (23 November 1996), Aycock admitted, "I have always been afraid of knives. I made pieces about my greatest fears, and that is what I did during this period. I am most afraid of being knifed to death, a fear I have had all my life."

16. Sanford Kwinter, "Alice Aycock at John Weber Gallery," *Art in America* 71 (April 1983), p. 181.

17. Susan Campbell, *Cook's Tools: The Complete Manual of Kitchen Implements and How to Use Them* (New York: Bantam Books, 1981).

18. "The glance of eternity" is an English translation of a phrase from Friedrich Nietzsche's discussion in *Thus Spake Zarathustra* of the merits of the true friend. Nietzsche argues that a true friend has the ability to recognize and love the eternal in someone who is being reprimanded for mere ephemeral flaws. Aycock has never read this book and is unaware of the term's connotations. Aycock, interview with author 8 August 2003.

19. Aycock, interview with author, 13 July 1997.

20. Ibid.

21. Quoted in Poirier, "The Ghost in the Machine," p. 85.

22. "Alice Aycock: The Wonderful Pig of Knowledge, an Interview with Stuart Morgan," in *Alice Aycock*, Serpentine Gallery, 1985, n.p.

23. Aycock, conversation with author, 8 August 2003. This point and the following observations in this paragraph are Aycock's.

24. Randy Rosen and Catherine C. Brawer, *Making Their Mark: Women Artists Move into the Mainstream, 1970–85* (New York: Abbeville Press, 1989), p. 177. Aycock points out that she first bought Cuisinart blades to study them but did not buy a Cuisinart to use in her kitchen until much later. Aycock, correspondence with author, 2 July 2001.

25. Quoted in Davis, "Sculpture Shock," p. 32.

26. Aycock, conversation with author, 8 August 2003. This and many of the following observations about Aycock's interest in magic as a heightened commitment to language come from this conversation.

27. *The Book of the Sacred Magic of Abra-Melin the Mage as Delivered by Abraham the Jew unto his Son Lamech: A Grimoire of the Fifteenth Century from an Old and Rare French Manuscript in the Bibliothèque de l'Arsenal at Paris* (1932; reprint, Chicago: De Laurence Company, 1948), p. 219.

28. Quoted in Fineberg, "Alice Aycock, Reflections on Her Work," pp. 27–28. Emendation: Aycock, conversation with author, 7 October 2003.

29. Van Damme, "Alice in Wonderland," p. 19. Georges Bataille reproduces several period photographs of this type of Chinese torture in *The Tears of Eros*, trans. Peter Connor (San Francisco: City Lights Books, 1989), pp. 204–206; trans. of *Les larmes d'Eros* (Paris: Jacques Pauvert, 1961).

30. "Alice Aycock: The Wonderful Pig of Knowledge," n.p., and Aycock, conversation with author, 13 July 1997.

31. Aycock, conversation with author, 7 October 2003.

32. Godwin, *Robert Fludd*, p. 10.

33. Ibid., p. 20.

34. Ibid., p. 15.

35. Aycock, conversation with author, 8 August 2003.

36. Poirier, "The Ghost in the Machine," p. 85.

37. Aycock, interview with author, 14 July 1997.

38. Ibid.

39. Róheim, *Magic and Schizophrenia*, p. 153.

40. Aycock, interview with author, 12 July 1997.

41. Ibid.

42. Aycock, conversation with author, 7 October 2003.

43. Godwin, *Robert Fludd*, p. 49.

44. Aycock, conversation with author, 14 July 1997.

45. Seen in terms of Fludd's hermeticism, this concept of a hypothetical unity through the creation of an alienated and alienating mirror image is most intriguing; it supports his elaboration of Light and Dark Alephs, mentioned earlier, that represent a primary way for an ineffable godhead to be manifested in the world. We might, in fact, conclude that Aycock has found a way to explain Lacan's mirror phase through Fludd's essential cosmology and vice versa.

Chapter 24

1. Kubler, *The Shape of Time.* Cf. pp. 26 and 41, but throughout his study, as in his usage of such terms as "'good' and 'bad' entrances," this art historian underscores the idea that art is like a game of chance.

2. Johan Huizinga, *Homo Ludens: A Study of the Play Element in Culture* (Boston: Beacon Press, 1938), p. 146.

3. Aycock, conversation with author, 8 August 2003.

4. Hermann Hesse, *The Glass Bead Game,* trans. Richard and Clara Winston (1943; reprint, New York: Holt, Rinehart and Winston, 1969), p. 1.

5. Ibid., p. 15.

6. Burnham, *Structure of Art,* p. 2.

7. Aycock, conversation with author, 8 August 2003.

8. Peckham, *Man's Rage for Chaos,* p. 78.

9. Aycock, conversation with author, 13 December 2000.

10. Barthes, "From Work to Text," in *Image—Music—Text,* explains, "In fact, *reading* in the sense of consuming, is far from *playing* with the text. 'Playing' must be understood here in all its polysemy: the text itself *plays* (like a door, like a machine with 'play'); and the reader plays twice over, playing the Text as one plays a game, looking for a practice which reproduces it, but in order that that practice not be reduced to a passive, inner *mimesis* (the Text is precisely that which resists such a reduction), also playing the Text in the musical sense of the term" (p. 162).

11. Aycock, interview with author, 12 July 1997.

12. Hesse, *The Glass Bead Game,* p. 83.

13. Aycock, conversation with author, 19 August 2003.

14. This and the following brief discussion of this game's history is indebted to Brian Love, *Play the Game* (Los Angeles: Reed Books, 1978), p. 9.

15. In *Through the Labyrinth,* Kern speculates that a board for this game may have been invented in Germany in the sixteenth century (p. 213).

16. Quoted in Fineberg, "Alice Aycock, Reflections on Her Work," p. 24.

17. Stephen W. Hawking, *A Brief History of Time: From the Big Bang to Black Holes* (New York: Bantam Books, 1988).

18. Alice Aycock, conversation with author, 22 August 2003.

19. Michel Foucault, *This Is Not a Pipe,* trans. and ed. James Harkness (Berkeley: University of California Press, 1982), p. 24. In addition to this statement, the tone of this part of the discussion of *The New & Favorite Game of The Universe and the Golden Goose Egg* is indebted to this classic Foucault text.

20. Ibid., p. 54.

21. Donna Stein, "Reinventing the World through Art," in Stein, *Alice Aycock: Waltzing Matilda,* p. 7.

22. David Wellbery, *Lessing's Laocoön* (Cambridge: Cambridge University Press, 1984), p. 31. The author thanks Professor Eric Garberson for suggesting this source.

23. Alice Aycock, correspondence with author, 17 March 2001.

24. Friedrich Nietzsche, "What Is Noble," in *Beyond Good and Evil: Prelude to a Philosophy of the Future,* trans. Walter Kaufmann (New York: Vintage Books, 1966), p. 229.

25. Edwin A. Dawes, *The Great Illusionists* (Secaucus, N.J.: Chartwell Books, 1979).

26. John Williams, *Early Spanish Manuscript Illumination* (New York: George Braziller, 1977), pp. 94–95.

27. Ibid., p. 95.

28. Aycock, interview with author, 23 November 1996.

29. "Alice Aycock: The Wonderful Pig of Knowledge, an Interview with Stuart Morgan," n.p.

30. Dawes, *The Great Illusionists,* p. 33.

Selected Bibliography

An exhaustive bibliography on Alice Aycock's works would contain many exhibition reviews as well as citations referring to her inclusion in a sizeable number of group exhibitions on a range of topics, of which some are germane to her art and others are not. The following selected bibliography includes the most rigorous and useful sources on this artist's work, along with those that have been particularly helpful in researching this monograph. It is divided into the following categories: writings by the artist, published interviews, books and catalogues, and articles.

Writings by Alice Aycock
(in chronological order)

Alice [Aycock] Segal. "The Tempietto: A Study of Tradition." Paper for Leo Steinberg's class, Art History 640, Hunter College, 20 May 1970, n.p. Artist's personal papers, New York City.

Alice [Aycock] Segal. "The *Gero Crucifix.*" Paper for Konrad Hoffmann's class, Medieval Art History 637, Hunter College, 12 January 1970, n.p. Artist's personal papers, New York City.

Alice [Aycock] Segal. "An Incomplete Examination of the Highway Network/User/Perceiver Systems." M.A. Thesis, Hunter College of the City University of New York, 13 May 1971. Thesis director, Robert Morris. Artist's personal papers, New York City.

"Four 36–38 Exposures." *Avalanche,* no. 4 (Spring 1972), pp. 28–31.

"Notes." *Tracks: A Journal of Artists' Writings* 2, no. 2 (Spring 1976), pp. 24–26.

"For Granny (1881–) Whose Lamps Are Going Out: A Short Lecture on the Effects of Afterimages." *Tracks: A Journal of Artists' Writings* 3, nos. 1 and 2 (Spring 1977), pp. 141–144.

Project Entitled "The Beginnings of a Complex . . . " (1976–77): Notes, Drawings, Photographs. Ed. Amy Baker. New York: Lapp Princess Press, in association with Printed Matter, 1977.

"Work 1972–1974." In Alan Sondheim, ed., *Individuals: Post-Movement Art in America.* New York: E. P. Dutton, 1977, pp. 104–121.

[Notes to Works]. In Monroe Denton, ed., *After Years of Rumination on the Events That Led Up to This Misfortune . . . Alice Aycock: Projects and Proposals 1971–1978.* Allentown, Pa.: Muhlenberg College Center for the Arts, 1978.

[Notes to Works]. In Edward F. Fry, *Alice Aycock Projects 1979–1981.* Tampa: University of South Florida, 1981.

[Notes to Works]. In *Alice Aycock: Retrospektive der Projekte und Ideen 1972–1983, Installation und Zeichnungen.* Stuttgart: Württembergischer Kunstverein, 1983, n.p.

"Alice Aycock on Constructivism." In Christopher Lyon, ed., *Contemporary Art in Context.* New York: Museum of Modern Art, 1990.

"Introduction to a Short Untitled Work of Fiction in Five Chapters (Work in Progress)." *Arti* 23 (January/February 1995), pp. 40–52, reprinted in Donna Stein, *Alice Aycock: Waltzing Matilda.* East Hampton, N.Y.: Guild Hall Museum, 1997.

"Script for Duchamp Talk." Typescript, artist's papers, New York City, n.d.

Published Interviews

Aycock, Alice, et al. "Round Table Discussions." In Hugh M. Davies and Ronald J. Onorato, *Sitings: Alice Aycock, Richard Fleischner, Mary Miss, George Trakas* Ed. Sally Yard. La Jolla: La Jolla Museum of Contemporary Art, 1986.

Campbell, Carole, and Phylis Floyd. "An Interview with Alice Aycock." *Kresge Art Museum Bulletin* 7 (Michigan State University, 1992), pp. 48–61.

Fineberg, Jonathan. "Alice Aycock, Reflections on Her Work: An Interview." In *Complex Visions: Sculpture and Drawings by Alice Aycock.* Mountainville, N.Y.: Storm King Art Center, 1990, pp. 7–39.

Kardon, Janet. "Janet Kardon Interviews Some Modern Maze-Makers," *Art International* 20 (April/May, 1976), pp. 64–66.

Meyer, Ruth K. "Interview with Alice Aycock." *D.A.A. Journal* (January 1980), pp. 6–9, 12–17.

Morgan, Stuart. "Alice Aycock: The Wonderful Pig of Knowledge, an Interview." In *Alice Aycock* (London: Serpentine Gallery, 1985), n.p.

Price, Aimée Brown. "Artist's Dialogue: A Conversation with Alice Aycock." *Architectural Digest* 40, no. 4 (April 1983), pp. 54, 58, 60.

"Talk with Alice Aycock, Tilman Osterwold and Andreas Vowinckel in July 1983 in Stuttgart." In *Alice Aycock: Retrospektive der Projekte und Ideen 1972–1983, Installation und Zeichnungen.* Stuttgart: Württembergischer Kunstverein, 1983, n.p.

Yanagi, Masahiko. "Alice in Magic Land: An Interview with Alice Aycock." Trans. Tetsuo Kinoshita. *Mizue* no. 956 (Autumn 1990), pp. 22–33.

Books and Catalogues

Alice Aycock and Robert Stackhouse: Sculpture at Laumeier. St. Louis: Laumeier Sculpture Park, 1988.

Alice Aycock: Retrospektive der Projekte und Ideen 1972–1983 Installation und Zeichnungen. Stuttgart: Württembergischer Kunstverein, 1983.

Armstrong, Nancy. *Fiction in the Age of Photography: The Legacy of British Realism.* Cambridge, Mass.: Harvard University Press, 1999.

Artpark 1977: The Program in Visual Arts. Lewiston, N.Y.: Artpark, 1977.

Bachelard, Gaston. *The Poetics of Space.* Trans. Maria Jolas. Boston: Beacon Press, 1969.

Baker, Kenneth. *Minimalism: Art of Circumstance.* New York: Abbeville Press, 1988.

Barthes, Roland. *Image—Music—Text.* Trans. Stephen Heath. New York: Hill and Wang, 1977.

———. *Sade/Fourier/Loyola.* Trans. Richard Miller. Baltimore: Johns Hopkins University Press, 1978.

———. *s/z.* Trans. Richard Miller. New York: Hill and Wang, 1974.

Bateson, Gregory. *Steps to an Ecology of Mind.* New York: Ballantine Books, 1972.

Battcock, Gregory, ed. *Minimal Art: A Critical Anthology.* New York: E.P. Dutton, 1968.

Benjamin, Walter. *Walter Benjamin: Selected Writings, Volume 1, 1913–1926.* Ed. Marcus Bullock and Michael W. Jennings. Cambridge, Mass.: Belknap Press of Harvard University Press, 1996.

Bennett, Jim, and Stephen Johnston. *The Geometry of War 1500–1750.* Oxford: Museum of the History of Science, University of Oxford, 1996.

Bettelheim, Bruno. *The Empty Fortress: Infantile Autism and the Birth of the Self.* New York: Free Press, 1967.

Blake, Kathleen. *Play, Games, and Sport: The Literary Works of Lewis Carroll.* Ithaca: Cornell University Press, 1974.

Bloom, Harold. *A Map of Misreading.* Oxford: Oxford University Press, 1975.

The Book of the Sacred Magic of Abra-Melin the Mage as Delivered by Abraham the Jew unto His Son Lamech: A Grimoire of the Fifteenth Century from an Old and Rare French Manuscript in the Bibliothèque de l'Arsenal at Paris. 1932. Reprint, Chicago: De Laurence Company, 1948.

Borges, Jorge Luis. *Ficciones*. Ed. Anthony Kerrigan. Trans. Emecé Editores. New York: Grove Press, 1962.

———. *Labyrinths: Selected Stories and Other Writings*. Ed. Donald A. Yates and James E. Irby. New York: New Directions, 1964.

———. *A Personal Anthology*. Ed. Anthony Kerrigan. New York: Grove Press, 1967.

Braithwaite, David. *Fairground Architecture: Excursions into Architecture Series*. London: Hugh Evelyn, 1968.

Bretano, Robyn, and Mark Savitt. *112 Workshop/112 Greene Street: History, Artists and Artworks*. New York: New York University Press, 1981.

Bukatman, Scott. *Terminal Identity: The Virtual Subject in Postmodern Science Fiction*. Durham: Duke University Press, 1993.

Burnham, Jack. *Beyond Modern Sculpture: The Effects of Science and Technology on the Sculpture of This Century*. New York: George Braziller, n.d. [1967].

———. *Great Western Salt Works: Essays on the Meaning of Post-Formalist Art*. New York: George Braziller, 1974.

———. *Software: Information Technology: Its New Meaning for Art*. New York: Jewish Museum, 1970.

———. *The Structure of Art*. New York: George Braziller, 1971.

Burton, Richard F. *The Book of the Thousand Nights and a Night*. London: Burton Club, 1900.

Carroll, Lewis. *Alice's Adventure in Wonderland & Through the Looking-Glass*. New York: Penguin Books, 1960.

Churchman, C. West. *The Design of Inquiring Systems: Basic Concepts of Systems and Organization*. New York: Basic Books, 1971.

Colpitt, Frances. *Minimal Art: The Critical Perspective*. Seattle: University of Washington Press, 1993.

Complex Visions: Sculpture and Drawings by Alice Aycock. Mountainville, N.Y.: Storm King Art Center, 1990.

Crawford, Curtis, ed. *Civil Disobedience: A Casebook*. New York: Thomas Y. Crowell, 1973.

Crombie, A.C. *Medieval and Early Modern Science*. Vol. 1 of *Science in the Middle Ages: v–xiii Centuries*. Cambridge, Mass.: Harvard University Press, 1963.

Cubbs, Joanne. *Eccentric Machines*. Sheboygan, Wisc.: John Michael Kohler Arts Center, 1987.

Debord, Guy. *The Society of the Spectacle*. Trans. Donald Nicholson-Smith. New York: Zone Books, 1995.

Deleuze, Gilles, and Félix Guattari. *Anti-Oedipus: Capitalism and Schizophrenia*. Trans. Robert Hurley, Mark Seem, and Helen R. Lane. Minneapolis: University of Minnesota Press, 1983.

———. *A Thousand Plateaus: Capitalism and Schizophrenia*. Trans. Brian Massumi. Minneapolis: University of Minnesota Press, 1987.

Denton, Monroe, ed. *After Years of Rumination on the Events That Led Up to This Misfortune . . . Alice Aycock: Projects and Proposals 1971–1978*. Allentown, Pa.: Muhlenberg College Center for the Arts, 1978.

———. *Alice Aycock*. Kansas City, Mo.: Grand Arts, 1995.

Doob, Penelope Reed. *The Idea of the Labyrinth: From Classical Antiquity through the Middle Ages*. Ithaca: Cornell University Press, 1990.

Dostoevsky, Fyodor. *The Brothers Karamazov*. Trans. Constance Garnett, rev. and ed. Ralph E. Matlaw. New York: W.W. Norton, 1976.

Drawings: The Pluralist Decade. Philadeliphia: Institute of Contemporary Art, University of Pennsylvania, 1980.

Duchamp, Marcel. *The Bride Stripped Bare by Her Bachelors, Even: A Typographic Version by Richard Hamilton of Marcel Duchamp's Green Box.* Trans. George Heard Hamilton. London: Percy Lund, Humphries & Co., 1960.

Eco, Umberto. *The Role of the Reader: Explorations in the Semiotics of Texts.* Bloomington: Indiana University Press, 1979.

Fine, Ruth E., and Mary Lee Corlett. *Graphic Studio: Contemporary Art from the Collaborative Workshop at the University of South Florida.* Washington: National Gallery of Art, 1992.

Fineberg, Jonathan. *Alice Aycock: Fantasies on the Tree of Life.* Urbana-Champaign: Krannert Art Museum, University of Illinois, 1992.

Foster, Hal. *The Return of the Real: The Avant-Garde at the End of the Century.* Cambridge, Mass.: MIT Press, 1996.

Foucault, Michel. *The Archaeology of Knowledge.* London: Tavistock, 1972.

——. *Discipline and Punish: The Birth of the Prison.* London: Allen Lane, 1977.

——. *Madness and Civilisation: A History of Insanity in the Age of Reason.* London: Tavistock, 1967.

——. *The Order of Things: An Archaeology of the Human Sciences.* London: Tavistock, 1970.

——. *This Is Not a Pipe.* Trans. and ed. James Harkness. Berkeley: University of California Press, 1982.

Fox, Howard N. *Metaphor: New Projects by Contemporary Sculptors.* Washington, D.C.: Smithsonian Institution Press, 1982.

Freud, Sigmund. *The Case of Schreber, Papers on Technique and Other Works.* Vol. 12 (1911–1913) of *The Standard Edition of the Complete Psychological Works of Sigmund Freud,* trans. and ed. James Strachey. London: Hogarth Press and Institute of Psychoanalysis, 1958.

Fry, Edward F. *Alice Aycock Projects 1979–1981.* Tampa: University of South Florida, 1981.

Gibson, Walter S. *Hieronymus Bosch.* New York: Praeger Publishers, 1973.

Giedion, Sigfried. *Mechanization Takes Command: A Contribution to Anonymous History.* New York: W. W. Norton, 1969.

——. *Space, Time and Architecture: The Growth of a New Tradition.* Cambridge, Mass.: Harvard University Press, 1967.

Ginsburg, Susan. *Robert Smithson: Drawings.* New York: New York Cultural Center, 1974.

Godwin, Joscelyn. *Robert Fludd: Hermetic Philosopher and Surveyor of Two Worlds.* Boulder, Colo.: Shambhala, 1979.

Goffman, Erving. *The Presentation of Self in Everyday Life.* Garden City, N.Y.: Anchor Doubleday, 1959.

Good, Arthur. *Magical Experiments or Science in Play.* Trans. Camden Curwen and Robert Waters. Philadelphia: David McKay, Publisher, 1892.

Gordon, John. *Louise Nevelson.* New York: Whitney Museum of American Art, 1967.

Gornick, Vivian, and Barbara Moran, eds. *Women in Sexist Society: Studies in Power and Powerlessness.* New York: Basic Books, 1971.

Hall, Edward T. *Handbook of Proxemic Research.* Washington, D.C.: Society for the Anthropology of Visual Communication, 1975.

——. *The Hidden Dimension.* Garden City, N.Y.: Anchor Books, 1969.

Hall, Michael D. *Stereoscopic Perspective: Reflections on American Fine and Folk Art.* Ann Arbor: UMI Research Press, 1988.

Hesse, Hermann. *The Glass Bead Game.* Trans. Richard and Clara Winston. New York: Holt, Rinehart and Winston, 1969.

Hillman, James. *The Dream and the Underworld.* New York: Harper & Row, 1979.

Hobbs, Robert. *Robert Smithson: Sculpture.* Ithaca: Cornell University Press, 1981.

Hoffmann, Konrad. *The Year 1200: A Centennial Exhibition at the Metropolitan Museum of Art.* New York: Metropolitan Museum of Art, distributed by New York Graphic Society, 1970.

Hoover, Marjorie L. *Meyerhold: The Art of Conscious Theater.* Amherst: University of Massachusetts Press, 1974.

The House That Art Built. Fullerton, Calif.: Main Art Gallery, Visual Arts Center, California State University, 1983.

Huizinga, Johan. *Homo Ludens: A Study of the Play Element in Culture.* Boston: Beacon Press, 1938.

Hultén, K. G. Pontus. *The Machine as Seen at the End of the Mechanical Age.* New York: Museum of Modern Art, 1968.

Hunter, Sam. *An American Renaissance: Painting and Sculpture since 1940.* New York: Abbeville Press, 1986.

Ifrah, Georges. *The Universal History of Computing from the Abacus to the Quantum Computer.* Trans. E. F. Harding. New York: John Wiley & Sons, 2001.

Jaskolski, Helmut. *The Labyrinth: Symbol of Fear, Rebirth, and Liberation.* Trans. Michael H. Kohn. Boston: Shambhala, 1997.

Kardon, Janet, ed. *Machineworks: Vito Acconci, Alice Aycock, Dennis Oppenheim.* Philadelphia: Institute of Contemporary Art, 1981.

Kern, Hermann. *Through the Labyrinth: Designs and Meaning over 5,000 Years.* Trans. Abigail Clay. Munich: Prestel, 2000.

Khan-Magomedov, Selim O. *Pioneers of Soviet Architecture: The Search for New Solutions in the 1920s and 1930s.* New York: Rizzoli, 1983.

Kostof, Spiro. *A History of Architecture: Settings and Rituals.* New York: Oxford University Press, 1985.

Kubler, George. *The Shape of Time: Remarks on the History of Things.* New Haven: Yale University Press, 1962.

Kuhn, Thomas S. *The Structure of Scientific Revolutions.* Chicago: University of Chicago Press, 1962.

Laing, R. D. *The Divided Self: An Existential Study in Sanity and Madness.* London: Penguin Books, 1964.

Lemagny, J. C. *Visionary Architects: Boullée, Ledoux, Lequeu.* Houston: University of St. Thomas, 1968.

Lippard, Lucy. *Overlay: Contemporary Art and the Art of Prehistory.* New York: Pantheon Books, 1983.

———. *Six Years: The Dematerialization of the Art Object from 1966 to 1972.* New York: Praeger, 1973; reprint, Berkeley: University of California Press, 1997.

Livingston, Jane, and Marcia Tucker. *Bruce Nauman.* New York: Los Angeles County Museum of Art and Praeger Publishers, 1973.

Love, Brian. *Play the Game.* Los Angeles: Reed Books, 1978.

Lyotard, Jean-François. *Phenomenology.* Trans. Brian Beakley. Albany: State University of New York, 1991.

Macann, Christopher. *Four Phenomenological Philosophers: Husserl, Heidegger, Sartre, Merleau-Ponty.* London: Routledge, 1993.

Machen, Arthur. *Tales of Horror and the Supernatural.* Ed. Philip Van Doren Stern. New York: Alfred A. Knopf, 1948.

Marter, Joan, ed. *Off Limits: Rutgers University and the Avant-Garde, 1957–1963.* Newark: Newark Museum; New Brunswick: Rutgers University Press, 1999.

Matthews, W. H. *Mazes and Labyrinths: Their History and Development*. New York: Dover Publications, 1970.

McLuhan, Marshall. *The Gutenberg Galaxy: The Making of Typographic Man*. New York: New American Library, 1969.

McShine, Kynaston L. *Information*. New York: Museum of Modern Art, 1970.

Mercier, Jacques. *Ethiopian Magic Scrolls*. New York: George Braziller, 1979.

Merleau-Ponty, Maurice. *Phenomenology of Perception*. Trans. Colin Smith. London: Routledge & Kegan Paul, 1962; reprint, New York: Routledge, 1989.

———. *The Primacy of Perception and Other Essays on Phenomenological Psychology, the Philosophy of Art, History and Politics*. Ed. James M. Edie. Evanston, Ill.: Northwestern University Press, 1964.

———. *Signs*. Trans. Richard C. McCleary. Evanston, Ill.: Northwestern University Press, 1964.

Meyer, James. *Minimalism: Art and Polemics in the Sixties*. New Haven: Yale University Press, 2001.

Moran, Dermot. *Introduction to Phenomenology*. London: Routledge, 2000.

Morris, Robert, *Continuous Project Altered Daily: The Writings of Robert Morris*. Cambridge, Mass., and New York: MIT Press and Solomon R. Guggenheim Museum, 1993.

Nauman, Dietrich, ed. *Film Architecture: Set Designs from Metropolis to Blade Runner*. Munich: Prestel, 1996.

Nietzsche, Friedrich. *Beyond Good and Evil: Prelude to a Philosophy of the Future*. Trans. Walter Kaufmann. New York: Vantage Books, 1966.

Onorato, Ronald J. *Labyrinth: Symbol and Meaning in Contemporary Art*. Norton, Mass.: Watson Gallery, Wheaton College, 1975.

Peckham, Morse. *Man's Rage for Chaos: Biology, Behavior, and the Arts*. New York: Schocken Books, 1967.

Rackin, Donald. *Alice's Adventures in Wonderland and Through the Looking-Glass: Nonsense, Sense, and Meaning*. New York: Twayne Publishers, 1991.

Rank, Otto. *Art and Artist: Creative Urge and Personality Development*. New York: Alfred A. Knopf, 1932; reprint, New York: W. W. Norton, 1989.

Rawson, Philip. *The Art of Tantra*. Greenwich, Conn.: New York Graphic Society, 1973.

Reinhardt, Debra L. *Laumeier Sculpture Park: Ten Sites: Works, Artists, Years*. St. Louis: Laumeier Sculpture Park, 1992.

Righini Bonelli, M. L., and T. Settle. *The Antique Instruments at the Museum of History of Science in Florence*. Florence: Arnaud, 1978.

Robert Morris. Washington, D.C.: Corcoran Gallery of Art, 1969.

Robins, Corinne. *The Pluralist Era: American Art 1968–1981*. New York: Harper & Row, 1984.

Róheim, Géza. *Magic and Schizophrenia*. New York: International Universities Press, 1955.

Rosen, Nancy D., and Edward F. Fry. *Projects in Nature: Eleven Environmental Works Executed at Merriewold West, Far Hills, New Jersey*. Far Hills, N.J.: Merriewold West, 1975.

Rosen, Randy, and Catherine C. Brawer, *Making Their Mark: Women Artists Move into the Mainstream, 1970–85*. New York: Abbeville Press, 1989.

Rudofsky, Bernard. *Architecture without Architects: A Short Introduction to Non-Pedigreed Architecture*. New York: Museum of Modern Art, 1965.

Sardar, Ziauddin. *Thomas Kuhn and the Science Wars*. New York: Totem Books, 2000.

Schimmel, Paul, ed. *American Narrative/Story Art: 1967–1977*. Houston: Contemporary Arts Museum, 1978.

Schmidt, Paul, ed. *Meyerhold at Work*. Trans. Paul Schmidt, Ilya Levin, and Vern McGee. Austin: University of Texas Press, 1980.

Scully, Vincent. *The Earth, the Temple, and the Gods: Greek Sacred Architecture*. New York: Frederick A. Praeger, 1969.

Sculpture at Cranbrook, 1979–1980: Stackhouse, Aycock, Armajani, Hall. Bloomfield Hills, Mich.: Cranbrook, 1980.

Sewell, Elizabeth. *The Field of Nonsense*. London: Chatto and Windus, 1952.

Silver, Alain, and James Ursini. *The Vampire Film: From Nosferatu to Interview with the Vampire*. New York: Limelight Editions, 1997.

Simon, Joan, ed. *Bruce Nauman*. New York: D.A.P., 1994.

Singer, Charles. *From Magic to Science: Essays on the Scientific Twilight*. London: Ernest Benn, 1928.

Sonfist, Alan, ed. *Art in the Land: A Critical Anthology of Environmental Art*. New York: E. P. Dutton, 1983.

Sorkin, Michael, ed. *Variations on a Theme Park: The New American City and the End of Public Space*. New York: Hill and Wang, 1992.

Spence, Jonathan D. *The Memory Palace of Matteo Ricci*. New York: Viking, 1984.

Steinberg, Leo. *Other Criteria: Confrontations with Twentieth-Century Art*. New York: Oxford University Press, 1972.

Steinberg, Saul. *The Labyrinth*. 1954. Reprint, New York: Harper & Brothers, 1960.

Stoops, Susan L., ed. *More than Minimal: Feminism and Abstraction in the '70s*. Waltham, Mass.: Rose Art Museum, Brandeis University, 1996.

Symons, James M. *Meyerhold's Theatre of the Grotesque: The Post-Revolutionary Productions, 1920–1932*. Coral Gables: University of Miami Press, 1971.

Tibbets, Paul, ed. *Perception: Selected Readings in Science and Phenomenology*. Chicago: Quadrangle Books, 1969.

Tschumi, Bernard. *Architecture and Disjunction*. Cambridge, Mass.: MIT Press, 1994.

Tucker, Marcia. *Robert Morris*. New York: Praeger Publishers for the Whitney Museum of American Art, 1970.

Tucker, Marcia, and James Monte. *Anti-Illusion: Procedures/Materials*. New York: Whitney Museum of American Art, 1969.

Uddin, M. Saleh. *Axonometric and Oblique Drawing: A 3-D Construction, Rendering, and Design Guide*. New York: McGraw-Hill, 1997.

Van Berkum, Ans, and Tom Biekkenhorst. *Science and Art*. Utrecht: Fentener van Vlissinger Fund, n.d.

Vasari, Giorgio. *Lives of Seventy of the Most Eminent Painters, Sculptors, and Architects*. Ed. E. H. and E. W. Blashfield and A. A. Hopkins. Vol. 1. New York: Charles Scribner's Sons, 1896.

———. *Vasari on Technique*. Ed. G. Baldwin Brown. Trans. Louisa S. Maclehose. New York: Dover, 1960.

Venturi, Robert. *Complexity and Contradiction in Architecture*. Museum of Modern Art Papers on Architecture. New York: Museum of Modern Art in association with the Graham Foundation for Advanced Studies in the Fine Arts, Chicago, 1966.

Venturi, Robert, Denise Scott Brown, and Steven Izenour. *Learning from Las Vegas: The Forgotten Symbolism of Architectural Form*. Cambridge, Mass.: MIT Press, 1972.

White Jr., Lynn. *Machina ex Deo: Essays in the Dynamism of Western Culture.* Cambridge, Mass.: MIT Press, 1968.

———. *Medieval Technology and Social Change.* Oxford: Clarendon Press, 1962.

Williams, John. *Early Spanish Manuscript Illumination.* New York: George Braziller, 1977.

Williams, Thomas A. *Eliphas Lévi: Master of Occultism.* Tuscaloosa: University of Alabama Press, 1975.

Wines, James. *De-Architecture.* New York: Rizzoli International, 1987.

Wines, James, and Herbert Muschamp. *Site.* New York: Rizzoli, 1989.

Wittgenstein, Ludwig. *Philosophical Investigations.* Trans. G. E. M. Anscombe. 3rd ed. Englewood Cliffs, N.J.: Prentice Hall, 1958.

Yates, Frances A. *The Art of Memory.* Chicago: University of Chicago Press, 1966.

Selected Articles

Albright, Thomas. "Alice Aycock's Personal Flights of Fancy." *San Francisco Chronicle,* 29 August 1979, p. 54.

Apgar, Evelyn Froggatt. "Machine in the Sculpture Garden." *Douglass Alumnae Bulletin* 58, no. 1 (Fall 1982), pp. 10–11.

Artner, Alan. "Alice Aycock Sculpture: A Roller Coaster Ride through the Middle Ages." *Chicago Tribune,* 6 February 1983.

Baker, Elizabeth, "Sexual Art-Politics." *Artnews* 69 (January 1971), pp. 30–33.

Baker, Kenneth. "A Close Read of Main Library's Art." *San Francisco Chronicle,* 12 April 1996.

Barthes, Roland. "The Structuralist Activity" and "To Write: An Intransitive Verb?" In Richard and Fernande DeGeorge, eds., *The Structuralists from Marx to Lévi-Strauss.* Garden City, N.Y.: Doubleday, 1972, pp. 148–167.

Benezra, Neal. "Surveying Nauman." In Joan Simon, ed., *Bruce Nauman.* Minneapolis: Walker Art Center, 1994, pp. 13–46.

Blankenstein, Amy. "Commissions." *Sculpture* 15 (May/June 1996), pp. 20–21.

Bois, Yve-Alain. "From –Infinity to 0 to +Infinity: Axonometry, or Lissitzky's Mathematical Paradigm." In *El Lissitzky: Architect, Painter, Photographer, Typographer.* Eindhoven: Municipal Van Abbemuseum, 1990.

Bourgeois, Jean-Louis. "Reviews." *Art in America* 65 (July/August, 1977), p. 94.

Chave, Anna C. "Minimalism and Biography." *Art Bulletin* 82, no. 1 (March 2000), pp. 149–163.

Crary, Jonathan. "Projects in Nature, Merriewold," *Arts Magazine* 50 (December 1975), pp. 52–53.

Davis, Judith March. "Sculpture Shock." *Rutgers Magazine* 70, no. 1 (Spring 1991), pp. 30–34.

Denton, Monroe. "Lexicon of the Work of Alice Aycock." *Arti* (January/February, 1995), pp. 58–79.

———. "Reading Alice Aycock: Systematic Anarchy." *Sculpture* 9, no. 4 (July/August 1990), pp. 48–51.

De Vuono, Frances. "Alice Aycock: John Weber Gallery." *New Art Examiner* 16 (September 1988), p. 54.

Diamond, Jamie. "Heavy Metal: Sculptor Alice Aycock's Outside Vision," *Lears* 4, no. 8 (October 1991), pp. 84–87.

Eisenman, Stephen F. "Alice Aycock, John Weber Gallery." *Arts Magazine* 57 (January 1983), pp. 40–41.

Felder, Carol. "Alice Aycock Competes with the World." *New Jersey Monthly* 4, no. 12 (October 1980), pp. 134–135, 137.

Fillin-Yeh, Susan. "The Technological Muse: Affiliation and Ambivalence in American Machine Imagery, 1840–1990." In *The Technological Museum*. Katonah, N.Y.: Katonah Museum of Art, 1990, pp. 12–26.

Fineberg, Jonathan. "Alice Aycock." In Jonathan Fineberg, *Art since 1940: Strategies of Being*. New York: Harry N. Abrams, 1995, pp. 388–395.

Fox, Howard N. "Selected Masterpiece." *Members' Calendar, The Los Angeles County Museum of Art* (July/August 1991), n.p.

——. "The Thorny Issues of Temporary Art." *Museum News* 57, no. 6 (July/August 1979), pp. 42–50.

Gebhard, David. "Charles Moore: Architecture and the New Vernacular." *Artforum* 5, no. 8 (May 1965), p. 53.

Glueck, Grace. "Art People." *New York Times,* 6 January 1978, p. C14.

——. "A Sculptor Whose Imagery Is Encyclopedic." *New York Times,* 15 August 1990, pp. C11, 14.

Hall, E.T. "Proxemics." *Current Anthropology* 9 (1968), pp. 83–108.

Halley, Peter. "The Crisis in Geometry." *Arts Magazine* 58 (Summer 1984), pp. 111–115.

Heinemann, Susan. "Reviews." *Artforum* 13 (Summer 1975), p. 78.

Kangas, Matthew. "Ceremonial Sculptures at the Nation's Edge: Aycock, McCafferty, Trakas." In Lawrence Hanson, *Site-Specific Sculpture Exhibition*. Bellingham: Western Gallery, Western Washington University, 1987, pp. 4–9.

Kaprow, Allan. "The Legacy of Jackson Pollock." *Artnews* 57, no. 6 (October 1968), pp. 24–26.

Kingsley, April. "Labyrinths, Philadelphia College of Art." *Artforum* 14 (February 1976), pp. 72–73.

——. "Six Women at Work in the Landscape." *Arts Magazine* 52 (April 1978).

Krauss, Rosalind. "Sense and Sensibility: Reflections on Post '60s Sculpture." *Artforum* 12, no. 3 (November 1973). Reprint in Amy Baker Sandback, ed., *Looking Critically: 21 Years of Artforum Magazine*. Ann Arbor: UMI Research Press, 1984, pp. 149–156.

Kwinter, Sanford. "Alice Aycock at John Weber Gallery." *Art in America* 71 (April 1983), pp. 180–181.

Larson, Kay. "Alice in Duchamp-Land." *New York* 14, no. 21 (25 May 1981), pp. 66–68.

——. "The See of Knowledge." *New York* 23, no. 29 (July 30, 1990), pp. 53–54.

Liebmann, Lisa. "Alice Aycock, Protetch-McNeil Gallery, NY." *Artforum* 22 (November 1983), pp. 75–76.

Lippard, Lucy. "Complexes: Architectural Sculpture in Nature." *Art in America* 67 (January 1979), pp. 86–97.

——. "Sculpture Sited at the Nassau County Museum." *Art in America* 65 (March 1977), p. 120.

Lorber, Richard. "Reviews." *Artforum* 15 (Summer 1977), pp. 64, 65.

Lubell, Ellen. "Mid-Winter Melange: Projects: Alice Aycock." *Soho Weekly News* 5, no. 15 (12–18 January 1978), p. 31.

Mifflin, Margot. "What Do Artists Dream?" *Artnews* 92 (October 1993), pp. 144–149.

Morgan, Stuart. "Alice Aycock: A Certain Image of Something I Like Very Much." *Arts Magazine* 52 (March 1978), pp. 118–119.

———. "Machine Works: Philadelphia Institute of Contemporary Art." *Artforum* 19 (Summer 1981), pp. 97–98.

———. "The Skateboard on Middle Ground: 'Looking' at Documenta 6." *Artscribe* 9 (November 1977), pp. 30–37.

———. "The State of Ideas, New York Chronicle." *Artscribe* 11 (1978), pp. 42–47.

Morris, Robert. "Aligned with Nazca." *Artforum* 14 (October 1975), pp. 26–39.

———. "American Quartet." *Art in America* 69, no. 10 (December 1981), pp. 92–105.

———. "The Present Tense of Space." *Art in America* 66 (January/February 1978), pp. 70–81.

———. "Notes on Sculpture, Part I," *Artforum* 4, no. 6 (February 1966), pp. 42–44; "Notes on Sculpture, Part II," *Artforum* 5, no. 2 (October 1966), pp. 20–23; "Notes on Sculpture, Part III," *Artforum* 5, no. 10 (June 1967), pp. 24–29.

Moser, Charlotte. "Aycock Looks beyond Formulas." *Chicago Sun-Times* (February 27, 1983), p. 5.

Muschamp, Herbert. "Room for Imagination in a Temple of Reason." *New York Times,* 12 May 1966, p. H54.

Nevins, Deborah. "An Interview with Mary Miss." *Princeton Journal: Thematic Studies in Architecture* 2 (1985), pp. 96–104.

Nochlin, Linda. "Why Are There No Great Women Artists?" In Vivian Gornick and Barbara Moran, eds., *Women in Sexist Society: Studies in Power and Powerlessness.* New York: Basic Books, 1971.

Phillips, Patricia C. "Alice Aycock: Doris C. Freedman Plaza." *Artforum* 26 (November 1987), p. 135.

Poirier, Maurice. "The Ghost in the Machine." *Artnews* 85, no. 8 (October 1986), pp. 78–85.

Pope-Hennessy, John. "Giovanni di Paolo." *Metropolitan Museum of Art Bulletin* 46, no. 2 (Fall 1988).

Richard, Paul. "Prop Art: Alice Aycock's Stagy Tower at 12th and G." *Washington Post,* 23 February 1980, B1.

Risatti, Howard. "The Sculpture of Alice Aycock and Some Observations on Her Work." *Woman's Art Journal* 6, no. 1 (Spring/Summer 1985), pp. 28–38.

Robbe-Grillet, Alain. "A Fresh Start for Fiction." In Barney Rosset, ed., *Evergreen Review Reader: A Ten-Year Anthology.* New York: Castle Books, 1968.

Rosen, Nancy D. "A Sense of Place: Five American Artists." *Studio International* 193 (February 1977), pp. 115–121.

Russell, John. "Houses, Nudes and a Clue to the Biennale." *New York Times,* 19 March 1978, pp. C31, C35.

Schneckenburger, Manfred. "Aycock: Project Planned for Burnet Woods Site." *Cincinnati Enquirer,* 6 May 1979, p. C24.

Schwartz, Joyce Pomeroy. "Public Art." In Joseph A. Wilkes, ed., *Encyclopedia of Architecture,* vol. 4. New York: John Wiley & Sons, 1989, pp. 112–139.

Sharp, Willoughby. "Nauman Interview." *Arts Magazine* 44, no. 5 (March 1970), pp. 22–27.

Simon, Joan. "Report from San Francisco: Art for Tomorrow's Archive." *Art in America* (November 1996), pp. 40–47.

Stein, Donna. "Reinventing the World through Art." In Donna Stein, ed., *Alice Aycock: Waltzing Matilda.* East Hampton, N.Y.: Guild Hall Museum, 1997.

Thorson, Alice. "An Artist on the Edge: Sculptor Alice Aycock Carves Out Images of Power and Danger." *Kansas City Star,* 12 October 1995, p. F6.

Tsai, Eugenie. "A Tale of (at Least) Two Cities: Alice Aycock's 'Large Scale Dis/Integration of Microelectric Memories (A Newly Revised Shantytown).'" *Arts Magazine* 56 (June 1982), pp. 134–141.

Tuchman, Phyllis. "An Interview with Carl Andre." *Artforum* 8, no. 10 (June 1970), pp. 55–61.

Van Damme, Leo. "Alice A. in Wonderland: The Investigations of Alice Aycock." *Arte Factum* (April/May 1984), pp. 16–21.

Van Wagner, Judith K. "Air-Built by Aycock." *Artery: The National Forum for College Art* 5, no. 2 (November/December, 1981), pp. 4–5.

Index

Page numbers in boldface type indicate illustrations.

415